THE LAST PRE-RAPHAELITE

THE LAST
PRE-RAPHAELITE

Edward Burne-Jones
and the Victorian Imagination

Fiona MacCarthy

For Anne,
with all good wishes,

Fiona MacCarthy

ff

faber and faber

First published in 2011
by Faber and Faber Ltd
Bloomsbury House
74–77 Great Russell Street
London WC1B 3DA

Typeset by RefineCatch Limited, Bungay, Suffolk
Printed in England by TJ International, Padstow, Cornwall
Designed by Ron Costley

A CIP record for this book
is available from the British Library

ISBN 978–0–571–22861–4

2 4 6 8 10 9 7 5 3 1

Contents

Illustrations

Black and White Photographs

THE LAST PRE-RAPHAELITE

7 Alice and John Lockwood Kipling. Bateman's, Burwash, Sussex. National Trust.

8 Dante Gabriel Rossetti and friends at 16 Cheyne Walk, photograph by W. & D. Downey. Virginia Surtees.

9 John Ruskin and Dante Gabriel Rossetti, photograph by W. & D. Downey. Trustees of the Watts Gallery, Compton, Surrey/The Bridgeman Art Library.

10 Jane Morris at 16 Cheyne Walk, photograph by John R. Parsons. Victoria & Albert Museum, London/The Stapleton Collection/The Bridgeman Art Library.

11 Maria Zambaco in Greek dress. Anne Conran.

12 Maria Zambaco, photograph by Frederick Hollyer. Trustees of the Watts Gallery, Compton, Surrey/The Bridgeman Art Library.

13 Edward Burne-Jones with George and Rosalind Howard at Naworth Castle. Peter Nahum At The Leicester Galleries.

14 Rosalind Howard on the day-bed in her drawing room at 1 Palace Green. William Waters.

15 The Burne-Jones and Morris families at the Grange, photograph by Frederick Hollyer. Private collection.

16 Frances Graham and her sister Amy. Frances Horner, *Time Remembered*, 1933.

17 Sir Coutts and Lady Lindsay *carte de visite*. Private collection.

18 Aubrey Beardsley, photograph by Frederick Henry Evans. Private collection.

19 Oscar Wilde, photograph by Napoleon Sarony.

20 The Grange, North End Lane, Fulham. Royal Borough of Kensington and Chelsea Archives.

21 Sitting room at the Grange, photograph by Frederick Hollyer. National Monuments Record.

22 Music room at the Grange, photograph by Frederick Hollyer. National Monuments Record.

23 The Garden Studio at the Grange. National Monuments Record.

24 Margaret Burne-Jones. Hammersmith and Fulham Archives.

x

Illustrations in Text

The Burne-Jones Macdonald
Family Tree

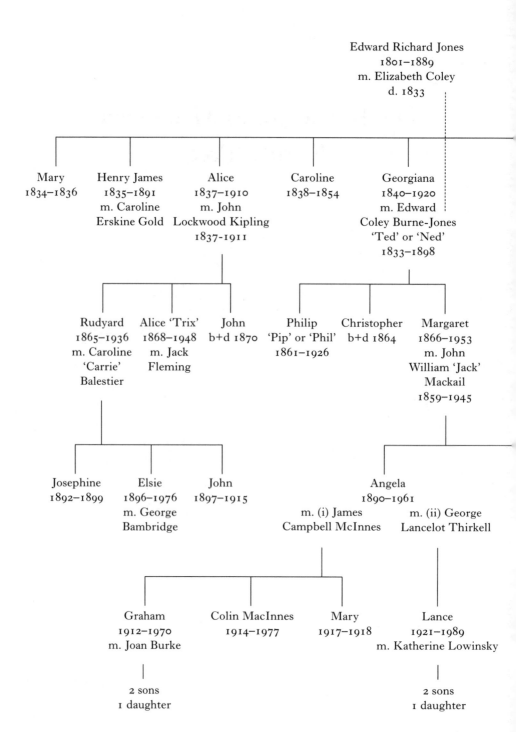

Edward Richard Jones
1801–1889
m. Elizabeth Coley
d. 1833

Mary
1834–1836

Henry James
1835–1891
m. Caroline
Erskine Gold

Alice
1837–1910
m. John
Lockwood Kipling
1837-1911

Caroline
1838–1854

Georgiana
1840–1920
m. Edward
Coley Burne-Jones
'Ted' or 'Ned'
1833–1898

Rudyard
1865–1936
m. Caroline
'Carrie'
Balestier

Alice 'Trix'
1868–1948
m. Jack
Fleming

John
b+d 1870

Philip
'Pip' or 'Phil'
1861–1926

Christopher
b+d 1864

Margaret
1866–1953
m. John
William 'Jack'
Mackail
1859–1945

Josephine
1892–1899

Elsie
1896–1976
m. George
Bambridge

John
1897–1915

Angela
1890–1961

m. (i) James
Campbell McInnes

m. (ii) George
Lancelot Thirkell

Graham
1912–1970
m. Joan Burke

Colin MacInnes
1914–1977

Mary
1917–1918

Lance
1921–1989
m. Katherine Lowinsky

2 sons
1 daughter

2 sons
1 daughter

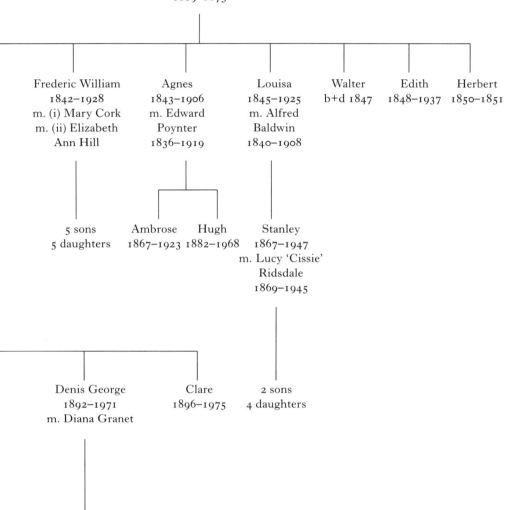

George Browne Macdonald
1805–1868
m. Hannah Jones
1809–1875

Frederic William
1842–1928
m. (i) Mary Cork
m. (ii) Elizabeth
Ann Hill

Agnes
1843–1906
m. Edward
Poynter
1836–1919

Louisa
1845–1925
m. Alfred
Baldwin
1840–1908

Walter
b+d 1847

Edith
1848–1937

Herbert
1850–1851

5 sons
5 daughters

Ambrose Hugh
1867–1923 1882–1968

Stanley
1867–1947
m. Lucy 'Cissie'
Ridsdale
1869–1945

Denis George
1892–1971
m. Diana Granet

Clare
1896–1975

2 sons
4 daughters

2 daughters

Preface

When Edward Burne-Jones died in 1898 a memorial service was held in Westminster Abbey, after special intervention from the Prince of Wales. The Abbey was packed and the sense of grief was genuine. This was the first time an English artist had been honoured in this way. The unworldly young recruit to the once derided Pre-Raphaelite movement had arrived at a unique position in late Victorian Britain: Sir Edward Burne-Jones, by now a baronet, had become an elder statesman of Victorian art. His driving force had always been a moral one; like his friend William Morris he was set against the age. But in many ways Burne-Jones had encapsulated it. He had become the licensed escapist of his period, perpetrating an art of ancient myths, magical landscapes, insistent sexual yearnings, that expressed deep psychological needs for his contemporaries. His paintings released forces half-hidden in the deep recesses of the Victorian imagination.

Burne-Jones had been a man of violent responses and antipathies who was apt to thrust a red-hot poker through a book he disapproved of, and he believed boldly in the power of art to counteract the spiritual degradation, the meanness and corruption he saw everywhere around him in the ruthlessly expansionist, imperialistic Britain of the nineteenth century. Crooked statesmen, unjust laws, rampant commercialisation. His visionary paintings offered an alternative scenario of the immaterial which for his

admirers became realer than the real. What did Burne-Jones mean by beauty? This is what he said:

I mean by a picture a beautiful romantic dream of something that never was, never will be – in a light better than any light that ever shone – in a land no one can define or remember, only desire – and the forms divinely beautiful.

Burne-Jones is a tantalising subject for biography partly because of his enormous productivity. He did just so much, in such different directions, with that very Victorian hyper-energy. As an artist Burne-Jones was extraordinarily versatile, working in a diversity of techniques and materials on many different scales. He resists any easy definition. Besides his large-scale paintings and whole sequences of pictures he made thousands of designs for stained glass, embroidery and tapestry, hand-painted furniture, clothes, shoes and jewellery. Loving music, Burne-Jones even started a campaign for the reform of piano design. In collaboration with William Morris he made numerous illustrations for books.

He never stopped designing. An evening's entertainment, after a hard day in the studio, would be the rapid drawing out of a cartoon for his latest stained-glass window, with his friends and his family gathered around. One of the problems for anybody trying to keep track of his chronology is his tendency to work on several assignments simultaneously. There was always a queue of projects in his mind. A painting begun in, say, 1869 might be abandoned for two decades then brought out again and finished in a frenzy of activity for an exhibition. Many works were never completed at all. *Unpainted Masterpieces*, one of the most brilliant of his self-caricatures, shows the artist in the studio overcome with shame, as a stack of blank canvases piles up in the background. Burne-Jones clients had to brace themselves for a long wait.

His character too can be maddeningly evasive. A peculiar doubleness pervades his personality. He was neurotic, depressive, prone to violent mood swings. The melancholy dreamer who seemed so withdrawn and solemn could suddenly become uproariously merry, whimsical and bantering with that particular Victorian

style of silliness. His laugh, we are told in the memoirs of the period, was 'of the Ho-ho! kind'. Visitors to his house would watch with fascination the sudden transformation of 'the mage into the conjuror at a children's party, like meeting the impish eyes of Puck beneath the cowl of a monk'. Burne-Jones was friends with many actors – Henry Irving, Ellen Terry, Sarah Bernhardt – and there was a strong element of staginess in him.

His charm was legendary. For one of his chief clients, the rising politician Arthur Balfour, Burne-Jones was simply the most charming man he ever met. People loved Burne-Jones for his intelligence and sweetness, his empathy and wit. But he was unpredictable. They knew they could not nail him. 'I want to reckon you up and it's like counting clouds,' John Ruskin once complained. Compared with Burne-Jones, his close friend William Morris – whose life I wrote some years ago – had been straightforward. Morris's personality had a grand consistency. Burne-Jones prevaricates and teases, tries to slip away.

So how to pin down a man with an innate resistance to biography? Burne-Jones had himself thrown out the challenge I found quite irresistible: 'lives of men who dream are not lives to tell, are they? . . . What is there to say about an artist or poet ever? . . . My life is what I long for, and love, and regret, and desire, and no one knows on earth.' I realised this was a book I had to take my time on. I allotted four years to it; it took me nearer six.

I felt it was a book that would need a lot of travel. One way to comprehend him was examining his places: Birmingham, the burgeoning industrial city that was Burne-Jones's birthplace; Oxford where Burne-Jones was an undergraduate and where he first discovered his vocation as an artist; London and especially West Kensington where Burne-Jones's house, The Grange, became so famous in its period as a beacon of Aesthetic Movement taste.

Most important was the tracing of his travels around Italy, a kind of artistic apprenticeship for him as he studied the great Italian artists of the fifteenth and sixteenth centuries. I followed the routes of his four journeys made in 1859, 1862, 1871 and 1873 to Venice and Florence and gradually south through Tuscany to

Rome, seeing what he saw and recorded in his notebooks and his sketchbooks, gradually understanding the paintings and the buildings that gave him such high moments of excitement. Burne-Jones returned to England Italianised. From then on his art would be crucial in the forming of the English dream of Italy that still persists.

One of my intentions in writing this biography has been to bring Burne-Jones out from under William Morris's shadow. He is all too often seen as Morris's rather wimpish junior partner, an idea in which he himself colluded in his beautiful cartoons of the two of them together. This ridiculously simplifies the truth. They were of course close friends, in a friendship dating back to Oxford when they were undergraduates together. They were working partners in the decorating firm set up by William Morris, the enterprise that became the highly successful Morris & Co. But creatively Burne-Jones was more than Morris's equal. He was the greater artist although Morris was unarguably the greater man.

Socially they moved in rather different London circles, increasingly so as Burne-Jones was cultivated by the well-to-do intellectuals and aesthetes while Morris became a committed revolutionary Socialist. Having previously described the agonising rift that arose between them in the 1880s from Morris's viewpoint it was interesting to approach their political divergence from the other side. Burne-Jones remained convinced that an artist's fundamental role within society lay not in political activism but in concentrating all his energies into producing works of art. This is a political debate that still continues. What precisely is an artist *for*?

Another of my main aims in this book has been to bring Burne-Jones's wife Georgiana much more into the foreground than she has been in previous biographies, including her own two-volume *Memorials* published in 1904. Georgie had a lot to contend with in Burne-Jones's scandalous liaison with his Greek muse and model Maria Zambaco and his long line of later adorations. She put up for years with her husband scribbling those discursive, entreating, intimate illustrated letters to his adored women in another room. In the end I think his bad behaviour fortified her. Georgie's own

tendresse for William Morris, in the continuing and fascinating soap opera of Pre-Raphaelite life, encouraged her into political involvement. This was a woman who broke out of her own doll's house and became a respected and hard-working Parish Councillor in the Sussex village of Rottingdean.

Burne-Jones was never not in love. In life as in art he was always in pursuit. It may seem a bit simplistic to trace his desperation for love, sex, the physical connection to the death of his mother in his early infancy. But there is ever present in his own accounts of his feelings and worst nightmares the fear of the loved person being snatched away. The story of his complicated love life has been hampered by the lack of easily accessible documentation. There is still no published collection of his letters: an extraordinary vacuum since Burne-Jones's letters are not only interesting in themselves but give a unique insight into English cultural life in the second half of the nineteenth century.

The last full-scale Burne-Jones biography was Penelope Fitzgerald's published in 1975, a book I much admire, written with a novelist's sensitivity to the nuances of emotional history. However, not all the sources now emerging were available to her. A long trawl through the masses of Burne-Jones correspondence still in private archives, in local history libraries and family collections has yielded much new information. It is now becoming possible to arrive at a much fuller account of Burne-Jones's family relationships and sexual history, especially his devastating love affair with Maria Zambaco, than has been feasible before.

I have also had the advantage of Josceline Dimbleby's research into Burne-Jones's last serious liaison which was with her own great-grandmother Helen Mary Gaskell. Dimbleby tells the story in her book *A Profound Secret*, published in 2004. My own account of the affair has been amplified through Josceline Dimbleby's generosity in making available her full transcriptions of Burne-Jones's correspondence with his beloved May.

'I suppose I have learned my lesson at last,' he wrote to May Gaskell three years before he died, 'the best in me has been

love and it brought me the most sorrow.' Love was certainly the stimulus for the finest examples of Burne-Jones's art: Nimuë pursuing and tantalising Merlin; Phyllis clasping Demaphoön in a desperate embrace as she emerges from the almond tree; Pygmalion kneeling, daunted, at the feet of his own work, the living, breathing woman the sculptor has created; the mermaid dragging a lover to the unknown depths of a cruel ocean. These are images of passion but in the end bleak pictures of men's and women's incompatibility.

It is this bleakness of vision that connects him to a twentieth-century art of psychosexual exploration. His influence extended to Freudian Vienna, to Oskar Kokoschka, Egon Schiele and the glittery, complicated and disturbing erotic dream paintings of Gustav Klimt. You can find echoes of Burne-Jones's search for love and beauty and sexual fulfilment in the work of the Swiss Symbolist painter Ferdinand Hodler. There is evidence of the strong impression made by Burne-Jones's art on the young 'Blue Period' Picasso and Picasso's contemporary Barcelona painters. His preoccupation with sex was to be echoed in the work of Eric Gill and Stanley Spencer. Of all British twentieth-century artists it is Spencer, with his unrelenting candour and the strangeness of his vision, who relates most closely to Burne-Jones.

Burne-Jones, as we have seen, resisted a biography, valuing his privacy. But in every work he ever made he gives himself away. My main source for this book in the end has been his paintings, his beautiful embroideries, the decorated furniture, that most wonderful stained glass and the sequence of brilliant cartoons which are equally, or even more, revealing. The life is there, self-evident, embedded in the art.

THE LAST PRE-RAPHAELITE

Birmingham
1833–52

Burne-Jones as an artist was obsessed with themes of questing. The traumatic adventures of Perseus on his travels to capture the head of the snaky-haired Medusa; the young prince's ardent journey through the thorny thickets towards the Sleeping Beauty; the quest of Arthur's knights for the mystic Holy Grail. These stories formed the basis for Burne-Jones's major works in painting and in tapestry. He returned to these magic narratives again and again, on varying scales and in different media. In a sense they became the story of his life. There is of course an underlying element of fairy tale, of mythical progression, in the way in which Edward or 'Ted' Jones, born into respectable poverty in Birmingham, transformed himself into Sir Edward Burne-Jones Bart., one of the great figures of the Victorian age.

His quest was for beauty. Born as he was on 28 August 1833, just before Queen Victoria came to the throne, Burne-Jones was to witness a vast increase in Britain's industrial growth and mechanised production. He was brought up in a Birmingham that had been recklessly expanded in the late eighteenth and early nineteenth century to become one of the foremost industrial towns in the whole country and he set himself against the increasingly materialistic spirit of the age. 'I love the immaterial,' he used to claim, and his life was to be spent in redefining the scope of what human existence could be: a thing of sustained ecstasy and visible beauty. He was not an idle dreamer but a productive artist of

enormous energy with a work ethic as pronounced as any industrial entrepreneur in his native Birmingham. As his nephew-by-marriage Stanley Baldwin pointed out, there was 'iron and granite' in Burne-Jones's soul.

His lifelong hope was for a new manifestation of art, a public art that would provide the spiritual quality so blatantly missing in many contemporary lives. His concept of beauty was deceptively simple:

I have no politics, and no party, and no particular hope: only this is true, that beauty is very beautiful, and softens, and comforts, and inspires, and rouses, and lifts up, and never fails.

Burne-Jones was born into a household of desolation. His mother died on 3 September, only six days after giving birth to her first son. An older sister, Edith, had already died in infancy. Elizabeth Jones, 'Betsy' to her husband, had been a true daughter of Birmingham, the town whose prosperity was built upon the metal-working trades to such an extent that it was vulgarly referred to as 'the hardware village'. Betsy's father, Benjamin Coley, was a jeweller with a workshop in Caroline Street, at the centre of the burgeoning Jewellery Quarter, a network of little master's houses, craft workshops and small-scale factories. The Coleys seem to have been something of a dynasty of jewellers: several other Coleys are listed in contemporary trade directories. Jewellery design was a branch of the decorative arts at which Burne-Jones himself was later to excel.

The boy's father, Edward Richard Jones, was an outsider, brought up in London by his widowed mother. She had died by the time he met Miss Coley in Stourbridge where they both happened to be staying. There was a feeling amongst the Coleys that their daughter was marrying beneath her and certainly her fiancé carried with him an aura of nervousness and gloom, a strain of Celtic melancholy that descended to his son. The married couple settled at 11 Bennett's Hill in Birmingham, a newly built house and showroom in what was then regarded as an 'upstart street' in the rapidly expanding commercial centre of the town. The house

was almost certainly paid for by Benjamin Coley. Here Edward Jones established a carving, gilding and frame-making business which, almost inevitably, failed to thrive.

All the same, it had apparently been a happy marriage. There is no remaining portrait but Betsy was reportedly pretty and cheerful, with (an attribute desperately needed in that household) an unusual degree of practical common sense. She recited poetry eagerly and treasured the collected works of her favourite Romantic writers,

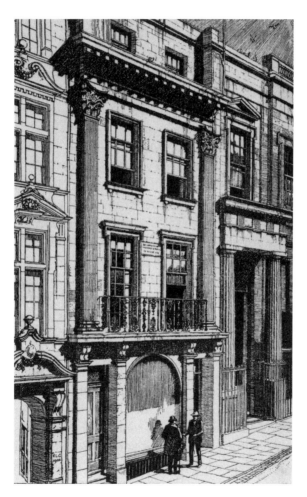

Bennett's Hill, Birmingham, Edward Burne-Jones's birthplace.

Coleridge, Byron, Keats and Walter Scott, the only books in an otherwise bookless house. For father and son her death was a disaster. Mr Jones, short and slight with a peculiarly small head, was innocent and pious. He was 'a very poetical little fellow', as his son later described him, 'tender-hearted and touching, quite unfit for the world into which he was pitched'. He was now appalled at the prospect of fending for himself. Physically his behaviour to the child was alarmingly erratic. For the first few years he could not bear to take the infant in his arms. Then he did a volte-face and clung to his small son, taking him on visits to his mother's grave on Holloway Head hill as soon as the child was old enough to walk there. She had died on a Sunday and these tearful expeditions became a Sunday ritual with the result that Burne-Jones always hated Sundays. The fierce grip of the father's large hand on the son's small one as they sat there at the graveside remained a painful memory in his old age.

His own guilt at his mother's death persisted. 'I don't think it is ever out of my mind what hurt I did when I was born,' he told his confidante and muse May Gaskell in the 1890s. He claimed that this had made him kind to women ever after, as a kind of recompense. But he was deceiving himself. With the women Burne-Jones loved – and there were to be many – he was gallant and protective, empathetic and cajoling, with the sweetness and charm that became a Burne-Jones trademark. But he could also be possessive and demanding, constantly in need of reassurance. The tragedy of his own upbringing had left him vulnerable. He was always apprehensive that any moment the object of his devotion would be snatched away.

As he later came to see it, the depressive tendencies to which Burne-Jones was always prone 'began with my beginning' and became 'a deep sunk fountain in me'. The house on Bennett's Hill had its showroom in the front, a room with a red carpet stacked with mirrors, picture frames and sometimes a few paintings. A separate side entrance led into much more basic quarters for the family. At the back across the yard was the workshop where his father worked long hours, often from four in the morning until

midnight, returning to the house to snatch some sleep beside the child already in his little bed in the corner of the upstairs room they shared. With his remote and nervy father it was an austere childhood. Though his father worked so hard, they lived on the edge of poverty. An old friend's first recollection of Burne-Jones was of 'a little boy in a red frock shelling peas'.

The child's health suffered from the instability of being handed from one incompetent nurse to another. Things only improved once a permanent nurse-housekeeper, Ann Sampson, was recruited by a friend of his dead mother's. Miss Sampson, known as 'Sam', was a young working-class woman brought up in the country. She was a good-hearted girl who diagnosed with much anxiety Mr Jones's emotional paralysis, his inability to 'rejoice in his own son'. She was doggedly devoted but bewildered by the introspective boy she now had charge of. He retreated more and more into secrecy. By the time Burne-Jones was ten, as his widow Georgiana rather tartly observes in her *Memorials* of her husband, 'the foundations had been laid of that citadel of the soul in which through life he entrenched himself'.

It was not an artistic upbringing, though Burne-Jones showed a precocious aptitude for drawing. His father's choice of trade seems to have been almost an accident. The few paintings brought in to him for framing were conventional and uninspiring. Whilst remembering his father as a naive nature lover who would walk miles to see a corn-field, Burne-Jones recalled that 'Art was always a great bewilderment to him, and he couldn't have learned in a thousand years to discuss one thing about it.' One of their Birmingham neighbours, Mr Caswell, was more artistically confident, buying old paintings at local sales and then improving them himself. His tour de force was a little Turner oil of Boulogne harbour with a calm blue sea which he turned into a storm scene, overpainting it with swirling white waves.

He saw talent in Burne-Jones, lending the child his paintbox and keeping his early drawings inscribed proudly with the name of his young protégé and the date when each 'remarkable drawing' was done. Mr Caswell also gave him engravings to copy. One of these copies, a group of deer done when Burne-Jones was seven, was still

in existence when Georgiana Burne-Jones wrote her *Memorials* of her husband in 1904. He got carried away with ambitions for his protégé: 'He used to say', Burne-Jones remembered, 'he was sure I should be a great historical painter . . . but his notion of a great historical painting was the signing of the Magna Charter or the landing of the Prince of Orange or the Queen opening her first Parliament.' Decades later, when Mr Caswell saw Burne-Jones's Pre-Raphaelite painting of *The Merciful Knight*, his early patron was appalled.

But if not exposed to art that he found of any interest, Burne-Jones as a child read voraciously. He read and he absorbed with peculiar intensity the Romantic poetry his mother had bequeathed to him as well as *Aesop's Fables* and various tales of mystery and chivalry. The one that most affected him was 'Sintram', the story in Friedrich de la Motte Fouqué's *Seasons* and the subject of Dürer's engraving of the knight 'riding by the rock and horribles all about him'. For the solitary child, suffering from a weak chest, too delicate to go out playing, reading was his main occupation. 'Books, books, and always books were the gates of the new world which he was entering,' as his wife recorded, and this love of story-telling, the suspensefulness of narrative, was to be the basis of Burne-Jones's creativity. It's interesting in view of their later close friendship and artistic collaboration to see how Burne-Jones's early reading mirrored William Morris's. The boy in Birmingham, child of the lower middle class, was brought up on the same stories as the child of the rich bourgeoisie in rural Essex. They met with this background in common, a shared inner experience of beauty and romance.

At the age of four Burne-Jones watched with great excitement the procession celebrating Queen Victoria's coronation wend its way through a proud Birmingham, confident of its industrial prowess. He was thrilled to be allowed to wave a banner standing in front of the house at Bennett's Hill. Only two years later, in 1839, Burne-Jones's ineffective father was sworn in as a special constable, one of several hundred, to help quell the Chartist rioters. 'I was born in a fiery time,' Burne-Jones recalled. In those middle decades of the

nineteenth century Birmingham was politically volatile and, for a child, a rather terrifying place. Tensions between the workers and employers and the often dire conditions of the trade had made Birmingham a centre of radical agitation.

The Birmingham Political Union had been active in the struggle for parliamentary reform that led to the Reform Act of 1832. But unsatisfied by the government's concessions, and emboldened by success, the Political Union protests gathered strength until it appeared to the town's establishment that Birmingham was threatened with a revolution. Many thousand radical protesters held inflammatory meetings in the Bull Ring and took to the streets, battling with the police, armed with stones and iron railings, tearing down the shutters of the local shops. The rioting and looting went on for several months through spring and summer of 1839. A contingent of London police was imported; the military was called in, with dragoons and riflemen stationed at strategic points in the centre of the town while cavalry and riflemen scoured the neighbourhood making numerous arrests.

By the end of the summer the crisis died down, leaving the whole Bull Ring area in ruins with considerable costs to be defrayed by the town. The riots, not surprisingly, gave young Burne-Jones bad nightmares. He would wake to see his father and Miss Sampson, with their 'large anxious faces', standing beside his bed. These night horrors and infantile imaginings would continue all through his adult life, recurring dreams of 'dark frightening rooms and staircases and footfalls following me – and doors that are dreadful and beasts that frighten me'. His early awareness of the terrors of the town helped to form the kind of artist that Burne-Jones would become. Such violent local confrontation between the poor and prosperous, the desperate rioters and self-protective citizens of Birmingham, was the start of the radicalisation of an artist whose solemn mythic paintings say more of the condition of Victorian England than a great deal more overtly political art.

There is a pattern in Burne-Jones's life of female rescuers, quasi-fairy figures who emerge out of the mists to offer succour to the invalid child or, later, to the delicate young man. The first of

these was Amelia Choyce, a younger sister of his mother's and the third wife of a farmer in the depths of the country at Wootton, Warwickshire. She invited him to stay. Suddenly from being the only child in a small town house he found himself in the commotion of a large extended family living on a working farm with fields all round. He made special friends with his aunt's eldest stepdaughter Maria who was then in her mid-teens and would become the first of his long line of loving female confidantes. In his sudden mood of high-spirited release Burne-Jones, then four or five, would entertain the household with his caricature portraits. Already he was showing the sheer joy in human eccentricity that later poured out in little sketches in his letters to his friends.

Miss Sampson too arranged treats for him, taking him to Blackpool, hopeful that sea air would build his strength up. They travelled and shared lodgings in Blackpool with a Birmingham Jewish merchant's family who lived next door on Bennett's Hill. Burne-Jones's earliest extant letter dated 20 June 1842 was written in Blackpool. It reads: 'My dear Papa, I should be very happy to see you at Blackpool, if you could come. I like the town very much indeed, but I think it should not be called Blackpool as there is more white houses than red ones.' He has illustrated the letter with outline sketches of two birds. Next day he describes a Blackpool donkey ride, which he had much enjoyed, and also in gleeful detail an attack on Miss Sampson, also on a donkey, by a little boy who fastened a string around the donkey's leg. The donkey threw her off and 'caused a pain in her head'. The naughty boy ran off. Burne-Jones describes the episode coolly, a little cruelly. He was wary of Miss Sampson's potentially overwhelming fondness. He resisted her intrusiveness into his inner world. 'What are you thinking of, Edward?' she would ask him. He had his answer ready. It was always 'Camels.' Even as a child he had developed a certain ruthlessness.

In September 1844, when he was eleven, he started as a day boy at King Edward VI's School in Birmingham. The school was in the central town thoroughfare of New Street, very close to his home at Bennett's Hill. King Edward's, the local grammar school, a

charitable foundation where the pupils paid no fees, had been recently rebuilt to designs by Sir Charles Barry assisted by Augustus Welby Northmore Pugin in the grandiose Tudor Gothic style they were later to develop for the Houses of Parliament. The building reflected Birmingham's burgeoning civic ambitions, finally realised when it achieved official status as a city in 1889. Architecture in Birmingham consciously drew on historic styles to dignify the present. Birmingham's Town Hall, completed ten years earlier than King Edward's School, took its inspiration from a classical Greek temple. The original design for King Edward's had included a quasi-ecclesiastical central spire. An aura of high-mindedness and dignity was aimed for. The headmaster at the time Burne-Jones entered the school was the Revd James Prince Lee, an imposing figure remembered by a former pupil as 'swarthy, hirsute and black of hair, lofty yet condescending, clothed in the majesty of his gown'.

This formidable classical scholar had taught at Rugby under the famous Thomas Arnold. James Prince Lee was conscious of his mission in disseminating Arnold's ideals of virtue acquired through learning to the youth of Victorian Birmingham. Several of Burne-Jones's contemporaries became leading figures in the Church of England. Bishops Lightfoot and Westcott were ex-pupils of King Edward's, while E. W. Benson was destined to become Archbishop of Canterbury. Indeed a bishopric was seen by Burne-Jones's in some ways surprisingly ambitious father as the summit of achievement for his son. In appearance Burne-Jones could well have matured into a bishop. But in personality he was too whimsical and prankish. 'The Archbishop of Canterbury ought to go about in corduroys,' he reflected in old age. 'If I'd been Archbishop of Canterbury wouldn't I have made 'em jump!'

This streak of originality and independence had begun emerging when Burne-Jones was still a schoolboy. To start with he had found the experience intimidating. In its Gothic portentousness, the exterior by Barry, elaborate interior fittings by Pugin, the building itself was physically daunting. The boys entered from New Street through the 'solemn portal', guarded by 'the calm judicious porter of those days'. They gathered in a great stone undercroft, a

typically Puginesque assembly of high vaulted roof, stone floor and seats and stained-glass windows with 'Edwardus Rex Fundator' in slanting Gothic letters. From the undercroft rose a grand theatrical stone staircase leading to the two big teaching rooms. King Edward's revered old boy Archbishop Benson claimed that for him as a schoolboy this had been a source of inspiration heavenward.

However, the reality of day-to-day existence for pupils at King Edward's was a great deal more mundane and, for a child of Burne-Jones's sensitivity, alarming. Before and after school hours the surging crowds of boys erupted through the corridors. The general hubbub, fighting, shouting reached a pitch that would remind one former pupil of 'a certain scene in Dante's Inferno'. Even in class, order was only kept by 'lavish use of corporal punish-ment', consisting of three or four hard strokes of the cane on the palm of the hand. Bullying was rife. Burne-Jones was all too evidently bullyable. 'I was the kind of little boy you kick if you are a bigger boy,' he later said; 'only once I remember a fattish boy fell when I hit him – but I think he did it out of kindness.'

One of the most persistent of Burne-Jones's tormentors would wait for him after school and turn him upside down, trundling him home on his hands, 'wheelbarrow fashion'. Another terrifying episode took place during school prayers when a boy who hated him surreptitiously stabbed him in the groin. He remembered the moment of feeling something warm trickling down his leg and finding it was blood. He was sick and then fainted and was taken home by one of the masters in a cab. The incident was never officially reported. Even Burne-Jones's father was not told.

Violent fights would often break out in the streets between King Edward's boys and town boys. The unruliness within the school was mirrored and encouraged by the wider violence of the town enlarging so rapidly beyond its natural limits. By the middle 1840s Birmingham's population was approaching a quarter of a million. Building and sanitation were glaringly inadequate. The whole town 'reeked with oil and smoke and sweat and drunkenness'. The pupils at the school could not avoid the often bestial scenes of

prizefighting and dogfighting and cockfighting. One of Burne-Jones's contemporaries recorded how

The country was going to hell apace . . . We were nearly all day boys, and we could not make short cuts to school without passing through slums of shocking squalor and misery, and often coming across incredible scenes of debauchery and brutality. I remember one Saturday night walking five miles from Birmingham into the Black Country, and in the last three miles I counted more than thirty lying dead drunk on the ground, nearly half of them women.

Even in the relatively respectable, salubrious environment of Bennett's Hill there were lurid scenes of domestic violence. A sadistic neighbour of the Joneses regularly horsewhipped his two sons with great ferocity. Burne-Jones never forgot the awful sound of it, 'the crack of the whip and the howl of the boy'. The boys would then be bundled out into the streets to wander in the night. One of them died of his abusive treatment, the other attempted to take poison. Yet the father was a well-regarded citizen.

But Burne-Jones as a boy was surprisingly resilient. He gradually developed strong and special defences. He was unusually intelligent. Originally he had entered King Edward's as a pupil in the English School, the commercial department recently established as part of the rebuilding and expansion of the school with the aim of providing a more practical form of education for Birmingham boys who would go into local trade or manufacturing. One might see this as precursor of the later discredited twentieth-century secondary modern stream. Most of these boys would leave school at sixteen. However, after four years in the English School, when he was fifteen, Burne-Jones was transferred to the Classical School where the education had the traditional Greek and Latin basis deemed suitable for gentlemen and essential for boys going on to university. The school insisted that all boys should have a sponsor and Burne-Jones was formally transferred to the Classical School on the recommendation of John Aston, a Birmingham button manufacturer, perhaps a friend or a connection of his jeweller relatives the Coleys.

He did well in the classics department, taking general prizes for Greek and Latin, history and religion and regularly winning

special prizes for drawing and for maths. One day he arrived home with a whole armful of prizes, wrapped them in the doormat and fainted flat on top of them. This was a highly strung and unpredictable young man. By autumn 1851 he had been promoted to the top class of the school. The love of classical mythology – the intense mysterious narratives of Cupid and Psyche, Venus and Aeneas, Perseus and the Graiae, the luring of the sirens (Burne-Jones was especially susceptible to sirens) – remained with him all his life and permeated his whole view of things. For Victorian male connoisseurs of art, with their own shared education in the classics, this reworking and reimagining of the myths of men and gods familiar since schooldays was part of his appeal.

He began to acquire his legendary breadth of knowledge. Burne-Jones haunted the school library. Amongst books he devoured were Layard's on Nineveh, Catlin's on the American Indians, Curzon's *Monasteries of the Levant*. No subject was too remote or too arcane. At fifteen he had embarked on writing his own history of the ancient world; later he would also start on 'An Epitome of Ancient Chronology, from the creation of the world to the birth of our Lord', an enterprise which, like Mr Casaubon's great oeuvre in George Eliot's novel *Middlemarch*, was evidently too ambitious ever to be finished. With a friend from King Edward's, Cormell Price, Burne-Jones established a museum of relics, curiosities, fossils, coins and minerals on the top floor of his father's house. Even more than Greece and Rome, Burne-Jones's interests were tending towards the far-flung and exotic, the civilisations of Babylon and Nineveh, Persia and Egypt. Building on this intellectual grasp and sense of widespread wonder, his art became a thing of endless possibilities. He promised to May Gaskell later, in the 1890s:

I'll open a little magic window – and you shall choose what land you will see, and what time in the world – you shall see Babylon being built if you like, or the Greeks coming into Greece, or the north Sea tossing and full of ships – or the piety of ancient France – plaintive notes of ancient Ireland, Kings of Samarcard – Nibelungen terrors – ah! I have raked with greedy hands into my treasure house since I was a mean wretched looking little object of ten till now.

It was this mastery of magic, this exotic range of reference, that gave him such a hold on the Victorian imagination.

Already at King Edward's he was drawing with the greatest of enjoyment and proficiency. 'Figure after figure, group after group would cover a sheet of foolscap almost as quickly as one could have written,' a school friend recollected, 'always without faltering or pausing, and with a look as if he saw them before him.' As he drew he went on talking. He drew and coloured maps showing roads and towns and sea monsters and ships, conjuring up extraordinary journeys. Drawing seemed to come to him absolutely naturally, then and later, absorbed into his daily existence. His drawings, said his wife, 'filled up moments of waiting, moments of silence, or uncomfortable moments, bringing everyone together again in wonder at the swiftness of their creation, and laughter at their endless fun'. They were Burne-Jones's means of negotiating his way into society. At King Edward's the shy and awkward son of the frame maker on Bennett's Hill made himself a centre of attention with his fantastical drawings of legions of small devils and caricatures of the masters most disliked.

Burne-Jones's caricatures led on to more ambitious subjects, ranging from dramatic warlike scenes from Roman history to treatments of such lurid contemporary subjects as the 1842 massacre in the Khyber Pass, missiles raining down on soldiers helplessly imprisoned by the vertical rocks, and Lady Sale's heroic intervention in the First Afghan War. Here is another parallel with William Morris, who made himself popular at boarding school at Marlborough by telling spellbinding stories to other boys. Burne-Jones had obvious natural ability but it appears that the level of the teaching he received both at King Edward's School and in the evening classes he attended at the Birmingham School of Design, one of a network of provincial art schools founded on the initiative of Sir Henry Cole, was only moderate. It was unfortunate that the drawing master at King Edward's and the director of the School of Design were one and the same Thomas Clark, a conventional landscape artist whose values did not interest a pupil already absorbed in the narrative possibilities of drawing. He was also, according to

Burne-Jones, lazy and self-absorbed. In fact so ineffective did Clark prove as a teacher he was forced to resign from the School of Design in 1851.

When Burne-Jones later claimed 'if there had been one cast from ancient Greek Sculpture or one faithful copy of a great Italian picture to be seen in Birmingham I should have begun to paint ten years before I did', it is possible to argue that the boy could have searched further for artistic reference points. For example, the Society of Artists in Temple Row in Birmingham held annual exhibitions showing work by almost all the leading contemporary artists. Visits to Charles Spozzi and his wife, good friends of Burne-Jones's early patron Mr Caswell, in their house in Hereford would have exposed him to their considerable collection of paintings by Birmingham's best-known living painter, David Cox. But he was apparently immune to such potential influence, strangely self-contained with a glimmering awareness of his own ability and of the potential social power of art.

Once he had entered the Classical department at King Edward's Burne-Jones began to make important friendships, some of which lasted all his life. His close circle in Birmingham included Richard Watson Dixon who became a Pre-Raphaelite poet and a clergyman, correspondent with and mentor of Gerard Manley Hopkins. Dixon's weird poem 'The Wizard's Funeral' appears in the anthologies of Victorian verse. Another friend, William Fulford, also became a poet, although of less distinction. Wilfred Heeley, a Fellow of Trinity College, Cambridge, had a promising career in the Indian Civil Service before dying young. Edwin Hatch became a classics professor and vice-principal of St Mary Hall at Oxford. Cormell ('Crom') Price, who had helped Burne-Jones with his museum, was the first headmaster of United Services College at Westward Ho, model for headmaster Bates in Kipling's *Stalky & Co*. Burne-Jones's nephew-by-marriage Rudyard Kipling was to be the most famous of pupils at Crom's school.

Of this close-knit group of friends, Henry ('Harry') Macdonald was in terms of his career the least significant. He failed his exams at Oxford and then failed in business in the States. But from the

point of view of Burne-Jones's personal history Harry was of the utmost importance in that his sister Georgiana was eventually to become Burne-Jones's wife. All in all, it was a remarkable group to emerge at one time from a provincial grammar school. These were idealistic and earnest young men affected for life by their upbringing in Birmingham at such a period of social flux. Looking back on those early days of friendship, a contemporary wrote:

the vision of high-souled ardent youth is indeed a radiant one. It was a time of quick springing life and abundant blossoming of great admirations, of devotion to high ideals, and boundless enjoyment of poetry and art.

The language is that of the chivalric novels of Charlotte M. Yonge. Much of Burne-Jones's life would be a history of brotherhoods: brotherhoods attempted, male friendships and groupings sometimes painfully dissolved. Here in Birmingham he found himself drawn into the first of these brotherhoods of valiant young men against the evils of the world.

It is at this point that we have the first description of Burne-Jones as seen by his future wife Georgiana Macdonald in 1852 when he visited the family home in Handsworth. The Macdonalds' father, the Revd George Browne Macdonald, was a Methodist minister recently transferred on the Methodist circuit from Huddersfield to Birmingham. Georgiana at the time was a child of twelve or so; Burne-Jones himself was in his nineteenth year. The girl was aware of 'an early maturity' about him, a sense of something in reserve. She describes him as:

Rather tall and very thin, though not especially slender, straightly built and with wide shoulders. Extremely pale he was, with the paleness that belongs to fair-haired people, and looked delicate, but not ill. His hair was perfectly straight, and of a colourless kind. His eyes were light grey (if their colour could be defined in words), and the space that their setting took up under his brow was extraordinary: the nose quite right in proportion, but very individual in outline, and a mouth large and well moulded, the lips meeting with absolute sweetness and repose. The shape of his head was domed, and noticeable for its even balance; his forehead, wide and rather high, was smooth and calm, and the line of the brow over the eyes was a fine one. From the eyes themselves power simply radiated,

and as he talked and listened, if anything moved him, not only his eyes but his whole face seemed lit up from within.

The young Burne-Jones was rather handsome, intense and almost medieval in appearance like one of his own knights in a San Grail tapestry. Yet he remained fixed in the belief that he was hopelessly plain. He depicts himself ruthlessly as a figure of pathos, ramshackle and hideous, in hundreds of his wonderful self-caricatures.

To his future wife, the young girl in the pinafore who opened the door to him on his Handsworth visits, her older brother's school friend seemed attractive but erratic. He would always love small children, especially female ones, and on his first visit he astonished Georgiana by seizing her youngest sister Edith, a child of about three, trapping her between his knees and pulling grotesque faces to amuse her. He was unused to children and surprised that Edith was alarmed. When roused by a subject his vehemence was startling. On the last of his visits to Handsworth, his farewell to the Macdonalds, who were moving on to London, someone mentioned a certain girl and said she was a flirt. Edward's face lit up with interest and a flood of words rushed out: 'A flirt's a beast, a bad beast, a vile beast, a wicked beast, a repulsive beast, an owl, a ghoul, a bat, a vampire.' Flirty women, like small girls, would be important in his life.

In those last years at King Edward's his horizons opened out. His regular visits to the art-loving Spozzis in Hereford on the edge of Wales, so close to the country of the melancholy Joneses, returned him to a sense of his Celtic roots. He gave his address on a letter to a school friend as 'Land of Caradoc, Bank of the Wye'. As a boy he had already been entranced by reading Macpherson's edition of the Celtic tales of Ossian. He and Crom Price used to read the book aloud to one another, pacing about in the old Birmingham cemetery. Even though he was later to be told Macpherson was a forgery, 'it couldn't be quite choked out of me and there was a forlorn note in it that gently broke my heart, like the blessed word "Mesopotamia"'. Now as he explored the romantic hilly countryside round Hereford and made little expeditions to the coast of Wales, impressed by the

beauty of the ships and sea, absorbing the seafaring legends of the Norsemen, Burne-Jones laid the foundations of his working life. He was to be both creating and responding to Victorian sensibilities in the general fascination with Celtic art and legend. The belief in his own Celtishness was ever present. He was later to acknowledge 'whatever I do in art, even if I deal with Greek or Norse legends, I want it in the spirit of a Celt'.

A lifelong enthusiasm for music began on his visits to Hereford. His hosts, the Spozzis, were intensely musical themselves, he singing and she playing the cello. As well as holding musical evenings at home, which Burne-Jones attended, they were much involved in the wider musical life of the cathedral. One of their friends was the dynamic Townsend Smith, cathedral organist and conductor of the already famous 'Three Choirs' whose Triennial Festivals he inaugurated.

At this period Burne-Jones also discovered London. Every summer from 1848 he visited his aunt Keturah, always to be referred to by his wife as 'the little aunt at Camberwell'. The exotically named Keturah, with her ever youthful optimism and her dark glancing eyes, was Edward Richard Jones's only sister. Once their father, Edward Biven Jones, had died young Keturah was adopted by her elderly great-uncle Edward Biven. There was little direct contact between the families. A question of snobbery? According to Georgiana, 'the carver-and-gilder's shop had always a little troubled her'. However, Keturah and her husband Thomas Burne had been godparents by proxy to Edward at his baptism in 1834 in St Philip's Church in Birmingham when the names given to the child were Edward Coley Burne. So Thomas, his uncle by marriage, was responsible for the Burne in Burne-Jones.

By the time her unknown godson came to visit her in Camberwell, Aunt Keturah was already on her third successful marriage. Mr Burne had been forty years older than Keturah, a friend and contemporary of her great-uncle. When he proposed to her he was in fact the guardian of his nineteen-year-old intended bride, who accepted the situation with composure, still calling her new husband Thomas Burne 'papa' and perching beside him on a footstool. When two younger

friends of her husband's – Robert Young and James Catherwood – both fell in love with her she kept both of them dangling until Thomas Burne was dead, leaving a substantial inheritance. Keturah was free to choose. First she married Robert Young, and when he himself died after eleven happy years, she married the still devoted James Catherwood. The Dickensian complexity of Keturah's story was a source of delight to Burne-Jones, a Dickens fan ever since he was a young man when he had once seen 'the immortal-eyed and ever glorious Dickens' acting in a play for charity in Birmingham Town Hall.

The letters he wrote home from his London visits to the Catherwoods exude the excitement of his new experiences. His uncle James took him on guided tours of the city: to St Paul's Cathedral; to the Bank of England where to the boy's amazement banknotes to the value of a million pounds were pressed into his hands; to Whitehall to see the place where Charles I was beheaded. He went on his first fascinated visits to the Zoo in Regent's Park, reporting to his father, 'Oh! I've been to the Regent's Zoological Society and seen the Hipp-hip-hip-(hurrah) opotamus, – a great, fat, huge, unwieldy, ugly, grovelling pig, with eyes duller than lead, a huge mouth, enormous jaws, monstrous head, puny legs, preposterous proportions.' The Zoo or 'Beast Garden' as he called it would remain one of his favourite places for an outing right into old age. His acute visual awareness of the oddities of animals, not just the hippopotami but elephants and tortoises, lions, bears and cobras, worked into his imagination, emerging in his animal cartoons and the fantastical beasts in many of his paintings. This mixture of humour and wonder in his attitude to animals was an essentially Victorian thing, just as evident in Lewis Carroll's stories and verses and William De Morgan's pottery.

It was also around 1850 that he paid the first of many visits to the British Museum. The museum became a prime source of inspiration at a time when he responded more easily to objects than to paintings. One of his letters describes how he had spent 'a considerable time' in the Nimroud or Assyrian room. 'I was quite surprised', he writes, 'at the clearness and beauty of the Sculpture. The bas-reliefs seem to be as perfect as when they emerged from

the workmen's shop, tho' not quite so clean.' He loved the closely written inscriptions and the scenes of violent action on the bas-reliefs: scenes of hunting, scenes of battle, tremendous sieges vividly described in the build-up of their detail:

A large battering-ram holding two warriors, one of which is discharging arrows and another shielding both, is the most prominent object. Several persons are swimming upon inflated skins. The besieged are hurling down large stones. The women are tearing their hair, a priest on the walls is offering incense.

Already he is strikingly aware of dramatic narrative and content. As he describes roaming through the Ethnographical rooms, the Zoological gallery, the Mammalia saloon you can sense how deeply these antiquities were moving him: 'the Lycian, Nimroud, Phigalian, Elgin, Egyptian, Etruscan, and above all the Fossil rooms put me into ecstasies'. It was not simply a matter of their age or of their size, though he shows a still schoolboyish excitement at the 'colossal-enormous' Egyptian figures in which a fist alone could be nearly four feet high. What is so revealing in these early letters is Burne-Jones's already sophisticated sense of the vast reserves of knowledge and beauty that awaited him to draw on from these fascinating artefacts of the ancient world.

In the Catherwood household he found a bonus uncle in the form of James Catherwood's brother Frederick, antiquary and explorer who had happened to touch down in Camberwell while Burne-Jones was there. Frederick was himself a meticulous architectural and antiquarian draughtsman who had worked with Sir John Soane. As a young man he had been an intrepid traveller, visiting Karnak and Baalbec and disguising himself in order to get into the Mosque of Omar in Jerusalem. He was the only one of Burne-Jones's relations to have any real influence on his artistic development. The drawings of remnants of long-dead civilisations made as Catherwood travelled through Central America made a great impression on the boy already entranced with cartography and ancient monuments, and the explorer-uncle was well aware of Burne-Jones's latent talent. But Catherwood was drowned when

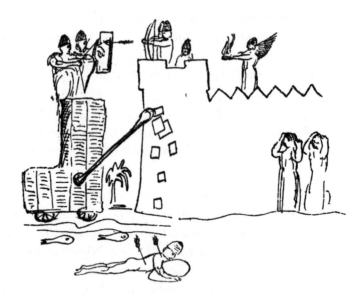

Sidon under siege by Assarhaddon. Sketch made at the British Museum in 1850 when Burne-Jones was a schoolboy.

the American steamship *Arctic* went down off Newfoundland in 1854.

In later life Burne-Jones would become a regular though discriminating theatregoer with several actresses amongst his closest friends. It was while staying with the Catherwoods that he had his earliest experience of the London stage. He was taken by his Uncle James to the Lyceum, which was then under the management of Charles Mathews. He stood in the pit and watched a performance of the magical adventure play *The Golden Branch*. The memory remained with him right into old age:

there was a beautiful fairy came down the golden branch and held out something, and I thought it was too beautiful ever to be, and I wondered, if I waited till I was grown up, whether she would be too old for me to marry her, which I should think would be more than probable, as she was very likely over forty and I wasn't above fourteen.

His first intimation of an alluring female, of which there would be many, and of love's all too frequent impossibility?

His 'peculiar catch of a laugh' was what the other boys remembered. In those final years at school Burne-Jones had established himself as a great joker, at the centre of his circle. He could make others laugh and would often double up with laughter himself, sometimes getting so excited he would slide down from his chair and roll around in contortions on the floor. But in spite of these outbursts of hysterical humour he was an essentially solemn young man, deeply religious as many of his friends were, considering the Church as 'his natural destination'. At this stage he had no concept of a career in art. Many of his high-speed sketches took the form of a young priest standing robed before an altar. He showed one of these to his friend Dixon with the comment 'That is what I hope to be one day.' To Frederick Catherwood's daughter Annie he went further, signing a letter 'Edouard Cardinal de Byrmynhame'.

His religion took a highly emotional form as he left the Evangelical Church party of his upbringing, the mainstream Church of England favoured by his father, and aligned himself with the then still controversial High Church movement known as the Tractarian or Oxford Movement. The Movement had been initiated in Oxford by three leading churchmen and university fellows, John Henry Newman, John Keble and Edward Bouverie Pusey, in 1833. It demanded a new interpretation of the Thirty-Nine Articles, a restoration of the ritual and ceremony of the ancient Church with a renewed emphasis on the central sacramental mysteries of the holy mass. Here was a new religion for disaffected youth, ready made for the 'abundantly susceptible and responsive' group of friends at King Edward's, Birmingham in the late 1840s who saw in this revived spirituality the means of combating the poverty and squalor they were conscious of around them. As described by Burne-Jones's future brother-in-law Frederic Macdonald:

The afterglow of the Oxford Movement was still in the sky, and it was not in the sphere of religion above that it made itself felt. It had rediscovered

the Middle Ages; it had banished for a while the eighteenth century and all its works – to come back again by and by with new meaning; it had given fresh stimulus to Art, and had reinforced the romantic and emotional elements of literature. So far as the theological side of the Movement was concerned, I think I am right in saying that every member of the group was influenced by it for a while.

Burne-Jones was later to suggest that his espousal of the Oxford Movement was an example of his automatic support for the minority cause. But for him more than for his King Edward's contemporaries there was a strong aesthetic dimension. Ceremonial entranced him. He remembered being taken as a child to a Catholic chapel where he watched the unfamiliar ritual of the service, snuffing up the odour of the incense: 'I used to think what a pity it was all wicked.' He was naturally drawn towards the beauty of the ancient Church, its buildings and its services. During his stay with the Spozzis in Hereford, the architecture of the medieval cathedral, then still unrestored, had made a great impression. The susceptible young man became a protégé of the recently ordained Reverend John Goss, a popular and personable young cathedral clergyman with a fine tenor voice.

Unusually in that cathedral environment, Goss was a High Churchman. He had been at Oxford during the intense and excitable time in the middle 1840s in which Newman seceded from the Anglican Church and became a Roman Catholic. Under Goss's influence the young Burne-Jones became an ardent Newmanite. Coincidentally, once he had been ordained as a priest of the Roman Catholic Church, Newman was appointed Superior of the new Birmingham Oratory at Maryvale, and Burne-Jones later described how when he was a schoolboy he trudged many miles on Sunday evenings to hear Newman preaching. 'Wherever he had told me to go then I would have gone. Lord! What a wheyfaced maniac I was.'

One obvious thing he responded to in Newman was his doctrine of austerity, his spiritual challenge to the wastefulness and self-indulgence of the Victorian bourgeoisie. 'In an age of sofas and cushions he taught me to be indifferent to comfort; and in an age

of materialism he taught me to venture all on the unseen.' Burne-Jones was later to attribute to Newman's charismatic personality his own built-in indifference to money or luxury or honours or any of the other temptations in the 'world's trumpery treasure house'. Even more important to him was Newman's concept of the potential for integrity within one single human life: 'he stands to me', Burne-Jones wrote later, 'as a great image and symbol of a man who never stooped, and who put all this world's life in one splendid venture, that he knew, as well as you or I, might fail, but with a glorious scorn of everything that was not his dream'.

At the age of eighteen he made an unforgettable visit to Mount St Bernard Abbey, a Cistercian monastery in Charnwood Forest. Burne-Jones was staying nearby with his hospitable relations the Choyces who had now moved from Warwickshire to a cheese farm in Leicestershire not far off. Mount St Bernard had been commissioned in the little wave of Roman Catholic revivalism sweeping through Britain in the 1840s by Ambrose Phillips, a young Catholic convert from a Whig family of Leicestershire landowners. The architect for this, the first new monastery to be built in England since the Reformation, was another young Catholic convert, A. W. N. Pugin, whose uplifting religious-medieval style was already familiar to Burne-Jones from Pugin's design work at King Edward's School.

The monastery deep in the forest land at Charnwood was conceived as the centre of a self-contained religious community and school, an ambitious expression of the Romantic Catholicism of the mid-nineteenth century. Even as a boy Burne-Jones had a highly developed sense of the chivalric combined with the yearning for a brotherhood. He was already, in spirit, on the fringes of this movement. His visit to Charnwood, where he met a friendly and persuasive monk, influenced him seriously towards monasticism. Though so far as we know he only went there once, Burne-Jones kept Charnwood in his inner mind as an ideal of constructive religious life in the rural English heartland. 'More and more my heart is pining for that monastery in Charnwood Forest,' he wrote in the midst of the London social whirl of 1896.

Burne-Jones was still strongly under Newman's influence when he went to Oxford in January 1853. This was to be his first step towards ordination. From now on, although he still returned on visits, he unlatched himself from Birmingham with the decisiveness and touch of ruthlessness that was part of his driven personality. He removed himself from the small house in the Birmingham suburbs, no. 1 Poplar Place, Bristol Road, to which the family had moved from Bennett's Hill in 1851. This was the house Burne-Jones's wife remembered as 'destitute of any visible thing that could appeal to the imagination; chairs, carpets, tables and table furniture each duller and more commonplace than the other'. To make ends meet, part of the house had been occupied by lodgers and Burne-Jones had still shared a small bedroom with his father. Over the next few years he would gradually detach himself not just from Poplar Place, but from the 'little father' too, and from the well-meaning but increasingly possessive Miss Sampson who had become neurotically jealous of his outside activities and his King Edward's friends.

He set himself against the whole environment of Birmingham, the ramshackle slums, the badly nourished inhabitants, the crude and ugly townscape caused by too rapid industrial development: 'blackguard, button-making, blundering, beastly, brutal, bellowing, blustering, bearish, boiler-bursting, beggarly, black Birmm'. Its brashness could drive him to despair. He claimed he didn't know he had a soul till he left Birmingham. 'I can't think it matters at all how I paint or what I am if I ever had the baseness to be born in such a hole,' he cried out to George Howard in the 1860s after a two-day visit to his native town. His friend Howard was in line to succeed to the earldom of Carlisle. He was later to tell the art writer Julia Cartwright, 'Birmingham is my city according to the facts, which I always rebel against as far as possible, but in reality Assisi is my birthplace.' He liked to claim St Francis as his patron saint.

But Burne-Jones's attempts to disown Birmingham were fantasies. It was obvious to him, as it would be to those who understood his work, that his upbringing in Birmingham affected him profoundly. The visionary quality implicit in his art, with its

emphasis on myth and legend, its obsessive search for beauty and romance, provides both a negation of and challenge to the mid-nineteenth-century urban environment in which he had grown up. 'When I work hard and paint visions and dreams and symbols for the understanding of the people I shall hold my head up better.' This was a thoroughly Birmingham ambition. With its pent-up energy and its ideals of betterment, Burne-Jones's native town gave him his sense of purpose and extraordinary staying power. Birmingham made him the artist that he was.

Oxford
1853–5

Burne-Jones's first sight of Oxford came in early June 1852 when he arrived uneasily at Exeter College to sit his matriculation papers. His impecunious father had relied upon him winning an exhibition to study at Oxford. But when a rival pupil at King Edward's won the exhibition Mr Jones was still determined to send his son to university at his own expense. Although to start with Burne-Jones had no connections with Oxford, over the years the city grew on him, affected him through various vicissitudes and phases, became such a place of intimate experience he came to refer to it as 'my own country'. Both intellectually and aesthetically, Oxford played a crucial role in his development.

The city Burne-Jones arrived in was the greatest contrast to his childhood Birmingham of endless wet Saturdays and sprawling suburbs, the huddle of small factories and little master's metal-working shops. The railway had only recently reached Oxford and the medieval city was still more or less intact. As travellers reached Oxford they would see the towers of the colleges and churches rising from the meadows and orchards encircling the city. Burne-Jones's first sight of the city was the same as that of Jude in Thomas Hardy's novel *Jude the Obscure*.

Architecturally Oxford was all of a piece: a grey stone city varied with an occasional yellow ochre wash on the pebble-dash houses in the poorer streets. There were still many old houses decorated externally with wood carving and stone carving. The Victorian

Gothic suburbs and the Cowley workers' houses had not yet arrived. It was a city of containment and consistency, completely dominated by the university. 'Oxford is a glorious place; god like! At night I have walked around the colleges under the full moon, and thought it would be heaven to live and die there.' So Burne-Jones wrote home to his father in a rush of early enthusiasm.

This still largely fifteenth-century Oxford encouraged the dream life that one finds in Burne-Jones's paintings. It was his place of early visions of the romantic, wistful, highly coloured medieval world. There is a sense of almost crazy ecstasy in the report sent to his father of a wintry visit to the Godstow Abbey ruins, the fragmentary remains of a Benedictine nunnery near Oxford where the legendary Fair Rosamond was believed to have been buried. This was one of many Burne-Jones pilgrimages to the site:

The day has gone down magnificently; all by the river's side I came back in a delirium of joy, the land was so enchanted with bright colours, blue and purple in the sky, shot over with a dust of golden shower, and in the water, a mirror'd counterpart, ruffled by a light west wind – and in my mind pictures of the old days, the abbey, and long processions of the faithful, banners of the cross, copes and crosiers, gay knights and ladies by the river bank, hawking parties and all the pageantry of the golden age – it made me feel so wild and mad I had to throw stones into the water to break the dream.

Such visions stayed in his mind, most directly evident in the watercolour *Fair Rosamond* painted by Burne-Jones around 1863, but still to be seen in his much later illustrations and tapestries. Intensely remembered imagery of Oxford, its townscape and its countryside, its winding streets and stone-roofed houses, waterways and bridges became part of his intimate topography.

The scale of the place suited him, the quietness and sweetness of its atmosphere, the quirkiness of character allowable, indeed encouraged, in an Oxford where donnish idiosyncrasies became a way of life. Burne-Jones, the caricaturist, adored oddities. He liked the scope for fantasy in the city that was also Lewis Carroll's Oxford. The creator of *Alice in Wonderland*, under his real name Charles

Lutwidge Dodgson, had entered Christ Church the year before Burne-Jones first arrived at Exeter. Burne-Jones later described the charm of Oxford's eccentric isolation: 'all friends and all one's world tied up in the little city – and no news to come – only rumours and gossips at the city gate, telling things a month old, and all wrong'.

Later in Burne-Jones's life Oxford became his place of solace and reinvigoration. He would retreat there for a day or two in times of emotional crisis, or when he had reached stagnation in his work, and wander round the favourite landmarks of his youth. Besides the always overwhelming beauty of the city he was strengthened by reminders all around him of Oxford's intellectual *raison d'être*, the assumption so built-in it remained more or less unspoken that the things of the mind mattered. Of all Victorian painters Burne-Jones was to become the most supremely intellectual.

Not everyone responded to the intellectuality of Burne-Jones's work, the range of scholarly reference, the literary bias. Henry James for example imagined critics saying that Burne-Jones's work was 'not painting, and has nothing to do with painting. It is literature, erudition . . . a reminiscence of Oxford, a luxury of culture.' James, although a friend of Burne-Jones, reluctantly admitted such a view though brutal was largely accurate: 'Oxford occupies a very large place in Mr. Burne-Jones's painting.' The feeling that Burne-Jones is intellectually demanding to the point of obscurity has dogged his reputation. But it is precisely this rich vein of allusiveness some people most admire.

Before he even got to Oxford Burne-Jones had succumbed to one of the nervous collapses that troubled him all his life. Through his teens he had always been delicate and easily tired after even slight exertion. But this was the most acute illness yet, lasting several weeks. He recovered enough to take up his place at Oxford in the middle of January 1853.

It was a disappointing start. Though several friends and con-temporaries from King Edward's – including William Fulford and Richard Watson Dixon – were also now at Oxford they formed their own nucleus in Pembroke College, which had traditional

connections with the school. Burne-Jones found himself isolated at Exeter, the college recommended to him by his Tractarian mentor in Hereford, the handsome and persuasive Reverend John Goss. Exeter turned out to be a bad choice: 'It was clear we had lighted on a distasteful land,' Burne-Jones reported sadly. Of his fellow undergraduates at Exeter roughly half were 'reading men', narrowly focused on their studies of the classics or scholastic theology, while the rest of the college consisted of the rowdies, brash young men who rowed and hunted, ate and drank intrepidly and shocked the prim, unworldly Burne-Jones with their uncouth manners and their boasting about sex. It seems that Exeter was top of the league table for recklessness and loutishness: 'this College is now the Brasenose of old times, very fast indeed'. The situation was made worse by overcrowding. Burne-Jones's entry had already been deferred by a term because there was no space for him, and when he finally arrived there was a box-and-cox arrangement whereby freshmen were billeted in lodgings in the town during the day, returning to college at night to sleep in the temporarily vacant sitting room of older undergraduates' sets of rooms. For the nervy young man his early weeks at Exeter were an agony.

Burne-Jones came to Oxford fervently Tractarian, high-minded and pedantic. In his own description he was 'omniscient in all questions of ecclesiastical rights, state encroachments, church architecture and priestly vestments'. He expected to find Oxford just as Newman had left it, 'like a room' (as his wife so tenderly expressed it) 'from which someone he loved had just gone out, and where at every turn he would find traces of his friend'. He was bitterly disappointed to discover that the spirit of Newman, the reason why he had come to Oxford in the first place, was no longer the dominant influence it had been. The Oxford Movement, which had reached its climax around 1840, had lost its impetus once Newman had seceded to Rome. By 1853 the whole atmosphere had changed. He found no religious fieriness, only apathy and languor. Of the 40 per cent or so of Oxford undergraduates being prepared to enter the Church, as Burne-Jones himself was, he respected very few of them. He later made the comment that 'the

sort of material that was being made into parsons' in the Oxford of the time would have prompted anybody sane to lose all faith in clergy. A profound disillusionment was setting in.

But he made one lasting friend. 'There, shoulder to shoulder, stood his life's companion', as Georgiana Burne-Jones was to put it, sentimentally but truly. Burne-Jones's close friendship and his long collaboration, a creative partnership of more than forty years, with the designer and poet William Morris has become almost a legend. Morris & Burne-Jones: their two names have become so inseparably linked, like the names of great Victorian department stores – Marshall & Snelgrove, Debenham & Freebody – that the circumstances of their original coming together are obscured. It appears that Burne-Jones had first spotted William Morris back in 1852 in the Exeter examination hall when they were both sitting their matriculation papers. Burne-Jones had registered the rather odd appearance of the young man sitting next to him, with his impatient manner and the out-of-control hair that inspired the nickname 'Topsy' Burne-Jones later gave him. He noticed that his neighbour handed in a Horace paper early, scrawling 'William Morris' on the folded script. But they made no contact until both arrived at Exeter a few months later as undergraduates.

Their friendship, then immediate, is in a way surprising. Burne-Jones and William Morris came from very different milieus, Burne-Jones from the provincial urban lower middle classes, Morris from a rich capitalist southern counties family. His father was a successful bill-broker in the city; the family fortunes derived from copper mines in Cornwall. When Burne-Jones, naively unaware of William Morris's social status, arrived on a visit to the lavish Morris family mansion, Water House in a then rural Walthamstow, he was anxiously amazed. Where Burne-Jones had his free place at King Edward's School in Birmingham Morris was sent, expensively, to Marlborough to be equipped as a Victorian gentleman. Even physically they made a total contrast. As a couple they would later prove a gift to the cartoonists, Burne-Jones so tall, thin and gangling, Morris a great deal shorter, increasingly thick-set, abrupt and jerky in his movements. Walking around Oxford in the

purple trousers that for a time they both affected, they made a curious pair.

But the things that differentiated Burne-Jones and William Morris were a great deal less important than the shared preoccupations at the basis of their friendship. By October 1853, when both at last moved into rooms in college, they were already inextricably linked. Both, when they arrived at Oxford, were religiously committed. William Morris like Burne-Jones intended to become a clergyman and he too toyed with notions of going over to Rome. They both had a long history of reading the same books. They were steeped in, for example, Kenelm Digby's spiritual manual *Mores Catholici*, a book so sacred to them both that each had been nervous about mentioning the subject. Burne-Jones still kept *Mores Catholici* beside his bed in his old age, dipping into it during wakeful nights and early mornings. It remained a kind of safeguard, a reminder of his youth.

They discovered their shared background in Romanticism. William Morris was the precocious child who had read all Scott's Waverley novels by the time he was seven and who used to ride his pony in the little suit of armour his indulgent parents bought him, like a miniature knight from *Ivanhoe*. Both were already Tennysonians, familiar with Alfred Tennyson's popular poetic landscapes of reverie and magic and the Arthurian legends that Burne-Jones and William Morris would revert to and reanimate in their own works. Tennyson's 'Morte d'Arthur', the start of his elaborate Arthurian cycle *Idylls of the King*, had been published in 1842. One of Burne-Jones's earliest memories of Oxford was of Morris reading Tennyson's 'The Lady of Shalott' in his odd half-chanting voice, with great stress put on the rhymes. Morris hated to be read to. Burne-Jones did the listening.

Morris, then the more sophisticated in his outlook, introduced Burne-Jones at Oxford to things beyond the Romantic Christianity and love of literature they already shared. When Burne-Jones said 'Morris's friendship began everything for me; everything that I afterwards cared for', what exactly did he mean? What I think he was implying was that Morris opened out a new world of possibilities that were not simply literary and learned but visual and practical.

The boy from Birmingham who had been so recently the school-boy, 'stuffed to the finger-nails with newest knowledge, inclined to High Churchism with a marvellous respect for the powers that be, whether in church or state, a strong Tory, and with a political creed consummating in Charles the First', gradually became aware of whole new realms of interest beyond those of conventional scholarship. He was already a formidable intellect, a skilled disputer and a star performer in the fashionable intellectual pastime of logical positivist debate. But with Morris's exuberant, enthusiastic guidance Burne-Jones was introduced to art, craft, architecture and the life of the imagination.

Morris was certainly familiar with John Ruskin's writings on art and architecture before he got to Oxford and it is likely that Burne-Jones, while still in Birmingham, had discovered Ruskin too. In 1853, when volumes two and three of Ruskin's *The Stones of Venice* were first published, they both of them devoured it. Burne-Jones wrote of his second volume, the 'Sea Stories', 'His style is more wonderful than ever; the most persuasive oratory we ever read . . . There never was such mind and soul so fused by language yet.' For him Ruskin's diction had the brilliancy of Shakespeare's 'had he written in prose'.

Morris and Burne-Jones's friendship was an intellectual partnership but it was also based on the outdoors, on their intimate excursions together by the river and into the countryside. They took to long afternoon ramblings around Oxford studying the buildings, down the lanes and through the quads, examining in detail the cloisters and the bell towers, the libraries, the entrance gates, the college halls, the city's whole profusion of architectural history. A special haunt was the thirteenth-century Merton College chapel, which had been recently restored by the Victorian Gothic architect William Butterfield and where they were driven wild with admiration for the startlingly fresh colours of J. Hungerford Pollen's painted timber roof. They explored the city seriously and excitedly, conscious of Ruskin's views on the ideal integrity of medieval craftsmanship, his concept of the social and moral worth of architecture. Morris and Burne-Jones perambulating Oxford

took a close-up view of Ruskin and saw how radically he affected their own lives.

William Morris's store of information was unusual in so young a man. Burne-Jones eagerly described him to Crom Price, his friend in Birmingham, as 'one of the cleverest fellows I know, and to me far more congenial in all his thoughts and likings than any-one it has been my good fortune to meet with'. It was Morris's 'taste and criticism in art and aesthetics generally' that most impressed him, and Morris was casually generous in sharing his specialist knowledge. His speed of observation was extraordinary: he would seem to half-look at a thing and turn away, but the memory of it would stay with him for life. Together at Oxford they started to build up the great shared storehouse of experience and knowledge they would draw on in their work over the coming decades. They pored over the medieval manuscripts on public dis-play at the Bodleian Library, Morris sharing his enthusiasm for the splendidly painted and illuminated thirteenth-century Apocalypse that became his model of the ideal book. The enthusiasm lasted. In 1897, Burne-Jones was still pointing out: 'There are two arts which others don't care for that Mr. Morris and I have found our greatest delight in – painted books and beautiful tapestry.' Both these arts had the power to draw them back into a reimagined medieval world.

But the two young men were also conscious of the present. For both, and for Morris in particular, their growing love of the medieval was not mere nostalgia. It became a starting point for a whole social and political campaign, providing a critique of the current Victorian standards of design and manufacture and atti-tudes to art. Already William Morris had built up a resistance to what he would describe as 'the ordinary bourgeois style of com-fort' of his upbringing, the ponderous reception rooms and stuffy furnishings of the increasingly prosperous Morris family homes. In a gesture of juvenile defiance, when his family took him to the Great Exhibition in the Crystal Palace in Hyde Park in 1851 Morris refused to enter it, knowing that this immense display of industrial ingenuity and prowess would not be to his taste.

Burne-Jones too would have his Crystal Palace moment. In 1854, by which time the Crystal Palace had been moved and re-erected at Sydenham, Burne-Jones went to see it, dismayed by the extent of architectural sameness, 'its gigantic wearisomeness, in its length of cheerless monotony, iron and glass, glass and iron'. He decided that the Palace was 'a fit apartment for fragrant shrubs, trickling fountains, muslin-de-laines, eau-de-Cologne, Grecian statues, strawberry ices and brass bands'. The joint force of their decision would eventually result in the foundation of the famous design and decorating firm Morris, Marshall, Faulkner & Co., their own practical campaign against the age.

From the autumn of 1854 Burne-Jones and William Morris had rooms alongside one another in the Exeter Old Buildings. These overlooked Broad Street, separated by a little open space with trees. 'They were tumbly old buildings, gable-roofed and pebble-dashed', as Burne-Jones described them, and were soon to be pulled down to make space for new buildings designed in a bland style that would enrage the friends. For the moment they revelled in the oddness of the buildings, small dark passages that led from the staircase to the sitting rooms, little flights of steps descending and ascending for no reason. It was a *Charley's Aunt* set-up, comedic and chaotic. Suddenly your face was banged against a closing door.

Their friendship went on flourishing in this close proximity. It was certainly not a sexual relationship but, in the manner of so many mid-Victorian male friendships, especially in the high-flown Tractarian religious environment, it had an intensely romantic element. Burne-Jones wrote of William Morris to his friend Crom Price, 'he has tinged my whole inner being with the beauty of his own, and I know not a single gift for which I owe such gratitude to Heaven as his friendship. If it were not for his boisterous mad outbursts and freaks, which break the romance he sheds around him – at least to me – he would be a perfect hero.' From Oxford days onwards, even in the midst of their most serious creative working partnership, there was a constant jokiness between them, an undercurrent of larkiness and chaff.

It was noted by the friends who had known him at King Edward's that once he got to Oxford Burne-Jones had experienced a great inward change. Richard Watson Dixon described how 'he began to show a more decided and stronger character than at school'. Burne-Jones relaxed and mellowed, became more demonstrative. He saw this as a time when 'he felt his heart burst into a blossom of love to his friends and all the men around him'. It was friendship with Morris that had given him this onrush of confidence.

Pembroke College lies towards the south of Oxford, tucked into the hinterland behind St Aldate's Church and hemmed in by the ancient city wall. Besides Exeter, the other focus of activity for Burne-Jones at Oxford was the rooms in Pembroke occupied by the 'little Birmingham colony', ex-members of King Edward's School. The 'colony' consisted of the rather overbearing William Fulford, the gentle, poetic and slightly grubby Dixon, and the budding mathematician Charles Faulkner who also came from Birmingham though from a different school. They were joined in October 1854, much to Burne-Jones's joy, by Cormell Price. These were old friends together, easy and convivial, still quite innocent and childish in spite of their earnestness and intelligence. 'We chatted about life, such as we knew it,' wrote Burne-Jones of their regular evenings in Faulkner's rooms at Pembroke, conveniently placed on the ground floor on the corner of the old quadrangle. They also chatted about ghosts, 'which Dixon believed in religiously but Faulkner despised, and many an evening we wound up with a bear-fight, and so at 11, home to Exeter and bed'.

William Morris had been easily infiltrated into the Birmingham set. At first they had patronisingly regarded him just as a pleasant boy but they quite quickly got his measure, impressed, sometimes alarmed by his 'fire and impetuosity', his great bodily strength, his unpredictably hot temper and his alarming habit, when most exasperated, of raining down vigorous blows on his own head. When Morris began composing his own poetry the Birmingham coterie was filled with admiration. 'It was something the like of which had never been heard before,' judged Dixon, having heard Morris

reading an early composition, the short spare melancholy picture poem 'The Willow and the Red Cliff'. It was on his own account, not just as Burne-Jones's adjunct, that Morris soon took his own place within the group.

All of them were still in their *Heir of Redclyffe* phase, strongly influenced by Charlotte M. Yonge's long chivalric novel, published in 1853. *The Heir of Redclyffe* tells the story of two cousins, the generous, fiery-tempered Guy (rather a William Morris character in fact) and the apparent goody-goody Philip who schemes to ruin Guy's chances of marrying his guardian's daughter Amy by blackening his character. After many ins and outs Guy refutes the charges and he and Amy marry. On their honeymoon they come upon the now repentant Philip ill with fearful fever. They nurse him back to health and Guy forgives him, only to catch the fever himself and die. For the Birmingham set *The Heir of Redclyffe* had everything: young chivalric handsome hero, snakelike villain, touches of social aspiration, a poignant deathbed scene. The glamour of piety entered the real lives of Burne-Jones and his friends. According to Dixon, 'We all had a notion of doing great things for man.' The notion of self-abnegation was alluring. Burne-Jones later described an episode that might have been imagined by Yonge herself: 'a poor fellow dying at college while I was at Oxford – his friends took it by turn to read *Pickwick* to him – he died in the middle of the description of Mr. Bob Sawyer's supper party – and we all thought he had made a good end'.

The topic of celibacy was eagerly discussed among the set. This, the ultimate test of Arthurian chivalry, was still being regarded by Burne-Jones as a feasible possibility. His mind was still set on the monastic brotherhood. He remained deeply affected by his visit to the Cistercian monastery in the forest. Once he had arrived at Oxford Burne-Jones had been among the many pilgrims setting out to Littlemore, the religious settlement established by Newman on land he had bought in 1840, where he and his colleagues lived in stark simplicity: bare walls, rough brick floor without a carpet, straw bed, one or two chairs, and a few books. It was at Littlemore that Newman was received into the Roman Catholic Church.

Since then other monastic communities had been springing up on Newman's model of scholarship combined with pastoral care. Especially inspiring to Burne-Jones, with his first-hand knowledge of urban poverty, was Hurrell Froude's *Project for the Revival of Religion in Great Towns*, an early blueprint for religious outreach in the city. Burne-Jones planned to form a small religious community of male clerical and lay members working in the heart of London. William Morris, who was due to inherit at least £700 a year in interest from the Devon Great Consols mining company when he came of age, was eager to finance the foundation of the monastery, and Burne-Jones wrote persuasively to Crom Price: 'remember I have set my heart on our founding a Brotherhood. If you fail me I shall misanthropize, misogynize, misobrephize, shut myself up in a cell(ar). Learn Sir Galahad by heart – he is to be the patron of our order.' This was in May 1853. In October 1854 Burne-Jones was still maintaining that the monastery stood a better chance than ever of being founded. But by this time he was sounding a little less convinced.

Other contrary interests had begun encroaching. Burne-Jones might have been busily reading Archdeacon Wilberforce's latest work on the Holy Eucharist at mealtimes, judging it 'the most controversial and truly theological work that has come out for ages', but he was also being seduced by more popular sensationalist writing. He felt almost ashamed of his addiction to the mystery tales of Edgar Allan Poe. 'His book of horrors is with me now,' Burne-Jones confessed sheepishly to his friend Crom Price: 'I know how contrary to all rules of taste are such writings, but there is something full of delicate refinement in all that hideousness.' He admired especially the stories in which Poe is most concerned with his subjects' motivation, as in 'The Murders in the Rue Morgue', 'The Purloined Letter', 'The Pit and the Pendulum' and others of Poe's 'marvellously startling' narratives. He considered 'The Fall of the House of Usher' to be 'very grand', perhaps his favourite of all. 'Some I think very "objectionable",' Burne-Jones reported, sounding distinctly thrilled with Poe's 'The Black Cat' and 'Mesmeric Revelation' in particular. This discovery of Poe is the

first sign of his later fascination with horrifying mysteries, a preoccupation with the sinister and ghoulish that pervades Burne-Jones's early Pre-Raphaelite apprenticeship.

And how wedded was he really to the celibate life? In her memoir of her husband Georgiana Burne-Jones asserts with touching confidence of the Oxford friends that 'the mystery which shrouds men and women from each other in youth was sacred to each one of them' and most likely she was right. But there were always yearnings. Even at school Burne-Jones had learned the useful trick of attaching himself to the most handsome of the other schoolboys in order to make himself more popular with girls. The Macdonald family had now left Birmingham but he was on especially affectionate terms with the sisters of Crom Price. While at Oxford there are hints of an unhappy love affair. He mentions to his fencing master Archibald MacLaren 'the heartaches and love-troubles I have been getting into'; to Crom Price he describes himself as 'suffering greater mental troubles than I ever remember'. The source of all these miseries has never been identified but the episode reveals the strong susceptibility to women that challenged his youthful ideals of celibacy. When, just a few years later, he and Swinburne defined heaven as 'a rose-garden full of stunners' – the Pre-Raphaelite word for women of particular sexual allure – we should not be surprised.

After a few terms at Oxford he had gone back to the drawing that had occupied so many hours in Birmingham. 'I have fallen back upon my drawing and intend cultivating it to some extent,' he told Crom Price. A visitor arriving in his rooms in March 1854 found him working on an illustration to Tennyson's 'The Lady of Shalott'. While Morris was preoccupied with architectural sketches, drawing windows, arches and gables, adorning his letters with hasty little sketches of floriated ornament, Burne-Jones spent whole days in Bagley Woods making detailed studies of foliage and flowers. Ruskin's view of the importance of direct and careful observation of nature as a means to truth in art, a truth both moral and material, would have been familiar to Burne-Jones from his

reading of Ruskin's *Modern Painters*. Artists 'should go to nature in all singleness of heart . . . rejecting nothing, selecting nothing and scorning nothing; believing all things to be right and good, and rejoicing in the truth'. He must have known those words by heart. In that sense Burne-Jones's discipleship of Ruskin had begun before he met him. His reading of Ruskin also introduced him to the new Pre-Raphaelite movement, hailed in the Edinburgh lectures as prophetic of a new aesthetic orthodoxy. When Burne-Jones actually saw the work of the Brotherhood – John Everett Millais, William Holman Hunt and Dante Gabriel Rossetti – he understood it instantaneously.

At Oxford Burne-Jones received his first commission. This was for a series of pen-and-ink drawings for a volume of ballads and poems on the fairy mythology of Europe. The compiler of *The Fairy Family*, Archibald MacLaren, was a versatile and interesting man with the energetic breadth of interest of his time. As well as being an expert on fairies he was an authority on physical education and had written several books on the subject. He had trained in medicine, become expert in fencing and gymnastics in Paris and took a holistic approach towards the physical aspects of the body. He was soon to be called on to train British military personnel at his Oxford gymnasium in Oriel Lane. Meanwhile, among his less professional pupils were Morris and Burne-Jones, who had been recommended to take fencing lessons in the hope of improving his still shaky state of health. Burne-Jones greatly enjoyed fencing. 'I was quick,' he wrote later, 'and though not strong, had a fairly strong wrist and could overbear my antagonist by momentary vehemence.' He did not, however, take to the more lumbering broadsword or brutal singlestick, much preferring the foil's romantic dash and passion. As he was to put it, 'I like a Dumas duel.'

A close friendship developed between the three of them. MacLaren, twelve years older, was avuncular and charming to Burne-Jones and William Morris, nurturing their talents and ambitions. He lived with his young wife in Summertown, then a small village to the north of Oxford, reached along a stretch of country road. The two went out regularly to dine with the MacLarens in

their low white house, where in the summer the veranda was festooned with roses and the garden was 'like a small Paradise shut in with white walls'. Burne-Jones made special friends with the MacLarens' daughter, little Mabel, first of the long line of his fondly wondering attachments to small girls. 'Is she old enough for a doll?' he asked her father, 'for a lady has promised to dress one completely for her, and I want to get a big one, like those in Baby-linen windows.' Besides baby talk, the conversation in Summertown was mainly about poetry and art. MacLaren was impressed by the drawings Burne-Jones showed him and asked him to provide illustrations for the book of fairy poems he was then preparing for publication.

In mid-Victorian England fairies were becoming popular. Romantic movement poets and novelists had focused new attention on the magical and inexplicable. Many European fairy tales were now reaching Britain in translation. The famous fairy tales by the Brothers Grimm were published in 1823 under the title *German Popular Stories*. Fairy mythology had become the subject of scholarly attention. Thomas Keightley's *Fairy Mythology*, acknowledged by MacLaren in his introduction to *The Fairy Family*, was the most highly regarded of these studies. MacLaren's 'book of ballads and metrical tales illustrating the fairy faith of Britain', as the title page defines it, was very much an enterprise of its period.

Burne-Jones began work on *The Fairy Family* in the spring of 1854 and the project was still in progress through 1855 and 1856. He made in all more than eighty designs: full-page illustrations, title pages, borders, incidental vignettes and decorative capitals. The designs were developed for reproduction by engraving and Burne-Jones carried them out in pencil or pen and ink, all in monochrome. Stylistically they are variable, spanning as they did such a formative period in Burne-Jones's artistic development. Some of the illustrations are still in the style of his comic schoolboy sketches, vigorous and busy, influenced by George Cruikshank, illustrator of Dickens. Cruikshank had also illustrated the English edition of Grimms' fairy tales as well as providing the frontispiece for Keightley's *Fairy Mythology*. Others of the few surviving

illustrations in the series are maturer, clearly showing the absorbed experience of Burne-Jones's Oxford years.

His new feeling for architecture is reflected in his landscapes of soaring spires and crenellated castles. His Gothicised lettering suggests the influence of the painted books that he and William Morris admired in the Bodleian. His stalwart knight in armour; his strange elongated women; the couple on the shore staring out across the moonlit lake as if transfixed: already there are hints of the curious atmosphere of stillness so characteristic of Burne-Jones's later work. Designing for MacLaren he developed his sense of narrative and wonder, penetrating into the meaning of the fairy tale. He was decisive about the special nature of doing drawings for children. He did not see these as in any sense '*false* drawings' but he maintained that 'in good drawing, in the assertion of facts in drawing, what men chiefly want is *particular* truth, and what children chiefly want is *general* truth'. In his work for *The Fairy Family* we see Burne-Jones the artist begin to find his feet.

It was, as all his works were, a considerable agony. Burne-Jones's nerves when working were always to be fraught. One early morning MacLaren was woken by the sound of gravel thrown at his bedroom window. He looked out to see Burne-Jones standing in the garden, haggard with lack of sleep having been up all night struggling with a drawing. He had walked to Summertown to discuss the problem with his client. The drawings for *The Fairy Family* were never finished. But, according to Georgiana Burne-Jones, 'Maclaren's forbearance and generosity about the whole matter never gave way.' When the book was published by Longman's in 1857 it contained only three illustrations by Burne-Jones, none of which was credited. MacLaren kept the dozens of unused designs. He offered them to Burne-Jones but he did not wish to claim what by then seemed to him embarrassing examples of his early trials. Most of the *Fairy Family* designs have disappeared but seven survived to find their way into the collection of Andrew Lloyd Webber, whose dream worlds and escapist fantasies pervaded the entertainment business in centuries to come.

*

No doubt this his first professional commission exacerbated his discontent with Oxford. The initial disappointments of Burne-Jones's first months in the city he had longed to live in, disillusionment which William Morris shared, had only strengthened in the intervening period. He would later say that Oxford was 'a terrible place when he was there . . . At Exeter they were all pedants.' The intellectual content of his examination courses was of little interest, and he and Morris were left 'absolutely desolate' by the lethargy and lack of commitment of the teaching. In the country generally this was a troubled time. The Crimean War was in progress: English and French forces began the siege of Sevastopol on 17 October 1854; the charge of the Light Brigade at Balaclava, made for ever memorable by Tennyson, took place later in the month. Meanwhile, Britain was devastated by the terrible cholera outbreak of that autumn. In this period of national crisis people felt destabilised, uncertain of their old life patterns and beliefs.

Attitudes were shifting within the little Birmingham colony at Oxford. The naive young men matured and questioned old loyalties. Yes they still loved Tennyson, read aloud authoritatively by William Fulford in a fine deep voice, and still more or less considered Tennyson the greatest poet of the century. But other literary influences gathered strength. Of contemporary poets Browning became a favourite, his sinewy complexities providing a new challenge to their sense of correct literary composition and settled moral values, bringing intimations of modernity. They also travelled back in time, discovered Geoffrey Chaucer and revelled in his storytelling vigour, including the indecent episodes. For both Morris and Burne-Jones, Chaucer was to be a hero. What Burne-Jones once described as the 'extreme simplicity and beautiful directness' of his nature much affected them, and Chaucer was to be the inspiration for some of their greatest collaborations. If John Ruskin, as Morris once insisted, had provided a new road along which they should travel then Chaucer did as well.

Gradually the group was becoming secularised. The niggling ecclesiastical debates lost their burning interest as Burne-Jones and his friends began to read more widely, especially in French

and German philosophy. They read Thomas Carlyle, absorbing his delineation of the hero as social visionary in his lectures *On Heroes, Hero-Worship, and the Heroic in History*, thrilling to his denunciations of contemporary society in *Chartism*, published in 1839, and *Past and Present* in 1843. 'Carlyle and Ruskin are not a historian and a critic – they are two old Hebrew Prophets alive now and thundering. Carlyle is a Scandinavian War God from the North.' His effect on Burne-Jones was ferocious and profound.

Carlyle in tackling 'the condition of England question' attacked an economic and political system in which the cash nexus had become the sole basis of relationship between man and man. Burne-Jones had no problem in applying this to Birmingham, as he did Carlyle's concern for the industrial poor. Carlyle's belief that honest and responsible work could bring about social regeneration also found an echo in Burne-Jones's own work-orientated personality. But most immediately influential in Carlyle's writings was his concept of moral directives independent of those of conventional religion, for which he had no time. George Eliot wrote in *The Leader* in 1855, 'there is hardly a superior or active mind of this generation that has not been modified by Carlyle's writings'. What applied to George Eliot applied to Burne-Jones too. As he wrote in that same year, the effect of their wide reading on the set was disconcerting: 'it shivered the belief of one, and palsied mine, I fear for years'.

Now began the painful process by which Burne-Jones would exchange one sort of religion for another – the religion of art. The anguish of those months is made clear in a letter he wrote to Maria Choyce, his childhood friend, the cousin on the farm. He contrasts the steadiness of his first two years at Oxford, years in which his faith was 'very firm and constant' and indeed still growing, times when plans for the future monastic community were developing, schemes that were 'romantic and utopian, but entirely meant', with an agonising present of growing religious doubt and disillusionment.

Burne-Jones was by no means alone in his dilemma. Hundreds of other young Englishmen were losing their faith in and around 1855. But his nervous temperament made his suffering acute, prone as he still was to collapses after exercising, periodic total

seizures of the limbs and headaches brought on by excess of tension, probably a form of migraine. He had anguished discussions with Charles Marriott, Newman's friend and disciple who had taken over from him as vicar of St Mary's Church in Oxford. In his desperation he renewed his old ideas of joining the Roman Catholic Church. By May 1855, as William Morris too began to question his vocation, plans for Burne-Jones's monastery were finally abandoned, along with their intention of becoming clergymen. 'Morris has become questionable in doctrinal points, and Ted is too Catholic to be ordained,' Cormell Price reported at the time. In retrospect Burne-Jones summed up the crisis they were facing: 'Slowly, and almost insensibly, without ever talking about it, I think we were both settling in our minds that the clerical life was not for us and art was growing more and more dominant daily.'

At the height of his despair Burne-Jones even attempted to sign up for the Crimea. 'I wanted to go and get killed,' he had announced, in an almost self-satiric tone of melodrama, applying for one of the army commissions being offered for recruits from the university. Fortunately he was rejected on grounds of his ill health. For 1855 was a pivotal year in which Burne-Jones, at the age of twenty-one, made the first of his four influential journeys to the Continent. And this was the summer in which he decided definitely on a career in art.

Northern France
1855

It is fascinating how in so long and close a friendship, in which Burne-Jones and Morris were entwined in many ways, their responses to their shared experience could be poles apart. This becomes clear on the working holiday they took in northern France in 1855. Morris had already made his first journey abroad – to Belgium and France – in the previous summer vacation from Oxford. For Burne-Jones this was the first time he had left England, and though he echoed Morris in his profound delight in the Gothic architecture of the great churches and cathedrals they visited, his excitement at his first sight of so many masterworks of painting in the art galleries in Paris was even more intense.

They set out via London in the middle of July. There were three in the party, the never entirely welcome William Fulford having been brought in as a last-minute substitute for Burne-Jones's and Morris's bosom friend Crom Price. The day before they left London Burne-Jones had called at the house in Walpole Street in Chelsea where the Macdonald family were living. Georgiana had happened to be out. Fifty years later she described the episode: 'Returning home I missed him so narrowly that I distinctly saw him walking down the street as I reached my door. "Jones and Morris and Fulford were going to France tomorrow," I was told; "Jones had just been to call". I knew it.'

The tour had been planned as a walking holiday so as not to involve Burne-Jones in travelling expenses he could not afford.

Morris was always sensitive to Burne-Jones's poverty and had once seriously suggested sharing his own income half-and-half, a generous offer Burne-Jones had refused. This was not a reading holiday. They took just one book with them, a volume of Keats's poems. It was planned as an itinerary of feasting with the eyes. After making the crossing from Folkestone to Boulogne, the travellers arrived in Abbeville late in the evening on 19 July. The next morning Burne-Jones was up early and started sketching. The haphazard streets and houses with their high-pitched roofs, ranged around the tall tower of St Wulfram's Church, struck him as beautiful in a new and foreign way. The town was encircled by low hills and green fields. They travelled on that same afternoon to Amiens, lingering in the cathedral until nine o'clock at night. Then the next day they walked on towards Beauvais with increasing difficulty since Morris's boots were causing him such pain that he abandoned them en route and bought a pair of carpet slippers in which he hobbled the remaining eighteen miles from Clermont up to Beauvais. From there on the idea of walking was discarded and they went on by horse-drawn cart or coach or train.

The cathedral at Amiens had impressed Burne-Jones. Fulford described him as having been 'speechless with admiration'. But of the nine cathedrals, and at least twenty-four churches of the highest architectural quality, it was the enormous and peculiarly spectacular cathedral at Beauvais that would stay for ever in his mind. The building of the cathedral had begun in the mid-thirteenth century but been abandoned at a point when the choir, carried upwards to a great height, had to be buttressed to prevent it from collapsing. The transept was built in the sixteenth century but the nave was never started. Was it the fact that the cathedral was unfinished that played on Burne-Jones's Romantic sensibility? The bizarre grandeur of Beauvais stayed with him for ever and in a letter written decades later he recreates the experience of attending High Mass in 'the most beautiful church in the world':

I remember it all – and the processions – and the trombones – and the ancient singing – more beautiful than anything I had ever heard and I

46

think I have never heard the like since. And the great organ that made the air tremble – and the greater organ that pealed out suddenly, and I thought the Day of Judgment had come – and the roof, and the long lights that are the most graceful things man has ever made.

What a day it was, and how alive I was, and young – and a blue dragon-fly stood still in the air so long that I could have painted him.

The poignant fact underlying this rapturous description is that Burne-Jones's visit to Beauvais took place just at the moment when his own religious vocation waned.

After Beauvais there was an argument over the next stop. Morris wanted to skirt around Paris and go on immediately to Chartres. He knew from the last visit how enraged he had been by crude restoration work in progress at Notre-Dame. But Burne-Jones was desperate to see the pictures in the Louvre and Fulford wanted to view Paris in general. Morris gave way, and after Vespers in the cathedral they left Beauvais for Paris and a programme of sight-seeing which apparently lasted for sixteen hours non-stop.

For Burne-Jones the great revelation of the visit was his first sight of medieval painting. For a young man growing up in the provinces in mid-Victorian England there were no opportunities to see the great art of thirteenth- and fourteenth-century Italy and Flanders. At Oxford the situation was little better. Burne-Jones later claimed, 'Of painting we knew nothing. It was before the time when photographs made all the galleries of Europe accessible, and what would have been better a thousand times for us, the wall paintings of Italy.' Black and white reproductions of Italian art in the handbooks published by the Arundel Society were just begin-ning to be circulated; there were one or two examples of early Italian art in the Taylorian museum; Ruskin's handbook to the Arena Chapel at Padua contained some crude woodcuts of Giotto's frescos. But although Burne-Jones was by now familiar with contemporary painting, including the works of the Pre-Raphaelite Brotherhood, his knowledge of European art was very limited. He had not, it appears, set foot in the National Gallery in London. Until he got to Paris Burne-Jones could not remember having seen any examples of 'ancient pictures' at all.

In this Morris was ahead of him. His travels of the previous summer had introduced him to the paintings of Van Eyck and Hans Memling. He had brought back photographs of Albrecht Dürer's engravings to show his friends at Oxford and spread word of the marvels of medieval art in the Musée de Cluny in Paris and the Louvre. Now he could share these pleasures at first hand. They allotted one whole day to the Picture Gallery at the Louvre, a collection rich in Italian art, the spoils of French imperial conquest. Here, as if plotting a surprise treat for a child, Morris made Burne-Jones shut his eyes while he led him up to Fra Angelico's *The Coronation of the Virgin*. When he was allowed to open them again Burne-Jones was 'transported with delight'. The visit to Paris altered his whole future attitude to art. Up to then painting had been a form of art he had more or less discounted. Now he realised that painting would be the central thing.

He was later to tell his studio assistant how this first sight of early Italian painting showed him the way in which he too could be a painter in the middle of the nineteenth century. So devoted did Burne-Jones remain to Fra Angelico, the Florentine Dominican, that as he grew older he almost came to *be* him, signing letters to his intimate friends as 'Angelo'. Amongst those who loved him it became his nickname. Frances Graham and her younger sister Agnes gave the explanation that 'we called him Angelo because he once said he felt good, like Fra Angelico'.

Burne-Jones had been developing the interest in medieval music and musical instruments we see in his stained-glass windows with their multitudes of angels playing dulcimers and clashing cymbals. At Oxford Burne-Jones, Morris, Dixon and Crom Price all belonged to the Plain-song Society which rehearsed in the Music Room in Holywell, and Burne-Jones sang plainsong in the daily morning services at St Thomas's Church. Now in Paris Burne-Jones had a musical experience of a rather different sort, when the party of friends went to hear Madame Alboni, the renowned Italian contralto, singing in Meyerbeer's five-act opera *Le Prophète*. This was Burne-Jones's choice of entertainment and he was enraptured. William Morris, beside him, was 'a good deal bored'.

Before they left Paris they made a visit to the Hôtel de Cluny, the fifteenth-century residence that had been opened as a museum in the previous decade. Here Burne-Jones would almost certainly have viewed the tapestries of the Lady and the Unicorn, not dissimilar in feeling to his own quasi-medieval tapestries of the 1890s conceived on a similarly palatial scale. He and Fulford also saw with their own eyes the depredations to the church of Notre-Dame that had already roused Morris to such fury. Public awareness of the building had intensified after publication of Victor Hugo's novel *Notre-Dame de Paris* and a lengthy programme of restoration work under Viollet-le-Duc began in 1845. Ten years later the site was still in chaos. On his previous visit Morris had found 'sculptures half down and lying in careless wrecks under the porches' awaiting restoration. Other visitors complained about crude painted replicas of the original sculptures placed in the niches of the western front.

Burne-Jones now found himself equally dismayed by the cavalier treatment of this great historic edifice. Seeing Notre-Dame with William Morris was important in bringing him round to Morris's view that the wholesale restoration of historic buildings now coming into fashion was wrongheaded to the point of sinfulness. Restoration falsified the architects' and craftsmen's original intentions, smoothing out the original vigour of the workmanship. Better to let buildings decay than to restore them. After Notre-Dame Burne-Jones shared the conviction that medieval buildings were better left alone.

On 25 July they finally headed on southwards towards Chartres. For Burne-Jones Chartres was, again, a formative experience. The great stone cathedral rising up out of the burnished gold cornfields of late summer was a sight not to be forgotten. There are obvious examples of how Morris was to draw on the history and architectural detail of Chartres in poetry and fiction, most evocatively in 'The Story of the Unknown Church' written soon after the travellers returned. For Burne-Jones the eventual legacy of Chartres is most obvious in his own designs for stained glass. Although the visit to France took place two years before he started designing

stained-glass windows on his own account and six years before William Morris's decorating firm, Morris, Marshall, Faulkner & Co., began to market the stained-glass windows that became such a staple of their repertoire, it was now, in Chartres Cathedral and in the church at Evreux, that Burne-Jones became aware of the possibilities of stained glass as a medium with its own intrinsic qualities quite different from those of easel painting.

He was able to relate the stained glass to the cathedral's marvellous medieval sculpture, elongated stone figures of saints and kings and queens. He started to see a stained-glass window as part of a great church's whole architectural entity, in relation to the soaring grandeur of the vaulting, the intricate geometry of the piers and shafts. Brilliant glowing colours in a dark solemn interior: his first sight of the twelfth-century North Rose Window at Chartres showed the young Burne-Jones what stained glass could be.

It was drizzling in Chartres on 27 July when they left at dawn for Rouen, now travelling north. This was an arduous journey with multiple changes from rail to one-horse conveyance to omnibus and back again to 'nasty, brimstone, noisy, shrieking railway train'. Burne-Jones was suffering from eye strain brought on by unaccustomed exposure to what had been, for most of the journey, the glaring summer sun. The sun was out, but getting low, by the time they got to Rouen and were faced with the cathedral that Morris, who had seen it the year earlier, remembered as the greatest pleasure he had ever had. Burne-Jones was drawn into what became almost a competition of superlatives. Which was his favourite cathedral? Was it Beauvais? Was it Chartres? Or was it Rouen, the cathedral in the centre of the city, its glorious façade rising above the colour and commotion of the local flower market? As he had loved Hereford, Burne-Jones enjoyed them all. Enjoyed them and recycled them, including long-remembered vistas and architectural details from these great cathedral cities in his drawings and paintings and designs.

Now, in early August, they were heading west on the last stage of their journey to Bayeux, Coutances and Avranches, to visit the waterbound Mont St Michel, a building from a fairy tale, finally

catching the ferry from Granville to Southampton. On Thursday 2 August they stopped en route in Le Havre. That night Burne-Jones and Morris took a walk along the quay, the busy port which bore the traffic of Le Havre's import/export trade. In Burne-Jones's own words, quoted in his wife's *Memorials*, 'we resolved definitely that we would begin a life of art, and put off our decision no longer – he should be an architect and I a painter'. This was not a dramatic moment of conversion, as it has often been portrayed. Burne-Jones himself explains, 'It was a resolve only needing a final conclusion; we were bent on that road for the whole past year.' That night's conversation had, however, strengthened their determination to abandon finally their plans to be ordained. After Le Havre they neither of them wavered from the life of art, though they would interpret it in very different ways. Burne-Jones was to look back on that walk along the quayside as 'the most memorable night of my life'.

Their decision had painful repercussions. Was it just coincidence that Morris purchased in Rouen the Tauchnitz edition of Thackeray's *The Newcomes*? This book contains the scene in which Clive, only son of a conventional Anglo-Indian army officer, Colonel Thomas Newcome, announces to his father that he intends to be an artist. Colonel Newcome's initial bewilderment was mirrored by that of William Morris's now widowed mother when faced with the news of her son's plans to become an architect. Burne-Jones too had his own personal involvement in Clive's story and indeed reviewed *The Newcomes* for *The Oxford & Cambridge Magazine*. We do not know in detail how Mr Jones reacted but he knew how perilous and socially suspect an artist's life could be.

Burne-Jones's anxiety and guilt pours out into a letter to his cousin Maria Choyce. 'Weary work this is doubting, doubting, doubting . . . friendly sympathy growing colder as the void broadens and deepens.' He was conscious of offending everybody with his ' "notions" and "way of going on" – general recklessness in fact'. He confesses to Maria that he hopes to be a painter, but feels no confidence in how he can achieve it. He will probably end up 'poor and nameless – very probably indeed'. But the alternative

now seemed to him impossible. He turned away in a revulsion of physical disgust at the Church of England's pretensions and decrepitude: 'anything, so it be not a parson – save me from that, for I have looked behind the veil, and am grown sick of false hair and teeth'.

So ended Burne-Jones's plans for ordination and his respect for the established Church of England. But this is not to be confused with a rejection of what he still regarded as the enduring values of the medieval Church. Medieval Christianity – the thing he so lovingly described as 'Christmas Carol Christianity' – became a vital element in Burne-Jones's art.

After northern France Burne-Jones returned to Birmingham and Morris went to stay with him. Georgiana Burne-Jones says, 'the little house in Bristol Road shone with their presence', perhaps glossing over the effect of William Morris's rumbustious personality in such close proximity to Mr Jones and the vigilant, possessive Miss Sampson in an already overcrowded house.

Much of their time was evidently spent in visiting the other members of their Oxford set, most of whom lived within a few miles of one another. Though their plans to form a monastic settlement had definitely faded, a new scheme had taken hold amongst the Brotherhood, as they now defined themselves, to start a magazine. Excited discussions took place among the friends as they moved around from Price's house to Dixon's house to Fulford's and back to Bristol Road. They went on long talkative walks; on one gloriously fine day they rambled round the Lickey Hills. Wilfred Heeley, another old King Edward's boy who was now at Cambridge, was brought into the discussions. Heeley nominated his own Cambridge literary friends to join the project, the most active of whom was Vernon Lushington. Although initiated in Birmingham the title was, ambitiously, *The Oxford and Cambridge Magazine*.

The idea behind the magazine was not simply to give these young men of literary ambitions an outlet for their work. It was seen as an agent of national reform, 'a medium for the expression

of their principles and enthusiasms'. The practical idealism of the Brotherhood had been fired by their admiration for F. D. Maurice and Charles Kingsley, leading figures in the Christian Socialist movement. On a typical Birmingham evening, when the 'brothers' met at Dixon's, they 'talked on myriad subjects' and Burne-Jones read aloud to them from *Yeast*, Charles Kingsley's novel dealing with multiple contemporary social and religious problems. Lancelot Smith, the young hero of *Yeast* who ends the novel inspired to regenerate his ailing country, stood as a role model to Burne-Jones and his friends, who were also impressed by Kingsley's later novels *Alton Locke, Hypatia: or, New Foes with an Old Face* and the just published *Westward Ho!*. The reformative zeal of Kingsley was behind Burne-Jones's optimism for the magazine. He told Maria Choyce in autumn 1855, 'we have such a deal to tell people, such a deal of scolding to administer, so many fights to wage and opposition to encounter that our spirits are quite rising with the emergency'.

The plans for the magazine were settled in more detail in what turned out to be Burne-Jones's final term at Oxford. Morris was the editor and proprietor, in his usual role of backer for the Brotherhood. It was calculated that the magazine, coming out monthly, could not be published for less than £500 a year: 'he hopes not to lose more than £300,' wrote Burne-Jones, 'but even that is a great deal'. Bell and Daldy were the publishers and the first number appeared on 1 January 1856. A thousand copies were printed, priced at one shilling. The contents are listed as Essays, Tales, Poetry and Notices of Books. In spite of the talents of some of the contributors, Morris's essays, poems and short stories being the thing that held the magazine together, it was not a commercial or, on the whole, an artistic success. Morris quickly lost interest in the exigencies of editing and paid William Fulford to take it over. Fulford included far too much of his own work. By the end of the year Bell and Daldy were reporting a considerable stock of unsold copies and *The Oxford and Cambridge Magazine* closed down.

Burne-Jones contributed at least three pieces to the magazine. In the first issue, as well as his review of Thackeray's *The Newcomes*,

was a love story entitled 'The Cousins, a Tale'. In issue two there was 'A Story of the North'. There may possibly have been a further contribution. Crom Price, in a letter written to Sydney Cockerell in 1902, argued for Burne-Jones's rather than William Morris's authorship of an article on 'Ruskin and *The Quarterly*', largely on grounds of style.

Of these, 'The Cousins' has by far the greatest interest. It was Fulford who first spread the news among the Brotherhood, meeting Dixon and saying 'He has written such a gorgeous tale, that man,' meaning Edward Burne-Jones, who later on, that evening, read his story out loud in Fulford's rooms. Dixon was overwhelmed:

We were all as if dumb at the end of it. I felt the commanding beauty and delicate phrasing, and also the goodness of heart that the writing showed. I had no notion before that E.B.-J. was gifted so highly for literature. His reading of it was very fine. As soon as he could, he rushed out and left us.

This post-performance shyness was very typical. 'The Cousins' is a complex, somewhat unlikely tale, told in the first person, of Charlie, the young man who is rejected by one cousin, the haughty, flighty Gertrude to whom he was engaged. He leaves England in despair and is eventually rescued and revived by the beautiful Onore who turns out to be another of his cousins, now living in France. The story ends happily with Charlie and Onore preparing to get married. 'It is a morning in May upon the hill of Canteleu . . . And below is the valley and the river, and the city of the towers.' Onore, with her 'stedfast look' and 'wide deep eyes', has unmistakable resemblances to little Georgiana Macdonald. The topography of Burne-Jones's story is clearly drawn from his recent expedition to northern France.

'The Cousins' is a tale with social conscience. There is a powerful sub-plot of suffering in the city. Serious business failures in the North as a result of factory strikes have repercussions on the leading City of London finance houses. Scenes of aristocratic licence are contrasted with the drab vulnerability of the London poor. Edward Burne-Jones is certainly not Dickens but he was a better writer than he wanted to acknowledge. His wife later explained

that 'After he became a painter he seemed to feel a kind of jealousy at the employment of any other means of expression than painting, and deliberately curbed the use of words in public.' Burne-Jones kept his best writing for his private letters, some of which are idiosyncratically brilliant.

The autumn brought a new excitement, the *Morte d'Arthur*, the book that of all books altered the direction of Burne-Jones and Morris's creative lives. *Le Morte d'Arthur* was the lengthy cycle of Arthurian legends written by Sir Thomas Malory, a knight from Warwickshire. It appears that he was working on it while he was in prison, charged with the unknightly crimes of violence, theft and rape. Malory's *magnum opus* was completed in 1471 and printed by Caxton in 1485. In 1817 Robert Southey, so-called 'Lake poet' and the current Poet Laureate, produced his own edition of Malory and this was the version Burne-Jones had discovered by chance in Cornish's, the bookseller in New Street in Birmingham where the impecunious undergraduate spent many hours each day reading voraciously and buying occasional cheap books to pacify the owner. The *Morte d'Arthur* was far beyond his means but when Morris came to stay in Birmingham he bought it almost without thinking and, wrote Burne-Jones, 'we feasted on it long'.

From the start it permeated their lives. There are descriptions in Crom Price's diary of walking 'round and round the garden with Ted, reading the Morte d'Arthur, the chapters about the death of Percival's sister and the Shalott lady'. The legends of Merlin; the tales of Sir Launcelot du Lake, Sir Gareth of Orkney, Tristram de Lyones; the Quest of the Holy Grail; Launcelot and Guenevere; the ineffably mysterious passing of Arthur. Malory's version of these stories had a toughness in the telling, a laconic quality of style compared to which Tennyson's versification now seemed gushing. For Burne-Jones Sir Thomas Malory was the real thing.

Why did the *Morte d'Arthur* have so powerful an impact? Burne-Jones attempted to analyse the phenomenon later in his life, to put the cult of Arthur in a wider social context:

To care as I care and as 3 or 4 others care one must have been born in the lull of things between the death of Keats and the first poems of Tennyson. There was some magic in the air then that made some people destined to go mad about the S. Grail.

Certainly Burne-Jones, born in 1833, was a child of the nostalgic chivalric revival that took Arthurianism as its key. The Arthurian knight, brave, virtuous and glamorous, was taken as the symbol for a movement to revive the moral fibre of the nation. The medievalist movement was not simply a literary one but spread through art and architecture, interior decoration and collecting. This was a time at which important collections of armour and medieval weapons were amassed, some of them brought out and put to use in the notorious Eglinton Tournament of 1839. A quasi-Arthurian revival of ideas of upholding the honour of the country was a political theme as appealing to the Radicals as to the Tories. A Tory faction called Young England was invented by the almost unbelievably Arthurian young Lord John Manners in 1842. Burne-Jones and his Oxford circle had indeed inherited a strong tradition of picturesque reformative idealism, a natural feeling for Arthurianism sharpened by their rediscovery of Malory himself. Burne-Jones further reworked and amplified the legends in a way that became almost a life's work. He knew his Malory by heart and surprised his later friends by the way he could 'roll out pages from the *Morte d'Arthur* at almost any length'.

Merlin being tempted by an all too irresistible Nimuë; the tragic histrionics of Tristram and Iseult; the Arthurian knights being armed and waved away on their quest by the ladies of Camelot; the dream of Sir Launcelot slumped in exhaustion at the entrance to the Chapel of the Holy Grail. Burne-Jones pondered and rein-vented these strange narratives, making them his own in his draw-ings, paintings, tapestries and his and William Morris's illustrated books. The Arthurian legends were, to him, not just material to draw on but had a profound significance. They acted as a kind of spiritual signpost, as he once acknowledged to his great friend Frances Horner when she was about to go and live in Glaston-bury, prime Arthurian country: 'Nothing was ever like Morte

d'Arthur – I don't mean any one book or any one poem, something that can never be written I mean, and can never go out of the heart.'

It had been expected that Burne-Jones would stay at Oxford until June of the next year and take his degree. However, he did not. After Christmas 1855 he drifted gradually away from the university without discussing his intentions with his father and without claiming the money from the Oxford exhibition he had now been granted. He later explained that he had been too ashamed. William Morris too had now left Exeter, having taken a pass degree, and he had entered the offices of the Victorian Gothic architect G. E. Street, who was then based in Oxford, as an architectural trainee.

Burne-Jones now gravitated towards London. How much had this to do with the letter he received from John Ruskin soon after he arrived to stay with his ever welcoming little Aunt Keturah in Camberwell? Ruskin wrote to acknowledge the copy of the January issue of *The Oxford and Cambridge Magazine* that Burne-Jones had sent him. Burne-Jones was overwhelmed by this direct communication from his hero, writing to Crom Price:

I'm not Ted any longer, I'm not E. C. B. Jones now – I've dropped my personality – I'm a correspondent with RUSKIN, and my future title is 'the man who wrote to Ruskin and got an answer by return'.

This was maybe overdoing things. But what is certain is that E. C. B. Jones, the boy from Birmingham, was to alter fundamentally in his ambitions and indeed in his appearance over the next few years.

Early London
1856–7

One of the little scrawled self-portraits in a letter of 1856 shows 'Ted Jones Painter', a Dick Whittington figure on his way, so he hopes, to fame and fortune in the city. He was to look back on that time in a romantic haze of longing for its freshness, expectation, relative simplicity, seeing 1856 as the year in which 'it never rained nor clouded, but was blue summer from Christmas to Christmas, and London streets glittered, and it was always morning, and the air sweet and full of bells'. This was the year he entered the Pre-Raphaelite world.

The link was Dante Gabriel Rossetti, a painter and a poet of Italian origin who was five years older than Burne-Jones. Rossetti was already a controversial figure in artistic circles as a founder of the Pre-Raphaelite Brotherhood. This was the self-invented name adopted in 1848 by a little group of disaffected artists centred on Rossetti, John Everett Millais and William Holman Hunt. Their ambitious idea was to regenerate the art of England by returning to the directness and simplicity of early Italian art before the time of Raphael. The Pre-Raphaelites published their own artistic-literary journal, *The Germ*.

Burne-Jones had been filled with admiration when he saw Rossetti's illustration to 'The Maids of Elfen-Mere', a fairy fantasy by the Irish poet William Allingham included in his *Day and Night Songs*. An earlier Allingham poem 'Up the airy mountain' became a kind of theme tune for aficionados of Victorian fairy folk.

For Burne-Jones, Rossetti's illustration opened out new vistas of what a modern drawing could be made to express: 'the weirdness of the Maids of Elfenmere, the musical timed movement of their arms together as they sing, the face of the man, above all, are such as only a great artist could conceive'. He infiltrated praise of Rossetti into his review of Thackeray's *The Newcomes* in *The Oxford and Cambridge Magazine*. The next stage was a longing to make actual contact with the artist, a face-to-face encounter: 'I wanted to look at him,' he said.

This was achieved when Burne-Jones tracked him down, practically stalked him, to the Working Men's College in Great Ormond Street where Rossetti taught drawing in the evening classes. The Working Men's College had been founded very recently, in 1854, by the controversial Christian Socialist preacher F. D. Maurice whose outspoken views had caused him to be ejected from King's College, London, where he had been Professor of Divinity. The College was an admirably Christian Socialist endeavour to broaden the horizons of the British working man, an early form of Open University in which experts in science, history, art and other subjects were brought in to share their knowledge. Rossetti had been recommended by John Ruskin, the first director of the drawing class.

The atmosphere among the staff was collegiate and rugged, in the Christian Socialist manner of masculine good cheer. Burne-Jones happened to arrive in the midst of a monthly progress meeting for staff and supporters of the college. He sat down at the long table where he ate thick bread and butter and was straight away drawn into conversation by one of the bachelor tutors, Dr Frederick James Furnivall, who introduced him across the table to a forthcoming-looking young man called Vernon Lushington. Burne-Jones recognised Lushington's name as that of the most distinguished of the Cambridge-based contributors to *The Oxford and Cambridge Magazine*. But where was Rossetti? Vernon Lushington, knowing Rossetti's dislike of Working Men's College community teas, doubted if he would appear. However, after an hour of speeches Rossetti sidled in 'and so', wrote Burne-Jones,

'I saw him for the first time, his face satisfying all my worship, and I listened to addresses no more, but had my fill of looking, only I would not be introduced to him'.

Burne-Jones finally met Rossetti just a few days later in Vernon Lushington's rooms in Doctors' Commons. Vernon's father Dr Lushington was a leading light of the Ecclesiastical Courts and Vernon himself was reading for the Bar. It was a convivial male gathering, including Rossetti's brother William and later Dante Gabriel himself. Burne-Jones had what he called his 'first fearful talk' with his hero, who was in a belligerent mood, castigating a man foolish enough to criticise Robert Browning's just-published poems *Men and Women*. Burne-Jones was carried away by Rossetti's fieriness as much as by his pre-eminence in art.

The next morning he visited Rossetti at his studio in Chatham Place in Blackfriars. This was in the dilapidated last building in the row leading down to the river, on the north-west corner of Blackfriars Bridge. Burne-Jones arrived to find Rossetti working on a watercolour of a monk at work on an illumination, an atmospherically religious painting of the robed and isolated artist-friar in his inner sanctum drawing a mouse from life while a small boy at his feet distracts the cat. Burne-Jones stayed for the whole day while they talked of poetry. Rossetti was especially intrigued by William Morris, a few of whose poems he already knew. Together they looked through Rossetti's many designs for pictures which were tossed haphazardly around a studio already piled with books. There was no one else about.

Eventually the two of them went out to dine. At no point did Burne-Jones admit to the fact that he too hoped to be a painter. But the meeting acquired an almost mystic meaning in his life, high in the line-up of the precious memories he later listed out for one of his greatest loves, May Gaskell: 'Sunday of Beauvais was the first day of creation, and the day I first saw Gabriel would be another – and there are six – and the seventh day is any day when I see you.'

When Burne-Jones first met Rossetti, how far was he aware of the Pre-Raphaelite movement, and Rossetti's work in particular, apart

from the illustration for 'The Maids of Elfen-Mere'? As we have seen, he had first read about the Pre-Raphaelites in Oxford two years earlier in Ruskin's commentary in the *Edinburgh Review*. The name of Rossetti was specifically mentioned. Just a little later Millais's *The Return of the Dove to the Ark* was put on display in James Wyatt's gallery in Oxford High Street. Burne-Jones and William Morris had gone to see the picture, 'and then', in Burne-Jones's words, 'we knew'. He knew that this was something altogether different from what passed for art in Birmingham, traditional paintings in which Burne-Jones had hated 'the kind of stuff that was going on in them'. From the first moment he saw the Millais picture, with its idiosyncratic way of treating the events of the Bible as if they happened yesterday, he instinctively understood the work of the Pre-Raphaelite Brotherhood.

He had then gone to the 1855 Royal Academy summer exhibition and admired the stark immediacy of Holman Hunt's *The Awakened Conscience* and *The Light of the World*, reporting that in contrast Edwin Landseer had 'drivelled his time away on another group of the royal family in Highland costume' while Daniel Maclise had 'managed to cover an acre of canvas with mangled bodies, and a host of meaningless faces in steel helmets'.

Through the spring and summer of that year Burne-Jones had determinedly sought out Pre-Raphaelite collectors, becoming familiar with many of the paintings we now think of as definitive examples of the Pre-Raphaelite genre. He and William Morris had walked over from Camberwell to Tottenham to see the picture gallery built by the entrepreneur Benjamin Windus on the proceeds of his patent Godfrey's Cordial. Windus's main enthusiasm was for Turner but he had also bought Ford Madox Brown's *The Last of England* as well as work by Millais and Rossetti.

In the collection of Thomas Coombe, head of the Clarendon Press in Oxford, they saw Holman Hunt's *A Converted British Family Sheltering a Christian Missionary from the Persecution of the Druids*, the painting which is now in the Ashmolean Museum, and Rossetti's watercolour of Dante drawing the head of Beatrice. On his visit to Paris Burne-Jones had been excited to discover

no fewer than seven Pre-Raphaelite pictures in an exhibition at the Beaux-Arts. Burne-Jones did not approve of the term Pre-Raphaelitism, which had started as an in-joke, considering it the most embarrassing of nicknames. But Pre-Raphaelite painting was, to him, a sacred thing.

For Burne-Jones, with his earnest provincial education, the attraction of Rossetti was that of an exotic. Rossetti's father, Gabriele Pasquale Giuseppe Rossetti, had been born near Naples but was forced out of Italy because of his involvement with the Carbonari, rebels against the Austrian occupation. He had arrived in England in 1824 and married Frances Polidori, a governess whose father was Italian. Dante Gabriel's uncle was the unreliable Doctor Polidori who had accompanied Byron on his European travels and written the lurid short story called 'The Vampyre', assumed by many to be Byron's work.

His father, the revolutionary in exile, found a post teaching I talian at King's College and laboured on his esoteric studies of Dante's *Divine Comedy*. The family was fixated on Dante Alighieri, the medieval Florentine poet and philosopher. The young artist, who had been baptised Gabriel Charles Dante, changed his name to Dante Gabriel in 1849. His highly religious and literary sister Christina was already writing poetry. Burne-Jones's worship of Rossetti was a matter of 'the mingling of blood in him, his own admiration and discrimination for all that was splendid; his surroundings and things he was brought up among, the people of all sorts of cultivation that he must have known from his earliest days'.

Physically, at the time, Rossetti was most striking. Georgiana when first introduced to him was conscious of the sensitivity of his artist's hands as well as the lovely olive colour of his skin. He had a Neapolitan confidence of manner and a memorably sweet and mellow voice. Burne-Jones once said 'Gabriel is half a woman' and there was an undercurrent of homoeroticism in their friendship. Burne-Jones was impressed by Rossetti's apparent carelessness, the nonchalance with which he never bothered making preparatory studies for his work: 'What he did, he did in a moment of time, designing was as easy as drinking wine to him.' But despite his

easy glamour, no one took more seriously than Rossetti the absolute centrality of art in human lives.

He encouraged Burne-Jones. He enjoyed the admiration. Soon he was referring to 'a certain youthful Jones' as 'one of the nicest young fellows in Dreamland'. From the spring of 1856, once Burne-Jones had made it clear that he meant to be an artist, he virtually took him on as an apprentice. There were no definite commitments: that was not Rossetti's style. He disliked formal instruction. Rossetti had himself been a student at the Royal Academy Schools, but maintained he had only ever made one drawing in the antique school, a ludicrous copy of the cast of an owl from the Elgin Marbles frieze. During his first few years in London Burne-Jones took evening life classes at Leigh's Art School (later Heatherley's) in Newman Street in Soho, but he claimed to have learned nothing. The long days spent with Rossetti in his studio or rambling the streets, talking and observing, were what really counted to him. He wrote to him much later, 'no one ever in this world owed so much to another as I do to you'.

What did Rossetti give him? Burne-Jones, now almost twenty-three, was an absolute beginner in contrast to, for instance, the Pre-Raphaelite painter John Millais who received his first silver medal from the Royal Academy when he was fourteen. Rossetti offered him the day-to-day experience of working alongside a painter who was making his way professionally, albeit precariously. Rossetti was already resistant to exhibiting, fearing hostility and ridicule, but he sold to a few private clients and John Ruskin was an admirer and supporter of his intensely visionary work.

Generously he made some practical suggestions as to how Burne-Jones could support himself in London as an artist. Rossetti might be able to get him a commission to draw the wood block for a proposed engraving of William Lindsay Windus's oil painting *Burd Helen*. Evidently at this stage Rossetti had not seen any actual examples of Burne-Jones's work and had underestimated his abilities. When William Morris showed him some of Burne-Jones's designs, presumably the illustrations for *The Fairy Family*, he took the offer back, flinging his arm round Burne-Jones's

shoulder, saying 'There are not three men in England, Ned, that could have done these things.' It was Rossetti, in an inspired moment of affection, who decided that Ted Jones should now be known as Ned.

From Rossetti he found a new stylistic direction. The contrast between pre-Rossetti and post-Rossetti work is obvious in Burne-Jones's *Fairy Family* illustrations. In his final drawings for the series the Cruikshank-inspired cartoonish busyness evaporates in favour of a flatter, more linear style with fewer, larger figures in the composition. A Pre-Raphaelite awkwardness and oddness has entered the equation. Under Rossetti's influence Burne-Jones now embarked on a series of pen-and-ink drawings of marvellous complexity and magically medieval atmosphere. Most are drawn in pen and ink on vellum, painstakingly detailed then scraped with a penknife to make the forms more subtle and to create highlights. The drawings were then finished with grey wash. *Going to the Battle; The Wise and Foolish Virgins; Buondelmonte's Wedding*: in these drawings the extraordinary detail builds up to make a dream world with the narrative conviction of a twentieth-century black and white art movie. Rossetti praised his pupil's pen-and-ink drawings as 'marvels of finish and imaginative detail, unequalled by anything unless perhaps Albert Dürer's finest works'. *The Waxen Image* of 1856, the first of the series of drawings Burne-Jones owned to, was based on Rossetti's poem 'Sister Helen'. It was, alas, destroyed in the Second World War.

But even more important than developing technique, Rossetti gave Burne-Jones the sense of his own worth. In his charmingly oblique and unofficial way he made Burne-Jones determined to succeed on his own terms: 'He taught me to have no fear or shame of my own ideas, to design perpetually, to seek no popularity, to be altogether myself.' He gave Burne-Jones the confidence to trust in his own judgement, simply to do 'the thing I liked most'.

Through the spring Burne-Jones had still been considering returning to Oxford to take his final examinations. He went back for the first week or so of summer term but soon became restless and

returned to London, giving up the whole idea. He was back in town for the particularly splendid 1856 Royal Academy summer exhibition which included – besides Windus's *Burd Helen* – Holman Hunt's *The Scapegoat*, Henry Wallis's *Chatterton*, five paintings by Millais and Arthur Hughes's poignant *April Love* which William Morris asked Burne-Jones to 'nobble' before anyone else bought it. An overawed Burne-Jones arrived at Hughes's house in Belgravia bearing Morris's cheque. 'My chief feeling then was surprise at an Oxford student buying pictures,' the painter still remembered in 1912.

Now he was so thoroughly within Rossetti's orbit, Burne-Jones left his Aunt Keturah's house in Camberwell and found himself lodgings at 18 Sloane Terrace, in Chelsea, then a far less fashionable area of London than it would become in the next century. He might have liked to remember the year 1856 as a time of endless blue skies but the reality was evidently harsher. Burne-Jones, on his own, was living hand-to-mouth. He was very often hungry. He once told a rich London hostess, 'you would shudder if I showed you places where I got food in that first year'. He was even reduced to spending the night on the steps of the church near Waterloo Station, in a state of hunger-induced collapse. He admitted later that he was often lonely, wandering the streets and gazing hopelessly into pawnbrokers' shops. The description he gave of himself as a wretched and solitary figure, adrift in the mêlée of the London crowds, reminds us of the plight of the hero in his story 'The Cousins' in *The Oxford and Cambridge Magazine*.

He was always to be ambivalent about London, the city in which he was settled from now on. Either he romanticised London as it had been in the time of Geoffrey Chaucer, a bright white gleaming city surrounding St Paul's original tall gilded spire; or, in another mood, he groused about London's mid-Victorian monotony and dreariness: 'Fogs and bitter cold, freezing and mist – spiky rain and snow and fog and the ceaseless crackling of fog signals, this is the daily life.'

On 9 June 1856 Edward Burne-Jones became engaged to Georgiana Macdonald. His lodgings in Sloane Terrace were

strategically close to the Wesleyan Sloane Square Chapel where her father had been minister since their move from Birmingham in 1853. Sometimes, filing out with the Sunday congregation, Georgiana would look up and glimpse her suitor's face watching from an upstairs window. She was still only fifteen but for her their engagement 'seemed to have been written from the beginning of the world'. She and her mother, in that devout, close household, knelt to ask for God's blessing once Burne-Jones had proposed and been immediately accepted. For him it was a way out of the impasse of his loneliness and into the bosom of the large, outgoing and appreciative family he knew so well already from his days in Birmingham. According to Frederic, Georgiana's slightly younger brother, who followed his father into the ministry, although Burne-Jones 'had as yet done nothing to indicate the quality and measure of his genius, we were as sure of him as we were of our own souls'. They particularly marvelled at the way he would show them pictures and engravings of sculpture and carvings and explain to them so confidently why one work was good while another was detestable.

Besides Frederic, Georgiana's family consisted of an older brother, the problematic Harry who had overlapped at Oxford with Burne-Jones, and five sisters. Three other siblings had died in infancy and another sister, Caroline, fell ill in 1852 in her mid-teens with the consumption which at that period was frequently a killer. Carrie's long-drawn-out and painful illness was a source of dreadful strain for the family surrounding her. By 14 May 1854 Harry Macdonald was writing to Crom Price of Carrie's increasing weakness: 'She is still cheerful and has no fear of death, which cannot be very far distant.' She died the next day. Georgiana would refer to Carrie as the lost sister of the Macdonald family, the one 'who came in between Alice and me'. Burne-Jones of course also had his lost sister, Edith, whom he had never even seen.

Especially in its female line, George Browne Macdonald's family was remarkable, proving how much social mobility was possible at this period for impecunious Wesleyan ministers' daughters of lively self-confidence and reasonable looks. Georgiana's older sister Alice, the flirty unpredictable sister who had once if not

twice been engaged to William Fulford, finally married John Lockwood Kipling, an artist and teacher specialising in architectural sculpture. They moved to India soon after their marriage, where John Kipling set up art school systems for the training of students of Indian arts and crafts first in Bombay and then in Lahore. He was himself a considerable designer, his great moment of glory being the commission for the Durbar Room for Queen Victoria at Osborne. The writer Rudyard Kipling was Alice and John's son.

One younger sister, Agnes, the most conventionally beautiful of the Macdonald girls, was to marry Edward Poynter, a successful historicist painter and ambitious bureaucrat who, like Burne-Jones, eventually became a baronet. Sir Edward Poynter held the rare distinction of being simultaneously President of the Royal Academy and Director of the National Gallery. Another of Georgiana's younger sisters, Louisa, known in the family as 'Louie', married the wealthy Worcestershire ironmaster and landowner Alfred Baldwin, a Tory establishment figure who became an MP in 1892. Their son Stanley had a long run as Conservative Prime Minister in the first half of the twentieth century.

Only Edith, the youngest, was to remain unmarried. She was musically the most gifted. Some of her songs were published. It has been suggested that she never found a husband because she was too witty and too sharp. She suffered the fate of many unmarried daughters of the time, becoming housekeeper-companion to her sister Louie and eventually writing a perceptive account of her upbringing, the privately circulated *Annals of the Macdonald Family*.

It is Edie who gives us a vivid description of her sister Georgiana's appearance: 'she was small, with dainty little hands and feet, rosy complexion, abundant hair, brown with bronze lights in it, and glorious dark-blue eyes'. She also lays stress on Georgie's moral strength: 'in that little frame dwelt a noble spirit . . . Her home affections were warm and true.' Although their father, the vigorous, courageous and deeply religious George Browne Macdonald, was devoted to his family, Edie points out that he was often absent,

travelling to give his famously eloquent sermons 'in all parts of the Methodist Connexion'.

It seems that Georgie was the daughter her often harassed mother Hannah leant on, and some of the stress of Carrie's illness must have devolved on her. When Fred was sent away to school in Jersey it was Georgie who wrote regularly, taking on the role of his spiritual adviser. 'She knew my weakness, and where a gentle warning of encouragement would be timely.' A formidable role for a girl not yet sixteen.

Of the sisters Georgiana was the most artistic. At the time of her engagement she was learning drawing at the Government School of Design, then in Gore House, South Kensington. Edward would often meet her on her way home, bringing her flowers. Her own professional ambitions were of the vaguest. 'I had no precise idea of what the profession of an artist meant, but felt it was well to be amongst those who painted pictures and wrote poetry,' as she recollected. But she had by this time read Ruskin's lectures, sent home from Oxford by her brother Harry, and Burne-Jones brought round his entire library of books by Ruskin as a present, arriving before breakfast on the morning after the day they were engaged. Morris came from Oxford bringing another present, Turner's *Rivers of France*, which he bashfully inscribed: he was awkward with women and he barely knew his friend's fiancée. The generous, forbearing Archibald MacLaren brought an opal ring for Georgie. This was not, however, such a welcome present since Burne-Jones believed superstitiously that opals were unlucky and the ring was hardly ever worn.

To Burne-Jones at the time the engagement was almost over-whelmingly important. He divided his life into the times before and after he loved Georgie. He confided to her little sister Louie he was now going to be 'a very different kind of fellow', steadier, more rooted, more ambitious in his work. He tells her he loves Georgie 'in some intense way that can never be expressed in words'. So intensely did he feel for her, he overcame his old Tractarian allegiances enough to attend Wesleyan chapel at her side. A further instance of his solemnity of purpose was the fact

that he announced his engagement to his father in the churchyard in Birmingham beside his mother's grave.

But there was no immediate prospect of their marriage. They had no source of income. Burne-Jones was at a very early stage of his career. Nor, given their joint innocence and Georgie's protective, highly moral background, was sex before marriage on the agenda. For Burne-Jones the next four years were a still sometimes lonely, often sexually frustrating continuation of the old bachelor routines.

His life in London became more convivial when William Morris arrived to live there too. G. E. Street had moved his architectural practice to London and Morris and Burne-Jones were now able to share lodgings financed by Mrs Morris. From the late summer of 1856 they lived at 1 Upper Gordon Street in Bloomsbury, rooms in a street of town houses so monotonous that Burne-Jones once went into the wrong door without noticing and got halfway up the stairs shouting for his dinner. Burne-Jones described the place as 'the quaintest room in all London, hung with brasses of old knights and drawings of Albert Dürer'. It was close to the British Museum where he began to work his way through the collection of illuminated manuscripts. The few weeks that they spent there lived in his memory as a time of great contentment. Rereading an old letter spurred nostalgic thoughts of 'such old autumns – Gordon Square and Topsy's first poems, and pen and ink drawings – such nice years'. He and William Morris seemed to him like two Babes in the Wood.

The snag was that the lodgings had no studio. By November, prompted by Rossetti, they had moved again to a larger set of rooms nearby at 17 Red Lion Square. Rossetti himself and another young Pre-Raphaelite painter, Walter Deverell, had previously lived there. In fact Deverell had died there, probably of Bright's disease, in 1854. He died having apparently painted just two pictures, one of which Burne-Jones would later purchase for £5. The accommodation at Red Lion Square, on the first floor of the house, consisted of a large north-facing studio with ceiling-height

window and two bedrooms. The rooms, unlike those at Upper Gordon Street, were unfurnished, giving scope to Morris for his first experiments in interior decoration and Burne-Jones for his earliest painted furniture.

Morris had commissioned a set of plain deal furniture to be constructed to his own design by a local carpenter: 'intensely mediaeval furniture', as Rossetti described it, 'tables and chairs like incubi and succubi'. The settle was especially monumental, so outsized that it could hardly be edged into the house. Burne-Jones was ecstatic about the high-back chairs, 'such as Barbarossa might have sat in', and a huge, round, rocklike table: 'they are as beautiful as mediaeval work, and when we have painted designs of knights and ladies upon them they will be perfect marvels'. Rossetti, Morris and Burne-Jones worked together on oil paintings for the large flat side panels of the settle and the cupboard that surmounted it. The backs of the chairs were decorated with scenes from William Morris's poems: one showing Guendolen high up in the witch tower, her long golden hair descending, another depicting the arming of the knight in Morris's 'Sir Galahad, a Christmas Mystery'. A self-portrait cartoon shows Burne-Jones at Red Lion Square examining one of the chair backs they had painted. This was to be the spirit of collaborative effort that formed William Morris's decorating firm.

There was an amiable chaos in the set-up. The housekeeper Mary Nicholson, known fondly as 'Red Lion Mary', was described by Burne-Jones as being 'very plain but a person of great charac-ter'. She had aspirations to modelling. When told she was too short she asked if she would be any use if she stood on a stool, and indeed Red Lion Mary does appear as one of the ladies accompany-ing Beatrice in Rossetti's painting *The Meeting of Dante and Beatrice in Florence*. She would stand around beside Burne-Jones and Morris 'to the neglect of all household duties. She read all our books. She read all our letters; people more experienced than I in housekeeping said she was very untidy.' Loyal, eager Red Lion Mary on the way to self-betterment made herself essential to the youthful, convivial Red Lion Square scene.

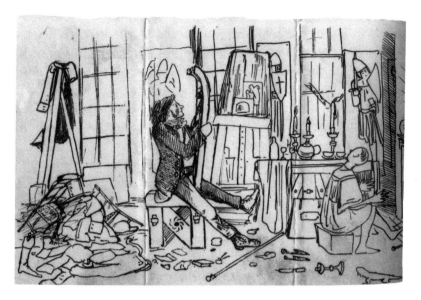

Burne-Jones in the rooms in Red Lion Square he shared with William Morris. The high-back chairs, designed by Morris, are now in the collection of the Delaware Art Museum.

The Macdonalds had now made yet another move from Chelsea to an ancient dingy house in Marylebone. Georgiana's father had been appointed minister at the Hinde Street Chapel. Georgiana would visit Burne-Jones at Red Lion Square, often bringing her little sister Louie with her. Of all the Macdonald sisters it was Louie who was his special pet. He made much of her talent for drawing and for her eleventh birthday took her to visit Rossetti on her own. Rossetti exerted his charm on her and gave her a proof of Holman Hunt's etching for the first number of the Pre-Raphaelite magazine *The Germ*, inscribing it with the date of her birth and his name entwined with hers.

Louie spent whole days with Burne-Jones and Morris in the studio, where she was given her own pencils and paints. Later Burne-Jones instructed her in wood-engraving. He encouraged Louie's little-girl ambitions, painting a dream vision of the future, telling her 'I do so look forward, dear, to the years afterwards, when we shall learn things together (you and Georgie and I, living

on some round tower by the sea, with Topsy) – so much about art there is to learn and live for.' Burne-Jones watched over her as Louie made two pen-and-ink drawings, one of which was of the prince waking the Sleeping Beauty. Georgie's little sister Louie, on the edge of puberty, was a child of an age he found easy to relate to, a young girl in a state of soon-to-be-ended innocence. The Sleeping Beauty was a theme Burne-Jones was to return to in his own painting with a near-obsessive frequency.

Even before he came to live in London William Morris had been gravitating into Rossetti's orbit. Now he was finally influenced by Rossetti's strong conviction that everybody competent to paint should be a painter to abandon architecture and become a painter too. His mother was dismayed when he announced this to her in his usual tactless manner and inevitably held Burne-Jones to blame. Morris's architectural colleague Philip Webb was also temporarily persuaded by Rossetti to become an artist. The first model who sat for him was surprised to find herself being measured accurately, as if she was a building. Even R. W. Dixon, the poet, attempted to paint. But not for long. Once Morris left Street's office he, Burne-Jones and Rossetti were for a while inseparable, influencing one another, exchanging ideas and information, forming a kind of triangle of creativity. As Burne-Jones and Morris became more Dantesque, affected in their work by Dante's strange poetic visions, Rossetti became more medievalist in outlook. He was now susceptible to Malory as well, apt to lean against the counter of the eating house in Cheapside the three of them frequented and pull out of his pocket a copy of *Morte d'Arthur*, reading extracts out loud to the assembled clientele.

Through Rossetti, Burne-Jones now had an ever widening circle of acquaintanceship. The Pre-Raphaelite Brotherhood had for some years ceased to be connected as a close-knit group. John Millais had married Effie, formerly John Ruskin's wife, in 1854 after the scandalous annulment of her marriage to Ruskin on grounds of non-consummation. By 1856 she and Millais were living in Scotland, near Effie's family home. William Holman Hunt had been away on several journeys to Egypt and Palestine,

painting biblical scenes in their authentic setting. The most extreme of the works resulting from these travels was of course *The Scapegoat*, showing the reviled creature on the shores of the Dead Sea. However, Hunt and Rossetti remained on terms of intimacy and Burne-Jones's first sight of Holman Hunt was in Rossetti's studio, 'a grand looking fellow with a great wiry golden beard and faithful violet eyes'. Rossetti sat beside him affectionately playing with the golden beard, 'passing his paint brush through the hair of it'.

As a practising artist Burne-Jones was accepted on an almost equal footing with other artists in the Pre-Raphaelite circle: Arthur Hughes, whose *April Love* painting he had 'nobbled' for Morris a year earlier; the sculptor Thomas Woolner; the cantankerously humorous Ford Madox Brown. 'Madox Brown is a lark!' Burne-Jones exclaimed. 'I asked him the other day if I wasn't very old to begin painting, and he said, "Oh no! There was a man I knew who began older; by the bye, he cut his throat the other day".'

As well as an education in art, Rossetti gave Burne-Jones a sense of greater sexual possibilities. The atmosphere around his studio, and other Pre-Raphaelite studios, was louche. The model very easily transformed into the mistress and in some cases the wife. Although there is no mention of Lizzie Siddal at this point in Georgiana's discreet memoir of her husband, Burne-Jones must have been aware of Rossetti's muse, model and long-term fiancée. Elizabeth Siddal, a girl of respectable working-class origins, was first spotted by the painter Walter Deverell working in a dressmaker's and millinery shop in Cranborne Alley off Leicester Square. Her peculiar style of beauty, her withdrawn and almost regal bearing, her heavily lidded eyes and red-gold hair had made her a favourite Pre-Raphaelite sitter. Lizzie Siddal is John Everett Millais's Ophelia, drowning beneath the opulently flowering bank. She had artistic talent, became Rossetti's pupil and was soon modelling exclusively for him.

There is no evidence that she was actually his mistress but from the early 1850s the enigmatic, delicate, neurotic Lizzie Siddal was more or less a fixture in Rossetti's studio. Ford Madox Brown, for

instance, calling at Chatham Place found 'Miss Siddall looking thinner and more deathlike and more beautiful and more ragged than ever, a real artist, a woman without parallel for many a long year'. Rossetti promised to marry her. He loved her but was still compulsively unfaithful. She hoped and he prevaricated. This became the pattern. With Rossetti and Lizzie, Burne-Jones had now entered a new scene of fascinating moral ambiguity.

Finally in this *annus mirabilis* Burne-Jones at last made contact with his revered correspondent, the man he considered a Luther of the arts. He and John Ruskin had first glimpsed one another in the May of 1856 in Rossetti's studio. Ruskin then went away on travels with his parents in Switzerland. But on 21 October, after his return, he called on Burne-Jones and Morris in Red Lion Square. Ruskin was interested and intrigued and said he planned to make a habit of calling every Thursday on his way to the Working Men's College to check on the progress of his new protégés. In December Burne-Jones and Morris were invited to dine at the Ruskin family home on Denmark Hill. Sir Walter and Lady Trevelyan and the

Rossetti's drawing of himself being drawn by Lizzie Siddal in his rooms in Chatham Place in 1853.

portrait painter Thomas Richmond were the other guests. Burne-Jones wrote home euphorically to Miss Sampson, still *in situ* as his father's housekeeper in Birmingham: 'Just back from being with our hero for four hours – so happy we've been: he is so kind to us, calls us his dear boys and makes us feel like such old friends.' He could scarcely get over his good fortune: Ruskin in real life was even 'better than his books, which are the best books in the world'.

In the long run Ruskin's influence on William Morris dwindled. Morris after all had less need of patronage. But for Burne-Jones Ruskin became almost a father substitute. They were connected all their lives in what became a complicated quasi-familial love-hate relationship. When the maid at Red Lion Square showed Ruskin in, announcing 'Your father, sir,' she was not wide of the mark.

John Ruskin was then, at the age of thirty-seven, the most authoritative art critic of the time. He is one of the most admirable but also the most baffling of all the major figures of the nineteenth century, a tall slight figure with sandy-coloured hair, reddish whiskers and piercing blue eyes that seemed to look right through you. Ruskin lisped, and his voice rose and fell at measured intervals, giving an impression of the cleric in the pulpit. He was a peculiar mixture of the ponderous and infantile, the solemn and the whimsical, the feminine and almost embarrassingly boisterous and boyish. Oddest of all was John Ruskin's combination of apparent political incompatibilities. This was a ramrod Tory whose visionary ideas of art and craft, and the part that art plays in any civilised society, have reverberated through from his own century to ours.

The Ruskin who met Burne-Jones in 1856 was a man in a particularly vulnerable state. He could not have been immune to the gossip surrounding the annulment of his marriage, although he pretended a sublime indifference. His psychological need to be in the position of chief patron and instructor to younger artists he admired had suffered from the rift with Millais once he was recast in the role of Ruskin's cuckolder, and from the disappearance of

Hunt on his long travels. Of the original three, the one remaining Pre-Raphaelite recipient of Ruskin's support was now Rossetti. Ruskin continued to buy Rossetti's paintings and also gave an allowance to Lizzie Siddal, encouraging her work and sympathising with her ailments. Now that Rossetti was finding Ruskin's torrents of advice extremely onerous, there an obvious vacancy.

Burne-Jones was younger than the original Pre-Raphaelites, who were in a sense beginning to outgrow the original promoter of their 'new and noble school'. Though so obviously talented he was still virtually untrained. He also very evidently worshipped Ruskin. A self-cartoon drawn at the time of his first letter from Ruskin shows Burne-Jones lying flat at the feet of a saintly figure of Ruskin in a halo. All this encouraged Ruskin to see him as potentially the leader of a second generation of Pre-Raphaelites. In another few years he would be heaping praise on him as 'the most wonderful of all the Pre-Raphaelites in redundance of delicate and pathetic fancy – inferior to Rossetti in depth – but beyond him in grace and sweetness'.

Ruskin's support was practical. An early visit to Red Lion Square was made with the intention of carrying off one of Burne-Jones's drawings in order to 'show it to lots of people'. Burne-Jones, honouring his side of the bargain, followed Ruskin's tenets of the authority of art achieved through a persistent study of natural forms. In a wild English May of 1857 we find Burne-Jones in Worcestershire and Warwickshire seeking authentic apple-blossom for his early watercolour *The Blessed Damozel*. In June he was painting Pre-Raphaelite lilies from life in the garden of Red Lion Square. A few weeks later he and Georgie were watching William Morris painting a tree in MacLaren's Oxford garden with such commitment that 'it was long before the grass grew again on the spot where his chair had stood'.

Burne-Jones was now acquiring his own clients. *The Blessed Damozel* had been commissioned, on Rossetti's recommendation, by T. E. Plint, a Leeds stockbroker. Although Mr Plint was to say a little wanly he would really have preferred a subject drawn from

scripture, the subject was taken from a Rossetti poem. Thomas Plint was, as Burne-Jones's clients needed to be, a man of easy-going optimism who paid for his pictures in advance by cheque. Once he had paid for a pair of relatively small designs for *The Blessed Damozel* he asked Burne-Jones for another painting 'of a more important size'. Burne-Jones also received a commission at this period from the Newcastle industrialist James Leathart, continuing a pattern of enthusiasm for Pre-Raphaelite painting amongst successful manufacturers of the industrial North. He began to gravitate from pen-and-ink to watercolour paintings which were more readily saleable. Other works were commissioned from within his own close circle: by F. J. Furnivall, for instance, and George Boyce. It was at this juncture that his doubting father began to approve of his choice of career.

At this stage Burne-Jones was beginning to design the stained-glass windows that remain one of his greatest claims to fame. He designed them all his life and his output was astonishing, reaching a productive height of almost a stained-glass cartoon a week. The earliest design, made in 1857, was *The Good Shepherd* for James Powell and Sons of Whitefriars, a leading stained-glass manufacturer. The commission was passed on to Burne-Jones by Rossetti, the first artist Powell had approached. Rossetti himself described the design with precision and *tendresse*: 'Christ is here represented as a real Shepherd, in such dress as is fit for walking the fields and hills. He carries the lost sheep on his shoulder, and it is chewing some vine leaves which are wound round his hat – a lovely idea, is it not?' Rossetti registered the loaf and bottle of wine, elements of the Communion, suspended from Christ's girdle and the wonderful glimpsed Gothic landscape in the background. 'The colour of the whole is beyond all description.' Rossetti's delight had been shared by Ruskin, apparently 'driven wild with joy'.

In these early years Burne-Jones was to design at least five more windows for Powell's: three for the chapel of St Andrew's College, Bradfield; the St Frideswide window for the Latin Chapel at Christ Church Cathedral in Oxford; for Waltham Abbey, a large and glorious tripartite Tree of Jesse window surmounted by a

great rose window showing the Seven Days of Creation with rejoicing host of angels, first example of the glorious assemblages of 'stunners' that became almost a trademark of Burne-Jones stained glass.

The Waltham Abbey window had been commissioned by William Burges, the architect in charge of the restoration of the building. The widespread restoration of churches and the building of new ones at that period of reawakened feeling for religious ritual and splendour had opened out a profitable market for stained glass. Burne-Jones also designed one window, maybe more, for Lavers and Barraud, Powell's rival. A further commission from the architect William Butterfield for a three-light window for St Columba's Church at Topcliffe in Yorkshire turned to a disaster when Butterfield accused Burne-Jones of sacrilegious treatment of the Virgin Mary, clasping the dove to her bosom in the Annunciation window. Burne-Jones refused to alter his design. The remaining two windows were handed over to another artist and are much inferior.

This initial little series of Burne-Jones stained-glass windows has a distinct character. The crowded, even hectic, brilliantly coloured windows could hardly be more different from the standard eighteenth-century English stained-glass windows in which the reliance on enamel colour washes gives them a kind of lethargy, like paintings on canvas on a giant scale with the leading that holds the stained glass in place ignored. Burne-Jones was already finding ways of giving stained-glass windows their own design totality by making the lead framework supporting the coloured glass components integral to the design.

Their *mouvementé* quality and the sense of human drama instilled into such scenes as the destruction of the Tower of Babel and the miraculous adventure of Oxford's patron saint, St Frideswide, stand in contrast to the more static and heraldic glass of A. W. N. Pugin and his Gothic Revival contemporaries. Burne-Jones's was essentially Pre-Raphaelite glass, vigorous, a little wayward and potentially unsettling. To his critics the figures in his windows were all too recognisably Pre-Raphaelite: 'the set, stony

stare of the eyes, the pursed-up trim, puritanical mouth, and the lank hair, plastered flat over the forehead'. It was uningratiating, deliberately so. It was genuine and true, in the manner the Pre-Raphaelite artists aspired to. This was human realism as achieved in the Arena Chapel by Giotto, one of the sacred places of Pre-Raphaelite art.

The most interesting thing is the way in which his early windows differ from the hundreds, even thousands, of designs Burne-Jones made later for the William Morris firm. These would be more of a collaborative venture. Nor could the Morris glassworks arrive at the density of colour available to Burne-Jones at Powell's. Here the young Burne-Jones was working on his own, dictating his own colours, arriving at designs which although a little outré and peculiar in their scale are almost deliriously rich in colour. Burne-Jones already shows signs of turning stained glass into a modern art form, prefiguring the stained glass of Matisse and Chagall.

Through midsummer and autumn of 1857 Burne-Jones was back in Oxford. Through his work in stained glass he already had a feeling for the decorative treatment of large architectural spaces. Now he had his first opportunity to paint a mural in the Debating Hall of Benjamin Woodward's recently completed Oxford Union building. The moving spirit in this project was Rossetti and it was decided that the theme for a sequence of paintings in ten bays of the Union gallery should be Arthurian. A number of established artists were invited to come and paint for free, the Union providing materials and living expenses. Holman Hunt's initials were inscribed optimistically on one of the bays. But he turned the invitation down, as did William Bell Scott and Ford Madox Brown. Besides Rossetti and Arthur Hughes, the painters assembled for a project that became known as 'the jovial campaign' were all relative novices: Burne-Jones and William Morris, John Hungerford Pollen, Valentine Prinsep and John Roddam Spencer Stanhope. Other helpers came and went.

Woodward's rugged red-brick Gothic building, designed in the same style as his tour de force University Museum, was then so new that the mortar was hardly dry and the rough brickwork only

thinly covered with plaster when the artists impetuously started work. Burne-Jones's subject was *Merlin Being Imprisoned Beneath a Stone by the Damsel of the Lake*. Malory's account of the tricking and entombment of Merlin the magician by Nimuë, the seductive lady of the lake, held an enduring fascination for Burne-Jones. So proprietorial towards Nimuë did he feel that the following year he complained to Tennyson that his own version of Nimuë in the forthcoming *Idylls of the King* was a travesty of Malory's original. Tennyson had made her almost a Victorian matron. The poet obligingly changed the name to Vivien.

Life at Red Lion Square had always been a little ramshackle. A visitor, George Birkbeck Hill, described a visit to Burne-Jones. Rossetti was also there. 'At night five mattresses were spread on the carpetless floor, and there I slept amidst painters and poets.' The bohemian informality was reproduced when Rossetti's new brotherhood of muralists assembled in Oxford. Burne-Jones, Morris and Rossetti took rooms at 87 High Street, opposite Queen's College. Their rooms were reached across a courtyard in which Val Prinsep, on his first night at Oxford, going there to dine, noticed 'a fine specimen of the vegetable marrow'. He saw a sketch by Rossetti of this same marrow in the sitting room, which opened onto the yard. Rossetti received him dressed in his plum-coloured frock-coat, confident and cordial. Then presently 'Ned Jones slipped into the room, opening the door just sufficiently wide to allow of his passing. "Ned," cried Rossetti, "you know Prinsep." The shy figure darted forward, the pale face lit up, and I was received with the kindly effusion which was natural to him.'

Work started on the murals at eight o'clock each morning and went on until light failed. Sometimes the artists would work at night by gaslight. They modelled from each other. Rossetti used Burne-Jones for the figure of the drowsing Launcelot in his mural *Sir Launcelot Prevented by His Sin from Entering the Chapel of the San Grail*. 'What fun we had in that Union! What jokes! What roars of laughter!' recollected Val Prinsep, a giant of a youth, then only nineteen but six foot one in height and weighing fifteen stone. He was able to pick up Burne-Jones bodily and carry him under

one arm up the ladder to the painting gallery. When the pair of windows in each painting bay were causing problems by letting in the light they were whitewashed over and covered with joke sketches. Burne-Jones started on a series of caricatures of William Morris, wild-haired, fat and vulnerable, looking a little piglike. He entitled these the Topsy Cartoons.

Jokes between them were already of the essence of the Burne-Jones/Morris friendship, uproarious jokes in which William Morris is the victim. There were just so many stories, many dating back to Oxford, told and retold among the group of friends. The day Morris got imprisoned in the suit of armour he had himself commissioned from a smith in Oxford, yelling inside his helmet, desperate to be released. The sewing up of his waistcoat so that when he put it on he seemed to be even fatter than he was. Burne-Jones's caricatures give a view of Morris as a figure of fun. It is possible to see in them an element of jealousy – extraordinary fondness with a little edge of cruelty. This became the basis of his feelings for his friend.

Burne-Jones and William Morris were the two most dedicated of the Oxford Union artists. According to Spencer Stanhope, Burne-Jones appeared unable to leave his picture of his Nimuë and Merlin 'as long as he thought he could improve it'. Once Morris finished his own mural, based on the disastrous triangular relationship of Sir Tristram, Sir Palomides and the fair Iseult, sadly prophetic of Morris's own love life, he turned his attention to the hipped and panelled roof where the painted decoration of strange birds and beasts and foliage created the impression of an all-enclosing medieval forest, charming but a little menacing as well.

In the evenings, back in the lodgings, work continued. Etched on Prinsep's memory was the quietly domestic scene of Rossetti on the sofa with his large melancholy eyes staring at Morris sitting reading at the table, fidgeting neurotically with his watch chain, while Burne-Jones worked at the detail of a pen-and-ink drawing. It seems likely that Burne-Jones and William Morris also found the time to carry out Arthurian painted decorations on the doors

and chimney piece of a room in Drawda Hall, a building in the High Street then belonging to University College. Their old friend Charley Faulkner, one of the original 'Birmingham set', having taken a First in Mathematics, had stayed on in Oxford to become a University College fellow. He too had been drawn into the Oxford Union decoration. The Drawda Hall paintings have traditionally been dated summer 1856 when in fact neither Burne-Jones nor Morris was in Oxford. It is more probable that these gawky but not unpleasing paintings date from the summer of the jovial campaign.

The pattern of close intimacy between Burne-Jones, Rossetti and Morris altered in the following Michaelmas term. 'Now we were four in company and not three,' wrote Burne-Jones registering the arrival on the scene of Algernon Charles Swinburne, a weird-looking young man, a beautiful grotesque, with tiny feet and hands, translucently white skin, a disproportionately large head and, stuck out almost at right angles, the floating red-gold hair that prompted Burne-Jones to nickname him 'Little Carrots'.

Swinburne, then at Balliol, had had a chequered history, having left Eton early, perhaps as a result of some sexual misdemeanour. The brutal regime at Eton certainly encouraged Swinburne's lifelong obsession with flagellation, and the undertow of sadism and masochism in his literary works. Dr Eddison, a visitor to Faulkner's rooms at University College, had looked across to Queen's and seeing a red frizzy head he had remarked, 'Why, there's a girl!' 'That's Swinburne,' he was told; 'won't he whop you when we tell him.' Already this was a figure of some notoriety.

The diminutive boy, who was already writing Shelley-inspired libertarian poetry, was brought to view the work in progress at the Oxford Union by Burne-Jones's Birmingham schoolfellow Edwin Hatch. He was already an admirer of *The Oxford and Cambridge Magazine*, and the shy, neurotic Swinburne was easily drawn into the easy camaraderie of the scene, the endless stream of jokes shared by the artists as they worked and the cult of medievalism they shared. His own poetry became more Arthurian in tenor. Swinburne's *Queen Yseult* is clearly imitative of Morris's *The*

Defence of Guenevere. Morris generously rated Swinburne's poem more highly than his own. 'Little Carrots' was to become one of the most highly regarded poets of the Victorian period, as Morris was himself. His place in Burne-Jones's personal mythology is crucial, and here his position is the opposite of Morris's. If Morris is the good angel, innocent and stalwart, then Swinburne is the wicked one, the tempter, leading Burne-Jones into bizarre byways of the sexual imagination.

From September the friends had moved from the High Street to a squalid 'crib' nearby in George Street, with fleas in the feather beds. Here Rossetti spent much of his time painting watercolours, to which Morris composed poems, and pursuing the Pre-Raphaelite sport of hunting 'stunners'. Walter Deverell finding Lizzie Siddal in the hat shop; Holman Hunt first noticing his model and inamorata Annie Miller in the street: there are multiple examples of the model glimpsed in passing, then cajoled into the studio. The smooth-talking Rossetti was a master of the art. He was to pick up two of his most successful models, Alexa Wilding and Fanny Cornforth, in the Strand. Fanny was at the time cracking nuts with her teeth and throwing the shells ostentatiously about. Another favourite model of Rossetti's at the time was Ruth Herbert, the tall golden-haired actress he first saw performing in a London theatre. When he drew a pencil study of her for the figure of the Virgin for his altarpiece for Llandaff Cathedral he added the word STUNNER beside Miss Herbert's head.

In an Oxford theatre in 1857 Rossetti and Burne-Jones spotted the young woman who became the ultimate stunner, the iconic female figure of Pre-Raphaelite art. They attended a performance, probably of the popular nautical drama *Ben Bolt*, in the temporary summer season at Russell's Indoor Tennis Court in Oriel Lane. This was previously the site of Archibald MacLaren's gymnasium. In the gallery above them was Jane Burden sitting with her sister Bessie. They were the daughters of an Oxford groom. Jane was then a tall dark girl of seventeen with strikingly unusual gypsy looks. Rossetti with Burne-Jones approached her after the performance, asking her to come and sit to him next day. She agreed at

the time, but she did not arrive. Perhaps she lost her nerve or was forbidden by her family. Modelling was not at that period considered a respectable occupation.

It was Burne-Jones who met her in the street a few days later. Either he or, more likely, Rossetti persuaded her parents to allow her to model. Rossetti made a series of drawings and sketches of Jane Burden, working in the first-floor drawing room at George Street. Most of these depict Janey as Guenevere, Arthur's adulterous queen. At this stage did Rossetti fall in love with Janey? How did Burne-Jones himself later view an episode in which he seems to have played a Pandarus-like role? His wife's *Memorials* reveal little. All that does seem certain is that common definitions of a 'stunner' altered. According to Val Prinsep, 'As this lady had dark hair the legendary "stunner" with the auburn hair was in abeyance for a time.'

Rossetti had allotted himself three of the ten murals. However, he had only half-finished his first, the *Sir Launcelot* mural, in the middle of November when he was called away to Matlock in Derbyshire, where Lizzie Siddal was then staying, alarmed by the news of her worsening condition. The nature of her long-term illness remains mysterious. At one point curvature of the spine was diagnosed and Lizzie was advised to enter Florence Nightingale's Harley Street sanatorium. When Lizzie was sent by Ruskin to consult the famous Oxford physician Dr Acland his diagnosis was of 'mental power long pent up and overtaxed'. No doubt much of this stress arose from Rossetti's philandering and failure to commit himself to marriage. Lizzie had now gone to Matlock Spa to try the hydropathic cure, but she was no better. Once Rossetti left for Matlock he did not return. William Morris took over, using Janey as his model, drawing and painting from her in the same upstairs sitting room. He became besotted with her. 'I cannot paint you but I love you', he wrote in desperate inarticulacy on his picture of Jane Burden as la Belle Iseult. By February 1858 Morris and Janey were engaged.

In that same month Burne-Jones's mural of Merlin and Nimuë was finally completed. Prinsep later judged that of all the Oxford

Union paintings Burne-Jones's was 'The only one of real artistic merit . . . It was fine in colour, excellent in design, and entirely new in aspect.' Working alongside him, he had been aware not only of Burne-Jones's manual dexterity but also of his 'instinctive knowledge of how a thing ought to be done'. All that was so far lacking was a proper mastery of human form. Gabriel's brother, William Michael Rossetti, was also complimentary if somewhat mystified, describing the Union murals as 'very new, curious, and with a ruddy bloom of health and pluck about them – Gabriel's very beautiful both in expression and colour; Jones's next, and to some extent *more* exactly the right kind of thing'.

But as a whole the project was ill-fated. With three bays still not yet completed, the paintings very quickly began deteriorating. The ground had never been properly prepared. By June 1858 the murals were already reported to be 'much defaced' because of damp and dust in the atmosphere and also because of heat and smoke from the gas chandeliers. In spite of several attempts to restore them they remain ghostly reminders of that summer of the popping of soda-water siphons and the screeching of Pre-Raphaelite obscenities.

Little Holland House
1858

Burne-Jones was twenty-five when he returned to London, now bearded and moustached, though still tentative in manner. Back in London he experienced a total change of scene. 1858 was the summer in which Burne-Jones went to live at Little Holland House in a high bohemian atmosphere totally at variance both with the privations of his upbringing in Birmingham and his rather doggedly provincial Oxford undergraduate life. It was also the summer in which Burne-Jones and William Morris, up to now so close in their activities and attitudes, showed the first signs of divergence of views.

Little Holland House in Holland Park was originally the dower house of Holland House itself, a famous political and social centre in the days of the 3rd Lord Holland when Byron used to visit and flirt with Lady Holland. It was here he first met his nemesis, Lady Caroline Lamb. By the mid-nineteenth century Little Holland House consisted of a pleasingly informal collection of buildings, some of them farm buildings getting slightly shabby, in what was still rural West Kensington.

Since 1850 Little Holland House had been leased by Sara Prinsep, mother of the aspiring artist Val, and her husband Thoby, a retired Indian civil servant. She was one of seven brilliant Pattle sisters, born into an Anglo-Indian family, several of whom would play key roles in Victorian London cultural life. She had married Thoby Prinsep in 1835. Even his friends admitted Thoby could be

tedious. A woman who knew him in India described him as 'the greatest bore Providence ever created'. But Sara was liveliness itself, a discriminating and determined creator of a salon where the leading artists, philosophers, musicians, politicians and writers of the period converged. Her guiding principles were beauty and asperity of mind.

At Little Holland House the mood was easygoing but at the same time heightened by a sense of expectation and a hint of sexual unconventionality which one visitor, the young George Du Maurier, found worrying: 'I seem to perceive a slight element of looseness, hein! which I don't sympathise with'. If the regime at Little Holland House reminds one of later Bloomsbury Group gatherings this is not surprising. Sara Prinsep's great-nieces were the painter Vanessa Bell and the writer Virginia Woolf.

Rossetti had introduced his protégé Burne-Jones into this charmed circle in July 1857, driving him out to Kensington in a hired hansom cab. 'You must know these people, Ned; they are remarkable people,' he was told. Ned was very nervous about meeting 'a lot of swells' who would frighten him to death. Rossetti, conscious of the need to establish the credentials of anybody brought within the Prinseps' orbit, introduced him as 'the greatest genius of the age'. The painfully shy young man with straggling straight fair hair passed muster with his hostess, who saw it as her mission to protect him and cajole him out of his initial gaucheness. Soon he was calling her 'Aunt Sara'. Ned 'fell under the spell of the house as many another did', his widow later recollected somewhat acidly. He liked what he had seen of the good-humoured, eager Val in the summer of the Oxford 'jovial campaign' and now their friendship became a lot more intimate. Gradually, willingly, Burne-Jones became an habitué of Little Holland House.

In 1858 he was seriously ill again. First there had been a nervous collapse beginning once he finished working on the Oxford Union. There are stories of him fainting on MacLaren's sofa. This became a lifelong pattern of breakdown following a period of intense creative productivity. Through the summer, back in Red Lion Square, he worsened. Summer 1858 was a notoriously hot one when the

temperature rose to 90 in the shade and the smell from the putrid River Thames, still an open sewer, came to be known as 'the Great Stink'. Burne-Jones might well have died had Sara Prinsep not arrived to rescue him from the fetid inner London air. According to Georgiana, 'she took possession of him bodily', drove him off in her carriage to Kensington and put him in the care of her own family doctor, Dr Bright, who forbade him either to touch or smell oil paint until he regained his strength. He was then so weak that he relied on Val Prinsep to carry him up and down the stairs.

Essentially Burne-Jones had been kidnapped by the woman he once called 'the nearest thing to a mother that I ever knew'. At first he had misgivings, frightened that once installed there he would be at Little Holland House for life and would lose touch with Rossetti. But he was too ill to resist and was quickly lulled into enjoyment of a London life that seemed to him almost exotic, 'foreign in its ease and brilliancy'. Mrs Prinsep's hospitality was lavish:

Often there would be dinner laid for thirty or forty people – much feasting and noise and clatter of tongues and dishes, and a certain free grand hospitality, and about the lawn people walking, and talking, and enjoying themselves without effort or constraint in a way that happened nowhere else in England. Thackeray, and Browning, and Tennyson were there, all of whom were mighty names to me, everyone who was of any mark in the world of thought or of art was there, and tall beautiful women amongst them, and that happened every week.

Burne-Jones's reference to tall women is pertinent. Not just six-foot Val but his father, mother and her sisters were bigger than the mid-Victorian norm. This was painfully obvious when Sara Prinsep paid a proprietorial visit of inspection to the home of Ned's diminutive fiancée Georgiana, arriving at the Methodist minister's small house in her carriage accompanied by her equally impressive sister Lady Somers. Georgie confessed that 'in spite of the gracefulness of the callers' the visit had been a considerable ordeal.

How could Burne-Jones, brought up in drab Birmingham, resist the generosity and glamour of a household in which art and beauty

were regarded as an integral part of everyday life? Thoby Prinsep's weak sight meant that the reception rooms were dimly lit. The rich colours of the decor glowed the more alluringly. There was a confident flamboyance in every detail of the *mise-en-scène*: 'The very strawberries that stood in little crimson hills upon the tables were larger and brighter than others.' The large garden felt expansive, groves of trees and spreading lawns easily accommodating the groups of famous friends who arrived each Sunday for the Prinseps' 'open house'. Some played bowls or croquet. Sometimes the musicians among them would perform, Charles Hallé on the piano, Alfredo Piatti on the cello, Joseph Joachim on the violin. There was a constant flow of conversation.

The young Burne-Jones was flattered, teased, made much of. Ruskin, a frequent visitor, on being shown one of Ned's drawings, exclaimed, 'Jones, you are gigantic!' This was overheard by Tennyson, who every time he saw him would hail him as 'Gigantic Jones'. His name for Burne-Jones maybe had a touch of irony for Tennyson was not a Pre-Raphaelite enthusiast. Ruskin caught the mood of affectionate badinage, describing Ned 'laughing sweetly at the faults of his own school as Tennyson declared them and glancing at me with half wet half sparkling eyes, as he saw me shrink'.

Sara Prinsep herself, with her Irish-French vivacity, was the dominant presence at Little Holland House. But her older sister Julia Margaret Cameron, who lived nearby in Putney, was a rival attraction on her visits to the Prinseps, fascinating those who met her with 'her incalculable ways, brilliant words and kind actions'. At the time Burne-Jones was captive at Little Holland House, Julia Margaret Cameron had yet to begin the career as a photographer that became 'the mingled terror and delight of her friends'. But just a few years later she became the most original, accomplished portrait photographer of the period, removing portraiture from the realms of the static studio *carte de visite* and making it an art form. Her portraits were dramatic close-up photographs taken against dark backgrounds and given an almost Rembrandt-like veracity and grandeur by her great skill in manipulating light.

With her powers of persuasion and the sisters' range of contacts she photographed the leading figures of the age: Thomas Carlyle, Charles Darwin, the scientist Sir John Herschel swathed in velvet with a floppy velvet cap. She caught Tennyson unkempt and slightly frenzied in the pose that became known as 'The Dirty Monk'. She could be imperious and careless with her sitters, once forgetting and abandoning Browning where she had posed him in a corner of the garden at Little Holland House. He sat there imprisoned in his heavy draperies. She used, one might almost say exploited, those around her. She would seize on friends, children, servants to pose for her photographic tableaux, fantastic little scenes from literature and legend. She and Burne-Jones were very much related in their ability to create compelling dream worlds, narratives of ideal beauty. Mrs Cameron too had a yen for the Arthurian. Her photographic genius sprang from the combination of sprightliness and staginess that characterised life at Little Holland House.

The women there had taken to wearing seductive flowing dresses instead of the more structured mid-Victorian crinoline. Sara Prinsep's sister Sophia Dalrymple, a gentler and more sympathetic presence in the household, could be recognised by 'the sound of soft, silken rustlings and the tinklings of silver bangles as she came and went'. Sophia was the youngest of the seven closely entwined Pattle sisters. In 1847 she had married John Warrender Dalrymple of the East India Company, but after six years with him in India had returned on her own and was living with the Prinseps at Little Holland House. Burne-Jones had evidently fallen a bit in love with her during that hot summer there. He was twenty-five and Mrs Dalrymple four years older. In the album of drawings and poems he assembled for Sophia over the next year or two he depicts himself in the frontispiece, the courtly lover-musician marked out by the word 'AMOR'. He signs letters to his 'Dearest Auntie' in terms of hopeless passion, such as 'Your abjectly devoted dog Ned'.

Burne-Jones wrote out all the poems in the album for Sophia. Three are by Rossetti who was also an adorer of her and evidently

collaborated on the volume. The selection of poems reflects their shared enthusiasms for Dante, Keats, Edgar Allan Poe, Scottish ballads, old French lyrics. There is also a reminder of the friendship with Tennyson, whose 'Wise and Foolish Virgins' from the *Idylls of the King* are included in the volume. Burne-Jones made all the drawings to illustrate the poems. These are delicately, beautifully medieval, drawing on his knowledge of illuminated manuscripts, and admiration for the prints of Albrecht Dürer, his love of staring sunflowers, castellated ramparts, the Blessed Damozel leaning out from her tall turret with those medieval lilies in her hand.

The album remained in the Dalrymple family and was only made public in 1981 in John Christian's edition. Biographically speaking it was an exciting rediscovery in that Burne-Jones's medieval images are also the pictures of that golden summer at Little Holland House. Scenes of young women lying languorously on the lawns; hints of decadence and weirdness, strange fruits and musky odours; the portrait of Sophia herself in floaty garments with a retinue of speeding lovebirds. The album for Sophia has unsettling undercurrents suggesting the richness of experience Burne-Jones underwent in that captive summer and the hint of danger.

No wonder Georgiana describes the episode a little edgily in her *Memorials* of her husband. William Morris too had many reservations about Burne-Jones's sojourn in that particular lap of luxury. Morris had, writes Georgiana, 'a defiant tone towards the fashionable life which existed there side by side with the literary and artistic'. He was always to remain anxiously disapproving of Burne-Jones's susceptibility to female blandishments and tendency to upward mobility.

Burne-Jones was not the only artist in residence at Little Holland House. There from the beginning had been an older and, by then, a more established painter, G. F. Watts. Like Burne-Jones, Watts had risen from a background of struggle. His family of London cabinet and pianoforte makers was beset by illnesses, deaths and

poverty. His childhood had been hard. But Watts's talent for drawing was precociously evident, as was his genius for attracting and keeping long-term patrons and protectors, first the 4th Lord Holland and his wife and then the Prinseps. It was Watts apparently who had first suggested that the Prinseps should lease Little Holland House, soon installing himself as their permanent guest. 'He came to stay three days, he stayed thirty years,' Sara was to comment uncomplainingly.

Watts the working artist had become the revered centre of attention in the domain of Sara and her sisters, the haven known satirically as Pattledom. Originally he had been besotted with the tall sister Virginia, who to his dismay soon married, becoming Lady Somers. It was another of the sisters, the amiable but slightly dangerous Sophia, who first christened Watts 'Signor', a title he lived up to by wearing a black skullcap and cultivating a silvery solemnity of manner. From then on in the art world Watts was always known as Signor. He called Sophia 'Sorella' in reciprocation.

George Du Maurier, describing his first visit to Little Holland House, was derisive about Watts's position of power in Mrs Prinsep's 'nest of preraphaelites, where Hunt, Millais, Rossetti, Watts, Leighton etc., Tennyson, the Brownings, and Thackeray etc. and tutti quanti receive dinners and incense, and cups of tea handed to them by these women almost kneeling'. Watts, he sneered, was being worshipped 'till his manliness hath almost departed'. The best part of the house had been turned into his studio and Signor would claim his position reclining on the drawing-room sofa as of right.

When Rossetti first took Burne-Jones to Little Holland House he had prepared him to meet Watts the great eccentric: 'he paints a queer sort of pictures about God and Creation'. This was still a few years before Watts made his disastrous marriage to the sixteen-year-old actress Ellen Terry, a liaison Sara Prinsep had connived at. When Burne-Jones first met him Watts was still the artist bachelor, dedicated to his increasingly abstruse, ambitious paintings treating great themes of time and death and judgement, conscious that the artist should also be the moralist, bringing philosophical

debate upliftingly, unmissably into the public realm. At this period Watts was completing the grandiose mural *Justice: a Hemicycle of Lawgivers* for the Great Hall of Lincoln's Inn, an intellectually challenging assembly of legal innovators back through history. Apart from the Oxford Union mural, Burne-Jones's work had up to now been relatively niggling. Watts gave him a feel for the grand scale.

The Prinseps' artist protégé was then hardly more than forty but he always seemed much older, prematurely elderly. Watts became, as Ruskin had before him, a quasi-father figure for Burne-Jones, respected, listened to and gently teased. Thrown together as they were in luxurious proximity in summer 1858 in that highly cultured house, they developed a great friendship, an easiness and closeness that lasted all their life.

Watts was a supreme technician. Burne-Jones always regarded him as 'a painter's painter' whose true greatness was not that of the poetic or the narrative painter: 'his greatness lies in his wonderful technique'. Watts's technical training had started very early. When still only a child he had worked in the studio of the sculptor William Behnes learning the academic methods of copying, making studies in physiognomy, making engravings after the old masters. Compared with Watts, Burne-Jones was conscious that, technically speaking, he was still a novice. If Rossetti had given him confidence in trusting his imaginative instincts, his proximity to Watts in the household of the Prinseps gave him an education in technique. 'It was Watts much later who compelled me to try and draw better.' Burne-Jones's drawings from now on have more professional fluency and finish.

It was also G. F. Watts who opened his eyes to Italy, his most loved country, the land that would become the major influence on Burne-Jones's attitude to art. Watts himself was an Italophile so dedicated he came to be known as 'England's Michelangelo'. He had spent formative years in Italy in the 1840s, the period at which he was living with the Hollands. Watts's self-portrait wearing a quasi-Renaissance suit of armour and another in the robes of a Venetian senator show how far he was by then self-identified with a romanticised Italian past.

He absorbed, and was absorbed into, Italian culture, consciously treading in the steps of the old masters, taking scenes from Italian history as the subjects for his grand narrative paintings such as the fresco *The Drowning of Lorenzo de Medici's Doctor* still *in situ* at Villa Careggi, the Hollands' former Medici villa in the hills outside Florence. While in Italy Watts began to practise in sculpture in addition to painting. What is Watts's figure of *Physical Energy* in Hyde Park other than a huge Renaissance sculpture?

An enhanced appreciation of the classical art of Greece and Rome; a perception that artists in mid-Victorian Britain could work in the Renaissance manner, using variable media, embracing painting, sculpture, architecture, metalwork; an almost limitless breadth of possibility: Burne-Jones was able to absorb all this from Watts. And maybe this was the intention of his mentor, John Ruskin. It has sometimes been suggested that Ruskin engineered his stay over the summer with the Prinseps on purpose to expose him to Watts's influence as a counterbalance to the medieval influence of Morris and Rossetti, felt by Ruskin to be getting unhealthily intense.

Ruskin was in his high Italian phase, his views on art refocused by his studies of Giorgione, Veronese and Titian, central figures in Ruskin's volume five of *Modern Painters*. He had to some extent lost enthusiasm for the Gothic Revival in favour of the sixteenth-century Venetian painters. He expected his protégés to move onwards with him. Ruskin had not been happy with what he now regarded as the narrow medievalism of the Oxford Union murals. 'The Oxford frescoes are far from right, far from what the lot of you should have done,' he told Val Prinsep, 'I'm tormented and anxious about you.' To Ruskin the Arthurian themes lacked gravitas both in the concept and the execution. This was not the art of spiritual power. He announced his intention of having 'a serious talk' with Prinsep. Burne-Jones too was exposed to the force of Ruskin's views.

Burne-Jones's work from now on becomes more classically Grecian, influenced by Watts, who kept casts of the Elgin Marbles in his studio, and indeed by the statuesque women of Little

Holland House. Ruskin once referred to Mrs Prinsep and her sisters as 'Elgin marbles with dark eyes'. There is also a new hint of the voluptuous Venetian style of art with a richness of texture and decorative detail, jewels, elaborately patterned textiles, and already the strange mood of suspended animation that becomes so powerful a factor in Burne-Jones's later work.

In autumn 1858, more or less recovered in health after his summer's cosseting, Burne-Jones was released from Little Holland House. He kept in touch with Watts. The Signor had become essential to his artistic landscape and his concept of what art could contribute to society. Watts was also to remain the keeper of Burne-Jones's conscience, working on with such solemnity, living so austerely, existing on a diet of lentils and rice pudding washed down with lemon barley water. Watts came to symbolise his ideal of unworldly creativity. 'In the midst of London,' said Burne-Jones, 'he is a hermit.' There were to be times when he wished he too could achieve a hermit's life like Watts.

Burne-Jones's return to Red Lion Square was melancholy. The old days of bonhomie and merriment were over. No longer would the friends roar with laughter as a disgruntled William Morris flung a disgusting Christmas pudding, made by their servant Red Lion Mary, down the stairs.

Morris was now preoccupied with his forthcoming marriage to Jane Burden, which took place in April 1859. Richard Watson Dixon officiated and Burne-Jones and other members of the Oxford set were present at the wedding at St Mary's Church in Oxford. As a wedding present Burne-Jones painted a large oak and deal wardrobe with scenes from Chaucer's 'Prioress's Tale', the story of the murder and miraculous resurrection of the young St Hugh of Lincoln. His own engagement to Georgiana continued unresolved with no date set for their marriage since he was still making very little money from his painting. The inevitable strains of long engagement worsened when Georgiana's father was moved to a new Methodist ministry in Manchester and the family left London. Burne-Jones had by this time moved into new lodgings

on the first floor of a house on the corner of Russell Place and Howland Street. He felt very much alone.

But then a sudden plan was made that put new heart in him and that fundamentally affected his whole thinking. In September 1859 Burne-Jones set off for Italy on a tour of the great artistic centres to study the early Italian masters, at John Ruskin's expense.

First Italian Journey
1859

Three was a magic number in Burne-Jones's circles. *The Three Musketeers* was a favourite book of his and William Morris's. When they were much older, in the 1890s, they would roar with delight and recognition as they read Jerome K. Jerome's *Three Men in a Boat*, a comic account of a chaotic journey up the Thames. There were three participants in Burne-Jones's first visit to Italy in 1859 as there had been four years earlier when he toured the cathedrals of northern France. This time instead of William Morris and William Fulford, Burne-Jones travelled with Val Prinsep and Charles Faulkner. Val, so large and jocular, was already intent on a career as an artist. Charley – the Oxford philosophy and mathematics don – was sensitive and ardent, a lover of art and an enthusiastic craftsman without himself having much talent for design.

The three of them set off in September on what was to be a six-week journey of discovery. None of them had been to Italy before. Burne-Jones, who was almost a professional bad traveller, was ill throughout the journey, overexcited by the quickly changing scenery, upset by the change of hours and diet, seasick as he crossed the Channel, made claustrophobic by confinement in a stuffy railway carriage as they travelled across France from Paris to Marseilles. Finally they took the boat from Marseilles to Livorno, arriving in the morning, disembarking and settling themselves down on some random blocks of stone in the harbour, which

was in the process of being reconstructed, the three of them gazing out over the blue sea.

'Yes, this was Italy – the land of the painter!' as Prinsep exclaims in his touchingly euphoric account of their adventures: 'the world of art and beauty was all before us, the sun shone with brighter and purer golden rays and the sea danced in the gentle breeze with greater joy, for we were all young and two of us were painters on our first artistic holiday'.

The itinerary took in Pisa, Florence, Siena, Bologna, Verona, Padua and Venice, ending in Milan. As Prinsep describes it, their programme was intensive, with hardly a major church or gallery in these cities that they did not conscientiously explore. Burne-Jones had been familiar in theory with the early Italian masters since his study of A. F. Rio's *The Poetry of Christian Art* while he was still at Oxford. He was by now aware of the sudden surge of Italian paintings being imported to Britain both by private enthusiasts and for the National Gallery, where the director Sir Charles Eastlake and his wife were discriminating and canny purchasers.

In the middle 1850s the National Gallery acquired a number of its now famous works by, for example, Veronese, Botticelli, Bellini and Mantegna. Many paintings originally made for Italy's churches and cathedrals were now brought across the Channel. In 1856 Eastlake paid £3,571 for the three surviving panels of Perugino's Pavia altarpiece. Uccello's panoramic masterpiece *The Battle of San Romano* was purchased for the gallery the next year. In 1858, when Burne-Jones first introduced his fiancée to John Ruskin, the meeting took place in the National Gallery's basement store where Ruskin showed them what Georgiana describes as 'some old pictures brought back from Italy by Sir Charles Eastlake, but not yet hung'. But although Burne-Jones by this time was relatively well informed about Italian art, the experience of seeing the work of the Italian painters *in situ* was altogether new and the sketchbook he used on this first Italian journey, now in the Fitzwilliam Museum in Cambridge, conveys his sheer excitement at coming face to face with Italian art in Italy.

Ruskin was their guide, the ever present influence on what the

travellers saw and their responses. Burne-Jones's sketchbooks focus on the artists and the works that Ruskin had recommended and approved. These were emphatically the painters of the early Renaissance and before. 'We bowed before Tintoret and scoffed at Sansovino,' as Prinsep explained it. 'A broken pediment was a thing of horror!' To Ruskin and his followers the overweening and unhealthy Italian High Renaissance was beyond the pale.

Pisa was the first stop for Burne-Jones and his companions, and here they made for the uniquely weird and striking architectural assemblage of cathedral, baptistery and leaning tower. In the Campo Santo Burne-Jones made copies of paintings by Simone Martini, Benozzo Gozzoli and the series of frescos attributed to Andrea Orcagna which included *The Triumph of Death, The Last Judgement* and *The Infernal Regions*, paintings revered by Ruskin as examples of ideal moral seriousness in art. The sketchbooks, with their lovely fluent drawings of small figures from Simone Martini, little heads from Ghirlandaio, show how rapidly Burne-Jones was learning and absorbing, accepting and sometimes superseding Ruskin's strictures. In a sense he was already making Italy his own.

It was Florence that came as the greatest revelation. By this time Burne-Jones felt a little bit recovered, writing to Georgiana happily that he was working tremendously hard at the pictures and would return 'quite an educated man'. The weather was glorious and in the country around Florence they were haymaking for the second time: 'all the vines are in full fruit, and roses are out everywhere'. They got into a routine of working through the day, taking a bathe at sunset, then dining and collapsing into bed by nine o'clock.

Florence was then on the brink of great expansion as provincial capital of the newly unified Italy under King Victor Emmanuel. Burne-Jones had arrived in Pisa just in time to hear the proclamation of Romagna's rejection of the Pope's temporal power. Under the new regime, with the extension of the railways and a dawning recognition of its artistic heritage, Florence was to reinvent itself as a centre of mass cultural tourism. In another twenty years the throng of eager art lovers, encouraged by Ruskin's guidebook

Mornings in Florence, and later gently satirised in E. M. Forster's *Room with a View*, would overwhelm the major works of art and architecture. But in 1859, relatively speaking, Burne-Jones still had the city to himself.

He took the tourist route: the Accademia, the Uffizi; the pictures and frescos in Santa Maria Novella and Santa Croce; the Pitti Palace. But everywhere he went it was with an artist's eye, observing sharply and retaining his impressions. The Little Chapel in Santa Croce painted by Giotto. Fra Angelico's angels in the convent of San Marco. The 'poor worn out Paolo Uccellos in the green cloister at Santa Maria Novella'. The della Robbia babies placed over the arches of Brunelleschi's Foundling Hospital. Some of the babies, Burne-Jones noticed, 'are tightly swaddled and are therefore happy, but of others their things are coming down and they are crying'. These are memories of Florence that lingered in his mind.

The authorities in Florence had started on a great task of identifying and reclassifying works in public collections. But around the city there were still discoveries to be made. In an outlying area near the Porta Romana Burne-Jones came upon a chapel full of della Robbia work. On this or a later visit he had found 'a Botticelli not mentioned anywhere' in a nunnery chapel at the end of a street near the Piazza Santa Maria Novella; 'it is a coronation of the Virgin, and has heaven and earth in it just as they are – heaven beginning six inches over the tops of our heads as it really does', he told a friend: 'it was terribly neglected and ruined and stuffed up with candles, which I took the British liberty of removing'.

Burne-Jones was early on the Botticelli trail; it was not until two decades later that adulation of Botticelli by the British became almost a commonplace. Ruskin lectured on him in the 1870s; the voice of Aestheticism Walter Pater cited him; Botticelli was turned into the sign and symbol of the Aesthetic Movement, adopted by the theorists of 'art for art's sake'. The mildly derisive adjective 'Botticellian' was coined. The fifteenth-century Florentine painter became the subject matter of Du Maurier's waspish *Punch* cartoons and the butt of such hearty Victorian jokes as 'Botticelli isn't a wine, you juggins – it's a cheese'.

But in 1859, when Burne-Jones first stood before another Botticelli, *The Coronation of the Virgin*, this time in the Accademia, Botticelli was a very specialist taste. Of the original Pre-Raphaelite brothers only Rossetti appreciated him. Now Burne-Jones too saw Botticelli's power as an artist. First of all he respected Botticelli's workmanship, his sheer professional stamina, citing him as an example of the value of not 'shirking', leaving parts of a painting not properly completed: 'Even M. Angelo shirks sometimes,' he would say, 'but Botticelli never; he thinks well about it before he begins and does what's beautiful always.'

He appreciated Botticelli's physical deliciousness, the sweetness of the detail. He remembered and described with an intense affection the round Botticelli painting of the Virgin and Child in the Pitti Palace 'where the Virgin holds down a dear little face to kiss another fat face'. His response to Botticelli came very close to ecstasy: 'no one is like him and never will be again'.

He kept Botticelli with him, an ideal and a safeguard. In the bleaker years back home he kept on yearning to return to Botticelli like an old friend or a lover, with a growing desperation: 'I want to see Botticelli's Calumny in the Uffizi dreadfully, and the Spring in the Belle Arte, – and the Dancing Choir that goes hand in hand up to heaven over the heads of four old men, in that same dear place.'

He would look back on Florence with a painful nostalgia, not only for its paintings and sculptures but for the place itself. He liked the pattern of side streets leading into great piazzas, the austere calm of the monasteries, the squall and movement of the markets. He saw Florence as a city that was itself, in its contrasts and coherence, its tradition of craftsmanship, a living work of art. Burne-Jones felt the poignant charm of it, the everyday grace in such details as the stall selling gillyflowers and scented lilies beside a city gate.

The rhythms of the city were imprinted on his consciousness. The idea of returning agonised and taunted him once he was back in London. 'Oh dear when I think that this very morning Florence is going on and I have to go into that muddle of work upstairs.'

*

After his epiphany in Florence it was possible the rest of his travels would prove an anticlimax. This was not the case. Ned, Val and Charley travelled on to Siena. Here they caught up with the Brownings. The writers Robert and Elizabeth Barrett Browning had been living in Florence since their secret marriage in 1846. Rossetti had provided Burne-Jones with a letter of introduction, or rather a reminder of their earlier acquaintanceship at Little Holland House, telling Browning, 'You know my friend Edward Jones very well; only, being modest, he insists that you do not know him well enough to warrant his calling on you in Florence.'

In fact by the time the English travellers reached Florence the Brownings had departed to a summer villa they had rented near Siena. Burne-Jones, with the others, called on them here one evening. At the villa they were met by a wild-looking old man with a shock of white hair who took one look at Val, glared, bowed and departed. This turned out to be the notoriously volatile poet and critic Walter Savage Landor, irascible as ever and by then extremely deaf. They were then taken in to meet the Brownings. Burne-Jones had admired Browning's poetry for years, seeing him as the 'deepest and intensest of all poets' who 'writes lower down in the heart of things'. There is, alas, no record of their Siena conversation.

Burne-Jones was lastingly impressed by the cathedral in Siena with its black-and-white-striped bell tower and its dazzling interior of black and white marble. It is built up of layer upon layer of art and craftsmanship, from the mosaic floors to the decorated capitals, the brilliantly detailed stained-glass window roundels, the dizzying bands of decoration round the dome: the sense of ambition and space is potent. This is one of the most dramatic interiors in the Western world. Hardly surprising that Wagner chose to use it as his model for the temple of the Holy Grail in *Parsifal*. Burne-Jones in Italy, with his own characteristically heightened sense of drama, became more and more aware of the power of the architectural ensemble.

Everywhere he looked in the cathedral there were stories. Stories underfoot in the fifty-six panels of the mosaic floor with

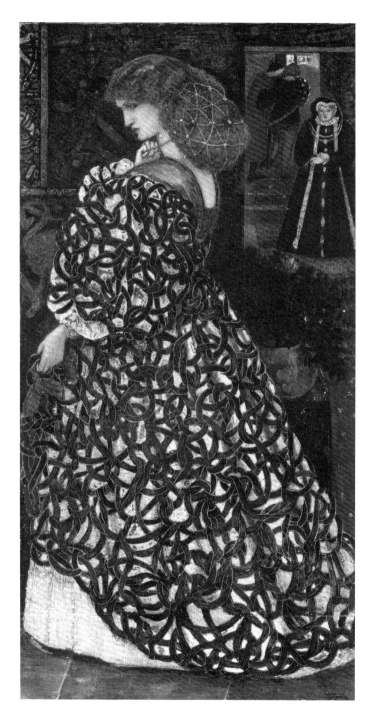

1 *Sidonia von Bork*, watercolour of 1860 showing the seductive sorceress from Johann Wilhelm Meinhold's Pomeranian gothic horror chronicle.

11 *Green Summer,* watercolour of 1864 conveying an idealised pastoral vision of life at
William Morris's Red House and showing the growing Italian influence
on Burne-Jones's work.

III *The Wedding Feast of Sir Degrevaunt*. One of a sequence of murals planned for Red House, of which only three were completed. The king and the queen at the centre of the ceremonial table are depictions of William Morris and his wife.

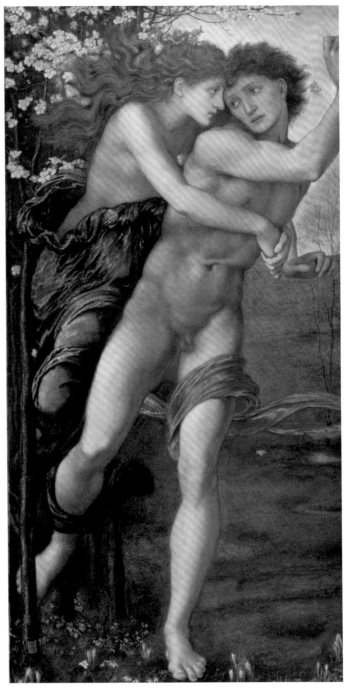

IV *Phyllis and Demophoön*, watercolour of 1870 shown at the Old Water-Colour Society where it caused a scandal on account of the male nudity and because the model for both heads was recognisably Burne-Jones's lover Maria Zambaco.

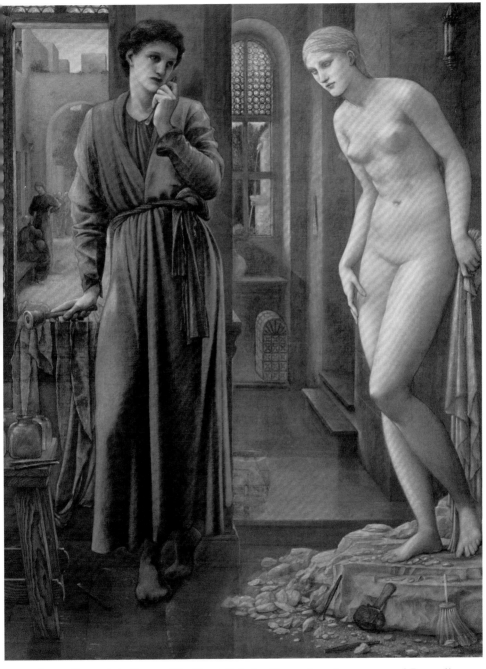

v *Pygmalion and the Image: The Hand Refrains*. Burne-Jones's sequence of Pygmalion pictures derives from William Morris's *The Earthly Paradise*. Maria Zambaco was the model for the woman the sculptor created out of stone.

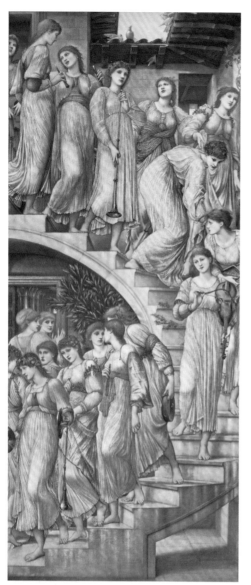
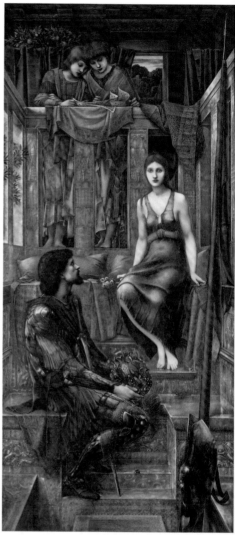

VI *The Golden Stairs*. A quintessential Aesthetic movement painting first shown at the Grosvenor Gallery in 1880. Many of the girls were modelled from the daughters of the Burne-Jones circle. No. 4 (from top) Margaret Burne-Jones; no. 9 May Morris; no. 13 Mary Gladstone; no. 15, with cymbals, Frances Graham.

VII *King Cophetua and the Beggar Maid*, oil, 1880–4. The painting that established Burne-Jones's reputation on the continent. After Burne-Jones's death it was bought from his executors by national subscription and presented to the Tate as his memorial.

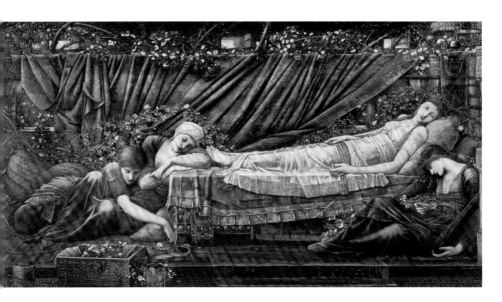

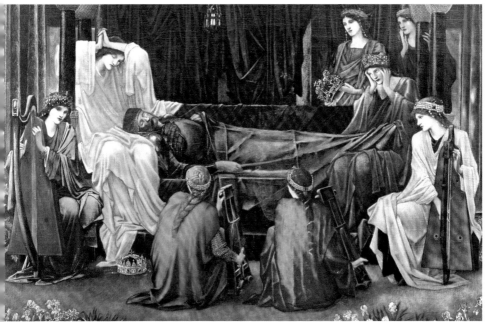

VIII *The Rose Bower* from the *Briar Rose* sequence. Burne-Jones was working on variations of the Sleeping Beauty story all his life. This large-scale oil painting, for which his daughter Margaret was the model for the princess, is now at Buscot Park in Oxfordshire.

IX *The Sleep of Arthur in Avalon*. Central panel from the painting that occupied Burne-Jones obsessively through his final decade. It left Britain in 1963 and is now in the Museo de Arte de Ponce in Puerto Rico.

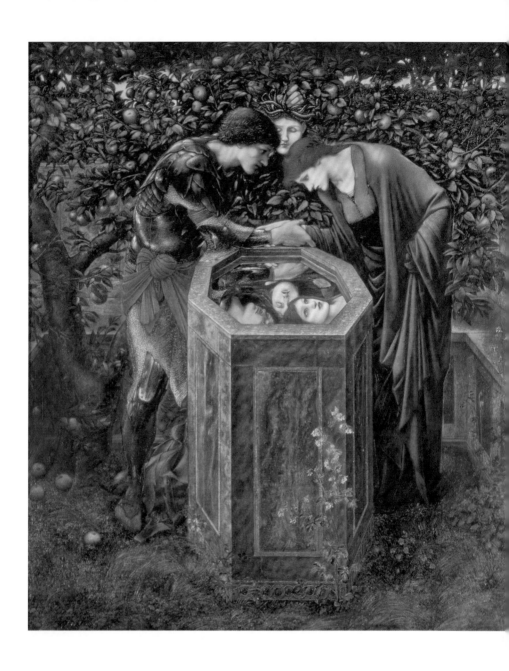

x *The Baleful Head* from the *Perseus* cycle. Commissioned in 1875 for Arthur Balfour's
drawing room in Carlton Gardens but never delivered. The *Perseus* series, magnificent but
still unfinished, is now in the Staatsgalerie in Stuttgart.

their biblical narratives, Virtues and Allegories. Narratives around the pulpit carved by Nicola Pisano with their crowds of little figures acting out the Christian story from the Visitation to Last Judgement day. There were yet more stories in the Piccolomini Library where in 1507 Pintoricchio completed his sequence of ten frescos showing the glorious events of the life of Pope Pius II, a member of the Piccolomini dynasty.

In his sketchbooks not long before he came to Italy Burne-Jones had made a mass of careful little tracings of medieval costume from Camille Bonnard's textbook *Costumes des XIIIe, XIVe et XVe Siècles* which reproduced figures from a number of well-known paintings of the period. This was a favourite Pre-Raphaelite source-book. Millais and Rossetti had both possessed a copy and Burne-Jones had immersed himself in all the detail of kings', queens' and knights' costume, annotating his drawings carefully with patterns and colours, like little fashion sketches; the complicated shapes of knights' helmets, spurs and weapons fascinated him. The accoutrements of battle extended to the horses, whose resplendent battle garb was delineated fondly with notes such as 'pattern of gold on horses petticoats'.

Up to now his enthusiasm for the physical reality of medieval crowd scenes, how people held themselves in chain mail, the way they wore their wimples, had been learned at second hand. Here in Siena, in Pinturicchio's cycle, what Burne-Jones had learned from textbooks was brought closer, made more vivid by the large-ness of the scale, the richness of the detail and the bright Italian landscapes stretching back into the distance. Here in the single space of the Piccolomini Library the spectator was enfolded in, surrounded by the narrative: ten episodes contained within a single room.

From Siena they travelled to Bologna, then Verona, then Padua, still under instruction from Ruskin, whose admiration for Giotto's frescos in the Arena Chapel at Padua was already familiar to Burne-Jones. Ruskin viewed these frescos, painted in the early fourteenth century, as prime examples of Christian art. He praised Giotto's painting as possessing an ideal simplicity and dignity,

the quality he called 'repose'. He connected this back to classical sculpture and forward again, in an unbroken line of beauty, to the work of the Pre-Raphaelites.

Besides Ruskin's admonitory writings on Giotto, Burne-Jones knew the frescos well from the Arundel Society reproductions. But these, being wood engravings, were in black and white. There was nothing to prepare him for the beauty of the colour of Giotto's actual frescos in the vaulted chapel: the pale rose-coloured gown in which Mary receives the annunciation from Gabriel; the lemon-yellow hooded cloak in which Judas betrays Jesus; the red robe of the Last Judgement; the soft gold of the haloes; the strong Italian blue of the overarching roof.

In this single chapel building there are thirty-nine paintings telling a multitude of stories: episodes from the history of Joachim and Ann; the Life of Mary; the Life and Death of Christ. The paintings even now have an extraordinary immediacy, painted with such verisimilitude and tenderness it seems that these were real events that happened to real people, although in another country and very long ago. The visit to Padua, even more than to Siena, sharpened Burne-Jones's sense of containment in narrative. He saw what could be done with the cyclical in art.

Giotto's frescos were a constant source of inspiration to Burne-Jones, as they would be to another British narrative artist – Stanley Spencer – in another century.

Then it was Venice and Burne-Jones was writing home from his hotel near the Rialto:

We are in the jolliest place in all the wide world at last – the queerest and jolliest a great way, and a million miles the most beautiful – so you must say goodbye, we mean to stay here always and never leave it again for a day. There never was such a city – all built in the sea you know, with the houses and palaces in the water and gondolas for Hansom cabs to take us everywhere: one comes every morning to take us from our hotel to break-fast in the great Square by the ducal palace and wonderful church – there every one breakfasts in the open air, and girls bring flowers to lay on your plates, and music plays and everything is so bright and stunning. All day

long we glide about the water streets in our boat, visiting palaces and churches – there are 100 islands all covered with churches and palaces, and all full of pictures, and bell-towers with big bells that ring all day long, and all the evening we sit out in the great square again and listen to music and see the sunset on the sea and the night up over the Adriatic.

For many Victorians on their first visit to Venice the city had a dreamlike quality. For Burne-Jones these first impressions of wonder were intensified because he was seeing it with an artist's sensibility.

He once, wisely, advised his young friend Frances Graham, 'You can't see Venice unless there's a little Venice inside you first.' Burne-Jones's Venice was also Byron's Venice, fixed in his mind from his schoolboy reading of the Romantic poets as a place of melancholy grandeur with its silent canals and funereal black gondolas, the beautiful poignancy of human glory wrecked. Physically and symbolically Venice was now sinking. As Byron wrote in *Marino Faliero*:

> Oh Venice! Venice! when thy marble walls
> Are level with the waters, there shall be
> A cry of nations o'er thy sunken halls,
> A loud lament along the sweeping sea!

Burne-Jones would have known those lines by heart.

But even more than the brilliantly readable and all-seducing Byron, his early impressions of Venice were coloured by John Ruskin whose great book *The Stones of Venice* had been such an influence on Burne-Jones's and William Morris's early lives. When Morris first read the chapter 'On the Nature of Gothic Architecture', while he was still at Oxford, it 'seemed to point out a new road on which the world should travel'. Its impact on Burne-Jones had been palpable as well.

Volumes one and two of Ruskin's *Stones of Venice* are in effect a guidebook on how to read the city, teaching its readers how precisely to discriminate between good and bad architecture. In *Stones of Venice* Ruskin gives a firm rebuttal to the Byronic, Romantic view of Venice as a place of inevitable natural decline. He

draws his arguments from sociology and politics, economics and religion, to show how on the contrary the medieval magnificence of Venice – its public buildings and its churches with their wealth of delicate architectural detail – were created from within a social structure that respected the craftsmen who constructed them, while the crass and careless architecture of a later period emanated from Renaissance power politics. These were corrupt buildings hastily erected to the self-glorification of the rulers of the city. Ruskin castigates the Renaissance as a period of decadence after which Venice went rapidly downhill. Impassioned and cranky, erudite and challenging, Ruskin's *Stones of Venice* lucidly contrasts the medieval principle of honouring fine craftsmanship and the ruthless industrialisation of Victorian Britain with a moral fervour Burne-Jones had found irresistible.

Here in Venice it was almost as if Ruskin had come with them. Val Prinsep describes how 'Ruskin in hand, we sought out every cornice, design, or ornament praised by him'. They avoided such late Renaissance horrors as palaces with ceilings painted by Tiepolo or show-off stucco work by Alessandro Vittorio, though Prinsep admitted that he later disloyally came around to them: 'Truffles and vintage wines are not appreciated by the young.'

Burne-Jones's sketchbooks tell us something of what he saw in Venice in 1859. Here is a pencil drawing of Titian's *St John the Evangelist* from the sacristy of Santa Maria della Salute. Here is a little copy of a Tintoretto. Most interesting of them all are Burne-Jones's copies of figures from the early sixteenth-century cycle of paintings by Vittore Carpaccio in the Scuola di San Giorgio degli Schiavoni, the headquarters for Dalmatians living in Venice. These were mainly merchants trading with the Levant.

Carpaccio's paintings show scenes from the lives of the patron saints of the Dalmatians: St Jerome, St Tryphon and St George. It may partly be his beautiful, affectionate telling of the legend of St George that has made this cycle so lastingly popular with English visitors. When Burne-Jones first discovered Carpaccio's now famous work, recommended in all guidebooks, it was virtually unknown. He had found Carpaccio even ahead of Ruskin. It was 1869 before

Ruskin wrote to him from Venice, having acted on Burne-Jones's recommendation and seen Carpaccio's paintings for himself:

MY DEAREST NED – There's nothing here like Carpaccio! There's a little bit of humble-pie for you! Well, the fact was, I had never once looked at him, having classed him in glance and thought with Gentile Bellini, and other men of the more or less incipient and hard schools. But this Carpaccio is a new world to me.

He went on to suggest that Carpaccio was what Burne-Jones would have been had he been born in Venice at that period and trained professionally in the traditional manner, serving an apprenticeship in an artist's studio from an early age. What did Ruskin mean by this anxiety about Burne-Jones's lack of training, his ongoing struggle to acquire the technique commensurate with his ambitions as a painter. More interestingly it shows Ruskin's instant understanding of the artistic rapport between Burne-Jones and Carpaccio in spite of the three and a half centuries that separated them.

Both believed in the simple power of the storyline. St Jerome leading his tamed lion into the monastery; St George taking arms against the terrifying dragon in order to set the princess free. These are tales told with the serious conviction that the stories are interesting in themselves and then made still more enthralling by the wealth of human detail, glowing colours, lavish textures, the whole exotic ambience. Carpaccio's evident love of grotesque creatures would have had a special appeal for Burne-Jones who himself adored animals, the curiouser the better. St George's dragon may be fearsome poised for action, but in defeat it is pathetic and endearing. How can St George contemplate killing such a creature lying beseechingly crumpled at his feet?

Burne-Jones would recall coming back from Venice 'thinking there could be no painting in the world but Carpaccio's and the other Venetians'. It seemed to him their only rival in terms of colour, perfection of finish and élan of storytelling was Hogarth's *Marriage à la Mode*.

<p style="text-align:center">*</p>

There were some scenes of farce in Venice, tales which Burne-Jones would tell again for years, embroidering and exaggerating details with the gleeful wit on which his reputation as a conversationalist would be founded. The story of the giant tarantula discovered in one of the bedrooms in their lodgings which they trapped in a washbasin where it terrorised them by leaping high into the air until, in desperation, they hurled it through the window and then worried that it might concuss a passer-by. The scene at the Douane where their passports were checked over. Ned and Charley duly answered to their names. When it came to 'Val Cameron Prinsep' the bewildered customs officer read out 'Valentine Comtesse Principessa'. There were roars of laughter when the outsize youth replied.

Partway through their stay in Venice Charley Faulkner had departed, needing to be back in Oxford for the start of the academic year. The three musketeers were now reduced to two, and they had lost the most practical among them. Burne-Jones and Prinsep, by now running out of money, took the train from Venice to Milan. Near Milan they were aware of small lights flickering on the graves of soldiers killed in the battle of Magenta fought on the previous 4 June. This was a battle in which the occupying Austrians had been decisively defeated by the French.

Burne-Jones, now very homesick, hustled Prinsep onwards. From Susa they took the public coach across the Mont Cenis Pass, recklessly refusing to believe an announcement that the route had been closed. They carried on through the night, packed uncomfortably tight in the diligence with four other travellers, only to be faced in the dawn light by the reason for the closure. An avalanche had destroyed the road ahead. The railway bridge and the railway line itself were swept away. It took them three days of walking and riding to get to the next station. At last they arrived at Dieppe and crossed the Channel to Newhaven. It was a long, rough crossing and Burne-Jones was so seasick he coughed up blood.

He got home that late October, his sketchbooks bulging with the records of the journey. He brought back with him to London details of his encounters with Titian and Mantegna, Simone Martini,

Benozzo Gozzoli, Filippino Lippi, Ghirlandaio, Bellini and the rest. In making a comparison between his brother Dante Gabriel Rossetti and Burne-Jones, William Rossetti was to claim convincingly that whereas Gabriel was the more original and independent artist Burne-Jones's powers of absorption were much greater. He was more directly influenced by old Italian art: 'His romantic treatment of classicism derives partly from Mantegna and Botticelli; his Christian art has affinities with Carpaccio, the Bellini, etc., and notably in the cast of draperies, even with art so remote as that of Byzantine times.' Georgiana was aware of the weeks he spent in Italy as an important time of emotional recognition: 'now he had seen the way in which great painters of a great time had painted what was in them, and had come back knowing that he was their own son'.

Burne-Jones returned with his mind full of the friezes, the Annunciations, Crucifixions, processions, angel choirs and great storytelling cycles, the Italianate concepts that would from now on shape his own artistic thinking. One of his first commissions after he returned from Venice was for an early-Renaissance-style triptych for a church in Brighton: three Bible story panels set within a golden frame. He came home more than ever confirmed in his intention not to be confined to drawing or easel painting but, like many artists in Renaissance Italy, to be involved in the whole range of decorative arts.

Having seen the great spectacular Italian churches – the theatrical black and white marble cathedral in Siena, St Mark's in Venice resplendent with mosaic – Burne-Jones had now returned confirmed in his ambition to work on the grand scale: 'I want big things to do', he would cry out, 'and vast spaces, and for common people to see them and say Oh! – only Oh!'

From now on Burne-Jones would refer to Italy as his own native country. His intensity of feeling was out of all proportion to the time he actually spent there and it sprang not only from his appreciation of Italian art and architecture but also from his love of the Italian way of being, the contentment and vivacity of everyday life. Even in the 1890s, when Burne-Jones was nearly sixty, he

could easily recapture the rapturous discoveries of that early visit. The slightest thing could trigger it. 'There's an organ in the distance playing an air they were playing all over Italy, when I first walked in its heavenly cities – how it all pours back on me.'

Russell Place
1860–2

Edward Burne-Jones and Georgiana Macdonald were married at last on 9 June 1860, exactly four years after their engagement. Burne-Jones was twenty-six and his wife nineteen.

After the long years of waiting, the decision seems to have been taken with surprising suddenness. Georgie, still living with her family in Manchester, had been invited for a month's stay earlier that summer with Ford Madox Brown and his gregarious second wife Emma in their house in Fortress Terrace, Kentish Town. Georgie was a special favourite with Madox Brown, who encouraged her work, allowing her to come and paint from a model in his studio, and she had been happily ensconced in the small house which in Pre-Raphaelite circles had become a byword for hospitality. At Fortress Terrace the family and many welcome friends sat down to dine at a long table off blue-and-white willow-pattern plates while the garrulous, opinionated Madox Brown, at the head of the table, kept up a long monologue. Georgie observed how 'sometimes he would pause, carving knife in hand, to go on with his story, until Mrs. Brown's soft voice could be heard breathing his name from her distant place and reminding him of his duties'. By the end of the visit Madox Brown had decided Ned and Georgie must be married without any more delay.

There had been little improvement in Burne-Jones's financial prospects. At the time of their marriage he possessed only about £30 in cash and he owed work, already paid for, to his one faithful

client Mr Plint. But by this time Georgie's parents put up no opposition, 'committing us both', she says, 'to the care of God'. And three days before the wedding there was a little miracle. A letter came from Mr Plint in Leeds acknowledging receipt of two pen-and-ink drawings and enclosing a £25 money order on account. This perfect client had surmised that his protégé would be in special need of extra funds.

The marriage took place in Manchester Cathedral, where Georgiana's parents had themselves been married. Of more significance to Burne-Jones was another coincidence: his wedding day was also the date of the death of Dante's Beatrice 570 years before. They decided to spend their wedding night in Chester, attracted by the prospect of the picturesque townscape of winding streets and half-timbered façades. They had planned to attend Sunday service in the cathedral. But the wedding plans were ruined by the illness of the bridegroom. Burne-Jones had been caught in a rainstorm two days earlier. On his wedding day he had a slight sore throat, which worsened dramatically so that by the next morning he could hardly speak and a local doctor had to be called in.

Georgiana Macdonald. Pencil drawing by Dante Gabriel Rossetti made around the time of her marriage to Edward Burne-Jones.

Even without this debacle, how well prepared for marriage were Burne-Jones and his wife? Being so close to the louche artistic ambience in which Rossetti moved, Burne-Jones could hardly have been immune to sex. But there is no hint that he himself had any mistresses. His shy gawkiness had made him stunner-proof. A nasty little story, of which Rossetti was the likely perpetrator, has a prostitute being bribed 5/– to follow him. As Burne-Jones remembered it:

He told her I was very timid and shy, and wanted her to speak to me. I saw him talking to her as I looked back and she came after me and I couldn't get rid of her. I said no, my dear. I'm just going home – for I'm never naughty with those poor things – but it was no use. She wouldn't go, and there we marched arm in arm down Regent Street. I don't know what any of my friends would have thought if he'd caught sight of me.

Ned was being teased cruelly for his unworldliness.

A cryptic reference in Georgiana's memoirs relates to Red Lion Square where good-hearted Red Lion Mary, naturally generous towards a fallen woman, 'could understand the honest kindness of a young man to such a one, and help him to feed and clothe her and get her back to her own people'. Ford Madox Brown's diary records an episode in which Burne-Jones rescues a prostitute.

There was always an asexual aspect to Burne-Jones, the residue of his original religious aspirations. 'You see I am a monk with a craving for a life with a woman – and am doomed at the outset,' he told May Gaskell wanly much later in his life. If on their wedding night Ned was, as seems likely, limited in his experience, Georgie was certainly innocence itself.

Another plan was thwarted by Burne-Jones's illness. With a curious symmetry Rossetti at long last had married Lizzie Siddal just a few weeks earlier, on 23 May. Their on–off relationship had caused him pangs of conscience. As Lizzie's health continued to decline she had gone to live in Hastings, and here, in St Clement's Church, the wedding finally took place, throwing Rossetti's lewd and passionate mistress Fanny Cornforth into paroxysms of grief and indignation. Rossetti and his bride arranged a honeymoon in

Paris where Ned and Georgie were to join them. There was great disappointment when this meeting proved impossible. Rossetti, whose addiction to animals far outstretched Burne-Jones's, consoled himself by buying two small dogs in Paris, one of which he called Punch in celebration of a favourite passage in Pepys's diaries which he and Lizzie were reading hilariously on their honeymoon. In Paris Rossetti was working on the disquieting pen-and-ink drawing *How They Met Themselves*: a couple encountering their double in a wood.

Ned and Georgie were back in London sooner than intended, back in Burne-Jones's rather squalid bachelor rooms in Russell Place. Nothing had been prepared for the arrival of the newly married couple. No chairs, only a good solid oak table, designed by Philip Webb and made at the charitable Industrial Home for Destitute Boys nearby in Euston Road, on which Georgie had to perch to receive her visitors, who commented on the bareness of the place. She was, however, delighted and surprised to find that in the nerve-racked week before the wedding Burne-Jones had painted his old deal sideboard, already in his rooms, with a beautiful design of medieval ladies feeding and in some cases fending off small animals, birds, fishes, swarms of bees and a big menacing newt. This sideboard, now in the Victoria and Albert Museum, reminds one of the hopefulness and sweetness of their early married life.

Soon chairs arrived and a new sofa. There were also wedding presents: a sewing machine from Watts; a little upright piano made by Priestley of Berner's Street from Aunt Keturah, Mrs Catherwood. This was made of unpolished American walnut which, again, provided a good surface for Burne-Jones to decorate. Inside the lid he painted an early version of a favourite subject, the *Chant d'Amour*. For the panel below the keyboard his subject was derived from Orcagna's *The Triumph of Death*, which he had seen and loved in Pisa. The painting takes the form of a frieze of seated women, some of them slumped in sleep, some playing instruments, while the tall figure of Death hovers ominously by. The lacquering

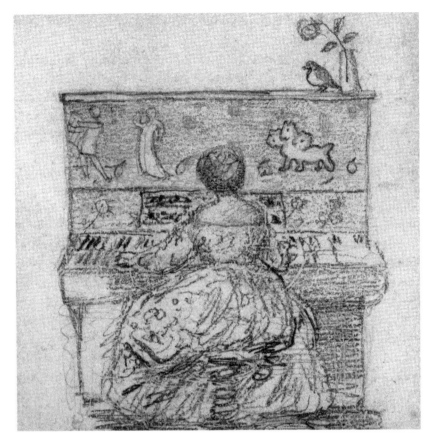

Georgie at the piano. The decorated piano is similar to the wedding-present
piano hand-painted by Burne-Jones.

of this panel was an enjoyably dramatic process since the colour
needed to be deepened while the lacquer was still liquid. Burne-
Jones used a red-hot poker to accomplish this.

What was Burne-Jones looking like in these early days of marriage?
A portrait drawing made in 1859 by a new friend, Simeon
Solomon, another promising artist of the second generation of
Pre-Raphaelites, shows a rather awkward and undistinguished
man, moustached and bearded with the lank straight hair that was
always a bit of an embarrassment to him. 'Oh!' he had once cried
out in front of Ruskin. 'I wish I had curly hair,' and Ruskin had

replied, 'It could not be Ned, you are always looking up, and it has to grow down – straight and ugly.'

However, in his quiet way Burne-Jones was very charming. 'Jones's face melts all away into its smile like a piece of sugar candy – he is white & fair,' Ruskin described him fondly. His conversation was subtle and amusing, with sudden flights of fancy, always intelligent. Madox Brown and William Morris, both tending towards boorishness, agreed that 'his manner of speaking was precisely that of a real swell. He never bawled and gesticulated as *we* did.' He was already adept at disguising his provincial origins. But people were becoming aware that behind his surface polish and the sweetness of his manner there was real force of will.

As for his wife, her small size, wide eyes and demure prettiness caused people to underestimate her. Descriptions of Ned's 'little praeraphaelite-looking wife Georgie' tend to be patronising. To Rossetti she was 'a charming and most gifted little woman'. For George Leslie Ned's wife looked 'like a little girl of fourteen, pretty and very unaffected'. Ruskin described her to his young American friend Charles Eliot Norton as 'a little country violet with blue eyes and long eyelashes – and as good and sweet as can be'. He went on to recount how shocked she had been when he took her to the theatre, 'suddenly seeing into an abyss of human life, both in suffering and in crime – of which she had no previous experience'.

But Georgie too was more formidable than she at first appeared. Far from being the 'wee little wife' the men of the Pre-Raphaelite circles looked down on, Georgie was astute, principled and sound in judgement. Brought up in a large, active Methodist household, moving from Birmingham to London and then north again to Manchester, Georgie was in many ways maturer than her husband. She still hoped to develop her own work as an artist and had optimistically brought her wood-engraving tools with her to Russell Place. The Burne-Joneses could just afford a servant and Georgie had no compunctions about asking the maid – 'a pretty one' – to model in the middle of the morning, when a more bourgeois bride would have been attending to the housework. Georgie was already

becoming a little bit bohemian, absorbed into the *moeurs* of the Pre-Raphaelite world.

Their life in Russell Place was companionable. Crom Price, who was beginning medical training, found lodgings opposite and they saw him every day. Swinburne too lived very near and would call in frequently bringing new poems with him and reading them out loud to his captive friends. Half a century later Georgie was still describing to a friend how, soon after she and Ned were married, 'Swinburne, with his red-gold hair, paced up and down the small room where Ned was painting', chanting the choruses from *Atalanta*. This was his poetic drama *Atalanta in Calydon*, which when it was published in 1865 brought Swinburne his first real literary fame. In the confined space of the Burne-Joneses' lodgings, he was 'restless beyond words', jittery and jiggling, almost dancing as he walked, moving his hands and feet even when sitting in a chair. When reading poetry he would raise his eyes to heaven in a rapt unconscious gaze and, according to Georgie, 'their clear green colour softened by thick brown eyelashes was unforgettable'.

One day Swinburne arrived in a state of great excitement with a present for Burne-Jones: a small square book with paper covers containing a twelfth-century Persian poem translated into English by an unnamed author which he and Rossetti had purchased from a bargain bookstall outside Quaritch's bookshop in Leicester Square. The poem, an ebullient sequence of pleasure-loving stanzas entitled *The Rubáiyát of Omar Khayyám*, had been published by Quaritsch in 1859 but had proved a total failure and the publisher was now offloading surplus copies. These were originally priced at one penny but once Swinburne and Rossetti had bought several copies the price was doubled, to Rossetti's indignation. It was later to rise a great deal higher.

Omar Khayyám became a kind of cult book in Pre-Raphaelite circles long before it achieved more general adulation in late Victorian England as a guidebook to the hedonism of the East. William Morris wrote out two copies on vellum in his exquisite calligraphy; Burne-Jones added his own painted illustrations to one of these.

A Book of Verses underneath the Bough,
A Jug of Wine, a Loaf of Bread – and Thou.

Once the translator's identity was finally revealed as Edward FitzGerald, a gentleman scholar living quietly in Suffolk, Burne-Jones became a bit disgruntled at the poem's fame: 'I hate poems about wine and women, I hate them put together in a poem.' But he kept on liking the things that had attracted him and Swinburne and Rossetti to the ancient Persian poem in the first place: the refreshing cynicism at the heart of it, its scepticism of divine providence, its mockery of human aggrandisement, the sheer effrontery of Khayyám's philosophy. All his life he went on loving its 'splendid blasphemies'.

The postponed Paris meeting between the two newly married couples – Ned and Georgie, Lizzie and Gabriel – finally took place in a very different environment: the 'Wombat's Lair' at the London Zoological Gardens at two o'clock on a July afternoon. Ford Madox Brown and Emma were also in the party. These were the early days of Rossetti's wombat mania. The first wombat, a quadruped from Australia, had arrived at the zoo in 1857 and Rossetti was entranced by its strange pathos of appearance, squat and stumpy and short-legged like an overweight small pig. The wombat could be moody, easily roused from almost stuporlike placidity to sudden violent anger. Burne-Jones too was susceptible to wombats, producing a whole series of little wombat sketches. The resemblance of the wombat, overweight and unpredictable, to William Morris became an irresistible, faintly malicious joke.

Lizzie evidently made a great effort for the outing. 'She was well enough to see us,' Georgie recollected, 'and I find her as beautiful as imagination, poor thing.' Slender, elegant and unusually tall, Lizzie wore a graceful, simple dress of the unstructured style that later became almost a uniform for art-loving women of the Aesthetic Movement. From the zoo Ned and Georgie went back to the Rossettis' Hampstead lodgings to which they had moved in the hope that the higher ground of Hampstead would prove healthier than Blackfriars. Here Georgie became conscious of an

Burne-Jones's pen-and-ink drawing of two wombats, showing his brilliant economy of line.

aura of 'romance and tragedy' between Lizzie and her husband, describing the scene later:

I see her in the little upstairs bedroom with its lattice window, to which she carried me when we arrived, and the mass of her beautiful deep-red hair as she took off her bonnet: she wore her hair very loosely fastened up, so that it fell in soft, heavy rings.

Up there in her room she showed Georgie a design she had just made. Its title, ominously, was *The Woeful Victory*.

Looking back on those years – 'those first wonderful years' – Burne-Jones saw himself as being in connected sets of three. Three was still the magic number: 'Gabriel and Morris and me was one set – And Gabriel and Swinburne and me was another set – And Gabriel and Ruskin and me (for a little time) was another set – And Simeon and Ruskin and me was another.' Simeon Solomon, 'the Jewjube' as they called him, born into a prosperous East London Jewish family, had now been absorbed into these inner circles. But there was also a foursome: Ned and Gabriel, Georgie and Lizzie, the women linked together in a loving – and intermittently resentful – solidarity of artists' wives.

The painter George Boyce called at Russell Place on 26 January 1861 and found Burne-Jones at work on a pen-and-ink drawing of *Childe Roland* for John Ruskin, a sombre and imaginative rendering of Browning's poem 'Childe Roland to the Dark Tower Came'. In the background is a mass of the big blatant staring sunflowers Burne-Jones so much adored. He worked in the small bare untidy studio adjoining the living room now cosily furnished with the indigo-blue curtains Georgie had embroidered and his own painted furniture.

He had a capacity for withdrawal from the interruptions and commotions of the household into his own creative world, and the year or so they spent in Russell Place was productive. Another visitor to the studio, George Leslie, describes Burne-Jones's pictures in progress in the early 1860s as 'mysterious and poetic', strongly reminiscent of the works of Albrecht Dürer: 'He had one of Theseus going into the dark forest, and Ariadne giving him the clue, and another of a young lady lying on her bed on St. Valentine's Day and Cupid putting his head in at the window, with mirror on the wall, and the servant setting out the breakfast reflected in it.'

Myth and fairy tale were still essential interests, as were Walter Scott novels and the Scottish border ballads Scott had popularised. Among the songs the Burne-Joneses and their friends played and sang around the painted piano in the sitting room in Russell

Place were the doom-laden early Scottish ballad 'Sir Patrick Spens' and, more appropriately, 'Busk ye, busk ye, my bonny, bonny bride!' A special favourite was 'Clerk Saunders', the subject of a small and very eerie Burne-Jones watercolour of this period. He was moving on from pen-and-ink drawing into a maturer phase of watercolour painting, under Rossetti's influence.

He was also developing new kinds of subject matter. The well-known pair of watercolours *Sidonia the Sorceress* and *Clara von Bork* now in the Tate Gallery show Burne-Jones in a completely new creative mood. The paintings illustrate the Gothic horror story *Sidonia von Bork: Die Klosterhexe* by Johann Wilhelm Meinhold. This had been published in 1849 in an English translation by Lady Wilde, Oscar Wilde's mother, who used the pen name 'Speranza'. In Meinhold's lurid story the Pomeranian noblewoman Sidonia von Bork is the glamorous epitome of evil, attracting multitudes of men and treating them appallingly. Her major coup is to bewitch the whole of the ruling house of Pomerania, either killing her victims or rendering them impotent. Sidonia's life of crime only ends when she is burned as a witch at Stettin at the age of eighty.

Burne-Jones's twin portraits show the cruel and seductive Sidonia when young and her foil, the good girl Clara, married to Sidonia's cousin. The way Burne-Jones has painted them, with heightened body colour and additional ox gall, gives them a great richness. They are more like oil paintings than conventional watercolours, with something of the sensuousness of sixteenth-century Venetian portraits. They remind us that only the previous September Burne-Jones had sketched Titian's *La Bella* at the Pitti Palace in Venice itself. The elaborate criss-crossing of the velvet decoration was apparently derived from a picture at Hampton Court, which the Rossettis and Burne-Joneses had visited together. The frames for the pictures were commissioned from Ned's father in a vain attempt to keep Mr Jones in work.

Sidonia shows Burne-Jones's growing interest in the outré, encouraged by the esoteric tastes of Swinburne and his now boon companion Simeon Solomon whom Burne-Jones had originally

introduced to him. Swinburne admired *Sidonia* as 'a real work of genius, but very horrible, the most horrible in literature'. Rossetti too shared this obsession with witches. While Ned was involved with *Sidonia* Rossetti was busy with a little watercolour of Lucretia Borgia, another of their heroines of female heartlessness. Both Burne-Jones's *Sidonia* and Rossetti's *Lucretia* resemble Fanny Cornforth in their blatant sensuality, while correct and demure Clara is rather a close likeness of the young Mrs Burne-Jones.

Thinking he had found a customer for *Sidonia*, Ruskin sent the painting on approval to Ellen Heaton, a wealthy, well-travelled, forthright maiden lady, daughter of a Leeds bookseller, for whom he acted as adviser on her purchases of works of art. This time however he had made a bad misjudgement. Miss Heaton was horrified. Ruskin took *Sidonia* back with a flurry of apologies. 'I am sorry to confess my entire *ignorance* of the subject,' he told her. 'I thought it was nothing but a spider-minded beautiful lady, of whom there are I suppose many living whom we regard without abhorrence.' Miss Heaton was offered a safer Burne-Jones option, *The Backgammon Players*, 'a picture of two people playing at chess in a garden'. But she turned down this suggestion as well. Ellen Heaton was a bit resistant to Burne-Jones.

There is a strange little sequel to *Sidonia*. In a Burne-Jones family album appears a photograph of his granddaughter Angela as a young woman in Sidonia the Sorceress fancy dress.

Now for the first time Ned Jones was beginning to sign himself 'Burne Jones', though he did not add the hyphen for another twenty years. Nor even now was his signature consistent. The painting of Sidonia is signed 'E. Burne Jones', the virtuous Clara just 'E. Jones'. Ned justified his change of nomenclature, adding in the family name Burne, as 'the natural yearning of mortal man not to be lost in the millions of Joneses'. He claimed to be acting not from pride but 'solely from dread of annihilation'.

He was making a few inroads into the wider world beyond the little studio in Russell Place. He was now a member of the Hogarth Club which he had helped to found with Spencer Stanhope and Ford Madox Brown. Membership was small, around forty artists,

Angela Mackail (the novelist Angela Thirkell) in costume as Sidonia von Bork.

architects and patrons, mainly the Pre-Raphaelites and their supporters.

Premises were first at 178 Piccadilly and later at 6 Waterloo Place. The Hogarth Club was a social club which also provided space for exhibitions of its members' work. Burne-Jones's 'exquisite cartoons' for a stained-glass window in Christ Church were viewed there by George Boyce in January 1860. Members also gathered at the Hogarth for life drawing. Boyce's diary for 12 March 1860 records a model named Baker – sex unspecified – sitting for the first time from 8.30 to 10.30. 'Present to draw: Brett, Prinsep, Jones, W. Rossetti and myself.'

The Hogarth Club did not last long. Burne-Jones looked back on it despairingly: 'It was the silliest club ever invented.' What had started as a place for chat and easy camaraderie became

deadened by bureaucracy: 'there had to be rules and meetings and secretaries and readings of papers and playing at Parliament'. It was his first, disenchanting experience of public life. The club had made an honorary member of Carlyle and he too found the bombardment of official communications unbearable, describing them as 'an afflictive phenomenon'. The Hogarth Club was disbanded in 1861.

Burne-Jones now had his own official connections with the Working Men's College, first assisting Madox Brown with his figure-drawing class, then taking a class of his own. His name was on the prospectus of the college as a teacher from January 1859 to March 1861. He was not the sort of teacher who pontificated: he taught through seeming to be on the same level as his students, enthusing them with the things he himself admired. He took them to the British Museum to draw from the sculptures on show there and invited his students to his own studio in Russell Place: 'We'll have a model, and we'll do some life-size heads together.' He assumed that his students agreed with his belief that art was the most important thing in the whole world and he treated them as if they were his 'brothers in art'.

More improbably, we find Burne-Jones at this period joining the Artists' Rifle Corps. This had been formed in 1859 at a time when an invasion by the French seemed a distinct probability. Leighton, Millais, Holman Hunt, Swinburne, Prinsep, Spencer Stanhope and many other artists volunteered to join the corps and wore a military uniform of grey and silver. Sham battles were fought in pleasant places in the country outside London, most often Kent or Surrey. Drills took place on Wimbledon Common and in Burlington House Gardens, an open piece of ground where the Royal Academy now stands.

William Morris tried hard as a member of the corps, although military drill was not his *métier*. Rossetti was argumentative and difficult, questioning orders. G. F. Watts made a memorable entry for a skirmish at Wimbledon, arriving on horseback on a windy day having ridden from Little Holland House: 'He looked very splendid; his beard was worn long, was very silky, and was blown

about in a fascinating fashion first over one shoulder and then the other.' Burne-Jones was reportedly a pretty good soldier, technically much more proficient than Rossetti. But he was not a very regular attender, resenting the time spent away from the studio. Georgie remembered him returning from the drill field 'a very tired man in a grey uniform'.

William Morris and his wife had by now left London. In June 1860 they moved into a new building which Morris had commissioned from his close friend the architect Philip Webb, whom he had first met when they both worked in Street's office. Morris's house was at Upton, a hamlet near Bexley Heath in Kent. It was known as Red House, built in glowing red brick in a beautifully purist Gothic style, turreted and gabled, its high walls and hipped roofs rising from the apple orchards. The internal spaces are generous and flowing, giving the sense of freedom of a twentieth-century open-plan design. Rossetti called the building 'more a poem than a house'. Through the early 1860s Red House provided the Burne-Joneses with another axis, almost a home from home.

Red House has now become such a central building in British architectural history, a proud possession of the National Trust, it is difficult to recapture the amazed delight with which Ned and Georgie first saw it, brought down by train by Morris for an early visit. They alighted at Abbey Wood Station, then right in the country, breathing 'a thin fresh air full of sweet smells' as they walked down the platform to be met by the wagonette from Red House. First a pull up the hill from the station followed by 'a swinging drive of three miles of winding road on higher ground', passing the huddle of labourers' cottages known as 'Hog's Hole' on the left, finally arriving at the gate and down the driveway to a porch vaulted like the entrance to a medieval church. In her memoirs Georgie vividly recollects the scene: 'I can see the tall figure of a girl standing alone in the porch to receive us.' This was Janey Morris whose strange gaunt beauty had made such an impression on Georgie the summer before, when she was first introduced to her in London, that she had a dream of Janey in the night.

The Burne-Joneses stayed several weeks on that first visit. It was a working holiday for Ned, in constant consultation with Morris over the internal decoration of the house. His notes radiate the optimism of the period, not just in the detail of the planned decorative schemes based on the romances and heroic legends they most loved but in the sense of wholeness, the creation of a new philosophy of being. The life to be lived at Red House was itself to be a work of art. As Burne-Jones saw it:

The house was strongly built of red brick, and red tile: the porches were deep and the plan of the house was two sides of a quadrangle. In the angle was a covered well. As we talked of decorating it plans grew apace. We fixed upon a romance for the drawing-room, a great favourite of ours called Sir Degrevaunt. I designed seven pictures from that poem, of which I painted three that summer and autumn in tempera. We schemed also subjects from Troy for the hall, and a great ship carrying Greek heroes for a larger space in the hall, but these remained only as schemes, none were designed except the ship.

Furniture from previous lodgings was recycled and adapted:

The great settle from Red Lion Square, with the three painted shutters above the seat, was put up at the end of the drawing-room, and there was a ladder to its top and a parapet round it, and a little door above, in the wall behind it, that led into the roof. There at Christmas time it was intended that minstrels should play and sing. I began a picture from the Niebelungen Lied on the inside of one of the shutters of this settle, and Morris painted in tempera a hanging below the Degrevaunt pictures, of bushy trees and parrots and labels on which he wrote the motto he adopted for his life, 'If I can'. He worked hard at this and the room began to look very beautiful.

Burne-Jones's large 'Prioress's Tale' wardrobe, originally painted as their wedding present, was installed in the Morrises' bedroom at Red House and Morris himself added to the decoration with paintings of medieval ladies on the inside panels of the doors. One of these, 'a woman with red hair and bright cheeks', was later identified by Janey as a portrait of Rossetti's wife.

After their long initial stay Ned and Georgie returned frequently for shorter periods, often Saturday afternoon to Monday morning.

There was to some extent a recreation of the mood of working holiday of the Oxford Union time. Charley Faulkner was also a Red House habitué, helping to paint patterns on the walls and ceilings. Ford Madox Brown and Rossetti often visited, Rossetti tending to leave Lizzie at Red House for a longer stay. There was great male bonhomie and badinage, fisticuffs and bear-fights, much practical joking and taunting of poor Morris. A favourite tease was to send their host to Coventry at his own table, refusing to exchange a word with him except through Janey as a go-between. After work the men would play bowls on the long stretch of grass that formed a bowling green on the south side of the house.

The young wives would sit together, spending mornings on their wood-engraving or embroidery, stitching at a daisy pattern worked in white and coloured worsted threads on rough indigo-blue serge. These embroidered hangings were designed by William Morris to cover the walls of the main bedroom at Red House. A Burne-Jones watercolour, *Green Summer*, showing a group of girls seated on the grass on a carpet of white daisies in an atmosphere of languor, epitomises early summers at Red House. In the afternoons the women would set out for local drives in the wagonette exploring the Kent countryside. Burne-Jones, who quite unlike William Morris was not a lover of country per se, resisted such expeditions, which he saw as meaningless: the only excursions that interested him were changes of scene that he could draw on directly for his work.

The pensive young woman in the centre of the group in Burne-Jones's *Green Summer* closely resembles Georgie with her smooth dark hair, her firm chin and steady gaze. Even more strikingly, the bridegroom and his bride in Burne-Jones's wall paintings for the Red House drawing room, based on the fifteenth-century Arthurian tale of Sir Degrevaunt, are idealised portraits of William and Janey Morris. Typical of the group's artistic outlook is the way in which their paintings represent themselves. In the Burne-Jones triptych painted in 1860 for St Paul's Church, Brighton, Morris and a haloed Janey are the models for the first king and the Virgin Mary at whose feet he kneels, whilst a shock-headed Swinburne

takes the role of a shepherd playing bagpipes with a devout bearded Burne-Jones in the corner to his right. They took to extremes the Pre-Raphaelite concept of art not for show, not as investment, but as an expression of truthfulness, a part of real life, an art of moral worth.

For Morris and Burne-Jones the painting of Red House was an act of affirmation of their friendship and shared standards and their hopes for a new future in which art took its place as central to the life of the community, the almost casual acceptance of everyday beauty that Burne-Jones had glimpsed while he was in Italy. The three Sir Degrevaunt tempera paintings he completed show *The Marriage of Sir Degrevaunt and Lady Melidor, The Wedding Procession* and *The Wedding Feast*, in which not only do the drawings of medieval costume in Burne-Jones's sketchbooks come into their own but the scenes of joyful ceremony represent an idealised version of life as it was lived at William Morris's Red House.

After the birth in January 1861 of the Morrises' first daughter Jenny a christening feast was held for all their friends which, in Georgie's description, seems like a re-enactment of Sir Degrevaunt and Lady Melidor's wedding feast. The Burne-Joneses, the Madox Browns and the Rossettis, Swinburne and other friends assembled for a splendid dinner, grouped around the massive T-shaped table in the hall, Rossetti 'sitting in a royal manner and munching raisins from a dish in front of him before dessert'. The guests stayed on for the night after the party, as they used to do in early days at Red Lion Square. Janey and Georgie 'went together with a candle to look at the beds strewn about the drawing room for the men'. Swinburne had a sofa; others, not so lucky, slept on the floor.

Wall paintings of the early 1860s are still being rediscovered at Red House like the treasures of a past civilisation, a lost time in which art became a mirror image of reality and everyday existence imitated art.

Out of Morris's ambitions to realise Red House as 'the beautifullest place on earth' a scheme arose that was to be of great importance to Burne-Jones's working life. This was the decorating firm

originally known as Morris, Marshall, Faulkner & Co., later recon-
stituted as Morris & Co. Suprisingly Burne-Jones, who would
become alongside Morris by far its most productive and important
of designers, was never included on the masthead of the company.

It has been suggested that the idea for the Firm, as it came to be
known, originated with Rossetti and Ford Madox Brown, and cer-
tainly they were implicated in the early plans. But Burne-Jones
who gives his own account of its inception explains it clearly as
Morris's own idea, arising from the need to furnish Red House.
Apart from the painted chairs and the great settle, the house was
entirely bare when he arrived there: 'nor could Morris have
endured any chair, table, sofa or bed, nor any hangings such as
were then in existence'. With his superhuman energy he set out
to organise the manufacturing 'of all things necessary for the
decoration of a house'.

Apart from the home-made hand-embroidered *Daisy* hangings
these products were at this stage commissioned from specialist
outside manufacturers. Philip Webb already had connections with
James Powell of Whitefriars who made the table glasses Webb
designed for Red House. These were ornate green-tinged glasses
with Venetian-style enamel decoration. Copper and brass candle-
holders had been made to Webb's specifications as well as fire-
dogs, a mirror and the two large oak tables that were so successfully
formed into a T-shape for Jenny's christening feast. Burne-Jones
had his own experience in designing stained glass for Powell's,
expertise that could be drawn on for plans which burgeoned out
from Morris's immediate problems in furnishing Red House into
the formation of a brotherhood of artists devoted to reforming the
taste of the whole nation by making available 'work of a genuine
and beautiful character'. According to Burne-Jones, Morris was at
this point in his life becoming anxious about his diminishing
income from the family copper mines. For him the Firm was a
business venture as well as a crusade.

The news spread. Boyce's diary records a visit to Burne-Jones
in Russell Place on 26 January 1861: 'He told me he and Morris
and Rossetti and Webb were going to set up a sort of shop where

they would jointly produce and sell painted furniture.' Rossetti explained more to William Allingham:

We are organising (but this is quite under the rose as yet) a company for the production of furniture and decoration of all kinds, for the sale of which we are going to open an actual shop! The men concerned are Madox Brown, Jones, Topsy, Webb (the architect of T's house), P. P. Marshall, Faulkner, and myself. Each of us is now producing, at his own charges, one or two (and some of us more) things towards the stock. We are not intending to compete with Crace's costly rubbish or anything of that sort, but to give real good taste at the price as far as possible of ordinary furniture.

With the exception of Peter Paul Marshall, an extrovert Scottish surveyor friend of Madox Brown's whose artistic contribution to the Firm was small, the names of the self-styled 'Fine Art Workmen' are predictable. Charley Faulkner, feeling isolated in Oxford, had resigned his fellowship and come to live in London where he combined training as a civil engineer with attempting to control the accounting side of Morris, Marshall, Faulkner & Co. In the original prospectus, issued in April 1861, Arthur Hughes's name is included as a member but he withdrew before the Firm was registered, unconvinced of its prospects of success.

As Morris's first biographer (and Burne-Jones's son-in-law) J. W. Mackail was later to point out, 'Seldom has a business been begun on a smaller capital.' Each of the partners held one share, and on its inauguration on 11 April the financing of the company was started with a levy of £1 each. On this basis, plus a loan of £100 from William Morris's mother, the first year's trading was done. Premises were taken at 8 Red Lion Square, close to Ned and Morris's old lodgings. The first floor was used for an office and a showroom with workshops up above. The Company was planning to be increasingly self-sufficient in making its own products. A kiln was built in the basement for firing stained glass and decorative tiles, and two craftsmen were recruited with three boy apprentices from the Destitute Boys' Home. Burne-Jones had already designed tiles for the fireplaces at Red House. Designs for tiles were among the earliest of Burne-Jones's projects for Morris,

Marshall, Faulkner & Co., carried out in his most delicate, evocative storytelling mode.

But the importance of his tiles was far eclipsed by Burne-Jones's stained-glass windows which he now designed for the Firm exclusively. His need of a regular source of income was more urgent after his faithful patron the good-hearted and beauty-loving Mr Plint died of 'increased breathlessness' on 16 July 1861 at the early age of thirty-eight. He left puzzlement and panic amongst his executors about works paid for in advance but not delivered. Mrs Plint's legal advisers had called on Rossetti, Brown and Burne-Jones 'wanting to see the pictures in progress for money paid by Plint, and could get no satisfaction'.

The regular commissions for designing stained-glass windows – providing the Firm's workshop with full-size black and white cartoons as a guide for the glass painters – came as a godsend at a time when Burne-Jones's painting was appreciated highly within a small circle of the cognoscenti but was still not generally known. Stained glass became the basis of his and his family's financial security. 'I have never been able to live by my pictures,' he recalled from the perspective of the 1890s: 'but for the designs of windows I should have lived in some poverty always – I have done many hundreds of them, and from some points they are as good works as I do.'

The earliest of the Firm's stained-glass commissions were for churches being newly built by the architect George Frederick Bodley who was just a few years older than Burne-Jones, a friend of Rossetti and part of the Hogarth Club clique. Bodley, who had trained with the well-known Gothicist George Gilbert Scott, was a perfectionist who, according to a later disciple, W. R. Lethaby, 'could do Gothic flavours to a miracle, and his churches are monuments of taste'. The first of the jobs for Bodley listed in Burne-Jones's account book of transactions for the Firm is dated 1861 for stained-glass windows for All Saints' Church at Selsley in Gloucestershire. Here Burne-Jones provided a Resurrection window with the figure of Christ rising, the soldiers on guard slumped disbelievingly beneath him, and a medievalist-Victorian interpretation of *Christ*

Blessing the Children, a complex composition of great beauty and *tendresse*.

Commissions were to follow over the next few years for Bodley's churches of St Martin's-on-the-Hill, Scarborough; St Michael and All Angels, Brighton; and All Saints' in Cambridge. The 1860s saw an important phase in the so-called aesthetico-Catholic revival, in which Anglo-Catholic worship was heightened and made more appealing to the public through the artistic coherence of the details of church building. This was a religion of beauty that encompassed church metalwork, embroidered altar cloths, painted ceilings, patterned floor tiles, stencilled walls and especially the glories of the Morris stained-glass windows, with their simple direct telling of the Bible tales.

The Firm's work on Bodley's churches was essentially teamwork, a development of the easy camaraderie and experimental fervour of the decoration of Red House and, before that, of the Oxford Union. The chancel roof of St Michael's, Brighton, was for instance hand-painted by Morris, Webb and Charley Faulkner, working precariously on the scaffolding. When it came to stained-glass windows, Philip Webb was chiefly responsible for the overall arrangement while Morris controlled the colour and assembly of the windows in the Red Lion Square workshops. In addition to Burne-Jones, individual windows were designed by almost all the partners, by Morris, Webb, Rossetti, even Peter Paul Marshall, with some especially fine, dramatic ones by Ford Madox Brown. Burne-Jones's early windows are perhaps the most confident in their design, most fluent. He was after all more experienced in the medium than his brother artists. But it was only later that he emerged as sole star designer of stained glass for the Morris company.

This had been a time of general fecundity as Janey gave birth to Jenny, her first daughter, and Lizzie, although ailing, became pregnant too. Rossetti had given up plans for finding them a house in the healthier environment of Hampstead or Highgate and they had spent the winter of 1860–1 back overlooking the Thames in Chatham Place. The landlord had extended their accommodation

by giving them rooms in the adjacent house, knocking through a connecting wall. Here Gabriel described how they had 'hung up their Japanese brooms': long whisks of peacock feathers, early signs of the encroaching Aesthetic Movement craze for *japonaiserie*. He had designed his own wallpaper. Lizzie's pictures were hung around the walls and Rossetti wrote to William Allingham in optimistic mood: 'Her latest designs would I am sure surprise and delight you, and I hope she is going to do better now – if she can only add a little more of the precision in carrying it out which it so much needs health and strength to attain, she will, I am sure, paint such pictures as no woman has painted yet.'

In the evenings when Ned and Georgie came to visit, the two men would retreat to the studio leaving Georgie and Lizzie tentatively to make friends. Georgie later described, perhaps with a sensitivity sharpened by subsequent events, that Lizzie was 'excited and melancholy' when they were alone: 'Gabriel's presence seemed needed to get her jarring nerves straight.' She could only relax when he came back into the room. In this state of almost pathological anxiety Lizzie came to depend on Georgie's understanding, undemanding companionship. 'My dear little Georgie,' Lizzie wrote to her, 'I hope you intend coming over with Ned tomorrow evening like a sweetmeat, it seems so long since I saw you dear.' She sent 'a willow-pattern dish full of love to you and Ned' – another signal of Aestheticism and the fashion for blue-and-white china which began with the Pre-Raphaelites.

Lizzie's baby was delivered stillborn on 2 May 1861, having been dead in the womb for two or three weeks. It would have been a daughter. Gabriel grieved deeply. Lizzie herself went gently off her head. When Georgie and Ned first went to see her she was sitting in a low chair beside the empty cradle looking like the Ophelia in Rossetti's watercolour. She cried out 'with a kind of soft wildness' warning Ned not to wake the child as they came in. It was a slow recovery. Two months later, staying with the Morrises at Red House, she wrote poignantly to Gabriel: 'If you can come down here on Saturday evening, I shall be very glad indeed. I want you to do something to the figure I have been trying to paint on the

wall. But I fear it must all come out for I am too blind and sick to see what I am about.'

Ned and Georgie were much with her. Georgie herself was now pregnant. Gabriel sent a note one day saying, 'By the bye, Lizzie has been talking to me of parting with a certain small wardrobe to you. But don't let her please. It looks like such a bad omen for us.' Lizzie's offer was tactfully refused. Ned was taking his position as a family man seriously. An old Birmingham friend commented on his new-found gravity: 'Edward seems to have got very quiet since his new responsibilities.' Lizzie's misfortune obviously unnerved him, and when he wrote to Crom Price, by now working in Russia as a tutor, to let him know that in about a month 'either a little Ned or a little Georgie' would appear he added 'don't tell, I keep it quiet for fear it should be a monster'.

A baby boy was born on 2 October 1861. Shortly before the birth Ned and Georgie had moved to a new, larger set of rooms at 62 Great Russell Street, a few streets away from Russell Place. They had little idea of the realities of childbirth and as Georgie's labour advanced and neither the doctor nor the midwife had appeared they were thrown into panic. Georgie could not decide whether she or Ned was the more frightened as he prepared to take charge of the delivery himself. In her later account of the incident she makes the interesting comment that for Burne-Jones 'intellect was a manageable force applicable to everything' and he put his sense of logic to the job in hand. But he was clearly overstrained and exhausted by the time the midwife came.

The child was named Philip and was quickly known as Phil. He aroused strong paternal feelings in Burne-Jones. The proud father was soon describing him as 'the prettiest boy known our friends do us the compliment to say'. Phil was to remain pretty, somewhat to his detriment. Staying at Great Russell Street at the time of the birth was Ned's own nurse Miss Sampson, who was able to relay the good news back to Birmingham. Janey and Lizzie came together to visit the mother and child, sitting side by side, both for the moment looking relatively healthy and a perfect contrast in their styles of beauty, Mrs Morris so dark and statuesque, Mrs

Rossetti pale, copper-haired, ethereal. 'Was there ever two such beautiful ladies!' the midwife had exclaimed.

The child was taken north to Manchester to be shown to his Macdonald relations. Ned joined them there for Philip's christening in Manchester Cathedral. The godparents, *in absentia*, were Ruskin and Rossetti. But by the time they returned to London via Birmingham, seeing Burne-Jones's father, a reaction had set in. Ned was suffering from a sore throat and a cough, his common signs of great exhaustion. On Christmas Eve he went to bed early, totally worn out, and he and Georgie noticed to their horror that he had now begun to cough up blood. Clutching the bloodstained handkerchief, Georgie summoned a cab to rush her to the doctor, Dr Radcliffe, who lived in Henrietta Street, Cavendish Square. Dr Radcliffe was extracted from a festive Christmas party, guests' coats and hats littering his consulting rooms, to view the evidence which, to Georgie, indicated her husband was near death. He obligingly came to examine Ned that evening, reporting reassuringly that the haemorrhage came not from the lungs but from the throat. But it was a sign that did not bode well for the future. Ned continued to be prone to infections of the throat.

He was still convalescing when something worse occurred, an event that reverberated round the Pre-Raphaelite world. Lizzie was dead from an overdose of laudanum. The news was brought to the Burne-Joneses on a dark cold morning, 11 February 1862, by Red Lion Mary who tapped on their door and stumbled out the words 'Mrs Rossetti'. She had died at 7.20 a.m.

Leaving Ned at home, Georgie had set straight off to Blackfriars. Retracing the story of those final hours, she understood that Lizzie had spent the previous evening out dining with Rossetti and Swinburne, with whom Lizzie had a particular rapport. She had been 'in good health (for her)' and apparently good spirits. Gabriel saw her home, watched her prepare for bed, then went out again to the Working Men's College. Lizzie was unconscious on his return, having overdosed on the laudanum prescribed for her to take medicinally. Three physicians and a surgeon worked through the night using a stomach pump but were unable to revive

her. Rossetti, at the inquest, would deny she had intended to kill herself. But almost certainly she had been driven beyond the limits of endurance by Rossetti's continuing unfaithfulness, and she was still mentally unhinged by the catastrophe of her stillborn child.

Georgie, viewing Lizzie's body laid out on the same bed where she used to lie chattering and laughing with her visitors only weeks before, could not escape the feeling it was all a dreadful dream. She had lost a loved companion as well as an artistic ally and potentially a collaborator. She and Lizzie had started on a project to write and illustrate a collection of fairy tales. The loss of Lizzie eroded her own future too.

Burne-Jones was very shocked, on Rossetti's account and on his own as well. Georgie told one of her sisters, 'Edward is greatly troubled as you will believe, and all the men.' She haunted all their memories. In 1918 the artist Charles Ricketts, of a younger generation, still had nostalgic recollections of how they had all, when young, been in love with Lizzie Siddal. Burne-Jones himself, with his sense of enigmatic female beauty, could hardly not have been susceptible.

Second Italian Journey
1862

On 15 May 1862 Burne-Jones set off again for Italy. This was a very different sort of journey from the larky boys-together expedition he had made with Val Prinsep and Charles Faulkner in 1859. He travelled with John Ruskin and they journeyed in some style, making a leisurely quasi-Byronic coach journey across Europe, staying in comfortable hotels, dining in their private room, going to the opera, visiting the galleries. Ruskin paid all expenses for their travels and, according to Georgie, 'did everything *en prince*'.

For Burne-Jones the journey was partly a tutorial. Ruskin was still showing signs of anxiety about the direction that his work was taking. He complained that 'Jones is always doing things which need one to get into a state of Dantesque Visionariness before one can see them, and I can't be troubled to get myself up, it tires me so.' Ruskin was still hoping to reform him, to turn him away from Gothic histrionics and imbue his protégé with proper principles of classical repose and artistic dignity by taking him to Italy under his own wing. Here Burne-Jones could absorb the great works at his leisure and make copies, following Ruskin's precise educative plan. Burne-Jones would reimburse his mentor's generosity by giving Ruskin the copies as a record after their return.

The plan for the joint visit to the Continent had been under discussion for at least a year. Georgie refers to it as 'a hope long cherished' and the previous September Ruskin had asked his father for financial help 'for art-purposes', mentioning £100

promised to Jones 'for sketches to be made at Venice or somewhere in Italy, if he goes there – from Venetian pictures'. With the birth of Phil and Burne-Jones's alarming blood-spitting illness the plan was put on hold, and when it was revived in spring 1862 there were not two travellers but three.

As well as an art training, the journey to Italy took on the character of a bizarre family outing. It was decided that Georgie should go with them, having arranged to leave baby Phil in Manchester with his grandparents and aunts. The young parents comforted themselves in the anxieties of parting by travelling with photographs and a drawing Ned had made of the infant. One of these pictures was brought out to show Ruskin in the railway carriage as they set out on the first lap of their journey, from London to Folkestone. Ruskin greeted it 'with wholesome chaff'.

He had his reservations about his young companions, mainly on account of their Christian names. As he once complained in his idiosyncratic way to Ellen Heaton, 'I'm going to take Mr. and Mrs. Jones – remember that I mayn't have to write the ugly names again that they're Edward and Georgie – to the theatre tonight.' But he was inordinately fond of them, calling them his children, lavishing his love on them. As well as a Burne-Jones training course the journey was conceived as a holiday, a treat for two young dependants who had been through a bad time. Though Ruskin was still only in his early forties he was looking careworn, older than his years. Ned and Georgie, still in their twenties, had a freshness and naivety of appearance and manner. The waiters in hotels in which they stopped en route tended to assume either Ned was Ruskin's son or Georgie his daughter. They were happy to go along with this, addressing Ruskin as 'dearest Oldie' and 'Papa'. Ruskin still was their hero intellectually, so lyrical yet so tough-minded, so far-seeing, the profoundest investigator of the objective. Besides, they were almost wholly dependent upon Ruskin for the advancement of Burne-Jones's career.

After crossing the Channel the travellers' first stop was at the Hôtel des Bains in Boulogne. In the afternoon Ruskin took them on a walk down to the beach. It was raining and the tide was out,

leaving a great stretch of wet sand. Ruskin, in a sudden mood of melancholy, left them behind, 'striding away by himself towards the sea'. To Ned and Georgie he seemed at that moment 'the very emblem of loneliness' and they never forgot the scene.

What were the reasons for John Ruskin's extreme gloom in the early summer of 1862? For Ruskin, as for many of his contemporaries, this was a period of religious turmoil in which his up to now relatively narrow evangelical views were being challenged by advances in science and a more rigorous biblical critique. If only the geologists would leave him alone! Ruskin once cried out in anguish. His old faith was feeling threatened. His own writing had also entered a controversial new phase. After publication of the fifth and final volume of *Modern Painters* in 1860 he had begun a series of passionate diatribes on political economy and its relation to personal morality. As he argued so splendidly, 'THERE IS NO WEALTH BUT LIFE'. Only a few days before starting on the journey he had finished his preface to *Unto This Last*, a volume in which he reprinted the essays originally published in the *Cornhill Magazine*. These fiercely anti-capitalist essays had not been well received.

Emotionally Ruskin was appallingly unsettled. After the humiliating failure of his marriage he had become still more dependent on his protective parents. But he found their well-meaning sympathy irksome, complaining of parental love that was not and never could be of any help to him. His own feelings of devotion were now dangerously fixed on a young Irish girl, Rose La Touche, whom he first met in London in 1858 when Ruskin was thirty-nine and Rose was barely ten. By 1862 he was identifying his feelings for Rose as sexual love and had begun on a disaster course that led to his proposal of marriage four years later. It is not clear how far the Burne-Joneses were aware of Ruskin's feelings for Rose when they set off on their travels. But Georgie was later to write understandingly of 'the fair-haired girl to whom as she grew' Ruskin gave his heart, 'with the tragic result that she could love no one else but him, yet not him completely'. And Ned was sympathetic, having his own devotions to fair-haired little girls.

After Boulogne they travelled on to Paris where Ruskin had
booked his party into the Hôtel Meurice, where coincidentally
Lizzie and Rossetti spent the first nights of their honeymoon
the year before. Ruskin conducted Ned and Georgie round the
Louvre and in the evening they went to the theatre, sitting in a
box. The next day, a Sunday, Georgie went to visit an English
friend who was married to a French Methodist preacher calling
himself Jean Wesley. Ruskin too went out to dine with friends,
returning to confess that his hostess for the evening had been his
early love Adèle Domecq, the daughter of his father's partner in
the sherry trade. Her rejection of Ruskin had caused a nervous
breakdown and his embarrassing withdrawal from Oxford Uni-
versity. Adèle, now Madame de Bethune, was married to a French-
man. After a convivial evening, once back at the hotel with Ned
and Georgie, Ruskin threw himself down on a couch, going into
raptures about what an admirable wife Adèle had become, praising
the skill with which she amused her sportsman husband by trans-
lating the jokes in *Punch* to him.

Ruskin's party proceeded from Paris to Dijon, then on into
Switzerland. At Basle they stayed in the Three Kings Hotel with a
view from their balcony across a rushing river. Here they enjoyed
eating the local *truite au bleu* for dinner. Then they lingered in
Lucerne for a few days. One afternoon, as Ruskin rowed them
round the lake, he and Burne-Jones became locked in a discussion
on current scientific discoveries about the formation of the earth
and the gradual evolution of animal life. With his almost too
vivid imagination Ned worked himself up into a frenzied state,
envisioning the period when huge white cockroaches ruled the
world.

Intellectually and aesthetically there were many points of sym-
pathy between Ruskin and Burne-Jones: their love of fine illus-
trated books; their shared sense of the chivalric and admiration for
the writings of Chaucer and Scott; their intensity of outlook, leav-
ened by an almost puerile jokiness. Both signed up to the ideal of
the close and loving brotherhood, almost mystically united against
the world's iniquities and follies. As Ruskin was to put it to his

protégé, 'All we true people must make up our minds – if we don't see – to feel each other – & never let go. Else the wicked ones will have it all their way.'

This close rapport developed as Ruskin, Ned and Georgie were travelling through Switzerland. From Lucerne they took the steamer up the lake towards Fluelen. Here they stayed in a simple Swiss hotel so as to be ready for an early start next morning when they would be crossing the St Gotthard Pass. Georgie described the companionable scene: 'I have a vision of us all three sitting together that evening, in a room with an exquisitely clean bare-boarded floor, and Mr. Ruskin reading Keats to us.'

They drove up the pass all day in glorious sunshine, arriving towards evening onto the high valley of Hôpital plain with a wide swift river running through it and the summits of the mountains encircling the valley. Next morning the coach and horses made the perilous descent down the zigzagging mountain road to Bellinzona and they were soon in Italy. On the following day the party reached the lakes of Lugano and Como, driving past luxuriant villas set in gardens where the roses, in Georgie's excited description, were 'bubbling over the tops of the high walls' and the beautiful Italian women struck Ned as 'spoiled studies' for Janey Morris. Dusk fell and the fireflies were lighting the night sky before the carriage reached Milan.

Here they stayed for a few days while Ruskin guided them around his special sites. There is an endearing picture in Georgie's reminiscences of Ruskin skipping about on the steep slopes of the cathedral roof so dangerously that they expected him to topple down to the piazza far below. At the Basilica of Sant'Ambrogio, the most ancient building in Milan, Ruskin imperiously had the church treasures unlocked from the safe behind the altar and brought out for the party to examine and admire. From Milan they went to Parma where Ruskin led them to Correggio's mural paintings of the grotto of Diana in the Camera di San Paolo and took them to hear *Rigoletto* at the opera house. In fact Ruskin took Georgie two nights running but Ned preferred to spend the second evening alone.

Returning to Milan, they parted. Ruskin remained behind while Ned and Georgie travelled on to Venice on their own. They were 'sorry to go', wrote Ruskin, 'and I was sorry to let them go, a little. Georgie nestled close to me when she said goodbye and said "you nice thing".' Why had Ruskin not planned to go to Venice with them? Partly perhaps because Venice was a problematic place to him, bound up in early memories of visits with his parents and, more painfully, of long winters spent there with Effie immediately after their marriage in 1849–50 and 1851–2 with Ruskin failing to consummate the marriage and Effie rather desperately flirting with the Austrian military officers, making the most of the Austro-Venetian social scene. The Ruskins' second winter stay erupted into farce and scandal following the suspected theft of Mrs Ruskin's jewels.

Besides, Ruskin had his own preoccupations in Milan. He was busy reassessing the work of the then virtually unknown early sixteenth-century Lombard painter Bernardino Luini, making a full-size copy of Luini's *St Catherine* in the church of San Maurizio Maggiore and composing his report on Luini for the Arundel Society. In Milan he was watching the post obsessively, hoping for letters from Rosie La Touche.

It was now early June. Ned and Georgie stopped briefly in Verona admiring the church of San Zeno, the amphitheatre and the profusion of fruit and flowers in the market in Piazza delle Erbe. They travelled on to Padua, arriving on a Sunday and spending the morning completely on their own in the Arena Chapel, which was then standing in isolated splendour in 'a kind of rough grassy orchard'. Georgie found its beauty 'unutterably touching' and Ned made copies in his sketchbook from the virtues and vices depicted in the bottom row of Giotto's frescos.

Then at last they were in Venice. Burne-Jones wrote to Ruskin thanking him for giving him 'this chance of seeing the old miracles'.

Venice was not a cheerful or fashionable place in 1862. The city had been under Austro-Hungarian occupation more or less

continuously since 1815. After a serious rebellion in 1848–9 the military presence had been strengthened. Ned and Georgie arrived to find artillery trained on the Piazzetta from the arcade of the Ducal Palace and uniformed officers everywhere in sight. Social life was muted. The hectic carnival spirit of Byron's days was over as many of the wealthy families moved to the mainland. The *palazzi* were beginning to look shabby, the Fenice opera house was closed indefinitely and the tourists stayed away.

Ned and Georgie, booked into the Hôtel de Ville, the former Palazzo Loredan on the Grand Canal, felt stranded. Ned wrote home to Rossetti:

Georgie and I are alone in a vast hotel, and dine alone at a table set for fifty . . . we are perishing though for home news, either no one will write to us or they write treason and enclose diagrams of new fortifications and the Austrians burn the letters – for none come to us except one very large one from Top, weighing a 100 weight and positively having 20 shilling stamps on it

Morris's package contained a wodge of tracing paper for Ned's stained-glass designs and not a word of news.

He was not feeling his best. A trip by gondola on their first evening had left him very seedy. He was feverish and ill in the night. Georgie suspected the illness was malarial, picked up from the murky canal waters, and from then on they went everywhere by foot. But Venice very quickly began to work its magic. Burne-Jones had a good sense of topography and was soon finding his way around the complicated and mysterious city as if he had been born there. 'Venice do look so jolly: there is not nearly as much heat as in a hot London day – besides a good fresh wind has been blowing all this week – it's simple heaven – except sometimes where there's a hell of stink enough to stifle you.' He could not resist retracing the steps of his earlier visit, reclaiming its excitement, afterwards telling Rossetti how he had taken Georgie round by harbour 'because I remembered when Val and I once passed under a brig we were startled'. And then there were great new surprises like the sunset he and Georgie watched one evening from

the Piazzetta when the façade of the Ducal Palace, flooded with a pink golden light, was reflected back again from the upturned faces of a silent, awestruck crowd.

They stayed in Venice for three weeks and Burne-Jones rallied enough to carry out Ruskin's commissions, taking his advice about 'smoothing the way at all the galleries and churches by largess'. The copies Ruskin ordered were of endangered pictures, to be captured before they deteriorated further, or of works he simply considered would be beneficial to Burne-Jones himself, who reported back to Ruskin on the progress he was making. He had been copying 'a little head of Paolo in the Ducal palace'. This was a detail from Veronese's *Thanksgiving for the Victory of Lepanto* in the Sala del Collegio, where Burne-Jones also made a study, as near to the original size as he could make it, of the head of Bacchus in Tintoretto's *Bacchus and Ariadne*. In *The Stones of Venice* Ruskin had lamented how this Tintoretto painting, 'once one of the noblest pictures in the world was now miserably faded, the sun being allowed to fall on it all day long'.

As well as the copies in the Ducal Palace, Burne-Jones made a copy of Tintoretto's *Marriage at Cana* in Santa Maria della Salute and sketches from Tintoretto's paintings in the Scuola di San Rocco, prime favourites of Ruskin's. One was a detail showing the high priest from the *Circumcision*, another a copy of the *Visitation* which Ruskin judged one of the most precious paintings in all Venice, indeed one of the works he most coveted for himself. Burne-Jones worked slowly and in difficult conditions. In the Scuola the light was particularly dim. He wrote back to Ruskin: 'A sketch is a slight name, but how long it takes – one could do a dozen designs for one little worthless copy, but O it does one good. Directly my eyes close a canvas appears and I scrawl away with brown and white – yes, dark figures on a white ground, that's the secret.'

Burne-Jones was characteristically apologetic about what he achieved in Venice, telling Ruskin he was only bringing him back 'four rotten little sketches'. There was a great deal more to it than that. Burne-Jones was not mechanically copying, he was thinking and

feeling about these paintings too, as you can see if you compare Tintoretto's *Visitation* in Venice with the Burne-Jones sketch of it now in the Ruskin Library at the University of Lancaster. He was absorbing the grandeur, the stillness, the freezing of the moment, taking from Tintoretto some of the artistic qualities that he would make his own. Such close-up concentration on the work of these great artists gave Burne-Jones an onrush of optimism. He told Ruskin, 'The look of the pictures has done me good; I feel that I could paint so much better already.' It was this second visit to Italy that laid the foundation of Burne-Jones's mature work.

Ned and Georgie celebrated the day when Burne-Jones finished his first sketch in the Ducal Palace by making an expedition to the island of Murano, half an hour by ferry. There is no record of whether they visited the local glassworks, established in the Middle Ages and in the 1860s employing about 2,500 glassmakers making the decorative coloured vessels for which Venice was so famous. They certainly viewed the twelfth-century church of Santa Maria e Donato since Georgie sent a detailed description back to Ruskin. The visit to Murano was in some ways disappointing; the whole island was deserted and looking 'very sad'. The church itself was shut and once they managed to get in, no doubt using Ruskin's recommended method of 'largess', they were dismayed to find the enormous vaulted space 'filled to the roof with ladders and scaffolding poles'. Even here wholesale restoration was under way. They did however manage to admire the richness of the decoration in the church: the 'great solemn figure of the Virgin', an elongated Byzantine Virgin Mary in mosaic standing out dramatically against the golden apse, and the wonderfully patterned tessellated floor with its peacocks, cockerels and a wolf slung on a pole. This again was a lesson in possibility. Burne-Jones was to develop his own mastery in designing for mosaic.

On another of their Venice days they visited Torcello, the island an hour and a half's boat ride from the city, to the west of the lagoon. They set out early and Burne-Jones told Ruskin he and Georgie had 'confided much poetic sentiment to each other on the

occasion – it was lovely beyond words'. The Italian journey was, after all, an extended honeymoon. Like the visit to Murano, Torcello was a high point. It was partly the remoteness of the island known to the locals as '*Torre e cielo*': the island defined by its tall brick *campanile* rising in an expanse of sky. Burne-Jones, with his feeling for the layerings of history, was intrigued by the fact that Torcello, once the very centre of Venice, site of its first cathedral, its first dwellings, the place from which Venice's trading vessels sailed, was now reduced in status to a tiny rural outpost to which occasional art-loving tourists came.

The vast bare brick cathedral interior impressed Ned and Georgie, as it would have enraptured William Morris, with its powerful simplicity. This great barn of a building has a kind of sea-washed quality, greeny-grey and weathered. But within the austere, almost functional interior the richness of decoration shines out: the elaborate marble carvings, the moiré-like marble texture of the columns, the crowded *mouvementé* mosaic of the *Last Judgement* and, as at Murano, the all-dominating figure of the Virgin in the apse, the twelve apostles ranged below her. This line-up of single figures – tall, thin and dignified, separate and yet together, sharing a floral carpet – was to influence Burne-Jones's own depictions of the saints.

The fifty-metre bell tower is a building on its own, standing in a green field a few yards from the cathedral. We can assume that Ned and Georgie ascended the tower Ruskin writes about so temptingly in *The Stones of Venice*, suggesting that visitors should climb it at sundown to catch the best of the great vista beyond the 'waste of wild sea moor'. To the north-east one could see the mountains; to the east the Adriatic; and then to the south, beyond the lagoon and rising out of the dark lake, Ruskin urged his readers to look out from the bell tower and see Venice itself stretched out into the distance, 'a multitude of towers, dark and scattered among square set shapes of clustered palaces, a long irregular line fretting the Southern sky'. Even though Ruskin was not actually with them he was ever present in that his words, his attitudes, his writings hung over Ned and Georgie's discovery of Venice. To Burne-

Jones, 'If the Stones of Venice had been 300 volumes instead of 3 it couldn't have been enough.'

Because of its history and its isolated beauty, Torcello remained central to Burne-Jones's comprehension of Venice. He would advise friends visiting Italy that one of the unmissable experiences was to row out to Torcello and lunch on figs. He was anxious for others to share his and Georgie's enthusiasms for the still almost undiscovered secrets of the city, the many architectural splendours that did not even rate a mention in the guidebooks. In 1879, when his friend Mary Gladstone was planning to visit Venice with her father William Gladstone, soon to start his second term as Prime Minister, Burne-Jones told them they could start in the traditional way by entering Venice in a gondola by moonlight but should then eschew the obvious set pieces. No need to search out every painting in the guidebook when Venice was itself the most amazing picture: 'get men to row you in and out of all the byways and watch every corner as you turn: windows and arches and gateways of the utmost beauty are ready to greet you at every turn'. This still seems good advice.

After the first weeks Burne-Jones was getting restless, wanting to be back in his own studio doing his own work. He became suddenly panic-stricken that this making of copies of Italian masterworks could be stifling his originality. 'Georgie begins to grow pining for her kid,' he told Ruskin. 'The post here is horrible, we get no letters from home, and are in utter darkness about our families.' They were hoping for an early release, but Ruskin was adamant that they should stay in Venice till Ned had completed his planned programme, then rejoin him in Milan for a further week of sketching.

They were still in Venice on Corpus Christi Day. From a high-up vantage point in one of the galleries of St Mark's basilica they watched the great religious procession form in the church below and then surge out round the piazza, a scene almost unchanged from the one shown in the picture *Procession in Piazza San Marco* painted by Gentile Bellini in 1496. Ned and Georgie had

marvelled at Bellini's panoramic painting in the Accademia, finding it 'quite as exact as a photograph, with colour besides'. Ned predicted this would soon be the *only* record of the original St Mark's now that the Italian workmen were hard at work restoring it. He reported indignantly to Ruskin that 'all the north side is covered up and peeled off'.

On their final morning Ned and Georgie went to the Piazza for a farewell visit and found a funeral mass in progress at St Mark's. They followed the procession of mourners with their candles out of the darkness of the church and into the sunlight. From the pavement the coffin with its crimson covering was loaded into the black funeral gondola and rowed rapidly away to San Michele, the island where Venetians buried their dead.

They were back in Milan by 10 July. On their earlier visit Burne-Jones had made a study of Gaudenzio Ferrari's *Adoration of the Magi* in Santa Maria della Pace. Now Ruskin urgently wanted him to copy 'two Christs' by Bernardino Luini in the church of San Maurizio. Once again, in carrying out Ruskin's commissions Burne-Jones found himself labouring under difficulties. San Maurizio was a large dilapidated church that had suffered from being used as a military hospital during the Franco-Sardinian war with Austria. The Luini frescos Ruskin wanted Ned to copy were on the walls of a chapel with hardly any light. Burne-Jones described a scene of comedy in a letter to Georgie's sisters Agnes and Louisa:

I am drawing from a fresco that has never been seen since the day it was painted, in jet darkness, in a chapel where candlesticks, paper flowers and wooden dolls abound freely – Ruskin, by treacherous smiles and winning courtesies and delicate tips, has wheedled the very candlesticks off the altar for my use and the saint's table and his everything that was his, and I draw everyday now by the light of eight altar candles; also a fat man stands at the door and says the church is shut if anybody comes.

So insistent was the fat man at the door that he even managed to scare away the church's priest.

While Ruskin held the candles for him Burne-Jones copied the Luini fresco of Christ and Mary Magdalene *Noli me tangere* in

Monastero Maggiore. He was later to describe Luini's head of Christ as the loveliest ever done and Luini as the artist 'in all the world who ever could do it . . . nothing is like him anywhere for perfect beauty'. Burne-Jones also made copies while he was in Milan of two single figures of the Saints Apollonia and Agatha. These were set in gilded frames decorated by the artist once he returned to England and signed 'E Burne-Jones Fecit'. Though these female saints are evidently copies of Italian originals there is indeed a definite Burne-Jonesiness about them, intimations of the self-contained and dreamy female figures that became the famous Burne-Jones type. Burne-Jones saints may bear aloft the symbols of their sainthood but they are also Pre-Raphaelite stunners. In these early visits to Venice and Milan we see the dawning of ideas for the groupings of women, the gatherings of stunners, mysterious and stately, in his later, maturer Italianate paintings *The Mill* and *The Golden Stairs*.

Ned and Georgie left for home on 19 July leaving Ruskin in Milan to take a pleasant evening walk along the north bastion of the city: 'all green, with quiet sunlight'. They had been away ten weeks. In retrospect that journey to Italy with Ruskin seemed to Burne-Jones to have been the best of times, with his view of art maturing and his marriage just beginning. He said that he and Ruskin had quarrelled a great deal and had been very happy. The squabbles with Ruskin were a sign of his gathering self-confidence. It was a journey he was always to remember with a pang of gratitude. 'My dear,' he wrote to Ruskin in 1877, 'there has been nothing in my life so sweet to look back upon as that journey to Milan twenty five years ago.'

Great Russell Street
1862–4

The first years of marriage were indubitably good years. Burne-Jones would look back wistfully to a time of hope that lasted through the 1860s, rhapsodising on 'eleven years that were bonny years'. He told his later inamorata Mrs Gaskell:

of them I love to think – years of the beginning of art in me – and Gabriel everyday, and Ruskin in his splendid days and Morris everyday and Swinburne everyday, and a thousand visions in one always, more real than the outer world.

The rooms in Great Russell Street, which Ned and Georgie had moved into only a few months before they left for Italy, were on the first floor of a four-storey early eighteenth-century brick town house. The accommodation consisted of the front-facing studio with two intercommunicating living rooms behind it. Never mind that one of these was minuscule or that the sitting room looked out onto a dingy small backyard and then the high blank wall of the house behind. Never mind that the previous occupant, the artist Henry Wallis, had recently absconded with the wife of George Meredith leaving some dusty tapestries hanging on the walls. Burne-Jones's reaction to the move had been euphoric. 'Come and stay with us', he wrote to his friend Crom Price, who was still in St Petersburg, tutoring the sons of Count Orloff-Davidoff, 'we are beautifully situated opposite the Museum, with a clear view of the trees in Russell Square out of the top windows, and an easy walk from

Tottenham Court Road and Holborn. My studio is the jolliest room except for dirt.'

Such close proximity to the British Museum was a bonus. They were close enough, in spring 1864, to watch Garibaldi arriving to visit his old friend and fellow freedom fighter Anthony Panizzi, now chief librarian of the museum and originator of the Round Reading Room. When the Italian leader reached the top step under the great portico he turned to acknowledge the enormous crowd assembled in the museum courtyard. Garibaldi was bareheaded and wearing his red shirt, the uniform of the revolution.

Burne-Jones made almost daily use of the museum's collections. Obeying G. F. Watts's and Ruskin's admonitions on the necessity of drawing more correctly in an academic sense, he was concentrating hard on improving his technique by making copies from the antique sculptures in the collection, in particular studying the Elgin Marbles, as his sketchbooks of the period show. The museum's medieval illuminated manuscripts were also wonderfully close to home and Burne-Jones would take his friends across Great Russell Street to study them, displaying the precious documents as if they were his own prized possessions.

His favourite of all was the *Roman de la Rose*, a Flemish fifteenth-century manuscript of Guillaume de Lorris's allegory of courtly love. In this erotic dream sequence the poet is led by the god of love into a hidden garden where he discovers a marvellous rose. At the heart of the rose lies the fulfilment of desire. Chaucer used de Lorris's allegory as the basis for his own *Romaunt of the Rose* which Burne-Jones first read at Oxford. Now his intimate study of the exquisitely illuminated Flemish manuscript, acquired by the British Museum in 1753 and one of the highlights of its manuscripts collection, opened out a theme that was to be with him all his life. When he took the painter George Boyce across the road to see the manuscript Boyce was equally impressed, finding it 'as fine as could well be in colour and gradation, tenderness of tone and manipulation, and purity of colour and light: the landscapes perfectly enchanting, the distances and skies suggesting Turner's best'.

The strange beauty and eroticism of the *Roman de la Rose* haunted Burne-Jones, supplying a series of subjects he would work through in a sequence of drawings and paintings, embroideries and tapestries. Love leading the Pilgrim: the sequence had its origins in Ned and Georgie's time in Bloomsbury and those early years of sexual self-discovery.

Burne-Jones had returned from Italy to find the Firm 'in great activity'. Morris, Marshall, Faulkner & Co. had been showing in public for the first time at the 1862 International Exhibition in South Kensington. This exhibition had been planned as the successor to the 1851 Great Exhibition. Prince Albert's untimely death had meant it was postponed from 1861 to 1862. It was held not in another Crystal Palace in Hyde Park but in a big brick temporary exhibition hall to the south of the newly opened Royal Horticultural Society Gardens which covered twenty acres between Exhibition Road and Queen's Gate. The exhibition had been conceived to show how far British manufacturing and education in design had improved since the 1851 exhibition. However, there was little control over selection, with the result that the visual standards were chaotic. According to a scathing writer, 'The Groves of Blarney were order and good taste in comparison with the conglomeration of organs, telescopes, light-houses, fountains, obelisks, pickles, furs, stuffs, porcelain, dolls, rocking horses, alabasters.' Even a statue of Lady Godiva was on show. This was the problematic context in which the Firm decided to unveil its work.

The Morris partners rented two stands costing £25 in the exhibition's Mediaeval Court, one to show furniture and decorative objects, the other stained glass. They were short of time to assemble the exhibits but Rossetti wrote optimistically to his friend Charles Eliot Norton in America that the Morris stained glass, if nothing else, 'may challenge any other firm to approach it'. He also confided to Norton:

A name perhaps new to you on our list – but destined to be unsurpassed – perhaps unequalled – in fame by any name of this generation – is Edward

Burne-Jones. He is a painter still younger than most of us by a good deal, and who has not yet exhibited, except at some private places; but I cannot convey to you in words the exquisite beauty of all he does. To me no art I know is so utterly delightful, except that of the best Venetians.

The Firm's exhibits included tours de force of painted furniture: *King René's Honeymoon Cabinet* and the *Backgammon Players' Cabinet* with panels by Burne-Jones developed from his water-colour painting of the subject. William Morris exhibited his own *St George Cabinet* painted with scenes from the legend of the saint. The decorative arts display showed the Firm's embroidery, an iron bedstead, a sofa and a washstand, Philip Webb's copper candle-sticks, some jewellery and painted tiles. On the stained-glass stand Rossetti's *Parable of the Vineyard* was a highlight. Although such brilliant individual designers exhibited, the aim was to arrive at artistic coherence. The Firm was developing what would later be defined as its own house style, conveying to the public a recognis-able set of design values.

This idea was not altogether new. Pugin had attempted some-thing of the sort in his display in the Mediaeval Court of the 1851 Great Exhibition. Pugin had died, aged only forty, in 1852. In a sense, Morris, Marshall, Faulkner & Co. were taking over where this uniquely enterprising architect-designer had left off. But where Pugin's design work was primarily religious in its emphasis, the Firm's creative idealism was more broadly based. In those formative years the Firm's church work would certainly be crucial, and important ecclesiastical commissions resulted from their presence at the exhibition. But Morris's ambition stretched out towards reforming domestic design in general, improving the way that ordinary people lived their daily lives.

On the whole the Firm's two stands were well received. Goods sold at the exhibition amounted to almost £150 and both stands were awarded medals by the Exhibition jury, particular praise being heaped on the stained glass for its beauty of colour and design. Burne-Jones came back from Venice after the exhibition had opened to a gratifying build-up of commissions both for stained

glass and for tiles. At the head of the list of services offered in the Firm's prospectus issued to the public was 'Mural Decoration either in Pictures or in Pattern Work, or merely in the arrangement of Colours, as applied to dwelling houses, churches, or public buildings'. This was followed by 'Stained Glass, especially with reference to its harmony with Mural Decoration'. These were the two aspects of the Firm's activity in which Burne-Jones's contribution was essential. His technical proficiency, his sheer imaginative fluency and sense of decoration were of the utmost value at a time when stained glass was by far the most important of the products of the Firm. Burne-Jones provided at least 144 cartoons for stained glass between 1862 and 1865.

His close personal rapport with Morris was a crucial factor in the Firm's early successes. Theirs was a working partnership based on sheer enjoyment of one another's company, a constant toing and froing of ideas. They thrived on an interchange of humour and male badinage, laughing hysterically at one another's jokes. Most importantly they shared the strong idealism that was central to the venture. Art was for everyone. Not just Red House but everybody's houses must be made into the beautifullest places on this earth.

As the Firm raised its profile with a fashionable public, commissions started coming in for interior decoration schemes for private houses. In the beginning these came mainly from artistic clients already on the Morris/Burne-Jones circuit: for George Boyce in Glebe Place, Chelsea; for Spencer Stanhope in Cobham, Surrey; for the decorator J. Aldam Heaton and his near neighbour Walter Dunlop in Bingley in Yorkshire. A patron who made the utmost use of Burne-Jones's narrative ingenuity was the watercolourist Myles Birket Foster whose neo-Tudor house, The Hill, at Witley in Surrey, then developing as a small-scale artists' colony, soon came to rival even Red House as a showcase for the artistic productions of the Firm.

For Birket Foster Burne-Jones designed three virtuoso tile panels to hang above the bedroom fireplaces at The Hill. These designs for the fairy tales of *Cinderella, Beauty and the Beast* and *Sleeping Beauty* were painted onto the white tin-glazed tiles

imported by Morris from Holland. Charley Faulkner's sisters, Kate and Lucy, now living with their brother in Queen Square in Bloomsbury, painted the tiles from Burne-Jones's master drawings and the tiles were fired in the Firm's kiln nearby in the Red Lion Square basement. It was, as always in the Burne-Jones circles, a close-knit, almost familial affair.

These fairy-tale tile panels are wonderful examples of Burne-Jones's delight in storytelling. The stories overspill into additional panels in the fireplaces below, full of glowing human detail. This was a time when the connection of fairy tales with childhood, which burgeoned over the next decades, was in its early days. It was a movement to which Burne-Jones was totally attuned; indeed he helped to form it. His tile narratives ask for a childlike belief in these weird stories: the prince transformed into a bear who then becomes a man again; the princess in her seemingly interminable stupor who is kissed and made awake. Burne-Jones's Sleeping Beauty bears an obvious relation to the erotic meaning of the *Roman de la Rose*. Ruskin went into raptures about his Cinderella, writing to Louisa, Marchioness of Waterford: 'How I wish you could see some designs for tiles which the P. R. B. people have been making . . . such a sweet Cinderella in her kitchen full of willow pattern plates – and such terrible mediaeval sisters with peaked caps – and such a handsome golden crowned prince – and delightful fairy godmother.' So enamoured was Ruskin of the *Cinderella* tiles, he was intending to commission some himself.

Amongst other designs that Burne-Jones made for Birket Foster in the 1860s was a cycle of paintings for the dining room based on the legend of St George and the Dragon. This was his first complete series of decorative paintings and Burne-Jones produced dozens of preparatory drawings. His dragon is not quite Carpaccio's dragon and the Princess is more of a nineteenth-century Aesthetic Movement maiden than an early Italian in attitude, clasping her hands in horror at the terrifying slaughter. But still this is a homage to Venice and the things that Burne-Jones found there: the poise of composition; the glorious depth of colour; and especially the knack of drawing the spectator into what is happening. This element of

theatre developed very strongly after his return from Italy and became a defining feature of his art.

After their travels in Italy, Ruskin stayed abroad for much of 1862. In August an attack by his father John James Ruskin on the friendship and support he lavished on Burne-Jones received a passionate response. He wrote indignantly:

You try all you can to withdraw me from the company of a man like Jones whose life is as pure as an archangel's, whose genius is as strange and high as that of Albert Dürer or Hans Memling – who loves me with the love as of a brother – and far more – of a devoted friend – whose knowledge of history and of poetry is as rich and varied, nay – far more rich and varied, and incomparably more *scholarly*, than Walter Scott's was at his age.

This vehemently argued defence of Burne-Jones in the face of his parents' continuing suspicions that this was an immoral sponger shows how greatly Ruskin had now come to depend on his companionship. Ruskin may have been a respected authority on art but Burne-Jones was in fact the only artist with whom he was in day-to-day contact, with whose family he was on terms of close affection, with whom he could be his unofficial self. Ruskin tried to persuade his parents that in keeping Burne-Jones at arm's length they were in fact depriving themselves: 'ask Jones out to any quiet dinner', he entreated them, 'ask him about me – ask him anything you want to know about mediaeval history – and try to forget he is poor'. He wanted them to have 'the pleasure of knowing' one of their son's real friends, 'and one of the most richly gifted, naturally, of modern painters'.

It is to their credit that after this long onslaught Mr and Mrs Ruskin took their son's advice and Ned and Georgie were invited to dine at Denmark Hill both with and without Ruskin. Georgie and Ruskin's father developed a particular rapport: she dealt well with older men. Mrs Ruskin asked to see Phil, her son's godchild and, shocked to discover that Ruskin had never given him a christening present, she herself provided the traditional silver knife, fork and

spoon. Early in 1863, when John Ruskin was abroad again, his father secretly bought the watercolour *Fair Rosamond* on which Burne-Jones was working. When he heard about the purchase Ruskin could not avoid a note of triumph, writing to Burne-Jones, 'I'm pleased more than you are that my father likes Rosamond.'

Since its inception, Ruskin had had a close association with the Working Men's College. More recently he had also been involved in women's education, becoming close adviser, a kind of intellectual figurehead, to a small progressive girls' school, Winnington Hall at Northwich in Cheshire where the headmistress was the formidable Margaret Bell. Miss Bell had first met Ruskin in 1859 in Manchester where he was giving a lecture on 'The Unity of Art'. She invited him to stay at the school and from then on he had taken up semi-permanent residence. Ruskin had his own room in the huge old-fashioned house set in a park that sloped down to the river. The Hall was a labyrinthine place with many galleries and stairways and a great octagonal drawing room where girls and staff assembled. Ruskin gave the school considerable financial support.

Not the least of its attractions for Ruskin was that this romantic place contained thirty-five girls whom he lectured on the Bible, instructed in geology and art. He supervised their music and watched as they played cricket. Winnington was one of the earliest cricket-playing girls' schools in England. Every Sunday during term Ruskin composed Sabbath letters for the schoolgirls he fondly called his 'birds'. He entrusted them with compiling the index for volume five of *Modern Painters*, under Miss Bell's supervision. The serious yet easygoing ambience of Winnington provided a welcome distraction from both the suffocating attentions of his parents and his complex relationship with Rose La Touche, which became more, not less, anguished as she grew towards maturity. He confided in a friend early in 1863, 'now she's got to be fifteen there's no making a pet of her any longer – and I don't know what to do'.

Ruskin was anxious to draw Burne-Jones into his precious Winnington Hall project. As a preliminary he escorted Miss Bell to Great Russell Street where she issued a pressing invitation.

Ruskin, Ned and Georgie travelled north together early in August, taking the dreaded train from Euston via Crewe. Arriving at Winnington, Georgie summed up the situation quickly: 'Miss Bell was an extremely clever woman of a powerful and masterful turn of mind, evidently understanding that Ruskin was the greatest man she had ever seen, and that she must make the utmost use of the intimacy he accorded her and the interest he took in her school.' The first evening at dinner Miss Bell, possibly nervous, 'talked as much as if it were her last opportunity of speech, and as one listened to her it seemed that no subject could be too high and no difficulty too great for her to deal with'. Burne-Jones, whose experience of bluestockings was minimal, was dazzled by her ostentatious brilliance. After dinner the whole school, both girls and teachers, assembled to welcome Ruskin, whose personality seemed to permeate the house. At Winnington, as well as cricket and croquet, dancing was encouraged, the girls dancing together in the school-room or long gallery wearing their white frocks. Ruskin himself would join in sometimes, taking part in a quadrille or country dance. Georgie describes his very thin and outré figure, 'scarcely more than a black line, as he moved about amongst the white girls in his evening dress'.

Ned and Georgie were at Winnington twice in that late summer of 1863. By the time of their second visit, in late August, Ruskin had become restless and despondent. He was thinking of leaving England altogether and building a house on the heights of Brezon above Bonneville in the Savoy Alps. He had begun negotiations to buy land. Ned and Georgie joined with Ruskin's father in attempting to make him change his mind, Ned suggesting he should find himself a quiet house in the English countryside where it would be easy for him either to live in solitude or, when the mood took him, to break out and lead a more sociable life. He attempted to bribe Ruskin with the promise of a tapestry room in the heart of this new house for which he would design a set of wall hangings with figures drawn from Chaucer's poem *The Legend of Goode Wimmen*. These hangings were to be embroidered by Ruskin's 'birds' at Winnington, under Georgie's direction.

Ruskin was 'deeply moved' by Burne-Jones's proposal, though not deterred from his intention of moving to the Alps. But he wanted the tapestry in any case. He approved of the suggestion of taking the Chaucerian 'Goode Wimmen' as the subject. 'I should like that better than any – any – anything,' he told Burne-Jones, 'and it is very beautiful and kind and lovely of the 12 damsels to work it for me'.

In designing the hangings Burne-Jones was already halfway there. He had begun a series of smaller embroidered figures from the *Morte d'Arthur* of which Georgie had now finished Merlin and Morgan le Fay and started on Arthur and Launcelot. She was a proficient embroiderer, having been taught tapestry-stitching techniques by William Morris. Burne-Jones was well versed in the details of Chaucer's long dream poem with its sequence of the famously wronged women of classical history who suffered for their love. He had already made a sequence of tiles showing such ill-used heroines as Cleopatra, Thisbe, Dido, Hypsipyle, Ariadne and Lucretia for Morris, Marshall, Faulkner & Co. He returned to Winnington, reporting back to Ruskin, 'already I have schemed it all out, assigned the figures and ordered the embroidery frames (i.e. Miss Bell ordered them) and the holland for working upon and the wools for working with, and now Winnington is full of excitement about it, and you are to have the sweetest and costliest room in all the world'.

Burne-Jones persevered with his plan to tempt Ruskin away from his projected move to Bonneville. He estimated that the work in embroidering fourteen or fifteen single figures on a green serge backcloth, each with its attendant scrolls, roses, birds and daisies, would take about a year. The twelve most proficient older girls would work on the big figures while the little ones embroidered daisies, butterflies and mice. Discussions with the schoolgirls were also time-consuming: how could Cleopatra and Medea be considered good women? they were anxious to know. Chaucer's heroines were to be 'in uniforms of blue and white, and red and white alternately'. There were variations in design according to the subject: for Dido, Hypsipyle, Medea and Ariadne, Burne-Jones

specified sea instead of grass and shells instead of daisies. He wrote hopefully to Ruskin, 'shall you like it, dear, and will it ever make a little amends for sorrow? I know it won't, only you pretend it will.'

As far as Burne-Jones was concerned, his visits to Winnington, planning and preparing the cartoons for the Good Women, became unalloyed delight. He enjoyed the admiration of all the eager schoolgirls, telling Ruskin, 'I can look six in the face at one time, I can play at cricket, and read aloud, and even paint with three or four looking on, and I am deeply in love with several at a time, and don't want to leave a bit.' At the St Patrick's Day school dance a very charming Irish girl persuaded Ned to dance with her and declare himself an Irishman, after which he rather proudly called himself a Paddy. He made studies of some of the Winnington Hall pupils for the tapestries, and flirted gently with the girls. 'I wonder Georgie isn't dreadfully jealous of Isabella,' Ruskin wrote in a mischievous tone to the girl's headmistress, 'the way Ned goes on about her is quite unpardonable – (I think) – He says that Lily is growing up so fast that he couldn't draw her – she wouldn't stop at the same height – I wonder if you'll have to put a stick in for her as one does for sweet pease.' Winnington was a fascinating, disconcerting episode in which innocence and freshness alternated with a slightly sinister sentimentality.

Ruskin never built a house at Bonneville. The retreat in rural England, with its magical central chamber hung with tapestries, as envisioned by Burne-Jones, did not materialise either. By March 1864, when Ned and Georgie were once again at Winnington, the embroidering of only one of the Good Women – Hypsipyle – had even been begun. It seems that the designs were beyond the schoolgirls' capabilities and the level of commitment was too much for Ned. Georgie commented sadly on the ending of the project: 'the joint embroidery scheme proved impracticable and the drawings alone remained as a symbol of loving intentions'. Miss Bell's school went bankrupt and closed in the early 1870s.

Ruskin commissioned from Burne-Jones a set of line drawings to be engraved as illustrations for his book of essays on political economy which was to be published in *Fraser's Magazine*. These

too were single figures from mythology and history – a Ceres, a Proserpine, a Plutus, a Circe, a Helen, a Tisiphone, a Lady Poverty 'and ever so many people more'. Ruskin wanted the essays later to be printed beautifully and made into a book everybody *had* to have. The commission served as a kind of consolation prize.

The rooms in Great Russell Street had a special atmosphere, welcoming and intellectual and homely with Ned dispensing hot toddy, Georgie pouring out the coffee for their gatherings of friends. The poet William Allingham gives the mood of it, writing in his diary for 1864, 'I went off to Ned Jones's, found Mrs. Ned and Pip, and F. Burton; talked of Christianity, Dante, Tennyson and Browning, etc. Enter Miss Hill and another lady, and Val Prinsep.' Miss Hill was Octavia Hill, another young protégée of Ruskin's. The future social reformer was already studying housing management. Little Phil, now growing up and 'chattering like a small magpie', added to the friendly inclusiveness of life in Bloomsbury. An evening routine developed of Ned's brother artists crowding into the studio, gossiping and drinking, while Ned himself continued working on his stained-glass cartoons or tile designs, sometimes joining in the conversation as he worked.

The friends Ned had made at Oxford were still central: the Morrises at Red House; Charley Faulkner and his sisters; Crom Price who returned from his tutorship in Russia to take a teaching post at Haileybury, first stage in a distinguished boys' public school career. Swinburne was constantly arriving at Great Russell Street, sometimes two or three times a day. But the original circle now expanded, becoming more sophisticated and more raffish. Increasingly the Burne-Jones gatherings included Simeon Solomon, one of the artists now designing stained glass for the Firm.

He came from a prosperous Jewish family who lived in Bishopsgate. His father was an importer of Leghorn hats. His brother Abraham and sister Rebecca were prolific artists too. Those who knew him all agreed that Simeon was an oddity. William Rossetti called him 'an unsightly little Israelite', with the thoughtless anti-Semitism of the times. William Blake Richmond, describing this

'fair little Hebrew, a Jew of the Jews', emphasised his extreme touchiness, his pride in his race, his consciousness of his own talent and the trace of mysticism in his outlook. 'He twisted ideas, had a genius for paradox, and when he is in a humorous vein, speaking with assumed seriousness, he convulsed his friends with laughter by his strange, weird imagination.' Georgie had at first had a resistance to Solomon, whom Burne-Jones respected greatly as an artist. When Georgie was told that this was 'the rising genius' she felt a pang of jealousy. But, like many other misfits, the small, intense and nervy, prematurely balding Simeon was taken under Georgie's wing.

The Burne-Jones inner circle was also infiltrated by a group of slightly younger artists, the so-called 'Paris gang' who had studied together in the late 1850s in the atelier of the French classical artist Charles Gleyre. The 'Paris gang' included George Du Maurier, J. M. Whistler, Edward Poynter, Thomas Lamont and Thomas Armstrong. They had all frequented the studio in the Notre-Dame des Champs that provided the setting for Du Maurier's novel *Trilby*, a best-seller when it was published in 1894. In this novel, which was based on his Paris student days, the characters are easily recognised. 'The Laird' is Lamont, 'Joe Sibley, the Idle Apprentice' is Whistler, 'Little Billee' is a close self-portrait of Du Maurier, while Poynter appears as 'Lorrimer, the Industrious Apprentice': 'a painstaking young enthusiast, of precocious culture, who read improving books, and did not share the enthusiasm of the quartier Latin, but spent his evenings at home with Handel, Michael Angelo and Dante, on the respectable side of the river'. Du Maurier makes an unlikeable figure out of Poynter, the dour *'chevalier de la triste figure'*.

Du Maurier had first met Burne-Jones through Val Prinsep. Val too had been in Paris at the time described in *Trilby*. Du Maurier immediately warmed to Ned, describing him as 'simply an angel and what a colourist'. They had the same sharply visual sense of humour. After his marriage Du Maurier and his wife Emma moved into rooms at 46 Great Russell Street, a few doors from Ned and Georgie. On an early visit to Burne-Jones's studio with its 'marvellously coloured paintings' Du Maurier was

delighted by the sense of camaraderie he found there: 'It's so jolly this help-each-other hand-in-glove with brother artist feeling among them. There was Jones with four or five fellows in the studio (Ruskin had just left).'

There were many more parties in Great Russell Street as the 'Paris gang' merged increasingly with the members of 'the clique', as Du Maurier called the Rossetti/Burne-Jones axis, the Pre-Raphaelite faction. Though they fraternised so amiably their attitudes to art and working practice remained distinct, 'the gang' being more academic and traditional, 'the clique' more open-minded and experimental, putting greater emphasis on craftmanship and work in the decorative arts.

The attractions of Great Russell Street were increased by the presence of Georgie's more flirtatious and frivolous younger sisters Agnes and Louie on regular family visits. The Macdonalds were now based in Wolverhampton. Du Maurier reported one particular 'delightful Evening at Burne-Jones's, who's got the jolliest wife and sisters-in-law imaginable'. Evidence suggests that Poynter's Paris career had not been quite so abstemious as it appears in *Trilby*. There are other recollections of evenings of oysters and grisettes. In any case Poynter was now evidently head-over-heels in love with Agnes Macdonald and it would not be long before they were engaged.

Besides the convivial parties at Great Russell Street, Ned made expeditions outwards. These were all-male parties, not totally respectable. On 28 July 1862, for instance, Ned spent the evening in Swinburne's rooms in Newman Street. Also present were Rossetti, Whistler, Val Prinsep and George Boyce. This was the summer when Swinburne acquired his copy of de Sade's *Justine*, which he generously handed round to his friends. He soon also had a copy of Laclos's demoniac novel *Les Liaisons Dangereuses*.

Rossetti, so soon after Lizzie's death, was back at his old habits of pursuing stunners. When Boyce went with him to the International Exhibition they had stopped to buy some ices at 'a stall near the Egyptian things where there was a very lovely girl of whom Gabriel obtained a promise to sit to him'. In 1862 Rossetti had

moved into a large old mansion, Tudor House in Cheyne Walk, where he lived in bohemian splendour, entertaining generously. On 30 April he held a lavish dinner in honour of a new client of his and Burne-Jones's, Mr James Leathart of Newcastle. They dined in the long drawing room which, according to Boyce, another of the guests, had been 'most exquisitely fitted by Gabriel with chintz hangings, pictures, porcelain and old furniture'. Ned was at this and many others of Rossetti's Chelsea dinners which continued riotously long into the night.

Rossetti wrote one of his limericks on Ned:

> There is a painter named Jones,
> (A cheer here, with kisses and groans).
> The course of his life
> Is a pang to the wife
> And a shame to the neighbours of Jones.

This image of the swashbuckling reprobate was something the bashful Burne-Jones found irresistible.

In early days at Great Russell Street Georgie was still intending to continue wood engraving. Just before Du Maurier's marriage she had been enlisted to teach Emma the technique of cutting the wood blocks from which both their husbands' illustrations could be printed. But this had to be abandoned when the inexperienced Emma drove the sharp graving tool into her hand. Georgie herself gradually lost heart about pursuing creative ambitions of her own. She cannot have been encouraged by John Ruskin's comments, 'I can't imagine anything prettier or more wifely than cutting one's husband's drawings on the woodblock. Only never work hard at it. Keep your rooms tidy, and baby happy – and then after that as much woodwork as you've time and liking for.' Georgie gave up. 'I stopped, as so many women do,' she tells us in her memoirs, 'well on this side of tolerable skill'. This was something she grieved about, finding it 'pathetic to think how we women longed to keep pace with the men, and how gladly they kept us by them until their pace quickened and we had to fall behind'.

From now on she became increasingly aware of being left

stranded in the living quarters while Ned and his cronies worked and chatted in the studio. Georgie was feeling her isolation.

This was a time of new opportunity for artists as technical advances in printing encouraged widespread use of wood-engraved illustrations in popular books and magazines. The Pre-Raphaelite artists – Millais, Rossetti, Hunt and others – had all contributed to what amounted to a revolution in making art accessible to the general public. One day Burne-Jones, in his studio, received a visit from the Dalziels, George and his younger brother Edward, whose family firm of wood engravers, known as the Dalziel Brothers, had done much to make this revolution possible. The entrepreneurial Dalziels were the major providers of illustrations for books and magazines in the mid-Victorian period.

Holman Hunt had recommended Burne-Jones to them as an illustrator for the journal *Good Words*, describing him as 'perhaps the most remarkable of all the younger men of the profession for talent', who would soon be filling 'the high position in general public favour which at present he holds in the professional world'. Hunt added: 'He has yet, I think, made but few if any drawings on wood, but he has had much practice in working with the point both with pencil and pen and ink on paper, and so would have no difficulty with the material.'

The visit to Great Russell Street was a success. The Dalziels gave an ecstatic report of 'a room crowded with works of varied kinds, in every sort of method, all showing wonderful power of design, vivid imagination, and richness of colour.' Burne-Jones had worked his charm and the Dalziels were so fascinated with the man and his art that they immediately commissioned a water-colour from him. Hearing he had recently painted a 'harmony in blue' painting for Ruskin, they settled for a 'harmony in red', the *Annunciation* watercolour which of all Burne-Jones's paintings stands as his most heartfelt homage to Fra Filippino Lippi and Fra Angelico. The Dalziels also commissioned an Italianate triptych of the Nativity, the gold-framed gouache painting that now hangs in the chapel of Lady Margaret Hall in Oxford.

Burne-Jones provided two illustrations for Alexander Strahan's publication *Good Words*. These were *Summer Snow* and *King Sigurd*, both accompanying verses on those subjects. He was also involved in the Dalziels' grandiose plans for an illustrated Bible, making drawings of *Ezekiel and the Burning Pot*, *The Eve of the Deluge*, *The Return of the Dove to the Ark*, *Christ in the Garden* and a set of small watercolour drawings of the days of creation. Only the Ezekiel drawing was used when the Bible was finally published in 1880, by which time Burne-Jones had become ashamed of his involvement. He entreated the Dalziels to withdraw the illustration, offering to substitute a new one free of charge. But he was too late. He had to live with it 'like an old sin'.

Why did Burne-Jones's relations with the Dalziels never flourish? Partly because his ideas were too perfectionist. His ideal remained the woodcuts of Albrecht Dürer carried out in sixteenth-century Germany in Dürer's own workshops under his personal direction. Burne-Jones admired the work of the more contemporary German wood engravers Ludwig Richter and Alfred Rethel, especially Rethel's *Another Dance of Death*. Engraving was a complex and demanding art. As Burne-Jones saw it, 'in engraving every faculty is needed – simplicity, the hardest of all things to learn – restraint in leaving out every idea that is not wanted (and perhaps forty come where five are wanted) – perfect outline, as correct as can be without effort, and, still more essentially, neat – and a due amount of quaintness'. The commercial practice of engraving in Britain had led to these ideals being impossibly debased.

It was the personal factor that was lacking. The relationship between the artist and the craftsman responsible for cutting the block from which the drawing would be printed was eroded in a large-scale, high-speed operation such as the Dalziels' in which several engravers might be working simultaneously on a single block. Commercial book production meant a division of labour that Burne-Jones and William Morris, in their own printing endeavours, would forever fight against.

In 1864 Burne-Jones was elected an associate member of the Old

Water-Colour Society. This had been at Ruskin's instigation. In writing to congratulate Burne-Jones on his election, Ruskin's father had mentioned that 'latterly there appears to be very great difficulty in obtaining admission into this Society'. On this his second attempt Burne-Jones and George Boyce were in with good majorities; Simeon Solomon failed to be elected. The Old Water-Colour Society, later the Royal Watercolour Society, was the second-oldest society of artists in Britain and the most prestigious after the Royal Academy. Its premises in Pall Mall gave Burne-Jones a regular public exhibition venue for his paintings, something he had never had before. Indeed, he had pleaded with George Dalziel to allow him to keep *The Annunciation* in his studio while Dalziel was abroad so that he could show it to prospective clients. Membership of the OWS gave him a level of exposure that was to help greatly in the development of his career.

The membership of the Society was biased towards traditional landscape and still-life painting, and Burne-Jones's initial reception was dispiriting. Edward Duncan, for instance, an artist specialising in sheep, ships and storms, refused to shake his hand and would never speak to him. The anti-Pre-Raphaelite faction on the hanging committee for the 1864 summer exhibition seems to have victimised both Boyce and Burne-Jones. Boyce's diary entry on the hanging reads, 'Disgusted at finding all my drawings in bad places. On the floor, one against the ceiling and 4 below the line.' Burne-Jones was dismayed to find one of his pictures, *The Merciful Knight*, displayed high up out of sight above the four main tiers of members' works in what the OWS stalwarts called 'the naughty boys' corner'. On arriving at the gallery on touching-up day he was aware of several members making disapproving murmurs. He identified 'one ugly big brute' standing at the centre of the group, arguing that the painting was so despicable it should not be allowed to stay on show. They questioned why he had ever been elected. Burne-Jones was aware that a core of fellow members had always been antagonistic to his work.

In that year's exhibition there were four works by Burne-Jones: *Fair Rosamond; Cinderella*, his watercolour version of the girl with

the glass slipper; *The Annunciation* painted for the Dalziels; and, largest and most controversial, *The Merciful Knight*, a watercolour showing the miraculous scene of Christ on the Cross stretching out to embrace a devout Florentine knight, St John Gualbert. Except for a loincloth, the figure of Christ is naked. The handsome, heroically charitable knight is encased in shining armour. The scene has the peculiar immediacy, the urgent realism, of earlier Pre-Raphaelite painting. The marigolds beneath the shrine in the forefront of the picture were painted from the marigolds growing in the garden in Russell Square near Ned and Georgie's rooms.

There was almost concerted disapproval from the critics. Burne-Jones's work attracted the level of opprobrium that had descended on Millais and Holman Hunt when they exhibited at the Royal Academy a decade earlier. The *Art Journal* described *The Annunciation* as 'a bedstead set above a garden, at which the Virgin kneels in her night-dress. The angel Gabriel in his flight appears to have been caught in an apple-tree; however, he manages to look in at a kind of trap-door opening to tell his errand.'

From the same source there was worse derision for *The Merciful Knight*, who 'seems to shake in his clattering armour'. To this critic, 'such ultra manifestations of mediaevalism, however well meant, must tend inevitably, though of course unconsciously, to bring ridicule upon truths which we all desire to hold in veneration'. It was only much later that this forceful, mystic painting began to be seen as an important turning point from Burne-Jones's tentative beginnings towards the paintings of his full maturity.

The convivial visits to Red House continued as the house itself matured, lost its initial startling rawness. The garden grew gradually more colourful, romantic, medieval in style with its geometry of lawns and wattle-fenced enclosures or *plaisances* set within the orchard. There was now a sweet-scented profusion of climbing roses, white jasmine and passion flowers trained up against the brick walls of the house.

It was Burne-Jones's *Green Summer* scene but more so. The visits to Red House were now gatherings of families. The Morrises'

second daughter May was born in 1862. Georgie's sister Louie recollected seeing her there as a baby of six weeks. Philip Burne-Jones was soon integrated into the household. In May 1864 Georgie wrote from Red House to William Allingham, 'We have been down here about a week, and are enjoying it so much, with our friends and the country. Phil is with us, and he shares the nursery of the Misses Morris, two beautiful children by this time.' A poignant memory of Red House at this period is of Swinburne lying on the grass in the orchard, his red hair spread out around him, while the little Morris daughters scattered rose-leaves over his laughing face.

The idea of sharing houses had been a recurrent one within the Burne-Jones circles, as it was to be again with young radicals in the Britain of the 1970s. It was part of an ideal of the remaking of society, of forming more fluid patterns of existence in the face of bourgeois familial conventions. Burne-Jones and Morris were already closely working partners. Morris was becoming weary of the daily commuting to the Firm's workshops in London. A plan evolved for the Burne-Jones family to join the Morrises at Upton, where Morris would build new workshops and Red House would be extended with a whole new wing, completing the full quadrangle. According to Ned, Philip Webb 'made a design for it so beautiful that life seemed to have no more in it to desire – but when the estimates came out it was clear that enthusiasm had outrun our wisdom and modifications had sadly to be made'.

Webb's plans for the Red House extension, now in the Victoria and Albert Museum, show how the intention was to give the Burne-Jones family a separate entrance and their own spacious living rooms. The garden and orchard would be spaces that they shared. The extension was not an imitation of Red House but a variant, distinguished by the timber-frame detailing and mixing of materials – brick, stone and tile – towards which Webb's architecture of that period was moving. The Burne-Jones extension would have had its own identity, connected to Red House but visually distinct.

Even as modified, the plan for joint living at Upton was a splendid one. Burne-Jones and Morris saw it as their personal version

of the 'lordly pleasure house' envisioned in Tennyson's 'The Palace of Art', a place of high ambitions and psychological expansiveness:

> Full of great rooms and small the palace stood,
> All various, each a perfect whole
> From living Nature, fit for every mood
> And change of my still soul.

They planned to build in the spring of 1865. Meanwhile, 'in order to lose no chance of being together', Ned, Georgie and Phil took an early autumn holiday at Littlehampton with the Morris and Faulkner families. They spent three contented weeks in what was then a relatively secluded seaside resort in West Sussex exploring the countryside and playing the statutory practical jokes on William Morris while maternal Mrs Faulkner attended to the housekeeping.

The evenings, as Georgie remembered them, were merry with old Red House teasings 'revived and amplified'. One of these consisted of the doctoring of cards for the nightly game of whist so that Morris at first seemed to hold the winning cards but gradually realised the others always trumped him. 'First came irritation and astonishment, then, as the well-laid scheme revealed itself, shoutings and fury – and finally laughter such as few could equal.' The sounds of the distant explosion reached Georgie and Janey, upstairs in their beds.

By the time of the Littlehampton holiday Georgie was pregnant again. Old Mr Jones, who had travelled down from Birmingham to join them, helped entertain Phil, playing with his grandson on sands that stretched right up to the edge of a green common. Littlehampton at that period still had no esplanade. Ned would stroll down, in a mood of unaccustomed idleness, to find them building sand banks and sitting on top of them triumphantly until the sea came in to break them down.

One of their walks took them to the ancient little church nearby at Climping, as yet mercifully unrestored, its worm-eaten pews festooned with spiders' webs and the stone floor green with mildew.

They wandered through the graveyard and sighed sentimentally over the inscription on the tiny gravestone of a girl who had died in the mid-eighteenth century aged eleven years, eleven months:

This little lamb that was so small
Did taste of death when Christ did call.

The happy holiday ended in a series of disasters. As soon as they got back to Great Russell Street, Phil developed scarlet fever. To start with the illness appeared mild. Ned's cousin Annie Catherwood was brought in to sit with and amuse the little invalid and then, with what Georgie was later to describe as 'incredible rashness', they asked Mrs Wheeler, the nurse they expected for the birth of Georgie's new baby in December, to come in and help look after Phil. Ned and Georgie then went off to stay at Red House. Georgie herself succumbed to scarlet fever just after they returned.

In the late afternoon of 28 October 1864 she gave premature birth to a second son. The tragic sequence of events is recorded in her mother Hannah Macdonald's diary. On 2 November it was confirmed that the baby too had scarlet fever. On 5 November Hannah received a telegram from Ned asking her to come urgently from Wolverhampton where her husband too was ill and bedridden. She arrived to find the family at Great Russell Street in 'a distressing state'. By 8 November Georgie was so ill that Dr Radcliffe had to be sent for in the night. The next day Mrs Macdonald herself fell ill with spasms and sickness continuing all night.

Through much of this time Georgie was delirious. Ned was grateful for the support of his bachelor friends who were relatively unafraid of spreading the infection. Edward Poynter and William De Morgan sat up with him through one especially nerve-racking night. In an imaginative gesture of sympathy Ruskin had the road outside the house 'laid as deep as a riding school with oak bark to prevent the clattering of horses hooves from reaching her'. Georgie was too ill to be able to feed or pay attention to her baby son.

On 19 November Georgie's mother returned home to her own household of invalids. Georgie herself now seemed a little better,

whereas George Macdonald had been becoming weaker and her daughter Alice was in bed with a cold too. A few days later Hannah came back from doing her shopping in the Wolverhampton market to find the news from Georgie that her baby had died during the night of 21 November. Georgie would remember with anguish how 'the babe I lost went from me before I was clear enough from the delirium of fever to realise anything'.

The child was just three weeks and three days old. It was Ned who decided to call him Christopher: he had borne such a heavy burden in crossing through 'the troubled waters of his short life'. Christopher Alvin Jones was buried a week after his death in Brompton Cemetery. Burne-Jones's friends were shocked and sympathetic, particularly Swinburne, who loved children and told Georgie, 'The news has struck half my pleasure in anything away for the present – I had been quite counting on the life of your poor little child and wondering when I might see it.' The bitter disappointment of the loss of her 'little shadowy babe' never quite left Georgie, even in her middle age: 'as every year comes round', she told a friend in 1892, 'I keep its birthday and death day, and a shadowy son of seven and twenty sometimes exists a moment for me'.

Phil had now recovered from his illness. Georgie gradually gathered strength and she and Ned went to Hastings for her to recuperate. 'I am *so* glad I did not die,' she told John Ruskin. But the death of Christopher brought with it other endings, most immediately the cancellation of the plans to move to Upton. The reason Ned gave was the simple lack of money after such a heavy period of medical expenditure at a time when he was too preoccupied to work. But no doubt there was more to it. At such a time of grief Burne-Jones had become more centred in on his own family. He may well have felt pressure to concentrate on the further advancement of his own career independently of the operation of the Firm. Further reflection on the Red House scheme perhaps persuaded him he could not but appear the unequal partner in it. There was always a hint of class resentment in his attitude to Morris, and these were 'the Towers of Topsy' after all.

Morris responded with his usual generosity, writing back:

As to our Palace of Art, I confess your letter was a blow to me at first, in short I cried; but I have got over it now. As to our being a miserable lot, old chap, speaking for myself I don't know, I refuse to make myself really unhappy for anything short of the loss of friends one can't do without. Suppose in all those troubles you had given us the slip what the devil should I have done?

Once the plan for the Burne-Jones extension was abandoned, Morris himself decided to move back to central London and Red House was sold in September 1865.

Another scheme to be cancelled in that year of the disasters was Burne-Jones's intention to return to Italy. After the success of the 1862 visit to Venice and Milan, Ruskin had proposed to take his 'children' on a study tour of Florence. When the death of his father in March 1864 made it impossible for him to go with them he suggested they should travel on their own, Ruskin as usual bearing the expense. Burne-Jones had longed for Florence, desperate to return to his ideal Italian city. But events of autumn 1864 made the plan unworkable.

A pall hung over the rooms in Great Russell Street. Ned forbade Georgie ever again to enter the bedroom where she had lain so dangerously ill, hallucinating and delirious. With Crom Price doggedly in attendance he set about finding them somewhere else to live. Once Georgie returned from Hastings he sent her to spend that Christmas with her parents and sisters. She came back to find the family installed in a new house in Kensington.

Kensington Square
1865–7

In early 1865 Ned and Georgie were installed at 41 Kensington Square, bringing with them the painted furniture, the books, the set of photographs of Memling's *St Ursula and her eleven thousand Virgins* that Ned had bought in a burst of wild extravagance and that had been the chief glory of the sitting room in Great Russell Street. In what was a kind of inter-brotherly house swap, Edward Poynter had moved into their old rooms in Bloomsbury while the Burne-Jones family went west. He was still pursuing Georgie's sister, the 'tyrannously beautiful' Agnes, and that April they were formally engaged.

Kensington Square was by no means unknown territory. Ned and Georgie had explored the area before back in 1858 when the Burne-Joneses, Ford Madox Brown and Arthur Hughes were hoping to find a house they could all live in with their families, forming an artistic community. They had seriously investigated Cedar House, a rambling twenty-room mansion with a large garden close to Kensington Square. But, like the sharing of Red House, this scheme had fallen through.

The house the Burne-Joneses eventually moved into was more self-contained, more modest, on the north side – the Holland Park side – of the square. Kensington Square was an unusual concept for the seventeenth century: a residential square on the edge of what was then a small village. Number 41, a brick-built four-storey house with an attic and a basement, had been rebuilt in 1804–5. Its

setting was still rural, with nothing except gardens between the square and the narrow high road leading westward out of London. Compared with Holborn, the area felt rarefied and quiet.

The Burne-Joneses were now living on the fringes of an area at that point just becoming London's main artistic centre. Holland Park was the district where the leading Victorian painters and sculptors built their studio houses in a near-palatial style. Already Ned's close associate Val Prinsep and the classicist painter Frederic Leighton, future President of the Royal Academy, with whom Ned's relationship was more equivocal, were building close by in Holland Park Road. Little Holland House, the scene of Burne-Jones's summer of luxury in 1858, was just a stroll away from Kensington Square. Georgie steeled herself to call on Mrs Dalrymple and in April Phil was taken there on his first visit. The small boy was plied with tea and bread and honey at a little table specially set out in the middle of the drawing room. Then G. F. Watts carried Pip off to his studio.

The house had two bedrooms and also a large upper room divided into two, 'nice rooms all', Ned reported euphorically to Allingham a few weeks after they arrived. This large upper room was earmarked for his studio. In fact Burne-Jones's double studio was not ideal as the north-facing section, where the light was best for painting, was long, narrow and cramped. A dismal curtain dividing one section from the other caused Agnes to suspect the room had previously been used for an invalid. The studio facing on the square was, by contrast, 'delightfully large', and was soon piled with pictures and screens and 'heaps of things'. The drawing room was papered with a Morris wallpaper and Ned told Allingham that their dear fat friend 'Topsy, who broadens hourly, has given us a Persian prayer carpet which amply furnishes our room'. Ned's account book with Morris, Marshall, Faulkner & Co. shows the purchase of six black ebonised rush-seated chairs, set against his earnings. And then with munificent generosity Ruskin presented him with 'the four great engravings of Albert Dürer' – *The Knight, Melancholy, St Hubert* and *Adam and Eve*. These were perfect impressions and so evidently valuable that Ned suddenly

felt himself a person of means, confident enough to 'saunter in Rotten Row'.

The house had its own long garden, good for playing bowls, and Ned had a plan for pitching a little pavilion on the lawn. He saw himself lying in the shade of it on warm summer days drinking *broglio* to remind him of Siena. The Burne-Joneses also had use of the square garden in common with the other Kensington Square neighbours. He and William Allingham were there on one June evening. 'Enter Mr. John Simon (from next door) and his niece. Mr S. a kind bright pleasant man and good, as well as an eminent surgeon, boyishly merry at times. He and his niece run a race to the house, then he jumps on the low wall and lies flat on it as if exhausted.' This exuberant next-door neighbour was the future Sir John Simon, leading light of public health reform.

The great event of those first few months in Kensington was the marriage of Georgie's elder sister Alice to John Lockwood Kipling. Alice was the most volatile and headstrong of the sisters. There was a story in the family that she had baked a mouse in a pie and dared a friend to eat it. Alice had been engaged at least twice before. One of her ex-fiancés was Ned's friend William Allingham. In 1863, through her Methodist minister brother Frederic, she had met the young artist John Lockwood Kipling, a serious young man, soothing in personality, himself the son of a Methodist minister. Kipling was then working for the Department of Science and Arts in South Kensington. After their marriage he and Alice would be en route for India. Kipling now had a new appointment as a teacher of architectural sculpture and modelling at the government art school in Bombay.

It had been decided to hold the wedding in London so as not to put a burden on the parents of the bride. George Macdonald, up in Wolverhampton, was no better, his famous Nonconformist fervour having dwindled into the inertia of the perpetual invalid. Alice and her sister Agnes came to stay in Kensington Square for the week before the wedding, helping Georgie with preparations and being much amused by an increasingly vocal and precocious Phil, 'a loving little thing' who called his aunts 'sweet little dears'.

Agnes marvelled that when he went too far and his parents threat-ened to whip him he would turn on them calmly, saying 'How cruel of you.'

Two days before the wedding Georgie went out to Knights-bridge to buy herself a bonnet. The happy pair were married by the bride's brother Frederic at St Mary Abbott's Church in Kensing-ton on 18 March, a freezing morning, and many of Ned and Georgie's friends were at the reception afterwards in Kensington Square. The newly married couple stayed on in England until 12 April, making an early start that morning to catch the SS *Ripon* sailing via Egypt to Bombay.

'Our dear ones have already left us,' wrote Agnes. There were particular family anxieties about Alice and her husband's departure for Bombay since Wilfred Heeley's young wife had died recently in India of cholera. Alice was indeed to have her share of health problems. But professionally and socially the move was a success. John Lockwood's career prospered, and on 30 December 1865 they had their first child, the boy who was named Rudyard after Lake Rudyard in Staffordshire, hallowed place where his parents had first met.

1865 was a great summer for parties, Pre-Raphaelite parties, resplendent but informal, held in the studio houses of the clique. On the evening of the Kiplings' departure for India Ned and Georgie attended a large party in Chelsea given by Rossetti. Originally he had planned it as a dinner, but he had asked so many people that it turned into an evening party with dozens of his artist friends thronging through the drawing room and studio at Tudor House in Cheyne Walk. Georgie's sister Agnes was wide-eyed at the scene: 'Just fancy large panelled rooms, narrow tall corridors with seats, a large garden at the back, at the front a paved courtyard with tall thin gates, then the narrow road and lastly the Thames in a flood of moonlight.'

William Morris and Janey had arrived with the Burne-Joneses. Georgie in her memoirs gives a list of other guests that provides a useful insight into the semi-bohemian mid-Victorian art world

then emerging in contrast to the more formal, lavish artists' life-style of Holland Park. At Cheyne Walk that night was William Rossetti, Gabriel's brother; William Bell Scott; Arthur Hughes and his wife; Alexander Munro the sculptor; Alphonse Legros the etcher, so recently arrived from France that his English was execrable, with his 'pale handsome English wife'. Swinburne was at the party, having had no need to travel, since he was now a resident at Cheyne Walk, in a bizarre new ménage with Rossetti. Ford Madox Brown, his wife and their two daughters arrived conspicuously late. They had taken two and a half hours to reach Chelsea, having travelled by train via Kew and Clapham Junction in order to save the cab fare from Kentish Town. Emma Brown, flush-faced and excitable, no doubt – as so often – a bit inebriated, spilt a cup of coffee down Georgie's blue silk dress.

There were notable absentees from Rossetti's party. One was his sister Christina, too religious to attend a party during Passion Week. The other of course was Lizzie. He had hung a number of her pen-and-ink sketches and watercolour paintings round the walls of the long river-facing drawing room 'where if ever a ghost returned to earth hers must have come to seek him', Georgie wrote.

A little later in the summer there was a reprise. More or less the same guests reassembled for a party given by the Browns at Fortress Terrace. This time there was supper during which Ford Madox Brown, who had placed Legros beside him, gave an apparently interminable version of the bloodthirsty story of Sidonia in French. Of the 'Paris gang' the artist James McNeil Whistler was also at the supper. Though born in Massachusetts, Whistler struck Georgie as looking 'ten times more like a Frenchman than Legros did, his face working with vivacity, his thick black hair curling down to his eye-brows, with an angry eye-glass fixed beneath it'. But Whistler's rather frightening appearance was balanced by reports of his loving behaviour to his widowed mother, accompanying her to church on weekday mornings. In the future, due to his famous painting *Arrangement in Black and Grey: Portrait of the Painter's Mother*, Whistler's mother became a species of celebrity.

The evening at Fortress Terrace was another gathering of way-ward glamour. Rossetti was there in 'a magnificent mood' accord-ing to Georgie, who tells us that no other word described his progress through the room in Kentish Town 'bringing pleasure to great and small by his beautiful urbanity, a prince among men'. Was Rossetti overdoing the magnificence? Morris and Janey were also at the party, accompanied by Janey's sister Bessie Burden. By this time there was a noticeable frisson of intimacy between Rossetti and William Morris's wife, a development that Ned and Georgie watched with agonised anxiety.

Another unmissable person at the party was Charles Augustus Howell, the mystery man of Pre-Raphaelite London, a swarthy handsome charmer who acted as an artists' agent and a dealer. Howell had been born in Oporto in Portugal. His father was an English-born drawing master and a wine merchant, his mother apparently a Portuguese aristocrat from whose high-born family Howell claimed to have inherited the historic religious decoration of the red ribbon of Christ he liked to flaunt. No one knew what to believe about his background. Rossetti summed him up in a limerick as

> A Portuguese person called Howell,
> Who lays on his lies with a trowel.

He had been abroad for the past seven years in a long exile from England possibly connected with Italian revolutionary conspiracy. At the time of the Browns' party he had only recently returned. Had he been serving as an attaché at the Portuguese embassy in Rome? Had he been diving for treasure off the coast of Portugal? Had he become a sheikh of an Arab tribe in Morocco? Rumours abounded. As Whistler observed, 'He had the gift of intimacy . . . it was easier to get involved with Howell than to get rid of him.' By the end of 1865 Howell had installed himself, recommended by Burne-Jones, as Ruskin's secretary and amanuensis and he would batten onto Burne-Jones too.

Georgie describes Howell bitterly as 'one who had come amongst us in friend's clothing, but inwardly he was a stranger to all that

our life meant'. In a way the Madox Brown party was a turning point, the start of a new period of treachery and blatancy, presaging the end of Ned and Georgie's innocence.

They paid a final visit to Red House in September, shortly before the Morrises departed. The two families took a last nostalgic drive around the countryside revisiting the little out-of-the-way places that William Morris loved. Indoors the conversation was centred on Burne-Jones's and Morris's giant new joint project: the plan to

William Morris doing cartwheels in Cavendish Square. Burne-Jones's long sequence of cartoons of Morris focus on his shock of curly hair and ever expanding girth.

180

bring out Morris's long narrative poem *The Earthly Paradise* in a folio edition illustrated with two or three hundred woodcuts made from drawings by Burne-Jones.

This was the work in progress Morris called his 'Big Story Book'. *The Earthly Paradise* was his major literary occupation from 1865 to 1870. The poem was Chaucerian in concept, a sequence of tales drawn from classical, Norse and medieval literature linked by a more personal poetic narrative. *The Earthly Paradise* proved enormously popular with its Victorian readers but was more of a trial to Morris's friends since he read it out loud at every stage of its gestation. Even the devoted Georgie sometimes had to bite her fingers or prick herself with pins to keep herself awake.

The first story in the sequence to be illustrated was 'Cupid and Psyche', taken from the version in Apuleius's *Golden Ass*. It was

Edward Burne-Jones enduring the longueurs of William Morris's
'Big Story Book'.

another quest tale, romantic and erotic, in which the protagonist was a headstrong woman. Burne-Jones began the work with great enthusiasm. His sketchbooks show his method of developing each image in several stages, from initial idea to more finished composition. Burne-Jones's final 'Cupid and Psyche' drawings, made in pencil on tracing paper, were rightly described by Sydney Cockerell as 'wonderfully delicate things'. Delicate but by no means complicated. Burne-Jones had always hated what he called 'scribbly work'. He was enraged beyond endurance by drawings that had 'wild work in all the corners, stupid senseless rot that takes an artist half a minute to sketch and an engraver half a week to engrave'. The style he arrived at was linear and graphic, closer to early woodcuts than to contemporary Victorian wood engravings. His models were the woodcuts in Francesco Colonna's late fifteenth-century Venetian *Hypnerotomachia Poliphili* of which William Morris possessed a fine copy. Burne-Jones made at least seventy designs for 'Cupid and Psyche' in 1865.

The cutting of the blocks was originally delegated to Swain, a trade engraver, a rival to the Dalziel Brothers. But this did not work out and soon the cutting of the blocks was being done, as usual with Morris, in-house and *en famille*, some by George Campfield, foreman of the stained-glass painters at the Firm, two by George Wardle, the firm's second manager, one by Charley Faulkner and others by his sister, another by Janey's sister Bessie Burden. Louisa Macdonald, whose early aptitude for wood engraving Burne-Jones had encouraged, had withdrawn from what would have been a key role in the project when she became engaged to Alfred Baldwin, from a prosperous Worcestershire manufacturing family. In the end William Morris, by no means unwillingly, took over responsibility for cutting the woodblocks himself, completing thirty-five out of a total forty-five or so blocks made to illustrate the poem. One of Burne-Jones's most tenderly affectionate caricatures of Morris shows him working at a woodblock bent over at his table, deep in concentration.

The big illustrated version of 'Cupid and Psyche' never saw the light of day. Trial pages set up at the Chiswick Press were judged

unsatisfactory. But Burne-Jones himself did not abandon a subject on which he had already expended so much effort, a theme that suited him so well in its lovely combination of classical myth and medieval fairy tale. As an artist Burne-Jones was a habitual recycler. Maybe this was a result of his parsimonious upbringing with Miss Sampson's admonitions of 'Waste not want not' ringing in his ears. Burne-Jones had his favourite high points of the story – Cupid finding the sleeping Psyche; Psyche being hauled before a furious Venus; Psyche gazing enraptured on Cupid in his bed; a distraught Psyche being rowed across the Styx; Psyche being rescued by the winged figure of Cupid; Psyche entering the portals of Olympus. All these subjects and others were reworked and reappeared in the form of watercolours, oil paintings and decorative murals. You might say that 'Cupid and Psyche' was to occupy Burne-Jones for all his working life.

Burne-Jones's contribution to the work of the Firm became more vital after Morris moved to 40 Queen Square, Holborn in the winter of 1865. The large house, very close to Ned and Georgie's old lodgings in Great Russell Street, had space for ground-floor offices and showroom. The old ballroom was turned into workshops, with additional workshops in a courtyard at the rear. The Morris family lived above the business premises. Charley Faulkner gave up his close involvement in the Firm, returning to academic life in Oxford. A new, young and optimistic manager, George Warington Taylor, was appointed and he attempted to bring the up to now haphazardly organised Firm into a new era of efficiency and profitability. The partners must be more productive: 'Morris and Ned will do no work except by driving,' he lamented to Rossetti. He was determined to make the most of the Firm's most promising area of expansion: stained glass.

The number of stained-glass commissions had been rising steadily from five in 1861, fifteen in 1862, sixteen in 1863 and 1864. Morris, Marshall, Faulkner & Co. had appeared prominently in the 1864 exhibition of contemporary British stained glass at the South Kensington Museum (later renamed the Victoria and

Albert), and aimed to 'elevate public taste in the appreciation' of the medium. They showed nineteen examples, six of which were bought for the museum collections. Perhaps as a result, the Firm's commissions rose to twenty-three in 1865. By the following year sales of stained glass amounted to £2,300 of the Firm's total sales of £3,000 and Warington Taylor was tempted to put an end to the other less profitable activities.

Why was Morris glass so remarkably successful? First, because it was artistically so distinctive and inventive, fusing as it did the romantic medieval and naturalistic Pre-Raphaelite styles. Second, because Burne-Jones's special qualities as a designer of stained glass were becoming evident. As a draughtsman he had now become enormously proficient. He could draw as if almost on automatic pilot. Philip Webb was to comment, 'He was wonderfully swift and confident. I have seen him draw quite a big cartoon for glass in the evening after dinner.' Burne-Jones's great élan, his sure sense of composition, is already clear in his best windows of the middle 1860s: his superb dramatic windows for St Michael and All Angels at Lyndhurst showing *Joshua staying the Sun and Moon* and *Elijah and the Priests of Baal*, a master stained-glass artist's composition of downward-moving spears and upturned priestly hands; his beautiful and poignant depiction of St Mary Magdalene for the church of St Ladoca at Ladock in Cornwall, showing her kneeling to anoint the feet of Christ in swathes of swirling art nouveauish hair.

Though other artists were still designing stained glass for the Firm, none had nearly so close a relationship with Morris. He and Ned were now so accustomed to working together that they used a kind of shorthand to communicate. For stained glass this was an ideal balance of the opposites: Burne-Jones so skilled in composition, the disposal of the figures; William Morris with his instinct for colour and for pattern. It was a formidable combination. Burne-Jones realised how indispensable he was and around this time he began the bitter grumbles in his account book about his level of remuneration. For instance, he entered in 1865, 'A very beautiful series of Angels & Saints for a Crucifixion absurdly cheap at £10.10s.' This was partly a joke, but partly not.

Burne-Jones's skills and talents would also prove essential to the increasingly large-scale and demanding interior decoration schemes the Firm now undertook as the ideas underlying the design of Red House began to be developed in a much more public sphere. Late in 1865, apparently at Rossetti's instigation, the South Kensington Museum asked Morris, Marshall, Faulkner & Co. to prepare designs and estimates for the Western Refreshment Room, soon to be known as the Green Dining Room. This was one of a new complex of three public refreshment rooms at the museum: the Renaissance-style Gamble Room being designed by the museum's own designers and the Grill Room or Dutch Kitchen commissioned from Burne-Jones's future brother-in-law Edward Poynter. In 1860s London, art and design was a remarkably small world.

The Firm's scheme for the Green Dining Room takes the form of decorative layering, colour upon colour, pattern upon pattern: first green-stained oak panelling, next a little series of ornate painted panels of the twelve figures of the Zodiac alternating with panels of foliage and fruit; then, high up towards the ceiling, a quasi-medieval decorative frieze of dogs chasing hares. This division of the wall surface into three areas – dado, filling and then frieze – would be adopted as the norm for middle-class 'artistic' houses of the 1870s and 1880s. The lovely ceiling pattern of golden-yellow leaves had been pricked directly into the wet plaster in the medieval manner as the patterns had been pricked with so many bursts of merriment on William Morris's own ceilings at Red House.

The overall design for the Green Dining Room was Philip Webb's. But Burne-Jones was responsible for the glowing painted panels of the Zodiac figures with attendant sun and moon and also for four stained-glass panels in the window showing *The Garland Weavers*, maidens in long white dresses gathering flowers from walled gardens and paved courtyards. These works are important to the success of the commission as a whole, contributing to the Green Dining Room's theatrical feeling of other-worldliness, the sense it gave its customers of entering into a mysterious green bower or a hidden chamber in an enchanted palace as described in one of William Morris's poetic narratives.

The Green Dining Room became a favourite meeting place for artists. The 'Paris gang' painters – Du Maurier, Poynter, Whistler, Lamont and Thomas Armstrong, a future Director of the South Kensington Museum – would gather there, treating the Green Dining Room as the equivalent of their old Paris haunts of the Progrès and Gréliches. By the 1880s it had entered the guide-books. Moncure Conway in his *Travels in South Kensington* remarks that one may dine at the museum 'amid one of the pleasantest little picture galleries in existence'. In the twenty-first century this is indeed still true.

Burne-Jones showed five paintings at the Old Water-Colour Society's summer exhibition in 1865. The *Art Journal* critic was especially caustic: 'there can, at all events, be little doubt that upon him has fallen to an eminent degree the common lot of being loved by the initiate few and laughed at by the profligate many. The fate which has come upon this artist, we are bound to say, he heartily deserves.' However, among the discriminating few who had viewed Burne-Jones's work in that summer's exhibition were Frederick Leyland and William Graham, whose patronage over the next few years put Burne-Jones's career onto a new footing.

Both were men of taste and means but they differed greatly in their approach to life and art. Leyland, who was only two years older than Burne-Jones, was a Liverpool shipowner, a self-made man ambitious and dynamic in his business ventures. His trans-atlantic steamship company, the Leyland Line, was operating twenty-five vessels by 1882. Leyland bought art like a Renaissance prince, as the expression of his opulence and the ratification of his status in the world. He collected Italian paintings, especially Botti-celli, but he was also avid in acquiring the work of his contemporary artists, becoming a major patron of Rossetti and of Whistler, who carried out the decoration of the controversial Peacock Dining Room in Leyland's house in Princes Gate in Kensington.

Leyland dreamed of 'living the life of an old Venetian merchant in modern London'. The particular Burne-Jones paintings he acquired were part of this romantic materialistic dream. They

were the paintings of most obvious dramatic interest and splendour. Ruskin might have been partially successful in expunging the Gothic horror element in Burne-Jones's painting: Ned was now becoming adept at Ruskinian statuesque. But he had also kept his love of the sensational storyline and this was the aspect of his work that Leyland went for. An early acquisition, *The Wine of Circe*, shows another of Burne-Jones's frightening enchantresses, one of his 'pet witches', with, at her feet, two sleek and beautiful black panthers shape-changed from her male admirers by her magic powers. When he bought the painting from the Old Water-Colour Society exhibition Leyland paid £100 beyond the asking price. This was his way.

Leyland's loyalty to Burne-Jones was of enormous help to him. His patron was willing to pay up front for paintings that, because of Burne-Jones's slow rate of productivity, took years to be completed. Over the years Leyland was to acquire *Phyllis and Demophoön, The Mirror of Venus, The Beguiling of Merlin*, all his works of greatest showiness. He and Burne-Jones were sociable together. Leyland's daughter Florence was to marry Ned's close old friend Val Prinsep. But there seems to have been no real warmth between Burne-Jones and the unattractively calculating Leyland, a bully and a womaniser, who was said to be 'hated thoroughly by a very large circle of acquaintance'.

William Graham was quite another matter. Graham was originally a Glaswegian, senior partner in his family's successful import business. He and Burne-Jones were of different generations. They first met in 1865, the year in which Graham bought *Le Chant d'Amour* from the Old Water-Colour Society exhibition, when Graham was forty-eight and Ned was fifteen years younger. Although shrewd in business, Graham was a gentle, endearing, rather quirky character who had recently been elected Liberal MP for the city of Glasgow. In Parliament he spoke mainly on Scottish and religious topics. He was a devout Presbyterian who assembled his large family and servants every day for morning service in his London house, usually including an extempore prayer of his own.

'His face was that of a saint,' wrote Georgie, 'and at times like one transfigured. He had an inborn perception about painting, and an instinct for old pictures that was marvellous. His eye was so keen that Edward said he knew good work even when it was upside down.' He was a wide-ranging enthusiast, buying fine examples of primitive Italian art as well as acquiring many major works by the Pre-Raphaelites.

William Graham formed one of the great Victorian collections and was to be appointed a Trustee of the National Gallery by his friend William Gladstone when he was Prime Minister. But there was a wonderful lack of pomposity in his attitude to art. His daughter Frances remembered how 'he bought pictures so largely, that our house in Grosvenor Place was literally lined with them in every room from floor to ceiling; old and modern, sacred and profane; they stood in heaps on the floor and on the chairs and tables'. Once when Burne-Jones showed him a painting that especially delighted him he went up and kissed it, as if it was an icon. But although so religious, Graham was not prudish. When Burne-Jones first knew him he thought it wise to keep hidden any pictures containing nude figures. But he soon discovered Graham liked those best of all.

In contrast to the grand dramatic works commissioned by Leyland, the paintings that Graham apparently preferred were the mood paintings influenced by Giorgione, sumptuous in colour, enigmatic in atmosphere. As well as *Le Chant d'Amour*, Graham acquired Burne-Jones's *Laus Veneris*. He was also involved for many years in the slow gestation of the *Briar Rose* series, endlessly patient and encouraging. Graham was the perfect client, sweetly accommodating, liking to come and watch while Burne-Jones painted but 'appearing and disappearing very swiftly'. He was generous in lending Burne-Jones paintings and drawings from his own collection, works by, say, Mantegna or Carpaccio which it occurred to him that Burne-Jones might like to live with for a while. 'I want to ask you truly may I send you more £SD,' he would ask when he surmised Burne-Jones was in financial need: 'it is quite convenient and such a pleasure if one can so that you may

think only of making beautiful work.' Burne-Jones knew how blessed he was in having Graham for his client, appreciating his simplicity and oddness. As he wrote to Frances: 'The two men I love best in the world are full of ardour and hope and eagerness – my beloved Morris and that Papa of yours . . . each has the heart of a little child and is full of hope.'

Frances was a child of five or six when her father first got to know Burne-Jones. 'Francie' was the fifth of his eight children, five of whom were girls. She was sometimes taken by her father to visit artists' studios, which were often opened at weekends to favoured visitors. Rossetti's house in Cheyne Walk especially thrilled her with its dark oak dining room, convex mirrors, unusual collection of blue-and-white china and the sight of Rossetti himself, coming out to them in slippers and 'a sort of dressing gown' to show them to his studio. Rossetti would talk to them and sometimes read his poetry 'with a deep booming voice that seemed to come out from his boots'.

At first their visits to Burne-Jones had seemed an anticlimax. But as usual he exerted his charm on the small girl, who, by the time she was about eleven, modelled for him as the bride in *The King's Wedding*, an exquisite small watercolour painted on vellum commissioned by her father. The little fair-haired bride sits a little apprehensively on a massive throne wearing a deep blue gold-embroidered robe. Ruskin, who was shown the painting when staying in the Grahams' Perthshire house, commented that 'her features are at least as beautiful as those of an ordinary Greek goddess'. Ruskin was an admirer of Frances Graham too, though not so ardent an admirer as Burne-Jones, whose fondness for the child became a lifelong passion, possibly consummated but more likely not.

He was later to explain to Frances how his devotion to her had begun at this very early stage: 'my heart has been full of love and blessing for you from years ago – when you were little'. And his feelings for the daughter had been closely bound up with his affection for the father: 'you were so like him to me from the first, like a womanly form of him – and that was why I so cared for you – and both lives were wonderfully interwoven in my imagination'.

Frances Graham was part of the long line of devotion that begins with the MacLarens' Mabel and the more forthcoming of the Winnington Hall schoolgirls and progresses to the Dollies and the Dossies, the Daphnes, Katies and 'sweet darling bright' little Elsies whom Burne-Jones spoiled and petted. What are we to make of Burne-Jones's adoration of little girls?

The first thing to be said is that conventions in adult behaviour towards children were very different in the middle nineteenth century from the wariness to which we have been accustomed today. The worship of the young girl, the innocent, had become almost a given in Pre-Raphaelite circles, the depiction of pre-pubescent beauty made more poignant by the sense that this was by its nature a temporary stage. Julia Margaret Cameron took this to extremes in her photographs of *belle sauvage* children, often semi-naked, posed in pairs or grouped together. Her portraits of wistful and scarcely nubile teenagers bear such bitter-sweet titles as *Rosebud Garden of Girls*. One of the girls in the garden with her sisters is Ellen Terry, teenage actress bride of G. F. Watts.

What now seems a rather startling freedom was allowed between the middle-aged men and small-to-teenage girls within the clique. With the connivance of their mothers Burne-Jones could write to his young friends directly, sending tenderly affectionate and funny little missives illustrated with his drawings, flights of fancy intended to make the recipient collapse in fits of giggles. It was an intimate form of correspondence. One-to-one meetings were permitted. Burne-Jones and indeed Ruskin evidently had access to the children of their friends without a chaperone. For instance, Constance Hilliard writes in her diary for 12 July 1865: 'Drive into London to see Mr. Jones the artist who is one of Cussy's dearest friends. A nice petting and grave talks. Sweet run in the garden, tea and talks, and another nice petting before I went to bed.'

'Cussy' was John Ruskin. Constance, who had recently lost her mother Pauline Trevelyan, who died while the family was travelling in Switzerland, was then fourteen. What did she mean by 'petting'? Caresses? Sweet-talking? A degree of innuendo? As I understand it, Burne-Jones's devotion to small girls and young

teenagers was different in kind from Ruskin's passion for Rose La Touche, less overtly sexual. But these things are mysterious to later generations. All one can say with certainty is that he depended deeply on his friendships with the 'pets'.

What he could not bear was any of his circle of little pets withdrawing. Their marriage was his nightmare. As they grew up he had been close to Georgie's sisters Agnes and Louisa, treating little Louie with particular *tendresse*. The announcements of both their engagements – first Agnes to Edward Poynter, then Louie to Alfred Baldwin – threw him into despondency. 'A little gloomy sulkiness is excusable in me,' he told Louisa, once his dearest and best pupil. 'I only had two wenches and they are both gone.' He felt as if a double tooth had been extracted. Burne-Jones was then working on a painting of another favourite story of his and William Morris's, *Saint Theophilus and the Angel*. The two girls posed together at the base of an all too symbolic frozen fountain are recognisable as Agnes and Louie, the wenches he had lost.

Ned and Georgie were not present at the sisters' joint wedding which was held in Wolverhampton in August 1866. Only two months earlier, at two thirty in the morning, Georgie had given birth to another child. This time all went well and the baby was a daughter, Margaret. 'So Phil's conjecture that it would be either a boy or girl was not unfounded,' said his father. He sent William De Morgan a letter with a drawing of a wonderfully plump baby to announce the birth: 'the new party whom I will for the present call Fatima grows very fat, and fold on fold of fat in her neck, down or some soft hairy stuff on her back'. The physicality of babies was always a delight to him, and his daughter Margaret became his pet of pets.

The Burne-Jones household blossomed out a bit in Kensington. Ned reported that Georgie was 'growing rather grand in her chintz room', dressing in a chintz gown to match the William Morris hangings. Phil now had his own nurse whom he referred to as 'my cook'. In 1866 Ned and Georgie too held a memorable party, a dance of which Madox Brown reported, 'the house, being newly decorated in the "Firm's" taste, looked charming, the women

The artist's family depicted by Burne-Jones in a letter to George Howard
soon after Margaret's birth.

looked lovely and the singing was unrivalled'. However, it had
almost ended in disaster when, just after the departure of the last
guests, the studio ceiling collapsed in a cascade of falling plaster.
William Morris, who was to have been sleeping on the sofa just
beneath it but had fortunately left to stay the night with Prinsep,
only narrowly escaped burial alive.

The Burne-Joneses' social circle was widening. An important
new friendship of this period was with George Howard, son of the
Hon. Charles Wentworth George Howard and nephew of the 8th
Earl of Carlisle. George had challenged his father's expectations by

insisting on becoming a painter. He studied in Italy with Giovanni Costa before returning to London in 1865 to continue his training at the Kensington School of Art and Heatherley's. He took to coming to Burne-Jones's studio in Kensington Square to work with him and learn from him. George Howard was soon to become Burne-Jones's closest of male confidants as well as a considerable patron. A friendship between Georgie and Rosalind, the highly intelligent and independent woman whom George had married in 1864, was slower to develop but became a very deep one. Georgie remembered vividly the Howards' first joint visit, 'young, fresh and eager about everything'.

Burne-Jones had also got to know his close neighbour and near-contemporary Frederic Leighton, who had begun building his substantial villa, Leighton House, in 1864 and moved in two years later. Burne-Jones had been aware of the impressively well-travelled and well-connected Leighton since Hogarth Club days but they had not been close. Although he had lived in Rome and Paris, Leighton had none of the bohemian bonhomie of the 'Paris gang' or the feeling for communal endeavour of the artists and designers with whom Burne-Jones mainly mixed. He was a remote and fastidious personality, formidably ambitious.

Burne-Jones may well have been in awe of his professional accomplishment. Leighton was an exquisite draughtsman. He must have been jealous of the growing success of an artist who was already in the forefront of the Victorian classical tradition. Leighton's *Syracusan Bride* had been the great sensation of the 1866 Royal Academy exhibition, and this immense, sculptural and soulless composition exemplifies the difference between Burne-Jones's and Leighton's attitudes to art. Leighton was the protagonist of '*l'art pour l'art*', art for art's sake, believing that art was too important to be seen as simply the vehicle of narrative. In this he was the diametric opposite of Burne-Jones who loved a story more than anything on earth.

Ned had been prejudiced against Leighton. But Leighton was determined to make friends. He called on Burne-Jones and 'in the handsomest manner expressed his high admiration of Jones as a painter, and his wish to serve him in any possible way, and to stand

well in his estimation'. Ned, susceptible to flattery and hating to rebuff those who sought him out, could not but cave in. Semi-friendship with Leighton connected him to a different section of the London art world, more fashionable, professional and sleek.

'I joined a number of men at Rossetti's dinner table in the long room. Sandys, the 2 Whistlers [the artist and his younger brother William], Chapman, Rose, Burne-Jones, Howell, and 3 others. Whist and brag after, the latter being carried on till about 5 in the morning.' This entry from George Boyce's diary for 1866 shows the late-night entertainment at Cheyne Walk still in full swing. But there were ominous undercurrents. The loyalties of Ned's original brotherhood were under threat. Rossetti's passionate involvement with Janey Morris was becoming embarrassingly blatant as they flirted with one another in public and Janey even spent nights at Cheyne Walk. For William Morris, although he bore it bravely, it was an intense humiliation.

Charles Howell, the 'Owl', also known as the Baron Münch-hausen of the circle, was now ever present, as Ruskin's secretary, as Rossetti's confidant, insinuating himself into all the doings and dealings of the group. At Ruskin's instigation, one of Howell's complicated dealings was to buy in Burne-Jones's pictures in the saleroom on Ruskin's account to be returned to Ned, who could then resell them. No wonder Burne-Jones was describing Howell as 'a character inestimably interesting and increasingly amusing' as his professional usefulness to him grew.

Both Ned and Georgie attended Howell's wedding to his cousin Kitty on 21 August 1867, which, according to Georgie, 'went off very pleasantly indeed'. Ned sent a fulsome description to George Howard of how 'Owl behaved most prettily at his wedding' attended by Ford Madox Brown, William Rossetti, George Boyce and Philip Webb as well as by 'Owl's famous cousin' and many of his aunts, who wept. William Morris signed the register. Burne-Jones gave the Howells a painting of Lucretia which he had just finished in time. Everyone made much of the dashing young bridegroom 'because he's nice and has curly hair'.

Ned was also, rather recklessly, becoming more involved with Swinburne and his boon companion and ally Simeon Solomon. Simeon's high-camp behaviour could be outrageous. Once at Swinburne's house he appeared in a Greek costume with laurel wreath and lyre, sandals and long flowing green drapery looking like 'a veritable Apollo, with exquisite profile and brilliant, far seeing eyes'. He put this costume on again for an evening with the expert in pornography Richard Monckton Milnes, afterwards Lord Houghton, adjusting it until he looked more like a Jewish prophet, then declaiming the long passages from Hebrew ritual he had first learned as a boy.

Swinburne and Solomon egged one another on with their wildnesses and drunken nude cavortings. Solomon made drawings for Swinburne's fragmentary novel *Lesbia Brandon*, with its decadent themes of incest and flagellation, and for his masochistic poem 'The Flogging Block'. Rossetti too encouraged Swinburne's daring, his visits to the north London flagellation parlours and his violently republican political views. They exchanged gleefully Rabelaisian letters with a wealth of long-running and indecent jokes.

Ned was drawn into this circle of obscenity. Solomon's barely hidden homosexuality may well have stimulated the hermaphrodite element in Burne-Jones's work. When Swinburne embarked on a bizarre relationship with Adah Menken, a popular American entertainer whose theatrical performances verged on the indecent, Burne-Jones drew a series of brilliantly scurrilous cartoons which he gave to Swinburne, entitling them *Ye Treue and Pitifulle Historie of Ye Poet and Ye Ancient Dame*. These cartoons, now in the British Library, depict the tiny poet helplessly prostrated before the powerful Adah. In one he is so crushed and dejected he is setting one of her letters on fire with his cigar.

The exchange of obscene letters between Swinburne and Burne-Jones, with their recurrent jokes of victimised curates and errant bishops, was to continue all their lives. For Burne-Jones, Swinburne's ebullient and sexually aberrant letters were a lasting joy. 'I do so love getting a letter from you,' he wrote to Swinburne

gratefully, 'and, when it comes, withdraw myself and gloat and scream with bliss.' Hardly any of the correspondence now remains since in his old age Burne-Jones had a panic-stricken blitz on Swinburne's letters and burned them. However, one example of a letter from Burne-Jones to Swinburne, sent just before the move to Kensington, survives:

My dear but Infamous Pote,

What a dreadful gift was your last letter. The anxiety I have had about it for fear it should get out of my pocket and be seen. It has been much worse than another Pip to me, much worse. Every time I change my clothes I have to find it and transfer it to the pocket that I wear, and when I leave town, as I have just done, it goes with me. For its genius my dear Sir, is such that I wouldn't destroy it for the world, and to keep it is destruction. It lies before me now with its respectable edge of black, and its wicked contents like – if the simile may be accorded me – a sinful clergyman. To the Jewjube I read it all, and our enjoyment was that we spent a whole morning in making pictures for you, such as Tiberias would have [given] provinces for. But sending them might be dangerous, and might be inopportune, so we burnt them. One I shall repeat to you. It was my own poor idea, not altogether valueless I trust. A clergyman of the established church is seen lying in an ecstatic dream in the fore-ground. Above him a lady is seen plunging from a trap door in the ceiling, about to impale herself upon him. How poorly does this describe one of my most successful designs. But you shall see it. And the little'un did a sweet composition too. Our brains, I may say, teem with them till you come to deliver us.

William Morris kept himself notably aloof from these gleeful if puerile exercises in pornography.

In 1866 Swinburne's *Poems and Ballads* was published. The collection was received with admiration and alarm. Admiration at its scope and immense originality, its technical skill and intellec-tual energy. For many of his readers Swinburne's iconoclastic themes were thrilling, a contrast to the easiness and blandness of so much mid-Victorian poetry. But his critics laid into him fiercely for his anti-monarchical and anti-Christian sentiments and his poetry's moral and sexual decadence. Made nervous by the strength of hostility, the publishers withdrew the book from circulation. It

reappeared a few months later but the heated controversy continued. *Poems and Ballads* was dedicated to Burne-Jones.

In many ways the dedication was appropriate. Not only was Burne-Jones his loyal friend, he was also his creative counterpart, attempting in visual art the kind of breakthrough Swinburne was achieving in poetry. They had many themes and imaginings in common.

> There sit the knights that were so great of hand,
> The ladies that were queens of fair green land,
> Grown grey and black now, brought unto the dust,
> Soiled, without raiment, clad about with sand.

Swinburne's imagination was pictorial as Burne-Jones's paintings were poetic, melancholy. These lines come from 'Laus Veneris', one of Swinburne's poems that Burne-Jones later took as the subject for a painting, one of his most superb.

But Burne-Jones had mixed feelings about *Poems and Ballads*, distancing himself from it in a letter to George Howard: 'some eight or ten perfect and wonderful poems and the rest is partly horrible and partly incomprehensible to me'.

With the birth of Margaret, the Burne-Jones family were into a routine of family summer holidays. In August 1866 it had been Lymington in Hampshire where Allingham, who was working in the south coast customs office, found them seaside lodgings, a long narrow schoolroom divided by a curtain into living space and sleeping space with a view straight over to the Isle of Wight. One afternoon Ned went to visit Tennyson at Freshwater where he was affably received. Time passed peacefully with walks across the fields and woodland, Ned doing a little sketching. Philip Webb and William Morris joined them for excursions to Winchester and Milford. They buried Morris up to the neck in shingle on the beach. A final memory for Allingham was of Baby Margaret, asleep on the large bed which Ned had transformed into a grotesque giantess 'by means of gloves and shoes peeping out at immense distances'. The moment of departure came:

'Nosegay, omnibus'. As they say goodbye they all promise to return.

But by the next summer there were changes in the air. The Kensington Square house had been sold and the new owner was unwilling to extend their lease. Instead of the seaside, the Burne-Jones and Morris families went to stay in Oxford. This was to be the last of their holidays together. Because it was the long vacation Ned and Georgie were able to rent some undergraduate rooms in St Giles.

There were some contented days. They celebrated Ned's thirty-fourth birthday by all going down the Thames in a boat as far as Wallingford. But Ned was getting restless, irritated by the constant noise of the small children. Baby Margaret, aged one and now able to walk, was racing round the countryside in pursuit of animals, 'shrieking for joy at the sight of them, and blowing kisses all over the landscape in her transports'. Burne-Jones was clearly longing to be back in London. 'Tell me how your work prospers – mention Mantegna to me,' he wrote in desperation to Charles Fairfax Murray, the studio assistant he had recently employed.

Why was Burne-Jones so restless, so unable to be happy in Oxford of all cities, a place that meant so much to him? Why did Ned and Georgie then spend such a miserable winter back in London? Both provided innocuous explanations. Ned claimed that he was desperately anxious to have a new house settled, pleading anxiety about Georgie's state of health. Georgie suggested that the reason for the malaise was simply that the two of them had lost their youth. But of course there was more to it. Ned was terribly affected by the start of a *grande passion* over which Georgie, in her memoirs, draws a tactful veil.

The Grange, One
1868–71

They moved into the new house towards the end of 1867. '[I]t is called the Grange, not moated however,' Ned informed George Howard; 'The Grange, Northend, Fulham is its name.' They knew the house by sight already, having spotted it the year before on a Sunday walk through Kensington with William Allingham when the house was already standing empty, as if awaiting them. The Grange was in fact a pair of substantial semi-detached red-brick houses built in the eighteenth century and at one time occupied by Samuel Richardson, author of the famous epistolary novel *Pamela*. Ned and Georgie decided to take the house to the north, which was now stuccoed over, because of its better potential studio.

Even the half-house seemed a bit too big and grand for them: it struck Ned as being on the scale of Castle Howard, the palatial house in Yorkshire that belonged to George's family. To fill some of the space and to help with the finances they started by sharing the house with Wilfred Heeley, recently returned from India where his wife had died so young. Solid, learned Wilfred Heeley had now remarried and his new wife, Josephine, was already pregnant. When Ned and Georgie took a long lease on the Grange in November the late-blooming roses were still out in the garden. Their sweet scent and that of the hedge of lavender were, in Georgie's memory, 'inseparably connected with the place and time'.

What Georgie was unaware of at this juncture was Ned's precise plans for the studio. George Howard, the friend most in

his confidence, was told of his intention to fit it with a skylight – 'and then I shall be more like real artists'. The first-floor drawing room would become a kind of gallery where visitors could view his 'showable' pictures, beyond which, up three steps and across a little landing, would be an inner sanctum of a studio, a place which 'only my most dear friends will penetrate'.

George was himself one of these friends. They planned to work there together regularly, sharing models. The studio was still damp with its new plaster when he wrote to an impatient George with dates for the next week:

The only two days at all engaged are Tuesday and Saturday when Mrs. Zambaco comes, and there is no reason why you should not come then if you want except that the room would be so full and I can't work so easily with many by. I am sure also she would change days if you found that you wanted to come for any purpose . . . I will always tell you when I have models that would interfere with other work as I tell her.

Who was Mrs Zambaco, already a fixture in Ned's visions for the studio, so accommodating to his alterations of plan? She was a young Greek woman, born Maria Terpsithea Cassavetti in 1843. Her mother Euphrosyne, a formidable woman known among her relations as 'the Duchess', was an Ionides, a member of one of the leading Greek families in London, a clan so cohesive and inter-linked by marriage they were often described as 'the Greek colony'. Maria's uncle Alexander Ionides was a connoisseur and collector and enthusiastic patron of G. F. Watts. Amongst Watts's numerous portraits of the Ionides family is a painting of four-year-old Maria in blue-green Turkish dress posed standing confidently on a deep red sofa. The Ionides family originally came from Constantinople.

Maria's father Demetrius John Cassavetti, a rich Greek merchant, had died in Paris when she was still in her mid-teens. She was left with a considerable fortune of her own and in 1861, in defiance of her family, she married another Demetrius, Demetrius-Alexander Zambaco, the doctor to the Greek community in Paris. This was the doctor who had attended Maria's father in his final illness, a dangerously emotional time. Rumours flew around

London that the impetuous Maria was 'attached by mere obstinacy to a Greek of low birth in Paris'. But Zambaco was not so easily dismissed. He was a serious medical careerist who submitted his thesis to the École de Médecine in Paris in 1857 and then became assistant to Professor Philippe Ricord, France's leading expert in venereal disease. Zambaco soon set up in private practice. The dermatological effects of syphilis became his special area of expertise.

Watts's portrait of Dr Zambaco at the time of his marriage shows a serious, handsome, saturnine young man staring out with his arms crossed, a little cold in manner. The companion portrait of Maria depicts the young bride as round-faced, demure and almost homely, with little of her later all too evident allure. The marriage lasted five years. The Zambacos had a son, Demetrius François, known as Frank, born brain-damaged, and a daughter, Maria Euphrosyne. In 1866 Maria came back to London, bringing her children and her fortune, estimated by Du Maurier at £80,000. She was even able to reclaim her dowry. Zambaco angrily refused her a divorce.

Back in London, living with her mother in a large luxurious house in Gloucester Gardens, just north of Hyde Park, the estranged Mrs Zambaco was in a socially ambivalent position. There is no suggestion that she cared or indeed that any of her Greek relations were anxious or embarrassed on Maria's behalf. Returning, she had increased in confidence and glamour. She fell back easily into the old routines and networks, mingling once again with the artists – Du Maurier, Whistler, Poynter, Armstrong, Rossetti – who had been entertained so lavishly and often at her uncle Alexander Ionides's house in Tulse Hill. Maria herself had ambitions as an artist and had taken lessons in Paris from Legros. Back in London she saw herself re-entering this talented, amusing artistic ambience.

We cannot be sure if Burne-Jones, in the early 1860s, had ever made the cab ride to Tulse Hill for the famous Sunday gatherings of penniless young artists and wealthy London Greeks. Perhaps he was too preoccupied with his own early married life. But then

from the middle 1860s we find him in the inner circles of the Greek colony. In 1864 Alexander's son and Maria's cousin Constantine Ionides, who was now Consul General for Greece, moved nearer into London, buying an imposing house in a newly developed estate adjoining Holland Park. Burne-Jones was a regular attender at the soirées held at no. 1 Holland Park where the Tulse Hill guests were reassembled in a setting of still greater patriarchical splendour. He described one typical Greek evening to George Howard: 'We were all there – says Madam Cassavetti to Howell having heard of his powers of caricaturing people "I wish you would imitate some one for us, Mr. Howell, could you imitate Whistler?" says he. "With pleasure, Madam, if you will send for a lad, I'll knock him down before you all".'

It was 'the Duchess', rich, bored, manipulative, who made the fatal introduction. Euphrosyne Cassavetti, still in her mid-forties, was only twenty years older than her daughter. A red chalk portrait by Burne-Jones makes them almost lookalikes with seductive flying hair and sensual lips. No doubt there was vicarious excitement in her scheme to commission Burne-Jones to paint Maria soon after her return from Paris in a double portrait with her friend and fellow Greek Marie Spartali, who had been her 'best-maid' at her marriage to Zambaco. The Duchess used Legros as intermediary to arrange for them to visit Burne-Jones's studio. This first meeting took place late in 1866, when Burne-Jones was still living in Kensington Square. The subject for the painting was left to him and, immersed as he was in illustrations for Morris's *The Earthly Paradise*, he chose an episode from 'Cupid and Psyche'. He was not pleased with the picture and embarrassed about asking, again via Legros, for a fee of £40.

Emotionally the damage was done. Over the next few months he made several more studies of Maria for the scene of *Cupid Delivering Psyche*. He had found his ideal model. Years later he remembered that hers was 'a wonderful head, neither profile was like the other quite, and the full face was different again'. He became obsessed with Maria not only as his model and his pupil but also as his lover and muse.

An adoring Burne-Jones attempting to paint Maria Zambaco.
Self-caricature of the late 1860s.

What made him so susceptible? First, and very obviously, this was a beautiful woman, a 'stunner' and yet more so. She had come back from Paris a very different person from the plump young Greek girl of her marriage portrait. She was slimmer, more exotic, with something of the animal magnetism and theatricality of the actress Sarah Bernhardt whom she had known in Paris. Other artists of the period were conscious of it too. Rossetti made several portrait drawings of Maria. 'She really is extremely beautiful when one gets to study her face,' he wrote to Mrs Morris. She was almost a rival to Janey herself.

Maria, her close friend Marie Spartali and her cousin Aglaia Coronio became a famous trio in Graeco-artistic circles, known as

'the Three Graces' on account of their esoteric style of beauty. Thomas Armstrong and his artist friends had been 'à genoux' before Marie Spartali when they first saw her. Du Maurier told his mother that Madame Coronio was one of the most charming women he had ever met. The three Graces appear together linked hand to hand in a mysterious waterside dance, nude male figures in the background, in Burne-Jones's atmospheric oil painting *The Mill*. This painting belonged originally to Maria's cousin Constantine Ionides, who strongly disapproved of her liaison with the artist. Like a furious Greek god he was said to have hurled 'some thunder right and left'. However, the picture is now in the Victoria and Albert Museum, a high point of the Ionides bequest.

Burne-Jones, so steeped in the chivalric tradition, had an automatic sympathy for women in distress whatever their social background: prostitutes, professional models, women of the upper class. 'Two things had tremendous power over him – beauty and misfortune – and far would he go to serve either,' Georgie tells us. Maria Zambaco qualified on both counts. No one knows the true reasons for the failure of her marriage but Dr Zambaco, the specialist in sexual aberrations, believed within the Cassavetti family to have been involved in child pornography, could have been too sexually exigent. Though such complex moral subjects were beyond the pale in polite society this was one of the themes to be treated by George Eliot, a close friend of Ned and Georgie's, in her novel *Daniel Deronda* a few years later on.

Maria exuded sexuality. The way of female behaviour in Greek circles had a freedom, an 'ease and tutoiement', that delighted and surprised visiting young men: 'The women will sometimes take one's hands in talking to one, or put their arm round the back of one's chair at dinner.' Du Maurier was amazed when, in the days before her marriage, the beautiful young Maria, thickly veiled, pursued him through Kensington Gardens with only a little girl as chaperone. A young Ionides cousin, another Alexander, was equally surprised when, taken to dry off in Maria's dressing room after falling into a Brighton swimming pool, she proceeded to undress unselfconsciously in front of the small boy. 'Her glorious red hair

and almost phosphorescent white skin still shone out from the gloom of that dressing room.' In a memoir written in the 1920s when he was an old man, he still sounds excited by the apparition of his exotic cousin who 'had a large heart and several *affaires de coeur*'.

Maria was a flamboyant woman of experience. It is not hard to see how Burne-Jones was seduced by the sexual promise she spectacularly offered. Burne-Jones had been obsessed by his own undesirability. His self-caricatures show a pathetic scarecrow figure, ugly, scraggy and unlovable. His closeness to the confident Rossetti had only increased his own feelings of sexual inadequacy. The painful episode with the prostitute revealed him as a booby, nervous with the fear of ridicule. Maria's flattering suggestiveness gave him sudden hope.

His marriage was by this time far from satisfactory. When Rossetti wrote his limerick on 'Georgy, whose life is one profligate orgy' he was surely being ironic. Orgiastic was just what Ned and Georgie's life was not. The Methodist decorum was too strong in Georgie's nature. The reverent mystique of their early days of marriage had by now been worn away with all their struggles. They had ceased sexual relations in order to avoid any more children. Burne-Jones viewed failed marriage later in self-justifying terms: 'after marriage both leave off trying to seem heroic to each other, and cease to take pains . . . the soul of any man or woman that is worth anything will somehow and somewhere get romance for itself'. A later friend, Graham Robertson, put it more succinctly: 'EBJ's surroundings were so extremely correct and "proper" that I think he *had* to break out occasionally.'

Part of the attraction, and part of the unfairness to Georgie who had herself abandoned her ambitions as an artist, was Maria's own serious intention to succeed. She was free and could afford to pursue art, unlike Georgie, since her mother's entourage of servants attended to her two children. A charming etching by Charles Keene shows Maria intent at her drawing board, pencil poised. She wears a beautifully bunchy Pre-Raphaelite gown. The early artistic promise that Du Maurier had been aware of back in 1860 when Maria was a girl had developed while she was in Paris to the point where ten years

later Rossetti was calling her 'a woman with great talent in a variety of ways, and with remarkable capacities for painting, which she is now cultivating to good effect'. She was later to acquire a reputation as a sculptor and especially a medallist. Four examples of her medals cast in bronze, originally shown at the Royal Academy, are now in the British Museum. She was always to acknowledge Burne-Jones as her teacher in the critical early years of her career.

Charles Keene's etching of Maria Zambaco.

Not everybody liked the Greek colony in London, with its exuberant clannishness and strange effusive manners. To their critics these Greek merchant families were 'a set of "furriners" of doubtful cleanliness'. For Burne-Jones the foreignness was an intoxication. His involvement with the all too willing Maria Terpsithea was as far from Birmingham as he had travelled yet. It took him back geographically to southern Europe, sultry land of his true loyalties, identified as such in his recent Italian journeys. The liaison with Maria, descended through her mother from the Byzantine Greeks of Constantinople and through her father to the Greeks of Thessaly, connected with his love and deep knowledge of the classics. They read Homer and Virgil together. When he claimed that Maria had been 'born at the foot of Olympus and looked and was primeval' this was factually inaccurate but emotionally right.

Did Burne-Jones at any point demur? It seems unlikely. He wrote later to May Gaskell, 'You ask me if I have ever found temptation irresistible – no, never – if I have given in I have given in with my whole will, and meant to do it.' A portrait of this period by Alphonse Legros, the man who had acted so successfully as go-between in the Burne-Jones–Zambaco affair, shows a very different Ned from the wispy, wimpish figure of earlier portraits. He has grown in authority, posed full face and wearing black against a quasi-Italian landscape setting. Even his beard has apparently filled out. He could be an Italian nobleman, even a prince, so compelling is his gaze.

There is no doubt that the liaison with Zambaco changed him. Once he had achieved the new freedom of the studio in the more spacious environs of the Grange, with Maria a semi-official visitor, his work began to flourish. Rossetti, visiting his studio in 1869, reported back to his own muse Janey Morris, 'I was particularly struck with a most beautiful single figure in profile with some smaller figures by a door in the background. This I thought one of the finest things he has done.' The painting that had so impressed Rossetti was Burne-Jones's watercolour *Beatrice*. The model for Beatrice was of course Zambaco. It is true to say Maria was an

inspiration to him and took him to new heights of imaginative power.

Up until the early 1860s the female figures in Burne-Jones's paintings had often been arrived at by preliminary portrait studies of Georgie and sometimes of her sisters. Georgie's is the sweet face of the Virgin in Burne-Jones's *The Annunciation*. He was later to use more professional models: Rossetti's mistress Fanny Cornforth; a dancer known as Reserva; the beautiful Italian Antonia Caiva; Ellen Smith, a waitress; Mrs Keane and her daughter Bessie; the 'noble-looking Miss Augusta Jones' who sat for *Astrologia* and for whom, according to Georgie, Edward 'had much regard and respect'. However, at this stage Burne-Jones's other models were mainly cast aside in favour of Maria Zambaco's delicate, distinctive and distinctly foreign features, her big, faintly baleful eyes, well-sculpted nose, neat pointed chin. In so many of his drawings and paintings of this period it is Maria's likeness that we see.

There she is in his series *Pygmalion and the Image*, the statue created to be worshipped by the artist; there she is as his enchantress in *The Wine of Circe*; his goddess in *Venus Concordia* and *Venus Discordia*; his temptress in *The Beguiling of Merlin*, the pursuit of the ancient magician by the sexually predatory Nimuë. If he saw her as Nimuë then he himself was Merlin. He was conscious of his own succumbing to enchantment: 'I was being turned into a hawthorn tree in the forest of Broceliande.' In his final version of the painting Nimuë has become a Gorgon, snakes entwined in her enticing Pre-Raphaelite hair.

Some of the drawings he made of Maria as preparatory studies were so personal and meaningful he hoarded them for decades. 'The heads done from that strange weird looking damsel I wouldn't sell – for a time at least I will keep them.' This was at a period when Burne-Jones was dispensing with much of his old work. It is not surprising that he wanted to hang on to these records of a new transfixing and alarming erotic consciousness.

One of the drawings, known as *Desiderium* and based on the figure of 'amorous Desyre' in Spenser's *Faerie Queene*, is a particularly lovely evocation of the irresistible Maria looking sideways. It is

now in the Tate Gallery. When Philip Burne-Jones presented the drawing in 1910 it had evidently been tampered with. A panel to the right of the woman's head had been chopped off. The Victorian art specialist Rupert Maas, who has studied a contemporary photograph taken of the work, believes that it depicted a man's penis and balls directly within the woman's line of vision and that Philip had censored his father's erotic fantasy. It is a tempting thesis but maybe it goes a little bit too far.

How far was Georgie aware of what was going on behind the closed doors of the studio kept private by her husband for his 'closest friends'? In her account of revisiting the Grange in 1899, after his death, she mentions one spot 'peculiarly associated with many memories – the outside of the studio door with the three steps and the little landing'. It seems likely she was in that common situation of knowing but preferring not to know. In May 1868 she was watched by William Allingham putting a brave face on it, arriving for a 'full dress party' at the Morrises' house at Queen Square. Among the female guests are 'Mrs. Morris, Miss Burden, Mrs. Ned (gay), Mrs. Howell, Mrs. Madox Brown (looks young with back to the window)'. Mrs Ned is wearing 'a gorgeous yellow gown'.

But just a few weeks later, in June, she had to face it. She found an incriminating letter in Ned's pocket, as her mother Hannah recorded in her diary. The sisters rallied round. To everybody else Georgie kept silent. Her instinctive reaction was, as Morris's had been to the defection of Janey, to stay stoic, involve herself with practicalities.

With a self-control that verged on the heroic Georgie kept the routines of the household continuing as usual after the fatal discovery was made. On 11 June she even assisted her sister Alice Kipling, who had returned temporarily from India, to give birth to a daughter at the Grange while Ned discreetly went out for a walk. The baby emerged so tiny and so white that Georgie at first assumed she had been stillborn. On the doctor's instructions she herself slapped the infant gently into life. When her breathing became regular the baby was rolled up in a blanket and laid carefully on a

chair in Burne-Jones's studio. Through that summer visitors were still welcomed to the Grange as if there was no crisis. In September when the American art scholar Charles Eliot Norton, the protégé of Ruskin, came to stay the night he was aware of nothing untoward about the Burne-Jones household. In fact he noted its atmosphere of beauty and serenity. Georgie and Ned charmed him: 'their life has much unusual sweetness and happiness'. It would be many months before Georgie finally broke down.

For Ned it was a different matter. He was already showing more obvious signs of strain. 'This year did little work through illness' is the entry for 1868 in the year-by-year record of his paintings he compiled. In September Georgie took the children to the seaside at Clevedon. Ned stayed a few days with them in Somerset and then fled home, writing a long lamentation to George Howard, who had noticed his erratic behaviour.

I have been ill all the year – really ill, ill in head and every way . . . if I could have pointed definitely to a heart disease or cancer, or consumption or something clear and obvious it would have been bearable to my friends but I have had no such luck – only I have felt intensely melancholy and depressed – the result of a good couple of years pondering about something and I have been a nuisance to everyone.

Ruskin was in Burne-Jones's confidence. In June he recorded in his diary his anxiety as Ned made a vain attempt at breaking with Maria. He postponed his foreign travels to come across each day to the Grange to spend three or four hours with Ned, trying to cajole him back to work. Ruskin went still further in subsidising Howell to the tune of £200 to move from Clapham to North End, 'the object being that he may be close to Jones, and keep him up in health and spirits', as William Rossetti noted. He added rather acidly, 'H buys for R almost everything that J paints.'

It was put about that Howell the arch-manoeuvrer had engineered a meeting at the Grange between Georgie and Maria Zambaco. In Whistler's maliciously exuberant account, the first time Ned saw the two of them together he fainted and in falling struck his head against the mantelpiece – ' "And", said Howell,

with the last convincing touch – the touch of realism only he could have invented – "whenever it's damp he feels it here", pointing to his temple.' No doubt the meeting had acquired some extra drama in the telling. This could hardly have been the first encounter between Ned's wife and mistress, who must, at the very least, have exchanged a frigid greeting passing on the stairs.

The rumours were circulating wildly in Pre-Raphaelite circles. Maria was now putting pressure on Burne-Jones to run away with her. They could live on a Greek island, the island called Syra as described in Homer's *Odyssey*, reclaim her classical heritage together. He was evidently very seriously tempted. But he lost his nerve.

'Poor old Ned's affairs have come to a smash altogether,' Rossetti told Madox Brown half anxiously, half gleefully, in January 1869. When Burne-Jones refused to leave for Greece with her, Maria had 'provided herself with laudanum for two at least, and insisted on their winding up matters in Lord Holland's Lane'. This, now renamed Holland Walk, is a long, steep, narrow path running north from Kensington High Street alongside Holland Park.

They walked on up the lane through a heavy London fog, Maria threatening to drink the poison, Burne-Jones hopelessly attempting to calm her down. Eventually they reached the bridge over Regent's Canal, beyond which was Warwick Crescent where Robert Browning lived. Rossetti described the scene of terrible hysteria as Maria 'tried to drown herself in the water in front of Browning's house & c. – bobbies collaring Ned who was rolling with her on the stones to prevent it, and God knows what else'.

It could have been a scene from a Wilkie Collins novel. The police were on alert for suicide attempts at this favourite location for the desperate. Before they could begin to investigate, Maria's large Greek cousin Luke Ionides loomed up out of the mists and somehow succeeded in calming the situation down. His arrival on the scene could not have been coincidence. He must have been following the arguing lovers all the way from Holland Park out of concern and perhaps an element of voyeurism. Luke was not only a close friend of Burne-Jones's, he was also one of Maria's

previous *amours*. Rosalind Howard suspected he had followed her 'to see what she was after', motivated by anger and jealousy. Luke led Maria away. Ned started to head back towards the Grange but fainted from all the anxiety and strain.

His boon companion William Morris was never needed more. They planned an escape. A few days later, on 23 January, Rossetti was reporting that

He and Topsy after the most dreadful to-do started for Rome suddenly, leaving the Greek damsel beating up the quarters of all his friends for him, and howling like Cassandra. Georgie has stayed behind. I hear today, however, that Top and Ned got no further than Dover, Ned being now so dreadfully ill that they will probably have to return to London. Of course the dodge will be not to let a single hint of their movements become known to anybody, or the Greek (whom I believe he is really bent on cutting) will catch him again.

As Georgie later explained Ned's abject return home, he had 'been too weak to face the journey when he reached Dover'. For two or three days he was desperately ill, Georgie telling nobody he had in fact returned.

She tried desperately to keep up an appearance of normality while fending people off. Charles Eliot Norton had now arrived back in London with his family. They had taken lodgings in South Kensington, besieging Ned and Georgie with notes, calls and invitations. Georgie made somewhat frantic apologies for him: 'I am very sorry that Edward won't be able to keep his promise of going with you to the South Kensington Museum tomorrow, but he has been obliged to leave Town for a while for perfect rest, by the Doctor's order, and has gone with Mr. Morris, leaving me to give his love to you, and say the goodbye he could not.' In that same week she had to deal with the landscape painter J. W. Inchbold, a well-known sponger, who turned up uninvited at the Grange.

Even with her sympathetic friend Rosalind Howard, Georgie had at first felt unable to be candid. When the Howards had driven out to the Grange on 26 January, bringing with them the Legros portrait of Ned and also £50, 'thinking that Georgy might need it', she continued with the subterfuge that Ned was still away, wanting

to keep him free from all disturbance. George Howard, having seen Ned's hat in the hall and noticed that 'the front room was locked with some one in it', had never been convinced.

Georgie could not accept the £50, but in writing to thank Rosalind for her 'tender thoughtfulness' in delivering the Legros portrait to the Grange she asked her to excuse the 'little deceit' which had been for Ned's benefit, to allow him to recover from the terrible irritation of the brain brought on by his tumultuous experiences. She also revealed something of the depth of her own suffering: 'Forgive my reserve the other day when you came, but I am obliged to show it in time of trouble or I should break down.'

From now on the forthright, loyal but somewhat unimaginative Rosalind Howard became her closest confidante on the condition of the marriage. Soon George, the charming, aristocratic *plein air* artist, would be performing the same service for Ned.

Burne-Jones was deeply shaken by the episode. He came to view the Zambaco debacle in almost cosmic terms: 'the like of the whole story will never happen in all the history of the world I verily believe'. He seems to have felt an immense chagrin that he had glimpsed an alternative existence, less mundane, more sexually charged, and that in the end he had not had the courage to pursue it, to abandon his arid marriage, to leave England with Maria. He was later to confide to William Graham's daughter Frances, 'how often I tried, with all the strength I could, years ago to be free – knowing there was nothing for me but pain, on that road – and I never never could'.

He might argue petulantly that no painter should be married: 'children and pictures are each too important to be produced by one man'. The great Italian painters were not married: 'Michael Angelo not married, Raphael not married, Fra Angelico not married, Signorelli not married'. But he knew really that his ties to Georgie, to his children, his studio, his work in progress were too strong to be relinquished. What he was now left with was a searing – and a lifelong – sense of guilt.

After his return from Dover in 1869 he was laid low for many weeks. Georgie's London sister Agnes sent bulletins to Louisa in

the country. On 30 January Ned was said to look as if he had been very ill, 'but I agree with Georgie that there is no danger of his going mad'. Agnes trusted he would give his wife no more alarms, 'for truly they pick the flesh off her darling bones'.

Mad or not, he was in a state of hypersensitivity. In February George Howard was kept up till one in the morning while Burne-Jones confided in him. He told his 'dearest George' he felt so tired and unwell he was thinking of sending himself to Coventry. 'I really need both silence and rest – I did not sleep at all in the night and tremble if a ring comes at the bell. I am strictly burying myself from friends – only on business I talk.' He had written to his inner circle of Morris, Webb, Rossetti and Howell telling all four of them the same.

In the middle of February Georgie went without Ned to Oxford, taking Phil with her and staying in lodgings in Museum Terrace near the new museum buildings. 'It feels funny sometimes', she told Rosalind, 'when Phil is gone to bed and I sit down to read as if I were the undergraduate to whom these rooms really belong, but it is snug, and what I have often longed for of late.' Ned came to visit them, so did Louie. In these new surroundings, in some ways so familiar from past visits, she arrived at a state of equilibrium.

She denied Rosalind's praise that she had acted as a heroine. 'Indeed, my dear, I am no heroine at all . . . I have simply acted all along from very simple little reasons which God and my husband know better than anyone – I don't know what God thinks of them.' She was determined to go through with her marriage. She and William Morris were at one on this. 'I know one thing,' Georgie wrote, 'and that is that there is love enough between Edward and me to last out a long life if it is given us.' Years later Burne-Jones began to speculate if he had not been born who would have been worse off. 'Would Georgie? Well it would have been much better for her', Burne-Jones had decided, 'she could have married a good clergyman.' In this he was in a way quite right.

In early April 1869 Georgie was back at home, resolute but still showing symptoms of her ordeal. The doctor was called in to attend to her 'frequent rushes of blood to the head'. There were

attempts to restore routines to normal. Sometimes life at the Grange seemed pleasant, gentle and convivial. One spring evening, when George Boyce came to visit Ned and Georgie, Rossetti too called in. 'Mrs. Jones sang several things of Glück and Beethoven and Schubert, and charmed us in this way till nearly 1 o'clock.'

The garden was beginning to blossom. They discovered a bed of lilies of the valley about twenty feet long. Soon there would be peaches, plums and apricots growing on the garden walls. Beyond the Burne-Joneses' garden there were fields with two marvellous trees, a huge elm and a walnut. The field around the walnut tree was used for carpet beating by their neighbours. Ned told an Italian model, with supreme insensitivity, that the swishing sound was that of Englishmen beating their wives.

Beyond the jokes, this was a year of altercations and dramas. Georgie writes very little on this period in her memoirs beyond the cryptic words 'Heart, thou and I are here, sad and alone' under the heading for her chapter on 1868–71. Ned wrote hardly any letters. We can only piece events together from outside evidence.

It is clear that in late May Morris finally exploded. 'My dearest Ned', he wrote on 25 May: 'I am afraid I was crabby last night, but I didn't mean to be, so pray forgive me – we seem to quarrel in speech now sometimes, and sometimes I think you find it hard to stand me, and no great wonder for I am like a hedgehog with nastiness – but again forgive me for I can't on any terms do without you.'

At the same time he wrote to Charles Fairfax Murray, who as well as being Ned's studio assistant carried out commissions for Morris and the Firm. Again the tone is grovellingly apologetic: 'My dear Murray, I was rude to you last night and drove you away from The Grange: please believe I didn't mean to be unkind, and forgive me. I could explain all to you in a word or two if an explanation were necessary to you, which I doubt.'

There had evidently been a colossal row. What had this been about? It seems likely that Morris, Ned's closest supporter through the Zambaco crisis, who had actually been with him when Ned in desperation attempted to leave England a few months earlier, had

been driven wild with anger by Ned's lack of contrition and the lasting injury to Georgie he had caused.

This was the time of a growing *tendresse* and reciprocal anxiety between Morris and Georgie who were, maritally speaking, now in the same boat, she with an errant husband, he with an absent wife. Again the details are not easy to retrieve. Morris's biographer (and Georgie's future son-in-law) J. W. Mackail was later to apologise for the inadequacy of his account of 'those stormy years of *The Earthly Paradise*', which had been rendered 'excessively flat owing to the amount of tact that had to be exercised right and left'. It is most unlikely that Morris and Georgie ever became lovers. But this was the beginning of a deep and constant friendship that from time to time was to break out into longing. Morris was a man of strictest honour. If he was 'a hedgehog with nastiness', this may have been a sign of fear that his feelings for Georgie were threatening his old ideals of brotherhood.

In late June Georgie went on her own to stay at Naworth, the Howards' castle in Cumberland. Rosalind had diagnosed that she was much in need of rest. Significantly, Pip, who had been given a toy printing press, had printed a story beginning 'Once upon a time a little boy said to his mama, "Mama, why do you look so unhappy?"' In the blustering northern summer weather and in Rosalind's bracing company she gathered strength.

Later in that year there was a further drama of the brotherhood, an ordeal of grief and memory for Ned and Georgie, when Rossetti obtained an order of exhumation in order to recover the poems he had buried in Lizzie Siddal's grave. He was planning a volume of his poetry and he needed the originals. The opening of the coffin took place on 28 September, overseen by the ubiquitous, unscrupulous Howell. There was no one else, Rossetti later commented, who could have been entrusted with such a trying task. The macabre scene in Highgate Cemetery has now entered legend. As Rosalind noted in her diary at the time, Lizzie 'looked as beautiful as when she died they say – quite unspoilt in her face – but when they moved the book part of the cheek came away with the book'. For Ned, once so close to Rossetti, so devoted, the melodramatic

episode served to underline their growing distance. He had not been told of it directly by Rossetti but only through the intermediary Howell.

A few weeks before Christmas there was yet another problematic confrontation. This time it was Rosalind Howard, the person who had most reason to be hostile to Maria Zambaco, knowing the full story, indignant at 'the awful and deliberate treachery of Mme. Z. making use of Georgy a whole year'. She had found it heartbreaking that the apparently ideal Burne-Jones marriage 'should have had its peace disturbed by this bad woman'. Meeting Maria, it seems Rosalind cut her dead.

She was in the midst of her own intricate and intimate transactions with Howell, who was making himself useful searching out bargain-price furniture for the Howards' new house in Kensington. Howell told her that Ned knew she had been rude to Madame Zambaco and wanted Rosalind to know he knew. 'So off I went at once to Ned Jones,' as she tells it in her diary. They had an hour's talk at the Grange, and 'he cried and was impetuous and eloquent and then gentle and tender and affectionate – in short everything by turns'.

Ned tried to convince her that if she was rude to Maria Zambaco then she had to cut him too: 'that they ought both to fare alike and that all the blame was his because his was the initiative in the whole matter'. To Rosalind he was contrite, very loving towards both the Howards, anxious to protect Georgie's friendship with Rosalind. But this was by no means the end of the affair.

The scandal was erupting into the public arena. Warington Taylor, the Firm's manager, was anxious that damage would be done to Morris, Marshall, Faulkner & Co. by its partners' illicit relationships, Rossetti's with Janey, Ned's with Maria. 'I only want the dignity of the firm maintained,' he wrote sternly in August 1869, 'and to let it be understood that we in no way sanction as a body the slightest irregularity of life . . . without some sort of tone is kept up the firm must sink, for no society ever lasted yet which ignored the fundamental principles of morality.' Many of those in the know

would have agreed with Jeanette Marshall, acerbic daughter of the doctor to many Pre-Raphaelite families: 'Why Mrs. Jones did not show old Jones the door I don't know.'

In 1870 five paintings by Burne-Jones were included in the Old Water-Colour Society's summer exhibition at their Pall Mall galleries. One of these was the watercolour *Phyllis and Demophoön* belonging to Burne-Jones's patron Frederick Leyland. The painting provoked the greatest public outcry in the society's history. It shows a dramatic episode from Ovid's *Heroides*, also told in Chaucer's 'Legend of Goode Wimmen', in which Phyllis, daughter of the King of Thrace, apparently betrayed in love by Theseus's son, kills herself and is turned by the gods into an almond tree. Burne-Jones illustrates the very moment when Demophoön returns to be reclaimed by Phyllis, leaning out enticingly, demandingly, clasping him around while still a part of her own tree.

The scandal arose first on the technical point that Demophoön's genitals were all too clearly visible, not covered by the drape of Phyllis's robe that winds around his upper thigh. Rossetti, writing to Janey, gloated over the painting's Botticellian beauty and its explicitness: 'Isn't Ned Jones's Phyllis and Demophoon just about as plain as a pikestaff in one corner – isn't it just!' The comparison he drew was with Zephyrus so blatantly embracing the nymph Chloris in the right-hand corner of Botticelli's *Primavera*. The subject matter of the Old Water-Colour Society exhibits was mostly fairly anodyne. Compared with other paintings shown in 1870 – *A Cloudy Day in Autumn*, for example, *Hulks at Plymouth* – *Phyllis and Demophoön* stood out as startlingly controversial.

Demophoön's genitalia was not the only problem. The fact of woman pursuing man was itself considered outré. To the *Times* art critic Tom Taylor 'the idea of a love chase, with a woman follower, is not pleasant', especially when the features of the face of Phyllis were unmistakably those of Maria Zambaco and the inscription *dic mihi quid feci? nisi non sapienter amavi?* (tell me what have I done? other than to love unwisely?) bore clear intimations of the artist's own recent amatory history to those in the know. There was also a political slant to the hostility. The nudity of Burne-Jones's 'fickle

and repentant lover' was seen to be as 'needlessly aggressive as the democratic opinions' of the painter himself.

Soon after the opening of the exhibition the society received an anonymous letter of complaint about the nudity of Demophoön from a man later identified as a Mr Leaf. The president Frederick Taylor was given the unenviable task of calling at the Grange to discuss the problems with Burne-Jones. Taylor was described by Georgie as 'a gentle and refined man, with less strength than his position demanded'. Among his own exhibits in 1870 were *Maternal Anxiety, Bringing Down the Rye* and *Breaking the Park Palings to Let the Hounds Through*. Tentatively he suggested that, to avoid any further controversy, Demophoön's genitals could be temporarily chalked over. Burne-Jones preferred to remove the painting from exhibition altogether.

Nor could he accept Taylor's subsequent proposal that his picture should be replaced by a work of similar dimensions by another OWCS member, Carl Haag, to be selected from his studio by Burne-Jones for the purpose. This was carrying indignity too far. 'I cannot look upon myself as having anything to do with the re-filling of the space now occupied by my picture, or accept any work intended for that purpose as lent to *me*,' he angrily replied. In the end *Phyllis and Demophoön* was replaced by *Frankfurt* by William Callow and a study by Brittan Willis. The titles of these works were pasted into the exhibition catalogues, obliterating the entry for Burne-Jones's controversial work.

He left his resignation until the exhibition ended in July. Then he wrote to say:

The conviction that my work is antagonistic to yours has grown in my mind for some years past, and cannot have been felt only on my side – therefore I accept your desertion of me this year merely as the result of so complete a want of sympathy between us in matters of Art, that it is useless for my name to be enrolled amongst yours any longer . . . in so grave a matter as this I cannot allow any feeling except the necessity for absolute freedom in my work to move me.

Frederic Burton, who had supported his election, resigned in sympathy.

Burne-Jones's outrage at this episode remained for ever linked in his mind with the concurrent agonies of the Zambaco love affair, still vivid in a letter of 1893 to May Gaskell:

The head of Phyllis in the Demophoön picture is from the same Greek damsel and would have done for a portrait – don't hate – some things are beyond scolding – hurricanes and tempests and billows of the sea – it's no use blaming them . . . no, don't hate – unless by chance you think your workmanship was bad; it was a glorious head – and belonged to a remote past – only it didn't do in English suburban surroundings – we are soaked in Puritanism and it will never be out of us and I have it and it makes us the most hypocritical race on earth.

However, in the later oil version of the subject Demophoön's private parts are delicately hidden behind a floating drapery.

When Burne-Jones told George Howard that the scene of Maria's attempted suicide meant the end of all his future life, what did he mean? Only – surely – that his hopes for them to run away together were definitely over. There was no getting away from his images of her, the drawings and paintings stacked up in his studio.

In his enduring love for her foreignness, her ostentatious sexuality, he was encouraged and abetted by Rossetti who made at least three portraits of Maria in 1870, one of them for Burne-Jones himself. He had specifically asked for a picture with a frame that locked. 'I think I have made a good portrait of Mary Zambaco,' Rossetti told Janey, 'and Ned is greatly delighted with it. Indeed I enclose a note from that poor old dear which I have just got, as it shows how nice he is. I like her very much and am sure her love is all in all to her. I never had an opportunity of understanding her before.'

Far from Ned and Maria having separated, they were planning an expedition out, only three days after Rossetti wrote this letter, to Evans's supper and singing club. Also included in the party was Maria's cousin Alecco Ionides's 'flame' Isabella Sechiari, another of the Greeks whom he was soon to marry. Janey and Rossetti were to be there too. Maria had been tactful in praising Janey Morris to Rossetti, who responded: 'I like Mary because she said

the sweet one was far more beautiful than anyone else in the world.'
And Rossetti felt Maria herself had increased in beauty within the
past year 'with all her love and trouble'. But he was afraid that
rainy walks and 'constant lowness' might now be endangering her
health.

Ned's continuing preoccupation with Maria was also being
encouraged by her mother, with whom Burne-Jones perfected the
manner that made him popular with older women, somewhere
between deference and flirtatiousness. As a birthday present for
Euphrosyne Cassavetti he painted the wonderful watercolour
portrait of Maria Zambaco in a sheeny blue-green dress with Cupid
leant teasingly over her right shoulder. Ned unabashedly identifies
her with the goddess Venus. In her left hand she clutches a spray
of white dimity representing passion. Her illuminated book is open
at the page illustrated with a miniature version of Burne-Jones's
own *Le Chant d'Amour*.

He sent it to his 'Dearest Madame Cassavetti' apologetically,
saying 'I have tried to make it like her, but can't.' He tells her he
needs another month on it, but 'take it as a poor symbol of my
gratitude for your thousands of kind deeds to me'. While Burne-
Jones was working on this portrait in summer 1870, Georgie and
the children were on a seaside holiday in Whitby at the suggestion
of her great new friend George Eliot, introduced to her by
Rosalind. George Eliot and her close companion G. H. Lewes
were in nearby lodgings and they all met daily. Georgie exploring
the Yorkshire cliffs and rock pools seems like the perfect picture of
Victorian wifely fortitude.

The following year Euphrosyne Cassavetti, with her reliable
poor taste, commissioned a nude study, *Venus Epithalamia*, for
which her daughter was the model. The painting was a present for
the marriage of Marie Spartali, Maria's bosom friend, to the
American art critic and journalist W. J. Stillman. The painting so
delighted Madame Cassavetti that she ordered a copy for herself,
made by Burne-Jones's assistant Charles Fairfax Murray. It hung
proudly in her London drawing room, almost as if in justification
of her daughter's and Burne-Jones's affair.

They were still nonchalant about being seen around together. Their names appear side by side in the records of visitors to the British Museum Print Room on two separate occasions in 1871. But by the middle of that year the tensions were mounting. On 4 July William Rossetti reported in his diary, 'Gabriel says that Jones, who is now (on account of Z and other matters) as bitterly hostile to Howell as he used to be profusely fond of him,' was putting pressure on Rossetti to break off his own relations with Howell. Such sudden switches from great fondness to violent hostility were part of the pattern of Ned's personality.

Far from being the cheering influence Ruskin had intended when he settled the Howells so close to Ned and Georgie, Howell had turned into a figure of malevolence. As well as his meddling in the Zambaco affair, Howell had been acting as Burne-Jones's agent and his sleight of hand in many of his dealings had now become apparent. He was a confident and enterprising fraudster, already in trouble for tricking William Morris into selling him wallpaper at less than its cost price. Even Ruskin had become disenchanted with Howell and dispensed with his services as secretary, one reason for the rift being 'the charges made against him of mis-dealings with Ruskin's money as connected with Jones'.

The wily Howell made use of Ned's well-known lack of funds to sell his work around the wealthy Greek colony. Luke Ionides tells the story in his memoirs of how Howell sold him five or six Burne-Jones drawings 'saying wouldn't I buy them, as B. J. was hard up'. He sold another batch of drawings to one of Luke's brothers as well as to his sister Aglaia Coronio. It turned out that the whole transaction had been trickery:

Shortly after, returning from the opera, as we walked along I said to B. J. that I had some doubts about Howell, as he had tried to cheat me over some china, and then B. J. told me that Howell had been to him and said, 'Poor Luke has no money, and he does so love beautiful drawings. Why don't you send him some drawings?' B. J. therefore gave him some drawings to give to me.

It was hard to keep track of Howell's subterfuges with his trade in imitation Burne-Jones drawings and Fairfax Murray's versions

of Burne-Jones studies which were sold by Howell as originals. For years after the quarrel Burne-Jones remained anxious about the number of spurious red chalk portrait heads in circulation: 'they go about the world and turn up to worry me'.

Worst of all in such a summer of quarrels and upheavals was Ned's serious disagreement with John Ruskin on the subject of Michelangelo. Ruskin had been working on a lecture on 'The relation between Michael Angelo and Tintoret', to be delivered in Oxford in June 1871. He read it out loud to Burne-Jones just after he had written it, on one of Ned's visits to him at Denmark Hill. Ned's response had been despairing: 'as I went home I wanted to drown myself in the Surrey Canal or get drunk in a tavern – it didn't seem worth while to strive any more if he could think it and write it'. He was in a state of shock.

What had prompted such an extreme reaction? In his lecture Ruskin had attacked Michelangelo's physicality and its impact: 'In every vain and proud designer who has since lived, that dark carnality of Michael Angelo's has fostered insolent science, and fleshly imagination.' Burne-Jones could hardly not take this and other such barbed comments as a personal attack, an attack on the Michelangelesque physicality now becoming so evident in his own painting and in particular a reproach to the fleshiness of *Phyllis and Demophoön*. Ruskin was himself super-sensitive to scandal, vulnerable in his longings for Rose La Touche. He was loving to and protective of Georgie. It seems that his earlier sympathy for Ned had transformed itself to criticism, almost to hostility. His horror at the 'dark carnality' of Michelangelo had an obvious application to the Zambaco affair.

Burne-Jones's work had not developed according to Ruskin's plan for it. As Georgie explains it, his dependence on Ruskin had naturally diminished 'as the strength and confidence of the disciple asserted themselves'. Ruskin distrusted the imagination that was 'Edward's life-breath'. She describes a wonderfully comic scene in which Ruskin, in the Grange studio, painstakingly painted a piece of pumice stone, wanting Ned to simultaneously make a study of fruit in minute detail. Ned flatly refused.

Carnality or not, there was at some point bound to be a distancing between them. The father–son relationship had been too close. In 1871 Ned wrote to Charles Eliot Norton about Ruskin:

You know more of him than I do, for literally I never see him nor hear from him, and when we meet we clip as of old and look as of old, but he quarrels with my pictures and I with his writing, and there is no peace between us – and you know all is up when friends don't admire each other's work.

Their 'clipping' continued, the half-embrace of greeting, Ned moving forward for Ruskin to clasp his arm up to the elbow in a gesture that drew them closely together. But the spontaneity was gone.

On 28 August he had a miserable thirty-eighth birthday. He was very depressed, 'trembly and sick all day'. Little Margaret wept because she had no money to buy a present for her father. A fortnight later Burne-Jones was no better and his doctor advised him that he had to go away. The doctor recommended going north. Burne-Jones decided to travel south. In mid-September he set off for Italy again, making his mind up suddenly and hardly giving Georgie any warning, 'so as to go without fuss'.

His discretion misfired. Georgie of course was devastated, confiding in Rosalind, 'I can write of nothing else, and disappointment is an unlovely theme.'

Third Italian Journey
1871

It was now nine years since Burne-Jones's visit to Italy with Ruskin. This was the first time he had set off on foreign travels on his own, leaving for a three-week journey in September and early October 1871. He was no longer journeying '*en prince*' as he and Georgie had previously done at Ruskin's expense, travelling by private coach and staying at the best hotels. He was now compelled to use a more economical and tiring combination of local diligence and 'infernal steam', finding his own lodgings at the local inns.

He travelled by train across France to Turin, arriving on 21 September. His route then took him south via Genoa to La Spezia, the region of Italy so strongly associated with the Romantic poets. Burne-Jones had been reading Shelley at this period. On to Pisa, Florence, San Gimignano, Orvieto, Viterbo and finally Rome, the most southerly point of a tightly packed itinerary. From Rome he went north again to Assisi, Perugia, Cortona and Arezzo, arriving back in Florence. Heading home, he took the Mediterranean coast road via Menton. Although he knew Genoa, Florence, Pisa and Siena from earlier journeys, many of these places, most significantly Rome, Orvieto and Arezzo, were new to him.

He was better prepared than on his previous journeys, artistically more decided, maturer in his knowledge. His sketchbooks of the later 1860s show his range of reference: copies after Mantegna, studies from Renaissance sculpture, drawings from Renaissance

sources, Michelangelo, Raphael, Marcantonio Raimondi, a wealth of detailed understanding built up over the years. These sketches were evidently precious to him. One of the sketchbooks, containing landscape details from paintings by Mantegna and Titian in the National Gallery, bears the note 'Whoever finds this book and brings it to the above address shall be rewarded to his content.'

Burne-Jones also hoarded photographs of Italian paintings and drawings, asking friends and associates travelling abroad to send him catalogues of engravings, entreating Charles Eliot Norton for example to 'choose as you would for yourself. You know what I like – all helpful pieces of modelling and sweet head-drawing, and nakeds by Leonardo and M. Angelo and Raphael – all round, fat babies – O you know so well.'

He reminded the co-operative Norton, 'I like the Florentine men more than all others – any M. Angelo that you think glorious add over and above the number fifty – the scene of Leonardo. If Ghirlandajo draws sweet girls running, and their dresses blown about, O please not to let me lose one.' These hundreds of photographs of old Italian paintings – Michelangelo's *Creation*, Leonardo's *Madonna of the Rocks*, his personal collection of past masterworks – were pasted into albums. They are now in the collection of University College Library in London, battered, flaking off with age, a dilapidated but still strangely moving testament to Burne-Jones's passionate attachment to the artists he saw as predecessors.

Besides photographs, his friend Charles Eliot Norton presented Burne-Jones with an example of the real thing, a fragment of the painting *The Rape of Europa* by Giorgione. The subject had been obscured by overpainting but Burne-Jones had it restored to reveal

a little bright jewel of Venice: so fresh and clear that I never saw it better. Dull sky had gone and green meadows come, and golden city; and stunted tree had gone and Europa's own very bull was trotting off with the frightened thing and jolting along out of the sweetest meadows. When I show it people they all say – all, all, say – is it painted on gold?

So excited was Burne-Jones he planned to have 'a glorious curly-wurly frame' for his new prize possession and put it on public show

and 'someday I shall have a correspondence with a German Professor and see my name in print'. In fact doubts have since been cast over whether the painting is by Giorgione. Could it be a Bonifacio or a Palma Vecchio? Burne-Jones had no such loss of confidence in his Giorgione and it is still in the Burne-Jones family.

There was no longer the sense of early traveller's discovery Burne-Jones had experienced on his previous visits to Italy in 1859 and 1862. Italy had now been opened up to the art tourists, with convenient rail connections running from Genoa south to Rome and from Livorno east to Florence. The contemporary edition of *Murray's Handbook for Travellers* shows how much Pisa, for example, was expanding, recommending two excellent hotels on the Long Arno, 'very clean, with great attention and civility', one of which was named Vittoria after Britain's queen. The guidebook gives its own detailed schedule for visiting the great artworks, the frescos by Giotto in the Campo Santo, the Orcagnas, the Gozzolis which Burne-Jones had once regarded as his own private preserve. Murray's *Handbook* had its recommended supplier of 'Photographic views of Pisa and the Frescoes in the Campo Santo' and reminded tourists of the Church of England service held on Sundays at 11.00 a.m. Burne-Jones's impatience shows in a description of Pisa as 'a kind of distant Hastings with Campo Santo thrown in'.

It was the same in Florence, only more so. Here again Murray's guidebook gives interesting evidence of the rapid Anglicisation of Tuscany by the time of Burne-Jones's third Italian journey and English adulation of Florence in particular, recommending the vantage points of the high ground of the Boboli Gardens, the Church of San Miniato, the fortress of Belvedere or the hills of Bellosguardo from which visitors could admire 'the picturesque forms of the buildings of the city, the bright villas scattered about the rich and wooded plain' with the spectacular mountains in the background. By the early 1870s 30,000 of Florence's population of 200,000 were English or American, and indeed Burne-Jones had hoped to coincide there with his Bostonian friend Charles Eliot Norton, now on European travels with his family.

Initially he was disappointed to discover that the Norton party had by then moved on to Dresden. But very soon, back in Florence and rerunning his old pleasures – the Duomo, the little Giotto chapel in Santa Croce, the della Robbia babies at the Ospedale, and especially the Botticelli paintings in the Uffizi and the Belle Arte – he recovered his equilibrium. He was viewing these treasures with a new maturity, building up the confidence to challenge Ruskin's tendency to overpraise the previously unconsidered trifle: 'it's pretty of him to find little unworshipped bits unjustly forgotten and exalt them: and human of him to exalt them too much – but he cannot yet build a statue but by digging a trench round it to make it taller, and if he praises Giotto today he must disentangle Raphael to make it intelligible'.

Burne-Jones felt more attuned to Florence than to any other city. It was the model for his enchanted garden of eternal beauty. 'I belong to old Florence,' he told Norton that same autumn, and the feeling never left him. In the 1880s he was telling Sidney Colvin, 'I have travelled everywhere – seen all places – but my home is Florence where Giotto lived.' If he could travel backwards in time it would be to Florence in the time of Botticelli, he was insisting well into old age.

From Florence he made his first visit to the nearby medieval town of San Gimignano. There are many picturesque old photographs of San Gimignano pasted into Burne-Jones's photographic records, his albums of delights. The town had become known as San Gimignano delle Belle Torre on account of its thirteen towers, the tallest of which, the Torre del Commune, was 175 feet tall. The tower had a particular place in Pre-Raphaelite iconography, the symbol of forceful incarceration and also of the fulfilment of desire. The story of Danaë and the brazen tower, where Jove came to impregnate her in a shower of gold, was a favourite of both William Morris and Burne-Jones.

In this small strange primitive tower town in Italy Burne-Jones was in his heaven. It was a place dominated by the religious. Of its two thousand inhabitants over a hundred were priests and friars and the town contained a penitentiary for convicted females sent

to the house of correction from all over Tuscany. In San Gimignano Burne-Jones studied the important paintings by Gozzoli in the Collegiate Church and the Church of Sant'Agostino, the frescos by Ghirlandaio, the delicate and beautiful paintings by the Sienese Simone Martini in the Palazzo Publico. He also discovered the inn that he was later to recommend to Fairfax Murray as the best in all Italy. Murray would find it in the central piazza, kept by 'most dear people'. The landlord's name was Giusti. 'Go into the kitchen and sit inside the chimney and think of me who spent a most happy evening there.' He used the San Gimignano townscape for the background of his painting *St Nicholas* soon after his return.

'I went to Orvieto I did, and Assisi.' The agonies over Maria Zambaco seem to be receding as he travels, caught up in the new sights and sounds and the exigencies, for a man as fundamentally incompetent as Ned was, of travelling round Italy unaccompanied. Orvieto was another new town for him and here he was lastingly impressed by Luca Signorelli's extraordinary frescos in the Chapel of San Brizio in Orvieto Cathedral, carried out from 1499 to 1502. At the dramatic centre of the cycle are the scenes from the Apocalypse, Signorelli's brilliantly inventive, ribald, erotic and frightening account of the end of the world. Signorelli was a master illustrator. Bernard Berenson called him the greatest of modern illustrators, and it is in this involvement with narrative that Signorelli and Burne-Jones meet.

The most haunting of the Apocalyptic frescos is *The Resurrection of the Flesh*, showing a crowd of naked figures stranded awaiting judgement on a lonely shore. Some are still pushing their way up through murky rock pools. Some are vulnerable women, shuddering together. Maybe Burne-Jones's thoughts returned a little to Maria. Certainly the enigmatic bleakness of the scene had a formidable influence on his later work, obvious in the starkness and strangeness of *The Sirens*, a painting that first evolved in the early 1870s. Burne-Jones envisaged a shore full of wraithlike women who lure men on to their destruction, looking out from the rocks, tall, beautiful, implacable. There is a great deal of Signorelli here.

He was receptive to ideas even when asleep. On the way to

The Sirens: caricature version of Burne-Jones's recurring nightmare of rotund women enticing men to their doom.

Rome, somewhere between Monte Fiascone and Viterbo, Burne-Jones had a dream of the nine Muses on Helicon so vivid that he drew it as soon as he woke up. By the time he got to Rome he was no longer feeling any sadness or depression and was better in health than he had been for several years. But his first sight of Rome had been anticlimactic. This was simply not the Rome he had expected, the mythical city of his imagination. He later warned Fairfax Murray, 'It isn't possible not to be disappointed with finding that one has made up an image out of hearsays and one's invention which has to be destroyed again – but if you have any luck a new Rome will soon construct itself.'

Burne-Jones never did come round to St Peter's, finding its classicism ponderous and empty, spiritually arid. It seems that the Church of Rome ceased to move him now that his Newmanite piety had gone. There is no trace of St Peter's in his sketchbook of the journey. But he responded avidly to the antiquities, finding the Pantheon glorious, making drawings in the Baths of Caracalla and the Golden House of Nero. And here in Rome, in the Sistine Chapel of the Vatican, came the culmination of Burne-Jones's quest for Michelangelo. His hunger for the works of the greatest Renaissance artist had been mounting over the past years as he entreated George Howard to find reproductions of Michelangelo's work for him in Italy: 'The Renaissance in me will not let me be

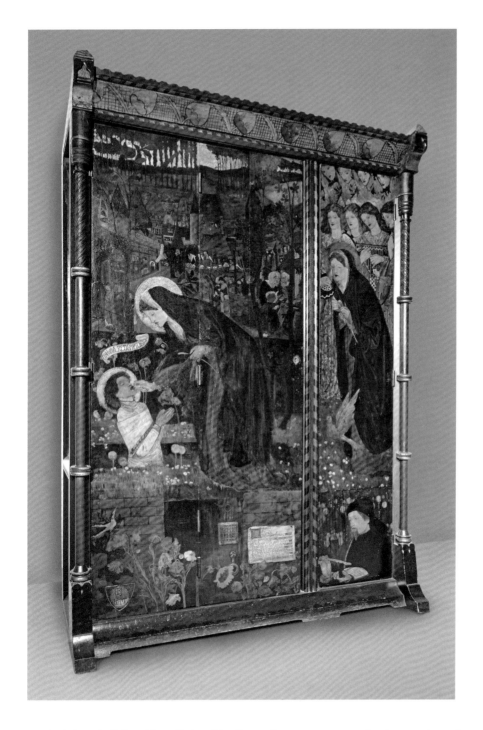

XI *The Prioress's Tale* cabinet. Painted by Burne-Jones as a present for the marriage of William Morris to Jane Burden in 1859. A prime example of Burne-Jones's personalised furniture. It is now in the Ashmolean Museum in Oxford.

How a Prince who by enchantment was under the form of a beast became a man again by the love of a gentle maiden

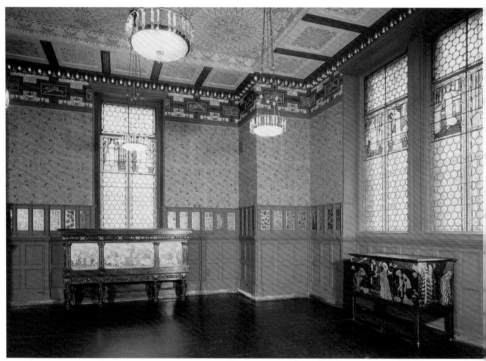

XII *Beauty and the Beast* tile panel designed c.1863 by Burne-Jones for the painter Myles Birket Foster's house, The Hill at Witley in Surrey. The tiles were hand-painted in the Morris workshops on tin-glazed earthenware Dutch blanks.

XIII The Green Dining Room at the South Kensington Museum (now the V&A), decorated by the Morris firm in the mid-1860s. The stained glass and painted panels are by Burne-Jones. The *Ladies and Animals* sideboard on the right was originally painted by Burne-Jones for his and his wife Georgiana's first home in Russell Place.

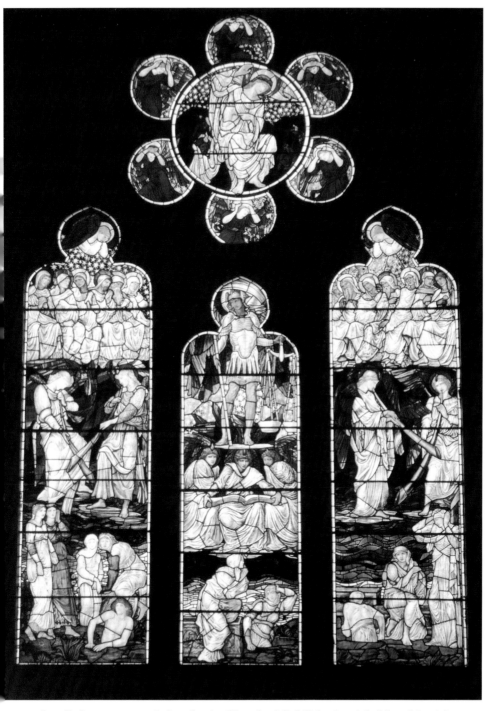

XIV *Last Judgement*, east window for the Church of St Michael and St Mary Magdalene, Easthampstead, Berkshire, 1875. A wonderful example of Burne-Jones's stained glass for Morris & Co., one of the great glories of Victorian church art.

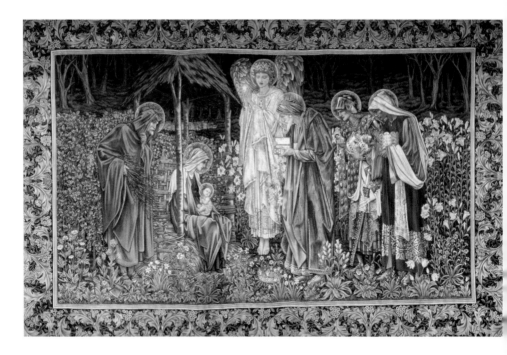

xv *The Adoration of the Magi*, wool and silk tapestry designed by Burne-Jones in 1887 and woven at the Morris works at Merton Abbey. The original version of this, the most popular of all the Merton tapestries, was made for the chapel of Exeter College, Oxford, where Burne-Jones and Morris had been undergraduates.

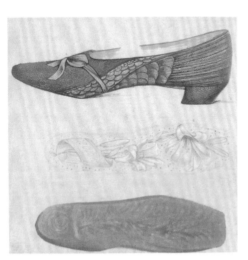

xvi Design for embroidered slippers for Frances Horner, one of Burne-Jones's adored women. His remarkable feeling for pattern and texture is evident in his many sketchbook drawings.

xvii The Whitelands Cross. A gold cross commissioned by John Ruskin from Burne-Jones for the May Queen festival at Whitelands College, a women's teacher training institution in Chelsea. The stylised floral jewellery design shows Burne-Jones's adeptness at working in different materials and on many different scales.

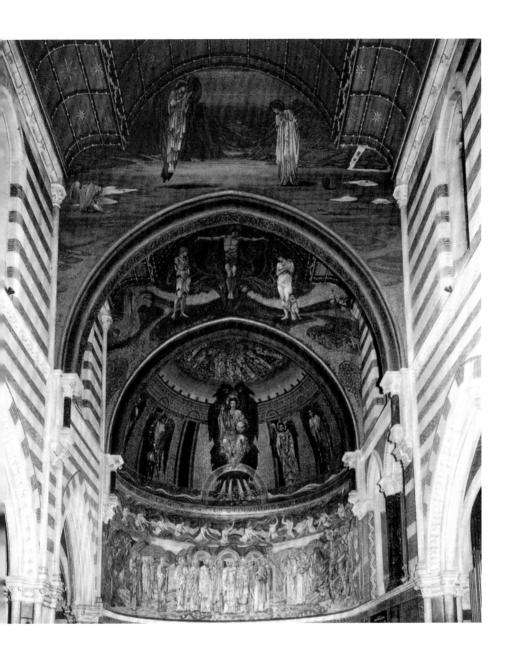

XVIII Mosaic decoration for St Paul's Within the Walls, the American Episcopalian church in Rome. Burne-Jones's largest and most spectacular commission was an ongoing project, not without its problems, through the 1880s and 1890s and was eventually completed in 1907, after Burne-Jones's death.

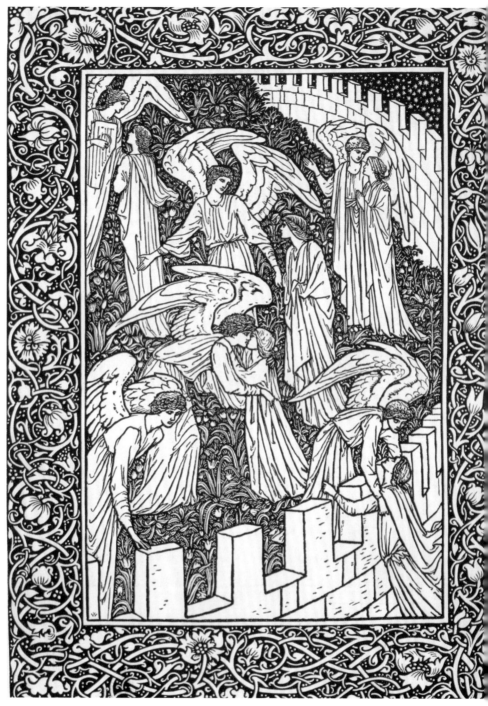

XIX *The Heavenly Paradise*, illustration by Burne-Jones for the Kelmscott Press edition of
The Golden Legend with decorative border by William Morris.
Their joint work for the Kelmscott Press exemplifies the creative interdependence
that continued until Morris's death in 1896.

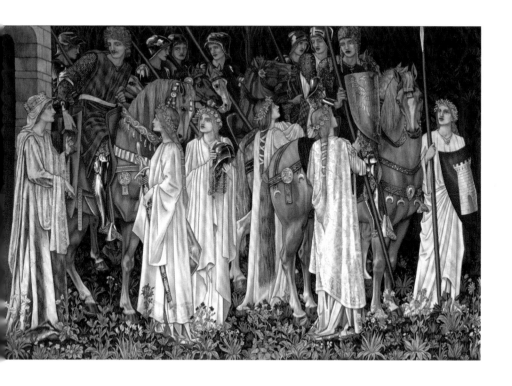

xx *The Arming and Departure of the Knights of the Round Table on the Quest for the Holy Grail*, wool and silk tapestry. One of the six narrative panels of the San Graal series designed by Burne-Jones in 1890–91 and woven at the Morris works at Merton Abbey.

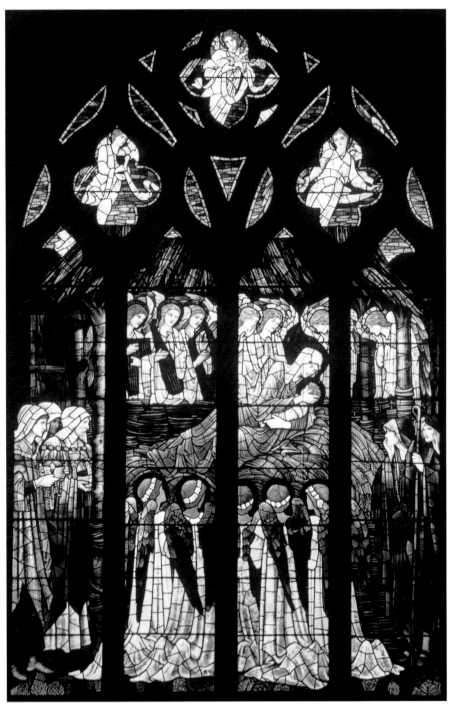

XXI *Nativity, with Magi and Angels*. Memorial window to W. E. Gladstone designed by Burne-Jones in 1898 and installed in Gladstone's local church of St Deiniol, Hawarden, Clwyd. A beautiful example of his later, more free-flowing, designs for stained glass.

satisfied with anything short of the illimitable party . . . somehow I must get them for I keep thinking and thinking of them.' Michelangelo's *The Creation of Adam* from the Sistine Chapel is one of the references stuck into his album, a black and white photograph, muted, indistinct. Now in Rome he was at last confronting the work itself.

The scope, the scale, the colour overwhelmed him. There are nine huge narrative paintings in the chapel running the whole length of the ceiling relaying the stories told in Genesis: God's creation of the world, the temptation and expulsion of Adam and Eve, Noah and the deluge, the origins of man's own history. There are sybils, prophets, other biblical figures in the spaces alongside. The overall impression is of an overpowering mass of bodies, intertwining, writhing figures in a kind of filmic sequence in which each of the narratives emerges as distinct. The familiar stories are retold with an astonishing creative energy and mastery of colour: soft pinks and greens, the hazy blue of distant mountains and the tints of naked flesh.

To Burne-Jones's great surprise and delight he found the frescos in better condition and more easily visible than he had been told. Georgie describes in her memoirs how 'he bought the best opera-glass he could find, folded his railway rug thickly, and, lying down on his back, read the ceiling from beginning to end, peering into every corner and revelling in its execution'. Burne-Jones on his travel rug exploring the Sistine Chapel ceiling is one of the great images of the Victorian age.

The experience of seeing these paintings in reality, their refulgence such a contrast to the shadowy drabness of his Sistine Chapel photographs, affected him profoundly. He noted in the sketchbook:

Haman is perfect and quite clear (of which the photograph is blurred) and the sleeping Adam quite fair (of which the photograph is dark). The chapel is perfect in proportion and covered with painting, and the tone is the same everywhere. Whoever first set the key of colour has been followed by the succeeding painters and the roof is the same too and every painter who has worked in it has used his utmost power.

231

The Baptism by Perugino; the three Botticellis, 'of which the temptation of Christ seemed most wonderful'; the two Signorellis, considered by Burne-Jones to be 'as beautiful as anything in the world'. The drama and completeness of the Sistine Chapel gave new meaning to the concept of artistic teamwork and an almost impossible standard to live up to when Burne-Jones himself was later given a commission to design mosaics for a church in Rome.

He left Rome convinced that nothing grander had ever been done in art than Michelangelo's prophets and sybils and angels in the Sistine Chapel. Raphael might be more perfect as an artist but for Burne-Jones Michelangelo had more of God in him. Raphael was predictable: you could measure him accurately to within an inch. But Michelangelo was immeasurable.

His sketchbook of this journey is more of a small notebook, 18 by 11 cm, with a marbled cover and brown leather spine. It is crammed not just with drawings but with notes of his impressions, scribbled down spontaneously, conveying his enjoyment. The notes, he wrote, 'are made for myself only – to help a weak memory – they will not amuse, and would have been written in Chinese if I had known that tongue'. As Burne-Jones travelled on through Italy he was ever conscious of the changing landscape, drawing the deep gorges, the winding roads, the fig trees, especially loving the sudden surprises of volcanic areas where the hills rose sharply from the plains with what seemed like whole little cities perched on top of them. He watched the human detail with his eager eyes, aware of regional differences in physiognomy. The Romans he rated the most beautiful Italians: 'No men or women look out of their eyes as they do.' Florentines were less conventionally beautiful but Burne-Jones found them bright and interesting in appearance. The Genoese were very handsome, especially the people living nearest to the sea. The saddest-looking people were those of Orvieto, gloomy but still striking, with expressively melancholy eyes. The poor Pisans came out worst, being rated the least interesting of the Italians he saw.

Burne-Jones was already biased in favour of Assisi, birthplace of St Francis. His own adoration of animals made him regard St Francis as his patron saint. The town struck him as a lovely, inspiriting, somewhat chaotic place with crowds of local worshippers thronging through the churches, cats and dogs allowed to roam freely round the altars. He even watched a man on horseback ride right into the big Gothic upper church of the basilica with its cycle of frescos of the life of St Francis painted partly by Giotto. He describes the church itself as 'very ruined', with the frescos in the lower church 'much hurt by smoke'. Burne-Jones was less impressed by the Giottos in Assisi than he was by Cimabue's paintings of the early story of Genesis. The expulsion of Adam and Eve from Paradise especially delighted him: 'The whole set looks wonderful and beyond any idea of Cimabue one had before.'

Assisi was a town of changing crowd scenes. On Burne-Jones's first day there was a *festa* for St Francis's Day, on the second a great fair spreading all along the main street and out amongst the hills. It was a wonderful sight: 'A long narrow street full of people of every possible colour of dress and then a great gateway and another long narrow street equally full and then a great gateway, and outside the walls a great market of white bulls, covering the hills above and below – beautiful white bulls by thousands, and the hills filled with people.' He gives us a thoroughly pictorial description. Assisi, like Orvieto, was one of the Italian towns that Burne-Jones 'learned by heart'.

When he got to Cortona he was less enthusiastic, finding the streets characterless, the people squalid and depressed and the city lacking obvious presence when you viewed it from the valley. But then in Arezzo his spirits rose again, and the reason for this was his new-found enthusiasm for the work of Piero della Francesca. Like his earlier feeling for Botticelli's painting this was an advanced taste for the time. Piero's cycle of frescos in the Cappella Maggiore in the church of San Francesco dates from the mid-fifteenth century. It illustrates stories from Jacobus de Voragine's *Golden Legend*, a thirteenth-century text that recounts the miracle of the wood of Christ's cross.

Burne-Jones would already have been familiar with the English version, published by Caxton in 1483, and indeed William Morris was to print his own version at the Kelmscott Press. But nothing could have prepared him for the originality and beauty of Piero della Francesca's paintings from these stories, the most sophisticated in terms of perspective and command of tonal values in the Italy of the period. His use of shadow and light and his strong sense of anatomy came as a revelation to Burne-Jones, who made copies of the frescos in his sketchbook, the *Victory of Constantine* rating a double page. He absorbed Piero's stillness of atmosphere. *The Queen of Sheba in adoration of the Wood* and the *Meeting of Solomon and the Queen of Sheba*; the mystic *Discovery and Proof of the True Cross*. These are solemn paintings in which strange things are happening. They have a static quality, a mysterious suspended animation, which Burne-Jones was to emulate in his own work. And the colour is remarkable, especially the blueness. Deep blues of people's garments. Pale, flecked blues of the skies. Like Piero, Burne-Jones loved blue: he thought it 'the most pure and beautiful colour in all the world'.

Back in Florence Burne-Jones fitted in an aficionado's visit to the house of Michelangelo, which had only been opened since 1858. Here, in a small room, he saw the artist's walking sticks, his slippers and his writing table, in another room his papers, poems and letters. Burne-Jones carefully examined the wax and clay models, a relief in marble, wonderful drawings and studies, frustrated that nothing had been photographed. If only he could have kept some visual records. 'It is', he notes, 'a quiet beautiful house and one can realise the life in it.' Before he left Florence he returned to Santa Maria Novella, to his favourite 'green cloister'. In Genoa he drew the orange trees, the olive trees, the nearby hill towns, making studies of the local architecture in a frenzy of departure from beloved Italy.

On the way back he stopped in Paris, calling in at the Louvre. Here his sketchbook concentrates on the Mantegna allegories, scribbled down in haste while the warders were not looking since copying the artworks there was not permitted. He surreptitiously

made copies from the *Triumph of Virtue*, copied Vulcan from the *Parnassus* and 'stole the lovely hair ribbons of the dancing muse'. He sketched 'a leg of Mantegna's Mercury, blue-tipped with gold both shoe and feather'. The magic is, as always with Burne-Jones, in the details, in his acute sense of decoration.

By the time Burne-Jones left Italy his list of the painters he loved most had extended: now 'I care most for Michael Angelo, Luca Signorelli, Mantegna, Orcagna, Giotto, Botticelli, Andrea del Sarto, Paolo Uccello, and Piero della Francesca.' In Perugia he had liked Perugino more than ever before, and in Florence Fra Angelico. His old loyalty to Titian and Raphael diminished. 'This time, for some reason, artistic excellence alone had little charm for me,' he said in an attempt to explain his unexpected imperviousness to the Raphaels in Rome.

In a long letter to Charles Eliot Norton written soon after his return Burne-Jones tried to analyse the good that had been done to him by his weeks away in Italy. Before he left he had been feeling

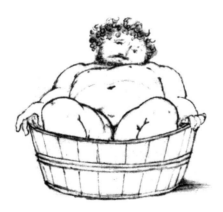

William Morris in Iceland squashed into a bathtub. One of Burne-Jones's cruellest and funniest Morris cartoons.

eccentric and isolated as an artist: 'the miserable feeling of being a mistake was growing'. Now he felt reintegrated, stronger and more purposeful: 'this short three weeks in that seventh heaven of a place has made me live again'. He was even contemplating returning to Italy for good if only he could get 'certain friends' of his to join him. In spite of Maria Zambaco, old ideas of artistic brotherhood died hard.

One of the friends who would not, however, have contemplated such a plan was William Morris. As Burne-Jones became more closely identified with Italy, Morris was moving steadily northward in his allegiances. Leaving Janey with Rossetti at Kelmscott Manor, the house in Oxfordshire they had taken in joint tenancy, he had travelled around Iceland in the summer of 1873, visiting the sites of the heroic Icelandic sagas. Morris came home reinvigorated, with a love of all things Nordic which Burne-Jones began to find a little irritating. 'I quarrel now with Morris about Art. He journeys to Iceland, and I to Italy – which is a symbol.' It was indeed a symbol, a portent of political differences in the years ahead.

The Grange, Two
1872

Burne-Jones returned from Italy with a surge of energy. His own optimistic record of the designs and paintings on which he was working in 1872 is now in the Burne-Jones papers at the Fitzwilliam Museum in Cambridge. There are thirty-four projects on the list and they include ideas and early versions of many of the paintings that are now considered quintessential Burne-Jones. The Sleeping Beauty series; *The Days of Creation; The Beguiling of Merlin; The Golden Stairs*; an enlarged oil version of *Le Chant d'Amour* for William Graham. These were all conceived in what seems an unstoppable outpouring of ideas.

This work-in-progress list gives us a fascinating insight into his way of working. He liked to have a multitude of projects, in varying stages of completion, on the go at once. 'I have sixty pictures, oil and water, in my studio and every day I would gladly begin a new one,' he wrote exultantly soon after he was home. He moved easily from pencil drawing to oil and watercolour painting, shifted almost without thinking from one scale to another. He was concentrating on the niggling detail of a little triptych of *Pyramus and Thisbe* painted in watercolour on vellum. At the same time he had started on the first of his large-scale decorative cycles, returning to the story of 'Cupid and Psyche' for the dining room of the Howards' new house, 1 Palace Green.

Burne-Jones was the master of the uncompleted project and many of these works took years and years to finish, often going

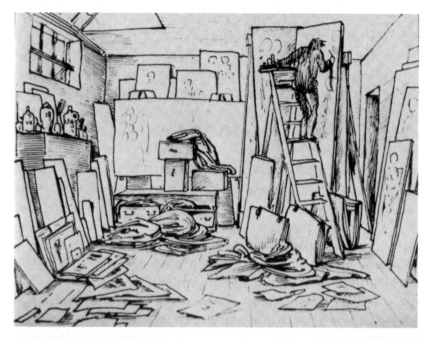

Self-caricature of Burne-Jones in his studio overwhelmed by work.

through numerous versions. *The Golden Stairs*, for instance, was not finally completed until 1880. *The Troy Triptych*, the pictorial epic of the Trojan Wars which had started life at Red House and to which Burne-Jones now returned with a new vigour, even producing a large quasi-Renaissance three-dimensional model, never saw the light of day. William Morris gave up waiting for Burne-Jones's contribution to his new long poem *Love is Enough*, though 'Many designs' for it are listed in the records. *Love is Enough* was published in 1872 without Burne-Jones's illustration.

This was not, of course, the way to make a living as an artist and although Burne-Jones by this time had opened his first bank account, introduced by William Morris to his own bank, Praed's of Fleet Street, he found it convenient to ignore financial realities. He told Fairfax Murray on his return from Italy, 'all my affairs are in their accustomed muddle'. It was to be many years before the family became financially secure.

238

However, the work itself flourished at this period as never before. It underwent a sea change, grew enormously in confidence, ambition. Burne-Jones's journey through Italy had altered his whole view of the possibilities in art, moving him away from the relatively static and decorative classicism that had preoccupied him in the 1860s to a more *mouvementé* and demanding way of painting, of greater dramatic power and psychological depth.

When he said that he now cared most for Michelangelo and Mantegna, Burne-Jones meant it. You can see it the Michelangelesque muscularity of *The Wheel of Fortune*, painted in the 1870s and said to have been his own favourite of his works, obviously related to Michelangelo's *Captives* in the Accademia in Florence of which Burne-Jones had kept an aide-memoire in his notebook. You can see it in his increasingly dynamic stained glass of the period. The volatile and vehement figures of the passions – Rage, Folly, Fear, Injustice – in his stained-glass windows for Jesus College Chapel in Cambridge. The blue-winged and alarming Angel of Victory in Christ Church Cathedral in Oxford, full of pent-up energy and flagellating lines. Then there is the wonderful Italianate west window for Calcutta Cathedral including his depiction of a coiled-up Brazen Serpent and an awe-inspiring Destruction of Sodom, the sinners being scourged by whirling flames. The window was commissioned to commemorate the 6th Earl of Mayo, Viceroy of India, who was assassinated in 1872. A Michelangelesque work for imperial India by a Victorian artist born in Birmingham. By the 1870s Burne-Jones was travelling far.

He looked back on the years between his resignation from the Old Water-Colour Society and the opening in 1877 of the Grosvenor Gallery as the 'seven blissfullest years of work that I ever had: no fuss, no publicity, no teasing about exhibitions, no getting pictures done against time'. Apart from a few pictures shown at the low-key Dudley Gallery in Piccadilly in 1872 and 1873, Burne-Jones's work was now removed from public scrutiny. But the visitors who came to his studio in Fulham were aware of significant developments. Charles Eliot Norton brought the Transcendentalist philosopher Ralph Waldo Emerson to the Grange in November 1872. Norton describes in his journal how the visit impressed the

New England intellectual: 'the richness and beauty of poetic fancy in the pictures, the simplicity, sweetness, and wide cultivation of B-J, struck him with surprise. He had not thought that there was so complete an artist in England. We stayed to lunch; talked of Raphael and Michel Angelo, of the Greek tragedians, of the impersonal quality of the highest genius as a rule.'

These may have been the 'blissfullest years' in terms of work but in other ways they were years of desolation. We have no exact record of how, on his return from Italy, Burne-Jones was received by Georgie but the trust and hopefulness of their early days of marriage were over. Mutual wariness set in. A link with the past was broken by the death in 1872 of Burne-Jones's Aunt Keturah, the 'little aunt' in Camberwell. She bequeathed an old diamond mourning ring to Georgie, set in gold with black enamel with gold chasing. Georgie, who otherwise wore little jewellery, wore Aunt Keturah's diamond from then on.

Still more devastating was the crisis in Burne-Jones's friendship with Rossetti. The previous year, when Morris was away in Iceland, Burne-Jones had at last made clear his disapproval of Rossetti's relationship with Janey and the effect that this had had on Morris. This might look like hypocrisy in view of Burne-Jones's own illicit relations with Maria Zambaco. But he saw Rossetti's takeover of Morris's beloved, the signs of which had started all those years ago in Oxford, in rather different terms, as a callous betrayal of the brotherhood of artists. His own feelings for the apparently stalwart but emotionally vulnerable Morris were protective. His resentment of Rossetti finally erupted. He confided in George Howard, 'With Rossetti I have had the skirmish I planned. First long letters and then a face to face row, but in each case I spoke my mind out to the full. The first time in my life I have experienced that relief with him.'

Since Burne-Jones's return from Italy relations had worsened. Ned had hardly seen him 'for he glooms much and dulls himself and gets ill and better and is restless and wants and wants, and I can't amuse him'. Rossetti had been in an increasingly neurotic

state since the publication in October 1871 of a scurrilously hostile review of his poetry by Robert Buchanan which appeared in the *Contemporary Review* under the title 'The fleshly school of poetry'. As well as attacking the sensuality of Rossetti's writing, Buchanan's barbs extended to the poet's own fleshliness and immorality. The resulting public scandal was one of the reasons for Rossetti's brooding, cutting himself off from even such an old devoted friend as Ned.

By June 1872 Rossetti had a breakdown, suffering a form of paranoia, hearing imagined, accusatory voices, believing that people were conspiring to destroy him. He attempted to kill himself by downing a phial of laudanum. Anxious friends arranged for him to convalesce in Scotland. Madox Brown, who went with him, sent frequent bulletins to Ned, attempting to make them as cheerful as possible. But there was no good news. He was 'utterly broken down', with the best estimate being of three to four months of slow recovery.

Burne-Jones told Norton that Rossetti's illness was the saddest sight that he had ever known, seeming 'to tinge everything with melancholy and foreboding'. It was not just a matter of his feelings of 'tenderness of friendship' for Rossetti but something much more elemental: 'he is the beginning of everything in me that I care for'. Though Rossetti made a semi-recovery, that old precious intimacy was now at an end.

At this time of many tensions art began to mirror life. Not long before the breakdown Rossetti had been writing a series of poems about several sets of lovers, all of them unhappy. Morris's quasi-medieval narrative poem sequence *Love is Enough* also took four sets of lovers as its subject, although in Morris's case 'THEY ARE ALL HAPPY'. For both these poets the subject matter came dangerously close to home. Rossetti's devotion to Janey was now in some ways paralleled by Morris's loving tenderness to Georgie. It was for her that he wrote out his *Book of Verse* in 1870, the book being presented to Georgie on her birthday in August; it was for Georgie that he wrote and then transcribed the vivid, detailed journal of his Icelandic travels. It was to her that he

submitted the first chapters of his only attempt at a contemporary novel, the work now known as *The Novel on Blue Paper* which tells the story of the love of two brothers for the same woman, Clara with the large grey eyes.

Whether because of its rather unimpressive literary qualities or because she found it too emotionally challenging, Georgie was not encouraging when Morris sent his novel to see if she could give him any hope: 'She gave me none.' Morris then abandoned it, dismissing it as 'nothing but landscape and sentiment'. The partly finished novel was eventually published in Penelope Fitzgerald's edition in 1982.

The permutations of lovers changed again when Maria Zambaco suddenly left London. The circumstances of her departure are mysterious. She returned to Paris in the winter of 1872, leaving her children with her mother. On 25 November William Morris was writing sympathetically to Maria's cousin Aglaia Coronio, 'I suppose you will have heard before this reaches you all about Mary's illness and how very ill she has been; though I hope it will all come right now. I did not see Ned for a fortnight, and Georgie scarcely more: it was a dismal time for all of us.' He added that 'quite apart from other matters' Ned himself had not been well at all.

What is still not clear is whether Maria Zambaco had left London because she was ill, worn out with the long-drawn-out on–off affair with Ned, or whether she had now abandoned him for another lover. The compulsive gossip Jeanette Marshall, who in any case greatly disliked Maria, calling her 'meretricious and so ugly' with 'a very awkward manner', had no doubt there was a lover, writing in her diary: 'I hear that Mme Z. after carrying on with Burne-Jones, tired of him (wh. I don't wonder at), and went off with another admirer. Burne fell deathly sick, but recovered.'

Ned himself later made excuses for Maria, explaining to May Gaskell: 'the one who hurt me was not wicked a bit – it was a hard life to lead and she broke down – that's all – she minded so much and so much feared to hurt that it drove her to cheat – she thought I couldn't like her if I knew she was passionate and so she hid it

away'. Remembering the scene of the suicide attempt, this was clearly an illusion.

Burne-Jones's work record tells us that he 'worked much' at *Love among the Ruins* in 1872. This was a painting he especially associated with Maria. The preliminary drawings illustrated the two lovers in a particularly passionate embrace. He painted two watercolour versions in the 1870s, the last of which he finished at the time when his own love affair was indeed in ruins. The painting was one of Burne-Jones's two exhibits at the Dudley Gallery in 1873. Du Maurier considered the painting 'very stunning – almost the best thing he's done I think, although the lovers are not quite to the taste of your humble servant . . . The woman is badly drawn, the length of the thighs being out of all reason and she has neither hips nor belly, and is as bottomless as the everlasting pit.'

For George Eliot the painting was beyond all criticism. Having seen *Love among the Ruins* and *The Hesperides* at the Dudley Gallery, she wrote to Ned to tell him how much his work inspired her: 'I want in gratitude to tell you that your work makes life larger and more beautiful to us.'

Fourth Italian Journey
1873

In April 1873 Burne-Jones departed for his fourth and final visit to Italy, hoping to be reinvigorated by the country that had previously been such 'a fountain of fresh life'. William Morris went with him, not entirely willingly, for his mind was already on his next Icelandic journey, planned for that same summer. But the spirit of comradeship was strong in William Morris and he accompanied Ned for the first week.

They crossed the Channel, surely vividly aware of their aborted journey of four years earlier, at the height of the Maria Zambaco crisis. It appears that they arrived in Paris with a secret agenda, Burne-Jones intent on seeing Maria there. We have no account of the details of his meeting with Madame Zambaco, but the episode has echoes of his painting *The Beguiling of Merlin* with an ageing Burne-Jones, who was now approaching forty and feeling a lot older, still being beguiled, still in desperate pursuit.

After Paris Morris travelled on with him to Florence, taking the train via Turin. It was William Morris's first visit to Italy, and as they passed over the Alps and down onto the plain of Piedmont on 'the most beautiful of all evenings' he reluctantly admitted himself thrilled. Even though the snow-capped mountains were still on either side of them, they were travelling through what seemed to Morris 'a country like a garden: green grass and feathery poplars, and abundance of pink blossomed leafless peach and almond trees'. This was the period of Morris's greatest fecundity in textile design.

They arrived in Florence on Easter Saturday and stayed at the Lione Bianco, a comfortable small inn. Burne-Jones was anxious for Morris to admire the city with which he so closely identified, but it was to be an uphill battle, with Morris now attuned to the dignified poverty of Iceland and resistant to what he saw as Florence's overbearing architecture, ostentatious expression of Renaissance power politics. They went out first thing the next morning to look at the Duomo and Santa Maria Novella, soon discovering that Easter was not the ideal week to be in Florence since the altarpieces in the churches were covered up and many of the galleries were closed. Nor was the weather as good as they had hoped. It rained every day and was just as cold as England, reinforcing Morris's anti-Italian prejudice: 'all his life he can speak of the bleak days he spent in Italy', Burne-Jones wrote sadly home to Phil. He was suffering too in the melancholy weather, describing himself as very tired, lacking the energy of earlier visits: 'I dreadfully want the sun and warm days.'

They spent the next two days attempting to recover from the journey and visiting their old friend John Roddam Spencer Stanhope in his studio at Bellosguardo, sitting around smoking and talking as they used to do together first in Oxford, then in London. Stanhope, known as 'Gholes' because of his habit of exclaiming 'O by Gholes!' when they were at work on the Oxford Union frescos, had been a member of that early inner circle. He was an easygoing, endlessly convivial, handsome man with aristocratic family connections. Georgie describes him as a boy at heart: 'who can forget Mr. Stanhope's laugh who had once heard it?' As a painter he had been apprenticed to Watts and it was Stanhope who, asked to give a view on Watts's initial plan to adopt the teenage Ellen Terry, had replied: 'I say she is *too old*.' When just a few days later Watts's intentions changed to marriage Stanhope's judgement was 'I say she is *too young*'.

Spencer Stanhope suffered badly from asthma and was now spending the winters in Florence, returning to his studio in Campden Hill in summer. This was the studio Ned borrowed while he was working on *Love among the Ruins*. Spencer Stanhope's Villa

Nuti in Bellosguardo was at the very centre of the cosmopolitan artistic and literary Florentine community, spectacularly sited as Burne-Jones was to discover when he walked up the hill beyond Porta Romana to find 'a pretty house that looks all over Florence, and you go up it by a long wall with roses in full flower showing over the top, and trees that you have never seen the like of all over the country, and there are Apennine Mountains at the back'.

Burne-Jones had had a high opinion of Spencer Stanhope's painting, considering his colour 'beyond any the finest in Europe; an extraordinary turn for landscape he had too – quite individual'. Rossetti had also much admired his work. But Stanhope never quite fulfilled this early promise. Ned's young friend Mary Gladstone was right when she described him as a follower of Burne-Jones's 'but with far less poetry'. Burne-Jones agreed sadly that Stanhope's later work had lapsed into the derivative: 'It was a great pity that he ever saw my work or that he ever saw Botticelli's.' After coming to Italy Stanhope's love of the old masters inhibited his originality.

He settled in Florence for good in 1880, painting large, populous Italianate pictures, such as the lugubrious *The Waters of Lethe by the Plains of Elysium*. He took as his pupil his niece Evelyn Pickering, who, with her husband the potter William De Morgan, would later settle in Florence too. Stanhope became a leading figure in local Anglo-American culture, working with Bodley on the decorations of the two Anglican churches in Florence. For one of these, Holy Trinity, he contributed a grandiose fourteen-section panelled altarpiece. But even he was forced to admit that an expatriate artist's life had limitations. Perhaps his visit to Stanhope gave Burne-Jones a premonition of the fate that would await him if he too became an adopted Florentine.

Before they parted company, Morris and Burne-Jones had driven up to Fiesole on what Morris called 'a queer wild showery afternoon'. They had visited San Miniato al Monte, where Morris was appalled by 'the barbarous so-called restoration of the Church'. Burne-Jones could remember it from his early visits in its

relatively pristine unreconstructed state. They went to Santa Croce which Morris soon decided was the finest church in Florence. They arrived in time to hear the singing of the Miserere. They made a quick day trip to see Prato and Pistoia too.

They just had time to wander through a street market in Florence, two Englishmen wide-eyed at 'the lemons and oranges for sale with the leaves still on them: miraculous frying going on, and all sorts of queer vegetables and cheeses to be sold'. Morris was avidly buying peasant pottery. He and Burne-Jones had a kind of running battle, part jovial, part serious, about the relative value of pottery and pictures, Ned arguing the inherent superiority of painting. 'Mind you,' grumbled Morris, 'he is a painter professed, so it isn't quite fair.'

On 13 April, early in the morning and laden with his purchases, Morris caught the train back from Florence towards London and Burne-Jones went on to Siena on his own.

Siena 'captivated my heart', he wrote soon afterwards. He had more time to spend there than on his previous visits in 1859 and 1871. The sketchbook of this visit overflows with his impressions of the steep architecture of the hill town with its often precipitous winding narrow streets, arches slung across from one building to another. He had, for the time being, recovered his old vigour, making copies from the paintings in the Instituto di Belle Arti and the chapel at the Palazzo Publico. On one of these pencil sketches, a wild-haired Apollo with a raven, Burne-Jones has scribbled in a reminder of the colours of the original: gold ground, red flames, gold cross, dark grey-blue robe. The detail always counts. On a little annotated sketch of a *predella* in Siena Cathedral he has noted the gold, the purple, the red ground with 'flowers painted naturally as in illuminated books'.

His days in the cathedral were the most productive. His appreciation of the inlaid marble decorations on the floors pours out over pages and pages of copies of these dramatic scenes, predominantly designs by Matteo di Giovanni made in the fifteenth century. Burne-Jones's copies show his particular fascination with

the Siena Cathedral *Massacre of the Innocents*, its furious emotions conveyed in swift-moving and incisive lines.

In Siena Burne-Jones had arranged to meet Charles Fairfax Murray, his former studio assistant. He too was making the most of making copies. 'Left Murray settling at work at the Pax in the Palazzo Publico,' Burne-Jones mentions in a letter. Fairfax Murray had been living in Italy for the past two years, basing himself in Pisa in the early days of his versatile career as a painter, copyist and connoisseur. He had recently been taken on by Ruskin as his copyist, an appointment Burne-Jones had negotiated for him, hoping to make amends for his disastrous recommendation of Charles Howell as Ruskin's secretary. Murray was now on his way to Rome to make copies for Ruskin of the Botticelli frescos in the Sistine Chapel and was also intending to compile an inventory of old master drawings in the galleries of Rome, correcting mistakes of attribution, tracing the connections between drawings and paintings. This was more or less uncharted territory and was to be the making of Murray's reputation in the lucrative profession of expert connoisseur.

For all his pleasure in his work in the cathedral, Burne-Jones was also sometimes overcome with sadness. 'Italy breaks my heart always,' he told Norton:

it is one thing to talk of it with friends over a fire, but to be in it, and have all the pining and longing that it makes harrowing one's heart, and to feel a long way off and to see long, beautiful, desolate streets and thoughtful, sorrowful faces everywhere, you see, my dear, that makes tears come.

At this point in the journey he was feeling very seedy, having caught a chill from his hours of work on the Duomo's ice-cold marble floor. He was unable to continue with his drawing, getting up very late and having to force himself to eat. When he left Siena early in May his condition was deteriorating fast.

A pathetic bulletin to his American friend Norton is scribbled down in transit in a little pocket book:

I am writing on the train going to Bologna, that's why my handwriting is trembly, not because I am drunk – for it is eight in the morning, and I am

not. I have been round to Volterra, and Gemignano, and now am off to Ravenna. The weather is still cold and stormy, and my cough shakes me a good deal and makes me feel weak and tired always, but good of other kind I am taking in.

Once he reached Ravenna he was feeling even worse. The memory of his horrible Ravenna illness recurs in a letter he sent to Agnes Graham in 1876: 'at Ravenna you will get a fever I know . . . take quinine in the morning before you go into the heavenly churches – they are five foot deep in sea water, with sham floors over the sea, and there one gets a fever'. By this time poor Ned was a mere shadow of himself. Can we assume that at least he struggled onwards to see the great Byzantine mosaics in San Vitale and the Church of S. Apollinare Nuovo and the tomb of Galla Placidia? It was the mosaics of Venice and Ravenna that he cited as his inspiration when, a decade later, he was working on his own mosaic decoration for the church of St Paul's Within-the-Walls in Rome.

Returning homewards at Bologna, he collapsed for several days, delirious, having to abandon his plans for Umbria. He limped back to London slowly. His doctor, Dr Radcliffe, predicted he would not shake off the effects of the Ravenna fever for at least two months. In fact it kept recurring all his life.

Had Maria Zambaco been in Siena with him? In February 1874 he wrote to Fairfax Murray: 'the fever Madame Zambaco caught in Italy still clings to her and I have to spend many anxious days on her account still'. It seems a suspicious coincidence. In any case, while he was with Murray in Siena Burne-Jones had commissioned a present for Maria, a copy of a panel by Duccio. He wrote to let Murray know it had been well received: 'the copy of the small Siena picture you did for Madame Zambaco was in every way delightful and satisfactory and it is now in a big gold frame, so wide that it is astonishing'.

But if they had indeed been together in Siena and the Duccio copy was a memento of their meeting, this was only a temporary episode. The following October Burne-Jones wrote to Fairfax Murray: 'I haven't said a word to you about that miserable affair

Mr. Morris told you of – because I want to help myself forget it and because there are no words for it really in any known tongue'.

This could have been the moment when Maria installed herself in Paris with another lover. Over the next few years there were sightings. Reports came through from her old friend Marie Spartali, now Mrs Stillman, who had called on her in Paris in the winter of 1877, that she seemed to be dying of consumption. Apparently, as Rossetti gossiped on to Janey Morris, 'She was very pale, very ill dressed, and (added Mrs S.) "She *must* be very ill, for her hair was quite black".' Burne-Jones, no doubt alarmed by this description, went to see her for himself in April 1878, travelling to Paris in the somewhat incongruous company of Phil, the earnest young art critic Sidney Colvin and the ever loyal friend Crom Price.

In October 1879 Marie Stillman had visited Maria again, reporting to Rossetti on the scene she found. As relayed by Rossetti to Janey:

Mary Z. and her little pseudo-husband do nothing but work awfully hard at painting and produce Ned Joneses without number. They seem however to be very dejected, and the account rather recalled the end of M. de Camors (if you ever read that horrid book) where the 2 lovers who have made all sorts of mistakes for each other's sake end by living in one house, walking about the grounds far apart, and never speaking to each other. I suppose it would be all right with the Greek lady if she had some kids by the connexion, but there are none.

The reference is to Octave Feuillet's popular novel *Monsieur de Camors*. Who was Maria Zambaco's 'little pseudo-husband'? There is an alluring theory in the Cassavetti family that it was the physically diminutive Charles Fairfax Murray. He was, after all, the supreme Burne-Jones copyist, his copies often being taken for the real thing. In his relations with Burne-Jones there was an element of jealousy, resentment at the lack of leeway given by the master. There would have been a satisfaction in copying his sexual liaisons as he did his works of art. He was, like so many others, attracted to Maria, having often acted as the messenger between them when he was working in Burne-Jones's studio at the height

of the affair. It was Fairfax Murray who had made the copy ordered by Maria's mother of her daughter as the naked Venus in Burne-Jones's *Venus Epithalamia*. When later in life he confessed to the American collector Samuel Bancroft that he had once had an affair with 'a favourite model of Burne-Jones's I was much smitten with', it is tempting to think it had been her.

One argument against the likelihood of Fairfax Murray being Maria's 'little pseudo-husband' is the fact that he already had a wife, the black-eyed Italian girl Angelica whom he had met in Pisa and married in 1875. This is not conclusive. Fairfax Murray was notorious for another long-running extramarital relationship with Blanche Richmond, who bore him four children. More significant perhaps is the fact that, although Burne-Jones and Fairfax Murray had their differences, their long professional and personal relationship continued through the decades with no apparent rift or recriminations until, after Burne-Jones's death, his one-time studio assistant finally took over his master's house, the Grange.

Maria returned to London in the early 1880s without her 'pseudo-husband', moving easily from then on between London and Paris. She took more lessons from Legros and began to make headway as a medallist and sculptor. She made entreating overtures, unsuccessfully, to Rodin, whom she saw as another potential '*cher maître*'. There was still contact between Maria and Burne-Jones. He provided Oscar Wilde with an introduction to her and she held a dinner party in Wilde's honour in Paris in 1883. Desultory gossip continued. Jeanette Marshall suggested, quite convincingly, in the 1880s that the two were working in studios close by one another in Campden Hill Gardens: 'There are only 2 studios side by side, and one is Mme Zambago's (like Lumbago!) & the next Mr. Burne-Jones' . . . If I were Mrs. B.J. I wd. soon have her wig off!!!'

Burne-Jones was still writing to Maria in 1888: 'Dear and ill-used friend. You must believe a bit that I never forget you – and you won't understand how hard I find it to write – come back some day and write and say you forgive your affect. friend EBJ.'

He did not of course forget her. But the journey to Italy in 1873 had in some ways been a turning point. Back in London in the middle 1870s Burne-Jones's emotional focus changed, away from the wayward, passionate young Greek to the cool, collected, charming, as yet sexually unawakened daughters of the English ruling classes: Frances Graham, Mary Gladstone, Laura Tennant. He was now entering his period of worship of the girls on the Golden Stairs.

The Grange, Three
1874–6

A few days before Christmas 1873 George Boyce called at the Grange to see Burne-Jones. 'Found him at home but his wife out. Saw Margaret and Philip and little boy Kipling.' Georgie's nephew Rudyard Kipling was by this time nearly eight and, in Georgie's sympathetic words, was 'now beginning the Anglo-Indian child's experience of separation from his own home'. He and his sister Trix had been sent back from Bombay to live with unknown hired guardians in Southsea, on the edge of Portsmouth. The regime in the House of Desolation, as Kipling came to think of it, was cruelly repressive. The children endured it for five and a half years. The only thing that saved him, according to Kipling's memoir of his childhood, was the Christmases he spent in the contrasting 'paradise' of love and affection at the Grange.

On that particular Christmas, the Christmas that followed Burne-Jones's return from Italy, a boisterous children's party took place in the hall, which was big enough for games of snap-dragon and a magic lantern show. Besides Phil, Margaret and Rudyard there were the Morrises' daughters, Jenny and May, and Ambrose, the Poynters' son, all with their parents. According to Georgie, 'Charles Faulkner and William De Morgan and Alling-ham enchanted us all by their pranks, in which Morris and Edward Poynter occasionally joined, and Burton's beautiful face beamed on the scene, while Mrs. Morris, placed safely out of the way, watched everything from her sofa.' This was the Grange that

stayed on in many people's memories, a house of high spirits and originality.

For Rudyard especially it was a haven. The isolated and traumatised child revelled in the company of his older cousins, making their secret plans as they climbed the sloping branches of the mulberry tree in the garden. He was comforted by the stable, watchful presence of 'the beloved Aunt herself' reading bedtime stories from *The Pirate* or *The Arabian Nights* to the children stretched out on the big sofas sucking toffee. At a slightly later stage he was drawn into the production of *The Scribbler*, a home-made magazine of which Jenny Morris was the editor and in which the Burne-Jones children were involved. Though his written contributions were slight ones, this was Kipling's indoctrination as a journalist.

He responded to the Grange's special atmosphere, remembering 'wonderful smells of paints and turpentine whiffing down from the big studio on the first floor' where his uncle worked. The many pictures finished or half-finished; the cartoons for stained glass drawn out full-scale in charcoal ranged along the walls of the corridors; artistic chairs and cupboards in the living rooms 'such as the world had not yet seen, for William Morris (our Deputy "Uncle Topsy") was just beginning to fabricate these things'. For the child, all this activity in art and craftsmanship made a link to the lost world of his sculptor father back in India. His Christmases at the Grange were recollected as poignant interludes of pleasure. When, eventually, the Grange was up for sale Kipling begged as a memento the open-work iron bell pull at the entrance and installed it at Bateman's, his own house in East Sussex, in the hope that future children would feel happy when they rang it, as he had always been suffused with joy on arriving at the Grange.

At the centre of the ménage was the working artist, the charming, elusive Burne-Jones whose 'golden voice' impressed his nephew. The Grange was essentially an artist's house, perhaps the most famous of its period. But the person who created this special ambience, sustaining it through thick and thin, was Georgie whose

response to her marital troubles was an onrush of almost super-human activity.

'Georgie is tremendous and stirs up the house to a froth every morning with energy,' Ned confided in George Howard with what became his usual combination of admiration and minor irritation at Georgie's competence. 'I get to work with reluctance at 10, wish I was dead at eleven, get hungry at 12, and all the rest of the day wish I was a gentleman and hadn't to paint.'

At the Grange it was Georgie who organised the servants: the cook, the gardener, the housemaids. This was never easy in the London of the time. At the Grange there were apparently no dramas as alarming as the drunken cook at Kensington Square who created havoc. But there are frequent references in the Burne-Jones correspondence to small domestic crises: 'Could you come and share the evening meal?' Ned asked George Howard. 'I don't call it dinner for the cook is going and is so cross that she dishes up many curious inventions of her own expressive of antipathy to the household.'

As cooks came and went it was sometimes his own fault. He confessed to giving notice to another while Georgie was out because she was so ugly: 'I could think of nothing all day but her face, if face it could be called.' There was evidently competition for servants in upwardly mobile Holland Park. Georgie refers to 'changing my three maid servants within six weeks and not yet knowing where to find substitutes for each of them'. Studio cleaners posed a particular problem since Burne-Jones hated strangers within his inner sanctum. The mountainous Mrs Wilkinson the charwoman assailing him with mop, carbolic soap and bucket became the subject of his most brilliant cartoons.

It was Georgie's role to deal with her husband's visitors. All too often they arrived at the Grange unannounced, either to be fended off or kept entertained in the gallery/reception room outside the studio until Burne-Jones was ready to receive them. One day, when Ned was out, Ruskin arrived with Cardinal Manning. Georgie took them upstairs to the gallery and listened with amusement as the two of them discussed *The Mirror of Venus*, on display on its

The dreaded Mrs Wilkinson mopping out Burne-Jones's studio.

easel. Manning asked if it was oil or watercolour. Because of the particular technique of Burne-Jones's painting it was not (and still is not) easy to tell. Ruskin said authoritatively, 'Pure water-colour, my Lord.' But he was mistaken. It was oil.

Until the 1890s, when Burne-Jones employed a secretary, Georgie dealt with much of the official correspondence from clients and from galleries. She took over the whole financial management of studio and household, operating the Praed's bank account, protecting her husband from his own financial problems.

As he later told May Gaskell: 'I can't manage a bit and get into dreadful messes, that is where Georgie has been so good – at the worst times she's never let me know and keeps all the ugly rubbish out of sight – years ago I handed all over to her, and I never sign a cheque even – or see money, except pocket money she gives me when I go into town.' Consciously or not, Georgie safeguarded her marriage by making herself indispensable to him.

The gentle routines established themselves. Burne-Jones ascending the stairs to the studio each morning with his teacup brought up still half-full from breakfast. William Morris arriving every weekend for what became their legendary Sunday mornings at the Grange. The Morris family had moved in 1872 to Horrington House in Turnham Green, only a short walk from the Grange. Morris would arrive for Sunday breakfast and he and Burne-Jones would then go off to the studio to pursue whatever joint project they were working on. In 1874 Ned described the scene to Norton: 'Every Sunday morning you may think of Morris and me together – he reads a book to me and I make drawings for a big Virgil he is writing – it is to be wonderful and put an end to printing.' The book he read was often a Walter Scott novel. The 'big Virgil' was a calligraphic version of *The Aeneid* written out on vellum by William Morris with twelve large pictures and many initial letters to be painted from Burne-Jones's designs. In the end less than half of this project was completed. There was never enough time.

For Sunday lunch and in the afternoons more visitors would come. The reception rooms were wonderful advertisements for William Morris furnishings. When Ned and Georgie first moved in they had ordered fifty-three pieces of Morris wallpaper in five patterns, besides textiles, furniture, tableware, drinking glasses and a generous stock of crates of wine. Memoirs of the period dwell on the convivial tea parties held under the mulberry tree in the walled garden where the regular Sunday throng of close friends and acquaintances admired the decorously artistic atmosphere. The visiting American Charles Eliot Norton soon decided that 'a pleasanter, simpler, sweeter home is not to be found in London, nor one which in its freedom from meaningless conventionality

and in its entire naturalness is more in contrast to the prevailing style of London homes'.

But there were always some dissident voices. Unlike Rudyard Kipling, the playwright and painter W. Graham Robertson, who visited the Grange as a young man, found the ambience 'not conducive to intimacy: there was a hush in the shadowy rooms, people moved slowly and spoke in carefully chosen words . . . Sometimes, at the Grange, one had an uncomfortable sensation of sitting up and balancing a biscuit on one's nose.'

A poignant series of photographs was taken in the garden of the Grange in summer 1874 by Frederick Hollyer. They show the Burne-Jones and Morris families together and include old Mr Jones on his annual visit to London, a surprisingly spruce figure dressed in Sunday best. The occasion was the looming separation of the children. Jenny and May Morris would soon be enrolled at Notting Hill High School, where eight-year-old Margaret Burne-Jones would join them. Phil, who was now twelve, was being sent away to boarding school.

In early life the Burne-Jones children had been taught at home. Then Phil had gone as a day boy to Kensington Grammar School in Kensington Square, where he had apparently settled in quite happily. Why was the decision made to send Phil away to boarding school? 'How we came to decide finally upon sending him from home to school does not matter,' writes Georgie, adopting the evasive tone she uses in her memoirs when approaching super-sensitive subjects, especially those connected with the Greeks. Was Phil being sent away because of the tensions in the household still connected with the Maria Zambaco affair? Ned's letters suggest that by the early 1870s Phil was becoming a problematic boy, 'dreadfulness and dearness strangely intermingled', difficult with his father, brutal to his sister – 'a thing to be alternately caressed and beaten to a jelly'. The metaphor is a disquieting one.

Another lingering question is the Burne-Joneses' choice of school for Phil. Georgie claims 'it will be easily understood' why they chose Marlborough, William Morris's old school. But in fact

Morris was unhappy at Marlborough and always maintained that he learned nothing there because nothing was taught. Ned and Georgie's choice of Marlborough, a particularly brutal boys' public school in those days, for a boy already highly strung and difficult, is incomprehensible. Swinburne, who had been so fond of Phil from the beginning, was especially disapproving, writing to Ned, 'I wish you hadn't put the dear little old chap under a cur who writes against me and lectures against Byron.' The head-master of Marlborough was then Frederic William Farrar, future Dean of Canterbury and author of a two-volume *Life of Christ*.

When the day of parting came Burne-Jones could hardly bear it:

Today I carry Phil off to Marlborough and come back I suppose tomor-row. There are red eyes all up and down the house and Georgie is giving way in a manner unworthy of her Roman virtue – last night we had a feast and sat at the high table Jenny and May and Phil and Margaret and down the long table as guests of inferior moment were Morris and Janey and the Poynters and Webb and Faulkner and his sister and my father – today we wake up rather dismally.

Phil's four years at Marlborough were a terrible ordeal for a nervous, spoilt and beautiful small boy. Right from the beginning he was bullied. His letters home are agonised. Georgie, 'the Spartan mother', advised him to fight back 'and got him a big black eye for her pains'. His father's advice was more long-term and philosophical. Phil should provoke the other boys as little as he could but change his ways in nothing: 'after all dear', he told Phil, Marlborough is 'the world in little, for when you are a man it will be just the same – only backs of hair brushes are not used, but things more tormenting'. His letters to Phil are good ones, wise and understanding, instilling self-reliance, and they reveal much about Burne-Jones's own defence against hostility, his determined preservation of 'the innermost soul that can always be kept locked'.

The lack of Phil around the house, the 'loss of daily sight and hearing', however badly his son might be behaving, was a source of real grief. It would not be so long before Stanley Baldwin, six years younger than Phil, would be approaching school age and Ned wrote to his mother: 'Don't send little Stan to school, Louie – it's much

worse than you would think – and I don't feel sure at all of the compensating good.' She did not take his advice: Stanley Baldwin went to Harrow while his cousin Ambrose Poynter was an Etonian.

If nothing else, his time at Marlborough gave Phil a veneer of sophistication. Philip Webb was staying with the Morrises at Kelmscott when Burne-Jones arrived with Phil on an exeat from school. Beside the 'monstrous fine gentleman' from Marlborough the notoriously crusty and unsociable architect felt 'like a musty old cheese'.

A bonus for Burne-Jones of Phil's four years at Marlborough was that the school was within easy reach of Oxford. He made visits, seeing Faulkner, seeing Ruskin who was now the Slade Professor, making boat trips down the Thames with William Morris, taking nostalgic walks around the places he loved most when he was himself at Exeter. Revisiting Oxford was a half-happy, half-sad experience that made him take stock of the passing of the years: 'how much happier than I ever hoped in some things and more calamitous than I ever dreaded in others'. Part of the sadness was that Morris, Marshall, Faulkner & Co., which had its first beginnings in the collaborative painting of the Oxford Union followed by the decoration of Red House, was on the verge of breaking up.

In August 1874 Morris announced to his six partners that he wanted to dissolve the Firm as originally constituted and take it into his sole ownership. Morris was anxious to develop the Firm further without having to justify his decisions to a somewhat erratic gathering of partners all of whom had their own outside preoccupations, Rossetti, Madox Brown and Burne-Jones as painters, Webb as an architect, Faulkner as an Oxford don and Marshall as a sanitary engineer. Morris had always been the creative driving force and now wanted the Firm under his complete control. Besides, he was short of money as dividends from Devon Great Consols started dwindling. He began to dispose of his interest in the company that had originally enriched his family and in 1875 he resigned his directorship.

Morris's ultimatum divided the partners. Burne-Jones, Webb and Faulkner, the closest of his friends, accepted the justice of his arguments and in any case saw the potential dangers of the unlimited liability clause in the terms of the original partnership. All the partners would be financially responsible if the Firm got into debt. Madox Brown, Rossetti and Marshall took an opposite view, employing the lawyer Theodore Watts to act for them in negotiations with Morris. Their argument was that their artistic effort, their range of contacts and their faith in the project in its early years had been essential to the Firm's success. For Morris to dissolve the partnership just at the point at which the business was becoming seriously profitable was palpably unfair.

The wrangle continued through the winter of 1874–5. Morris was very bitter, threatening to throw the whole affair into Chancery. Burne-Jones was agonised by the possibility of 'the ignominy of an open row'. So many of his hopes and loyalties felt threatened. He wrote to Rossetti: 'I must say I feel ashamed of the remarks of a philosophic world at the spectacle of a set of old friends breaking down in this humiliating way.'

In the end, in March 1875, Morris paid £1,000 each in compensation to Rossetti, Madox Brown and Marshall. Philip Webb made no claim and indeed insisted on forgoing the arrears of salary to which he was entitled. Burne-Jones and Faulkner waived their partners' rights to compensation. On 31 March the announcement was made that Morris, Marshall, Faulkner & Co. had been dissolved and that the business would continue under Morris's sole ownership, trading as Morris & Co.

In many ways the new arrangements benefited Burne-Jones. Though he and Philip Webb were no longer partners they were appointed designers to the company, in a role that would now be described as 'design consultant', Burne-Jones supplying designs for stained glass and Webb advising on furniture and interior decoration. Burne-Jones was already, in spite of his laments about Morris's meanness of remuneration, making a reasonable income from his stained glass for the Firm, his earnings through fees having risen from £106 in 1871 to £1,013 in 1874. Now, as the

Firm's sole stained-glass designer, that income would rise higher.

The Morris & Co. 'Catalogue of Designs used for Windows Executed from June 1876' is a testament to Burne-Jones's professional stamina. The originality and freshness of his early stained-glass windows may have dwindled as many old designs were recycled and adapted. There is some sense of that pioneering excitement being lost. But the sheer quantity and confidence of Burne-Jones's Morris & Co. windows is amazing. It was at this period that the definition of a Victorian stained-glass window began to be a window by Burne-Jones.

But if the reconstitution of the Firm did no harm to Burne-Jones professionally it was a disaster in personal terms, setting brother against brother, old friend against old friend. Deteriorating relations between Ned and 'the irascible, quarrelsome old Brown', evident at the time of the Zambaco affair, became still more acrimonious as Brown felt his loss of income from the stained-glass windows he had up to now been designing for the Firm. He became a little paranoid about the way Ned ridiculed and teased him, forgetting that Ned made even more barbed attacks on William Morris. He felt, unreasonably, that Burne-Jones should have appreciated more the talents of his son Oliver, known as Nolly, and made more efforts to advance him in the world of art. When Nolly, the precociously gifted artist and writer, died of blood poisoning in November 1874, aged nineteen, Ned was shocked and felt a real grief. But he and Georgie felt unable to follow their instinct to call round and mourn with the bereaved family. All they could do was send a formal written message of condolence. The rift had gone too far.

With Rossetti the situation was no better. He had been in a state of terrible inertia since his mental breakdown, unresponsive to the visits Burne-Jones paid him, no longer bothering to ask what Ned was working on or to show him his own paintings. There had been a small rapprochement after Ned had seen Rossetti's *Proserpine* at Leyland's and had written to tell him how greatly he admired it. Rossetti had registered pleasure. But with the quarrelsome breakup of the Firm the clouds again descended. 'As for Mr. Rossetti,'

Burne-Jones was writing indignantly in August 1875, 'I never see him – and think he has lost all care of some of his old friends.'

There was a further crisis of old friendship when Simeon Solomon was arrested in a public lavatory in February 1873 and charged with indecent behaviour and 'attempting to commit sodomy'. He was jailed for a fortnight before standing trial at Clerkenwell Sessions. The man he was charged with, George Roberts, a stable-man, was sentenced to eighteen months' hard labour. Presumably because of the obvious disparity of their social backgrounds, Solomon's more lenient sentence of eighteen months' imprison-ment with light labour was reduced to a £100 fine and a term of police supervision. It seems there had been a similar episode, around 1867, which had caused Solomon to leave England in a hurry. But this was a much more public and damning sequence of events and it threw his former friends into disarray.

Few of the inner Pre-Raphaelite circle could have been unaware of Simeon Solomon's homosexual proclivities, evident not just in his day-to-day behaviour but the driving force in the androgynous mysticism of his art. The *Times* critic had, for instance, only the year before, viewed Solomon's *Autumn Love* as 'one of those allegorical designs which usually suggest something unwholesome in senti-ment'. His intimates may have been anxious about the repercus-sions of his sexual blatancy at a time when sodomy was a criminal offence, but they appear to have been hoping for the best. But now, faced with his public prosecution, most of his former friends took fright and disowned him. This was a scandal that they feared could rebound on them.

Rossetti, for instance, wrote to Ford Madox Brown: 'Have you heard these horrors about little Solomon? His intimate, Davies, writes me: "He has just escaped the hand of the law for the second time, accused of the vilest proclivities, and is now in semi-confinement somewhere or other. I have said little about it on account of the family who have suffered bitterly. I hope I shall never see him again."' The now ultra-respectable Edward Poynter was no doubt alarmed to remember the portfolio of indecent

drawings Simeon had dedicated to him in 1865. Even Swinburne, who had been his closest collaborator, his partner in scurrility, began referring to him as 'a thing unmentionable alike by men or women, as equally abhorrent to either – nay to the very beasts'.

It seems that only Ned continued to support him, although, according to William Davies, 'sickened to death with the beastly circumstances of Solomon's arrest'. The following year, in a Paris public lavatory, he repeated the offence and was sentenced by a French court to three months in prison and a fine of 16 francs. Returning to London, Simeon became an alcoholic and a loner, wandering the city streets, St Giles's Workhouse at Seven Dials in Holborn becoming his only semi-fixed place of residence. He claimed to like St Giles's because it was so central. He picked up a few pennies as a pavement artist and was becoming mentally unstable. In 1880 he wrote to Burne-Jones from hospital where he had arrived in rags and without shoes. Ned and Georgie braced themselves to go and visit him and Ned wrote to his most potentially influential friends, the society solicitor George Lewis and his wife, to see if they could intervene on Solomon's behalf.

But things went from bad to worse. Solomon apparently repaid the Burne-Joneses' loyalty and kindness by carrying out a burglary at the Grange. He liked to tell the tale of how he and Jim Clinch, a professional burglar accomplice from the workhouse, arrived at the house in 'a remote neighbourhood of London' of a well-known artist friend from whom he had already received 'a considerable dole'. They broke in one evening, both drunk, and made for the dining-room silver. The commotion woke the household. Georgie sent Phil to fetch a policeman. The policeman and Ned surprised the burglars. Burne-Jones was then obliged to bribe the policeman in order to save Solomon from arrest.

Solomon lived on for decades, a destitute and sombre Gustave Doré figure occasionally spotted by people who had known him on the brink of what had seemed such a brilliant career plying his poor trade on the pavement in Brompton Road, or jostled along by the milling crowds in Fleet Street. He had balded prematurely and his big beard was now snow-white. Contemplating the complex

tragic cycle of his life, a range of experience so remote from his own, Ned may have recollected a comment made years earlier: 'You know, Simeon, we are mere schoolboys compared with you.'

Through the 1870s the closest of Burne-Jones's client relation- ships was with George and Rosalind Howard. Such productive friendships arose from his refusal to separate the professional and personal. 'Your loving friendship', he confided in George Howard, 'is one of the best things I have in life.' It was his philosophy, as it was William Morris's, that art was life and vice versa and that one of life's chief pleasures was in bringing to fruition the creative ambitions of the people you loved most.

Burne-Jones had first been drawn into the Howards' plans for their London house, no. 1 Palace Green, back in 1869 when the large red-brick house designed by Philip Webb was still under construction. George and Rosalind conceived it as a studio house like others in that area of Kensington, a palace of art with space for entertaining on a lavish scale. He shared in their excitement, climbing up the ladders to the second floor of the four-storey building in what is now Kensington Palace Gardens, often referred to as Millionaires' Row. In those days the area felt more relaxed, less urban, and there was still a green opposite the house.

In spite of their aristocratic connections the Howards were not rich: they had liquidated shares to finance the building. But they were young, both still in their twenties. They were energetic and they had ideals. Their choice of architect, inspired by their admi- ration for Philip Webb's studio house for Val Prinsep, had run them into trouble with the Commissioners of Woods and Forests, and they had endured the Victorian equivalent of a planning dis- pute when Philip Webb's designs were initially turned down as being too outré for the site. Webb finally, reluctantly, modified the plans but the house as built was still a beacon of modernity in Kensington. It was also a considerable showcase for Burne-Jones.

The house was decorated by the Morris firm in their well-tested Green Dining Room mode of painted ceilings, painted panelling and wallpapers, layerings of pattern. A contemporary photograph

shows Rosalind lying on a day-bed in her newly decorated boudoir, a sleeping beauty in her bower. In the boudoir hung four pictures by Burne-Jones: studies for *St Dorothy*, *The Merciful Knight*, *The Mirror of Venus* and a chalk head of a woman. In George Howard's third-floor studio, decorated with Morris's *Pomegranate* chintz, was a study by Burne-Jones for his painting *The Fates*. On the first-floor landing stood an organ for which Webb designed the case and Burne-Jones decorated it. Rosalind exclaimed in her diary: 'E B Jones has done a beautiful picture for me in my organ. How good and dear he is to do that for me. It is most lovely in colour and composition and sentiment. It is a man in red drapery playing an organ.' In the thrill of the moment she had failed to recognise St Cecilia.

Burne-Jones was involved, with Webb and Morris, in many of the detailed decisions. Rosalind was, for instance, discouraged from hanging William Morris's *Sunflower* wallpaper in her boudoir in its gilt and lacquer version as its glitter would be in competition with the paintings. Burne-Jones and Morris suggested a red paper would be better, with woodwork painted a contrasting blueyeggshell: 'I went this morning to see the room where Morris has hung a piece of red hanging by the picture – it seemed to do but of course we cannot tell if you would like it.' Morris's *Iris* chintz in red was finally decided on. There are also references to Burne-Jones directing the men moving the furniture. Such hands-on involvement reflected a whole shared informal attitude to art.

Burne-Jones's tour de force at 1 Palace Green had been part of the planning from a very early stage. In winter 1869 Rosalind had written in her diary: 'Ned Jones says he will paint the frieze in the dining room. How delightful. I think the house will be quite lovely.' Decorated dining rooms were then coming into fashion. Mid-Victorian diners were feeling the need for something sensational to look at while they ate. Whistler would be painting his spectacular Peacock Room for Leyland within the next few years. In designing the dining room on the ground floor at 1 Palace Green, Webb had carefully provided 'a very good space' flowing around the upper panelling, awaiting a sequence of murals by Burne-Jones.

He had already planned out the frieze and made preliminary watercolour designs when the canvases were ordered. It was an ambitious sequence, a cycle of twelve panels in the grand Italian manner of Pinturicchio, Perugino and Mantegna, painters that the Howards, like Burne-Jones, had admired on their travels in Italy. The designs for the murals were developed from Burne-Jones's abandoned drawings for the 'Cupid and Psyche' story which the Howards had seen in his studio. The narrative paintings were designed to run horizontally around the dining-room walls, enfolding the diners in the dramas of the love quest. Burne-Jones's scheme for *Cupid and Psyche* was customised, adapted to fit the architecture of the room. Provision was made for Philip Webb's grand fireplace, two flue grilles being integrated in the composition. The happy ending panel, showing Psyche received by the gods on Olympus, was positioned on a lower level occupying its own triumphal Gothic niche.

The panels were begun in Burne-Jones's studio and gradually moved to Palace Green to be worked on *in situ*. But as so often with Burne-Jones's ambitious projects, progress was extremely slow, interrupted by illness, depression, diversion to other work and frequent urges to revise his original designs. Thomas Rooke, Burne-Jones's studio assistant, worked on *Cupid and Psyche* under his direction. Then in the middle 1870s Walter Crane, a younger admirer of Burne-Jones's and a friend of the Howards, was brought in to virtually take over the project, finding the canvases in various stages of development, 'some blank, some just commenced, some, in parts, considerably advanced'.

Crane describes in his autobiography how he allowed himself 'considerable freedom' in working on the canvases back in his own studio, especially on subjects Burne-Jones had not yet started or had not got far with, though he claims to have 'endeavoured to preserve the spirit and feeling of the original designs'. Crane then brought the canvases to Palace Green, sending an optimistic letter to George Howard, who was then at Naworth Castle, telling him that they had been put up into position on the wall. 'Burne-Jones', he says, 'then joined me, and we both worked on the frieze, in situ,

Burne-Jones and Walter Crane working on the *Cupid and Psyche* murals
at 1 Palace Green. Sketch in letter from Walter Crane to George Howard.

on trestles.' Included in Crane's letter is a jaunty little sketch of
Ned and himself working happily together.

Crane's optimism was misplaced. Burne-Jones was horrified to
see what Crane had done and now, at this late stage, he felt com-
pelled to start repainting all the figures himself as well as redesign-
ing whole areas of background. 'I hope Crane won't be hurt,' he
told George Howard. 'I have had to alter much. I think they were
painted in too dry a material for some of the colour wipes off with
a dry duster.'

The *Cupid and Psyche* frieze, which still has a not entirely
successful dryness of texture, was not finally completed until 1882

and Burne-Jones was never satisfied with it. 'As to Palace Green I am sore vexed,' he wrote. 'I wanted to make it a delight.' But to others who saw it installed in the relatively austere dining room, the effect of the romantic-mythological frieze set between the decorative coffered ceiling and the glittery gold and silver panel of the dado was altogether magical. For a critic writing in *The Studio*, 'the whole appears to glow like a page of an illuminated manuscript'.

Meanwhile the Howards, not deterred by the delays and complications of working with Burne-Jones, recommended him in the 1870s to design a series of stained-glass windows for their local church, St Martin's at Brampton, close to Naworth Castle. The architect again was Philip Webb and the church a fine example of his quirkily uncompromising style. All the glass in the church is by Burne-Jones and the magnificent east window, commissioned to commemorate George Howard's father the Hon. Charles Howard, is perhaps the prime example of his mid-period stained glass. There are three rows of figures, wonderfully coloured in rich crimsons, purples, russets. The angels have blue wings. In the lower central panel is the strange and lovely image of 'the Pelican in her piety', taken from the bestiaries, the bird standing for one of the types of Christ. The pelican bends her long neck to feed her young, the nest standing on elegantly convoluted branches of a tree seized upon by Nikolaus Pevsner, when he saw the window in the mid-twentieth century, as a starting point for art nouveau.

Burne-Jones describes the east window ironically but proudly in his Morris & Co. account book as 'a colossal work of fifteen subjects – a masterpiece of style, a *chef d'oeuvre* of invention, a *capo d'opera* of conception – fifteen compartments – a Herculean labour', grumbling that at £200 it was a bargain. Morris, as colourist, was pleased with it as well, writing to George Howard, 'I am very glad indeed that you think the east window a success. I was very nervous about it, as the cartoons were so good that I should have been quite upset if I had not done them something like justice.' This quotation tells us much about the intimate nature of his and Burne-Jones's artistic collaboration.

The connection between Burne-Jones and the Howards con-
tinued through the years and gathered strength. Burne-Jones
designed stained glass for Lanercost Priory, the ancient church
with its ruined monastery buildings on the River Irthing close to
Naworth. There were projects for Naworth Castle itself, including
the never-to-be-delivered fresco of *Arthur in Avalon* for the
library. Morris & Co. stained glass, textiles, wallpapers and fur-
nishings were ordered in almost reckless quantities both for
Naworth and for Castle Howard, which George and Rosalind
eventually inherited. The artist/client relationship survived the
vicissitudes of the Howards' marriage as the increasingly dogmatic
Rosalind became a campaigner for temperance and women's
suffrage. Burne-Jones helped to form their taste as the Howards'
faithful and imaginative patronage gave him great creative
opportunities.

But there were always differences. The Howards were relatively
worldly and sociable people, enthusiastic givers of house parties
and dinner parties, gatherers together of the leading intellectuals,
politicians, writers and artists of the age. Burne-Jones, although
he could now shine in such society, from time to time evinced the
creative person's panic at being swallowed up by chattering
crowds. In August 1874 he went to stay at Naworth Castle. George
and Rosalind's welcome could not have been warmer. William
Morris was staying at Naworth too and a reunion was arranged
with their old Oxford friend Dixon, who was now a minor canon
of Carlisle Cathedral. 'My Naworth journey was very pleasant',
wrote Ned, 'and I could well have prolonged it, but the horizon
grew thick with gathering guests, and I fled.'

In 1875 Burne-Jones acquired a new and important friend and
client, Arthur Balfour. For Burne-Jones, who saw himself as a
reformer and republican, this new connection may strike one as
surprising. Balfour had been elected a Conservative MP just the
year before. He would serve in the cabinet of his uncle Lord
Salisbury, in 1902 becoming Prime Minister himself. It was
Arthur Balfour who, as Foreign Secretary, brokered the 'Balfour

Declaration' of 1917 which assured the Jews of a 'national home' in Palestine.

But Balfour was not a predictable Conservative. Tall, laconic in manner, emotionally distant, Balfour was an intellectual and connoisseur. A devotee of philosophical argument, his first book *A Defence of Philosophic Doubt* would be published in 1879. He was a man of taste who loved good music, a regular attender at the concerts at St James's Hall. He insisted on good food, having a special hatred for tapioca pudding. His niece remembered how 'Plenty of cream was apt to be his criterion for dishes, just as velvet was his criterion for women's dress'. Balfour set great store by friendship, being a leading light, indeed the central figure, of 'the Souls', the self-consciously witty and well-bred group of young men and women who gathered at the country-house parties of the next two decades. Burne-Jones responded to his charm and strange elusive personality and what started as a professional commission soon developed into an enduring love of Balfour, 'both him and his company'.

Arthur Balfour was originally taken to the Grange by Lady Airlie, an old friend of his mother's. There is a suggestion that the expedition had been planned to cheer him up after the sudden death from typhoid of May Lyttelton, the girl he planned to marry. Meeting Burne-Jones in his studio, Balfour tells us in his memoirs he 'at once fell a prey both to the man and his art'. It may have been at this point that he saw, admired and earmarked for himself the monumental painting *The Wheel of Fortune*, one of many works in progress. He certainly entered into discussions for the decoration of the drawing room at 4 Carlton Gardens, the house he had moved into in 1871. Burne-Jones was soon telling George Howard, 'I have just had a commission I shall like for a young man named Balfour . . . he wants pictures to go round a room, some story or another which will be very pleasant work – he is very delightful and amicable and so young that it is painful.' Balfour at the time was twenty-six.

Balfour had wanted 'his new friend' to design for the dining room 'a series of pictures characteristic of his art'. The story

proposed by Burne-Jones was the Perseus legend, based once
again on one of the narratives, 'The Doom of King Acrisius', from
William Morris's *The Earthly Paradise*. This is the story of Per-
seus's search for and destruction of the Gorgon Medusa and his
rescue of Andromeda from the sea monster who attacks her on the
rock. It was indeed typical of Burne-Jones's art in that it was
another quest tale, a chivalric narrative in classical guise. More
than that, the *Perseus* series can be read as a contemporary com-
ment on the condition of England, a depiction of the search for an
alternative world of beauty in an age of moral degradation and
squalor. A pertinent subject for the drawing room of a future
Prime Minister and a philosopher.

After viewing the room Burne-Jones was determined that paint-
ings and architecture should be planned out in conjunction. 'The
whole room', he told Balfour, 'should be in harmony and the whole
should look as if nothing was an afterthought but all had naturally
grown together.' He demanded that the whole room should be
panelled in oak reaching from floor level to a height of six and a
half feet and surmounted by the sequence of pictures 'painted in
a light key, something in tone resembling the procession by
Mantegna at Hampton Court'. Balfour had been proud of his well-
lit drawing room, but Burne-Jones now decided that the light was too
dazzling to do justice to the pictures and insisted that the windows
should be reglazed with small bevelled plate-glass panes.

In his negotiations with Balfour we get a fascinating glimpse of
Burne-Jones the artist, confident, high-minded to the verge of
arrogance. 'The chief argument against this total change is the fact
that the room might look incongruous with the rest of the house,
but what can one do in these days, with the inheritance of a hun-
dred years of ugliness and dreariness before us, but clear a little
space as a sort of testimony that we don't like it though we have to
bear it.' Only in the matter of cost is he more bashful, suggesting
a £500 advance 'either altogether or payable at sums of a hundred
at a time'. The total cost of the *Perseus* panels was at this stage
estimated at £3,800.

As with all his new subjects there was an immediate onrush of

activity. Burne-Jones mapped out the grand scheme for the project. We can still see his preliminary plan for the cycle of ten paintings to be ranged around the walls set in a unifying border of gilded stuccowork in William Morris's *Acanthus* design. Burne-Jones made special provision for the spaces above the fireplace and doors where two of the four intended *Perseus* panels in gesso relief would be hung. His sketchbooks show his depth of concentration as the subject started gripping his imagination.

There are pages and pages of preliminary studies. Nude sketches of figures, then the same figures clothed. Drapery studies. Details of rock forms and seascape, birds and animals. There are many alternative versions of the monster from which Perseus rescues Andromeda, variations of fangs and scales and fins, the elongated head, the forked tongue and gnashing teeth. There is still the same love and exuberance of drawing for its own sake people noticed in Burne-Jones when he was a boy. The grotesque head of Medusa especially transfixed him. He wrote to Phil at Marlborough to tell him he had been working at the British Museum 'looking up all the most ancient ways of portraying Medusa, and they are very few but very interesting, and I know much more about it than I did'.

His way of working was rooted in craftsmanship. For Perseus he made a clay model, which took him a whole week and he allotted a further week to modelling a snake to wind around the image, the effect he needed for the slaying of the monster in *The Doom Fulfilled*. Sometimes the studio resembled a theatrical costumier's as Burne-Jones worked out his ideas in three dimensions. He told Phil: 'All evening your Mama and I have been shaping a cap for Perseus, and hosen for him and a sword.'

When it came to live models for the cycle Burne-Jones reverted to his old habits of pursuing stunners. In spring 1877, Richard Wagner came to England to conduct a series of concerts and Burne-Jones, unusually, went to a morning rehearsal at the Albert Hall where he spotted in the audience a girl whose head struck him as perfect for the *Perseus* series. He achieved an introduction through a friend, Richard Grosvenor, to twenty-one-year-old

Margaret Benson. 'She has often been called my "Burne-Jones daughter",' said Mrs Benson, agreeing to Burne-Jones's request that she should model for him. In this knowing, sophisticated section of society Burne-Jones was now becoming a name to conjure with. He made many studies of Margaret Benson and was also to enrol her brother William – the metalwork designer W. A. S. Benson – as a model for his second series of *Pygmalion* pictures and, later, for the King in *King Cophetua and the Beggar Maid*.

Burne-Jones worked on the *Perseus* series for the next two decades, adapting the designs, repainting the cartoons, removing extraneous detail, paring down to its essential elements the cycle that is his undoubted masterwork. He once said of the paintings that they 'grow as slowly as granite hills'. Only four of the oils were ever finished. The patient Arthur Balfour waited uncomplaining. In 1875, at the start of the commission, Burne-Jones had urged him to complete the decoration of the drawing room so that 'even if the pictures had to wait and if they were never added the room would still look beautiful'. Balfour could never claim not to have been warned.

With the increase in Burne-Jones's large-scale work the studio became more than ever crowded and inadequate. In desperation, a small additional studio-storeroom was built as an extension alongside the original first-floor studio and stacks of canvases, cartoons, spare easels and working materials were kept there. But it was a losing battle. Even once *The Days of Creation* had left to go on exhibition, the studio seemed fuller rather than emptier. Burne-Jones moaned, 'My rooms are so full of work – too full – and I have begun so much that if I live to be as old as the oldest inhabitant of Fulham I shall never complete it.' Plans eventually had to be made for a separate larger purpose-built studio at the end of the garden of the Grange.

Burne-Jones was now operating his studio on the lines of a Renaissance atelier, using studio assistants to carry out the routine tasks of transferring his original drawings to working cartoons for stained glass and tapestry, carrying out his decorative schemes and

doing the preliminary underpainting on Burne-Jones's canvases. They were also employed in making copies of the master's works. Holman Hunt was almost certainly exaggerating when he claimed that Burne-Jones was employing twenty studio assistants. But after Fairfax Murray, who had been a sixteen-year-old boy when he first arrived to assist Burne-Jones in 1866, and Thomas Rooke who followed three years later, numerous assistants and pupils came and went. Henry Ellis Wooldridge; Francis Lathrop, an American who worked with Burne-Jones from 1871; James Melhuish Strudwick from the later 1870s. These were some of the names that appear in the records. Burne-Jones later recruited a studio boy, 'the sharpest and most impudent' of the many applicants from the charitable Boys' Brigade.

There was to some extent a floating population of studio assistants passed around the artist circles of Burne-Jones, Henry Holiday, Leighton and Watts. Most assistants were employed on a temporary basis. Burne-Jones pointed out: 'I cannot keep them always at work – for they can prepare for me in one month what would take me twelve to finish.' His attitude to his assistants was autocratic. Once the preparatory work was done, he took over. Fairfax Murray found the process frustrating and demeaning: 'an artist like Mr Jones cannot be satisfied with any work but his own . . . He insists that it is useful to have it so prepared for him, but there is no pleasure in doing a little thing carefully and spending days over it [for it to be] destroyed ruthlessly in a few moments.' The gentler, less ambitious Thomas Rooke – referred to by Burne-Jones as 'little Rooke' or 'Rookie' – remained his chief assistant almost all his working life.

On St Valentine's Day, 14 February 1875, Frances Graham received an extraordinary card. Her friend Mary Gladstone comments in her diary: 'F has got such a beauty from Mr. Burne-Jones – a big picture of Cupid dragging a maiden through all the meshes and mazes of Love. He has got a glory of little birds, so pretty.' This was a pencil study for *Love and the Pilgrim*. The card marks the beginning of a new intense relationship between Burne-Jones

and Frances, the child he had first loved because she was so much in the likeness of her father. Now he began to love Frances for herself and it was a love that lasted all his life.

As she described it in retrospect, 'When I was eighteen or nineteen, Edward Burne-Jones, who was about forty, and living a quiet life, became my friend, and poured into my lucky lap all the treasures of one of the most wonderful minds that was ever created.' He would come to the house in Grosvenor Place and dine there two or three times a week with William Graham and the family. Frances, her sister Agnes and their father made expeditions together with Burne-Jones to art galleries, to circuses and plays. Ellen Terry and Henry Irving were then at the height of their fame and Burne-Jones had become a close friend of them both.

What was the attraction of Frances for Burne-Jones? The beautiful, adorable child had now grown into a young woman of great poise, originality and intelligence. Her friend Margot Tennant, later Margot Asquith, describes Frances as 'a leader in what was called the high-art William Morris school and one of the few girls who ever had a salon in London'. She dressed in unusual Aesthetic clothes and summed people up quickly with her 'ghost eyes', as a small boy once described them. Frances was no one's fool. She was well read, quick and witty, a leader of 'the Souls'. But she had an inherent purity of outlook, a sense of morality that answered Burne-Jones's own fastidious work ethic. If Maria Zambaco had the sudden attraction of the alien, with Frances he was back on his old familiar ground.

Ruskin adored her too when Burne-Jones introduced them. 'The new pet is Frances Graham of Glasgow,' he wrote to Sara Anderson, 'and she is a great pet of Edward Jones's.' Frances took Ruskin to the first English performance of Wagner's *Die Meistersinger* which he found an ordeal, complaining, 'Oh, that someone would sing Annie Laurie to me.' But he and Ned gloated together over 'Francie' as Burne-Jones made a multitude of portrait drawings of his new inamorata. Frances was the model for the face of the sea-nymph on the right in *The Arming of Perseus*. In *The Golden Stairs* Frances is the girl at the bottom of the stairway about to

clash her cymbals. When her father commissioned Burne-Jones to decorate a piano for Frances, probably a present for her twenty-first birthday, he used the story of Orpheus and Eurydice. She modelled for Eurydice; Burne-Jones himself is Pluto, keeping her captive. As with Maria Zambaco, Frances's features are embedded in his work.

Behind Frances on the fateful marble staircase is her older and somewhat less decorative friend Mary Gladstone, third of the four daughters of William Gladstone, the great Liberal leader whose first term as Prime Minister ended in 1874. It seems the highly cultured and artistic Mary Gladstone first visited Burne-Jones's studio at the Grange in that same year on a studio tour that also took in Spencer Stanhope's studio on Campden Hill and W. B. Richmond's at Beavor Lodge in Kensington. Burne-Jones happened to be out but her diary tells us that she found the studio 'a treat, cram full of lovely things'. The picture she liked best was 'Pygmalion standing before his statue. The statue isn't half pretty enough, but he is beautiful in rapt contemplation of his work.'

A year later, at a formal dinner party, she was taken in to dinner by Burne-Jones. They 'talked hard' and he told her many things the earnest young woman thought worth remembering. One of the comments that especially struck her was that Robert Browning's outside was merely 'moss'. The social persona was negligible. It was the works of a man that were his real self.

Mary Gladstone judged Burne-Jones 'delightfully un-P. B. for such a P. B. artist': by P. B. she means 'Passionate Brompton', current usage for Pre-Raphaelite droopiness and sighs. Their friendship developed. In June 1875 she went with Frances to the Grange where they looked through Burne-Jones's sketches for Morris's *Virgil* and 'at his designs for the Balfour room'. These had a special poignancy for Mary who had been in love with Arthur Balfour, evidently without reciprocation. The visit ended with tea in the studio followed by a stroll around the 'pretty, old-fashioned garden'. They picked roses. Mary noted in her diary that on his own home ground Burne-Jones had seemed a little shy.

Burne-Jones's intimacy with Mary Gladstone developed in tandem with his devotion to Frances. There is a sense of his playing one off against the other. But whereas Burne-Jones's love of Frances was in part a sexual longing, his relations with Mary were gallant but platonic. 'Very odd how my greatest friends are all about fifty, Lord A [Lord Acton], Mr B-J, and Sir A. Gordon. But it's a pleasant footing because so delightfully safe,' Mary Gladstone wrote contentedly a few years later on.

It was partly through Mary that Burne-Jones got drawn into his most active phase of political involvement. This was the Eastern Question Affair in which Gladstone galvanised public opinion against Turkish massacres of Orthodox Christians in the Balkans. Turkey was ignoring Russian protests. Mary herself was at the centre of the agitation, describing in her diary for 4 September 1876, written at Hawarden Castle, how 'Papa rushed off to London Sunday night, pamphlet in hand, beyond anything agog over the Bulgarian horrors, which pass description. The whole country is aflame, meetings all over the place. There is no conceivable or unconceivable atrocity those villainous Turks have not been capable of.' This pamphlet was *The Bulgarian Horrors and the Eastern Question*, the most famous and effective of Gladstone's pamphlets, which called for the withdrawal of the Turks 'bag and baggage' and made him a hero of popular moral outrage as protest meetings were held throughout the country. A crowd of 30,000 gathered to applaud him at Blackheath.

Burne-Jones was swept up into the protests of 1876, joining the mass crowds in Trafalgar Square and Hyde Park. 'The summer has been made really nightmarey to me by thinking over these doleful miseries – and it seems a shame to be comfortable and a shame to be happy.' In spite of an inherent dislike of organised politics he became a member of the Eastern Question Association, of which William Morris was treasurer. Underlying the demonstrations was the intolerable prospect of England, for cynical diplomatic reasons, taking the side of Turkey in the looming Russian-Turkish War.

Burne-Jones had been unwell and was not strong enough to

attend the EQA's great National Conference, which lasted for nine hours, at St James's Hall in December 1876 although Georgie was there in the ladies' galleries and Morris conspicuous in the front row. However, he made a serious attempt to attend another big public meeting in May 1877, after Russia's declaration of war on Turkey, only failing to get in because the meeting was so crammed. He and Georgie, with the Faulkners and Cormell Price, attended the Workmen's Neutrality Demonstration held at Exeter Hall on 16 January 1878 at which the whole audience rose to its feet to sing 'Wake, London Lads', words composed by William Morris to the tune of 'The Hardy Norseman's Home of Yore'.

But this rousing scene was really the beginning of the end. Only weeks later, on the rumour that the Russians had entered Constantinople, the majority of Liberals withdrew their support from Gladstone's policies on the Eastern Question and Gladstone himself caved in and advocated support for Russia. 'You see,' wrote Burne-Jones bitterly, 'we always did look on the Rule Britannia time as possible and it's come now . . . our heads will sink with shame at the dishonour and business of such a war as people want now.' He felt a rush of animosity to Gladstone, blaming him for throwing his supporters over.

For Burne-Jones it was a time of profound disillusionment with politics and shame at the months his involvement with the EQA had stolen from his painting. He now made a resolution, mapped out for himself a new sense of priorities: 'I mustn't again if I can help it leave my studio as I did this winter and throw myself into causes I can scarcely help.'

The Grosvenor Gallery
1877–80

Over the 'seven blissfullest years' in which Burne-Jones had not exhibited his reputation had risen, but only within the close circle of friends and admirers who had viewed his paintings in the studio. George Eliot saw the dangers of this neurotic privacy: 'Burne-Jones goes on transcending himself and is rising into the inconvenient celebrity which is made up of echoes as well as voices.' She urged him at least to show a collection of his pictures temporarily 'in a separate little gallery' so that the rest of the world could see the work his intimates were finding so remarkable. Some former fans of Burne-Jones, for instance the woman who had gone into raptures over *Phyllis and Demophoön* in 1870 and then had seen no more of him, simply assumed that he was dead.

All this changed dramatically with the opening of the Grosvenor Gallery on 1 May 1877. The Grosvenor was an independent private gallery at 135–7 New Bond Street. It lay to the left approaching towards Oxford Street, an ambitious venture in its own impressive purpose-built premises in the Italian style. Indeed the marble doorway was said to have been salvaged from Palladio's Church of Santa Lucia in Venice when it was demolished to make way for the railway station. The gallery was founded by Sir Coutts Lindsay, a quixotic Scottish landowner and himself a painter. His wife Blanche was also an amateur artist. Blanche's mother, Hannah FitzRoy, had been born a Rothschild and it was Lady Lindsay who provided at least half of the finance for the Grosvenor.

The idea of the new gallery was to provide an alternative to the Royal Academy, a fashionable central London exhibition space in which the ambience was more welcoming, less formal. Consciously challenging the system by which the artists showing at the Royal Academy belonged to a self-elected establishment elite, the artists at the Grosvenor were there by invitation, chosen by Coutts Lindsay and his co-administrators Charles Hallé and Joseph Comyns Carr as representing the best of British avant-garde. Lindsay was in a way the Charles Saatchi of his day and Burne-Jones was, from the start, the Grosvenor's leading artist. 'From that day', Georgie tells us in her memoirs, 'he belonged to the world in a sense that he had never done before, for his existence became widely known and his name famous.' The reclusive artist had been transformed, uneasily, into a cult figure of his period.

Besides Burne-Jones, the artists who most obviously fitted the Grosvenor Gallery's 'alternative' criteria were Ford Madox Brown and Dante Gabriel Rossetti. Madox Brown, insulted by the late arrival of his invitation, had huffily refused to become a Grosvenor artist. Rossetti, by now so paranoid and antisocial, sent his refusal too, objecting to the lack of logic in the policy by which a gallery set up in opposition to the Royal Academy was evidently willing to exhibit certain Academicians' work and pleading his own unwillingness to show paintings with which he felt so endlessly dissatisfied. However, he wished the venture well, sending a letter to Hallé which was later published in *The Times*: 'Your plan *must* succeed were it but for one name associated with it – that of Burne-Jones – a name representing the loveliest art we have.' Rossetti's generous words led to a temporary rapprochement between the two sadly estranged old friends.

Burne-Jones respected Rossetti's decision: 'As to the Grosvenor Gallery if you have made up your mind we won't talk about it. I should have liked a fellow-martyr – that's natural – as it is I shall feel very naked against the shafts.' Eight of his pictures had been chosen for the inaugural exhibition, most of them begun in the early 1870s: three large-scale compositions, *The Days of Creation, The Mirror of Venus, The Beguiling of Merlin,* and five big single-figure

paintings of *Temperamentia, Fides, Spes*, a Sibyl and *St George*. As the opening approached he became more panic-stricken about facing such unaccustomed exposure. By the end of April Burne-Jones was complaining, 'I worked till Thursday night at pictures for the Grosvenor, and now I want never to hear the word again.'

At the gallery itself preparations were frenzied. Though the main galleries were finished, other parts of the building were not totally completed, and the hanging of the pictures was still in progress late into the night before the scheduled opening. On 1 May the Grosvenor opened to the public, as many as seven thousand paying the shilling entrance fee. *The Illustrated London News* published a wood engraving showing the excited, crowded scene. But the celebration dinner and private reception had to be postponed for another week.

On 7 May Sir Coutts and Lady Lindsay gave a memorable dinner in the Grosvenor's own restaurant below the main picture gallery. The Prince and Princess of Wales were present and according to the artist and socialite Louise Jopling, herself a Grosvenor exhibitor, 'all that London held of talent and distinguished birth were summoned to meet them'. There was then a grand reception in the galleries upstairs. The twenty-three-year-old Oscar Wilde, temporarily suspended from Oxford after taking an overlong holiday in Greece and now hoping to embark on a career as a critic, appeared at the reception wearing a remarkable bronze-red coat constructed by his tailor to his own design. The back was cut to resemble the outline of a cello, making him a musical instrument in motion. Oscar Wilde, like Burne-Jones, was to become a kind of symbol of the Grosvenor, a satirist's dream figure of effeteness and excess.

The Grosvenor was a palace of art indeed, impressing visitors with its scale and its theatricality of decor. The young art writer Julia Cartwright was enraptured by her first visit ten days after the opening, recording in her diary, 'The gallery is very splendid, a Grand Palazzo entrance with vases and marble scattered about. Ceilings and walls are gorgeous with gilding of stars and crescents.' The effect was that of arriving at a very opulent private house.

Visitors progressed through a long marble-pillared vestibule toward the grand staircase. On either side of the hallway were rooms for entertaining and relaxing: a smoking room and billiard room, a ladies' drawing room for taking afternoon tea. A circulating library was later opened. The Grosvenor offered the facilities of a conventional London club but with the difference that this was a setting in which art and artists were nurtured and admired.

There were two main galleries for paintings, a smaller sculpture gallery and a watercolour gallery with green silk on the walls. At the top of the staircase the visitors turned right. Another smaller flight of steps led into the East Gallery, which opened out into the West Gallery, the largest and most prestigious exhibition space. The critic W. Graham Robertson was still a boy of ten or eleven when the Grosvenor opened but he never forgot the 'wonder and delight' of his first sight of a place 'quite unlike the ordinary picture gallery. It suggested the interior of some old Venetian palace, and the pictures, hung well apart from each other against dim rich brocades and amongst fine pieces of antique furniture, showed to unusual advantage.'

Burne-Jones was in the star position for the opening. His eight paintings were hung as a group in the West Gallery, occupying the whole of one end wall. *The Days of Creation* was in the centre flanked by *The Mirror of Venus* and *The Beguiling of Merlin*, with the single-figure paintings in a row above. Burne-Jones himself was to grumble that the crimson silk damask chosen by the Lindsays as the background to the paintings 'sucks all the colour out of pictures, and only those painted in grey will stand it – Merlin doesn't hurt because it's black and white, but the Mirror is gone I don't know where'. In spite of his misgivings, and in a crowded setting in which over sixty painters and sculptors exhibited more than two hundred works, the idiosyncratic beauty of Burne-Jones's visionary art stood out.

1877 was a strong year at the Grosvenor. Of the original Pre-Raphaelites Holman Hunt and Millais, unlike Rossetti, had accepted invitations to take part. Work from G. F. Watts and Leighton, amongst other Royal Academicians, was selected for

that inaugural exhibition. Albert Moore, Alphonse Legros and Burne-Jones's friend George Howard were also represented. J. M. Whistler exhibited eight pictures, one of which, the abstract *Nocturne in Black and Gold: The Falling Rocket*, led to a famous libel case after Ruskin attacked it in a ferocious review. Of Burne-Jones's stylistic disciples, Spencer Stanhope, J. M. Strudwick and Walter Crane were shown alongside him in the West Gallery with work by two women artists, Evelyn Pickering and Marie Spartali. Crane's picture *The Renaissance of Venus* was praised by several critics as a promising exercise in the Burne-Jones territory of 'mysteries and miracle pictures'. But it was Burne-Jones himself who most convincingly encapsulated the new artistic spirit of the age.

What was it that made Burne-Jones the central figure of the so-called 'Aesthetic Movement', a trend in the art of the later 1870s in which new styles and new aesthetic principles established themselves, an art in which mood and evocation was more valued than literal representation? Henry James, reviewing the first Grosvenor Gallery show, was in no doubt that Burne-Jones, certainly 'the lion of the exhibition', owed his lionship 'partly to his "queerness" as well as to the air of mystery surrounding an artist whose work had not been seen in public for so long'.

By 'queerness' Henry James meant Burne-Jones's sense of other-worldliness, the queer silence of his work, its suspended animation, the way the mythological fused with the medieval. It was thoughtful, it was cryptic and not everybody liked it. The *Times* critic for example surmised that to many people Burne-Jones's pictures at the Grosvenor were 'unintelligible puzzles of which they do not care to attempt the solution; to others they are occasions of angry antagonism or contemptuous ridicule'. Burne-Jones's pictures, he predicted, would be viewed with the same derision that greeted the original Pre-Raphaelite exhibits at the Royal Academy back in 1850s as 'unaccountable freaks of individual eccentricity, or the strange and unwholesome fruits of hopeless wanderings in the mazes of mysticism and medievalism'.

But for people less automatically dismissive, the artistic upper classes, the morally aware and cultured households of the suburbs, Burne-Jones brought hope and reassurance. For such people Burne-Jones stood for the enduring life of the imagination and for its importance in countering the growing materialism, the advancing industrialisation, the encroaching moral squalor of the age. Henry James explains so well the particular and powerful appeal of Burne-Jones's art:

It is the art of culture, of reflection, of intellectual luxury, of aesthetic refinement, of people who look at the world and at life not directly, as it were, and in all its accidental reality but in the reflection and ornamental portrait of it furnished by art itself in other manifestations; furnished by literature, by poetry, by history, by erudition.

The success of the Grosvenor Gallery and Burne-Jones's growing fame were intertwined. In the second summer exhibition in 1878 Burne-Jones showed eleven paintings, including the richly coloured oils *Laus Veneris* and *Le Chant d'Amour* lent by their owner William Graham. By this time the reputation of the Grosvenor was such that people arrived expecting the outrageous. Henry James overheard a woman telling her male companion she was rather disappointed: 'I expected the arrangement of the pictures would be more unusual.' He wondered if she had wanted Burne-Jones's paintings to be shown back to front or upside down.

In 1879 there were five Burne-Jones exhibits: *The Annunciation* and the four *Pygmalion* oils. Mary Gladstone was at the private view, commenting in her diary, 'The B-Jones's are splendid, specially Pyg. and Galatea . . . P's attitude in No 1, "The Heart Desires", lost in worshipping contemplation, is ideal in its thoughtful repose'. She found *The Annunciation* 'very beautiful, tho' the Angel looks a little too much hanging, not floating'. The following year, 1880, Burne-Jones would be exhibiting the picture that became most closely associated with the Grosvenor Gallery, the defining painting of the Aesthetic Movement, in which Mary Gladstone herself makes an appearance. This was *The Golden Stairs*.

He had begun the painting in 1876. Even in early days it had been taxing. He told Mary: 'have just begun to paint the girls on the staircase – feeling tottery on the top of the steps where I sit though'. He used a precarious wooden platform in his studio to reach up to the top of a painting nine feet tall. Burne-Jones was still working on *The Golden Stairs* up to the last minute. On 22 April 1880 Georgie noted in her diary: 'The picture is finished, and so is the painter almost. He has never been so pushed for time in his life.' The recurrence of the Grosvenor exhibition deadline year by year made Burne-Jones sick with nerves.

The painting, soon acclaimed as Burne-Jones's masterpiece so far, shows him at his most abstract, neoclassical and moody. While the painting was in progress Burne-Jones had toyed with other titles, *The King's Wedding* and *Music on the Stairs*, and the idea of harmony is dominant, not just in the actual musical instruments carried by the maidens but also in the pale and subtle harmony of colouring and the flowing rhythms of the composition as the girls descend the stairs. At the same time one enthusiastic critic, F. G. Stephens, saw the picture as a homage to Piero della Francesca: the pale golden flesh tones, the girls' broad foreheads, their 'deep-set, narrow eyes and their fixed look, even the general contours and the poising of the heads on the shoulders, plainly tell of the influence of that lovely painter and poetic designer'. It is Burne-Jones's quintessential dream picture. The girls on the stairway have a somnambulistic look.

Its meaning was consciously obscure. Maiden minstrels preparing to take part in a concert? Virgins descending into sexual awareness? As the letters flooded in from all over the world asking Burne-Jones to provide an explanation he refused to commit himself, mischievously claiming to be mystified himself. He left the meaning to the viewer: according to Georgie, 'he wanted everyone to see in it what they could for themselves'. But certainly the charm of the picture for many aficionados of the Grosvenor was that the girls could be recognised. Although the figures were those of professional models, the faces were the girls of Burne-Jones's own close circle. He had asked George Howard to suggest 'a nice

innocent damsel or two' to fill up 'his staircase picture'. As well as Frances Graham, Mary Gladstone and Laura Tennant, the features of May Morris, Mary Stuart Wortley and Burne-Jones's daughter Margaret could easily be identified.

The Golden Stairs was bought by Cyril Flowers, later Lord Battersea, a rising Liberal politician who entered Parliament in 1880. He had recently married Constance Rothschild, a kins-woman and intimate friend of Lady Lindsay's. The painting was a feature of the Flowers' new home, Surrey House at Marble Arch, where they built up an impressive and enterprising collection. Relatively young, rich, sensitive and ardent, Cyril and Constance Flowers were just the sort of people who, in the 1880s, admired and saw the point of Burne-Jones's art and supported the gallery with which he was so closely identified. In 1881, the first year in which Burne-Jones showed nothing in the Grosvenor's exhibition, his fans could not believe it: 'a Grosvenor without Mr. Burne-Jones is a *Hamlet* with Hamlet left out'.

Now in the 1880s Burne-Jones began to be not only admired but also mocked as the inspiring genius of the Aesthetic Movement, the 'craze' as Henry James in slight despair defined it. Like the hippy 'flower power' movement of the 1960s, the 'craze' was a phenomenon that developed out of small and radical beginnings to affect the mainstream culture of the time in terms of fashion, decor, attitude. It soon became the target for satire. Both the Grosvenor Gallery and Burne-Jones were drawn on for W. S. Gilbert's opera *Patience* which opened at the Opéra Comique in London in 1881 and which introduced the concept of the 'greenery-yallery Grosvenor Gallery foot-in-the-grave young man'.

The plot hinges on two aesthetes, Grosvenor and Bunthorne, the latter ludicrously poetic with his medieval lily, bearing a distinct resemblance to Oscar Wilde. The costumes were floaty, unstructured and artistic, the women's gowns apparently derived directly from Burne-Jones's painting. Luke Ionides recalled how on a trip to Paris with W. S. Gilbert he had first made the sugges-tion 'How beautiful a play would be with the characters dressed in

Liberty costumes like those in Burne-Jones's "Golden Stairs".' Within the next few days Gilbert had altered his main characters from two rival curates to two rival poets and decided that the girls of the chorus would wear gowns made of the Indian silks being specially imported for Arthur Lasenby Liberty's oriental emporium in Regent Street, the popular destination for Aesthetic Movement shoppers. The silks for the gowns of this quasi-Burne-Jones chorus were apparently selected by Gilbert himself.

As ridicule of the aesthetes became itself a fashion, Burne-Jones was in the line of fire. The magazine *Vanity Fair* teased the girls on *The Golden Stairs* for being dressed in tinfoil gowns. The excesses of the movement were brilliantly captured in Du Maurier's series of cartoons for *Punch*, appearing through the 1870s and early 1880s, which focused in coruscating detail on the chattering classes of the time with their William Morris hangings, their De Morgan jars and chargers, their rush-seated black ebonised oak chairs. Foremost in his cast of excruciating characters is the pretentious artistic hostess Mrs Cimabue Brown, a raptly ridiculous worshipper of Italy and all too recognisably a Burne-Jones woman with her haggard features and frizzed Aesthetic hair.

Du Maurier's characters are Grosvenor Gallery habitués. Mrs Cimabue Brown is a satiric version of Mrs Comyns Carr, wife of Sir Coutts Lindsay's co-director Joseph and herself a theatre costume designer. The fawned-over artist Maudle paints in the Burne-Jones manner but lamentably badly. Du Maurier's cartoon featuring a painting by Maudle entitled *A Love-Agony* and purporting to be a portrait of the famous 'art-for-art's-sake' poet Jellaby Postlethwaite is an obvious parody of Burne-Jones in his most mythological mode. The poet reclines by a lily pond. A lovebird swoops above the effeminate figure, scantily dressed and garlanded with flowers, banks of beautiful Pre-Raphaelite lilies in the background. The cartoon bears a clear message of sexual ambiguity. The Colonel, Du Maurier's voice of blimpish outrage, 'declared that the whole thing makes him sick'.

Burne-Jones appears himself in a few of these cartoons. His artist's signature can just be made out on a picture in Du Maurier's

A LOVE-AGONY. DESIGN BY MAUDLE.

(*With Verses by Jellaby Postlethwaite, who is also said to have sat for the Picture.*)

RONDEL.

So an thou be, that faintest in such wise,
With love-wan eyelids on love-wanton eyes,
Fain of thyself! I faint, adoring thee,
Fain of thy kisses, fainer of thy sighs,
Yet fainest, love! an thou wert fain of me,
 So an thou be!

Yea, lo! for veriest fainness faint I, Sweet,
Of thy spare bosom, where no shadows meet,
And lean strait hip, and limp delicious knee!
For joy thereof I swoon, and my pulse-beat
Is as of one that wasteth amorously,
 So an thou be!

Shepherd art thou, or nymph, that ailest there?
Lily of Love, or Rose? Search they, who care,
Thy likeness for a sign! For, verily,
Naught reck I, Fairest, so an thou be but Fair!
E'en as he recks not, that hath limnèd thee,
 So an thou Be!

[*The Colonel declares that the whole thing makes him sick. Grigsby, we regret to say, has set J. P.'s poem to music of his own.*]

Du Maurier's cartoon *A Love-Agony* for *Punch*, 5 June 1880.

satire on celebrity culture, *The Appalling Diffusion of Taste*. Burne-Jones can be spotted, a silky-bearded figure looking furtive on the sidelines of *Nincompoopiana – The Mutual Admiration Society*, which shows the dreaded 'too-too-utterly' Mrs Cimabue Brown holding a reception for Postlethwaite and Maudle, both of whom, deservedly, are 'quite unknown to fame'.

In another cartoon, *Modern Aesthetics*, three maidens with tennis racquets tell their non-Aesthetic parents they've 'been practising old Greek attitudes at lawn-tennis'. When their father responds 'Hope you like it, I'm sure' the girls reply 'Very much Papa – only we NEVER hit the BALL!' The screen behind them is adorned with Grecian maidens painted in the Burne-Jones style, a reminder of the scandal of Burne-Jones and Maria Zambaco. These were

in-jokes, coded messages, in which the inferences would be obvious to Grosvenor Gallery aficionados, to metropolitan people in the know.

The genre of gentle Pre-Raphaelite satire continued into another century, with for example E. H. Shepherd's *The Pre-Raphaelite Cocktail Party* of 1910 and Max Beerbohm's lovely series of watercolour drawings of *Rossetti and his Circle* first published in 1922. For cartoonists the long lanky lugubrious figure of Edward Burne-Jones proved particularly irresistible. But the best Burne-Jones cartoons, which show him as a creature of grovelling incompetence, of abject anxiety, were those he made himself.

Burne-Jones colluded in his rise to fame. He played up to the experience of what was in many ways a cult of personality. At the opening of the Grosvenor not only his eight paintings but his portrait was exhibited. This was the impressive artist-and-prophet portrait painted in 1870 by G. F. Watts. Edward Poynter's portrait of Georgie also featured, the picture of a perfect Aesthetic Movement wife, drinking tea from a delicately balanced china cup. At her waist, on a gold chain, she wears the ball-shaped gold watch studded with chrysolites bought for her by Burne-Jones in their early years of marriage. Essential to the image of Burne-Jones as it developed was that of the artist at home and *en famille*.

The tenebrous, remote old house in which the artist lived and worked was part of the magic. When W. Graham Robertson first visited the Grange, penetrating the building which stood well back from the road behind its wall and iron gate, the hushed atmosphere suggested 'the Sleeping Palace of Faerie Love'. The large low entrance hall was dark and led into a still more shadowy small dining room with its deep green Morris *Willow*-pattern walls. To the boy it seemed that Burne-Jones 'lived in a tinted gloom' through which the clear spots of sudden colour – pictures, painted furniture, oriental rugs – 'shone jewel-like'.

In fact by then the 'Faerie Palace' was no longer so remote. The area around the Grange was being developed fast. By 1880, much to Burne-Jones's horror, it was no longer designated Fulham but

West Kensington. The house was easily accessible from central London by bus or by District Railway which stopped at the new West Kensington station. When the young Julia Cartwright, chaperoned by her father, made the first of her expeditions to see Burne-Jones she wrote briskly in her diary, 'It is so easy really from Sloane Square to West Kensington and then a few streets to the Grange on the Fulham Road.'

But for many of the visitors their first sight of the Grange remained a romantic experience, an enchantment. W. Graham Robertson was lastingly affected by the scene. First he meets Georgie, the diminutive figure seated under the mulberry tree, her clear grey eyes gazing out less judgementally than enquiringly 'in their grave wisdom, their crystal purity'. Then he encounters the self-confident and rather solemn Margaret, now in her early teens and becoming 'almost unnecessarily pretty'. He registers Phil, at the age of almost twenty 'hospitable and excitable'. Finally the master, Burne-Jones, appears himself, walking out of the house and coming down the garden. W. Graham Robertson's description of Burne-Jones in his Grosvenor Gallery period is the most vivid that we have.

His face with its great width across the eyes and brows, tapering oddly towards the chin, was strangely like his own pictorial type; its intense pallor gave it a luminous appearance added to by his large grey-blue eyes and silvered hair; his long coat and high waistcoat produced an impression indefinitely clerical; he wore a dark blue shirt and a blue tie drawn through a ring in which was set a pale blue jewel.

He might have been a priest newly stepped down from the altar, the thunder of great litanies still in his ears, a mystic with a spirit but half recalled from the threshold of another and a fairer world; but as one gazed in reverence the hieratic calm of the face would be broken by a smile so mischievous, so quaintly malign, as to unfrock the priest at once and transform the image into the conjuror at a children's party. The change was almost startling; it was like meeting the impish eyes of Puck beneath the cowl of a monk.

Not all his friends found this persona quite so charming. Rossetti for example found his new affectations very trying,

complaining to Janey in 1881 that Burne-Jones's 'style in conversation is getting beyond the pussy-cat and attaining the dicky-bird'.

Burne-Jones was tempted to play up to his new image. There were aspects of his fame he found amusing. He recounted to George Howard how he took a lady down to dinner at Kensington Palace and she told him 'she had acted in a tableau vivant of the Venus Mirror and how Merlin is going to be a tableau – how funny people are'. By the late 1870s Burne-Jones was going more and more into London society – though not, Georgie commented defensively, so much as the people who were already in it. He was invited to join the Athenaeum, strengthening the Club's artistic coterie of Leighton, Millais, Alma-Tadema and Poynter, though his brother-in-law beat him onto the subcommittee for the redecoration of the club, securing for himself the commission for the Coffee Room, which was done out in resplendent ancient Roman style.

The circle of Burne-Jones's friendships aggrandised. He would sometimes be summoned to one of Gladstone's famous London breakfasts and in August 1879 he was invited to stay at Hawarden Castle, the imposing Gladstone family house in its park above the estuary of the River Dee. Burne-Jones had already been in correspondence with Mary about the possibility of designing a stained-glass window for Gladstone's study at Hawarden, proposing a figure of Homer for the formidable Homer specialist, and this may have been a reason for the visit. But the window for the study did not materialise.

He arrived feeling apprehensive, not unlike Ruskin who arriving at Hawarden just a few years earlier had pre-organised a telegram that might in desperation be sent to summon him home. His first sight of the castle did not reassure him. It was an overbearing building, a relatively modest country mansion restored and enlarged by Gladstone's wife's father, Sir Stephen Glynne, in the early nineteenth century in full-blown Gothic style with crenellations, arches, turrets. Hawarden was just the kind of building Burne-Jones most despised, typical of the nouveau riche abominations he

saw rising through the land 'like hotels at railway stations . . . oh! the windows – the passages, the bedrooms, the fireplaces, the everything!'.

But he was soon won over by the genuineness of the welcome he was given, reporting to Rosalind Howard that he never saw 'a simpler household or a more unworldly one'. In spite of his recent disillusionment with Gladstone over his handling of the Eastern Question Burne-Jones managed to be tactful, saying nothing confrontational: he 'sat like a curate and smiled faintly'. He and Gladstone's daughter Mary lay around on the grass under the trees while Burne-Jones drew her portrait. However, the excitement of the visit took its toll. He had arrived feeling unwell. He suffered from violent diarrhoea all the time he was at Hawarden, aggravated by the medicinal arsenic he was taking: 'the worst possible thing!' When he left he had planned to travel on to Naworth to stay with the Howards, but got no further than Warrington. Once again Burne-Jones's 'hateful nerves' had broken down.

In spite of his success, Burne-Jones could never quite get over the conviction that he was an impostor. He was conscious of being 'the stupidest guest they ever had at Hawarden'. He lived in constant fear that he would one day be unmasked. He was nervous of official appointments, especially those that involved speaking in public. When Burne-Jones was approached as the obvious candidate to follow William Morris as President of the Fine Art Society in Birmingham he explained to Morris, 'The difficulty would be the lecture, a thing as you know so utterly out of my way, which I could not possibly make light of . . . all my habits of labour for many years now have been carrying me further and further from the possibility of easily expressing myself by words.' It was not, of course, that Burne-Jones was not a brilliant conversationalist: his wit and erudition were becoming legendary. Nor was it that he had no views on art and its relation to life: Burne-Jones had thousands. But he took the view that the labour of shaping his philosophy of art into presentable form would be out of all proportion to its usefulness and that the time would be better spent pursuing what he called his 'ordinary work'.

He could not always fend off such demands. The most agonising and humiliating of Burne-Jones's public appearances at this period was as chief expert witness for the defence in the Whistler vs Ruskin libel trial of 1878. When Whistler's highly abstract compositions were first shown at the Grosvenor they were by no means universally praised. Henry James, for instance, reviewing the show wrote, 'I will not speak of Mr. Whistler's "Nocturnes in Black and Gold" and in "Blue and Silver", of his "Arrangements", "Harmonies" and "Impressions", because I frankly confess they do not amuse me . . . to be interesting it seems to me that a picture should have some relation to life as well as painting.' But Henry James's comments were politesse itself compared with those of Ruskin, who let rip in *Fors Clavigera*, his circular letter to the workmen of Great Britain:

For Mr. Whistler's own sake, no less than for the protection of the purchaser, Sir Coutts Lindsay ought not to have admitted works into the gallery in which the ill-educated conceit of the artist so nearly approached the aspect of wilful imposture. I have seen, and heard, much of cockney impudence before now; but never expected to hear a coxcomb ask two hundred guineas for flinging a pot of paint in the public's face.

The volatile, pugnacious Whistler took immediate umbrage. He took Ruskin to court, claiming damages of £1,000.

Ruskin was exhilarated by the prospect of a public battle with the opportunity it would give him to publicise his views: 'It's mere nuts and nectar to me the notion of having to answer for myself in court.' For Burne-Jones the prospect was a great deal trickier, for in the same review in which Ruskin had castigated Whistler his own exhibits had received fulsome praise as 'simply the only artwork at present produced in England which will be received by the future as "classics" in its kind'. His position was potentially embarrassing. But bound as he was to Ruskin by old ties of love, gratitude and admiration, when Ruskin asked him to testify at the trial there was little he could do but to offer his support.

How far did Burne-Jones genuinely agree with Ruskin's views on Whistler and how far was he simply following the party line out

of loyalty? The subject has been much debated. Certainly the pre-trial statement prepared by Burne-Jones for Ruskin's lawyers is vehemently hostile, claiming that scarcely anyone regarded Mr Whistler as a serious person; that Whistler was a con man, working 'the art of brag' so as to succeed among a semi-artistic public; that he never produced anything but sketches, 'more or less clever, often stupid, sometimes sheerly insolent'. The thrust of his attack was on Whistler's lack of finish. Burne-Jones claimed that Whistler's conscious plan had been 'to found a school of incapacity'. The sarcastic tone of his comments suggests an element of personal vindictiveness, reminding one that though, in the early 'Paris gang' days, the two aspiring artists had been friends, differences had developed: a quarrel between Whistler and Legros in 1867 in which Burne-Jones had taken Legros's side, and more recently Burne-Jones's estrangement from Charles Howell, with whom Whistler remained on friendly terms.

Burne-Jones was still standing firm in his opinion of Whistler's art when, just before the trial, Walter Crane happened to be sitting next to him at a dinner given by Frederick Leyland to his artist friends, most of whom were Grosvenor Gallery exhibitors, at 49 Princes Gate. The dinner of course took place in the Peacock Room decorated for Leyland by Whistler. Crane naively expressed appreciation of Whistler's work. He was 'rather surprised to find, however, that Burne-Jones could not, or would not, see his merits as an artist, or recognise the difference in his aims as an artist. He seemed to think there was only *one* right way of painting.' Burne-Jones rather testily cut the discussion short. The scene had a delicious irony, taking place as it did in Whistler's tour de force of a dining room in which the radical modernity of the decoration so dramatically challenged the historicist complexities of Morris & Co. interiors.

It was now sixteen months since Ruskin's scathing comments on Whistler in *Fors Clavigera* first appeared. The libel trial opened in the High Court on 25 November 1878. The case had been delayed for so long because of Ruskin's illness. His always problematic mental equilibrium had been affected by his agonising on–off

relationship with Rose La Touche, and hopes of their eventual marriage ended when she died in 1875 at the age of twenty-seven, after years of ill health. Ruskin had suffered a severe mental breakdown in the early months of 1878, found wandering and confused at Brantwood, his home in the Lake District. When the Whistler libel trial eventually began Ruskin was advised not to appear. Other leading artists who might have been expected to testify for Ruskin wisely made themselves unavailable and Burne-Jones was backed up only by the *Times* art critic Tom Taylor and by William Powell Frith, whose popular work *Derby Day* was judged in Burne-Jones circles to be irretrievably commonplace.

Burne-Jones was very nervous. Georgie tried to calm him down on the night before the trial by reading aloud to him from *Pickwick Papers*. On the day he was to testify William Morris had to almost drag him bodily to court. He was frightened by the scene in the hot and crowded courtroom in which the trial was held under the imposing auspices of Sir John Walter Huddleston, last of the legal barons and well known as the possessor of 'the tiniest feet, the best kept hands and the most popular wife in London'. The wigs and facial expressions of the lawyers alarmed him. Called into the witness box, he later confessed that he 'trembled a good deal', his tongue got lodged in the roof of his mouth – 'and I dare say I spluttered and was ridiculous'.

The violence of his views as submitted in writing was considerably modified as Burne-Jones was cross-examined on day two of the trial. Defining himself as a painter of twenty years' standing who had 'painted some works that have become known to the public within the last two or three years', Burne-Jones began by stating stoutly his belief that 'complete finish' should be the object of all artists.

When Whistler's *Nocturne in Blue and Silver* was displayed in court Burne-Jones maintained that as a work of art it lacked the necessary finish but allowed that the painting had many good qualities: 'It is masterly in some respects, especially in colour.' Faced with another *Nocturne – Battersea Bridge* – Burne-Jones judged that the colour here was even better. He half-defended

the third picture, *Nocturne in Black and Gold*, showing fire-works at Cremorne, maintaining that night was notoriously difficult to paint: 'I have never seen one picture of night that was successful.'

Continuing a trial that could well have been a scene in Lewis Carroll's *Alice in Wonderland*, a painting by Titian was next brought into court, a portrait of the doge of Venice Andrea Gritti from Ruskin's own collection. The defence's idea was to demon-strate the painterly finish that Whistler's work so lamentably lacked. But once again Burne-Jones managed to sabotage the argument, admitting that 'in Mr. Whistler's pictures I see marks of great labour and artistic skill'. If Whistler had not fulfilled his early promise, this was often the lot of the poor artist: 'the diffi-culties in painting increase daily as the work progresses; that is the reason so many of us fail. We are none of us perfect.' But Mr Whistler's pictures 'showed an almost unrivalled appreciation of atmosphere'. In giving his evidence Burne-Jones had almost turned himself into a witness for the prosecution. Ruskin lost the case and was required to pay a farthing damages.

Why the volte-face? Because he was so tense and nervous in the public arena he had lost control, forgotten the line he was expected to be following. He felt he had let himself be put into a pillory. He had 'never disliked anything so much' in his life. His testimony had been the more erratic because, in his heart of hearts, as he later admitted, he thought Ruskin had been wrong and Whistler right. After the trial he went into a predictable nervous collapse, unable to sleep, unable to work. He wrote to apologise to Ruskin, telling him 'I was like Nathaniel Winkle after all', Winkle being the character in *Pickwick Papers* of whom Charles Dickens writes: 'Lawyers hold that there are two kinds of particularly bad wit-nesses: a reluctant witness, and a too-willing witness; it was Mr. Winkle's fate to figure in both characters.' He sent Ruskin a half portion of a half-penny stamp to repay him for the damages.

The following autumn when Whistler left for Italy, bankrupt and in debt, Burne-Jones wrote to Mary Gladstone: 'Mr. Whistler has started for Venice (and if I were going would he entice me out

to the Ghetto and do for me?) I wish all that trial thing hadn't been, so much I wish it – and I wish he knew that it made me sorry, but he wouldn't believe.' Two decades later, when the painters of metropolitan squalor Wilson Steer and Walter Sickert were in the ascendant, Burne-Jones had come around to feeling that 'Really by the side of those fellows Whistler's a kind of Van Eyck.'

His next public appearance was relatively harmless, though again less than impressive. Burne-Jones was drawn into the campaign against the restoration, or as he and William Morris saw it, the 'destruction' of the west front of St Mark's in Venice. An international protest was mounted by the Society for the Protection of Ancient Buildings, the pioneer conservation body that Morris had founded in 1877 and of which Burne-Jones had been an early member. This was the Society's first major public campaign, with meetings being called in London, Birmingham and Oxford. Burne-Jones had been successful in enlisting Gladstone's support, arguing emotionally that there was no excuse for a project dreamed up merely to give employment to Italian workmen: 'it means the ruin of Venice to some of us – such loss of irrecoverable irreplaceable beauty as breaks one's heart to think of'. Disraeli, now Lord Beaconsfield, was another of the many influential people who signed the SPAB petition.

Burne-Jones was prevailed upon by Morris to be one of the six speakers at the Oxford protest meeting on 15 November 1879. According to Georgie, this was his one and only formal public speech. W. A. S. Benson, on his way to Oxford, found on the platform at Paddington Morris and the painter William Richmond, soon 'joined by Burne-Jones and Street the architect all going to make a row about St Mark's'. Morris had photographs with him and Street actual samples of mosaic removed from the building in the course of restoration.

The meeting was held in the Sheldonian Theatre in the early afternoon. A large and sympathetic audience of Oxford grandees had assembled, amongst whom the only notable absentee was Ruskin, England's most eloquent authority on Venice. Asked to take part, he refused point-blank, saying 'I am not coming. I have nothing to

say.' He was still mentally unbalanced, erratic in behaviour, and he had now resigned his Oxford Slade Professorship. He could not bring himself to make a personal appearance, though he gave a rather arm's-length support to the campaign.

First to speak was G. E. Street, with whom Morris had studied when Street's architectural practice was in Oxford. Street was followed by Burne-Jones, speaking from the artist's point of view. As in the High Court the previous year he was clearly very nervous, reported to have read his speech 'at such a pace and in such low tones that it was difficult to catch what he said'. But even if Burne-Jones's Oxford intervention was of doubtful value the campaign as a whole must be counted a success. Even before the petition bearing two thousand signatures was presented to the authorities in Italy, work on restoring St Mark's west front had been halted and new guidelines were issued for future restoration work. The importance of the victory for the SPAB lay not in this single case but in its implications for the future. As Burne-Jones put it, 'it means more than St. Mark's – we want to strike now at all these cruel destructions and obliterations'. He and Morris were instigators of a movement that gathered force in the later nineteenth and twentieth centuries: the consciousness of communal responsibilities towards the cultural heritage of the world.

In the late 1870s Burne-Jones's friendship with George Eliot deepened. What had begun as a closeness between women, Georgie and George Eliot, at the time of the Maria Zambaco crisis, now became more of a triangular relationship, an emotional shift that had the effect of bringing Ned and Georgie closer together in their admiration and sometimes their anxiety for a woman so exceptionally strong and yet so vulnerable too.

The rapport between Burne-Jones and George Eliot is surprising. She was far from the usual type of Burne-Jones woman. Normally he went for sweetness and light, finding ugly women so distressing and repugnant he could hardly bring himself to speak to them. Physically George Eliot verged on plainness. He was generally terrified of intellectual women; she was one of the most

ambitious and psychologically penetrating writers of the age. George Eliot had a certain tiresomeness of personality. 'Her manner was too intense, she leans over to you till her face is close to yours, and speaks in very low and eager tones,' wrote Charles Eliot Norton when he first met her. But all this was forgiven in the mutual understanding and respect the great writer and the great artist came to feel for one another. Burne-Jones gratefully confessed himself won over by George Eliot, 'her heart the most sympathetic to me I ever knew'.

In November 1878, to her great dismay, George Lewes died of enteritis and cancer. The two of them had now been living together openly, though controversially, for more than twenty years. At his death Georgie and Ned were united in concern: 'I never saw anyone so unfit to be alone in the world as that poor Mrs Lewes,' wrote Burne-Jones.

The following autumn he went on his own to visit her at Witley, near Haslemere in Surrey, where she and Lewes had found themselves a country house, the Heights, with a steep slope of a garden. As he described the visit, 'she met me at the gate and looked well – and in the afternoon we went for a long drive – it is a solitary life, but evidently does not vex her – but it is rather her choice than her fate'. *Daniel Deronda* had been published in 1876 and it seemed she was still preoccupied with Jewish questions, 'for the table was covered with Jewish books'. Burne-Jones felt that there was no one alive better to talk to, 'for she speaks always carefully so that nothing has to be taken back or qualified – and her knowledge is really deep'.

She was not, however, the most practical of people and the visit to Witley ended in farce when she said goodbye at the door, told him vaguely to turn right to get to the station and disappeared inside. It was dark, he stumbled down the drive and into the lane. Hearing a train approach in the distance he scrambled over a fence and got to the station, but – as he later told the tale – he got there upside down, 'much torn by brambles and considerably bruised, after having fallen, and rolled down a fairly perpendicular bank about thirty feet high'.

The last time they saw George Eliot was in summer 1880 when she called at the Grange to say goodbye before going abroad. She first sat with Ned in the studio before coming down to talk to Georgie, who found her even gentler and more affectionate than usual and less fitted than ever 'to do battle with daily life'. A fortnight later they were shocked to receive a letter telling them that she was about to marry a banker, John Cross. She at the time was sixty; he more than twenty years her junior. She was evidently nervous about her friends' response: 'If it alters your conception of me so thoroughly that you must henceforth regard me as a new person, a stranger to you, I shall not take it hardly, for I myself a little while ago should have said this thing could not be.'

The marriage took place in London. On the honeymoon in Venice, Cross, who was said to have been a depressive, either fell or threw himself from the balcony of their hotel into the Grand Canal in what was possibly an accident or possibly a suicide attempt. Rumours proliferated. Six months after they returned to London, George Eliot died of kidney disease. With her death, Burne-Jones lost his best interpreter. It was she, with her power of intelligence, who saw the historical sweep of his imagination and understood the meaning of Burne-Jones's 'strain of special sadness' as a critique of contemporary society in all its moral crassness and its lack of responsibility for the environment. She saw this sadness as 'inwrought with pure elevating sensibility to all that is sweet and beautiful in the story of a man and in the face of the Earth'.

Rottingdean, One
1881–2

In 1880 Burne-Jones took a house outside London. 'No doubt you know that he has bought a mansion near Brighton,' Rossetti told Janey Morris with a touch of malice. 'He appears to be culminating.' Mrs Morris, who was more sensible and practical than she appears in her portraits, replied, 'I knew that Ned had a little place in Brighton, and a very wise thing too, the sea air is the only thing that braces up the nerves. I wish that I had such a place and that Kelmscott was off my hands.' In fact, far from being a mansion, Ned and Georgie's new house was a small whitewashed cottage known as Aubrey House in the seaside village of Rottingdean. Though later extended, it was always modest, and they were to rename it North End House, partly as a tribute to their London house, the Grange, on North End Road and also because it stood facing the north end of the village street, which ran up from the beach to the church and village green.

They had been looking for a house by the sea for several years, a holiday home for the family and a place within easy reach of London where Burne-Jones himself 'might run down at any moment and find quiet'. His lionisation by the London social world was taking its toll. At times he complained he was feeling like a cab horse, overdriven in all directions. At dinner parties in London he, the famous artist and brilliant conversationalist, was expected to perform. Burne-Jones, like Janey Morris, was a dreamer and one of his bad nightmares was of a maid at a dinner

302

party handing him a plate of soup full of large bluebottles: when he complained 'she said "I would give a deal to get rid of them"'.

Staying with friends at their houses in the country could be nightmarish as well. Georgie lamented how it always ended in Burne-Jones 'expending his strength by entertaining his entertainers', making drawings for them, reading aloud, initiating discussions 'in which he poured forth the things he knew and stirred his hearers to fresh thought – all pleasure at the time, but exhaustion afterwards'. He desperately needed a house of his own to which he could retreat to recharge his energies and think about his work.

Burne-Jones first came upon Rottingdean in autumn 1877. He was feeling weary and in need of two or three days away to 'play about a bit'. Perhaps Brighton, perhaps Oxford? 'I should like the sea, but I hate Brighton, and I love Oxford, but it isn't the sea.' In the end Brighton was decided on. He went with Arthur Balfour's younger brother Eustace, an architect and member of the Holland Park set. The visit was doubly memorable. Ned and Eustace bought two ferocious owls from the bazaar on the old chain pier, called them Socrates and Eustacia, and brought them back to London. Socrates, the Burne-Jones owl, was given a warm welcome by Georgie, but to her growing horror subsisted on raw meat which he gorged on through the night so that every morning she found his cage 'bespattered with blood, his beak crimson, and his eyes dim from the orgy'. Eustacia came to visit and behaved in exactly the same way. Both owls had to be ejected, and soon disappeared together. Burne-Jones later teased Georgie by telling her that he had ordered a replacement owl from Paris. It was typical of his rather cranky sense of humour that when it arrived it was a plaster cast.

On that visit to Brighton Burne-Jones had walked out a few miles east along the cliffs to the little village of Rottingdean which, although on the coast, was more of a farming than a fishing village, marked out by a windmill with its great black sails. He was immediately impressed by the old church, built in flint and originally

Saxon with a square-form central tower. A sketch in one of his letters shows the church and local coastguards, 'who march about and look tremendous, and peer through telescopes suddenly as if the Armada was in sight and they must give the alarm'.

In summer 1880 'a fiasco of a holiday' spent travelling in a desultory way round Wiltshire, Devon and Somerset decided Ned and Georgie to begin a search in earnest for a house on the Sussex coast. Georgie set off to house-hunt, instructed by Burne-Jones that if Brighton yielded nothing she should carry on to Rottingdean. On a perfect autumn afternoon she walked across the downs, entering the village from the north. Rottingdean was as yet undeveloped: 'the little place lay peacefully within its grey garden walls, the sails of the windmill were turning slowly in the sun, and the miller's black timber cottage was still there'. The road into the village took her straight to the door of a house on the village green. The cottage, then known as Aubrey House, stood empty and they bought it straight away.

Through the winter the three-storey building was made ready. The Burne-Joneses took on as their architect their friend W. A. S. Benson, an early exponent of the Arts and Crafts movement at its most rational and simple. Benson would quote William Morris on the aim of architecture being that of 'creating a building with all the appliances fit for carrying on a dignified and happy life'. Georgie in her memoirs praises the way in which he improved and adapted the rather poky little cottage to their needs. Much of the plain oak furniture was specially designed by Benson and built in. A bookcase designed by Burne-Jones to be fitted into the angle of a wall was another feature of an interior in some ways more in tune with early twentieth-century modernism than the medievalist amplitude of Morris's Red House.

In his handbook of simple living *Notes on Some of the Minor Arts*, published in 1883, Benson uses as the frontispiece an illustration of 'a sitting-room in a seaside cottage' which, although he does not name it, is at least partly based on the Burne-Jones sitting room at Rottingdean. He adds the description:

the walls and woodwork are simply white, the furniture is plain oak with blue print curtains and coverings, and, in the centre of the floor, one rich rug is laid; on either side of the shrine-like mantelpiece, with its mirror reflecting the contained doorway into an adjoining room, extends a line of shelves at a convenient height above the seats below; but the chief charm of the room is in a wide bay window with a deep-cushioned couch right across it, having a pleasant prospect over the village green and the downs beyond.

The piece of furniture of greatest interest in the sitting room was the green-stained oak piano designed in collaboration by Benson and Burne-Jones. It was purpose-made by Broadwood's and the normally black keys were ivory stained a matching green. This piano was the simpler country-cottage counterpart of the grand piano purpose-designed for the Grange a few years earlier and it was part of a campaign by Burne-Jones to improve and beautify the design of pianos, such a central feature of the Victorian drawing room. 'I have been wanting for years to reform pianos,' he had written to Kate Faulkner, 'since they are as it were the very altar of homes, and a second hearth to people'. It seemed to him immoral that pianos should generally be so hideous.

He tried to argue Broadwood's, London's leading piano manufacturer, into varying the colours, simplifying the shape, getting rid of the extraneous bulbous turned legs and fretwork inner desk, returning the piano to the form-follows-function purity of the eighteenth-century harpsichord in which the design of the case followed the deployment of the strings inside. He wanted to make sure that these pianos were affordable by people at all levels of society, the man with £20 as well as the duke with £1,000 to spend. In the climate of the times this was too much to expect. But in the early 1880s he was partially successful in his piano-reform plans in that Broadwood's produced several oak pianos specially commissioned to Burne-Jones's designs with Kate Faulkner's gold-and-silver gesso decoration. A marvellous example, a grand piano made for Constantine Ionides, is now in the Victoria and Albert Museum.

The house at Rottingdean was in some ways just a simple seaside cottage, austere and high-minded in its ambience, a predecessor

of the Cultured Cottage satirised in Osbert Lancaster's *Homes Sweet Homes*. Burne-Jones refers to it fondly as 'the little funny place' with its 'white washed walls and scant furniture – indeed it is my idea of furnishing a little house'. But it had its idiosyncrasies and unexpected glories. His granddaughter was later to write of the excitement of coming face to face with a series of four stained-glass windows 'of jewelled brilliance' telling the story of the Sangraal: the summoning of the knights, the quest for the Graal, its discovery in Sarras, guarded by the angels. These glorious designs were set into the wall above the housemaid's sink. The moral of it struck her. 'The Holy Grail above a housemaid's sink, both needed, both a part of daily life.' The perfect expression of Burne-Jones philosophy?

As a retreat from the exigencies of West Kensington, the new cottage was to prove a great success. During 1882, for instance, Burne-Jones himself went to Rottingdean – alias 'the dean of the Rottings' – two or three times. He and Georgie took a long late summer holiday in Rottingdean as well. This became the annual routine and they were almost always at the seaside for Burne-Jones's birthday on 28 August. They avoided having visitors likely to prove an effort, inviting people on the level of Crom Price, Thomas Rooke, Burne-Jones's studio assistant, 'and other intimate and unexacting friends'. Crom was especially indulged, allowed to smoke in bed 'till all is blue and he himself black'. When they ran out of rooms they farmed their guests out in the village or rented the house next door.

In early years they employed a local housekeeper, a well-meaning but uncontrollable old woman with a mania for flowers who arranged overflowing vases of cowslips, forget-me-nots, sweet-briar and pansies and great pots of gorse to greet them. But problems developed. Burne-Jones began complaining: 'The housekeeper is very terrible – her name is Thrasher and she has a deep man's voice and wants to talk very much – we have told her she is never to speak but only to listen.' He decided that never had a surname, even in the Bible, been 'more prophetically true and expressive'. Mrs

Thrasher finally exploded, arguing back and writing incoherent letters. A worthy couple, Mr and Mrs Mounter, were appointed to replace her, judged to be 'less interesting but more reliable'.

The Burne-Jones children were a great preoccupation to their parents. Phil in particular was a constant worry. In the close family proximities of seaside holidays at Rottingdean, anxieties about Phil's future accumulated. He had not done well at Marl-borough and had made no friends: 'he does not seem to find any to care for out of his 500 and odd fellow scholars', wrote Georgie. Burne-Jones had set his heart on Phil following him to Oxford, but this too had been a struggle, with Phil having to be privately tutored at the Grange. Georgie's frustrated outbursts to Rosalind Howard made her, in retrospect, feel a little guilty: 'I feel as if I have been unjust to the boy to say as much as I did and certainly there is no need for me to feel while he is 17 as much disappoint-ment as I might if he were 21 . . . neither hope nor patience are exhausted in my heart.' Phil, as he was growing up, seemed to mystify his parents. As he had been as a baby so he still remained in adulthood, the 'small stranger within our gates'.

Finally, in 1880, Phil entered University College but like his Uncle Harry he left Oxford early, without taking his degree. In July 1882 he wrote shamefacedly to Mary Elcho, first of the glamorous women with whom Phil became infatuated, to tell her he had been 'ploughed'. Ignominiously he came back to live at home. The idea had always been that he would follow his father and become an artist. But here as well his progress was erratic. Early on Phil was given his own small studio at home at the Grange. He also some-times worked at the nearby studio of his father's friend W. B. Richmond. However, he found it very difficult to settle, always prone to mood swings and fatally attracted to the dissipations of high society.

Burne-Jones was to describe how, starting in his early twenties, Phil had 'gone out a great deal in the highest of the high world and move[d] in circles one can scarcely mention without a gasp'. To what does one attribute Phil's restless social climbing, his pattern of endemic insecurity? First perhaps to the strain of melancholy

and depression in both the Jones and the Macdonald families. His father similarly, when he was a young man, had been grateful for the lavish patronage of Little Holland House. So far as Phil was concerned there were all the extra pressures of being the now renowned Burne-Jones's son, growing up aware that the words 'son of the painter, who also painted' were likely to be his epitaph.

The adolescent Margaret also had her problems, though in most ways she was better adjusted than her brother, enjoying the classes at Notting Hill High School and still excelling at gymnastics. She was one of a group of bright intelligent young girls, several of them daughters of her parents' artist friends. The girls formed what they called their 'Spression' club, united in their love of Burne-Jones's 'Spression' creatures, the endearing shapeless animals, part pig, part dog, part wombat, that appear in a whole series of 'Spression' cartoons. Georgie, conscious of her own lack of formal education, was keen that Margaret should go on to university. In spite of the aspersions Burne-Jones routinely cast on academic women, and Girton girls in particular, in 1878 he had taken her to Cambridge where Mary Gladstone's sister Helen, a student at the newly opened women's college Newnham Hall, had offered to show her round both Newnham and Girton. In preparation for the visit her father had bought her 'the most glorious hat in all Kensington – blue to astonishment, feathered and otherwise glorious'.

All the same, Margaret was shy to the point of paralysis. She had had an unusual upbringing that to some extent set her apart from her contemporaries. Rudyard Kipling recognised this when he later described his Burne-Jones cousin as 'a maiden I knew since I was six but who lived an entirely different life from mine – all among the aesthetic folk and the writer-men of Oscar Wilde's epicene stamp'. Indeed, Oscar Wilde wrote a poem to Margaret, 'To M. B.-J':

> Sweet are the summer meadows,
> Blue is the summer sky,
> And the swallows like flickering shadows
> Over the tall corn fly.

And the red rose flames on the thicket,
 And the red breast sings on the spray,
And the drowsy hum of the cricket
 Comes from the new-mown hay.
And the morning dewdrops glisten,
 And the lark is on the wing:
Ah, how can you stop and listen
 To what I have to sing!

This was the child who was taken by her mother to stay with John Ruskin at Brantwood, a dismal rainy visit when he tried to amuse her by taking her into the drawing room and playing at jumping over piles of books that he built up on the floor. Indeed, Ruskin apparently wrote Margaret 'the kind of letters that Mr. Ruskin ought not to have written to a young girl', discovered after her death by her daughter, who then burned them. The beautiful young girl, small in scale like her mother and extremely self-composed, had her portrait painted many times. When G. F. Watts suggested painting her, Burne-Jones responded eagerly: 'O Margaret! and will you really? and is it true? all Saturdays and Sundays she is free and not at school.' W. B. Richmond, who adored his own daughter Helen's friend, had painted Margaret three times by the time she was twenty-two and was apparently reduced to tears when she became engaged.

Part of the trouble with Margaret was certainly her father's extreme possessiveness. The 'exceptionally strong attachment', as Georgie described the deep feelings of Burne-Jones towards his daughter, had the effect of making her seem older than her years. It has sometimes been suggested that these feelings were incestuous. There is no evidence for this in his many surviving letters to his daughter, although to a modern sensibility the protestations of his love for her are somewhat cloying. Certainly his anxieties on her behalf exceed the normal bounds. For example, when Margaret was invited to the Isle of Arran, travelling with Phil and staying with friends, he worked himself into such a state of apprehension that he had her portrait painted urgently. This was one of the three portraits by W. B. Richmond. Her father felt convinced that

Margaret would fall ill or have a fatal accident and never return home.

Rottingdean became a gathering point for the extended family of Baldwins and Poynters. Louie Baldwin had been ailing all through the 1870s, suffering from an unspecified but sadly debilitating illness. She and Alfred often took the next-door cottage. The bracing south-coast breezes may have done her good. Their son Stanley, a 'plain, pink, thin boy' at this period, had started well at Harrow, being sporting and academically competitive. But the future Prime Minister's school career was spoiled by a disgraceful episode in 1883 when he was discovered with a cache of so-called 'juvenile pornography'. He was not expelled but disciplined and cautioned and his confidence declined.

The closest of Ned and Georgie's nephews was still Rudyard Kipling, who was now a boarder at the United Services College at Westward Ho! in Bideford, north Devon. Westward Ho!, as the school itself came to be known, was a new school, founded in 1874 to provide a public-school education for the sons of impecunious army officers. The first headmaster was Crom Price whom Kipling's mother Alice had known well in her early days in Birmingham, as she had written to remind him. The 'lean, slow-spoken, bearded Arab-complexioned man', as Kipling would describe him, was already well known to Rudyard too, familarly addressed as 'Uncle Crom'. Price was one of his kindly Deputy-Uncles, another being William Morris. Both were frequent visitors when he was staying at the Grange.

Westward Ho! was bleak and raw, still struggling for existence and prone to the bullying that was then rife in all English public schools. Rudyard took time to settle in. But he did make friends, forming the little gang he later fictionalised as Stalky, M'Turk and Beetle in his novel *Stalky & Co.*, the book in which Crom Price appears as the benevolent headmaster. It was Price who encouraged Kipling's writing, gave him access to his own study library and allotted him the task of editing the school newspaper, apparently revived for this very purpose. He attempted to teach Russian to his protégé, but with less success.

Perhaps most important of all in the education of the nervy, rootless boy was the sense of connection with the past that Crom Price brought him as he drew on his pipe and in his 'low, soft drawl' reminisced about the men of his youth who had gone on to do great things as writers and as artists. Crom gave the achievements of Rudyard Kipling's family a context and encouraged him to return at last to India once he had left Westward Ho! and take up the post he had been offered as a journalist on the *Civil and Military Gazette* in Lahore. He sailed in September 1882, having spent his last few days in England staying with his aunt and uncle at Rottingdean.

By the early 1880s Burne-Jones was conscious of a lessening of energy: 'the blaze is going out of me' he wrote, 'and I grow tired and can't work as I used to do ten years ago'. He was now relying on the cottage by the sea, as Morris thought of Kelmscott, to be a place of creative reinvigoration.

It was the first time Burne-Jones had lived outside a city and he loved the change of pace of a village that still felt apart and relatively primitive, without gas and without railway. The daily omnibus from Brighton took forty minutes and when a stranger arrived on the green local village children were apt to stick their tongues out. It was not that Rottingdean was absolutely quiet. As he discovered, the countryside had its own cacophonies of sound from two in the morning when the first cock started crowing to ten at night when the last yelling baby was put to sleep. But Rottingdean noises were different from Kensington noises, and this he found refreshing. Besides, 'out on the downs it is peace like at the beginning of time'.

Watching a cart drawn by two black oxen, as in medieval times, Burne-Jones felt enriched and soothed by the experience: as the oxen passed 'so has the spirit of hatred that was in me and suddenly I feel good and kind, and will go out and give a penny to someone'. He never got tired of the view from his window in his studio-bedroom, over the village pond to 'the little grey church on the windy hill'. What he especially liked was the point at which the

church tower intersected with the beginning of the downs. This view recurs in his private book of sketches, the English rural proximities providing a new stimulus. There were also famous sunsets. Georgie wrote to a friend who was borrowing the house, 'I hope you have some of the sunsets for which we value Rotting-dean, when the pink reflection in the East from the sun in the West turns the little church into mother o'pearl. I should like you to know that the full moon is larger than in London.' For a painter, one of the advantages of the Sussex coast was its quality of light.

In 1882 he started on a project especially associated with Rotting-dean. This was *The Flower Book*, described by Georgie as 'the most soothing piece of work that he ever did'. It was less a book of accurate botanical drawings than a sequence of small watercolour paintings, each six inches across, in which the name of a flower provided the inspiration for the image. He wanted the name of the flower and the picture 'to be one soul together and indissoluble'. *Love in a Mist* for example shows Love captured within a swirling cloud, struggling to be released. Thirty-eight of these watercolours were completed over the next sixteen years, at irregular intervals when he was in the mood. Most of them were made during his so-called holidays at Aubrey House.

The Flower Book was developed in collaboration with a new friend, Eleanor Leighton, wife of Sir Baldwin Leighton, a baronet whose family seat was Loton Park in Shropshire. Her own family, the de Tableys, were still grander and she was to inherit Tabley Hall in Cheshire on the death of her brother the 3rd Baron de Tabley. The Leightons also had a London house, off Grosvenor Square. Lady Leighton, a Grosvenor Gallery enthusiast, was just the sort of fashionable art lover who appears in Du Maurier's cartoons. She had just turned forty, he was nearing fifty when they met at an evening party in the garden of a house in St James's Street. Soon the ever susceptible Burne-Jones was paying her visits when she was in London, entreating 'don't ask any one, only let me come quietly – I can talk to you about a hundred things and if people are there I can't talk half as much'.

Lady Leighton was flirtatious and effusive, an eager correspondent and a sender of lavish presents. Grapes, apples, flowers, game and gilt-clawed Christmas turkeys rained down on the Burne-Joneses from the Loton Park estate. One unfortunate incident seems to have arisen when Georgie found one of Lady Leighton's gushing letters lurking in a book. When Burne-Jones told her what had happened Lady Leighton wrote to Georgie, sensibly advising her to burn the letter, and Ned made the promise never to use one of her letters for a book-marker again.

When Burne-Jones wrote to ask for suggestions for flower names, Lady Leighton was eager to oblige. 'I am wildly excited over the book,' she wrote. She was dying to know how he was planning doing it: 'just flowers and names? or a little "Libretto" to each page?'. How was he going to bind the book? she asked him: 'oh please in a cover printed all over with flowers that spell your name. Good night. I shall dream of this book.' Burne-Jones entreated her to send him as many flower names as possible – 'for alack it is not one in ten that I can use'.

She fed him with suggestions. The names that he pursued for his beautiful, personal and highly esoteric *Flower Book* are the ones that meant the most to him pictorially. *Ladder of Heaven* shows a winged soul climbing up the edge of a rainbow. *Scattered Starwort* is an image of angels casting stars through the sky as if they were sowing celestial seed. *White Garden*, which shows the Annunciation taking place in a garden of lilies, is a homage to the garden at Aubrey House, where the glorious white lilies grew as much as six feet tall.

It was a long work in progress that reflected the land he saw around him, the cliffs, the Sussex downs, the hayfields, woods and thickets, clear and starry skies. *The Flower Book* became an integral part of his Rottingdean routine, a celebration of its marvels:

It was all like one day, nothing happened, the sun beat upon the hills and they were covered with wheat-sheaves, making tears gather to the eyes. I had my Book of Flowers with me, and designed five new ones – the Key of Spring I did, and Love in a Tangle, and Witches' Tree and the Grave

of the Sea and Black Archangel and Golden Greeting. I wish Golden Greeting were quite true – just as I did it I wish it might really be.

Burne-Jones chose his subjects from a multitude of sources, myths, folk tales, fairy tales. The range of reference is biblical, Arthurian, Dantesque, Miltonic. He drew on his personal depth of knowledge, his affections for the stories of the past, and the strange melancholy pictures are all the more compelling for the scale of their treatment, the way in which the stories are reduced to their essentials, confined in a small space. There are memories of Botticelli, Blake, Rossetti and also Lizzie Siddal in the gawky human figures. You can find a foretaste of surrealism in the little roundel painting entitled *Morning Glories* which shows angels spreading out the clouds at dawn above a burnished cornfield. But the whole visionary intensity of *The Flower Book* is unmistakably Burne-Jones, and what had begun as a secret private project drew a wider audience when it was eventually published in facsimile by the Fine Art Society in 1905.

One of the *Flower Book* roundels, *Grave of the Sea*, shows a drowned man, a corpse, discovered by a mermaid. Rottingdean had reinforced his avid interest in sea creatures, mythological, magical sea-nymphs and mermaids. In the 1870s he had even provided a *Mermaid* design for a Morris & Co. woven fabric. William Morris himself designed the leafy background. But Burne-Jones's mermaid fabric was not in fact produced. In the early 1880s he described how he designed 'many scenes of life under the sea; of mermaids, mermen, and mer-babies: the best was a mer-wife giving her mer-baby an air bath and it is howling with misery. There are four designs of hide-and-seek, and a coral forest and mermaids dragging mortals down, and tragedies, comedies, and melodrama in plenty.'

Burne-Jones had an almost morbid fascination with the mermaid's physicality, the point at which the woman merged into the fish, the slitheriness, the scaliness. A mermaid was part a threat and part a joke. One early morning in his studio in London he was drawing a mermaid with a scaly tail when a model came in and

asked him what it was. He told her it was a portrait of the Dowager Countess of Dorking and she seemed quite satisfied.

When in 1886 he came to paint his major mermaid picture, *The Depths of the Sea*, many people who saw it identified the mermaid with Laura Tennant (later Laura Lyttelton), one of the most popular and charming young women of 'the Souls'. Georgie always encouraged this interpretation. But perhaps at another level the mermaid, with her phosphorescent and highly erotic curving tail, suggested the assiduously admiring Lady Leighton and others of her kind, the social hostesses so temptingly fluttering around him, beckoning and flattering, luring him towards a not uncongenial doom.

The Grange, Four
1883

In the 1880s Burne-Jones returned to Oxford in new-found glory. In June 1881 he was awarded an Honorary Doctorate by the University. Phil and Margaret were there watching him receive it dressed in a scarlet gown with 'crimson sleeves like a flamingo'. The colour did not suit him, but the ceremony pleased him: 'everything was very kind and everyone – and it has been a bright day. The bells have rung all day and the streets looked bright, and the people gay.'

In the spring of 1883 Ruskin returned to Oxford after a long absence. He had now been reappointed to the Slade Professorship he resigned because of illness five years earlier. Ruskin had been preparing the Slade lecture that would further consolidate Burne-Jones's reputation. This was a lecture in a series on 'Recent English Art' in which Ruskin considered, among others, Leighton, Alma-Tadema and Kate Greenaway. One of these lectures, 'The Mythic Schools of Painting', would concentrate on Edward Burne-Jones and G. F. Watts. Ruskin wrote to Burne-Jones beforehand saying, 'I want to come and see all the pictures you've got . . . The next lecture in Oxford is to be about you – and I want to reckon you up, and it's like counting clouds.'

Ever since the quarrel over Michelangelo, Burne-Jones's relations with Ruskin had been wary. Since then there had been the acute embarrassment of the Whistler vs Ruskin libel trial. Ned and Georgie had both been in an agony of worry over Ruskin's

fluctuating mental state. Indeed they themselves, and particularly Georgie, had sometimes been the subject of his nightmares and hallucinations. But there were now hopes that his condition had stabilised. Towards the end of the previous year, when Burne-Jones heard him lecture at the London Institute, he had felt relieved at Ruskin's evident improvement, telling Charles Eliot Norton, 'Ruskin flourishes – gave a lecture on Cistercian architecture the other day that was like most ancient times and of his very best, and looks well – really stronger than for many a year past.'

Ruskin's 1883 Slade lectures on current English artists, given in the University Galleries, were an instant great success. After two hundred people had to be turned away from the first lecture in the series, Ruskin took to giving a repeat performance the next day or a few days later. Admission was by ticket. The lecture on Burne-Jones was delivered on 12 May and repeated on 16 May.

Ruskin had written to Burne-Jones some days before to tell him he had finished writing the lecture and apologising in advance that there was no chance of him covering all the necessary ground: this was merely a first sketch of what he hoped to say in future. Burne-Jones had been in any case flattered and delighted, telling Ruskin, 'I'm so glad you're going to say a word about me in my own country – that is Oxford. I feel very happy about it and it's a surprise.' Part of his happiness lay in the thought that it was in Oxford he and William Morris had first read and been inspired by *The Stones of Venice*, the book that had become a kind of handbook for their lives in art.

In 'The Mythic School of Painting' Ruskin gives a thoroughly generous assessment of Burne-Jones, 'this greatly gifted and highly trained English painter'. He praises his technique, especially his precision and mastery of drawing: 'an outline by Burne-Jones is as pure as the lines of engraving on an Etruscan mirror'. He makes appreciative comments on Burne-Jones's sense of colour, whilst maintaining that he is essentially a chiaroscurist: in contrast to Rossetti, 'who could conceive in colour only, he prefers subjects which can be divested of superficial attractiveness; appeal

first to the intellect and the heart; and convey their lesson either through intricacies of delicate line, or in the dimness or coruscation of ominous light'. Most of all Ruskin stressed the high intent of Burne-Jones's work, its visionary imaginative quality:

It should be a ground of just pride to all of us here in Oxford, that out of this University came the painter whose indefatigable scholarship and exhaustless fancy have together fitted him for this task, in a degree far distinguishing him above all contemporary European designers.

In describing Burne-Jones in such high-flown terms Ruskin was defining the Burne-Jones he most wanted to see. In fact, when he had gone to view Ned's paintings in his studio Ruskin was less enthusiastic, as shown by a frustrated little entry in his diary: 'At National Gallery and Ned's, but vexed with his new pale colours and linear design.' Ruskin found it disquieting that Ned was now seen by many as the figurehead of the 'Aesthetic Movement' in art he so distrusted. However, Ruskin managed to gloss over these doubts and delivered a lecture that was to all intents and purposes a long paean of praise. He ended by encouraging members of the audience to view his own selection of photographs of Burne-Jones's work. These had been placed on display in a cabinet in the upper gallery above the lecture hall. The photographs included *The Days of Creation*; three drawings for *The Song of Solomon* and two from *The Romance of the Rose*; 'the great one of Athena inspiring Humanity'; and the story of St George and Sabra. Ruskin was boosting Burne-Jones in his prime mythical mode.

The lecture was widely circulated. One of the people who read the report of it in his evening paper was Swinburne, who, with his own sweet memories of Pre-Raphaelite Oxford, was moved to write to Ned:

I never did till now read anything in praise of your work that seemed to me really and perfectly apt and adequate. I do envy Ruskin the authority and the eloquence which give such effect to his praise. It is just what I "see in a glass darkly" that he brings out and lights up and with the very best words possible; while the others (who cannot draw), like Shakespeare, have eyes for wonder but lack tongues to praise.

Finally, two months later, in July 1883, Burne-Jones and William Morris returned to Oxford together to be made Honorary Fellows of their old college, Exeter. Although he had been unhappy as an undergraduate, made to feel an oddity and a failure, he was delighted and moved by these new accolades, coming almost thirty years after he left Oxford, seeing them as a kind of exoneration.

In the same year as the lecture, Ruskin drew Burne-Jones into his schemes for Whitelands College in Chelsea, a teacher-training college for women where the ambitious High Church principal, the Reverend John Faunthorpe, was active in enlisting the support of the great and the good of the period. In an enterprise that had many parallels with Winnington, Ruskin brought in Burne-Jones to design a series of stained-glass windows for the chapel dedicated to his favourite and ill-fated St Ursula, patron saint of young girls, who with her eleven thousand maiden followers had been murdered by the Huns. A St Ursula window, Ruskin suggested, should be followed by windows showing 'some more cheerful Rectorial or Governmental Saints'. In all, twelve single-figure windows illustrating female saints, many of them virgin martyrs, were designed by Burne-Jones and made by Morris & Co. At the time William Morris judged the Whitelands window of St Martha, the Bethany housewife with her keys and pail of water, the finest stained glass the Firm had ever made.

At Whitelands, Ruskin and Faunthorpe initiated annual May Day ceremonies, reviving the practice Ruskin had started back at Winnington with the annual election of the May Queen, who had been chosen secretly by ballot. The May Queen was the girl considered by her fellows to be, as Ruskin put it, '*the likeablest and loveablest*'. The ceremony was Ruskin's tacit tribute to his dead love Rose La Touche. Each white-robed Queen was, year by year, presented with a gold cross and necklet, specially commissioned by Ruskin, together with a lavishly bound copy of one of Ruskin's works, her choice being between *Sesame and Lilies* and *The Queen of Air*.

In 1883, the third year of the Whitelands festivities, Burne-Jones was the chosen designer of the cross. As always, he put great effort into arriving at the concept, making multitudes of sketches, playing with possibilities, finally complaining to Ruskin, 'You don't know how hard I find that little cross to do – I think I have made fifty designs – but yesterday I chose 3 for you – and I want you to say which you like best.'

The design finally decided on was a simple Greek-pattern cross entwined with branches of May delicately formed in gold. The leaves have a greenish tint. The silvery-pink hawthorn blossoms formed an all too poignant memorial to Rose, now so irrevocably, as Ruskin had lamented, 'gone where the hawthorn blossoms go'. The cross was made at a professional jeweller's, Ryder of Bond Street. Ruskin was not present at the May Day ceremony but Georgie was there to fasten the necklet and cross on his behalf on the Queen of the May, twenty-year-old Edith Martindale from Staveley in Kendal. When the ceremony ended the national anthem was sung by the assembled students, all dressed in white with baskets of flowers and flowers in their hair, and their new queen proclaimed a holiday.

The Whitelands Cross is now on long-term loan to the British Museum and it shows Burne-Jones's skill and versatility at working on the small as well as the large scale. His sketchbooks show a flow of ideas for jewellery designs, some evidently drawn from medieval and Byzantine examples: birds in olive trees as seen in Italian mosaics; the symbolism of the human heart which fascinated him and of which he had much esoteric knowledge. Though Georgie, in her memoirs, could recall just one example of a jewel, besides the Whitelands Cross, which was actually made – a brooch in the form of a dove in pink coral and turquoise, surrounded by green enamel olive branches – there were certainly others. Laura Tennant, for instance, possessed a Burne-Jones bird brooch. Some of his sketch designs include precise instructions for the craftsman, suggesting that these too may well have been made up.

The language of jewels, like the language of flowers, made a direct appeal to him. He once explained to Frances Graham:

Sapphire is truth, and I am never without it. Ruby is passion, and I need it not. Emerald is hope, and I need it . . . amethyst, or as the little stone man I know called it Hammersmith, is devotion – I have it – and Topaz is jealousy, and is right nasty. Sapphires I make my totem of! Prase is a wicked little jewel, have none of him. I gave one to Margaret, and it winked and blinked and looked so evil she put it away.

Precious stones had an almost human power over him. They were part of the richness of his fantasy life.

Early in the 1880s Lady Frederick Cavendish, dining at Lady Stanley of Alderley's, had what she called 'a P. B. neighbour in the shape of Burne-Jones the painter. He was interesting, but desperately self-conscious.' She was one of the few people at this period who did not succumb to the Burne-Jones charm. This was after all the man whom Henry James described as 'a wonderfully nice creature' and whom the American poet Emma Lazarus, although initially resistant, was very soon comparing to a medieval saint, 'so gentle, kind and earnest and so full of poetry and imagination that he shines out of all the people I have seen, with a sort of glamour of his own'.

The Burne-Jones glamour was enhanced, given an element of secrecy, by the completion of the Garden Studio, a long white rough-cast structure at the bottom of the garden where the more formal flower beds and lawns opened out into a meadow. The studio building was designed by W. A. S. Benson, the architect who had adapted the Burne-Joneses' house at Rottingdean. Originally it had been envisaged as a store for large canvases in progress as well as a means of achieving extra privacy, screening off the new houses that were now encroaching on the Grange. On 28 December 1882 Phil reported: 'The New Studio is quite finished now, and today they are putting up an Electric bell which is connected to the house, so that if any one tries to steal pictures from the bottom of the garden we shall hear the alarm bell over the house.'

Soon a skylight was installed, hot-water pipes had been laid and the building was being used by Burne-Jones not just as a store but

as an extra studio where he worked on large-scale cartoons and canvases. Completed pictures could be passed out for transportation to an exhibition or delivery to a client through a slit in the wall leading straight out to the road. The separate, rather mysterious outhouse, approached in the summer through the tall pink hollyhocks, became part of the Burne-Jones mythology. The French critic Robert de la Sizeranne was overcome with the romance of it:

Sir E. Burne-Jones is in his studio. To reach it he has to cross a long garden, half meadow, half orchard, as green as the lawns of Meraugis, as wooded as the forest Brocéliande. It is completely shut in, so no intruder can disturb him . . . Outside, drops of fine rain, London rain, patter on the leaves one by one.

This was the new destination for favoured visitors. Mary Gladstone, doing her rounds of artists' studios in April 1883, noted in her diary, 'Burne-Jones was the great break, his new studio in the garden.' Here she saw Arthur Balfour's *The Wheel of Fortune* finished and *The Hours* 'of gorgeous colour'. She had tea and 'a most pleasant sight of Mr. and Mrs. B-J'.

When W. Graham Robertson first visited the Garden Studio, describing it as 'a huge barrack of a place, like a schoolroom or a gymnasium', he found the full-size gouache studies of the *Perseus* series ranged around the bare whitewashed walls. Many other pictures, begun and then abandoned, temporarily or permanently, hung on the walls or 'stood dustily in corners'. He noticed the early version of *Love and the Pilgrim*, *The Prioress's Tale*, *The Masque of Cupid*, various designs for *The Romaunt of the Rose* and the first panel of the *Briar Rose* series, the Prince battling through the wood towards the enchanted castle.

The studio was equipped with a tall set of artist's steps with higher and lower platforms which Burne-Jones would ascend to reach the upper areas of his canvases. His little granddaughter Angela was later to remember sitting on those steps with her head wrapped in 'a many-coloured piece of silk and bound with a coronet' while Burne-Jones made studies of the crown and drapery for

one of the mourning queens in his epic – and unfinished – painting of King Arthur in Avalon.

For Burne-Jones the great thing about the Garden Studio, besides the extra space, was the independent life it gave him, removed across the orchard from Georgie's watchful eye. Although it had no house number, the studio had its own separate entrance from Lisgar Terrace. Coachmen were advised to approach the studio by turning down Avonmore Road, where – perhaps not so coincidentally – Maria Zambaco had a house when she returned intermittently from Paris. When Coutts Lindsay's wife left him in acrimonious circumstances in 1882 she was offered the use of a studio next door to Burne-Jones's. Blanche was one of those artistic women in distress to whom Burne-Jones could be relied on to offer sympathy.

The Garden Studio was an ideal setting for those tête-à-têtes in which the artist in his blue working smock had now come to excel. It provided a quiet, reassuring place for painting portraits of the women in his milieu and especially their children. This was something he was now increasingly involved with. Burne-Jones did not consider portrait painting as a central or indeed an important occupation but it was sometimes difficult not to yield to pressure. It was in the Garden Studio that he painted the Comyns Carrs' small golden-haired son Philip while his mother sat beside them reading a fairy tale.

Although so private, the Garden Studio gave Burne-Jones a connection with local London street life. He found the sounds quite moving: the tradesman's boy whistling, the cries of sweeps and hawkers, the shouts of the children as they came home from school at midday and then again at teatime, often banging mischievously on the studio door. One day he actually captured one small 'yelling infant' but quickly let him go again. He particularly loved the sounds of the street organ: 'Pretty those tunes are, they quite melt my heart.'

Though Burne-Jones was now so much in demand, he stayed evasive. Henry James complained about how difficult it was to nail

him: when Burne-Jones was at home he was working and when he was working he was not at home. Though he had so many would-be friends, he was choosy. Lady Frances Balfour, wife of Arthur Balfour's brother Eustace, remembered, 'It was only after he had tried the ground and found a firm footing under his feet that he would come to our house for a meal. Evening dress and all the mailed panoply of society he loathed.' He was wary of being trapped by people whose views he found antipathetic or who treated him as a cultural trophy. He needed those who could share his visual sensitivity and keep up with the free play of his imagination, his speculative mindset. As Frances Balfour appreciatively put it, 'You never knew where you would find Burne-Jones.'

Among their close friends and patrons of this period were Madeline and Percy Wyndham, near-contemporaries of Ned and Georgie's who, like Arthur Balfour, were in the inner circle of the Souls. The Hon. Percy Wyndham was Conservative MP for West Cumberland, a hunting-and-shooting aristocrat, eccentric and irascible, given to wild swearing. Burne-Jones admired him but found him rather nerve-racking. When he was reading Pepys's diaries a comparison soon struck him: 'he is so like Percy Wyndham that I must for old friendship, or at least acquaintance sake, stand by him – but sometimes when he talks I mean to leave the room'.

Madeline was deeply spiritual, an artist, a skilful embroiderer. She later studied with the Arts and Crafts enameller Alexander Fisher. She was also apparently the first woman in England to smoke. Georgie summed up her soulful side: 'She is an Angel . . . She has the master-key of life – love – which unlocks everything for her and makes one feel her immortal.' Madeline was darkly beautiful, with an intense expression and responsive grey-green eyes. Her portrait by Watts, shown in the first exhibition at the Grosvenor Gallery, elicited from one visitor the comment |that she looked as if she had £30,000 a year. But, though rich, the Wyndhams were not vulgar with their money. They were creatures of taste, and they bought and commissioned with extra-ordinary care.

Burne-Jones was a loather of country-house weekends, finding that they sapped his energy, but for Madeline's sake and that of her eldest daughter Mary he had made the concession of going to stay with the Wyndhams at Wilbury, their house in Wiltshire, enduring the taunts of William Morris that he was going over to the Tories. When the Wyndhams went on to build a vast new country house, Clouds at East Knoyle, to plans by Philip Webb, Burne-Jones's work was integral to the *mise-en-scène*.

Webb finalised his design in 1881 and building and decoration went on through the early 1880s, being finally completed in 1886. Clouds was a palace of art envisaged for grand-scale entertaining. W. R. Lethaby felt the house had been 'imagined by its gifted hostess as a palace of weekending for politicians'. Clouds was furnished in the lavishly discriminating new Aesthetic style with Morris & Co. carpets and curtains, wallpapers and hangings, Philip Webb purpose-built oak bookcases and furniture, Burne-Jones paintings: the total Morris look. The Wyndhams had been at the forefront of the founding of the Royal School of Art Needlework in London, for which Burne-Jones supplied designs. Two of these, *Poesis* and *Musica*, were originally intended for portières worked by the students in brown crewel on linen. The Wyndhams acquired the cartoons of both these designs, which Burne-Jones then worked up in colour. A most spectacular silk embroidered version of *Poesis* was also made for Clouds.

In a dominant position over the main staircase was a cartoon for Burne-Jones's mosaics for the American Church in Rome, a scene of the Ascension showing Christ aloft, surrounded by archangels, blessing those on earth. Again Burne-Jones had elaborated the original cartoon, painting in the figures in raw umber, gilding the haloes and repainting the faces and the hands. The *Ascension* cartoon was one of the works of art destroyed in the disastrous fire that virtually gutted the house in the early hours of 6 January 1889. The fire had been started by a housemaid leaving a lighted candle in a cupboard. Georgie could hardly believe the horror of it, writing to the Wyndhams' daughter Mary, 'Again and again it comes to me as a fresh shock – it seems so utterly impossible that

that beautiful monument of loving and successful labour should have disappeared.' Though Clouds was remarkably rapidly rebuilt, rising again like the phoenix from the ashes, and some of the furnishings were miraculously saved, all that remained of *The Ascension* was a photograph on which Madeline had scribbled 'All gone. Alas! Alas!'

In June 1881 Rossetti wrote to Janey: 'I heard something almost inconceivable – that is, that Ned has gone to spend a week at the countryside house of Lewis the Police Lawyer! I shd. as soon have thought of his applying for a lodging in Newgate.' Rossetti is referring to George, later Sir George, Lewis, the Jewish criminal and divorce lawyer who became a pivotal figure in Victorian society. He first achieved celebrity in the Balham Mystery case of 1876 when Lewis represented the parents of the victim at the inquest into the poisoning of Charles Bravo. He acted in notorious society lawsuits, notably the Crawford–Dilke scandal of 1885–6, and was later to successfully defend the Prince of Wales in the so-called Royal Baccarat affair. Oscar Wilde, a friend, described him as 'Brilliant, Formidable, Concerned in every great case in England. He knows about us all and forgives us all.' George Lewis was a portly, bewhiskered and monocled, eminently cartoonable figure who wore a fur coat even in sweltering midsummer. He has been well described as the Lord Goodman of his day.

Burne-Jones's friendship with the Lewis family burgeoned in the 1880s. George Lewis's second wife, the German-Jewish Elizabeth Eberstadt, was equally formidable in her way, a cultivated, clever, socially ambitious woman who created a brilliant late Victorian London salon at their house at 88 Portland Place. George Henschel, Robert Browning, Arthur Sullivan, Ellen Terry, Henry Irving, Lillie Langtry, Henry James, Oscar Wilde, Du Maurier, Alma-Tadema, Whistler, Sargent: few people resisted her invitations. Graham Robertson described her as 'a strange woman . . . with a wonderful gift of sympathy and understanding. I would as soon take her opinion of a man as anyone's. (She doesn't know so much about women).' Determinedly but subtly, Elizabeth Lewis

drew Burne-Jones into her network, asking him to London evening parties and inviting him to stay at Ashley Cottage, their country retreat in Walton-on-Thames.

Burne-Jones responded in the way he often did with alluring middle-aged sophisticated women. Initially he was bashful, taking up his pose of pitiable object, pleading his humility in the face of the glittering entertainments she was offering. 'I haven't chocolate cakes – only penny buns and bread and butter and you don't like poverty.' But soon his tone changes to the pleasure of flirtation and he asks her to visit, promising her as he promised Lady Leighton, as he would later be promising May Gaskell, to try to keep other people away. Soon he is suggesting himself to go and stay at Walton while Georgie and Margaret are safely away on holiday.

From then on Burne-Jones was often at Walton: 'happy happy Walton' he calls it. He sketches the long low double-cottage building in its setting of lush water meadows. His letters become more intimate, effusive: he wants Elizabeth 'to sit in soft places and I will bring you things'. He vows to dedicate himself more and more to beauty. 'I will paint you as you are now,' he tells her, 'so that one day your children shall have some symbol to remember you by – and they need look no more at those shameful impudent photographs. You shall have no brown background but heavenly blue. I will paint you as I remember you in the long walk looking as if you had been born and lived always in the trees.' The painting in fact does not seem to have materialised, but a delicately loving drawing of Elizabeth Lewis has survived.

There was a curious episode at Walton when he was working on one of his pictures of a mermaid. As he passed the cottage of one of the keepers of the estate he noticed, perching on the rim of a well, a girl of about twelve, 'a lovely creature with fair hair and grey eyes, dressed in a scarlet gown'. She had bare legs and feet and she seemed too shy to speak. According to Elizabeth, Burne-Jones seemed under a spell when he came back to the house. He at once made a drawing of the girl from memory and used it for the head of the mermaid in his painting. What was strange was that no

one could later identify the child. Elizabeth wondered if it could have been a sprite.

To hang above the fireplace at Walton Burne-Jones designed a low-relief decorative panel in tempera and gilt on gesso. The subject is *The Garden of the Hesperides*. The peculiarity is that instead of the mythological three daughters of Hesperus guarding the golden apples of Hera, Burne-Jones painted only two. This was presumably in tribute to the daughters of the house, Gertie and Katie, whom – especially Katie – Burne-Jones loved and teased and wrote to. His letters to Katie, who was four when the correspondence started, are marvels of their kind.

These sly, whimsical, gleefully illustrated letters are the ultimate example of Burne-Jones's talent for forming a creative rapport with little children, entering a child's imaginative mind. He was already well practised in making comical and sometimes deliciously frightening sequences of drawings for his own children. But letters to Katie were different because she was part of another, richer, more complicated household and because she was already a peculiarly knowing and self-confident small child who, even at four, had the famous artist's measure. 'This morning', he told Phil, writing from Ashley Cottage, Katie 'appeared before I got up in my bedroom and insisted with screams on stopping while I got into my tub – and I never had such trouble to get free in all my life . . . she says tomorrow she will see me in my tub, which fills |me with terror'. No wonder Oscar Wilde referred to little Katie's 'fascinating villainy'.

It was apparently Katie who invented Burne-Jones's own caricature persona for the letters, the birdman artist Mr Beak. They contain inspired variants on many of the usual Burne-Jones creatures, the dogs and pigs and babies whose flabbiness he loves. Burne-Jones invents a magical flower – the *mischevia fabiformia* – a lily of the valley with a plump baby growing out between the leaves which he assures Katie he found growing in his garden. These are fairy tales with hints of the visually macabre as Burne-Jones, for example, transforms his small fat piglets into well-rounded pork pies.

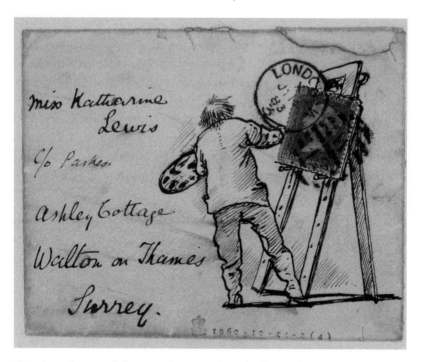

Envelope for one of the many letters written by Burne-Jones to Katie Lewis.

They are stories with a touch of sexual provocation, particularly obvious in a sequence in which he undresses a doll and then, pretending to be shocked by her horrid leather body, gradually puts lovely clothes on her again. 'Katie,' he writes to her, 'I have been very particular not to make my drawing rude, it isn't rude is it dear. I was a bit shocked this afternoon, to tell you the truth, and I was very glad your papa was not by.' Though ostensibly to Katie, he knew they would be read by her mother. In a way these were letters for Elizabeth as well.

Burne-Jones's narrative drawings are in a particular Victorian tradition of illustration for children. They resemble Tenniel's drawings for Lewis Carroll's *Alice* books in responding to the topsy-turviness with which a child views the adult world. Their economy of draughtsmanship and glorious sense of fantasy are not unlike Edward Lear's. But Burne-Jones's fantasies are more worrying, more haunting, as in the story he illustrates for Katie

showing how he has lost his half of his poor cat. The despairing
Burne-Jones figure stands crumpled in a corner while his daughter
Margaret holds up half a cat's body, the front half with the head.
'She has to cover up the end of her half with an apron,' he explains
to Katie. His comic drawings reveal much of his own dual personality, the bleak black melancholy that so strangely co-existed with
an almost manic high-spiritedness.

Burne-Jones painted portraits of both Elizabeth's daughters,
Gertie and Katie Lewis. The portrait of Katie, which was

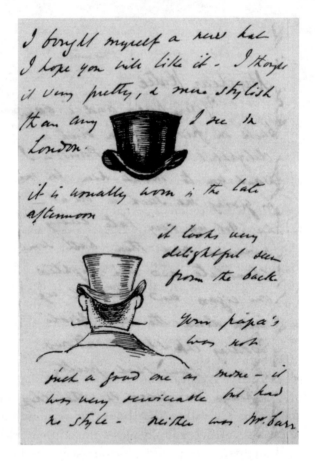

Extract from a letter to Katie illustrating Burne-Jones's fashionable new
hat in contrast to the shabbier hat worn by her father George Lewis,
the well-known London solicitor.

exhibited at the Grosvenor in 1887, shows the pale-faced child in a midnight-blue dress stretched out on the cushions of a sofa reading quietly. The book is open at an illustration of St George and the dragon. At her feet is an orange and her little wild-haired dog. The picture has the stillness of a Dutch interior. When, years later, Burne-Jones went to Portland Place to give Katie's portrait to her father, George Lewis, a surprisingly shy man, was overcome with awkwardness. 'He didn't know what to do to thank me,' Burne-Jones recollected:

All he could do was to make me take away as many boxes of cigars as he could lay hands on. He fidgeted about the room to try and find something to give me that I would like, and couldn't satisfy himself at all. Rather pathetic, wasn't it, to see a man in that state who is the terror of the aristocracy of England and knows enough to hang half the Dukes and Duchesses in the kingdom.

Like her mother, Katie, who lived to a great age, cultivated famous men, her greatest devotee being Bernard Berenson.

Burne-Jones had got to know Oscar Wilde well through the Lewises, both at the Portland Place dinners and over weekends at Walton-on-Thames. Here Joe Comyns Carr of the Grosvenor Gallery and his wife Alice were also frequent guests. Alice remembered Oscar Wilde being 'fresh from Oxford then, and considerably esteemed as a wit himself, though not, as Joe shows in his Reminiscences, always above the suspicion of borrowing'. She was conscious of Burne-Jones having 'a kindly liking' for the young man.

There was already a considerable resistance to the formidably affected Oscar in the London art world. In 1881, when his first book of poetry was published, Rossetti had growled to Janey Morris, 'I saw the wretched Oscar Wilde and glanced at enough to see clearly what trash it is. Did Georgie say that Ned really admired it? If so he must have gone drivelling.' William Morris had just managed to overcome his initial suspicion when he met Wilde at a party at the Richmonds': 'I must admit that as the devil is painted blacker than he is, so it fares with O. W. Not but what he is an ass, but he is certainly clever too.'

Burne-Jones was more predisposed in Oscar's favour. First of all there was the link through Meinhold's *Sidonia the Sorceress* which Oscar Wilde's mother 'Speranza' had translated and Burne-Jones read so avidly. Then, even when an undergraduate Wilde had admired Burne-Jones's work, and his rooms at Magdalen were hung with photographs of *The Beguiling of Merlin, The Days of Creation, The Mirror of Venus* and Burne-Jones's painting of Christ and Mary Magdalene. Wilde considered his reproduction of *Spes* to be the most beautiful of the whole collection: 'It seems to me to be full of infinite pathos and love, and to be a vision of what that hope is which comes "to those who sit in darkness".' When he moved to London and was living off the Strand in the building he named Thames House, his Burne-Jones and Blake drawings, along with the Damascus tiles, the blue china, the lilies and Edward Poynter's portrait of Lillie Langtry, were integral to Wilde's own Aesthetic style of decoration.

At the time of their joint exposure to the flurry of publicity and satire that followed the opening of the Grosvenor Gallery, Wilde made great efforts to cultivate Burne-Jones. 'Oscar Wilde was very nice to me,' he told Elizabeth, 'and came across the other day to say how pleased he was – and he looked so genuinely glad that I loved him.' Burne-Jones was still so insecure that he warmed to those who liked him. Burne-Jones the humorist loved Oscar's witticisms too, finding him the funniest man he ever knew. Very soon Oscar had his entrée to the Grange.

'Mr. Oscar Wilde came here yesterday,' wrote Margaret in January 1881, 'he is very much better than people make him out to be – he didn't drivel at all here, although he did bring father some lilies. He talked sensibly and interestingly.' The following year Rudyard Kipling's sister Trix, meeting Oscar at the Grange, was less enthusiastic. He had only been there for supper – 'luckily, for he is a dish I love not'. Trix observed that Oscar 'talked incessantly, and at any pause Phil, who sat next to him, gasped: "Oscar, tell us so and so", and set him off again. He hardly seemed to look at Margaret who was as white and beautiful as a fairy tale, and took very little notice of Auntie Georgie. Uncle Ned was unusually silent, and

winced, I think, when Oscar addressed him as "Master".' Oscar
Wilde was Phil's 'new adoration', she noted cattily. He was evidently
treated as a trusted uncle, allowed to take Phil and Margaret out on
river trips, infiltrated into the domesticity of the Grange.

At the end of December 1881 Wilde set off to America to give a
series of lectures on the modern artistic movement in England.
Whistler, aware that Wilde was likely to praise the Pre-Raphaelites
and still rankling from the libel trial, had made the bitchy
comment 'If you get sea-sick, throw up Burne-Jones.' And indeed
when Oscar Wilde delivered his lecture on 'The English Renais-
sance of Art' in New York on 9 January 1882 Burne-Jones was
lauded as a spiritual artist opposing the insensitive materialism of
the age. 'I remember once, in talking to Mr. Burne-Jones about
modern science, him saying to me, "the more materialistic science
becomes, the more angels shall I paint: their wings are my protest
in favour of the immortality of the soul".'

Burne-Jones had provided Oscar with an introduction to Charles
Eliot Norton. Meeting Henry James in Washington, Wilde, dressed
tastefully in knee breeches with a flowing yellow silk handkerchief,
had boasted, 'I am going to *Bossston*; there I have a letter to the
dearest friend of my dearest friend – Charles Norton from Burne-
Jones.' Norton was now Professor of the History of Art at
Harvard. Burne-Jones had indeed written a rather fulsome letter
recommending 'my friend Mr Oscar Wilde, who has much bright-
ened this last of my declining years'. Just a few months later
Burne-Jones was having some misgivings about the wisdom of
this introduction. 'Was it funny of me to send you that fantastic
Oscar? I hadn't much hope you could affect him – but I had a
liking for him and from time to time took up cudgels on his behalf
– and I thought it would do him good to see you: it was kinder to
him than you.'

What was Burne-Jones really feeling about Oscar at this junc-
ture? As well as being amused by him, he respected him for what
seemed a wonderfully true instinct for the beautiful. As he tried to
explain to Norton, 'he knows little or nothing of art, nor could
ever know – only the right word and right thing did make his soul

leap up so swiftly that I couldn't help liking him'. But he could already sense that Oscar was endangered by his reckless associations and 'worthless tags of things that were clinging about him'. Burne-Jones had a certain ruthlessness and he could see a time when friendship with Oscar would be no longer tenable. He told Norton, 'I dare say bye and bye I shall give him up.'

Georgie too felt a tremor of anxiety when, in 1884, the Burne-Joneses were invited to a Kensington dinner party given to celebrate the engagement of Oscar Wilde to a young woman from Dublin, Constance Lloyd. 'It was like a dream – but not a bad one: he behaved well and the girl was nice.' But several times she found herself falling into a trance as she was sitting at the dinner table, meditating on the unexpectedness of the event.

The early 1880s was a period of departures, some tragic, some more comical. On 9 April 1882, having suffered a mild stroke, Rossetti died at Birchington-on-Sea in Kent. He was only fifty-three. Although he had written to congratulate Rossetti on the publication of his *Ballads and Sonnets* in the previous October, Burne-Jones had not seen him for well over a year and he took his death hard. Having set off intending to travel to the funeral at Birchington, he turned back at the station, feeling too upset and ill. Nor did he have the courage to see the exhibition hastily assembled in London to mark Rossetti's death, explaining, 'I haven't the heart to go and see those first things of his that were such miracles to me. What a world it did look then – twenty seven years ago; and he the centre of it all to me.'

After Rossetti's death there was a scramble, as there had been after the death of Byron, to collect up and destroy any letters that might sully his posthumous reputation. Gabriel's much more conventional brother William was the leader of this clean-up operation, searching Cheyne Walk for Ruskin's confidential letters and the 'mildly chaffy indecencies that Swinburne used to pen – strings of punning banter ringing the changes on any impropriety that he could start'. The one example William Rossetti discovered 'found its way into the fire at once'.

In this flurry of anxiety Janey Morris called on Ned to tell him she suspected Fanny Cornforth had a cache of possibly incriminating letters which she might try to sell or use as a means of blackmail. Burne-Jones then went to see William Rossetti to tell him he was dining that evening with the solicitor George Lewis, 'his man of business', and intended to consult him about what action to take. Would Rossetti accompany him? Burne-Jones and Lewis's first suggestion was that Joe Comyns Carr should be sent round to Fanny 'as an amateur, enquire about drawings, and then about letters, and report result'. William Rossetti vetoed this proposal on grounds that Carr was too involved in the art world and potentially irresponsible. Finally George Lewis offered to go and see Fanny on his own. There is alas no record of the interview between England's most famous lawyer and Rossetti's 'Helephant', but it seems that the suspicions about Fanny petered out.

William Rossetti gave Burne-Jones some personal mementoes of his brother: gloves, spectacles, drawings and manuscript sonnets. Burne-Jones was glad to have them but he really hardly needed them for in the months and years after Rossetti's death the intimate memories came flooding back of the friend and artist as he had been back in his prime. It was the recollection of Gabriel's vivid physicality he clung to, 'after whom all other men are films for faintness'. The Italianate expansiveness of gesture, the great grip of his handshake. William Morris's handshake, Burne-Jones noticed, had no pressure. It was 'like a pad for you to do what you will with'. But 'Gabriel was different – if he loved you his fingers bent round and round yours and each one pressed and he never hurried to take it away.'

Irritated by the many inaccurate accounts of Rossetti that began to circulate after his death, Burne-Jones planned to write a memoir of his own and made some preliminary notes for it: 'Gabriel. His talk, its sanity and measure of it – his tone of voice – his hands – his charm – his dislike of all big-wig and pompous things – his craze for funny animals – generally his love for animals – his religion – his wife.' The memoir did not materialise. Nor did the stained-glass windows originally planned to be commissioned from

Burne-Jones and Ford Madox Brown for the parish church at Birchington where Rossetti is buried ever see the light of day.

An element of farce entered the Burne-Jones household two months after Rossetti's death, in June 1882. Ned's father, nearing eighty, was becoming doddery. Miss Sampson, always temperamental, had become so angrily impatient with him she had to be dismissed. Ned himself had little time or inclination to take the train to Birmingham to sort the problem out. So Mr Jones had been brought south and settled in a house in Ealing with a young servant maid. All was apparently going well when Burne-Jones, escaping the multitude of Sunday afternoon callers, went to visit his father. He was back in record time with the news that his father had married the servant maid. This development had put him in a state of shock. Temporarily he felt unbalanced by it. All his life he had assumed his dead mother was irreplaceable.

Mr Jones and his bride were dispatched again to Birmingham. It is significant that in giving her account of Mr Jones's second marriage in her memoirs Georgie never once mentions the servant girl's name.

These were years of many painful emotional upheavals. The girls on the golden stairs were being decimated. Burne-Jones's idolised young women were departing from his orbit. First, in autumn 1882, his beloved Frances Graham announced her engagement to John – known as Jack – Horner, a man fifteen years her senior, the original Little Jack Horner of the nursery rhyme. Faced with the announcement, Burne-Jones evidently did his best to appear self-controlled in public. Mary Gladstone's diary for 18 November registers 'tea at B-Js with Frances and Jack . . . Dined in Grov. Place, very nice and I loved Jack.' But more privately he was dismayed, writing to Ruskin over the loss of 'Francie' in the tone of whimsical jocularity that often hides deep feeling, recalling how much of his own work had been designed for her specifically:

many a patient design went to adorning Frances' ways. Sirens for her girdle, Heavens and Paradises for her prayer-books, Virtues and Vices for her necklace-boxes – ah! The folly of me from the beginning – and now in the classic words of Mr. Swiveller 'she has gone and married a market gardener' . . . Oh these minxes! You and I will yet build us a bower and have our mosaics which none of them shall ever see.

The sense of his betrayal was the worse because Jack Horner was a country landowner with a large estate, Mells Park in Somerset, who later became the government Commissioner of Woods and Forests. The quotation from Mr Swiveller – Dick Swiveller – is taken from Dickens's *The Old Curiosity Shop*. The turning of Jack Horner into a 'market gardener' implies his recognition that his artistic, sophisticated Frances was being removed to an alien world. After the wedding silence descended. There was no more correspondence for the next two years.

The next defection amongst daughters of Burne-Jones's friends and patrons was that of Mary Wyndham, who in 1883 married Hugo Charteris, Lord Elcho and later 11th Earl of Wemyss. The eldest daughter of Percy and Madeline Wyndham had been brought up alongside the Burne-Jones children, sharing with Phil and Margaret the code language of the 'Spression', the word used by the children to denote 'anything we specially loved, quaint, amusing, charming, inexpressibly "expressive"', as Mary still remembered in her grand old age. Again Burne-Jones felt bereft at the departure of the beautiful, sexually forthcoming, disconcertingly direct, rather scatty Mary, realising that she too had been removed to a more elevated, distant social sphere, though perhaps his desolation was not quite so great as Phil's, who had worshipped Mary with a hang-dog hopelessness since their family holidays at Wilbury.

Mary, later Countess of Wemyss and chatelaine of Stanway, adored confidante of Arthur Balfour, lover of her mother's lover Wilfrid Scawen Blunt whose child she bore, remained an Arthurian symbol of desire to him: 'always', he had told her, 'I shall be your champion – with ears on the alert for the least cause of offence, and fingers on my sword'. But once she was married it could never be the same.

337

The next of his girl loves to desert was Mary Gladstone. In 1884 he complained to Lady Leighton that he had scarcely seen Mary all year, and then in December 1885 she wrote to let him know she was engaged to the curate at Hawarden, Harry Drew. Mary was under no illusions. Harry possessed none of the qualities that would recommend him to the world, being 'the most shy and humble and quiet and penniless' of people. But he was the first person who had ever loved her whose love she had been able to return.

In a way, the news that Mary was marrying a curate was harder for Burne-Jones to accept than the engagement between Frances and her 'market gardener' Jack Horner. A curate was, after all, what he himself had once intended to become and curacy had been the theme of some of his and Swinburne's most indecent jokes. Faced with the announcement, Burne-Jones once again endeavoured to make light of it, telling Lady Leighton he had sent Mary his blessing: 'I assure you I send blessings like a bishop, my hands are always being lifted in benediction.'

He wrote to tell Mary he preferred curates to bishops, especially when they were perpetual curates: 'I am glad you will leave that big world', he told her, 'it never was anything to you or yours'. His reaction was more tactful than that of John Ruskin, who asked if she thought she would get recompense in heaven for living in a cottage in poverty. Burne-Jones did however allow himself a moment of sulkiness as Mary evidently threatened severing connections: 'I don't quite see why you say it is goodbye.'

Finally there was the double loss of Laura Tennant, most golden of the girls on the golden stairs. 'Half-child, half-Kelpie', an admirer, Doll Liddell, had described the daughter of the wealthy Scottish industrialist and Liberal MP Sir Charles Tennant: 'she had reduced fascination to a fine art in a style entirely her own. I have never known her meet any man or hardly any woman whom she could not subjugate in a few days.' Tennyson called her 'little witch' and asked her to kiss him. Laura was glad to do so. At the Grange, where they all loved her, she was known as 'the Siren'. Burne-Jones was enthralled by Laura's sexual precocity: 'with so

much fuel and fire as she has in her, she can surely make some-thing splendid of her life'.

In May 1885 Laura married Alfred Lyttelton, whose family was closely connected with the Gladstones. Alfred was said to be W. E. Gladstone's favourite nephew. As a wedding present for Laura, Burne-Jones had made a design to be carried out in hammered silver with the motto '*Immortale quod opto*'. But it was not even finished when Laura died aged twenty-three on the Saturday before Easter 1886, six hours after having given birth to a baby son. When the news reached him on Easter Day Burne-Jones was at work finishing his painting *Morning of the Resurrection*. Surrepti-tiously he dedicated it to Laura, inscribing 'In Memoriam L. L. Easter 1886' in letters so minuscule that when the painting was exhibited at the Grosvenor Gallery no one was aware of the dedication.

Burne-Jones felt bitter despair over the death of Laura. 'It is the sorrowfullest ending,' he wrote, 'poor, bright, sweet little thing. I dread knowing any more of people, or watching in a stupid unhelp-ful way the calamities that rain upon them.' His Secret Book of Designs, as his private sketchbook now in the British Museum has come to be known, contains a sequence of ideas for memorials to 'that little darling' Laura Lyttelton. One of Burne-Jones's memorial projects was the design for a decorative book cover for the 'pretty fragments' of the story for children Laura had been composing. Another, more ambitious and substantial, was the bas-relief memorial in gesso, a technique with which he had just started to experiment. Burne-Jones liked the sense of permanence of a material he saw as 'durable as granite and enduring till the Judgement Day'. The eight-foot-high monument in pure white gesso, commissioned by Laura's bosom friend Frances Horner, is still *in situ* in St Andrew's Church at Mells.

The effigy takes the form of a peacock, symbol of the Resurrec-tion, standing on a laurel tree. The laurel tree, as Burne-Jones conceived the composition, 'bursts through the sides of the tomb with a determination to go on living, and refusing to be dead'. The feathery tail of the peacock sweeps down through the whole length

of the tall panel. This is a thoroughly Aesthetic Movement monument. One night Burne-Jones experienced a strangely vivid dream of the flirty but sensitive and enigmatic Laura coming to take a look at her own 'peacock tomb'.

Besides the chalk-white version for the church, Burne-Jones had a cast made of the effigy which he then painted in rich colours on gold and put up in the entrance at the Grange. When Leighton saw it he said he wished to die there and then so that Burne-Jones could make a monument to him.

Burne-Jones never quite got over the early death of Laura Lyttelton, whose small son himself died two years later of tubercular meningitis. 'We shall all feel it, all of us, to the end of our days,' he wrote to Mary Gladstone, now transformed to Mary Drew. Its effect on him was to return him to the intimate affections of the now young married women of the Souls as their revered artist, the maker of their monuments, in a kind of high-priest role that was part avuncular and part permittedly erotic.

With the commission of Laura's monument for Mells he was more or less back on his old terms of love with Frances, and their intimate correspondence resumed. When he sent a gloriously coloured gouache sketch of the peacock tomb to Mary Elcho he gave her his advice tenderly, suggestively: 'If you put the little peacock anywhere, prythee let it be in some remote room in your own innermost bower.'

The Grange, Five
1884

When Burne-Jones's painting *King Cophetua and the Beggar Maid* was shown at the Grosvenor Gallery in 1884 it marked the highest point of his career. The picture was received with even greater acclaim than his admirers' previous favourite *The Golden Stairs* and it was the work that established Burne-Jones's reputation on the Continent. Perhaps of all his paintings this is the one that sums up most exactly his philosophy of art, his conviction that a life lived through beauty was everybody's birthright regardless of their income or their social position. As he wrote: 'that is a type of life I should most love – a centre of beauty so surrounded with beauty that you scarcely notice it – take it for granted – a land where the lowest is as worthy as the King and yet the King is there'.

The subject was taken from a sixteenth-century ballad that relates how a king fell in love at first sight with a beautiful and destitute young woman clothed in grey. Tennyson had used the story as the basis for his poem 'The Beggar Maid' of 1842. Burne-Jones, psychologically attuned to such tales of sudden abject adoration, had painted several earlier versions of the subject. For this larger-scale work in oil he first made a cartoon, then worked flat out on the canvas from October 1883. 'I work daily at Cophetua and his maid,' he wrote to Frances. 'I torment myself everyday – everyday I know it was a mistake for me to be a painter – Yet I'd die if I wasn't one. I never learn a bit how to paint – no former

work ever helps me – every new picture is a new puzzle – and I love myself and am bewildered.' For Burne-Jones the actual processes of painting had become a kind of blissful agony.

Part of the problem was the clothing of the beggar maid. How to arrive at a convincingly beggarly coat that would not 'look unappetizing' to King Cophetua? After several attempts Burne-Jones arrived at a tunic of Grecian simplicity, alluringly see-through but in a convincingly demure shade of grey. Great attention was paid to authenticity of detail. Not only did W. A. S. Benson model for the King, he also used his metalworking skills to make the golden crown Cophetua symbolically offers up in homage to the maid. It is likely that Benson also made the full-size models for the King's armour and the discarded shield in the foreground of the picture.

When Henry James took the aspiring portrait painter John Singer Sargent, recently arrived in London, to visit Burne-Jones's studio they found *King Cophetua* well advanced enough for James to judge it 'his finest thing'. For Alfred Gilbert, who also saw the picture at Burne-Jones's studio, it 'roused mingled feelings of wonder and joy'. The young sculptor, whose greatest claim to fame is the statue of Eros at Piccadilly Circus, became an instant proselyte, experiencing an overwhelming rush of sympathy for Burne-Jones and his aims. But by the time *King Cophetua* was finished Burne-Jones was in his usual state of exhaustion and despair. On 23 April 1884 he told Madeline Wyndham, 'This very hour I have ended my work on my picture. I am very tired of it – I can see nothing any more in it, I have stared it out of all countenance and it has no word for me. It is like a child that one watches without ceasing till it grows up, and lo! it is a stranger.'

In May, once the painting went on exhibition, the majority of those who saw it were bowled over by Burne-Jones's use of colour: the dark rich golds and azures, black, bronze, crimson, olive, brown and grey, the tones and tints so subtly merging and beautifully graded. The critic F. G. Stephens, writing in *The Athenaeum*, judged that 'Technically speaking, this picture is far more complete, better drawn, more solidly painted, more searchingly designed than any we have had from the painter before.' *The Times*

went even further by deciding that not only was *King Cophetua and the Beggar Maid* the finest work Burne-Jones had yet painted, it was 'one of the finest pictures ever painted by an Englishman'.

Its Renaissance antecedents were obvious. The echoes of Mantegna's *Madonna della Vittoria*, the painting in the Louvre of which Burne-Jones possessed a photograph. The resemblance to Crivelli's *Annunciation*, which Burne-Jones would have seen often in the National Gallery, in the density of colour and the closed-in verticality of architectural setting, the sense of the emotional challenge taking place in a claustrophobic space. Thomas Rooke, Burne-Jones's studio assistant, referred to this painting as being 'in the Crivelli manner'. But there was a great deal more to it than that.

The acclaim that greeted *King Cophetua and the Beggar Maid* was less to do with Burne-Jones's Renaissance influences than with his contemporary relevance. It was the idea, the moral meaning of the picture, that intrigued and stimulated both the critics and the public, the stark contrasts between capitalists and under-classes, wide gulfs between the factory owners and the workers. Claude Phillips summed this up in *The Magazine of Art*: 'The spirit which informs his art is essentially and entirely modern, and as far asunder as the poles from that which inspired his proto-types.' The painting encapsulated many bitter social conflicts of the Victorian age and it established Burne-Jones on a new footing as the most important painter of his time.

Beyond the Grosvenor Gallery, the spread of his reputation was assisted by reproductions of his work. Though as we have seen in his relations with the Dalziel Brothers he was antipathetic to run-of-the-mill steel engravings, from the 1880s he was searching out printmakers with the skill to reproduce his paintings by etching and engraving processes, producing small specialist editions of prints that had their own validity as works of art. He kept a strict control over such reproductions. *King Cophetua* was one of his paintings that translated superbly well to photogravure.

Burne-Jones's work was still more widely circulated in the cheaper form of photographic reproductions. Here he worked closely

with his Kensington neighbour Frederick Hollyer, a photographer especially adept with works of art. There was no snobbish resistance to these photographic versions: many of Burne-Jones's friends and close admirers had their walls hung with reproductions of his paintings. Cynthia Asquith for example recalled that just as soon as she acquired a chequebook she 'rushed out to buy framed photographs' of twelve Burne-Jones pictures. One of these was *The Beguiling of Merlin*; another *King Cophetua and the Beggar Maid*.

Like many famous paintings it had a further life as the subject of lampoon. In 1884, just a few weeks after it first went on show, it was the subject of a *Punch* cartoon in which the Medieval Royal Personage says to the Pallid Maiden: 'Oh I say, look here, you've been sitting on my crown.' The *Punch* cartoonist adds: 'Yes; and she looks as if she had, too, poor thing.' In his own comic drawing *King Cophetua and the Beggar Maid in the style of Rubens*, with the Beggar Maid a buxom semi-naked bathing beauty and the King a swarthy warrior in heroic Grecian helmet, Burne-Jones wonderfully ridicules himself.

As Georgie points out in her memoirs, the designing and completion of this large-scale painting took place at the time when a serious political 'divergence of opinion' between Burne-Jones and Morris was just beginning: 'the thought of the King and the Beggar lay deep in both their minds'. Morris's growing despair at Britain's class divisiveness and the almost universal apathy to art was propelling him into political activism. He felt deeply the irony of his own position as the successful decorator 'ministering to the swinish luxury of the rich' whilst his aims of bringing art to the great mass of the people had got nowhere. He had reached the point of understanding that his political visions would not be realised until society itself was fundamentally restructured, and in 1883 he took the desperate step of joining the Democratic Federation, a small new revolutionary Socialist party whose leader was the Marxist Henry Mayers Hyndman. It was a decisive move out of his class and far beyond his artistic comfort zone, and many of his friends, including Burne-Jones, looked on aghast.

Burne-Jones's cartoon version of *King Cophetua and the Beggar Maid*
in the style of Rubens.

It was not that he did not sympathise with Morris's viewpoint,
the hopes and fears for art that underlay his politics. Burne-Jones's
own alignments, after all, were radical. He had supported Morris
and George Howard in the Eastern Question Association. He and
Morris were both present at a meeting at the Mansion House in
February 1882 held in protest against the Russian pogroms that
followed Tsar Alexander II's assassination.

Certainly in his own friendships Burne-Jones had been gradu-
ally drifting towards the aristocratic, wealthy families of taste. But

his close friends were much more the Aesthetic Movement liberals than fox-hunting jingoistic Tories, the Rule Britannia people that Burne-Jones so despised. Compared with his brother-in-law Poynter and Georgie's sister Agnes, Burne-Jones's politics stood out as positively dangerous, as is shown in a letter written in his comic cockney inviting Thomas Armstrong to a dinner party at which, besides the Poynters, the guests were to include Morris and George Howard:

polyticks is forbid because of divergers vews mr poynter and 'is good lady they been toris . . . so we muss fall back on social scandle of which there is alwis plenty.

But although sharing so much of Morris's outlook, Burne-Jones regretted what he could only see as a defection as his old close friend and colleague crossed the 'river of fire' into the unknown of revolutionary politics. In personal terms he feared for the outcome of a move that would inevitably remove Morris from his own special work, his total expertise in design and craftsmanship. It was all very well for Ruskin to expend his energies on political controversy: 'I never minded him doing it,' Burne-Jones recollected. 'I liked him to do it. I liked it extremely in *Unto this Last* and in *Fors Clavigera*, but for Morris to take it up was different.' Unlike Ruskin, Morris was 'before all things a poet and an artist'. Burne-Jones viewed it as positively dangerous for someone of Morris's nervous sensibilities to leave the world he knew for a Socialist movement still so much in its uncertain infancy it earned the jibe that the whole of its membership could be contained in a four-wheel London cab.

Burne-Jones guiltily admitted his anxieties contained an element of selfishness.

How can some men help having an ideal of the world they want, and feeling for it as for a religion, and sometimes being fanatical for it and unwise – as men are too for the religion that they love? It must be, and Morris is quite right, only for my sake I wish he could be out of it all and busy only for the things he used to be busy about.

He dreaded the loss of their day-to-day collaborations, the longevity of their artistic sympathy, their hilariously easy jokes.

Beyond this was the deepening divergence of views between Burne-Jones and Morris about the role of the artist in society. As Morris became more actively involved with the SDF, setting his mind to acquiring Marxist theory, street-preaching at Sunday morning meetings, giving increasingly inflammatory lectures up and down the country, focusing his considerable energies towards a workers' revolution optimistically planned for 1889, Burne-Jones felt increasingly convinced that an artist's first and most crucial duty was to his art and that for him at least, as his friend the critic Sidney Colvin saw it, 'the artist's life and the politician's or agitator's were physically as well as morally incompatible'.

Now the days of his tentative political involvement were more than ever over. As Morris aligned himself with the comrades and 'the Cause' in their public demonstrations and their propagandist publications, Burne-Jones saw himself as consciously retreating: 'I shall never try again to leave the world that I can control to my heart's desire – the little world that has the walls of my workroom for its furthest horizon; – and I want Morris back in it, and want him to write divine books and leave the rest.'

The strains put on their friendship were considerable. Crom Price, the frequent visitor, was an anxious witness to the deteriorating relations between Morris and 'the Grange', noting in January 1884 not just William Morris's growing disagreements with Ned but 'a good deal of argument between him and Georgie on Socialism – in which she held her own – the little rift of opinions will I trust get no wider'. But it inevitably did.

The old Sunday morning routine at the Grange continued. Morris still shouted for pig's flesh and after they had eaten break-fast he and Ned still went off together to the studio. Once the Garden Studio was completed it was here where they discussed Burne-Jones's latest cartoon for stained glass or for one of the large-scale tapestries with which Morris & Co. were now increasingly involved. But there were new constraints between two friends so used to a constant interchange of ideas and opinions: he

347

'is always our dear Morris', wrote Georgie, 'but alas some topics are all but tabooed between him and Ned'. Morris now often needed to leave the Grange in the middle of the morning to start on his Sunday street-preaching and he went to spread the Socialist message 'unsped by sympathy'.

Part of the anguish for Burne-Jones was the conviction that the Socialists were exploiting Morris's heroic innocence. This was the famous poet, a man of obvious stature, useful to the SDF as, in Hyndman's words, 'a University man who had achieved for himself a European fame'. SDF membership, as it gradually grew, consisted of a random assortment of recruits from the old working men's and radical clubs, European and Russian political refugees, many of whose English was limited, together with a number of disaffected gentlemen and revolutionary intellectuals. Burne-Jones shuddered to see Morris so wilfully aligning himself with the sort of social riff-raff he himself had removed himself from in leaving Birmingham. He hated to see Morris in such company 'who ought to have the best'.

Burne-Jones may have had a few hopes at the beginning that Morris's integrity and intellectual vigour would bring some sense of direction to the Socialist movement. 'When he went into it', Burne-Jones later recollected, 'I thought he would have subdued the ignorant, conceited, mistaken rancour of it all – that he'd teach them some humility and give them some sense of obedience, with his splendid bird's eye view of all that had happened in the world and his genius for History in the abstract.' But such hopes were short-lived: 'he did them absolutely no good – they got complete possession of him'. As Burne-Jones saw it, those friends of Morris who followed him into Socialism, 'the nice men' like Philip Webb, Charley Faulkner and Robert Catterson-Smith, were just as ineffective, shouted down by the 'noisy, rancorous creatures' who were dominant in the SDF.

In 1884 William Morris broke with Hyndman on the issue of whether Socialists should seek parliamentary representation. Morris, who saw parliamentary government as in itself corrupt, emerged as the leader of the breakaway faction, forming a new party,

the Socialist League. Burne-Jones responded joyfully to news of the split, writing to George Howard, 'I sing paians of delight to myself that Morris is quit of Hyndman but I am also heartily sorry for Morris – who does win my heart's admiration at every turn.' He confessed he was still sighing for their 'ancient times'.

Burne-Jones had been mortified by Morris's relentless public exposure on behalf of the Socialists. The inflammatory speech 'Art and Democracy' which Morris gave in Oxford in the hall of University College, with Ruskin and many of the university's great and good in the audience, had been widely reported. Burne-Jones may have expected that with Morris's secession from the SDF this unwelcome publicity would die down. This was far from the case. Morris braced himself to use all possible means of publicising his new party, the Socialist League, and explaining his vision of a total transformation of society, creating new conditions in which art could flourish.

Again Burne-Jones watched in an agony that easily transformed into a fury as Morris, through the mid-1880s, committed himself more single-mindedly than ever to the Socialist cause, neglecting his business, disengaging himself from his and Ned's joint projects, endangering his already precarious state of health. He was horrified to read a political interview with Morris in *The Pall Mall Gazette*, complaining to Elizabeth Lewis 'why did he let himself be interviewed at all? – and how changed he is with all this hateful company that he has to keep'.

As the Socialist League gradually expanded, making inroads into the Northern manufacturing towns and establishing a strong presence in Glasgow, Morris kept himself dangerously in the forefront of its public protest meetings and demonstrations. In September 1885, after a demonstration in Limehouse, he appeared before the magistrate at Thames Police Court charged with assaulting a policeman and breaking his helmet. When asked for his occupation Morris replied, 'I am an artist, and a literary man, pretty well known, I think, throughout Europe,' after which he was immediately set free. He came under regular police surveillance, and in July 1886 he was issued with a summons for

obstruction in Bell Street, Marylebone, and fined 1s plus costs. On 13 November 1887, the day to be known as 'Bloody Sunday', he was marching in one of the columns of protesters viciously broken up by the police as it was approaching Trafalgar Square. Morris's selflessly reckless activities sank Burne-Jones into a misery of incomprehension. Artists were made to make art, not to dissipate their energies and talents by marching on Trafalgar Square.

The Socialist League published its own propagandist newspaper, *The Commonweal*, of which Morris was financier, editor, leader writer and chief reporter. Burne-Jones was so appalled by the paper's tone and content that he did his best to ban it from the Grange. Georgie, however, took out a subscription in her name only. 'Please address Commonweal to Mrs Burne-Jones not to *Mr*,' she instructed the Editor, knowing very well that the editor was Morris. She took *The Commonweal* because she wanted to keep up with what Morris was doing and saying in public.

But even Georgie, who loved Morris and would listen to his arguments more patiently than Ned, could not go along with the radical fierceness of his politics: 'if we are walking side by side it is in a kind of labyrinth, with a high wall between us'. He had removed himself even from her.

Rome
1885

Christmas Day 1885 saw the unveiling of Burne-Jones's mosaic of *The Heavenly Jerusalem* in the apse of St Paul's Within-the-Walls in Rome. This resplendent large-scale work for the new American church in the Eternal City was the nearest he came to realising his ambitions for 'big things to do' in enormous public spaces, 'in choirs and places where they sing'. He accepted joyfully when the commission was first mooted: according to Georgie's account in the *Memorials*, 'the chance of working on so large a scale was irresistible'. Not least of the attractions for Burne-Jones the Italophile was that this was a commission for Rome.

The idea of ancient Rome lay deep in the imagination of many of Burne-Jones's contemporary artists, influenced as they had been by their boyhood reading of such novels as J. G. Lockhart's *Valerius; a Roman Story* and Edward Bulwer-Lytton's *The Last Days of Pompeii*. From the middle 1860s it had been the fashion to paint panoramic pictures in which quasi-authentic Roman life was recreated with pullulating crowd scenes of citizens and soldiers, dramas of poisonings and martyrdoms and violence alternating with genteelly erotic depictions of the customs of the Roman bath. Burne-Jones was all too familiar with the genre. Examples of these reimaginings were his friend Alma-Tadema's theatrical *A Roman Emperor, AD 41*, painted in 1871, and his brother-in-law Poynter's *The Ides of March* of 1883. But in accepting the commission for St Paul's Burne-Jones's relationship with Rome became quite

another thing. He was now himself, so to speak, a local artist, directly involved in the construction of the modern Roman city in its newly cosmopolitan incarnation.

St Paul's Within-the-Walls was the first Protestant church to be built within the walls of the Vatican City, following the Republican liberation of Rome from papal rule in September 1870. The new regime established a policy of religious toleration that permitted the building of a new church for American expatriates in Rome on a site in Via Nazionale, then still in a relatively rural area but under development as the first new street of modern Rome, the link between Piazza Venezia, Piazza della Repubblica and the train station, Stazione Termini. Most significantly in religious terms, the American church was very close to the Quirinal Palace, until recently the papal residence and now the palace of the kings of Italy.

It was typical of the new mood of internationalism that the American Protestant Episcopalians appointed an English architect, G. E. Street, the Gothic Revivalist who at the time of the commission in 1872 was already working on his largest and, at the time, most problematic British building, the Law Courts in the Strand. Street had made a speciality of Anglican churches in foreign cities. He was the architect of English churches in Paris, Geneva and Constantinople, and by coincidence the Church of England congregation in Rome had also just commissioned a new church from him, All Souls on Via Babuino.

The cornerstone for Street's church for 'the Yankee Episcopalians', as he called them, was consecrated in March 1876. St Paul's was to be a large church, big enough to seat seven hundred people, built in stone and brick. The building was conceived in Street's characteristic nineteenth-century adaptation of Romanesque Gothic with the high vaults, patterned encaustic tiles and polychromatic brickwork, the mastery of detail and highly crafted finishes that made his English congregations in a foreign land feel instantly at home. Although in Rome, the Yankee church could almost be in Oxford. Street had known Burne-Jones for years as the friend of his own one-time pupil William Morris. Since then he had watched

his reputation burgeon. Street completely understood Burne-Jones's versatile talents as a decorative designer and his sense of himself as an artist of great spaces. He had seen how his stained glass combined with the architecture of church buildings to give a new dimension of religious experience. When it came to the mosaics for St Paul's Within-the-Walls, Burne-Jones was an obvious choice.

The commission almost foundered when Street died in December 1881. A few weeks later Burne-Jones was writing to George Howard, 'the Roman Church I shall give up. Street is dead who could have stood between me and the cloth and could have helped me also with the workmen. I shall write this week and throw up the affair.' But his resignation was prevented by the rector, Dr Robert J. Nevin, a man of great vision and determination who was a former Union artillery officer in the American Civil War. Nevin visited Burne-Jones in London and dangled the prospect of a scheme of decoration more complete and spectacular than Street himself envisaged. Burne-Jones's mosaics were to cover the whole interior of St Paul's. 'Dr. Nevin has just gone', he told Mary Gladstone in 1882, 'and the Mosaic will be fun, won't it, especially if it spreads over the Church.'

Even before he went to Italy he had loved the idea of mosaic decoration with its richness, its glittering colour, its magical transformations of texture according to the light. 'I'm sure Heaven is paved in mosaics of good actions and good intentions like serpentine and porphyry,' he had written to Georgie's little sisters more than twenty years before. After he had travelled to Italy with Ruskin and examined the Byzantine mosaics *in situ* the idea of building a chapel entirely encrusted with mosaics, like the mausoleum of Galla Placidia in Ravenna, became one of their shared secret fantasies. The mosaic chapel of their dreams was originally conceived as a many-domed Byzantine edifice but Burne-Jones then reconfigured the building as a great decorated barn with a barrel roof, resembling the Arena Chapel in Padua. The roof was planned to hold their gods, symbols and hierarchies. The walls, with windows on one side only, would bear the complicated

narratives of their own histories with beasts and more mosaic dec-
oration below. The Ruskin–Burne-Jones chapel is surely one of
the great unbuilt buildings of all time.

Burne-Jones set to work on St Paul's Within-the-Walls with
this backlog of memories. He saw it, with his usual sense of doom,
as 'an unthankful task no one will ever care for – but for the sake of
many ancient loves I am doing it – for love of Venice and Ravenna
and the seven impenetrable centuries between them'. Because the
work at St Paul's depended on Dr Nevin's success in fundraising,
the commission for Burne-Jones's mosaics came in stages. Once a
gift from the banker Junius Spencer Morgan, father of the financier
J. P. Morgan, had been negotiated he was able to embark on the
design for the great curved semi-dome of the apse, *Christ Enthroned
in the Heavenly Jerusalem*. Christ sits in glory with the archangels
around him. Burne-Jones's granddaughter remembered, as a
child, being overawed by the large-scale gouache studies for the
Rome mosaic that hung over the fireplace in the drawing room of
the family house at Rottingdean:

Gabriel with the lily, Raphael who cares for children, Uriel, Azrael,
Chemuel. But when it came to Lucifer there was only a black opening in
the walls of heaven near where Michael stood, with tongues of flame
licking up from the pit. It made one stand rather quiet for a moment and
then one turned and climbed up on to the window seat.

Work on this first phase went on for several years. In his work
book, now in the Fitzwilliam Museum in Cambridge, he made the
entry for 1883 'Worked much on the mosaic for the church in
Rome.' For 1884 Burne-Jones was still recording 'Working on
the mosaic very hard – which was finished towards the end of the
year.' Progress was slow because Burne-Jones, as always, was
involved with other projects simultaneously. This was also a
period at which he was preoccupied with the *Briar Rose* cycle and
had begun *The Sleep of Arthur in Avalon*.

'It would be impossible to describe the anxiety and labour con-
nected with the mosaic,' Georgie comments in her diary. Although
he had experience with painted tiles, mosaic was a new medium

for him, with its own delicate traditional techniques. He made the job more difficult by his reluctance to travel to Italy to supervise the work. In 1882 he explained to Mary Gladstone, 'I hate travelling, especially alone – and feel it waste of time for me and my true life is here in the studio.'

This meant he had to operate a complex commission by remote control. The mosaics were being made in Venice by the Venezia-Murano Company. On their Sunday mornings in the garden studio Burne-Jones and William Morris, giving what time he could spare from the Socialist cause, would sort through the Venezia-Murano's box of colour samples of little mosaic pieces, selecting the tesserae of the precise shade required to match Burne-Jones's original design. The reference numbers of the tesserae were listed as a guide for the Venetian workmen, as in 'Clouds – centre blue 551 – lighter tin 1675 pink 1785–1139 for outer rim – sky – 1685. 551. 1675. 1804'. These colour lists were then sent out to Venice accompanied by Burne-Jones's cartoons. In fact the first cartoon was transported as a favour by Lawrence Alma-Tadema on one of his own journeys to Italy.

The craftsmen in Venice used the colour lists to translate Burne-Jones's drawings to mosaic. Area by area, the tesserae were actually glued to the cartoons, separated into sections, and the completed sections then finally rejoined. It is strange to think that the cartoons drawn by Burne-Jones in West Kensington are now embedded under the mosaics in St Paul's Within-the-Walls. But Burne-Jones had departed from the usual practice in also sending to Venice drawings of some of the details – a head and part of a nimbus and an angel's wing – 'with tesserae arranged in the way I feel the mosaic should be executed'. He suggested that if the workmen had this drawing beside them it would help them: 'they would soon fall into the way of designing the flow of lines'.

When the first sample was returned to him it was hopeless. The mosaic fragment, showing an angel with a harp, bore little resemblance to his original. He concluded that the craftsmen were wilfully ignoring his cartoon and working to their own agenda. Thomas Rooke, who happened to be in Venice in summer 1884,

was sent to the mosaic works to remonstrate: 'O Rookie', Burne-Jones wrote, 'scold them, pitch into them, bully them, curse and refrain not'. He complained that the men were not keeping to his outline and were ignoring his instructions on colour: 'they have made yellow hair against Red Indian faces' when what he had envisaged was 'the hair dark, the faces sweetly pale – the eyebrows straight, the darkness under them steady and solemn, the gradation of colour delicate and soft'. He made unfavourable comparisons with the mosaics recently installed at the South Kensington Museum. He threatened to destroy his cartoons and hand back the money. He was almost in despair.

His complaints paid off. The workmen adapted their methods and the next sample from Venice was satisfactory. 'Mosaic has come – very careful, as good as I ever hoped for,' he reported to Thomas Rooke in September 1884. The last cartoons for the mosaic for the apse were dispatched to Italy by mid-November and over the next few years Burne-Jones turned his mind to the remainder of the project, his plans to cover all the walls of the church from floor to ceiling with mosaics. As he told Frances Horner, 'I want to go on with the American Church at Rome and have designed some bonny things to do there.'

These 'bonny things' included *The Annunciation*; a crucifixion scene, *The Tree of Life*; a celebratory *Earthly Paradise* to cover the wall of the apse beneath the semi-dome; and a dramatic, fearful, crowded *Fall of the Rebel Angels*, planned to occupy the steep forty-foot wall immediately inside the entrance to the church. But after the sudden death of Dr Nevin's rich American patron Junius Spencer Morgan there were long delays while other sponsorship was sought. In the end only the *Annunciation* and *Tree of Life* mosaics were completed in Burne-Jones's lifetime, both being unveiled in 1894. *The Earthly Paradise*, alias *The Church Militant*, finally appeared in 1907 in a posthumous version by Thomas Rooke. It is safe to say Burne-Jones would not have approved of this stilted composition, anaemic in its colour, with its bizarre convention of infiltrating into the gathering of saints portraits of St Paul's leading parishioners, well-wishers and public figures,

one of which, in the guise of St John Chrysostom, is the bearded Burne-Jones himself with Georgie as St Barbara and Thomas Rooke as St Longinus, the foot soldier with a spear. *The Fall of the Rebel Angels* did not materialise but Burne-Jones's composition took on another life as a great painting, now known as *The Fall of Lucifer*. The original design, worked up in gouache and gold paint, Miltonesque in its weird grandeur, is in the Lloyd Webber collection, one of the most powerful of all Burne-Jones's works.

When the American architectural historian Henry-Russell Hitchcock called St Paul's Within-the-Walls 'a major work of the Victorian age . . . one of the most complete and gorgeous Victorian Church interiors' he was conscious of the crucial importance of Burne-Jones's mosaics to the spectacular effect of the ensemble. Right at the beginning, when Street had first given him the measurements and degree of curvature of St Paul's great apse, Burne-Jones had constructed a scale model, now in the Victoria and Albert Museum, which he kept by him as he carried out the work. He kept strictly to the principle that design for mosaic needed to be 'VISIBLE, INTELLIGIBLE at a distance, at a good height'. By the middle 1890s, once the mosaics were more or less completed, visitors were drawn into the dramatic Christian narrative unfolding, wave upon wave, down the long length of the aisle.

First, on the 'triumphal' or choir arch, is Burne-Jones's *Annunciation*, a highly original and strangely haunting treatment in which Mary receives the message from Gabriel not in an enclosed domestic setting but out in a desperate desert, a parched land where Mary has come to look for water. It is dawn and her pitcher sits beside her on the ground. Beyond the *Annunciation*, further up the nave, on the second chancel arch, is the *Tree of Life* mosaic. Christ has come, the sun has risen and the sky is azure. The aridity of the desert now gives way to a green and lavish landscape in the centre of which rises the tree of life which is also the tree of Christ's sacrifice and redemption. The complex gnarled entwining branches of the tree have the delight in oddity of a Victorian fairy tale.

Finally the eye arrives at *The Heavenly Jerusalem*, Burne-Jones's rereading of the Book of Revelation showing Christ raising his

right hand in blessing as his left holds the great globe of the earth. Christ's feet rest on the rainbow, just the sort of rainbow William Morris saw in Iceland, arching over the four cascading streams of the river of life. Seraphim and Cherubim crowd around Christ's throne while in the bowl of heaven above him Burne-Jones's largest-ever host of angels play their heavenly instruments and sing. When Burne-Jones understandably became a bit resistant to producing any new designs for angels, saying 'I must have by now designed enough to fill Europe', it may well have been St Paul's Within-the-Walls that he was thinking of.

Writing of the Rome mosaics he told a friend, 'I love to work in that fettered way, and am better in a prison than in the open air always.' He enjoyed the way in which 'the severe limitations of mosaics are all obeyed and observed'. His approach to such a commission was altogether different from that of, say, Leighton or Poynter. Like William Morris, Burne-Jones was fascinated by the demands made by the craft in works of art, by materials and technique and by evolving a channel of communication with the practitioners, the craftsmen actually working on the project, that would finally achieve the results he had envisaged.

For his final two mosaics – *The Annunciation* and *The Tree of Life* – he evolved a more foolproof method and, abandoning the complicated system of numbering, he pre-selected the tesserae for each area and sent them in packages labelled, say, 'mountains' or 'deserts' to the Venezia-Murano Company along with his cartoons and a coloured pen sketch indicating at a glance how the cartoons fitted together. He loved the idea of his mosaic's permanency, its independence of the fashionable art market: 'it can't be sold and will be in Rome and will last for ever'. A mosaic was *not* a picture but inherently a part of its architectural setting, as he was always eager to explain.

His 'mighty Mosaic', as he liked to call it, was there in the city he had always hankered after. The Roman Catholic Church had been a source of faintly guilt-ridden fascination since the days of snuffing up the odour of the incense in the Catholic chapel in Birmingham as a little child. This was the man who saw the last

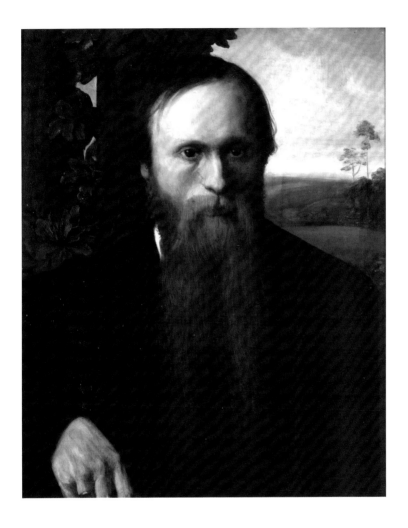

xxii Edward Burne-Jones by Alphonse Legros, oil, 1868–9. Legros had been a friend of Burne-Jones since his arrival in London from France in the early 1860s. The portrait was made soon after the start of the Zambaco affair.

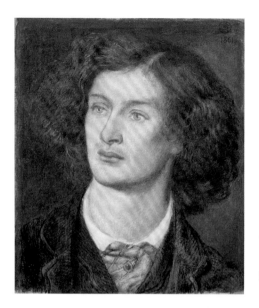

XXIII Algernon Charles Swinburne by Dante
Gabriel Rossetti, oil, 1861. This portrait
dates from the time when Swinburne was
living close to the newly-married Edward and
Georgiana Burne-Jones in Bloomsbury.

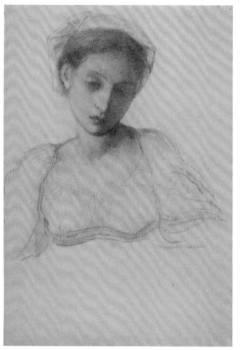

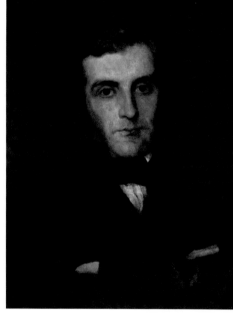

XXIV Maria Zambaco in traditional Greek costume, pencil portrait by Burne-Jones, 1867–8.
XXV Doctor Demetrius-Alexander Zambaco, specialist in sexually transmitted diseases, whose
practice was in Paris. This portrait by G. F. Watts was made around the time of his short-
lived marriage to Maria Cassavetti in 1861.

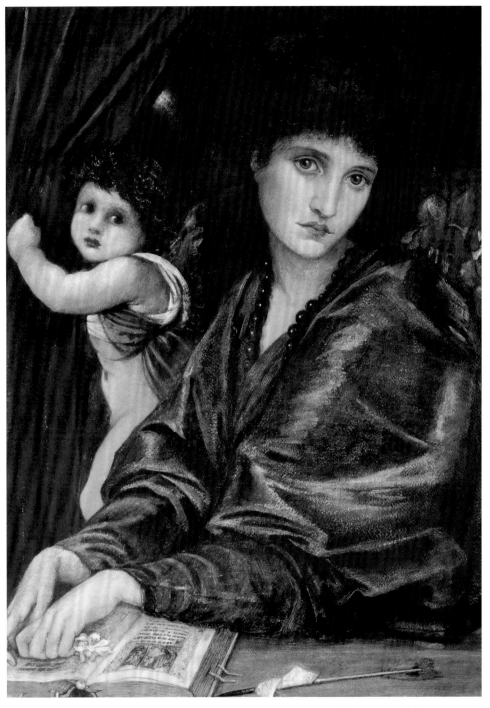

XXVI Maria Zambaco. This dramatic portrait, with its pictorial messages of love, was commissioned by Maria's conniving mother as her birthday present and painted by Burne-Jones during the summer of 1870 while his wife and children were on holiday in Whitby. The portrait has something of the sultry glamour of Rossetti's contemporary portraits of Jane Morris.

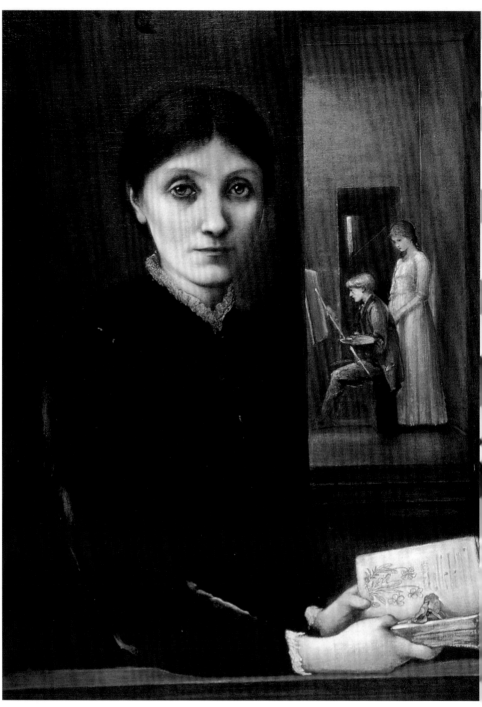

XXVII Georgiana Burne-Jones and her children Philip and Margaret. Burne-Jones's portrait
was begun in 1883 when he and Georgie had been married for twenty-three years. Her steady
character shines out from the portrait and her book is open at the entry for the pansy or
heartsease, symbol of enduring love.

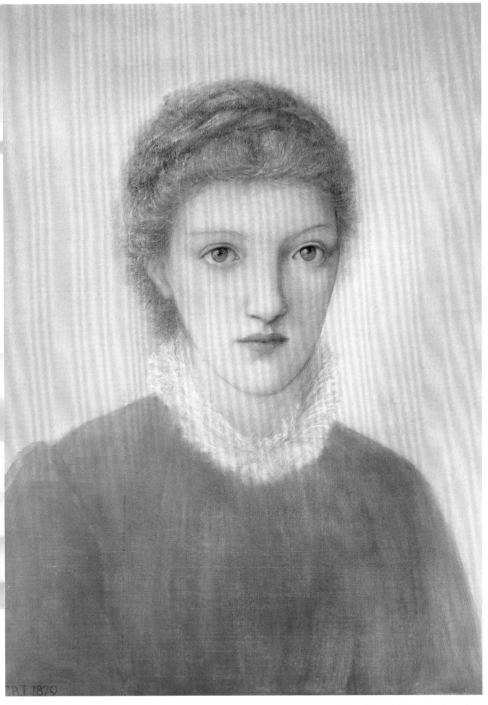

XXVIII Frances Graham by Edward Burne-Jones, oil, 1879. The daughter of Burne-Jones's faithful patron, Liberal MP William Graham, was the most important of the younger women with whom the artist formed adoring but semi-platonic relationships.
Frances, later Lady Horner, described Burne-Jones in her memoirs as 'my greatest friend for all my grown up life'.

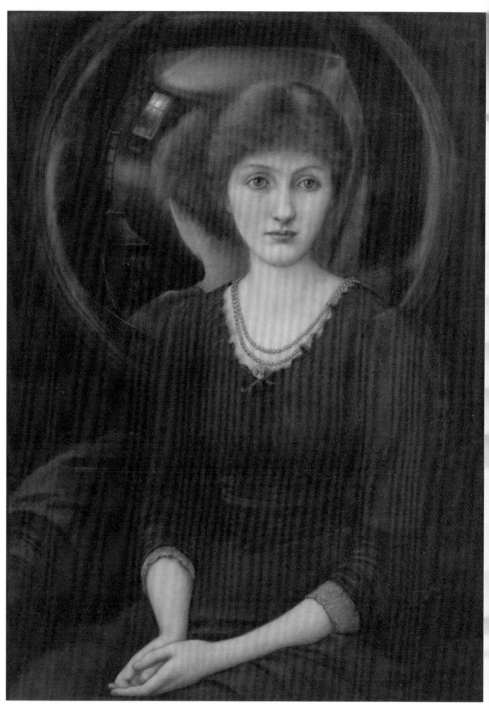

xxix Margaret Burne-Jones, painted by her father in 1885–6, two years before her marriage to J. W. Mackail. Burne-Jones's relationship with Margaret, his 'dear companion', was unusually close and this portrait brings out her rather remote and guarded personality.

xxx Katie Lewis, oil, 1886. Katie was the youngest child of Sir George Lewis, the most famously successful London solicitor of the period, and his socially ambitious wife Elizabeth. Some of Burne-Jones's most delicious illustrated letters were written to the self-confident small girl.

xxxi Ignace Jan Paderewski. Burne-Jones's pencil portrait of the Polish pianist was made in 1890. Paderewski had been brought to the Grange studio by his fellow musician George Henschel, who played and sang while Burne-Jones drew.

XXXII Baronne Madeleine Deslandes, oil, 1894. The subject of one of Burne-Jones's rare commissioned portraits was a writer of Symbolist novels. Madeleine, daughter of Baron Vivier-Deslandes, was in her late twenties when the portrait was made. It is typical of Burne-Jones's approach to portraiture in conveying a sense of the Baronne's inner life.

refuge of beauty as being in the ancient Church. The central idea of medieval Christianity and 'all it has gathered to itself made the Europe that I exist in', he once said.

Burne-Jones was still flirting with the notion that his ideal career would have been that of a wicked old cardinal listening to Gregorian chants, and sometimes he entertained his friends with his cardinal impersonations, tottering about and croaking some verses from the Vulgate. He craved the decorative qualities of Rome, the Church that wrote its gospels in gold on purple vellum, and he even had a plot of persuading Dr Nevin to turn his Episcopalian church over to the Pope.

When in 1891 the proposal was made that Burne-Jones should design mosaics for the four semi-domes below the big central dome of St Paul's Cathedral in London, he was slightly tempted but finally refused. St Paul's was a building that 'crushed and depressed' him both aesthetically and politically. He loathed its architectural pomp and emptiness and its status as the place of worship of the stock exchange, the bankers, the commercial world of London that Burne-Jones despised and loathed. It was nonsense, he decided, to put mosaics there, useless to try to do anything with so unpromising, corrupt and unsympathetic a building – 'but let it chill the soul of man and gently prepare him for the next glacial cataclysm'.

So he rejected the commission, which was finally carried out by W. B. Richmond. 'I couldn't face it,' he said later, 'and yet I love mosaics better than anything else in the world.'

The Royal Academy
1885–7

Through the summer of 1885 Burne-Jones's best patron and sup-
porter William Graham lay dying. Gladstone had appointed him
a Trustee of the National Gallery only the year before. His last
decade had been clouded by illness and grief at the sudden deaths
of his two sons. Rutherford had died of diphtheria at the age of
twenty-three, to be followed by his younger brother who was
found unconscious by his sister Frances on the morning he was
due to return to school at Eton. The boy had had a cold and a care-
less nurse had given him a fatal overdose of medicine containing
morphine. The shock of Willy's death at the age of seventeen
affected his father dreadfully. A drawing of William Graham by
Burne-Jones, made in the early 1880s, shows an emaciated ancient
man with staring eyes. Graham looked more and more like St
Jerome in the wilderness in those last sad years.

He had now lost heart in picture collecting. But, knowing how
ill he was, he was determined to leave Burne-Jones's financial
affairs on a proper footing for the future. 'I have for the last year
or two undertaken out of personal friendship, the entire charge of
the pecuniary interests of Mr E. Burne-Jones as regards the dis-
posal of his pictures,' Graham wrote to a prospective client, taking
on the role of agent. He pushed up the value of Burne-Jones's
major works, negotiating the sale of *The Mill* to Constantine
Ionides for £1,800 in 1882 and *The Wheel of Fortune* to Arthur
Balfour for £2,000 the following year. In 1884, the year in which

King Cophetua and the Beggar Maid was at last completed, he put pressure on the Earl of Wharncliffe, who had originally commissioned the painting for £1,000, to increase the price: 'Representing as it does almost the whole of his "important" work of the last twelve months, I need not say that the disposal of it for £1000 must involve very serious actual loss to him.' He proposed £3,000. When Wharncliffe was late in paying the final instalment Graham himself offered to make good the difference.

He lectured Burne-Jones about taking seriously the question of copyright. The artist had up to now naively been allowing Frederick Hollyer to photograph his paintings without payment and then sell on the resulting photographs. Graham pointed out that this was patently unjust. Graham also wanted to ensure that a fee for engraving rights should be part of any painting's negotiated purchase price and that all engravings should be subject to Burne-Jones's inspection and approval. As Graham pointed out to Lord Wharncliffe, 'He has always been very fastidious as to work of this kind.'

By May 1885 it was clear that William Graham, who by now had stomach cancer, was terminally ill. This gave a new urgency to his determination to make Burne-Jones see sense over his long-term financial strategy. First he needed to bring in some income straight away by completing some of the commissioned copies of original paintings still awaiting his attention in the studio: 'I daresay it may be difficult for you to combine these "spending money" labours with the more important work', Graham wrote cajolingly, 'and I must just keep poking you! isn't it so. I am sure no man living works *harder* and more conscientiously but you kill yourself with overanxiety and overfastidiousness.'

Finally William Graham achieved his greatest coup on behalf of Burne-Jones in negotiating the advance sale of the *Briar Rose* cycle to the powerful London dealer William Agnew. This was the planned sequence of large-scale oil paintings on the Sleeping Princess subject originally suggested by William Graham to Burne-Jones back in 1869. In Graham's final scheme of things the *Briar Rose* cycle could provide Burne-Jones with a capital sum

that would cushion him against any future loss of clients, changes of fashion in the art market or his own debilitating illness. Having entered into discussions with William Agnew, the head of the family firm, he told Burne-Jones, 'Mr A. is now pretty well prepared to go down to posterity as your "Maecenas".'

Graham had become so weakened by his illness and was in such great pain that he had left his house in London and was being looked after by his daughter Agnes, now Lady Jekyll, at Oakdene, near Guildford in Surrey. In these final weeks the successful sale of the *Briar Rose* cycle was his great preoccupation. He had wanted to be present at Burne-Jones's studio in May when the first *Briar Rose* picture, the scene of the prince arriving in the tangled forest, was ready to be shown to William Agnew and his nephew. Unable to travel, he sent Burne-Jones a worldly-wise warning: 'They are very clever and very insinuating and you will like the young one better than his uncle W. A. but it is just as well to put me forward as the "buffer" or go between *in all discussions* else your bon-hommie may be inveigled into unnecessary admissions.' All went well and the business was concluded at William Graham's bedside at Oakdene on 30 June 1885: 'Agnew has just gone and has behaved so well and so kindly and it is all settled and the price is £15,000,' Graham reported to Burne-Jones with relief. The deal would be worth around £1.8 million in today's currency.

He now had just a fortnight to live. Frances and Jack Horner had taken a house in Guildford to be near him. Burne-Jones came down to see him, bringing bunches of moss roses from the Grange garden for the sickroom. He would also send little brightly coloured paintings to hang beside the bed. It was William Graham's love of Burne-Jones's sense of colour that had been the attraction in the first place. 'When you write me put three dabs of colour in the corners just like having a grape when my mouth is dry,' he asked. He was by now quite near the end.

Once he died, the body was laid out in the drawing room. Frances's friend Mary Gladstone described the scene: 'The drawing room arranged like a chapel, the white coffin buried in flowers and a great beautiful Angel of Burne-Jones's guarding the whole with

tender gravity.' Burne-Jones himself was sent for and he joined the family in a little extempore service, 'large window opening on to terrace with splendid distant view and the sun flashing out into the solemn room'. Burne-Jones asked that the small paintings he had made for William Graham should be buried with him in his coffin in the necropolis of St Mungo's Cathedral in Glasgow. This wish was carried out, though both Frances and Agnes kept a painting for themselves.

Now not only had Burne-Jones lost Frances to marriage, he had also lost her father, his wisest of advisers. 'Fifty times a year', he lamented, 'I shall be perplexed about matters he would have made smooth for me.' William Graham's long and agonising illness may have been a reason for a series of decisions in the middle 1880s that reversed his previous thinking. It was almost as if he had become destabilised. One of these volte-faces was his acceptance in 1885 of the presidency of the Society of Artists in Birmingham, which he had previously refused. He took it on the understanding that he would not be expected to make speeches or give formal lectures. But if the authorities felt it would be useful for him to visit the Schools of Design 'or meet the artists and pupils in some quiet way, without pomp or circumstance', he would be delighted to do so.

Burne-Jones spent a whole day at the School of Art commenting on the work of the more advanced students. He gave advice on the selection of plaster casts of ancient art that would be most useful, suggesting that his friend W. B. Richmond, who had made a selection of exemplary casts of Greek sculptures while he was Slade Professor at Oxford, should be asked to make similar proposals for Birmingham. Burne-Jones worked on the principle that sets of art-school casts could be judged by the absence or presence of *Laocoön and His Sons*, the bravura first-century Hellenistic Greek sculpture in the Vatican, reproductions of which had by now become a cliché: 'If Laocoön's there,' Burne-Jones shuddered, 'all's amiss.'

In his new mood of good will towards Birmingham Burne-Jones paid a visit to his father and presumably was greeted by his new

young stepmother as well. He went to see Miss Sampson who was now settled comfortably in the suburbs, took her for a long drive and listened patiently to her detailed bulletins on old friends and acquaintances. He gave a whole day to a nostalgic revisit to the farm at Harris Bridge where his aunt Amelia Choyce, now in her vigorous mid-seventies, still lived.

The strains of the previous months had softened his attitudes, sharpened his awareness. He found Birmingham not nearly such a place of desolation as he had imagined it. He viewed it quite suddenly as a resplendent city 'of white stone, full of brave architecture, carved and painted'. Burne-Jones was now responsive to the optimistic spirit of the place, the huge municipal improvements, the sense of entrepreneurial energy. He regarded Birmingham as potentially 'the beginner of new life to England'. His recent commission to design a very large *Ascension* window for St Philip's Church may have been an element in this sudden warmth of feeling for the city of his birth.

Still more unexpectedly, in June 1885 Burne-Jones was elected an Associate of the Royal Academy, an institution from which he had deliberately kept his distance and which he had very often ridiculed. The Academy then operated a two-tier system whereby an artist, sculptor or architect elected an Associate would be eligible for re-election as a full Royal Academician within the next few years. When a messenger was sent round to the Grange to announce the news of his election Burne-Jones was asleep on the sofa in the drawing room. Georgie did not even bother to arouse him, so certain was she that this was either a misunderstanding or a joke. The messenger was told it must be a mistake and was sent away.

But in the next morning's post a letter arrived from the president Frederic Leighton, written at his club the night before, confirming Burne-Jones's election in the most effusive terms:

Dear Ned, an event has just occurred which has filled me with the deepest satisfaction and with real joy. A spontaneous act of justice has been done at Burlington House – the largest meeting of members that I ever saw has by a majority elected you an Associate of the Royal Academy. I am not

aware that any other case exists of an Artist being elected who has never exhibited, nay has pointedly abstained from exhibiting on our walls. It is a pure tribute to your genius and therefore a true rejoicing to your affectionate old friend Fred Leighton.

In the same post was a letter from his brother-in-law Edward Poynter, himself a long-serving Royal Academician, telling him his name had been proposed by Briton Riviere, an Academician Burne-Jones did not even know, although his father William Riviere had been one of the Oxford Union artists more than twenty years before.

Should he accept or not? Burne-Jones deliberated. He first sent a note and then went over to see Leighton at his house in Kensington. He arrived there looking so grave and apprehensive that Leighton burst out, 'Don't say you have come to refuse it, Ned!' Leighton reassured him, talked him into acceptance. But by the time he had returned home more doubts had arisen and he wrote again. The main technical reason for his anxiety was his loyalty to the Grosvenor Gallery where he had been given such a star position right from the beginning. He had friends there who would see his joining of the Royal Academy as a defection. He knew only too well he was a slow and anxious artist. Producing work for the Grosvenor alone was a great burden. How could he manage to exhibit annually at the Grosvenor and at the Royal Academy as well?

Besides such practical arguments, Burne-Jones felt unhappy in principle about joining an elite establishment body. He was opposed to academies in general, feared the loss of his hard-won independence, and regarded the artistic values of the majority of Royal Academicians as antipathetic if not totally absurd. As Henry James wrote of Millais, almost an R. A. fixture, who had been elected a Royal Academy Associate back in 1853, 'he does not make pictures in the sense that Burne-Jones does'. Burne-Jones knew very well that his introspective, intellectual style of painting would look outré, 'strange and without reason', on the walls of the Academy. He was alarmed by the Academy's backlog of history and build-up of tradition, its position as a focus of the London

social season. He felt instinctively that this was not the place for him.

William Morris advised Burne-Jones against acceptance with his usual vehemence: 'As to the Academy, I don't see why their action should force Ned into doing what he disapproves of, since they did not ask him first.' Burne-Jones was surely also conscious of Rossetti's horror from beyond the grave. Rossetti had once said that if the Royal Academy were ever to elect him he would immediately put the matter in the hands of his solicitor. However, in spite of all the arguments against, Burne-Jones finally decided not to reject the appointment. Why was this?

He had been won over by the warmth and generosity of Leighton's approach to him, flattered and enthused by what Leighton had described as his own 'anxious dream' to make the Academy 'a truly and nobly representative Institution including in its ranks and mustering on its walls all the best life of our country's Art'. As Burne-Jones confessed to F. G. Stephens, the urgent tone of Leighton's invitation had been 'hard to thwart'. He had other good friends who were already either Associates or Royal Academicians: Val Prinsep, for instance, G. F. Watts and Lawrence Alma-Tadema, the ebulliently sociable Flemish-born painter with whose family the Burne-Joneses were at this period on especially close terms. He was touched when the well-known sculptor Joseph Edgar Boehm, with whom he had already collaborated on commissions from George Howard, urged him not to refuse the offered Associateship: 'So many of us are frightened you may do us.' Burne-Jones was always nervous of hurting people's feelings and managed to persuade himself of the validity of G. F. Watts's argument, a view he had up to now always rejected, that he 'could help the cause of Art more effectually' by joining the Academy than by remaining outside.

He was swayed by the hope that if his unknown sponsor Briton Riviere had so unexpectedly supported him there might well be other members of the Academy sympathetic to his work. An entry in the diary of the young Beatrix Potter, referring to Burne-Jones's Academy election, provides a perhaps more realistic explanation

for Riviere's support of him: 'The fact is, the Academy is jealous of outsiders, and will not, if avoidable, take in any one who may be a rival, which induced Breton Riviere to suggest B-J who is not likely to paint animals.' She implies that the election had in fact been controversial: 'Old Barlow is indignant . . . Mr. Millais says they should have all sorts.'

Burne-Jones wrote to the Academy formally accepting: 'Gentlemen, accept my thanks and cordial recognition of the unlooked for and great honour you have done me by electing me as a member of your body.' But almost as soon as the letter had gone he felt gloomily aware he had made the wrong decision. He and Georgie paced up and down their sitting room in silence, side by side.

For his first appearance at Burlington House, the Royal Academy summer exhibition of 1886, Burne-Jones sent in his large mermaid painting *The Depths of the Sea*. While painting it he had been grateful for the loan from his fellow artist Henry Holiday of a very large tank, a glorified fish tank with a plate-glass front, full of water tinted a convincing greeny-blue. This tank had first been used by Holiday for his own picture of the Rhinemaidens in Wagner's *Das Rheingold*. Burne-Jones's vision of the helpless male figure being dragged down to the ocean's depths in the embrace of a mermaid whose features are a throwback to Maria Zambaco's as much as Laura Lyttleton's possesses an eerie authenticity.

He was pleased with the picture, with its many complex associations, its strange erotic symbolism, but he feared it would be 'lost entirely' in the visual hurly-burly of the Academy where as many as two thousand works were hung in close proximity. And indeed the *Times* critic surmised that the RA hanging committee had been at a loss 'in providing Mr. Burne-Jones's mermaid with proper neighbours', finally deciding upon flanking her with 'portraits of modern ladies in red'. They had hung some small landscapes below the 'modern ladies' and, at a higher level, 'a rather ghastly picture of the end of a stag hunt'. The contrast with the Grosvenor was all too evident.

There were positive responses. The reliably favourable critic F. G. Stephens, writing in the *Athenaeum*, recognised *The Depths*

of the Sea as 'a picture of importance, representing a new and dif-
ficult subject. It possesses noble and subtle charms of colour, it is
finished with extraordinary care.' His sole criticism was of Burne-
Jones's handling of the male nude figure, which Stephens con-
sidered 'the weak portion of the work'. Enthusiastic comments on
the painting had even reached as far as India, Rudyard Kipling
writing back to Margaret to tell her 'you would be amused to see
how much the Indian journals contain about your Father. Blessed
if our London sporting correspondent of all people of earth didn't
fly off at score about his "Mermaid and Mariner". The S. C. had
been to see it and it had impressed him wonderfully.' But for other
more discriminating viewers the picture had been killed by its
incongruous surroundings, Burne-Jones's special qualities sub-
merged by a show in which the emphasis was on the anecdotal, the
sentimental, the historicist. Urged by Leighton, he attended the
annual Academy banquet on 1 May 1886, travelling up and back
by train from Rottingdean. But by July he had sunk into a black
depression. He was never to exhibit at the Royal Academy again.

A year or two later, after Watts had remonstrated with him for
his failure to send in any work for the summer exhibition, he
wrote, 'I wouldn't mind confessing to you privately that I feel a bit
offended with the Academy – not much but enough to make me
a bit indifferent to the affair.' He was beginning to feel himself
rejected. Whereas during the original selection of Associates, when
fifteen candidates were considered, Burne-Jones and A. Harvey
Moore, a landscape and marine painter, had been elected with a
good majority, when it came to the next stage, the election of full
Royal Academicians, things had not gone so well.

On 7 January 1887, with one RA vacancy to fill, Burne-Jones,
along with Poynter and Val Prinsep, was present at the election
meeting in the General Assembly Room at Burlington House. He
was in the final four but lost out to the painter Marcus Stone. On
10 March, when an election was held to replace the retired RA
painter George Richmond, Burne-Jones did not attend and the
pattern was repeated. He got through to round two but Luke
Fildes was elected. Burne-Jones felt hurt and offended, grumbling

to Watts, 'It's a rude old habit of theirs, this of offering unsolicited honours to men who can do without them, and then, instead of perfecting their act of grace, waiting till the day of graceful action is past.'

Burne-Jones was never made a full Academician. In the election of May 1888 he received only one vote and he did little better in subsequent years. Partly this was his own fault for not exhibiting, as well as for refusing to act as a visitor in the Academy painting schools, pleading his ill health, and for keeping himself so deliberately separate from the Royal Academy camaraderie. He never got over his resentment at the feeling of being the visitor who, instead of being welcomed in, was kept permanently outside on the doormat in the hall, and in 1893 he finally resigned the Associateship, sending a letter to the President and Council complaining that 'you on your part have never asked me to enter further than the threshold which you invited me to cross, and I, on mine, have found that it was too late for me to change the direction of my life, so as to be able to carry on the traditions of a school in which I did not grow up'.

He pointed out that for the past eight years he had found himself 'involuntarily forced into competition at each successive election for the final admission which you have denied me. These facts have gradually brought me to the conclusion that it would be a relief to both of us, if without reproach from either side our formal connection is brought to an end'. The letter was read out at a meeting of the Council on 21 February 1893 with Leighton, whose response to Burne-Jones's resignation had been one of 'pain and distress', taking the chair. Also present was Burne-Jones's increasingly pompous brother-in-law, Poynter, whose views are not recorded. The official papers of the Royal Academy inform us that Burne-Jones resigned 'because he was never elected full Royal Academician and it was distasteful to him to be in competition with other artists'.

Burne-Jones described the severance as a divorce. It had been a bitter episode after which, in a frank and private letter to his friend May Gaskell, he revealed his feelings about the sixty or

so members of the Academy: 'It is an honour to be associated with about six of them – and nothing at all to be associated with about a dozen of them – and positive disgrace to be allied with the rest.'

In 1886, once again in defiance of his better judgement, Burne-Jones rejoined the Old Water-Colour Society, now renamed the Royal Watercolour Society. This was the society from which he and Frederic Burton had resigned in 1870, over the *Phyllis and Demophoön* scandal. Once again he succumbed to the personal approach, this time from the watercolourist Alfred Hunt who wrote to him emotionally asking him to 'resume your old place among us', maintaining that Burne-Jones's resignation 'along with Sir F. Burton, was the most serious blow which the Society has sustained in our time'.

Hunt managed to counter Burne-Jones's arguments that he had no work left to exhibit once his commitments to the Grosvenor had been honoured; he was 'useless at all meetings', which tended to dishearten him for days afterwards; he was not in any case in support in principle of such fragmented gatherings of artists as the RWS and the Academy. Burne-Jones looked for a much broader brotherhood of artists. 'My real home', he told Hunt, 'would be in a society which embraces and covers all art – everything that art enters into – and the disintegration of art and the development and favouring of little portions of it is a sore matter to me.'

Hunt pursued him resourcefully, determined to bring back into the Society not just Burne-Jones but also Sir Frederic Burton, now Director of the National Gallery, who had resigned earlier in his support. '*You must come in,*' wrote Hunt in a further letter of entreaty to Burne-Jones, who then consulted Burton and both were re-elected on 1 December 1886. He took some part in Society affairs, attended meetings, sat on Council, sometimes exhibited in the winter exhibition. But, as with the Academy, his heart was never in it. 'Why on earth', he once exclaimed, 'and in the name of what infernal ghoul we fret our hearts out yearly over these trumpery exhibitions, I cannot think – it has nothing on earth to

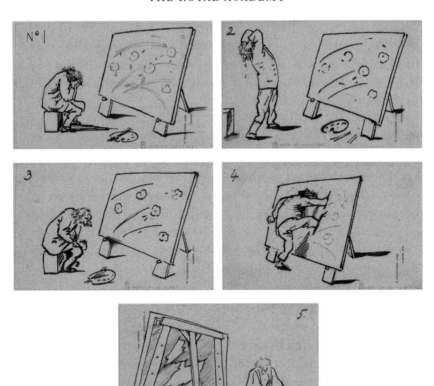

Cartoon sequence *The Artist attempting to join the world of Art with Disastrous Results.*

do with me really, and is a mere weak-minded flabby acquiescence in a system I hate, loathe and abjure.'

Finally, in this mood of growing disenchantment with the London art world, Burne-Jones launched an attack on the Grosvenor Gallery that helped to bring about its acrimonious closing down. As Georgie tells the story, Burne-Jones 'lit the match that led to the explosion', sending a formal letter to Charles Hallé, as director, on 3 October 1887 saying, 'I am troubled and anxious more than I can say by the way in which it seems to me the Gallery has been gradually slipping from its position and from the point to which it was so laboriously worked up, to that of a room which can

be hired for evening parties.' This letter was intended to be passed on to Sir Coutts Lindsay. Burne-Jones's anxiety was all the more intense since he was, as he put it, 'so wrapped up in the place' that his own reputation would inevitably suffer as a result of the Grosvenor's decline.

The Grosvenor's financial footing had never been a sound one. The income of the gallery came almost entirely from the shilling entrance fee charged to the public. It seems that no commission was taken from the artist when a painting was sold and in any case many of the pictures on show at the Grosvenor were on loan from private collections. The restaurant did not pay and the gallery's finances were always under threat from Sir Coutts's endemic extravagance: for instance the 3,600 plates adorned with the Lindsay crest with which he had equipped the restaurant.

A time of crisis came in 1882 when Blanche Lindsay left her husband, finally losing patience with the mistresses, the illegitimate children and endlessly ongoing flirtations. Most flamboyant was the affair with the beautiful Countess Somers, who had borne Sir Coutts two sons. Burne-Jones, as we have seen, took Blanche's side. This was the man so tender-hearted towards tragic women he could not bring himself to read *Anna Karenina*:

I suspect it is in Russian, as if it is I know what to expect, and I couldn't bear it. There would be a beautiful woman in it – and all that is best in a woman, and she would be miserable and love some trumpery fool (as they do) and die of finding out she had been a fool – and it would be beautifully written and full of nature and just like life.

Faced with the real-life miseries of Lady Lindsay, Burne-Jones had behaved with his usual romantic gallantry. Besides helping her to settle in the studio close by him at the Grange, he and Georgie would invite the now lone woman to lunch and Sunday suppers. In summer 1884 there was a further disaster when Blanche Lindsay had a serious fall on the stairs from her studio, suffering brain damage that left her an invalid for the next two years. Burne-Jones would go to visit her in the silent and depressing little house at the extreme end of St John's Wood where she

was being looked after by her two daughters. Although her mind was wandering, her hearing and sight were now unbearably acute. She could not stand loud noises or bright lights. Burne-Jones described the scene to Eleanor Leighton:

As to poor Lady Lindsay it is a woful and sorrowful tale – this is now the eleventh week of living in black darkness and thick silence . . . Her last appearance in the world was at Val Prinsep's wedding breakfast – and now he has been married long enough to have beaten his wife and been separated . . . and still she lies there – and her poor little maidens are the colour of this paper with living in the dark, and creeping about stealthily to make no noise.

He found her plight appallingly affecting. After one of these visits to the house of affliction he wrote, 'I am a sombre and a changed man.' Once Lady Lindsay partially recovered and returned to her house in Hans Place, Knightsbridge, Burne-Jones was still assiduous in visiting her regularly, asking her out to the theatre, trying to cheer her up. His behaviour towards her was particularly generous in a man to whom large women were a horror, for in her troubles, as shown by before-and-after photographs, Blanche Lindsay had become almost grotesquely fat. Encountering her at Burlington House, Mary Gladstone sadly noted, 'Poor deserted Lady Lindsay, a garish figure that almost destroyed sympathy.' Burne-Jones's loyalty to Blanche, which never wavered, fuelled his animosity towards Sir Coutts.

The separation had the effect not only of exacerbating the Grosvenor Gallery's monetary problems, since Lady Lindsay now withdrew her financial support, it also alienated former supporters. Blanche's kinswoman Constance Battersea was one example, invoking Rothschild solidarity in now cold-shouldering the Grosvenor. Effie Millais, with her own painful experience of scandal, was also to make her disapproval felt. By 1884, faced with the prospect of closure, Coutts Lindsay brought in a business manager, Joseph Pyke, from the world of commercial jewellery, in the attempt to generate more income. It was Pyke who had the then innovative idea of bringing in an electric generator, which was housed in the

sub-basement, flooding the galleries with an unaccustomed glare of light and generating electricity for local shops and houses.

As part of these desperate measures Pyke attempted to make the restaurant more widely popular, introducing an orchestra and advertising the facilities in newspapers and on billboards in Bond Street. By 1886 the galleries themselves were being leased out to what Hallé disgustedly described as a 'smoking drinking and comic song-singing' club. They were rented out for balls, dinners, entertainments and events, and it was maliciously rumoured around London that placards advertising soup and ices were being hung in front of Burne-Jones's paintings. It was at this point that his patience snapped and he expressed his view that the serious reputation of the Grosvenor was suffering: 'steadily and surely', as he wrote to Hallé, 'the Gallery is losing caste: club rooms, concert rooms, and the rest, were not in the plans, and must and will degrade it. One night we are a background for tobacco and another for flirting – excellent things both, but then not there.'

Sir Coutts never responded to his complaints. On 2 November 1887 *The Times* announced the resignation of both directors, Hallé and Comyns Carr, from the Grosvenor Gallery. Burne-Jones's own resignation followed soon after. The whole affair had sickened and depressed him. He could not bear to see the *raison d'être* of the Grosvenor – the painters and the paintings – so diminished. He wrote to George Howard, describing the problems and enlisting his support: 'it seems to me I am always resigning something or other, although I should have said I was a peaceable fellow enough'.

Within weeks of his resignation from the Grosvenor Burne-Jones was involved in plans for the opening of what became its replacement. The New Gallery was conceived as the latest major exhibition space for London's artistic avant-garde. Hallé and Comyns Carr would run it jointly using the Grosvenor's method of personal selection of works from the studios of artists connected with the gallery. Again this stood in marked contrast to the arcane in-house selection processes of the Royal Academy. Hallé and

Comyns Carr were supported by many of the principal artists from the Grosvenor. Comyns Carr's wife Alice makes it clear in her memoirs that Burne-Jones's presence was considered crucial to the project. Burne-Jones, Alma-Tadema, Herkomer, W. B. Richmond, Alfred Gilbert, Holman Hunt and even the former Secretary of the Grosvenor, J. W. Beck, were on the Consulting Committee for the gallery. In January 1888 Hallé was reporting: 'Yesterday I was with Herkomer in Bushey all the morning and with Burne-Jones and Tadema all the afternoon.'

For the New Gallery they chose a site in Regent Street. It was large, covering a quarter of an acre, and had originally been a fruit market, granted by the Crown to a job-master named Newman as a reward for having delivered the first news of the victory at Waterloo. It had later been used as a metropolitan meat market, which had now closed down. Hallé had eagerly seen its possibilities: 'We shall have I think the handsomest picture gallery in London.' They were barely five minutes from the Academy. They would be the only picture gallery in Regent Street: 'for beauty of workmanship in furniture, stuffs, jewellery etc. Regent Street can make as good a show as any street in Europe'. The most fashionable store of the 1880s, Liberty's, was conveniently close. The spacious site would allow for two large picture galleries and a central court as well as entrance hall, refreshment rooms and offices. The architect Edward Robert Robson was appointed and building started just before Christmas 1887.

With the opening planned for the following May the construction schedule was tight, with two hundred builders working by day and another hundred and fifty on the night shift. Joe Comyns Carr went down to the site every evening to set the night shift going, and often on their way back from the theatre he and his wife Alice would pay a surprise visit. She remembered how all through the spring of 1888 the huge flares from the building site, standing out dramatically against the night sky, lit up the whole of Regent Street.

Burne-Jones entered into the excitement of the preparations. In a letter to Eleanor Leighton he gives her a preview of the delights

of the New Gallery: 'You will enter in Regent Street, and at once, in five paces, be in a marvellous place reminding you of Cairo and Damascus, and in another minute, without going up one step, you will be gazing on pictures – such as they happen to be.' The quasi-Eastern effect had been created by Robson's lavish use of marble and gilding. A fountain played in the paved courtyard. For the opening exhibition on 5 May Burne-Jones sent three spectacular oil paintings as well as several drawings. The paintings were hung in pride of place in the West Gallery, two of Arthur Balfour's *Perseus* pictures – *The Rock of Doom* and *The Doom Fulfilled* – flanking one of his most beautiful, evocative paintings, *The Tower of Brass*.

The pensive, anxious figure of Danaë watching the brazen tower under construction had a clear contemporary meaning of beauty under threat from cupidity surely not lost on Gladstone, who arrived early at the private view. 'My husband escorted him round,' Alice Comyns Carr recollected. 'Mr Gladstone was particularly interested in two Burne-Jones canvases, one of Perseus and Andromeda, and the other the tragic figure of Danaë, in a crimson robe, watching the building of her prison.' The head of Danaë had been modelled by the poignantly beautiful Marie Spartali, now Mrs Stillman, yet another tangible reminder of Burne-Jones's liaison with the Greeks.

The tension of completing these three major paintings was too much for Burne-Jones. He broke down, was unable to attend the private view. Instead he went to Rottingdean. While resting there he wrote, 'I have seen no newspapers, only people tell me the Gallery is successful, and I am pleased.'

Rottingdean, Two
1888–9

While the New Gallery was under construction Burne-Jones was faced with the event he had most dreaded. In February 1888 came the announcement that his beloved Margaret had got herself engaged. His daughter had been his closest of companions. She had soon replaced her mother as his favourite reader in his studio, regaling him with Thackeray's novels as he worked. They would go on expeditions together around London, marvelling at sudden vistas and exploring hidden corners. An account in Margaret's diary of a midwinter visit with her father to the charitable institution of the Charterhouse leaves a wonderful impression of the easy closeness of their companionship. Burne-Jones and John Millais were competitive in their devotion to their daughters, outdoing one another with their boasts. 'Ah, but *you* don't take your daughter's breakfast up to her in bed,' said Burne-Jones. Millais riposted, 'Yes, I do.'

He had come to depend on the presence in the house of his little demure daughter in her beautiful flowery Aesthetic Movement clothes. He relied on her as his bulwark against Georgie's sometimes hurtful if unspoken criticism. He loved the quietly remote and quizzical expression that he captures so subtly in the portrait of his daughter posed in front of a mirror in a deep-blue dress. This was a quality that Henry James had also recognised in describing Margaret, 'with her *detached* exterior'. Burne-Jones had come to appreciate his daughter's style of beauty all the more

as she grew older: artistically she was his ideal female type. He needed his daughter close by him, and in his obsessive way he treasured her virginity. Through the previous year he had been working on the *Briar Rose*, painting the Sleeping Princess from Margaret, then still his ideal model for the somnolent beauty 'with her unawakened heart'.

But it had been useless for Burne-Jones to give his daughter the present of a moonstone with the superstitious hope, as he later admitted, that she would never marry and stay with him. Mary Gladstone, now Mrs Drew, arriving at the Grange for luncheon in early 1888, found a fait accompli with the newly engaged Margaret looking 'a dream of loveliness and love in a big armchair at head of table, clad in blue with daffodils in front'. After lunch Burne-Jones took Mary into his study and poured his troubles out.

The man Margaret was marrying was John William Mackail, the son of a Scottish Free Church minister, a tall, conventionally handsome and earnest intellectual who still retained traces of a Scottish burr. Jack Mackail had been at Balliol, had received two first-class degrees and won a whole series of scholarships and prizes. At Oxford he was generally regarded as the most brilliant scholar of his generation, and Cynthia Asquith was later to describe him as 'the most complete walking encyclopedia I've ever met'. By a curious coincidence, on the same day in 1881 on which Burne-Jones returned to Oxford with Margaret and Philip in attendance to receive his honorary doctorate, Mackail, then still an under-graduate, was honoured as the winner of the Newdigate Prize and they had watched him reading his prize-winning composition out aloud in the Sheldonian, a poem on the subject of Thermopylae. Seven years later, at the time of the engagement, Mackail was a civil servant, working in Whitehall as an examiner in the education depart-ment. He was then twenty-eight and Margaret was twenty-one.

When Burne-Jones first heard the news he felt angry and betrayed. Up to now he had regarded the 'grave learned' Mackail as a friend of the family who simply came to talk with him about books. For him to appear in this new role as Margaret's suitor seemed like duplicity. He wrote to Sebastian Evans: 'Did you ever

in this house see a man named McKail? And should you from his face and expression have thought him capable of deep treachery to me? Well he has asked my Margaret to go away from me, and not only that but to go away with him.' The fact that he misspells Mackail's name, as if wanting to brush him off or to belittle him, is no doubt significant of his distress.

To Eleanor Leighton he was even more revealing of his inner terrors: 'Here is my darling Margaret upon whom I depend for everything and without whom I should crumble into senility in an hour – and what has she done? Yes, what indeed but engaged herself. And I wanted to write cheerfully about it and can't – I lose so much and for a little while shall feel nasty and spiteful and grudging.' Georgie did her best to counteract the misery, telling her friends how good a match it was, extolling Mackail's career prospects, mentioning the friends they already had in common, praising his upright looks and his exceptionally good kind eyes. To her nephew Rudyard Kipling she went as far as saying that this was the one man on earth she would have liked Margaret to have chosen. Whereas Burne-Jones could not bring himself to use his future son-in-law's Christian name, referring to him rather maliciously as 'Djacq', Georgie took to it enthusiastically, saying, 'I never thought to love the name "Jack" but I do now for his sake.'

Burne-Jones went on feeling heavy-hearted that whole summer, 'more long faced and solemn than I like'. He was counting the days with dread until the marriage, arranged for September in Rottingdean. He was unable to settle, suffering from nervous tremblings, asking Lady Leighton, his flower-book adviser, if she could recommend some soothing herb. Left at Rottingdean while Margaret and Georgie were in London planning the wedding clothes and trousseau, he roamed around the house 'peeping into rooms and sighing and being altogether horrible'. He watched himself behaving like one of those maudlin fathers in bad novels and bad plays. By the end of August wedding presents were arriving. The little hall was crammed with them: glass, pottery, engravings, watercolour drawings, 'metal things like surgical instruments, God knows what they are meant for'. One of the

more welcome presents was a *Hammersmith* rug from William and Janey Morris, dispatched from the new Morris works at Merton Abbey. Morris thoughtfully made the practical suggestion that when it got dirty the rug could be returned to Merton to be washed.

The wedding had been settled for 4 September, consciously avoiding 3 September, the still sensitive date of Burne-Jones's mother's death. In the weeks of preparation he could not help himself wandering across to the little grey church trying to imagine what the wedding would be like. 'I daresay I shall scarcely feel at all,' he thought, 'only be stupid and dazed – so it has been with me always in big troubles.' The day before the wedding he wrote distractedly to Rudyard Kipling saying, 'tomorrow is the fatal 4th . . . I hope I shall behave well, and not be sick, at the very altar – and what do girls want with men – didn't I flatter her enough, glare at her enough, fetch and carry and be abject enough!' On the night before her marriage Margaret wrote him a tender, comic letter saying he had not, after all, been a bad father. He kept her precious letter all his life.

In the end Burne-Jones considered he behaved 'pretty well'. In describing the wedding to her sister Louisa, who was too ill to be present, Agnes told her with relief that there had been 'no scenes, no tears'. The church service was at one o'clock. It was a lovely day, dry, sunny, slightly breezy with a brilliant blue sky. There was quite a crowd outside the church to watch Margaret walk across the green with her father and her mother on each side.

Margaret wore a white silk gown and according to her fashion-conscious aunt Agnes she 'looked quite lovely, perfectly dressed for taste and fit'. Round her neck she wore the simple one-strand pearl necklace William Graham had given her when she was a girl. She carried what her father called 'a bush of white roses and jasmine'. Her mother was dressed in a rich greeny-grey silk gown trimmed with cream silk robings, in what was for her a very modish style. As they approached the churchyard gate, four local girls appeared with baskets of rose leaves which they showered on the bridal procession down the path to the church door. One of these girls in white was Cissie Ridsdale, who four years later would

be treading the same route as Georgie's nephew Stanley Baldwin's bride.

As he had predicted, Burne-Jones passed through the ceremony in a trance, hardly aware of any individual faces. After the wedding the family party returned to Aubrey House. There had been a panic about the non-arrival of the wedding luncheon, coming by train from London, and Phil had had to spend the morning in Brighton, where he managed to sort the problem out. The banquet table was set in Burne-Jones's studio-bedroom, rearranged for the event. The walls were hung all round with embroidered curtains that had been put away for twenty years, presumably the heavy blue serge hangings with the Morris daisy pattern that had formed the background to Ned and Georgie's own early married life. Branches of myrtle and roses were strewn around the room. The wedding cake itself was decorated with fresh summer flowers.

Then it was time for Margaret and Jack to leave, she now having changed into her going-away clothes, a fawn embroidered cashmere dress with a very pretty hat. They were spending the first week of their honeymoon in Chichester then travelling on to Winchester and Glastonbury, of which Margaret, still her father's daughter, wrote contentedly, 'It is a perfect setting to the Arthurian legends: one was in a dream of them all the time.'

Burne-Jones felt relieved when the long ordeal was over. He had been able to focus on very little work during the summer, hardly any painting, only a few drawings. He was glad to be back in London in the studio. Margaret and Jack had taken a house in Young Street, off Kensington High Street, only a stone's throw from Kensington Square where Margaret was born. There were visits between the Grange and the newly married couple almost every day.

All the same, the removal of his daughter affected Burne-Jones deeply. And it wasn't only Margaret: she took her much-loved Persian cat with her. Burne-Jones missed 'the beautiful hairy oriental beauty that moaned, gasped and gave birth'. The episode had aged him. In 1888 he began making a will: 'as if that mattered – the estate being valued at under twenty seven pounds four

shillings'. He felt he had arrived at that state of mind when the arrival of a letter or the opening of a door was less a reason for anticipation than dread. Later Thomas Rooke mentioned having seen him at this period walking to South Kensington looking very white and old. 'I thought it was the turn of life for you,' he had suggested. 'No it was the parting,' the parting from Margaret, Burne-Jones had replied.

Over the next few years Burne-Jones designed and the family donated a series of stained-glass windows for St Margaret's, Rottingdean, commemorating Margaret's wedding in the church. *Pro unica filia Margareta in hac S. Margaretae aede feliciter nupta Edwardus Burne Jones pictor dedicavit*, the inscription reads. One of two windows he designed for the chancel is a figure of St Margaret herself conflated with the image of his daughter: her features, downcast eyes, her stance, her cornflower-blue dress. The maiden's halo is inscribed 'Sancta Margareta' in Gothicky letters, in case of any doubt.

And indeed to him the name had a double sacred meaning. As he saw it, Margaret had been a sort of necessary safeguard, a means of preventing his propensity for love from escalating into further scandal and disaster, and this was why he took her marriage so hard. He once tried to explain this to Frances: 'didn't it occur to you if I had Margaret by me it might be for my sake that I might have protection against myself'.

Through the winter of 1886 Burne-Jones's work was once again on show at the New Gallery in the first exhibition of the newly formed Arts and Crafts Exhibition Society. This was part of a whole radical movement of the period inspired by William Morris's lectures and writings, and most of all by his own practical experiments in the revival of the crafts. It drew in a new generation of idealistic archi-tects and artists who formed individualistic guilds and workshops attempting to do away with false distinctions between the fine and decorative arts and at the same time, often somewhat painfully, working out new ways of relating art to life. The Arts and Crafts Exhibition Society was an offshoot of the Art Workers' Guild,

which had been founded in 1884 to provide a gathering point for members of the movement. The Society was formed to give these ideas a more public visibility. The two organisations shared many of the same members, most of whom were already friends or colleagues of Burne-Jones. Walter Crane was the first Chairman of the Society and William ('Brass') Benson the first Secretary. It was apparently in an early committee meeting, when the society was still at planning stage, that the bookbinder T. J. Cobden-Sanderson invented the descriptive definition 'Arts and Crafts'.

The Exhibition Society took up many of Burne-Jones's now lifelong beliefs in the importance of design, materials and finish; the close relationship between art and craft techniques. 'His spirit lived in the language of design,' as Joe Comyns Carr had once so well expressed it. Burne-Jones's free and flexible interpretation of art was enormously influential in its time, as was his belief in the power of art to counteract the spiritual poverty of life. Among his disciples of a younger generation was the architect C. R. Ashbee, who had set up his own Guild of Handicraft in the East End of London in 1886. When Ashbee had gone to ask him for advice about opening an art school in Whitechapel, Burne-Jones received him kindly and invited him to lunch at the Grange: 'He sitting stately at the head of his table in blue and silver, – grey beard peaked, Velazquez-like, – with blue shirt Morris-like and silver studs and amethyst set in silver'. Just as much as William Morris, though in another way, Burne-Jones was the role model for the Arts and Crafts.

But although he sympathised with the tenor of the movement he resisted real involvement. He had become wary of artistic institutions since his unhappy experiences with the Old Watercolour Society and, more recently, the Royal Academy. He was not a founder member of the Arts and Crafts Exhibition Society. He joined a little later, evidently with reluctance. He did not become a member of the Art Workers' Guild until 1891 and he resigned again two years later. This signifies Burne-Jones's never resolved conflict between his romantic ideals of brotherhood and his sense of himself as the solitary artist, his notion of having 'always been

a little painter, painting away in a room and having to think of nothing but my work'.

His political divergences with William Morris may well have been another reason for his caution in entering the public world of Arts and Crafts. In the late 1880s Morris was at his most politically vehement. His ferociously well-argued article on 'The revival of Handicraft' was published in the *Fortnightly Review* in 1888. In it Morris makes a passionate case for the importance of the work-man's own human contribution to his work. Citing Marx's 'great work entitled "Capital"', William Morris analyses the progression by which the widespread use of machinery in factory production has gradually come to supersede hand labour, transforming the workman 'who was once a handicraftsman helped by tools, and next a part of a machine' now into a mere tender of machines. Faced with such a situation, what do we do next? For Morris a vio-lent workers' revolution had become the only possible conclusion. For Burne-Jones it had not. To him the name Karl Marx did not have the magical resonance it had for William Morris. He would certainly have wanted to avoid all possibility of public confronta-tion on the subject of politics with his greatest friend.

As soon as the Arts and Crafts Exhibition opened at the New Gallery, Burne-Jones came around to it. The standard was higher than he had expected: 'amongst some stuff and nonsense are some beautiful things, delightful to look at, and here for the first time one can measure a bit the change that has happened in the last twenty years. I felt little short of despair when I heard of the project, and now I am a bit elated'. The converted produce market, with its high vaulted ceiling, large central space and upper gallery for showing smaller items, provided a good background for Arts and Crafts work in a dazzling variety of materials and styles. The art writer Julia Cartwright shared Burne-Jones's elation:

when the New Gallery opened its doors, a thrill of pleasure and surprise ran through the spectators. Many of us remember the beautiful effect of the Central Court – the pyramid of De Morgan tiles glowing with the ruby lustre of old Gubbio ware, with Persian and Rhodian blues, Mr.

Benson's luminous copper fountain, Mr. Sumner's *sgraffito* designs and gesso roundels, the glorious tapestries from Merton Abbey, and all the lovely colour and pattern in silk embroideries and exquisitely tooled morocco, that meet the eye.

Besides his many Morris & Co. designs for tapestries, embroideries, stained glass, which included the cartoon for the new *Ascension* window at St Philip's, Birmingham, Burne-Jones also exhibited on his own account. Julia Cartwright had been especially thrilled by his gold Renaissance-style cassone with its design of the Garden of Hesperides. One of the experimental Broadwood pianos with gesso decoration by Kate Faulkner was on show. Burne-Jones described how at the exhibition opening he kept taking people up to it and 'lauding it to the skies' without noticing a label on the top that credited the design to him. 'I only designed the *form*,' Burne-Jones explained, 'trying to follow the lines of an ancient harpsichord . . . so a false impression of my character has gone forth, not for the first time – and an injustice has been done to an admirable designer, which matters worse.'

It was not just the splendour of the exhibition but the new idea behind it that people found exciting, the underlying 'art-that-is-life' philosophy. Writing of De Morgan, Morris, Walter Crane and others, Julia Cartwright's responsiveness flows over: 'Certainly these men make every part of life beautiful and good.' People began to see that there was as much art, in the sense of fine judgement as to form and technique, in the design of a table lamp or piano as in an easel painting. They began to grasp the concept of another kind of artist who worked in a different but just as valid way. Bernard Shaw, in a perceptively mischievous review of the exhibition in *The Studio*, suggested that some of the multitude of painters who exhibited in London galleries should reinvent themselves as architects, engineers, potters, cabinet makers, silversmiths or bookbinders. The first Arts and Crafts Exhibition marked a first stage in this process, the first public demonstration of the design profession as it emerged in the Britain of the twentieth century.

As an added attraction in the course of the New Gallery exhibition a series of evening lectures was arranged in which leading practitioners spoke about their craft. One of these was given by William Morris on the subject of 'Tapestry and Carpet Weaving'. Not only was this a statement of his views on designing woven textiles, it was also a practical demonstration. Morris had had a model loom specially constructed to his design and set up on a platform in the gallery so that people could watch him actually weaving. He had carefully assembled examples of historic tapestry he most admired, asking Thomas Armstrong to make available the early sixteenth-century tapestry *The Three Fates* from the South Kensington Museum collection. He also brought along his own rare Southern Persian carpet that usually hung in the dining room at Kelmscott House.

Burne-Jones was at the lecture, where he drew a caricature of William Morris weaving, in a style one can best describe as 'William Morris cosy'. This is one of the most delicate, funny and affectionate of Burne-Jones's long series of Morris cartoons, showing the weaver hunched up over the loom, tousled head bent, on tiptoe with concentration, his generous posterior spread out across the bench. It is an image, comic but respectful, that tells us a great deal about the enduring nature of their friendship. They might have their profound political differences but when it came to tapestry they thought almost as one.

In his lecture Morris described tapestry quite boldly as 'the noblest of the weaving arts'. This was how Burne-Jones regarded it as well. He too had been indoctrinated as a young man, the Tapestry Courts at the South Kensington Museum opening his eyes to the potential of tapestry in terms of richness of colour, variation of texture and the extraordinary subtlety of detail achieved in the best of the medieval weavings. 'I remember', wrote Georgie, 'those little courts of Tapestry were like Chapels to him.' His and Morris's success in jointly reviving the weaving of tapestry in Victorian Britain was an aspect of their shared romanticism.

As early as 1877 Morris advised Thomas Wardle, the Leek manufacturer then considering embarking on tapestry production,

386

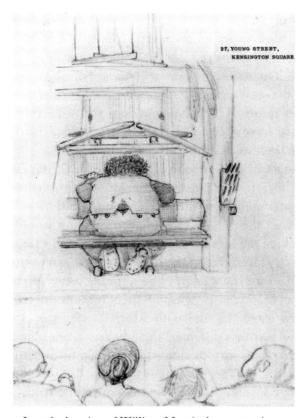

27, YOUNG STREET,
KENSINGTON SQUARE

Burne-Jones's drawing of William Morris demonstrating weaving
at the New Gallery.

that there was 'only one man at present living who can give you
pictures at once good enough and suitable for tapestry – to wit
Burne-Jones'. As with the Firm's stained glass, Burne-Jones's
involvement was crucial once Morris in the late 1870s embarked
on tapestry himself. William Morris's solo designs are relatively
clumsy. It was their collaboration, with Burne-Jones supplying
the figures and the outline composition while Morris and his
chief assistant Henry Dearle filled in the decorative detail and the
borders, that gave Morris & Co. tapestry its real originality.

Morris's move of his workshops to Merton Abbey in south
London in 1881 allowed the Firm's making of tapestry to flourish.
The weaving of large-scale Arras-type tapestries took place in its

own large workshop, a shed that overlooked the millpond. To start with three high-warp looms were installed. A system evolved whereby Burne-Jones drew out his designs to scale at about fifteen inches high. These designs were then passed on to William Morris. For example, receiving the drawings for *Pomona* and *Flora*, he told his daughter Jenny, 'Uncle Ned has done me two lovely figures for tapestry but I have got to design a background for them.' Morris's suggestions then went back to Burne-Jones.

Instead of a full-size cartoon being made for the tapestry, as had been usual for stained glass, Burne-Jones's original was photographed professionally to full size and mounted. Morris and later Dearle drew in the detail. The finished drawing would be placed against the loom at Merton Abbey and traced onto the warp. The weavers were placed facing the back of the tapestry with a mirror in front reflecting the design. The tapestry weavers were mostly young boys, preferred because of their nimble fingers and their quickness to learn. In line with Morris's views on the creative input of the Firm's craftsmen the weavers were allowed a little latitude, sometimes introducing plants copied from nature, flowers brought in from the Merton Abbey gardens. But weaving a Burne-Jones tapestry was still repetitive and exhausting work.

To begin with Burne-Jones's tapestries were natural developments from his single-figure designs for embroideries and stained glass. His first tapestry, *Pomona*, designed in 1882, for which Burne-Jones received £25, was also produced as an embroidery by the Royal School of Needlework. The *St Agnes* tapestry, woven once in 1887 and again in 1888–9, derives from a Burne-Jones window for St Helen's Church in Welton. But by the later 1880s, as he grew in confidence, Burne-Jones's designs for tapestry became grander in concept, more dramatic, more processional. He had kept in his mind since his visit to Rome the tapestry in the Vatican Museum showing the Pope and Charlemagne together. His tapestries for Merton Abbey from now on have a similar over-the-top ambitiousness.

His approach to tapestry was always painterly in terms of composition and design. This was one of the things he had always loved

about it, the scope and scale and the particular artistic possibilities: 'Big tapestry's beautifully half-way between painting and ornament – I know nothing that's so deliciously half-way.' The most popular of all Burne-Jones's Merton Abbey tapestries, *The Adoration of the Magi*, in fact evolved side by side with a painting treating the same subject under a different title, *The Star of Bethlehem*. The tapestry came first, with a commission in 1886 from the Rector of Exeter College in Oxford, where Morris and Burne-Jones were now Honorary Fellows, for a tapestry for the chapel. It seems that the Rector, John Prideaux Lightfoot, proposed the biblical story of the three wise men as it appears in the medieval legend of the Kings of Cologne in which Gaspar, King of Godolie, Melchior, King of Tarsis and Balthazar, King of Nubia travel to Bethlehem to prostrate themselves before the Holy Child.

When Burne-Jones was approached the following year by the Corporation of Birmingham to paint a large-scale work for the new municipal Museum and Art Gallery he was able to sell his native city a £2,000 watercolour treatment of the same idea. Both tapestry and watercolour had a clear resounding contemporary message, similar to that of *King Cophetua* but more obviously spiritual. The three kings were power figures divesting themselves of the symbols of their glory, bowing the head before the Virgin and the Christ Child's innocence and beauty. With its figure of the angel suspended above ground this is a wonderfully grave, eccentric painting. Far from being a straightforward Christian interpretation, the composition is imbued, as the *Art Journal* was to comment, with Burne-Jones's 'own peculiar vein of mysticism'.

In both its versions, the woven and the painted, the subject of the Magi made a lasting impact. After the first weaving of the tapestry had been delivered as a joint gift to their old college by Burne-Jones and William Morris, nine more versions of the tapestry were made. This was to prove the most popular of all the Merton Abbey tapestries. Versions were supplied to Eton College Chapel, to St Andrew's Church at Roker and to foreign buyers as far afield as Russia and Australia. Wilfrid Scawen Blunt commissioned a replica for his house in Sussex. Blunt and his wife Lady Anne had

founded the famous Crabbet Arabian stud and he asked for an Arab horse and a camel to be included in the tapestry, a suggestion William Morris had resisted, explaining that 'it would not be easy to get a horse into the original design'.

The *Star of Bethlehem* watercolour, first shown at the New Gallery in the summer of 1891, was the centre of attention in the loan exhibition of Pre-Raphaelite art when it opened that autumn in Birmingham. The painting was given reverential treatment when permanently installed in the city gallery. A disciple of Burne-Jones's, Bernard Sleigh, laid a floral tribute beneath it every 28 August, commemorating the birthday of the artist. A casual visitor, a Mrs Alice Hyde Oxenham, related her experience of coming face to face with religious inspiration in an unexpected context: 'chance led my footsteps to Birmingham, and there of all places – in grimy, smoky, manufacturing Birmingham – I found "The Star of Bethlehem", by Mr. Burne Jones. Here, and here alone, was what I sought.'

The image of the *Adoration of the Magi* found its place in the spiritual experience of the nation, an object of pilgrimage and soon to be the subject of a thousand Christmas cards. While Holman Hunt's *The Light of the World* was unarguably the most famous of nineteenth-century religious images, Burne-Jones's *Adoration of the Magi* had, and still has, its following as well.

In the Irish Home Rule agitation of the 1880s Burne-Jones had been emphatically on the side of the Irish nationalists. 'I do like Paddies very much because they are unlucky, because Anguish is their king, because they make splendid legends,' he once said, referring to Anguish, King of Ireland, one of Arthur's knights. In October 1888 he went several times to the law courts with George Lewis to watch Charles Stewart Parnell, the Irish nationalist leader, defend himself against the charge that he had condoned the so-called Phoenix Park murders of 1882, when the Irish chief secretary Lord Frederick Cavendish and his permanent under-secretary Thomas Burke were brutally stabbed to death in Phoenix Park in Dublin.

The investigation hinged on letters written purportedly by Parnell himself in support of the murders, facsimiles of which were published in *The Times*. The proceedings of the Parnell Commission were followed with huge interest and the sittings turned into something of a London social event. Henry James, for instance, noted: 'Burne-Jones and I met a couple of times at the thrilling, throbbing Parnell trial, during the infinitely interesting episode of the letters . . . Unfortunately, or rather fortunately, getting in was supremely difficult.'

For Burne-Jones the arraignment of Parnell was an agonising demonstration of English hypocrisy, bringing about his final disenchantment with political and public life. He saw Parnell as a sacrificial victim. As an artist Burne-Jones was powerfully affected by Parnell's strikingly attractive physiognomy as he viewed it in the courtroom: 'he had a most beautiful face, it was like Christ's. The profile of it was just like the traditional representation of Christ's face, but the full face wasn't quite so good. Photographs of him give no idea of the fineness of it.'

Parnell's eventual acquittal of the charges was largely due to Lewis. It was he who had examined the series of incriminating letters and concluded they were forgeries, providing vital ammunition for the defence lawyer, Sir Charles Russell. Under Russell's relentless cross-examination the forger, Richard Pigott, eventually broke down and admitted he had sold the letters to *The Times*. Pigott ran off to Madrid where he committed suicide. George Lewis was knighted in 1892, one of the main reasons for his elevation being his key role in the Parnell affair.

The winter of 1888–9 was one of intense emotional pressures. At the end of October Charles Faulkner, upright, vigorous, loyal, intellectual Charley, suffered a serious stroke. He was left permanently paralysed, lingering on in an only semi-conscious condition for the next three years. Of all the Oxford friends it was Charley Faulkner who had followed William Morris most wholeheartedly into Socialism. It seemed to many who knew him that the rigours of revolutionary politics, the meetings and street preachings, far from the

academic world to which he was accustomed, had fatally under-mined his health. Burne-Jones could not escape his own feelings of guilt, conscious of failing Morris when it came to politics. Charles Faulkner in contrast had been the stalwart friend.

In January 1889 the news came that old Mr Jones was seriously ill. Burne-Jones, with Crom Price in sympathetic attendance, set off for Birmingham. His father died a week after they arrived. The body was brought back to London to be buried in the grave in Brompton Cemetery where the Burne-Joneses' baby Christopher and Aunt Keturah already lay. He solved the tricky problem of the servant-girl-turned-widow by arranging for her father to come to London with her, where he took lodgings, so that they could both be present at the funeral. Burne-Jones led his young stepmother to the graveside on his arm. He proposed that, unless she married again, she should eventually be buried alongside his father. However, she remarried, no doubt to his relief.

There was a general sense of time inexorably passing, especially obvious at the annual musical afternoons given by Leighton at Leighton House where the London art world was assembled in the drawing room to listen to such stars as Joachim and Piatti. These parties took place on a Sunday in March, the only occasion on which some of the guests would have seen one another over the whole year. Meeting and greeting acquaintances and friends, the ravages of time were often very evident. As Leighton's invitees died or became too infirm to attend his gatherings, no new guests were brought in to replace them. 'It is like the Waterloo banquet,' Burne-Jones observed:

in a few years we shall be forty, twenty, five in number – listening to the best music the time can give. It is pitiful to hear the guests say one over-repeated thing to each other: 'You don't look a bit changed, not a bit.' They do look changed, dreadfully changed – they are fat where they were thin, and thin where they were plump, and dim-eyed and disillusioned all round, but one constant thing they say is that they don't look changed.

Life at the Grange itself was winding down. As Burne-Jones had known and feared, the house felt empty without Margaret. She and Jack, now ensconced in their little house in Young Street,

had begun attempting to keep themselves to themselves. Although in theory still living at home, Phil in fact was rarely at the Grange. He was either out working in his own studio in West Kensington or was allowing himself to be distracted by his friends, having infiltrated himself into a dazzlingly high-powered and sophisticated London politico-social world. Burne-Jones told Lady Leighton, 'he lives a sublime life – moving in circles which would never admit me to their quintessential communions – a rather glorious Phil these days, of whom I see little'. His mother, in a more exasperated tone, referred to Phil's life of frenzied pleasure-seeking as a 'period of reaction from us and our ways'.

Inevitably Phil's work suffered. His small-scale paintings and the watercolour portraits of children in which he had begun to specialise all too evidently lacked his father's scope and power. Burne-Jones himself sent no new work to the 1889 New Gallery exhibition, only a few studies and drawings. Phil in effect replaced his father. Ned, as always, tried to see the best in him, praising his eye for colour, spreading it around his friends that Phil was working well and was producing 'delicate, unpretentious work, full of feeling'. But critics and visitors to the New Gallery were less than kind. Robert Browning, for example, judged Phil's pictures as 'clever but rather "finicking"'.

Henry James went further in a personal analysis, seeing Phil as psychologically lightweight in contrast to his father: 'Phil follows him at a very long interval, but with, also, an apparent absence of suspicion of what painting really consists of which, as he has not his father's beautiful genius to give one something to *bite*, promises ill for his future career.' However, he foresaw that Phil – 'a tremendous little Tory' with his entrée to the Salisbury coterie – could subsist on his charm, having a '*real* genius for talk and laughter'. Even if he could not make his living as an artist, Henry James predicted that Phil would 'flourish all his days'. He was not to be proved right.

Burne-Jones's sense of isolation in his own household was exacerbated by Georgie's sudden interest in the then burgeoning women's movement. He complained that the Grange was bursting

at the seams with petitions and correspondence from 'the Fawcetts, the Garrett Andersons' and other prominent members of the feminist faction. 'I don't know what part Georgie takes as yet,' he wrote anxiously to Eleanor Leighton, 'but if she takes any part at all I retire to a convent.' He knew and liked many strong-minded women – Rosalind Howard, Elizabeth Lewis – but the thought of them en masse was a source of real terror, a physical repulsion way beyond a joke.

Visitors to the Grange in the later 1880s describe an increasingly dilapidated scene. On the evening of a summer garden party, at which a Hungarian band had been hired to play for dancing, the Grange could be seen to have turned into a parody of its former glory. Even the sympathetic Mary Drew admitted there was rather a dearth of female beauty. Though Mrs Morris was present, she was now 'a glorious wreck'. The acerbic Jeanette Marshall described a scene of horror, as of the Aesthetic Movement gone to seed:

Under the apple tree at the further end of the garden, whose branches interfered considerably with my comfort, a ghastly and aesthetic company was assembled . . . Mrs. Stillman and Effie (who is a telegraph post!), Mrs. Morris (who looks like a maniac) and her eldest daughter (who is out and out the ugliest person I ever saw), Mme Coronio (looking awful!)

Through summer 1889 Burne-Jones had been unwell again with an illness he self-diagnosed as a recurrence of the 'ancient malaria' with which he had been stricken in beautiful Ravenna sixteen years earlier. Remembering that journey, the illness still seemed to him worthwhile. In the autumn he was cheered by the arrival back in England from Calcutta of his favourite nephew-by-marriage Rudyard Kipling, who had now decided to attempt to make his way as a writer. Before he moved into his own chambers in London he stayed with the Burne-Joneses at the Grange. There were many family gatherings to welcome him, one of which, held on 18 December 1889, he described in vigorous detail in a letter to a friend:

Dined at the Burne Jones's to meet my Uncle Fred Macdonald the Methodist preacher and his Nephew George a weedy sucking solicitor, just going on the Continent for 5 weeks. Fred is the wit of our family and

told us queer tales. Aunt Georgie has stuck the pallid boy George with his back to the fire. He was much too polite to ask for a screen so he was! Then he drank too many glasses of clinging clammy Saumur. (I love my Aunt Georgie but I don't drink her wines.) Then when the ladies (represented by Mrs. Poynter (Aunt Aggie) and Edith Macdonald the unmarried Aunt) had retreated, George wrapped himself round one of Burne Jones's best Havanas! (I love my Uncle Ned and I *do* smoke his cigars when I get 'em). That didn't agree with George. He was – not to put too fine a point on it – AWFUL SICK! I misremember what occurred but Phil ran for the slop bowl and I ran for the hall.

As life at the Grange became more muted and the Burne-Jones family expanded, Rottingdean became the new centre of gravitation. In 1889 Ned and Georgie acquired the next-door property, Prospect Cottage to the south. Georgie explained one of the incentives for the purchase being 'the likelihood of very tiresome neighbours'. Ned, more specifically, told Lady Leighton that they had to buy the next-door cottage to stop it being used as 'a sanitorium for scrofulous orphans'. It was at this point, when Aubrey House and Prospect Cottage were connected, that the Burne-Joneses' Sussex home became known as North End House.

Once again W. A. S. Benson was called in to extend the building to his own design, building a new entrance and a studio. 'The magician's hand has been upon it (I allude to Mr. Benson),' Burne-Jones wrote delightedly, describing the transformation whereby 'another house has been added and new rooms built, and windows turned south that were east, and there is a garden now and ilexes and bay-trees and fig-trees, and a man's garth where coarse friends may smoke'. Burne-Jones had a romantic ideal of French family life with the generations living together in one large house, grandparents and grandchildren all within reach and within call of one another. He wanted to reproduce this at North End House, providing a bower with a bow window for Margaret, a study for Jack, a new family dining room with hangings around it, a still-room 'for Georgie to make scents and jams'. Essential to the plan was 'a sublime bedroom for Phil'. So entranced was he with the new possibilities of Rottingdean, he toyed with the idea of living there

permanently, using London only as a place to see his friends. Georgie too became increasingly focused upon Sussex: 'It is strange', she wrote, 'how we turn to country life now, and get more and more to consider Rottingdean as our home.'

The new extension was to be furnished in the simple country style that Benson had initiated in the original cottage. Burne-Jones enlisted the help of Lady Leighton in commissioning oak furniture made locally in Shropshire. The sketches he sent her have the quasi-primitive character of the furniture made for his and William Morris's former rooms in Red Lion Square. Gradually the oak furniture for Rottingdean accumulated: a cupboard, a clock, a medieval-style oak chair. The pièce de résistance was a settle for the 'pothouse room'. Burne-Jones resisted the idea of any cushions for the settle, maintaining 'it is good for me not to give way to luxuries but to learn hardship and endurance'. He shared the purist outlook of Morris who believed that if you wanted to be comfortable you should go to bed.

For Burne-Jones the 'pothouse', converted from the old brick-floor kitchen, was his greatest source of happiness at Rottingdean. Here he created his own place of escape, a male retreat known as 'the Merry Mermaid' where he and his cronies could drink and smoke and 'rattle the dice box'. His model for the decor was that of the snug bar of an old country inn with whitewashed walls. Georgie made short red curtains for the windows and the half-glazed door. Besides the settle there was an armchair and a black oak long table and a country-style dresser 'full of the madcappest pottery', ordinary German earthenware painted in exuberant colours that Burne-Jones loved for its authentic tastelessness. In winter the fire would crackle in the grate and Burne-Jones felt at home and a little bit defiant, telling Lady Leighton, 'Georgie says it is very overdone and crowded – I don't think so – it is the cosiest nook in the world.'

In the summer he would stroll out into the small garden, which was roughly the size of the dining room, scented with sweet briar rose and honeysuckle, and listen to the buzzing of Rottingdean's

The Merry Mermaid 'pothouse'. Burne-Jones's sketch of his favourite room in
the house at Rottingdean.

particularly fine fat bees. The village was full of swifts, speeding
beyond the rooftops. Late in life he was discovering bucolic
pleasures, simple recurring joys of Sussex countryside.

By the late 1880s Burne-Jones was feeling increasingly out of step
with painting on the Continent. He had not been to Paris since
1878 but he had viewed the work of Degas, Monet, Pissarro and
other Impressionist artists at London exhibitions. His response to
the Impressionists ranged from bewilderment to hostility. Faced
with Degas's *Baisser du Rideau* when it was on show in White's

Gallery in King Street, St James's, Burne-Jones had apparently expressed surprise that anyone should paint 'the fag end of a ballet'. As well as the lack of solemnity of subject it was the lack of finish in Impressionist painting that Burne-Jones found offensive. This of course had been the basis of his critique of Whistler in the Whistler vs Ruskin libel trial.

'What do they do, these Impressionists?' he asked. The thing he decried about their paintings was the muzziness, the emphasis on atmosphere rather than intellectual depth. 'They do make atmosphere,' he gave as his opinion one day to Thomas Rooke, 'but they don't make anything else. They don't make beauty, they don't make design, they don't make ideas, they don't make anything else but atmosphere and I don't think that's enough'. When he needed an antidote all he had to do was to go to the National Gallery and look at a Van Eyck, admire the tone of it, the beauty in the colour of every tiny object, the sheer skill, the depth of meaning in a very little room.

In the course of the 1880s, without Burne-Jones being very much aware of it, a new movement, Symbolism, had gathered strength in France and Belgium. This was a movement that called itself defiantly *a contrario*, a contrary force against Naturalism, against Impressionism, against the vulgar commercialism and cliché-ridden tendencies of modern art in favour of the legend, myth, allegory, mystic suggestiveness of paraphrase and dream. One of Symbolism's inspirations from the past was the mid-century English Pre-Raphaelite movement. The works of Holman Hunt and Rossetti were rediscovered and admired. Burne-Jones concurrently began to be revered as a contemporary hero, his works compared to those of Gustave Moreau on account of their poetic subtleties and strangeness. Indeed Moreau was on the jury that, to his surprise, awarded Burne-Jones with a gold medal at the Exposition Universelle in Paris in 1889. At the same time he received the cross of the Légion d'honneur and was made a corresponding member of the Académie des Beaux-Arts.

Their first sight of *King Cophetua and the Beggar Maid* left a strong impression on its Continental viewers. The critic Robert de la

Sizeranne remembered coming through from the brash and crowded, boastfully materialistic technical section of the Exposition into the 'silent and beautiful' section where English Art was shown and gazing at Burne-Jones's dream of kingly sacrifice to beauty: 'It was the revenge of art on life.' For the Belgian Symbolist painter Fernand Khnopff the image left spectators 'enwrapped by this living atmosphere of dream-love and of spiritualised fire'. Far from being the spent force that he feared, Burne-Jones now found himself acknowledged widely as a leader of the European Symbolists.

Although pleased and flattered, Burne-Jones kept his distance from the Continental art world. He had learned from his experience in London of the perils of involvement with the art establishment, and as he grew older had got better at evading demands on his time and energy.

Christmas 1889 was a quiet one. Georgie, Margaret and Jack had gone to Rottingdean. Burne-Jones, Phil and Rudyard Kipling, on their own in London, had what Kipling called 'a dreary-lively dinner' at Burne-Jones's favourite pot-house, the Solferino Inn near Leicester Square. The owner, an Italian, had not expected customers and was giving the waiters their own Christmas feast. The Burne-Jones party joined in; the landlord provided drinks on the house. 'It was funny dining there,' Burne-Jones wrote later, 'as if one had no friends.'

The end of the decade was marked by a funeral. Burne-Jones broke off work early on 31 December to pay a duty visit to Westminster Abbey where Browning was being buried. Browning had died in Venice but the body, to Burne-Jones's disapproval, had been reclaimed by England to be buried and commemorated in an abbey that was already crowded out with bulky and artistically obnoxious monuments: 'I hate that beautiful heaven to be turned into a Stonemason's yard for any one. No one is good enough to spoil that divine citadel, and I am sick of dead bodies and want them burnt and scattered to winds.' Burne-Jones was an early advocate of cremation, which had only been permitted in Britain since 1884.

He watched the humdrum funeral with a sinking heart: 'No candles, no incense, no copes, no nothing that was nice.' The procession, he grumbled, was ramshackle and paltry, with one dwarfish church canon who was only four feet high walking alongside another nine feet tall. He complained that the coffin covered with a pall carried on the shoulders of six men looked like a giant beetle. The abbey had no sense of theatre at all.

As he stood on the sidelines of Browning's funeral we can sense Burne-Jones's desperation for a heightening of drama. How much better for Browning to have stayed in Royal Venice. His responses turn into a lament for the condition of England as he saw it, the loss of its bravery of medieval ceremony, its sounds and colours muted, its instinctive responses to art deadened by late Victorian conventionality. He wrote longingly: 'I would have given something for a banner or two, and much I would have given if a chorister had come out of the triforium and rent the air with a trumpet. How flat these English are.'

Mells

1890–3

'Work at Sleeping Beauty coming to an end – within sight now. And such a winter I have had.' The huge expenditure of energy in the completing of four large canvases, taking them through many stages of anxious rethinking, revising and repainting, had left Burne-Jones exhausted, as he confessed to his client Frederick Leyland: 'Of course I'm done up as normal – quite at end of myself for a bit.'

The *Briar Rose* cycle went on show in April 1890 at Agnew's Gallery in Old Bond Street. Agnew's act of faith in commissioning the series was fully justified by large crowds and considerable accolades. This was the high point of the trajectory of fame that began thirteen years earlier with *The Golden Stairs*. Looking back, Burne-Jones's *Times* obituary recorded that 'thousands of the most cultivated people in London hastened to see, and passionately to admire, the painter's masterpiece'. After their Bond Street showing the *Briar Rose* paintings were exhibited in Liverpool. Then the following year they were shown at Toynbee Hall, the university settlement in Whitechapel whose founder, the Reverend Samuel Barnett, pursued an enlightened policy of exhibiting the best contemporary artists, free of charge, in one of the poorest and most socially problematic areas of London. As in Bond Street, the enthusiastic crowds poured in.

The reasons for the *Briar Rose*'s widespread popularity are clear. The Sleeping Beauty fairy tale, based on Charles Perrault's

telling of the story in his seventeenth-century *Contes du Temps Passé*, was well known in the Victorian period both in its version by the Brothers Grimm and its evocative treatment in Tennyson's 'The Day-Dream'. The valour of the quest through the thorny forest; the mysterious spellbound suspension of activity; the psychologically startling act of liberation through a kiss that is both invasion and salvation; the knowledge that the kiss now changes everything. Taken simply as a story it is beautiful, compelling. Quite young children can respond to it. When in summer 1890 Julia Cartwright and her husband took their little daughter Cissie to see the Burne-Jones paintings 'she entered keenly into all the details and was charmed with the "Sleeping Beauty" . . . the roses delighted her. We went on to the Zoo.'

The *Briar Rose* sequence is one of Burne-Jones's most intensely and enchantingly Pre-Raphaelite works in its exactness of descriptive detail, its truth to nature, its verisimilitude. So anxious was Burne-Jones to make his thorn thickets authentic that he wrote to Lady Leighton:

I wonder if in the woods near you there are tangles of briar rose – and if deep in some tangle there is a hoary, aged, ancestor of the tangle – thick as a mist and with long horrible spikes on it – and if 3 or 4 feet of such a one might be carved out for me by a 'feller' and sent to me.

The feller complied. An unwieldy parcel arrived and Burne-Jones announced, 'The briars have come and are all that my soul lusted for.' He was glad to be able to correct his painting, having previously made the thorns 'too big, too hooked and sharp'.

The search for authenticity extended to the armour. Burne-Jones later explained, 'My nearest approach to archaeology is in the Sleeping Beauty, where I took the pains to make the armour of the knights later than the palace and ornaments and caskets and things and dresses of the ladies and courtiers.' He made studies from the armour in the collection of Sir Coutts Lindsay, at the time when he and Lindsay were still on speaking terms, as well as designing and constructing some pieces of armour himself, collaborating once again with William 'Brass' Benson, the architect

and specialist in metalwork. He was not so much concerned with pure historical correctness as with imaginative credibility. As he put it, 'I know so much about it as to have a right to play with the subject.' Such creative attention to detail, together with the depth and quasi-Venetian richness of the colour, gives the *Briar Rose* paintings their strange compelling character. These seem to be scenes both in and out of time.

Beyond the fairy-tale narrative, the captivating detail, these were paintings with a message for the age. The Briar is the 'tangle of world's wrong and right', as William Morris expressed it in a poem concurrent with Burne-Jones's paintings that was later published in *Poems by the Way*. The theme is the quest for ideal beauty in a corrupt and apathetic world.

The ideas that Burne-Jones had been developing since his first designs for the Firm's *Sleeping Beauty* tiles in the early 1860s had now reached a full maturity. The complicated story, as told by the Brothers Grimm, beginning in the palace with the christening of the baby in the cradle, has now been reduced down to just four key elements, each replete with meaning: the terrifying challenge of *The Briar Wood; The Council Chamber* with the king and his attendants in deep sleep; *The Garden Court* with its soporific maidens; the final central image of the princess, *The Rose Bower*. Burne-Jones the storyteller has been subsumed into Burne-Jones the Symbolist. He had come to see the limits of too much explanation. 'As to the Briar Rose,' he wrote, 'I want it to stop with the princess asleep . . . to leave all the afterwards to the invention and imagination of the people, and tell them no more.'

The four *Briar Rose* paintings were bought by Alexander Henderson, later the 1st Lord Faringdon, a successful stockbroker and financier, for Buscot Park in Berkshire, the house and substantial estate he had just bought. Henderson was already the owner of *The Days of Creation*, among other Burne-Jones works. He was anxious that the artist should approve the position he planned for them, around the walls of the saloon. Buscot is just a few miles from William Morris's Kelmscott Manor. Burne-Jones drove over from Kelmscott and proposed extending the frames of the

four paintings and flanking them with four additional panels painted with flowers and branches as if they were extensions of the princess's rose bower. According to Georgie, the sequence of pictures now filled the available wall space 'as if they had been designed for it'. The furnishings of the saloon were integrated: a huge Morris carpet, Morris & Co. chintzes on the sofas and the chairs, a richly embroidered cover on the table. The effect, as with the *Cupid and Psyche* series in the Howards' house in Kensington, was of containment within some magical and secret room.

Not everyone, however, was moved to admiration. Wilfrid Scawen Blunt, successor to Rossetti as Janey Morris's lover, was staying at Kelmscott in 1892. He recorded in his confidential memoirs: 'After luncheon we went to Buscot House to see Burne-Jones's Briar Rose series. They belong to one Henderson, a nouveau riche, and we found the unfortunate pictures killed by their surroundings. The effect was of a beautiful woman vulgarly apparelled with a Jew husband and red haired monsters of children.' The current National Trust setting for the paintings, in an Empire-style drawing room with ornate giltwood furniture, an idiom that drove both Burne-Jones and William Morris to near-apoplectic fury, is certainly ill-judged. But in my view these extraordinary works can rise above it. Burne-Jones's Sleeping Beauty is one of the real artistic triumphs of the Victorian age.

For almost as long as the Sleeping Beauty sequence Burne-Jones had been considering *The Car of Love*. The idea for this painting, also at times known as *Love's Wayfaring* or *The Chariot of Love*, was another of his long-term obsessions, conceived as far back as 1871, appearing in his work notes for 1872 as one of four pictures 'which above all others I desire to paint and count my chief designs for some years to come'. The recurring subject was of Cupid standing upright on a great wheeled chariot, a robust wooden structure like a giant farm cart, being wheeled through the streets by a surging crowd of lovers, male and female, some happy and laughing, others struggling, groaning, bowed down by the weight. He planned to paint it life-size. The theme was not a new one. It

was taken from one of Petrarch's *Triumphs*, a popular subject in early Italian Renaissance art. But Burne-Jones found in it a personal connection, equating his own searches for artistic perfection, his own painful amatory longings with the overburdened figures in the picture. 'It's the old story with me', he wrote wanly to Elizabeth Lewis in 1890, 'Love and his overdriven steeds.'

He had sent her a photograph of his original outline for the picture, a rough black charcoal sketch made hastily one evening around the time of the unhappy ending of the Maria Zambaco affair. Should he resume the picture? He wanted her opinion. He had his own mixed feelings: 'Sometimes I have thought it would do, and sometimes it has terrified me and seemed a little degraded. I want to use my time very carefully and do only my best.' Eleanor encouraged him to continue with it. The monumental *Car of Love* canvas can be spotted looming large in contemporary photographs of the Garden Studio, the muscular Michelangelesque figures of the male lovers dragging Cupid's chariot being 'harnessed together with carefully designed thongs'.

In the early 1890s Burne-Jones was unmistakably in thrall to love himself. The object of his passions was not a new one. In his intensely susceptible late fifties his old adoration for Frances Graham, now Mrs Horner, had revived. His marriage to Georgie had settled into its late pattern of irritated fondness. He was in a condition of floating emotions following his daughter's marriage. His feelings refocused on the generous yet slightly remote Francie whose delicate features he had drawn so often. Mrs Horner, now the mother of four children, had kept her youthful figure although her hair was white.

For so many years, since Burne-Jones first knew the eighteen-year-old Frances, there had been an element of fantasy, of tale-telling, in their relationship. They would take imaginary journeys, children's-book itineraries, just the two of them: 'When we betake ourselves to the East I will do the geography if you will do the cooking . . . We meet at Constantinople, and after there is one necklace of wonders till we come back finally to Damascus the

405

abode of peace . . . Will this be a nice plan?' But gradually the playfulness, the fantasies receded. Burne-Jones began demanding more of Frances, and to some extent she seems to have reciprocated, explaining later to her friend Edith Lyttelton, 'I loved that sort of constant claiming love so.'

Her marriage to the straightforward, manly, self-deprecating country squire Jack Horner had not proved as unhappy as he had predicted. But for the sophisticated spiritual Frances there were disadvantages to being the squire's wife, isolated for most of the year in the little village of Mells in Somerset, a community so old-fashioned and hierarchical that the villagers even had to consult the squire on the naming of their children. Frances found the clannish Horner family oppressive: 'I felt a daughter of Heth among them,' she recollected. Though Mells Park was a pleasant, comfortable Georgian house with a lake and spectacular views over the Mendips, Frances's natural habitat was London. She confided in Burne-Jones, 'I hate the country – I always thought I did, but now I am quite sure of it – It is cold and you can't stay out, and when you are indoors you might as well be dead.'

Frances had suffered from depression after the birth of Mark, her second son, in July 1891. The following year Burne-Jones had evidently made moves to put their friendship onto a new footing, writing more frequent and more impassioned letters. In May 1892 there was a scene out in the country when Burne-Jones first made advances in the somewhat unlikely environs of a haystack. There is a reference in his correspondence to 'what I told you by the hayrick at Milford'. In June he poured out his feelings: 'it is hard to write unless I may say all the wild loving words that come first to my heart . . . and I am living in a dream – is it a month ago? how unpremeditated it all was – I glided into this heavenly land as perhaps we glide into a new life after this – without shock or surprise or bewilderment – only content.'

The wild loving words continue through that summer. He tells her only she has the key that can unlock his inner world. The language is intimate and insinuating: 'you won't lose the key will you? – I know the pocket where you put keys now and I want to

lie there for ever.' He asks her if she knew beforehand what 'a seething pot or cauldron' she had been stirring up. He reverts to the loved books of her Graham childhood in describing his enchantment: 'it's like a fairy tale'. In 1892 these ecstasies poured out of him. '*All* the romance and beauty of my life means you, and my days are ending in splendour through you,' he wrote with lavish passion. He told her she made up for the debacle of his affair with Maria Zambaco, a sweetly late in life compensation for his years of indignity and pain.

But even with Frances there were problems and frustrations. The Horners were not wealthy and until Jack Horner was appointed official Commissioner of Woods and Forests in 1895 they had no house in London. On Frances's intermittent visits to rented accommodation or to friends she was busy and preoccupied, back at the sociable convivial centre of 'the Souls'. Burne-Jones became frustrated by her unavailability, complaining to May Gaskell that even when Frances was in London in summer 1892 he had seen her very little: 'fifty people ate her up . . . She looked bright and well, and is always kind, but I always feel she sails along in the blue very far out of reach – and I potter along.'

By late summer his letters were sounding rather desperate. On 16 September he wrote: 'I love you till I wonder I'm not more tiresome than I am . . . I will try never to be bad again – I will – I will . . . if our hands have to loosen our souls never shall.' The next day another missive: 'in the world that need never be over-come I shall be at your side, or nestling between your feet – so move them gently or don't move them at all'. On 18 September he describes himself as 'tingling, trembling all day long', thinking about Frances with 'some funny mingling of awe and worship and wantonness'.

There are dozens and dozens of Burne-Jones's letters to Frances. He instructed her to burn them but she did not. Only a few of hers survive. But it is not difficult to conjecture that she had got alarmed at this outpouring of emotion. Frances certainly adored Burne-Jones but it seems that she preferred him as her mentor and dis-tant admirer rather than her lover. However, instructing him

firmly that he was to love not just her but her whole family, in October 1892 she asked him down to Mells.

It was his first visit. He had always put off going to see Frances in her domestic setting, telling himself that if he stayed away from Mells he could keep up the illusion that she was not married and that she had no children. But now, at last persuaded, he set off for Somerset by train, breaking the journey at Clouds, the Wyndhams' house in Wiltshire recently rebuilt and restored after the fire. He wrote to Frances en route, a blow-by-blow account of his anxiety and nervousness:

I'm travelling to Clouds and in a minute comes the Guildford tunnel . . . It is so strange – and I vowed so long and loud I would never go to you . . . I shall be dumb I know – I shall never know what to say to you. Will you lead me about by the hand? . . . may I sleep on the mat outside your door?

Passing Wilton House on his right, near Salisbury, he imbued it with a personal and sacred meaning as a house where Frances sometimes stayed.

He left the train at Tisbury, dined with the Wyndhams, went upstairs to bed, 'hugged and devoured' the letter Frances had sent ahead to greet him there and wrote to her again:

the moon is beautiful bright – its almost more beautiful than can be borne, and it made me heartbreaky to think of you, and my love sundered from you as it is and fleeting fast to the great sea – yet if I saw you daily I couldn't worship or love more.

He added: 'Georgie didn't come – she hates staying in houses – so do I.'

For Burne-Jones the journey was a pilgrimage of love, a true-life version of the quest themes of his paintings and his tapestries. Arriving at Mells, he was reunited with many deeply meaningful objects from the past. Paintings he remembered well from William Graham's collection. The *Orpheus and Eurydice* piano commissioned from Burne-Jones for Frances's birthday by her father. Embroidered panels stitched by Frances as he had instructed. His own stained-glass designs. The little *Rubáiyát of*

Omar Khayyám written out and illuminated by William Morris with Burne-Jones's miniature paintings, a manuscript inscribed lovingly to Frances. And a more recent addition, a gilded box with what Burne-Jones described as 'shield things on it'. He had designed it, Weekes had modelled it in stucco, Vaccani had gilded it and then, Burne-Jones told Frances, he had painted it himself: 'It is a source of infantile delight to me that you like to have things of my hand in your house.'

There were no untoward episodes while Burne-Jones was at Mells. Frances's sister Agnes Jekyll was also staying. It seems he was successfully fended off. Once he left, he wrote calmly and conventionally to thank his hostess, telling her 'it is so nice now to know where you live and all the ways of the day'. But ten days later his frustrations erupted: 'I shall make up for all that evil week . . . to have had you altogether, my dear, would have been such heaven that I suppose no man has ever been let to have such happiness.' Then on 5 November: 'how shall we ever get comfortable again?'

It was clear he had expected too much from Frances when she had apparently come back to him in May. He had read too much into their tender hayrick scene, underestimated her family ties, her sense of social position and duty to her husband, her unwillingness to expose herself to scandal, perhaps her simple inability to respond to the physical advances of an ageing man. He blamed her friends, her entourage of up-and-coming liberal politicians such as H. H. Asquith and R. B. Haldane: 'you are in the thick and swim of a world I can't like or rest in for an hour', he told her, 'a world of restless pleasure and unreal brilliancy and it fits you and you like it and would be dull without it and the thought of it chills me and makes me angry and stony'. He was bitterly disappointed in her apparent lack of interest in his work. He had put out some pages of his new designs for William Morris's Kelmscott Press edition of *The Golden Legend* and she had hardly given them a glance.

'O my dear my dear what a thing you have frivoled away that can never be got back.' He could see now that ideas of a more intimately physical relationship with Frances were over. He told

her, 'I am sick with longing always and hopeless desires that have never known and can never know fruition.' He signed his name just as he always had to her – 'Angelico'.

It was a readjustment rather than a rift. They were not just friends but had for long been co-practitioners. An unbreakable bond lay not just in old affections but in the objects they had made together, Burne-Jones as the artist, Frances as his interpreter, embroidering and stitching, bringing his designs into tangible reality. In the church at Mells is a wonderful embroidery, the tall figure of an angel sheltering a group of children beneath great flaming wings. The Pevsner guide to Somerset describes it, correctly, as 'Large piece with angels, very much in the Pre-Raphaelite taste and made by the Lady of the Manor, Mrs. Horner, who was a friend of Burne-Jones.'

In his world of the floating emotions Burne-Jones had found a new love, Helen Mary Gaskell, known to her friends as May. It seems they had met briefly at a London dinner party in the spring of 1892. Not long after, May visited Burne-Jones at the Grange, brought by Frances Horner her friend and near-contemporary. At the time of this visit, which included the statutory stroll down the garden to the Garden Studio, May was thirty-nine, Burne-Jones was fifty-eight. She was beautiful in a piquant girlish manner. She was also, a further recommendation, a lady in distress, unhappily married to Captain Henry Brooks Gaskell of the 9th Queen's Royal Lancers, an ex-army officer who neglected her and bullied her. Burne-Jones told May later he had loved her straight away:

I keep thinking of that first sight of you . . . I still see those divine little figures moving in a land no man ever saw, in a light none can dream of – better than Italy sun ever did.

It was his very painterly vision of love.

May had three children. At the time he fell in love with their mother, Amy was seventeen, Hal thirteen, Daphne five. May also had three substantial houses: Kiddington Hall in Oxfordshire; Beaumont Hall, a farming estate in Lancashire; and a town house,

3 Marble Arch. She had a busy social life in London, giving elegant dinner parties where the guests might be Jack and Frances Horner, Percy and Madeline Wyndham and the Elchos, Arthur Balfour, Herbert Asquith. Like Frances she was in the inner circles of 'the Souls' and the Liberal elite. After dinner May, who was very musical, would sing or play her Steinway in the drawing room. Burne-Jones looked on adoringly: 'I watched you from the sofa and you looked like all the Queens of the world.'

He had easily detected that his Lady at the Marble Arch, as he liked to call her, had an inner core of loneliness. Early on in their relationship May had been invited to the Grange on a Sunday afternoon. Georgie, Phil and Burne-Jones were gathered to receive her. Burne-Jones had been conscious of her sense of isolation: 'I don't think you liked your visit', he told her later, 'so many of one family, and you quite alone – and I couldn't bear you to go out alone in the cold and darkness and wanted to see you safe then – always fidgeting to see you safe'. Because May had made a comment on his untidy studio he brought in his charwoman, the vastly energetic Mrs Wilkinson, to bottom it, the process that he normally delayed as long as possible, afraid that she might even start on washing down his paintings. But for May he was prepared to put up with Mrs Wilkinson for days.

She brought out his deepest feelings of protectiveness, the feelings the more self-reliant Georgie had resisted through their long and gently sparring married life. May had been damaged by her own unhappy marriage, terrorised into numbness. There are hints in the letters of physical abuse. She was nervy, unconfident and very often ill, so dependent on medication that Burne-Jones was sometimes fearful for her, reminded of Rossetti's addiction to chloral. He seized upon his role as this vulnerable woman's champion, her protector. He wrote to her in high chivalric mode:

I have thought of you always as a girl in fields . . . in a white frock, in a green field, where you once told me in one of your letters the garden of your life had been trampled on, and its flowers crushed. I knew it, and vowed I would build such a wall around the garden that no trampling should ever be again.

The imagery is that of medieval romance. The beautiful vision of the protective wall built around the garden is a picture from an illuminated manuscript, one of the treasures Burne-Jones and William Morris had pored over together since their youth. But this, after all, was not the fourteenth century but late Victorian London. May was a married woman. Burne-Jones began to worry about compromising her: 'Tomorrow about 5 I will go to you – but the footman will think I come very often,' he wrote during that first winter of 1892.

It was agreed between them that their intimacy was to be 'a profound secret'. No one was to hear 'the faintest whisper of this friendship', Burne-Jones assured her. It was to be a friendship that would help her and sustain her and make her 'want to live'. He promised, 'I'll write gently and softly to you every day and afterwards in my heart you shall find refuge from all bitterness and grief.' The discreet letters he had promised her poured out of him in a kind of frenzy of communication, often as many as five a day delivered by the then very frequent postal service. Two years after the correspondence started, Burne-Jones reckoned he had sent her seven hundred letters. He told her to burn them, as he had instructed Frances Horner and others. Fortunately for posterity, few of the recipients of Burne-Jones's uniquely wild and witty, erudite, fantastical love letters did as they were told.

One day he wrote to May: 'I wish I could post myself – how scared you would be if I was handed in on a tray with your other letters – I'm flat enough and stamped on enough I'm sure for post – and a penny is my full value.' Often his love letters are illustrated letters, elaborated with the weird and semi-macabre humour he was unable to resist.

He was a creature less of sexual treachery than of peculiar emotional elasticity. His devotion to May had been developing concurrently with his rather frantic overtures to Frances in the summer of 1892 and his finally disappointing journey to Mells. In all his new-found devotion to May his fear of hurting Frances was ever present. Though the relationship with May was supposed to be a secret, Frances, so close to May herself, soon became aware of

it. Burne-Jones could be careless. There were acrimonious scenes like the one referred to in a late October letter: 'as Frances won't be there (I suppose) I should commit no indiscretions of speech as I did the other night – but should speak guardedly as becomes my years – she lays pitfalls for me, and I fall into them invariably'. He managed to persuade himself – and May – that Frances had no right to complain of his disloyalty: 'she has no right in the matter at all – nor do I so much matter to her as that . . . if I was necessary to her she had a splendid chance, only her own hands destroyed that chance'. At the same time he wanted Frances to comprehend that his love for May was no flibbertigibbet temporary passion but something true and tender and deeply serious.

No more than with Frances was this a fully physical relationship. There are signs of physical longing in his letters, half-comic threats, for instance, that he would like to eat her up. After one of May's visits to the Grange he writes apologising for his uncontrolled behaviour: 'I gave you a heavy time this afternoon sweet lady . . . you looked pained and troubled at me – did my hands hurt you? Or were you sorry for me?' But it seems unlikely that he and May were lovers in the modern understanding of the word.

He describes his feelings for her in more abstract terms as the ultimate spiritual experience, thanking God for giving him 'this delicious, holy sweet friendship to take away the bitterness and disappointment of the past'. Burne-Jones's final decade would be a calmer time of artistic reassessment, a reduction to essentials. Some of this new mood, in which his work arrived at a final plateau of achievement, can be attributed to his love for May.

Though May was so musical she seems to have been relatively ignorant of visual things. Art was not embedded in her background, as it was in Frances Horner's. Part of Burne-Jones's project to improve her life, to make her 'life days prettier' for her, lay in teaching her, indoctrinating her, taking her to see the things he loved himself. Together they planned expeditions. To Hampton Court, for instance, to look at the Mantegnas. To the British Museum for the manuscripts. To Richmond Park: 'off we'll go galloping in clouds of dust or splashing through puddles of mud',

he wrote excitedly – 'and we'll ramble there and talk and dine at a window and tell tales'. Later, writing to her friend Lord Milner, May remembered 'one very delicious day in London' which she spent 'buying a new dress (very pretty) and wandering from one lovely thing to another with BJ in South Kensington. It is one of the most instructive and heavenly things I know to go round with a man who sees Beauty – clearly and simply Beauty.'

Though Burne-Jones rarely visited the Morris family at Kelmscott House in Hammersmith, finding the house gloomy and a little ghostly, complaining of its *Wuthering Heights* feel, he took May and her daughter to tea there, to meet Morris. May seems to have found William Morris disconcerting. He had always been unkempt and now, in his Kelmscott Press phase, having come straight from the press room, he appeared distinctly dirty. Burne-Jones did his best to mediate:

You said he wasn't clean – he really is underneath – but always pencils and ink and the day's messes in work stick to him, and like to get on him, and if ever anything has to be spilled to make up the necessary average of spilling, it spills on him. But he boils himself in tubs daily, and is very clean really – but he needs more explaining than anyone who ever lived except Swift – who was dirty inside – the nasty thing – and this one is cleaner inside than is at all necessary.

Desperate for his new love to appreciate Morris, he tells her how greatly the visit had pleased him: 'He liked the ladies who called on him the other afternoon very much – that is tremendous – that is a conquest – he was pleased you noticed his teacup and said he liked you to laugh at it.' William Morris's teacup was preposterously large.

Burne-Jones's influence on May would soon be evident in the way his art began to infiltrate the house at Marble Arch. Contemporary photographs show a photogravure version of one of the *Briar Rose* paintings in her bedroom, hung above her bed, while above the dressing table is a reproduction of Watts's portrait of Burne-Jones, lit by candles like a little shrine. May's and Amy's bedrooms had William Morris wallpaper. A Morris embroidered screen stood in the drawing room. Burne-Jones encouraged May in her own

embroidery. After visits with him to the South Kensington Museum she was later to embark on her own version of a sixteenth-century German embroidered quilt. May remembered: 'He used to go to the museum with me in the evenings, and draw the designs for me whilst I copied the very intricate stitches to work.' As with Frances Horner, the designing and the stitching was a tangible expression of their love.

Burne-Jones's life became gradually more entwined with that of the Gaskell family. In the early summer of 1893 he began to paint what is now a famous portrait of May's daughter Amy, an enigmatic picture of the beautiful but moody late teenager who died young, in 1910, a suspected suicide. Burne-Jones had instructed she should sit for her portrait wearing a black dress. May's son Hal, while still a boy at Eton, was aiming to become a professional artist. Burne-Jones encouraged him with lessons and advice. In his holidays Hal was often at the studio and he later, briefly, studied with Thomas Rooke in Paris. May's little daughter Daphne was enrolled delightedly as the latest Burne-Jones 'pet'. He was soon writing her a sequence of comic illustrated letters, as ebullient as those he had sent to Katie Lewis: 'darlink dafny, I foregot to say I do want a cat but I think I want a fat hevy tabby chap like Tommus'. Thomas was the cat belonging to the Gaskells. 'I want a hevy fellow with a face like a poik py.'

Burne-Jones made close friends with May's father Canon Melville. In the spring of 1893 May took him on a visit to the house near the cathedral in College Green in Worcester. He was roused to a high pitch of emotion by the sight of the little drawing room 'full of ancient souvenirs' of her early life, even the piano she had played on as a girl. 'I loved to see you,' he told May later, 'with that dear father ministering to him and lightening everything with your sweet brilliant passings to and fro – the glidings in and out of doors that I love to watch.' He had not been able to restrain himself from embracing her there in the place with which May seemed 'in real harmony'. The gentle intellectual Cathedral Close setting brought out May's true nature in a way in which the house at Marble Arch did not.

As Burne-Jones became immersed in May's family circle there was even a bizarre encounter with her husband. Captain Gaskell took him to dine at the staunchly male Welcome Club in London where Burne-Jones describes them drinking deep 'as men drank in the last century – no nonsense about it but deep goblets of foaming wine'. The conversation centred on May's welfare and happiness. Burne-Jones extracted the promise from her husband that he would never 'be cross' with May again. As the conversation ended, 'we both smiled and lighted fresh cigars, or rather he lighted a fresh one from my burning one – so that the compact seemed to be sealed with a kind of hellish and infernal kiss of fire'. In spite of these valiant attempts at marriage guidance there is no evidence that May's married life improved.

For long stretches of the summer May was with the children at Beaumont Hall, the Gaskells' large Jacobean house near Lancaster. Burne-Jones felt her absence keenly and when she suggested he should come and stay at Beaumont in August 1893 he accepted eagerly: 'It is change I want, yes and need – not change of air only – but at Beaumont it will be change – such sweet change for me.' He was still anxious about Frances's reactions, less than a year after his fraught visit to Mells, and he consulted May about the wisest tactics: 'hadn't I better say I'm going to you – there must be a scene someday – I don't like to hurt – can't bear to hurt, but go to you I must – I think about it every moment – and I see all the rooms – and I talk to you all day long'.

Georgie's responses to this sudden flight northwards worried him as well. As May began to make firm arrangements for his journey, instructing him to catch the 10.30 train from Euston, and he thought harder about the implications, his anxieties increased. 'It will cost a great deal that journey,' he told her, 'it will cost the coming away and I dread it – the journey back, the emptiness, the days hard to be lived through . . . I'm half frightened of the visit – of what it will be to come back and the dark dark days, and at times the sharp craving and the hunger insupportable.'

Burne-Jones's departure for Beaumont was forestalled by the sudden devastating news of the destruction of his painting *Love*

among the Ruins. He was down at Rottingdean, Georgie was away and Luke Ionides was staying. He and Luke were having their usual convivial time, gossiping and smoking in the Merry Mermaid, when Phil arrived with details of the disastrous accident. While it was in Goupil's studio in Paris, awaiting photogravure reproduction, the watercolour painting had been washed over with white of egg. This in spite of a printed warning on the back of the canvas that the surface would be damaged by the slightest moisture. An ignorant photographer, assuming that the painting was an oil, had treated the surface in order to enhance the colour, make it shinier. Luke Ionides remembered that when he heard the news 'the sorrow B. J. felt was difficult to bear'.

Love among the Ruins was a painting he had finished back in 1872, after which it was shown at the Dudley Gallery. It had been bought by Frederick Craven, a Burne-Jones collector from Manchester, and had since then been exhibited widely in England and in France. At the time of its destruction the painting was in Paris for an exhibition of the Société Nationale des Beaux-Arts. To Burne-Jones himself it had a special resonance, the head of the female figure being almost certainly modelled from Maria Zambaco and the composition as a whole being partly celebration and partly lamentation on their ultimately doomed affair.

He returned with Phil to London straight away to view the damage, dismayed to find that just as he had feared 'the whole thing' had gone, so it seemed, beyond repair. He wrote urgently to May putting off his visit: 'Saturday night I have come home and seen the ruin – Love in the Ruins with a vengeance – all gone – as if the devil had hated it and had had his way.' He asked her to be 'soft and nice' to him, assuming her understanding of just how much the painting had meant to him: 'it was mine – very me of me and I must be sorry for a bit'. Frances, who had known him so much longer and understood Burne-Jones's vicissitudes of character, wrote offering her sympathy: 'if only it hadn't been that one . . . if only I could put my arms round you and comfort you'.

The owner of the painting, Frederick Craven, served a writ on the Goupil Gallery, claiming £5,000 in damages. Though the

painting was insured for £2,500, the insurance company had refused to accept liability on grounds that the photographer's tampering with the surface of the painting had not been an 'accident' in the accepted meaning of the term. Goupil's lawyers sent a cautionary letter around the English press, instructing them not to allude to the incident pending the court case. For fear of libel action an account of the disaster written by M. H. Spielmann, editor of *The Magazine of Art*, had to be withdrawn.

Burne-Jones himself issued widespread warnings to his friends and fellow artists of the dangers of entrusting their paintings to foreign studios: 'I was absolutely ignorant of the fact that photographers abroad tamper with the surface of the works committed to them.' His anger at the damage done to *Love among the Ruins* led him into an attack on photographic reproduction in general, a cavalier method that now threatened to supplant the more careful and sensitive techniques of engraving: 'these photographic processes – at the best poor mechanical affairs – have drawn out of the world a skilful and beautiful art'.

Burne-Jones was always more resilient than he appeared. Within twenty-four hours of examining the damage he had measured up the ruined canvas and ordered another of exactly the same size. His original painting was put back to front on an easel in his studio, where it remained for the next few years while Burne-Jones started on a new *Love among the Ruins*, this time a version in oils, using his old notes and studies. He was conscious of the fact that he could never make it quite the same: 'here and there', he wrote, 'it might be a little more skilful – at the cost perhaps of some simplicity that pleased people' in the original version. Not only was he now more assured as an artist, he was in some ways quite another person since those desperate days of the Zambaco affair.

Burne-Jones eventually got to Beaumont, later than intended. Phil, who had been his great support throughout the episode, had encouraged him to go, knowing that May would be his greatest comfort. The disaster had left him feeling very shaky. All his life he had been prone to what he called 'a kind of nervous rheumatism' after any sudden shock, bringing on a destabilising aching of

the legs that could last for many days. He warned May he might arrive walking 'stiffly and absurdly'. Not surprisingly, the visit was not a great success. As he later recollected, 'there was an unhappy walk in a narrow green lane and I leaned over a gate and was very unhappy – a year had been cut away from my life – and my picture had been destroyed'. There was also an especially bad moment in the schoolroom, so distressing that he had felt unable to stay another night. May had soothed him and tried to dissuade him from going as she sat sweetly beside him on a garden seat. But here on her home ground he had begun to see the limitations to his love for a middle-aged and married woman, just as the realities of his relationship with Frances had dawned on him the year before while he was at Mells.

He was back at Rottingdean for his sixtieth birthday on 28 August. How was he received by Georgie? She was still set on the course of heroic resignation on which she had decided all those years before. The following year, when Burne-Jones made another visit to May Gaskell at Beaumont, on the way to stay with the Gladstones at Hawarden, Georgie came as well.

The onrush of love for May had caused Burne-Jones to refocus, to take the long view of his life: 'there tonight I lie,' he told her in the course of a sleepless night, 'and think over my strange history – the sorrows – the drifting – the chagrins – the deep waters'. The maudlin quality that was always in his nature increased as he grew older. In the early 1890s his always poor health began deteriorating further. Julia Cartwright, arriving at the Grange to interview the artist, found him wearing 'a dark sort of wrap with a hood and girdle, very like a carmelite dress. "Don't think I am a shaven monk", he said, "only it was the warmest thing I had at hand".' He had been suffering from a succession of colds.

In 1891 the general flu epidemic had struck him particularly badly. Georgie caught it too and they had to have two resident nurses, a day nurse and a night nurse. Burne-Jones hated this dependency: 'it's so ludicrous and ignominious – to be washed like a baby is so silly and have one's hair brushed'. Georgie felt that he

never totally recovered. The illness left him in a worse state of depression than he had ever known.

Only weeks later he had a painful accident, falling in the street as he crossed a slippery wooden pavement plank and displacing the arm bone from its socket at the shoulder. As Georgie told George Howard anxiously, 'the muscle has disappeared entirely for the present – there is no more than in a baby's arm – and he has to take regular exercise for it to try to restore his strength'. Even more alarming, his eyesight was now failing. He was later to describe to Thomas Rooke the gruesome operation carried out in 1892 by three doctors in his bedroom in the Grange. He had been carried upstairs and glimpsed by accident through a crack in the door 'a thick wire being made red hot in a little furnace, that looked so much like a medieval torture business'. The doctors tied his legs, pinioned his hands and covered his face to apply the chloroform, 'and then they began pumping away and nothing happened but the feeling of being suffocated and being burst open'. He felt certain they were killing him and he started struggling until he finally lost consciousness. The next thing he remembered was Phil's face beside him, 'looking as large as the room'. On being told the operation might have to be repeated he decided he would opt for hospital next time.

In 1893 he succumbed to a bad attack of flu again. Friends seeing him at this period were anxiously aware of the change in him. He was even thinner than before and it seems that his memory had been affected. He was suffering from problems with his teeth, the cold sea winds of Rottingdean tending to bring on a fierce attack of toothache. He was treated by a rigorous American dentist with a London practice who sat him in his 'best easy chair' and turned his lamps upon the defenceless lanky man stretched out before him, his mouth kept forcibly wide open through appointments each lasting for an hour and a half. Burne-Jones's descriptions of these physical indignities have the same edgy humour as his self-caricatures.

He told Joe Comyns Carr the story of a visit to his doctor, who asked him how many cigars he smoked a day. 'Oh, I think about

six,' he told the doctor, who advised him to limit himself to only three. Burne-Jones then confided with a chuckle: 'You know, my dear Carr, I never did smoke more than three.'

The roll call of deaths amongst his friends and acquaintances in the early 1890s unsettled him. In November 1890 the shifty Charles Augustus Howell died, eliciting the comment from Ellen Terry 'Howell is *really* dead *this* time!' Georgie's ne'er-do-well brother Harry died in New York in June 1891. Having been trapped for years in a series of uncongenial jobs in stockbrokers' offices, he had suddenly died of cancer of the throat just as his brother Fred and nephew Rudyard Kipling were crossing the Atlantic on their way to visit him. 'Poor Harry Mac is dead,' Burne-Jones informed Crom Price who had known them both so long.

The following October he was much more deeply affected by the death of Charles Parnell, the Irish patriot whose campaign for Home Rule he had supported and whose political victimisation, as he saw it, he deplored. Parnell was a romantic hero to him whose death he described in apocalyptic terms:

Today about noon came as it seemed the world's end. Sudden black, and out of the blackness a flash like the opening of Hell's mouth and after the flash a roar like Domesday, and after the roar a lull, and then a wind before which all things bent and broke, and the garden is full of shattered branches, and a big poplar lies across the garden wall. All these signs are because Parnell is gone.

In January 1892 Burne-Jones's early patron Frederick Leyland died from a heart attack as he was travelling on the London Underground between Mansion House and Blackfriars. He had remained a faithful client and they had been discussing Leighton's long-running commission for Burne-Jones's painting *The Sirens*, his vision of women luring men to their destruction, only weeks before. Burne-Jones's final commission was to design a tomb for Leyland, a Romanesque shrine in white Carrara marble with sloping copper roof and bronze decoration of floating fronds and flower heads entwining in a *mouvementé* and extravagant memorial to one of the most energetic Victorian connoisseurs. Leyland's tomb,

which still stands out in the sepulchral splendours of Brompton Cemetery, is one of Burne-Jones's most extraordinary works, the ultimate example of how far he pushed the boundaries of art, craft and design.

In this time of many funerals Burne-Jones attended Tennyson's on 12 October 1892. He had last seen the Poet Laureate the previous August when he had been invited to lunch with the Tennysons at Aldworth in Surrey, taking Margaret with him. Tennyson had invited Margaret to return another day with her own two children, Angela who had been born in 1890 and baby Denis born in 1892, so that he could give them his blessing. But this was not to be. The funeral was held at Westminster Abbey, where Tennyson's allotted grave was next to Browning's and in front of the monument to Chaucer. Burne-Jones liked an element of drama in a funeral and in this respect Tennyson's, like Browning's, disappointed him profoundly: 'there should have been street music, some soldiers and some trumpets, and bells muffled all over London, and rumbling drums. I did hate it so heartily, but as he sleeps by Chaucer I dare say they woke and had nice talks in the night.'

Burne-Jones was not at the funeral of Madox Brown in 1893, although Georgie attended. Old Brown had died from podagra, a form of gout. Burne-Jones felt guilty at his absence, conscious that for three or four years, after he had first arrived in London, Brown had been an important figure in his life, supporting him and Georgie materially, encouraging him artistically. But then the difficulties between them had arisen. 'He knew no middle way between loving and hating,' Burne-Jones wrote on the day that Brown was buried, 'and I ought to understand that – a turbulent head, impetuous, unjust – always interesting; but it was more fun for those he liked than those he hated – and today they put him out of sight.'

But in spite of all his illness, the knowledge that he was ageing, the fast-rising death toll amongst his contemporaries, Burne-Jones still kept the openness to new ideas and friendships more usual in a younger man. He had first met the young Polish concert pianist Ignace Jan Paderewski in 1890, the year of his enormously successful London debut. There had been one of those chance encounters

in the street that occur so often in Pre-Raphaelite histories. It turned into legend, appearing in two versions. The first, recounted in Paderewski's *Memoirs*, was that the musician had been seated in a hansom cab on his way to St John's Wood when an elderly gentleman exuding an unusual aura of nobility and power walked slowly towards him. Paderewski, impressed by this venerable figure, had hailed him from the cab.

Burne-Jones's own account, more likely because more contemporary, was that both were walking down the street when they encountered one another. Paderewski's appearance was so striking that once Burne-Jones had passed him he turned round to walk past him again. When he got back to the Grange he announced that he had seen an archangel, a golden-haired Archangel Gabriel striding the streets of London, and he made a sketch from memory at once.

Just a few days later, by a strange coincidence, Paderewski, who was being lionised in London, was brought round to Burne-Jones's studio by his fellow musician George Henschel. The archangel was immediately recognised, identified. Burne-Jones found his appearance astonishingly moving. The intense pale face, the shock of hair: 'He looks so like Swinburne looked at twenty, that I could cry over past things.' With Paderewski actually in the house he was able to complete the portrait from life. The pianist remembered the intense concentration, almost the ferocity, with which Burne-Jones had worked. This became Paderewski's publicity portrait. Burne-Jones's drawing was photographed by Hollyer and copies were made which Paderewski would sign and give out to his fans.

The artist and the pianist became great friends. Burne-Jones attended all Paderewski's concerts when he was in London. In June 1893 Burne-Jones wrote of a visit to the Grange: 'Paderewski on Thursday, and a delightful and most happy two hours I had with him, and I love him.' What he loved especially was the Pole's old-style Romantic courtesy, his beautiful low bows and 'a hand that clings in shaking hands and doesn't want to go'. He made use of Paderewski's sensitive nobility of features as the basis for several of the Knights of the Round Table in the *Morte d'Arthur* tapestries.

Burne-Jones's archangel was later to become Prime Minister of Poland when the newly independent nation was established in 1919.

A retrospective exhibition of Burne-Jones's work was held at the New Gallery in 1893, opening in January and running for three and a half months. Two hundred and thirty-five works were shown. Burne-Jones had dreaded this event, feeling that a retrospective should not be held until an artist was dead. 'It will be like looking in a magic mirror, and seeing myself at 25 and 30, and 35 and 40, and 45 and 50, and so on to the hundred and tenth year I have now, and I don't like it a bit.' He had gone in briefly while the pictures were being hung but could not bring himself to visit the exhibition later, so fearful was he of being faced with the paintings he now regarded as old ghosts.

But Burne-Jones changed his attitude when the exhibition was well received. The Prince of Wales agreed to attend a special evening reception, as did Cardinal Vaughan, who arrived wearing his pontifical crimson. This was his first appearance in public since the Pope appointed him to the Cardinalate. Burne-Jones was especially pleased by the reaction to his paintings of his former friend George Du Maurier. There had been a coolness between them since Du Maurier's all too perspicacious series of Aesthetic Movement cartoons in *Punch*. Du Maurier now wrote to Burne-Jones to tell him that the exhibition gave him 'a peculiar sensation of pleasure – *très doux et un peu triste* – like opening an old diary'. He remembered so well where and when he had first seen these particular paintings and how they had originally struck him: 'I can't tell you with what pleasure I saw Merlin and Nimue, the Merciful Knight, Circe and her black panther, and others that I had so loved in the happy days of youth.'

Many of the star exhibits first seen at the Grosvenor Gallery were reassembled for the retrospective: *Laus Veneris, Le Chant d'Amour, The Wheel of Fortune, King Cophetua*. Viewed from this new perspective, Burne-Jones's work seemed the more impressive, cementing his reputation and winning him new converts. G. F. Watts wrote to tell him: 'I know from the opinion of some

individuals not all formerly great admirers! that you and Holman
Hunt are the men the future will delight to honour, I ought not to
leave out Rossetti.' Watts could not resist adding, 'Millais is of
course a painter but that is not enough.' One result of the exhi-
bition was to arouse interest in Burne-Jones amongst a younger
generation of British painters, encouraging what was to be a new
movement in twentieth-century Romantic and figurative art.

His retrospective left Burne-Jones in a ruminative mood, think-
ing to himself about the lifespan of an artist, which in his own

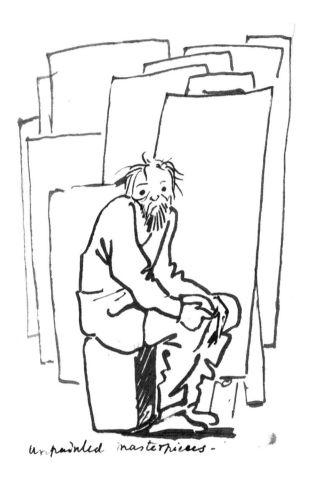

Unpainted Masterpieces self-caricature.

case he had come to see as an initial youthful phase of experimentation and mistakes followed by a middle period of nervous self-awareness, 'scarcely daring to put the right foot in front of the other, for self-conscious shame'. It was only in an artist's final decades, approaching old age, that he achieved the confidence to know what he was doing 'and what must be left undone'.

Burne-Jones's acute self-analysis ties in with more modern psychologists' perception of a creative artist's tendency to enter a 'third age' of productivity, a stage of late maturity in which extraneous elements give way to a new coherence and clarity of vision. This can certainly be sensed in the colossal strangeness of Burne-Jones's later works, and in the 1890s, in spite of his ill health, he felt a whole new surge of visionary energy. On his better days he felt the Himalayas were before him. But he knew that time was passing and was ever anxious about how much more he could achieve before the 'trumpet call'.

Kelmscott, One
1894–5

At New Year 1894 Burne-Jones was made a baronet, an event that Margaret's friend Venetia Benson recorded in her diary as 'most "beciting" news'. The offer had been made in a formal letter from Gladstone, writing from Biarritz with 'the sanction of Her Majesty'. The honour was to be a mark of recognition of 'the high position' that Burne-Jones had achieved in his 'noble art'. 'Perhaps I give more pleasure to myself in writing this letter, than I shall give to you on your receiving it,' Gladstone had added. He was right in his perception that Burne-Jones, once the 'bitter Republican', could only have mixed feelings about being elevated to the baronetcy. 'I scarcely dare tell Georgie, so profound is her scorn', he confided to May Gaskell, 'and I half like it and half don't care 2d.' Georgie indeed felt uneasy at her husband's acquisition of a title and refused to let the servants at the Grange address her as 'your Ladyship'.

Why did Burne-Jones accept an honour that put him into such an embarrassing position with so many of his nearest and dearest, William Morris in particular? As Jane Morris expressed it, 'The baronetcy is considered a joke by most people, we had not heard of it before seeing the announcement in the papers – my husband refused to believe it at first.' Burne-Jones may have been at least partially won over by Gladstone's argument that this was not so much a personal honour as a public honour for art in general, 'a great profession which has not always received in this respect

anything approaching to liberal treatment'. His personal fondness for the Gladstone family no doubt influenced him too. But his main consideration was the thought of the succession and the pressure that was put upon him to accept by Phil.

For Phil, the unsuccessful son with the highest of social aspirations, drifting from house party to house party, the heirdom to a baronetcy was an obvious boon, giving him a fixed position in society. Burne-Jones saw this all too clearly: 'I do love Phil', he wrote to May, 'I ought to please him – I am responsible for his life – and it is the first time I have been called upon to do a thing I dislike for his sake.' When it seemed possible that Burne-Jones's republican scruples would cause him to refuse, Phil was 'seen to be pining on his stalk'. Once his father told him he was going to accept, he came up to the desk where Burne-Jones was writing yet another letter to May Gaskell, put his arms around him from behind and said, 'I know you have done this for my sake.' When Burne-Jones attempted to deny that this was so, Phil gave him 'a cuddle round the neck and cried a bit'. Even Georgie's resistance had weakened. She decided to put no difficulties in the way of 'anything that Phil would prize'.

Once Burne-Jones's baronetcy became a fait accompli William Morris also came partially around: 'Well, a man can be an ass for the sake of his children.' He was conscious of his own dogged devotion to his daughter Jenny who had suffered from epilepsy since her mid-teens. Janey Morris spread the rumour that Sir George Lewis had 'started the idea – in case his daughter wanted to marry Phil, so that he might be their *equal in rank*. It is all too funny, and makes one roar with laughing – I have got over the sadness of it now.' If this was indeed true then Sir George was to be thwarted, since his daughter Katie was still unmarried when she died in 1961.

With the baronetcy came the granting of heraldic arms and an accompanying motto. Burne-Jones chose Wings and Stars for his arms and the motto *Sequar et attingam* – 'I will follow and attain'. At the same time he applied for the royal licence to change his surname from Jones to Burne-Jones, making official the usage that

had in fact been current for the last two decades. He was now Sir Edward Coley Burne Burne-Jones. As the letters of congratulation poured in, Burne-Jones felt understandably diffident about his new persona. He replied to George Du Maurier: 'Oh let me be E. B. J. to you always – these changes are nothing, are no changes at all: E. B. J. I shall be to the end I hope, to you and all who like me. Meantime a far more important matter is this: are you going to kill Trilby, or be kind to her?' Du Maurier's enormously popular story of Paris studio life was at the time being serialised in *Harper's* and Burne-Jones was following it avidly. All his sympathies were with the artist's model Trilby who had fallen into the evil clutches of Svengali. He entreated Du Maurier, 'I cannot have her killed.'

Burne-Jones was aware of a lessening of energy. In order to keep working, his gadabout London life, as Georgie called it tartly, had to be reduced to no more than two or three evenings a week. William Morris too was now showing signs of tiring: 'Sad', said Ned, 'to see even *his* enormous vitality diminishing.' With his excess of nervous energy and tendency to gout, Morris had never been as robust as he appeared and the years of Socialist struggle had taken their toll. He was no longer at the centre of the movement. After acrimonious arguments on policy and the infiltration of his party by an extremist anarchist faction, Morris had been edged out of the Socialist League and had formed his own independent Hammersmith Socialist Society. Though his views on the politics of art had not diminished, he was now less taken up by the day-to-day stress of revolutionary activism. He was able to refocus.

The 1890s saw a stepping up of William Morris's involvement in the works at Merton Abbey and the revival of the handcrafts. The close creative partnership between Morris and Burne-Jones was resurrected at a time when both were ageing visibly. Though barely in their sixties, a double portrait taken by Hollyer at this period shows them already looking like old men. They were conscious that time was running out. 'The best way of lengthening out the rest of our days, old chap,' said Morris, 'is to finish off our old things.'

In 1891 Morris brought his multifarious activities in the so-called book arts, as a calligrapher and illuminator, a designer of typefaces and ornamental graphics, an expert in printing inks and handmade papers, to a practical conclusion. He founded his own printing press, the Kelmscott Press in Upper Mall in Hammersmith, installing an Albion handpress and producing his own idiosyncratic choice of titles, ranging from reprints of medieval texts and English classics to his own poems and romances. The books he chose to print were, as he explained it, the books that he most loved to read and to possess. Burne-Jones's illustrations were integral to Morris's plans for the press. Now, late in both their lives, the ambitions that had started with their long-abandoned 'Cupid and Psyche' project began to be realised. Their 'old dream of making a beautiful book with beautiful pictures in it' took shape at last, albeit in quite another form.

Altogether 106 illustrations by Burne-Jones appear in Kelmscott Press editions. When one takes into account the many hundred more sketches and trial designs, some of them rejected at an early stage by Morris, who was always brutally frank in criticism, it is clear that Burne-Jones's work for the press was a very big commitment on top of his continuing provision of cartoons for Morris & Co. stained glass and tapestry.

The first of his wood-engraved illustrations to appear were two designs for *The Golden Legend*, a thirteenth-century collection of lives of the saints by Jacobus de Voragine in Caxton's translation. Originally he had agreed to design a frontispiece. But he was late in delivering and the two designs he finally produced were inserted in the main body of the book. When Burne-Jones saw the proofs in September 1891 he 'went crazy with pleasure'. Swinburne acclaimed the large quarto edition, set in Morris's Golden type, as 'the most superbly beautiful book that ever, I should think, came from any press'. The Burne-Jones illustrations show the expulsion of Adam and Eve from the Garden of Eden and *The Heavenly Paradise*, an emotional reunion of young women and their guardian angels clasped in joy within the walls of a celestial city. He had his own tangible visions of heaven as a battlemented hill town in Italy.

Their most monumental joint project was the Kelmscott *Chaucer*, which contained eighty-seven Burne-Jones illustrations and preoccupied them from 1891 until the book was published in 1896. Chaucer was an obvious choice for both of them, a writer they had revelled in since early days at Oxford, Morris being entranced by his mastery of narrative, his faith in a storyline, telling it directly through from start to finish. To some people even Morris's appearance was Chaucerian, simple, stalwart, medieval.

Burne-Jones too was steeped in Chaucer, especially attuned to *The Legend of Goode Wimmen*. For the tale of *The Romaunt of the Rose* he made a drawing showing the earthbound Chaucer sleeping in his bed, a curtain drawn in front of him, books on the shelf behind him, while Chaucer's spirit, his creative doppelgänger, travels off into the realms of the imagination. To Burne-Jones, as to Morris, Chaucer seemed a real person: 'I wonder, if Chaucer were alive now, or is aware of what is going on, whether he'd be satisfied with my pictures to his book or whether he'd prefer impressionist ones.' He speculated about whether if Chaucer and Morris ever met in heaven they would quarrel.

After the disruptions of the Socialist years, Burne-Jones and Morris were back in their Sunday morning routine of breakfast followed by a long working session in the studio. These Sundays were now mainly devoted to the Kelmscott Press. 'All the time Morris is designing his borders here on Sunday morning one hears his teeth almost gnashing – at least gnattering and grinding together.' William Morris's unselfconsciously strange habits, the way he strode about the room like a warlike ancient Viking, had never ceased to charm Burne-Jones or to remind him of their old shared history of fierce idealism: 'he belongs to the big past I once had when we were all young and strong and meant to beat this world to bits and trample its trumpery life out'. Working on the *Chaucer*, Burne-Jones felt some of his lost energy return.

The book was conceived on an architectural scale. Burne-Jones once described it as 'something like a cathedral to stroll through and linger, a kind of pocket Chartres in fact'. On other occasions he referred to Morris as the architect or 'Magister Lapicida' while

his own role was that of the carver of the images in the cathedral at Amiens. It was a work of collaborative craftsmanship. Morris had designed a new typeface for the book, a version of his Troy type which he named the Chaucer type. The two of them discussed in detail which of Chaucer's tales should be illustrated, Burne-Jones's tastes veering to the tales of courtly love, especially 'The Knight's Tale', while Morris urged him not to neglect Chaucer's more bawdy stories. Maybe Morris was just teasing. Burne-Jones recalled to Swinburne, 'especially he had hopes of my treatment of The Miller's Tale, but he ever had more robust and daring parts than I could assume'.

Burne-Jones made his original drawings in pencil, as close in scale as possible to the finished wood engraving. Because these drawings were too delicate in outline to be copied immediately onto the engraving block, a very pale platinotype photographic print was made and then washed over faintly with Chinese white. An expert technical assistant – first Fairfax Murray then, when he became too busy, Robert Catterson-Smith – carefully drew over the lines with a brush, and after Burne-Jones had himself approved them, these images were then rephotographed onto the wood-block. A particularly skilled old-time engraver, W. H. Hooper, was brought out of retirement to complete the work. Burne-Jones was satisfied with this complex method, making friends with Catterson-Smith, who later became headmaster of Birmingham School of Art. He maintained that their co-operation was so perfect he regarded his assistant as a tool in his own hand.

The success of the Kelmscott *Chaucer* is its marvellous ambition and complexity, the balance of words, typeface, decorative borders and Burne-Jones's always fresh and surprising illustrations. The effect is rather that of being entrapped in a dense and magical forest like those in William Morris's supernatural novels. The methods used in arriving at the giant book were very slow ones. The cutting of the blocks was sometimes unsuccessful first time round. Burne-Jones, as he admitted, was frequently distracted from the *Chaucer* by his clandestine pursuit of May Gaskell: William Morris had 'looked so disappointed that I have done nothing since

last year', he told May in 1893, 'and I couldn't tell him why'. But the following year, with almost forty *Chaucer* designs completed, he reckoned he was over halfway through the project. Printing was started at the Kelmscott Press in August 1894. Burne-Jones wrote a few months later: 'I have just finished another Chaucer drawing, it is the greatest of delights to me to make them, and I am beginning to feel in the mood to do nothing else all my days, only one should starve I suppose.' In 1895 he finished the last drawing for the final Chaucer poem, *Troilus and Criseyde*.

During the gestation of the *Chaucer* the Kelmscott Press had been expanding to the point at which around a dozen compositors and pressmen were employed. Additional premises in Hammersmith were taken and a second and then a third Albion press installed, the last reinforced to allow for the considerable pressure needed to print the woodcuts in the *Chaucer*. As the Press developed Burne-Jones was drawn into many other plans for future publication of the books that he and William Morris loved and valued most.

Burne-Jones was especially thrilled with the idea proposed by Arnold Dolmetsch, the leader of the early music revival, for an edition of the collection of three hundred early English songs that Dolmetsch had discovered in the British Museum. Morris and Dolmetsch came for lunch at the Grange to discuss the possibilities. If Dolmetsch were to edit the book, Morris print it and Burne-Jones himself design the woodcuts he foresaw that 'we should have a blissful old age amongst us'. There were also, inevitably, plans for a Kelmscott Press *Morte d'Arthur*. But neither of these was to materialise.

On his first visit to Burne-Jones's studio in November 1890 the young Sydney Cockerell, soon to be taken on as William Morris's factotum and secretary to the Kelmscott Press, had noticed 'a large drawing of the visit of the Magi executed for Birmingham from the design used in the Exeter College tapestry – also rough designs for another series of tapestries to represent the search for the Holy Grail'. Through the first half of the 1890s, simultaneously with

the Kelmscott *Chaucer*, another large-scale collaboration between Burne-Jones and Morris, a project in a similar style of late Victorian complexity and grandeur, was taking shape.

The six *Holy Grail* tapestries, the first sequence of which were woven at the Morris & Co. works at Merton Abbey from 1891 to 1895, were a kind of culmination of Burne-Jones and William Morris's years of work together, their shared feeling for *Morte d'Arthur* and the practical friendship that was such a central factor in their lives. For example, when Burne-Jones needed payment urgently for his tapestry or stained-glass designs Morris intervened with the Morris & Co. manager: 'Mr. Burne-Jones wants some cash £200 say; if you cannot manage it I think I can, only with somewhat more than a week's delay.' There was an ease between them and great generosity.

The commission for the tapestries came from William Knox D'Arcy, an entrepreneur who had made a fortune through gold-mining in Australia, returning to England to form the Anglo-Persian Oil Company, precursor of British Petroleum. Morris the Socialist had his deep misgivings about the commission for Morris & Co. to carry out a complete redecoration scheme for D'Arcy's recently remodelled Stanmore Hall near Harrow, 'a house of a very rich [man] – and such a wretched uncomfortable place! a sham Gothic house of fifty year ago now being added to by a young architect of the commercial type – men who are very bad'.

Burne-Jones too had some misgivings about his own part in the commission, the design of six large tapestries for the dining room at Stanmore Hall: 'tapestry to go round a big room – not in an ancient room, such bliss isn't for me – in some new fangled place'. All the same, he was prepared to make the most of the opportunity D'Arcy's commission gave him to do what he had never done before, to design a whole cycle of tapestries, the narrative winding its way round all the four walls of the imposing if pretentious dining room.

Burne-Jones and Morris discussed the possibilities, considering carefully the spaces to be filled and such technical aspects as the natural light in the dining room. A decision was taken to

concentrate on 'The Quest for the San Graal', the sequence of linked narratives coming towards the end of Malory's *Morte d'Arthur*. These tell the story of how the knights depart from the Round Table on a mission to discover the Grail, the mystic vessel believed to contain blood shed by Christ on the cross. Their chosen subject for the tapestries contained the combination of boyish adventure and high symbolism that had such a lasting appeal for them. The Holy Grail story appeared to them not only from the point of view of narrative 'the most beautiful and complete episode' in Malory, it was also already 'in itself a series of pictures', only awaiting Burne-Jones's personal interpretation.

The tapestries were envisaged as a two-tier sequence, Burne-Jones's six large-scale narrative scenes forming a continuous frieze around the walls. Beneath the first five was a set of six smaller 'verdures', tapestries designed by Henry Dearle, showing deer in a forest and knights' shields suspended from the trees. For Burne-Jones's tapestries he and Morris had selected their six crucial scenes of highest drama from the Malory stories they almost knew by heart: *The Knights of the Round Table Summoned to the Quest by the Strange Damsel; The Arming and Departure of the Knights; The Failure of Sir Gawaine; The Failure of Sir Launcelot*; the arrival of the ship to take the three remaining questing knights, Bors, Percival and Galahad, to Sarras, the land of the soul. Gradually, as their sins discredit them, the knights are all discarded except the faultless Galahad. The last tapestry is that of *The Attainment* as the vision of the Grail kept in the holy chapel is finally vouchsafed to Galahad alone.

Burne-Jones's interpretation is a free one, not linked to a specific time or place. His Arthurian vision mingles the medieval authenticity of heraldry and armour with Italian Renaissance elements. The tapestries have something of the beauty and composure of a Botticelli painting, the stretched-out human forms of Signorelli. Attendant maidens stand in Aesthetic Movement attitudes. The failed knights Gawaine and Ewain are viewed by Burne-Jones as self-indulgent late Victorian playboys not unlike poor Phil, failing the test of nobility and purity, 'handsome gentlemen set on this

world's glory'. Burne-Jones felt he loved Malory so much he was permitted to take liberties with him.

The *Holy Grail* tapestries took over Merton Abbey's three high-warp looms almost entirely for the period of their weaving, with Morris and Dearle supervising the production. Like the Kelmscott *Chaucer* work on such a scale posed a considerable challenge to William Morris's craftsmen, and Burne-Jones, on at least one of their Sunday morning work sessions, had to tackle Morris on problems of quality control: 'Scolded him well about the Tapestry – and he confessed it was so, that he ought to have looked after it better, and promises to have them back and see what can be done – nothing can be done except by the needle now – but the lips shall be paled and the eyes softened – that he promises.' Evidently the features of some of the figures had been judged unsatisfactory by the designer. Such day-to-day detailed discussion and adjustment was of the essence of their working partnership.

Though he made his original designs on quite a small scale, Burne-Jones had the imaginative reach to envisage their effect on a much larger scale *in situ*. The Stanmore Hall tapestries were 2.4 metres high, designed to be viewed from a distance. As shown in contemporary photographs, the *Holy Grail* cycle, once assembled in the dining room, was spectacularly grand, worth the £3,500 that D'Arcy paid for them, of which £1,000 went to Burne-Jones as his design fee. A business associate of D'Arcy's, George McCulloch, was so impressed by the Stanmore Hall tapestries he ordered a full set of the narrative scenes plus one of the smaller verdures for himself. McCulloch's set was shown at the Paris Exhibition of 1900 and again at the Wembley Exhibition of 1925. Several more weavings of partial sets or single *Holy Grail* tapestries were made at Merton Abbey, but the original full narrative sequences have now all been separated out.

Burne-Jones himself would have liked the project to go on for ever, so deeply was he attuned to it. There was a day in 1897 when Thomas Rooke arrived at breakfast at the Grange bringing in a drawing of what purported to be the original chapel of the San Graal, deep in the forest seven miles from Lockes. It was a little

round chapel, apparently built seven hundred years ago and filled from top to bottom with wall paintings, now in ruin. 'Oh my dear,' he told Frances Horner, 'I should have lived then, the world was so after my heart.'

Burne-Jones felt so possessive about the Arthurian legends that alternative attitudes annoyed him. While the *Holy Grail* tapestries were under way Dr Sebastian Evans was compiling his own scholarly *The High History of the Holy Grail*, a two-volume translation of the French medieval prose romance *Perceval le gallois*. Sebastian Evans, the barrister and Tory journalist with his old Birmingham connections, was now becoming one of the close male cronies of Burne-Jones's later years. They enjoyed discussing logic and philosophy and while Sebastian Evans's translation was in progress he brought it to the studio to read it out loud to Burne-Jones while he was painting.

But fond as he was of Evans, Burne-Jones could not approve of the way he intellectualised a subject about which he himself felt so totally emotional. Georgie understood well how for her husband the Arthurian was 'a living power'. Evans's approach seemed to him merely pedantic. However, he contributed two illustrations to the book when it was published, one of the San Graal chapel and the other a reworking of the *Sir Galahad* stained-glass window that adorned the landing of Burne-Jones's house at Rottingdean.

Aubrey Beardsley's version of *Morte d'Arthur* was more threatening to an artist who regarded the Arthurian as his sacred territory. He and Beardsley had first met in July 1891 when the eighteen-year-old aspiring artist had arrived with his slightly older sister Mabel at the Grange. It was a speculative visit. They were touring artists' studios in London and had heard the Burne-Jones studio was open to the public on Sunday afternoons. Beardsley had brought his portfolio of drawings with him in case an opportunity arose to show it to the artist. The studio in fact was closed to visitors without appointments but Burne-Jones, watching from the window as the two of them departed, hurried down the street after them and asked them in. Their mother had a theory that

Burne-Jones had been attracted by Mabel's profusion of beautiful red hair.

He looked carefully at Aubrey's drawings, all made recently. At this late stage in his life Burne-Jones was generous in encouraging the young, and according to Beardsley he had then exclaimed, 'There is *no* doubt about your gift, one day will you most assuredly paint very great and beautiful pictures.' He found the drawings '*full* of thought, poetry and imagination'. It was a hot summer day and Aubrey and Mabel were invited to join the Burne-Joneses' Sunday afternoon tea party out on the lawn. Among the guests were Oscar and Constance Wilde, 'charming people' as Beardsley described them. The Wildes took the Beardsleys home in their carriage. Oscar was impressed with Aubrey, the already emaciated figure with a face 'like a silver hatchet' under his long red hair, and they became friends instantly.

Burne-Jones's advice to Beardsley had been practical. He promised to find him the very best art school, with the result that Beardsley enrolled in evening classes at Westminster School of Art under Professor Fred Brown. He encouraged Beardsley to visit him often and to bring his latest drawings with him. Beardsley became familiar with Burne-Jones's own collection and presented his mentor with his wonderfully decorative Wagnerian pen-and-ink drawing *Siegfried Act II* which, at least for a time, hung alongside the Dürer engravings in the drawing room at the Grange.

William Morris was more initially suspicious when Aymer Vallance, art connoisseur and aesthete, go-between and busybody, took Beardsley to see him at Kelmscott House early in 1892. Vallance was aware that he was in search of alternative illustrators for the Kelmscott Press in addition to Burne-Jones, who already had too great a workload. Vallance also knew that Morris was then planning an edition of Meinhold's *Sidonia the Sorceress* and he advised Beardsley to include a trial design for Sidonia in his portfolio. Beardsley's concept of Sidonia fell on stony ground. Morris complained that Sidonia's face was 'not pretty enough'. His only words of praise were limp ones: 'I see you have a feeling for draperies, and I advise you to cultivate it.' Morris's high-handedness may

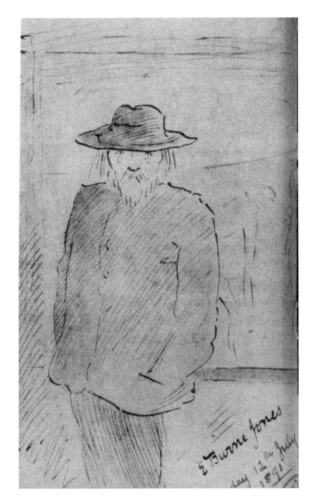

Sketch of Burne-Jones by Aubrey Beardsley.

have arisen from his dislike of the show-off indecencies, the elements of satiric subversiveness, that had by now entered Aubrey Beardsley's work. It was also no doubt loyalty, the sensing of a rival to Burne-Jones the brother artist he so doggedly regarded as beyond compare.

In 1892 Beardsley was given a commission by the publisher J. M. Dent to illustrate a popular edition of Malory's *Morte d'Arthur* produced by the new modern line-block and linotype

439

machines, a direct challenge to the expensive hand-printing methods of the Kelmscott Press. With a cynical opportunism Dent offered Beardsley £250 to illustrate the book 'in the manner of Burne-Jones'. At first around four hundred illustrations were envisaged but Beardsley's output amounted to almost six hundred drawings: full- or double-page illustrations, chapter openings, borders, initial ornaments. The project continued for the next two and a half years, during which Beardsley's illustrations developed from an initial dependence on Burne-Jones into realms much more sexually ambivalent and wittily provocative. He was working simultaneously on illustrations for *Salomé*, increasingly bound up in the philosophy of 'evil for evil's sake' pursued by Oscar Wilde.

As his designs for Dent's *Morte d'Arthur* progressed Beardsley began ruthlessly to parody Burne-Jones with his attenuated figures of melancholy knights and wistful ladies, undermining the solemnity of the Kelmscott Press endeavours. When Beardsley called at the Grange and Burne-Jones enquired politely how King Arthur was going, Beardsley told him 'he'd be precious glad when it was done, he hated it so'. Then why had he accepted the commission? Burne-Jones asked him. He replied it was 'because he had been asked', maintaining that he 'hated the story and he hated all medieval things'. Burne-Jones, shocked, told Thomas Rooke 'he never saw such a pitiful exhibition in his life'.

The visit ended quickly, with Burne-Jones left to wonder why Beardsley took the trouble to come at all, 'unless it was to show off and let me know my influence with him was over'. Later he happened to meet Beardsley's sister Mabel at Victoria Station on his way to Rottingdean. She came up to him 'with her simple, straightforward looking face with a saddish look on it, as though to say, I'm sorry you don't like what my Brother is doing any longer'. This was putting it mildly. Burne-Jones had been appalled.

He explained his revulsion in sexual terms. He admitted being shocked by drawings 'more lustful than any I've seen – not that I've seen many', indicating a woman drawn by Beardsley with breasts larger than her exaggeratedly tiny head, making her appear like a mere lustful animal. 'Lust does frighten me', said Burne-Jones

wanly: 'I don't know why I've such a dread of lust.' He seems to have felt threatened by Beardsley's own indeterminate sexuality. As his work began appearing in *The Studio* magazine and he was appointed art editor of the new avant-garde periodical *The Yellow Book*, Beardsley became a cult figure for the 1890s decadents, men Burne-Jones described as 'all that horrid set of semi-sodomites'.

Burne-Jones accused Beardsley of having been 'entirely invented by critics'. But he was astute enough to realise this was not actually so. Beardsley's sphere of genius was as a graphic artist who exploited modern methods of commercial reproduction. The pared-down linearity of his boldly graphic images, the quasi-Japanese reductionism of his style, was ideally suited to the process block. This was a context in which the fine lines and delicate elaboration of Burne-Jones's drawings for the Kelmscott Press began to look a little passé and Beardsley's bolder graphics were the coming thing.

But Burne-Jones remained combative. In 1897 when Rudyard Kipling's son John was born, he wrote Kipling a spoof letter of congratulation with an illustration:

Dear Sir, I can do drawings in the style of Mr. Aubrey Beardsley which I understand you admire – I send you an example hoping for a favourable answer from you.

The drawing was of the Kiplings' cook dancing for joy at the birth of an heir. It is in Beardsley's beautifully lewd *Yellow Book* style showing a grossly fat cook prancing, a sinuously phallic lamp-post in the background. The cook is rather shockingly naked to the waist.

In 1894 Burne-Jones was asked to design the scenery and costumes for Comyns Carr's play *King Arthur* at the Lyceum Theatre with Henry Irving as Arthur and Ellen Terry as Guenevere. His experience as a theatre designer was limited to William Benson's brother Frank's undergraduate production of the *Agamemnon* of Aeschylus performed in Greek in Oxford back in 1880 when Burne-Jones, William Richmond and Lawrence Alma-Tadema had been brought in to assist with the classical draperies. Nor was

Burne-Jones entirely an enthusiast of drama, preferring to watch pantomime, burlesque or dance, the sensational Kate Vaughan, inventor of the 'skirt-dance', being a particular favourite of his. He naturally had his personal misgivings about the whole idea of a popular dramatisation of King Arthur: 'I can't expect people to feel about the subject as I do, and have always,' he explained. 'It is such a sacred land to me that nothing in the world touches it in comparison.' But Comyns Carr, Irving and Ellen Terry were all friends of his. When Irving intervened and begged him to be part of it he found it impossible to turn the project down.

Burne-Jones was at work on his interminable painting *The Sleep of Arthur in Avalon* when Joe Comyns Carr came to the Garden Studio to read the play through to him. His remit was to design four sets for the production, the Magic Mere, the Hall of Camelot, the May Scene and the Scene in the Turret. One of the reservations Burne-Jones made in accepting the commission was that he should not be involved in the detailed realisation of his designs, and so his sketch drawings, with tentative suggestions for colour, were handed over to the Lyceum's professional scene painters, whose initial resistance to what they saw as the artist's impractical demands on them was overcome by Irving's diplomacy.

Burne-Jones took his daughter Margaret with him on a visit to one of the scene painters, Hawes Craven, in his working studio high up in the Lyceum building. 'We looked down sheer depths to the stage, and upwards to more platforms and more ropes and an indefinite roof – it all looked vast and impressive,' wrote Margaret in her diary. 'Then we watched him paint.' Burne-Jones, with his yearning to decorate great spaces, was evidently impressed by the vast scale on which the work of scene painting was carried out and, envying Hawes Craven's extra-large brushes, he went home and ordered a number of huge paintbrushes for his own work on *The Car of Love*.

When it came to the costumes, Burne-Jones's initial sketch designs in pencil, pen and ink and body colour were realised by Charles Karl, the in-house designer of the theatrical costumiers L. & H. Nathan. Karl spent four months working out the practical

detail in Burne-Jones's studio of a production on an enormous scale demanding fifty or sixty Arthurian suits of armour, all different in design. Some were made in London, other suits were farmed out to workshops in Paris, in Vienna, in Italy, wherever the craftsmen best suited to the particular type of armour could be found.

In designing the armour for *Arthur* Burne-Jones drew on a whole backlog of experience, the drawings in his very early costume sketchbooks, the research and model-making he had done for *Perseus*. Burne-Jones's design for Henry Irving's armour in the first scene of the play, in which Arthur takes possession of the sword Excalibur, was especially successful. Alice Comyns Carr considered this was 'one of his greatest triumphs', while Graham Robertson comments in his memoirs, 'it is curious how little I can recall of the whole production beyond Irving's figure in black armour, which seemed as though it had stepped from the canvas of Burne-Jones'. Four suits of armour not finally used in the production were kept by Burne-Jones at the Grange.

Mrs Comyns Carr made herself responsible for Ellen Terry's costumes, finding herself faced with some problems in translating Burne-Jones's sketches for Guenevere into costumes the actress could actually wear. For instance, the silver cloak he had envisaged embroidered with gold and encrusted with turquoises proved impractically heavy. 'I can't breathe in it much less act in it,' Ellen Terry complained when she first wore it at the dress rehearsal, insisting that the majority of turquoises had to be cut off.

Burne-Jones had been present at the dress rehearsal, although leaving at midnight. He could see the rehearsal would be going on all night. Having had so little to do with the production, he was shocked by some of the alterations made to his designs. The scene of the wood in May time, which he considered he had 'made very pretty', had been ruined: 'fir trees which I hate instead of beeches and birches which I love'. He had carefully designed a subdued and dignified costume for Merlin. Merlin was a figure in the Arthurian legends Burne-Jones took seriously, as is obvious from his painting *Merlin and Nimuë*. The producers had turned Merlin into a

travesty: 'they have set aside my design', he told May Gaskell, 'and made him filthy and horrible – like a witch in Macbeth . . . Morgan le Fay is simply dreadful. You remember she is half divine in the ancient story – as Merlin is – here they are scandal mongering gossips.' Few of his original designs remained unscathed. Irving had himself jettisoned the turban-style headdress Burne-Jones had designed for Genevieve Ward as Morgan le Fay with the shout 'Moses and Aaron rolled into one! Take the thing off!'

Also at the dress rehearsal was Sir Arthur Sullivan, who had composed the music for *King Arthur*. Sullivan apparently was 'in a frenzy', telling Burne-Jones he would have given £100 to be out of it. Because of his friendship with the leading actors and with the Comyns Carrs, Burne-Jones made a superhuman effort to be tactful: 'I had my own thoughts,' he wrote, 'but can consume my own smoke.'

He was not present at the first performance of *King Arthur* on 14 January 1895, remaining at home at the Grange and playing dominoes, although the papers reported him as being at the theatre and constantly leaving his box to superintend his sets and costumes. He resisted making the designer's statutory appearance on stage at the end of the performance at first nights, forced to make his bow beside the stars of the production. He hated the prospect of standing in front of his own set for the curtain call. Burne-Jones was reluctant to associate himself publicly with a production with which he felt so fundamentally out of sympathy.

As the play developed he had come to disapprove of what he saw as a falsely romanticised interpretation of the Arthurian legends that followed Tennyson rather than Malory in omitting Arthur's incest with his half-sister Margawse, fathering Mordred who brings about his doom. He disliked what he saw as the opportunistic imperialist message inserted by Comyns Carr into the Arthurian stories, 'catchpenny jingo bits about England and the sea which Carr should be ashamed of – all the more that it is not sincere in him'. He may also have been influenced by the fact that he and Phil had been in the audience only days before at the disastrous first night of Henry James's play *Guy Domville*, received with hoots and jeers and catcalls from the gallery once the curtain fell.

Comyns Carr's *King Arthur* in fact was received well, running for a hundred performances in London and twelve in the provinces before being taken on tour in America. Much of the production's success was due to Burne-Jones's sets, held to have created 'a very real sensation, for nothing like them had ever been seen before, even on Irving's stage, which held the palm for such effects'. The most impressive of Burne-Jones's designs was for the rich Byzantine-inspired hall of Camelot with its three great rounded arches through which the river could be seen winding towards the sea. This made a superb background for the scene of the farewell of the knights in shining armour with uplifted spears and flying pennants. Bernard Shaw, reviewing the play, described it as a 'splendid picture'. No doubt there was more left of Burne-Jones's vision for *King Arthur* than he himself implies. The young Augustus John, having gone to see it with his sister Gwen, was so carried away by the *mise-en-scène* that, on returning to their lodgings, he seized a heavy walking stick, raised it above his head and, 'while reciting appropriate lines', smashed the chandelier.

The production had a strange and rather mystic ending when the scenery and props, having come back from the States, were destroyed by a fire in the Lyceum stores at Southwark in 1898. Only the Excalibur sword – the prop that Hawes Craven, to Burne-Jones's irritation, insisted on calling 'Excelsior' – was found miraculously intact.

In the spring of 1895 another, grimmer real-life drama was unfolding. On 3 April Oscar Wilde's slander suit against the Marquis of Queensberry, who had accused him of 'posing as a somdomite' [sic], began. Burne-Jones had feared the worst of this event, confiding to May Gaskell, 'I don't know what has been the matter with me these 2 days – such an ominous feeling I have had at my heart's root of some impending trouble and disaster.'

As the trial unfolded, with its detailed allegations of Wilde's sexual relations with a succession of male youths of working-class background, Wilde's friends and associates became increasingly aghast. Burne-Jones, who had once defended Oscar Wilde on

grounds that 'artists must see all people, and study all', was now drawn into the general anti-Oscar panic. On 4 April, the second day of the trial, he wrote to May expressing his own horror, a pervading 'sense of dilapidation and failure'. The previous night Alma-Tadema had 'brought sad news of the state of Leighton, who seems to be breaking down', Burne-Jones reported, 'and Carr told me seriously in a corner he felt his head going and had done for weeks past, and he was frightened, and there is that horrible creature who has brought mockery on every thing I love to think of, at the bar of justice to-day'. Georgie too was reported by a visitor to lunch at the Grange on 5 April to be 'very much distressed'.

What had turned the non-judgemental and apparently sexually tolerant Burne-Jones, the one-time ally in blasphemy with Swinburne, who had acted with such kindness towards Simeon Solomon after his arrest, into such a bitter enemy of Oscar Wilde's? It was partly no doubt protectiveness of his own family, particularly Phil who had so greatly adored Oscar. It was also that the Aubrey Beardsley episode still rankled. He wrote to May a few days later, 'I wish Beardsley could be got rid of too.' At the basis of his dismay was his perception that Wilde had betrayed the cause of beauty, turned aesthetic values ugly, and in Burne-Jones's eyes this was a heinous crime.

Wilde, charged with offences under the Criminal Law Amendment Act, was tried and found guilty on 25 May of gross indecency with two male prostitutes. He was sentenced to two years' penal servitude with hard labour. Burne-Jones, in another outburst, wondered why

the poor wretch, who has done so much harm, and made the enemy everywhere to blaspheme, hadn't had the common courage to shoot himself – I looked eagerly for it but it didn't happen but we shall be in clearer air now he is ended and others must go too . . . I hope we have seen the last of the yellow book. I hope no decent being will go to any of those plays.

Indeed, following the trial Wilde's name as the author was removed from the hoardings of the West End theatres where *An Ideal*

Husband and *The Importance of Being Earnest* were playing, and then not long afterwards both plays were taken off.

Oscar, still the fervent admirer of Burne-Jones, wrote to his former lover Lord Alfred Douglas from H. M. Prison, Reading, listing the seizure from his Tite Street house of some of his most treasured possessions by the bailiffs: 'all my charming things', he told Douglas, 'were to be sold'. At the top of the list came his Burne-Jones drawings, followed by his Whistlers, his Monticelli, his Simeon Solomons, his blue-and-white china, his library with its irreplaceable collection of presentation volumes that included a book with a dedication from William Morris to Paul Verlaine. In this same letter from prison Wilde launched into an analysis of art in what he saw as its most piercingly spiritual form: 'wherever there is a romantic movement in Art, there somehow or under some form, is Christ, or the soul of Christ'. For Wilde, in his own humiliation and suffering, Christ was to be found in such works of art as Shakespeare's *Romeo and Juliet*, Hugo's *Les Misérables*, Baudelaire's *Les Fleurs du Mal*, in what Wilde called 'the note of pity' in the Russian novels. He saw this same quality of beauty and humanity in the stained glass, tapestries and 'quattrocento work' of Burne-Jones and William Morris.

Burne-Jones soon relented in his attitude to Wilde. In late February 1896 a lady arrived without forewarning at the Grange and was announced by the maid as Constance Holland. 'And lo!' wrote Burne-Jones, 'it was poor desolate heartbroken Constance Wilde. I was glad to see the poor waif, and so was Georgie.' Constance, now nearly destitute, had changed her name to Holland. The Burne-Joneses lent her £150.

A year later, shortly before Wilde was released, Burne-Jones's initial repulsion had turned to sympathy: 'I should shake hands or bow to him if I saw him.' He speculated gently, recalling the old Oscar, 'Very likely he'll keep out of everyone's way – go abroad, perhaps – but there's no telling what state of mind he may be in, or what he has been turned into by this time.' When he read Wilde's *De Profundis* he commented, 'That is a splendid poem of Oscar's – the best thing he ever did in his forlorn life – but what can be his

future? – alack and alas.' Oscar Wilde did go abroad, as Burne-Jones had predicted, and they never met again.

Parallel with Wilde's, another drama was erupting that affected Burne-Jones deeply. This was the mysterious case of Luke Ionides, the son of Constantine, Burne-Jones's close friend and once indeed his rival for the affections of Maria Zambaco. In August 1869, just a few months after Maria's attempted suicide, Luke had married Elfrida Bird, the daughter of a Welbeck Street doctor. They had seven children. The eldest, Alexander George, had been presented at birth by Burne-Jones, Rossetti and Morris with a sixteenth-century Dutch cradle of which the wooden side panels were painted by Burne-Jones.

The Ionides family lived in artistic luxury in a large house in Upper Phillimore Gardens on Campden Hill, from which Luke was easily tempted by Burne-Jones to make bachelor outings. 'Tomorrow Solferino: 7½?' On another evening Burne-Jones suggests meeting 'at the pot house – Church St., isn't it Soho?' Sometimes Phil would accompany them on these expeditions. Burne-Jones's invitations to adventure were beautifully written out, extravaganza calligraphic compositions. He wrote 'Lukie' with a swirly and wonderfully elongated 'L'.

A place they especially enjoyed on their male forays was the Westminster Aquarium where the sideshows and freak shows included a famous American Tattooed Lady, Emma De Burgh, who had a virtuoso reproduction of Leonardo's *The Last Supper* tattooed right across her back. Luke recorded that 'B. J. was enchanted with her, and on our return to the Grange, he made a drawing of her back to send a friend.' Three years or so later, hearing that the Tattooed Lady had returned, he persuaded Luke to come again to see her. By this time the lady had grown extremely fat. As she had expanded, so had the tattoo, 'so that all the disciples at the Last Supper wore a broad grin'.

Now, after all these evenings of hilarity and happiness, Luke was in serious trouble. Burne-Jones seems to have been his closest confidant. He told May in the same letter written on 3 April 1895

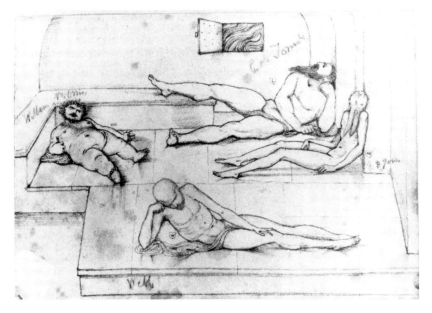

Burne-Jones in a Turkish bath with William Morris, Philip Webb and the
gigantic Greek Luke Ionides in their roistering younger days.

in which he expressed his forebodings at the trial of Oscar Wilde
that 'the Luke story sickened me with its vulgar ugliness'. What
did he imply? The way Burne-Jones links the two cases has caused
people to suspect that with Luke too there was a looming homo-
sexual scandal. This seems unlikely since Luke Ionides, '*le beau
Luc*' as he was sometimes called, was known to be an inveterate
womaniser, apt to bore Burne-Jones to death with tales of his past
conquests. It was evidently more of a financial debacle, the failure
of his business as a city stockbroker, which coincided with his
separation from Elfrida. Luke left Phillimore Gardens and began
to live the life of a wandering bachelor again.

Burne-Jones was anxiously sympathetic. Luke wrote later of his
unfailing kindness: 'I never had a better friend.' His policy was to
be bracing. 'Luke has gone,' he wrote after an emotional visit,
'crying a bit – but I would have none of it and wouldn't seem
touched – for it is bad for him.' As Luke's visits became more fre-
quent and pathetic he was tempted to find excuses for sending him

away, 'but he is so heartbroken and wretched – it is like leaving a leper to die in the road and I can't do it'. He found himself intervening on Luke's behalf with one of Luke's wealthier Ionides brothers: 'the brother', he told May, 'has seven hundred and eighty five thousand pounds to play with, and he must and shall give two hundred pounds to Luke – or else I must and I won't'.

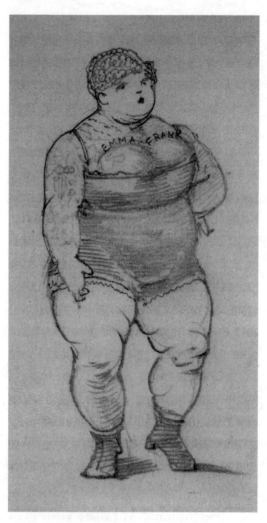

Emma De Burgh, the Tattooed Lady, front view.

Constructively, Burne-Jones encouraged Luke to take up his painting again. He even found himself comforting Elfrida on the disappearance of her husband with the perhaps not entirely welcome information 'men do that sort of thing'.

Hymenaeus, the painting Burne-Jones gave to Luke and Elfrida for their marriage, a richly classical composition in orange and

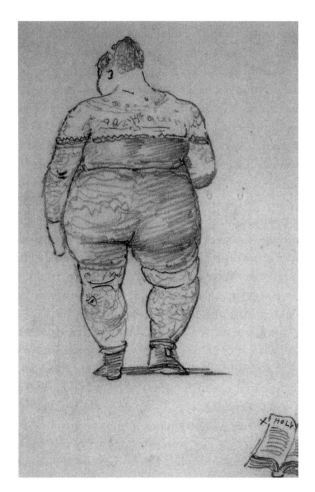

Emma De Burgh, back view.

451

gold showing Hymen, god of marriage, performing the nuptials of a young man and woman, was sold by Agnew's in 1898, following Luke's bankruptcy. It is now in the Pre-Raphaelite collection in Delaware. In 1900 the disgraced Luke Ionides was 'hammered' and ejected from the Stock Exchange.

In 1895 Burne-Jones was finishing the portrait of a lady that was, for him, unusual in that it was a full-scale commissioned portrait rather than a more informal painting or drawing of his family or friends. Burne-Jones maintained he 'absolutely hated' painting portraits for which he was paid. It was such a perpetual worry. 'People were never satisfied,' he said. However, he had overcome his natural reluctance in accepting the commission for a full-length portrait of Lady Windsor, young wife of the 14th Baron Windsor. Her given names were Alberta Victoria Sarah Caroline but she was known as Gay, a name that belied her introverted character. The Windsors were wealthy art lovers and 'Souls', and Burne-Jones presumably knew his subject socially, though with less of the intimacy with which he had once painted the girls on *The Golden Stairs*.

The portrait was destined for the Windsors' new home, Hewell Grange, near Redditch, the ambitious architectural design of which derived from the sixteenth-century Montacute House in Somerset. Here the painting would hang on the oak-panelled grand staircase. This was in effect a high-society portrait, Burne-Jones's answer to John Singer Sargent, an artist about whom he was particularly caustic, accusing him of being 'a very bad painter indeed' though claiming to like Sargent personally: 'An age that makes Sargent its ideal painter, what can we say of it?'

There was perhaps a modicum of jealousy involved in that Frances Horner had commissioned Sargent to paint a portrait of the Horners' daughter Cicely. How dare she? Cicely was *his*, he told her. Discovering that Frances had now summoned Sargent to Mells to discuss a further portrait of Cicely, Burne-Jones had exploded and told Frances what he thought of her chosen portrait painter: 'The colour is often hideous – and not one faintest glimmer of imagination he has.' Perhaps fortunately, Burne-Jones was not

to live to see the completion of Sargent's luxuriantly materialistic portrait of Madeline Wyndham's three daughters – the famous *Wyndham Sisters*, one of whom was his own beloved Mary Elcho – unveiled in 1900 at the Royal Academy.

Compared with the worldly John Singer Sargent, Burne-Jones's approach to portraiture was high-minded. His *Lady Windsor* is in effect an anti-society portrait. One of his most scathing criticisms of Sargent was that his portraiture was vacuous: 'his art hasn't much to say except that he watched closely'. Burne-Jones's view was that to be worth anything portraiture must reach into the inner soul, the psyche, of the subject. He wanted to achieve 'the expression of character and moral quality, not of anything temporary, fleeting, accidental'. In portraying Lady Windsor Burne-Jones takes a Symbolist approach, reducing her to psychological essentials. He paints her as a woman statuesque and muted, draped in a demure, almost nunlike grey gown.

Gay's mother Lady Paget recognised her withdrawn, pensive daughter in this portrait. The critics were less convinced when *Lady Windsor* was shown at the New Gallery in 1895. Could anybody actually be so sad? The *Times* critic demanded, 'why pervade a portrait, like that of Lady Windsor, with a world-weariness which would seem to imply that there was no joy left to be drawn either from things of the senses or from things of the soul?' And was her life indeed so joyless? In fact Gay's later life was to be enlivened by a long-running and passionate affair with George Wyndham, Madeline and Percy's politician son whose dark and dashing looks were legendary. George Wyndham was once described by no less a connoisseur than Sarah Bernhardt as the best-looking man she had ever seen.

Burne-Jones's 1890s wave of Continental fame increased after his discovery, at last, of an engraver he could trust to 'translate' his paintings into photogravure prints. This artist-craftsman was Félix-Stanislas Jasiński, a Pole who later took French citizenship. He had come to Burne-Jones's attention in 1892 when Arthur Tooth published Jasiński's superb etching after Botticelli's *Primavera*.

The following year his first etching from a Burne-Jones painting was commissioned by the *Gazette des Beaux-Arts*. This was the scene from the *Perseus* cycle in which the hero confronts the three fearful sisters of the Gorgons, the scene known in England as *Perseus and the Graiae* and in France as *Persée et les Soeurs des Gorgones*.

From 1894 Tooth published a prestige series of large Burne-Jones engravings on vellum by Jasiński, beginning with *The Golden Stairs*. Jasiński, like Burne-Jones, worked extremely slowly, exiling himself to remote Ballancourt and sometimes taking as much as a year to perfect a single etching plate. His own melancholy nature made it easy for him to enter Burne-Jones's wistful imaginative world and his prints were reinterpretations, not just copies. Some people were even of the opinion that Burne-Jones looked better in black and white. The Bloomsbury artist Duncan Grant recollected his first sight of a Burne-Jones photogravure print while he was still at boarding school as his first aesthetic experience.

There was a strong personal rapport between the artist and the printmaker. 'Such a solemn pale little thing he is out of the world, as such an artist should be,' wrote Burne-Jones of Jasiński: 'it is the highest honour ever done me that he is so content to translate me.' Jasiński's work was already very well known on the Continent and his series of engravings confirmed Burne-Jones's European standing as the most impressive of the Pre-Raphaelites.

By the middle 1890s Burne-Jones had many contacts with the progressive art movements on the Continent. His work began to be illustrated in the influential magazines *Die Kunst* and *The Studio*. Just a few years later Sergei Diaghilev reproduced a Burne-Jones painting, *The Baleful Head*, in his avant-garde magazine *Mir iskusstva* (*World of Art*), published in St Petersburg. His reputation spread.

One artist who came to see Burne-Jones at the Grange was the Belgian Symbolist Fernand Khnopff. Khnopff exhibited regularly in London and had been appointed Brussels correspondent for *The Studio* magazine. The two artists exchanged drawings. In 1896 Khnopff gave Burne-Jones a pencil portrait of a woman with a

challenging expression entitled *Study of a Sphinx* and bearing a dedication: 'Sir Edward Burne-Jones from Fernand Khnopff'. A contemporary photograph of the so-called White Room, a Charles Rennie Mackintosh-like all-white interior in Khnopff's house in Brussels, shows a reproduction of Burne-Jones's *The Wheel of Fortune* alongside a beaten metal mirror on the wall. It has often been noted that Burne-Jones's portrait *Lady Windsor* and Khnopff's 1887 portrait of his sister have certain similarities of style.

The sheer number of Continental visitors arriving at the Grange began to be a problem. Burne-Jones complained about the frequency of visits from 'those frogs'. One of his letters describes a taxing day when William, the studio boy, announced, ' "It's the French Sir" as if they had landed at Hastings . . . and they have parleyvooed at poor me for three hours'. A group of French visitors, leafing through his drawings, discovered a Burne-Jones parody of a French Impressionist picture that he had long forgotten. Burne-Jones, who was worried that this might cause offence, tore the drawing up, 'which seemed equally to grieve and impress them'. They left the Grange obsequiously, 'with many deep bows'.

A more significant visitor from Paris was Baronne Madeleine Deslandes, subject of another of Burne-Jones's rare commissioned portraits. She was a French aristocrat, the daughter of Auguste Emile, Baron Vivier-Deslandes, and a minor celebrity in Parisian Symbolist circles, having published a number of romantic novels and short stories under the pseudonym 'Ossit'. It was said of her writing that it resembled 'the scent of white lilac or the notes of a violin on a hot night'. She had been married to Maurice Napoléon Emile, Comte Fleury, but they had separated and she reverted to her family name, calling herself Baronne Deslandes, establishing a Paris literary and artistic salon and becoming an intense enthusiast, a '*fervente*', of Burne-Jones. It seems likely that the Baronne put up some of the money for *La Belle au Bois dormant*, a play inspired by Burne-Jones's Sleeping Beauty paintings produced at the experimental Théâtre de l'Œuvre in Paris in May 1894.

Meanwhile the Baronne had been in London preparing an adulatory article on Burne-Jones for *Le Figaro*. She stayed at the

Savoy and visited the Grange. The article was published in May 1893. She also commissioned a portrait which Burne-Jones was working on in December 1895 when Thomas Rooke's studio diary refers to him as 'painting dress and background of portrait of Parisian lady'. The picture still appears in his record of work in progress in 1896, entered as 'Portrait of Madeleine Deslandes', the use of the Christian name perhaps implying a degree of intimacy had arisen. Certainly Georgie disapproved of the commission, saying in a letter, 'he has finished a portrait of a French lady, who *would* be painted by him, and has been several times to sit'. The finished portrait was shown in Paris at the Salon du Champ-de-Mars in that same year.

As with Lady Windsor this is not a showy picture but a strange and austere portrait in which the inner life of the sitter is suggested. The Baronne appears as remote and rather soulful in her deep midnight-blue dress, her hands clasped in her lap. She looks, as she was, spoilt and worldly, a rich Jewess, but there is a more mysterious suggestion of clairvoyance, even sorcery, in her almost unearthly pallor and the crystal ball that sits balanced in her lap. The idea of women as sphinxlike keeps recurring amongst the writers and artists of the 1890s and Burne-Jones's unsettling, inscrutable portrait of Madeleine Deslandes allies him with the decadent movement of the time.

This was the last picture by Burne-Jones to be exhibited in Paris in his lifetime, nor was he to return there himself. He refused to go with Phil when he suggested they should travel together to France, saying 'I don't want it – if I go I shall go almost secretly, and call only on one or two painters – for I am not in the mood for any fussing.' More and more Burne-Jones was withdrawing into his own inner reverie.

Kelmscott, Two
1895–6

As Burne-Jones grew older a feeling of bleakness was overtaking him. In May 1895 he recorded a sad evening: 'I sat between Henry James and Du Maurier and we talked all dinner through of friends who were ill and friends who had died – and of blindness, and of the end of life.'

Even as someone who now claimed to live a life apart from politics, he was affected deeply by the worsening situation in South Africa. The reckless 'Jameson raid' of late December 1895, in which the British forces marched across the Transvaal border and were then forced to surrender to the Boers, confirmed his worst fears of British imperialist aggressiveness. 'What a rum affair out in the Transvaal,' he commented to Thomas Rooke a few days later. 'It's that rascal Rhodes that's at the bottom of it.' As other world powers – the French, Germans, Russians and Americans – came out in opposition to British policy, Burne-Jones found himself agreeing, expressing his belief that 'it wouldn't be in the least for the good of the world to have another great Anglo Saxon empire in South Africa, and the other nations are quite right to stop it'. At London dinner parties he propounded these views bravely, even though they very often had what he described as a torpedo effect.

Burne-Jones was now conscious of being almost always a turmoil of emotion, with work his only safeguard. 'They used to tell lies about age, and say feelings grow blunted and less keen – it is a

lie, everything is keener, and sharper, and the power of resistance less.' One of his painfully sensitive perceptions was that his long campaign for art, to bring people to widespread appreciation of beauty, had been failing. An example of this was the threatened destruction in 1896 of the Royal Hospital in Chelsea, Wren's superlative seventeenth-century building for army veterans. In spite of his usual antipathy to classical architecture, his dismay at the potential loss of this important visual feature of the historic city provoked him to write to the newspapers in protest: 'There are scores of streets that it would be a gain and delight to pull down if space is needed for any public purpose, but no one ever proposes that – the thing that usually suggests destruction is some beautiful or dignified building that has by chance survived and can never be replaced.'

Partly as a result of Burne-Jones's intervention, Chelsea Hospital was saved. But he became more disillusioned and disgusted as he watched a general tide of crude bombastic commercial developments obliterate the intrinsic historic beauties of the city he remembered from his early London years. Looking around him, Burne-Jones became aware of ugliness, grotesqueness everywhere. 'Do you know', he asked Frances, 'how grimy-souled people get in London, how sodden and sickening?' These bitter antipathies are evident in his increasingly political cartoons of the middle 1890s: old jingoistic bores snoozing in clubland in armchairs, large ingratiating hostesses in evening dress with heaving bosoms and bustles precariously perched upon huge bottoms. Such hideous, pretentious, evil people were the objects of his hate.

As his hopes for the universal spread of beauty dwindled, his old horrors of big masterful women became the more intense. One of his recurring dreams was of marrying 'very undesirably, hairy fat women' and waking in the morning in the marriage bed appalled. Now he unleashed a whole series of caricatures of 'Prominent Women' based on newspaper cuttings of 'advanced' women of the late Victorian age. These were gleefully assembled and pasted into scrapbooks in collusion with his young friend Violet Maxse. Burne-Jones's nightmare women were uniformly ugly and obese.

Even his one-time idol the actress Sarah Bernhardt, whose figure was once sylphlike, ceased to please him: 'she has grown phat – and has protuberances and expansions and developments of outline for which I am truly sorry – and perhaps it is better I die young after all'.

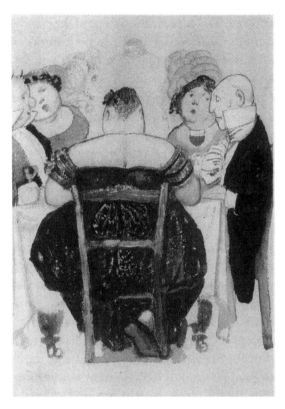

A Dinner Party full of the 'Prominent Women' who caused Burne-Jones such horror and were frequently the objects of his caricatures.

Burne-Jones had been temporarily invigorated by his friendship with the Maxses. Violet and her older sister Olive were the daughters of Admiral Frederick Augustus Maxse, a man of great charm and fiery temperament, a Crimean War hero who had carried dispatches through the Russian lines. Their mother Cecilia, who soon separated from her husband, was a gentler character, an

art lover and friend of many artists, including Whistler, Sickert and Burne-Jones. Cecilia had the rare distinction of having part-nered Leighton in the Princess of Wales's quadrille at the famous Marlborough House fancy-dress ball of 1874. Both her daughters were artistic and Burne-Jones taught them drawing, Violet soon becoming his prime favourite. Georgie too appreciated her, asking Eleanor Leighton, 'Do you know her and her sister? They are quite exceptionally dear, good and interesting girls – and to my mind there is an over and above charm in *her*.'

Violet, then in her early twenties, joined the long succession of Burne-Jones 'pets'. She was short and slender with delicate features. She was also strong-minded and ambitious. Burne-Jones encour-aged her to go to Paris to study art at Julian's studio, an unusually enterprising move for an upper-class young woman at that period. Just before she left he sent Violet a tender letter: 'Look, if ever in your pretty life you want me to talk seriously, I will give all the mind to the matter that I have – if ever hereafter I can serve you in any way – give you counsel and judgment I will with all my power give it wisely – but till you want me to pull a long face I shall con-tinue, I daresay, to talk rubbish.' Talking rubbish, he admitted, was his defensive mechanism, a sign of the peculiar duality in him.

There was an increasingly close rapport between them. Burne-Jones flirted with her sweetly, unwound his adoration. 'I think you are beautiful,' he told her, 'and an old artist may tell a young girl that without hurt or blame.' On one of Violet's visits to the Grange, when the maid had refused to let her enter, explaining that Burne-Jones was ill, he told her that he had been lying on the sofa asleep when he awoke suddenly, just at the time Violet had rung the bell. He had felt quite certain, still only half-awake, that she was actually in the room. Not only in the room but walking straight towards him: 'And after I was awake I still saw you clearly,' he had told her, 'and then it was gone and I only thought what a very clear dream it had been.'

But in spite of his mystic vision of Violet, in spite of their exchange of affectionate letters, their jokes about fat women, his serious encouragement of her artistic talents, Violet – like all the

rest – became engaged. Her fiancé was Lord Edward Cecil, a soldier and son of the Prime Minister Lord Salisbury. History repeated itself as Burne-Jones sent a desolate letter of congratulation: 'Can anybody be good enough is what I ask . . . I am sure I wish no harm to people but just for form's sake and a little ceremony I hope many men will drown themselves today.' True to form, he relented to the extent of sending a drawing as a wedding present and attending their very grand marriage at St Saviour's Church in Chelsea in the summer of 1894. Within the next few years, accompanying her husband to South Africa, Violet fell in love with Sir Alfred Milner, then the High Commissioner. Edward died young and Violet married Milner. As Viscountess Milner she herself became an extreme imperialist.

With Violet married, Burne-Jones was left with Olive. She was also unusually pretty. Burne-Jones drew her and joked with her and wrote to her. He was back to his old tricks of playing one sister off against the other, keeping his letters to Olive a secret. But Olive lacked Violet's spark of originality, her uncompromising energy, and it was not the same.

With the defection of Violet Maxse, Burne-Jones's emotional life became more arid. There was still May Gaskell, with the beloved Frances Horner in the background. But May was becoming less available, preoccupied with family responsibilities, worn down by her marital struggles and her recurring but unspecified illnesses. She was living the life of the itinerant invalid, travelling around the English seaside hotels, trying out a spa hotel in Switzerland. During 1895 and 1896 she was frequently abroad and Burne-Jones found her absence hard to bear. He was now paying his debt to 'happy Fortune', he told her: 'for I had you so much, saw you so often, grew bright and happy in your delicious company so many times – and I knew the empty days would come – they are just what I knew they would be – a hunger of heart – hunger hunger – pacified by little sops of letters – but hunger always – hollow gnawing at the heart'.

Meanwhile, Burne-Jones's marriage was at an endless impasse. He looked back on married life with a gigantic weariness, writing

in 1895: 'I am so tired suddenly of all the past years – of the long years between twenty years ago and two years ago – tired as if they had worn me out.' Twenty years back had seen the final breakup with Maria Zambaco. Reaching the thirty-sixth anniversary of his and Georgie's wedding, it seemed more like the one hundred and thirty-fourth. It was not that they were not still fond of one another. But Georgie's prim appearance and rather puritanical dress sense, the throwback to her Methodist upbringing, annoyed him. Once in desperation he had gone out and bought a hat for her, 'for', he told May, 'she gets horrid hats and bonnets – Baptist bonnets and frocks she gets always – and so I circumvented her and bought a pretty one'.

Georgie had a knack, which annoyed her husband greatly, of assembling ill-judged parties of incongruous people, 'just the very people who can't get on'. He warned off May Gaskell from attending Georgie's birthday party: 'if she writes and asks you to come *please don't*'. If only his wife could guess, he wrote despairingly, 'what I should like and what I should hate'. Georgie's imperviousness to Burne-Jones's inner feelings, built up so self-defensively over the years, had now become a source of enormous irritation. He resented her attitude of holier-than-thou.

Besides, as they grew older, and their marriage lost its zestfulness, silence had descended. Georgie, unlike Burne-Jones and more like William Morris, disapproved of gossip and any talk of scandal: 'she excludes thus what might be interesting enough', he complained, 'indeed she goes too far'. He describes in a letter a depressing little scene on the train as they were travelling down from the North to London via Crewe: 'Georgie is sound asleep, nor have I anything to say to her.' He confessed to May he seldom dreamed of Georgie, 'who is always unkind in dreams'.

The balance of power in the marriage had been changing. Georgie took on more activities outside the home. Not for nothing had Georgie attended a performance of Ibsen's *A Doll's House* in 1893. Not long afterwards she wrote, 'I've been indoors most of the winter (all the evenings) and find myself looking around with very fresh eyes.' She found herself suddenly intensely interested in

the political struggles of the period and the possibilities of women's emancipation. Years before when her friend Rosalind Howard first spoke up for the equality of women, Georgie had slightly disapproved. Now relatively late in life she too had seen the light.

From the early 1890s Burne-Jones employed a secretary, Sara Anderson, who had previously filled the exacting role of private secretary to John Ruskin. 'The skill and tact with which she filled her most unconventional post at the Grange was a great help to us,' wrote Georgie with some feeling. In particular, Miss Anderson's arrival released Georgie from the paperwork involved in the running of the studio, allowing her to take a larger role in public life. Both she and Ned had been involved in the setting up of the South London Art Gallery in Camberwell, an enlightened institution that was open, unusually, on Sundays when people were not working and that aimed to spread the love of art amongst the London poor. But though Burne-Jones maintained an interest in the project it was Georgie who involved herself in the detailed administration, attending council meetings and negotiating loans of pictures for gallery exhibitions from their artist friends.

She took on a more ambitious commitment in entering local politics in Sussex. The Local Government Act of 1894, the major achievement of Gladstone's final administration, inaugurated elective Parish Councils, at the same time granting married women the right to vote in these elections. In December 1894 Georgie stood for election to the Parish Council at Rottingdean, encouraged by William Morris: 'Well now,' he wrote to her, 'I hope you will come in at the head of the poll.' Burne-Jones managed to be generous about his wife's achievements, praising the candidature letter she composed for the Rottingdean electors. 'So luminously put and simple,' he described it. He could not but admire Georgie's energy: 'She is so busy – she is rousing the village – she is marching about – she is going like a flame through the village.' Georgie won her seat on the Council, losing it the following year, but being re-elected in 1896. Burne-Jones's pride in her achievement was tempered by a certain husbandly resentment – as when he described

her leaving the Grange to attend a Rottingdean Parish Council meeting looking 'so pert and fierce'.

Through 1895 Burne-Jones was aware of looming problems with his heart. Working late in the studio, the thumpings in his heart were sometimes so alarming he was forced to lie down. In July, without telling Georgie, he went to consult a leading heart specialist, stopping off at the Athenaeum on the way home to send a semi-reassuring letter to May Gaskell: 'it is all right about the heart throbbings – they may bang themselves about as much as they like – the heart is all right, only some mechanical difficulty that will go when more strength comes'.

More immediately worrying was a fast deterioration in the health of William Morris. A danger sign came early in 1896 in the middle of a Sunday breakfast at the Grange when Morris started leaning right over the table, his forehead on his hand, in a state of semi-collapse. Over the next few weeks his condition fluctuated and Burne-Jones was writing, 'Morris has been ill again – I am very frightened – better now, but the ground beneath one is shifting, and I travel amongst quicksands.' As Morris was declining, Burne-Jones was in the final stages of his painting *The Dream of Launcelot*, a gloomy, ghostly, almost surreal version of the fourth of the *Holy Grail* tapestries. The painting of Launcelot collapsed in a deep slumber, in his armour, at the entrance to the San Graal chapel bore poignant memories of Rossetti who had taken the same subject for his mural at the Oxford Union, a painting now sadly faded and decayed.

It was Burne-Jones's turn to take Morris to the doctor. By 21 February 1896 Morris was suddenly seeming so much worse that Burne-Jones was seriously alarmed and telegraphed Sir William Broadbent, the best-known consultant of his day, physician in ordinary to Edward Prince of Wales, physician extraordinary to Queen Victoria, requesting an immediate appointment. Burne-Jones escorted Morris to Broadbent's spacious consulting rooms in Brook Street, where the royal physician spent three-quarters of an hour examining the revolutionary Socialist. He confirmed that

Morris suffered from diabetes amongst other complications. 'He is ill and the tendency is bad – but things have not yet gone so far as to feel alarm – only his nursing and way of life must be rigid,' as Burne-Jones reported Broadbent's verdict. He concluded, 'better than I feared – not quite so good as I hoped'.

As Morris was declining, the great Kelmscott Press *Chaucer* was in its final stages. Burne-Jones had finished the last of his designs over the previous cold wet Christmas at Rottingdean. He was by this time feeling much more confident about the nerve-racking processes of translating his drawings into wood engravings: 'they are going better and better; we've got into the way of it by this time; that is the best of a big piece of work'. By the end of January, with the final pages going through the presses, all his work was done except for looking through the proof sheets: '12 more designs are yet to come and then the last sheets will be folded.'

But he was still anxious about the final outcome of the project in which his own contribution was so crucial: 'Finishing is such nervous work,' he confessed to Thomas Rooke in April. 'I don't get irritable but nervous beyond all telling. Oh, what a time I've had! Nearly cried on Saturday.' Finally in May, when the printing was completed, he felt unburdened and light-hearted and drew a quick cartoon, a biblical pastiche inscribed 'Bless ye my children', showing Morris and Burne-Jones embraced by Chaucer in a halo, looking infinitely satisfied.

The Kelmscott *Chaucer* was published on 26 June 1896. 425 copies were printed on paper with 13 special vellum copies. Burne-Jones had managed to acquire an advance copy, bound in the white pigskin cover that Morris had designed, as a present for his daughter Margaret on her birthday on 3 June. He played one of his childlike jokes on her by handing her a bulky shapeless parcel from which the resplendent volume emerged as a surprise. Just a few weeks later he was travelling through London at high speed in a cab when 'something glorious flashed out of a shop window right into the cab'. He just had time to see it was the *Chaucer*. The story as he told it has the resonance of one of William Morris's fantasy novels of the 1890s, the magical ending of the quest.

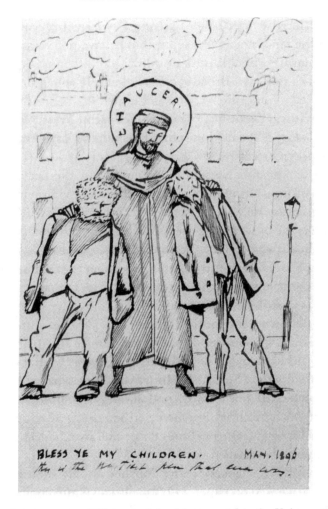

BLESS YE MY CHILDREN. MAY, 1896

Burne-Jones cartoon of Chaucer giving his approval to the Kelmscott Press
edition of his works.

Morris, as was his way, seemed to lose interest in the *Chaucer*
once it had been published. Burne-Jones, more retentive, could
not just abandon it. He kept on turning the pages and gloating
over them, the grandeurs and the subtleties: 'It doesn't matter
whether it's a picture or a page of print, they're equally beautiful.'
Part of his feeling was of course the fact of the *Chaucer* having
been such a joint venture and now almost certainly their last big

466

project. 'I have worked at it with love,' he told Morris's friend the bookman F. S. Ellis, 'and was almost as sorry as glad when the work was done'. He and Morris had signed a joint dedication in the copy they gave Swinburne and the now almost agonised memories came back: 'When Morris and I were little chaps in Oxford, if such a book had come out then we should just have gone off our heads, but we have made at the end of our days the very thing we would have made then if we could.'

While the Kelmscott *Chaucer* was in its final stages, Burne-Jones, rather against his better judgement, had started a new series of illustrations for the Kelmscott Press. This was for the planned edition of Morris's epic poem *The Story of Sigurd the Volsung and the Fall of the Nibelungs*, his own version in anapaestic couplets of the heroic tales from the Icelandic *Volsunga Saga*. Morris's *Sigurd*, first published in 1876, had done much to arouse British popular interest in Nordic culture. The Kelmscott Press edition, first announced in autumn 1895, was pre-advertised as containing twenty-five illustrations, an optimistic figure later increased to forty. Burne-Jones was beginning his design for *Sigurd Slaying the Dragon* in January 1896.

Even Georgie admits in her memoirs that the drawings for Sigurd were the only piece of work he ever undertook with Morris 'without his heart being in it'. This was partly a matter of the north vs south divide, Morris's enthusiasm for the barren Icelandic wastelands versus Burne-Jones's love of sultry Italy. Nor was Burne-Jones attuned to saga literature in the way he was to Chaucer. Its brutal histrionics alienated him. Technically speaking he found *Sigurd* a problem, lacking scenes and characters that were obviously suitable for illustration: 'I have got to make up my mind what each chap is to be like before I begin – must make a kind of ground plan first of all. There are five or six important subjects that are all very well, but some are quite impossible.'

The pullulating battle in the hall of Atli posed particular problems. Burne-Jones puzzled over how to get that 'fighting struggling mass of men into a few inches of illustration space'. Beyond this was the unremitting violence of the Sigurd story which threatened

467

to envelop him: 'glorious it is – but grim and grisly, and I wish it was over', he admitted. It seems as if he only struggled on with it in an attempt at cheering William Morris up.

Through the summer of 1896 Burne-Jones was tense and grumpy. He was unexpectedly upset by the death in May of old Alfred Hunt, the Corpus Christi fellow and theologian who had turned to painting, drawn in by the Pre-Raphaelites. Burne-Jones registered Hunt's death as another lost link with those sacred Oxford days. He was wholly disapproving when he visited the National Portrait Gallery in its new building off Trafalgar Square, calling it 'a pokey hole' and judging that, with the exception of the portraits by G. F. Watts, 'a dreadful lot of things they have there. His are the only things that have any pretensions to be art at all. The rest aren't much above the level of Madame Tussaud's. A great deal too much Royal Family there is.' By July Burne-Jones describes himself as 'caving in a bit', desperately anxious about Morris's condition, feeling constantly giddy and sick.

Neglecting his own work, he had taken the now enfeebled Morris on little expeditions, trying to stimulate his interests. They went together to the Society of Antiquaries to look at English manuscripts and Morris was delighted to find the Windmill Psalter, from which he himself had four fine pages in his manuscript collection at home. Early in July, while Morris was staying in the Norfolk Hotel, Folkestone, dispatched there to take the sea air by his doctors, Burne-Jones went across from Rottingdean to visit him, returning with his heart 'full of misgivings'. If Morris were taken from him, he said, he would feel as if a limb had been removed.

Sir William Broadbent had also recommended a sea voyage and finally, unwillingly, Morris set off with a Socialist friend, John Carruthers, on 22 July for an unutterably gloomy month-long meander around the fjords of Norway in the cruise ship SS *Garonne*. When he returned Burne-Jones could see that he was worsening. 'The voyage has done him more harm than good,' he told Eleanor Leighton, 'and complications have come and we are

all alarmed, even the most hopeful of his friends . . . I go about wretchedly and see no consolation. He looks so ill, with a certain look in his eyes I have learned to dread.'

Morris had by now developed lung problems, which proved to be tubercular. Congestion of the lung set in. It was clear to Burne-Jones that he would never come to the Grange again on Sunday mornings and he began to visit Morris at Kelmscott House in Hammersmith in a reversal of their old routine. Kelmscott House became a house of heartbreak through September as Morris weakened further. By Wednesday 1 October it was clear the end was near. Burne-Jones wrote to George Howard: 'I don't think there was much pain ever – but the weakness was pitiful and for the last day or two I don't think he knew us. A loving band of friends nursed him and sat up with him at night always.' Ned and Georgie alternated their visits, Georgie going in the mornings and Ned in the afternoons.

Georgie was with him when he died on Friday 3 October. Burne-Jones was quickly summoned and Morris's young secretary Sydney Cockerell, himself convulsed with tears, took him in to see the body. Cockerell was later to describe how 'Burne-Jones became quite unhinged at Morris's death', going down on his knees and weeping at the bedside. When Emery Walker, who was also deeply affected, helped him up he leaned forward to kiss Morris. It was a kind of death for him as well for, as he saw it, 'all their ideas and plans and work had been together all their lives'.

He braced himself to go to Morris's funeral at Kelmscott, accompanying the coffin on the train from Paddington to Lechlade with a sad group of his close friends and associates. It was a terribly wet day building up towards a tempest in the afternoon. The mourners followed the coffin, now transferred to a farm wagon drawn by a dappled grey carthorse in a clanking harness, along the dripping lanes to the little Kelmscott church, where there was a simple service. The rain stopped for a few minutes as Morris's body was lowered into the country churchyard grave. Burne-Jones, as his oldest and closest friend, stood at the head of the grave supporting Janey. His mixture of responsibility and grief

strangely altered his appearance. Jack Mackail noted his impressions of 'E B-J standing by grave with Mrs. Morris, seemingly 6 feet high and broad-proportioned – like St. George'.

For Burne-Jones, who had attended so many recent funerals, Morris's funeral seemed like the ideal, quiet and full of meaning where Tennyson's and Leighton's had been flatulent. 'The burial was as sweet and touching as those others were foolish', he told May Gaskell, 'and the little wagon with its floor of moss and willow branches broke one's heart it was so beautiful – and of course there were no kings there – the king was being buried and there were no others left.'

Burne-Jones resisted all requests to write obituaries of Morris, feeling he had known him so well that any account he gave would lack the necessary detachment. When he received an invitation from Morris's old colleagues in the Social Democratic Federation to attend and speak at a memorial meeting at Holborn Town Hall, it was Georgie who responded that 'of course' this would be 'quite out of his power', asking Sydney Cockerell to send an apology. Within a few days of the funeral at Kelmscott Morris's biographer had been appointed. He was the Burne-Joneses' son-in-law, Jack Mackail.

Burne-Jones himself felt his best memorial to Morris would be to return to his work with a new energy. He 'flew at his work' in a post-funeral frenzy that Georgie found alarming. The first task he gave himself was the drawing of two cartoons for stained glass for St Cuthbert's Church in Newcastle, one of *Daniel lamenting his son Absalom*, the other – *Daniel Consoled* – showing the bereaved Daniel 'making up his mind to it and pulling himself together'. The subject of grief and its assuagement was not a coincidence. Burne-Jones had chosen the two linked subjects specially. *Daniel Consoled* was started and finished in a single afternoon.

It was just a little later that Burne-Jones started working on the finest of all his designs for stained-glass windows, the *Last Judgement* for St Philip's Church in Birmingham. Burne-Jones the medievalist and Gothicist was violently prejudiced against the early eighteenth-century church building with its row of upper

galleries: 'what a church is that of St. Philip's contemptible and shocking, only fit for a public library – into which they should turn it'. But in a mood of sudden generosity he more or less donated the *Last Judgement* to Birmingham, charging only a nominal design fee. Now, after the loss of Morris, he was conscious that this was more or less his last stained-glass design: 'everything has to finish up some day or other, and I don't think any time can be more appropriate than now'.

Essentially Burne-Jones's greatest window shows:

Christ in white, seated in Judgement at the top, surrounded by a host of Angels in red, with red wings; in the C. an Angel blows the Last Trump; below their feet, cities and buildings falling in ruins; below again, the dead standing upon their graves, in red, blue, green and white.

Evocative as this description is, it gives no true impression of the extraordinary impact of this window, its almost Expressionist quality of movement, the fluency with which the design spreads right across the whole surface of the glazing, the relationship between the stained glass and the architectural masonry that frames it. Light shines out of darkness. It has something of the power and coherence of a vast symphonic poem.

Nor does the bare description of the window convey the richness and density of colour, as splendid as anything Morris & Co. had yet achieved. Burne-Jones had always had his reservations about the quality of Morris's stained glass, urging him to try to achieve more depth of colour. He had sometimes entreated him to set up his own furnaces, become more independent. Now in Morris's absence there had been nothing for it but for Burne-Jones himself to go to Merton Abbey to supervise the colour, negotiating carefully with Henry Dearle, the one-time workshop supervisor now advanced to Morris & Co.'s principal designer, a notoriously proud and touchy man.

Merton had become a 'ghost-ridden' place to him. In Morris's lifetime he had never gone alone and now his heart sank at the prospect of a day there. But, keeping faith with Morris, for the next two years he persevered. And with these final stained-glass windows Burne-Jones achieved something of quite another order

from the sweetly tentative stained glass in the early Bodley churches or the splendid but more formal single-figure windows of his middle period at, say, Jesus College Chapel in Cambridge or All Hallows Church at Allerton near Liverpool.

The Birmingham *Last Judgement* is suddenly quite different and it heralded a new evolution of stained glass as an art form in the coming century.

Avalon
1897–8

As Burne-Jones withdrew into a kind of world apart, his epic work *The Sleep of Arthur in Avalon* became his great preoccupation. He had hardly been able to confront it over the dreadful months of William Morris's gradual deterioration. 'Avalon gets to look vile,' he had complained. The painting of the once-majestic figure stretched out on the bier came just too close to his own grief and over the summer of 1896 a few little studies for the details of the picture, made in tints of gold on coloured grounds, had been as much as he could achieve. But after Morris's final illness and the funeral Burne-Jones returned to *Arthur in Avalon* with a refocusing of energy that grew into an obsession. George Howard had long ago relinquished all claim to the painting he originally commissioned in the early 1880s. Burne-Jones did not now ever expect to sell it. But he had come to regard his work on this vast painting, a last homage to Malory and a memorial to Morris, almost as a sacred charge.

He had begun *Arthur in Avalon* more than twenty years before with the idea of putting into it all that he most cared for. The subject is the final scene and prophetic climax of Malory's *Le Morte d'Arthur*: 'Some men yet say that King Arthur is not dead, but had by the will of our Lord Jesus Christ into another place; and men say that he will come again'. The mortally wounded King has been transported by three queens to the magic island of Avalon, where he now lies in a trancelike state awaiting his potential summons to return.

The scene has the eerie feel of suspended animation peculiar to Burne-Jones and in this vast painting more pronounced than ever. In this hallowed isle King Arthur sleeps within a golden tomb, whose rich metallic roof derives from the Pala d'Oro at St Mark's in Venice and the shrine of St Simeon at Zara. In Burne-Jones's own 'sacred land' of the Arthurian it is no accident that the King's tall, willowy, pensive attendants are all female. The *Avalon* painting is the ultimate expression of his own life's quest for love.

Originally the painting was planned in triptych form with two side panels containing other visual elements. A gathering of Hill Fairies listening to the music of the attendant queens is mentioned in Georgie's memoirs. According to the artist these were to have been 'he-fairies and she-fairies, looking ecstatic and silly and very uncombed'. A pitched battle in progress behind the rocks to the right of the picture was apparently another possibility. But these were – perhaps fortunately – dropped in favour of the concentration of theme and relative simplicity of composition that gives the painting its hypnotic quality. The scene is focused inwards. Only the mysterious black-hooded figure in the corner with the mirror, that favourite Burne-Jones method of providing depth within depth, reflects the scene of mourning back towards the world outside.

'When I begin to colour this it shall be like tapestry colour.' Burne-Jones's comment, thrown out as he was arranging the draperies on two of the models for the figures kneeling in the front of Arthur's tomb, is pertinent because in some ways his *Avalon* painting cries out to be a tapestry, rivalling Burne-Jones's *Holy Grail* tapestries in its narrative ambition and scale. It is in fact a painting in which textiles figure prominently in the flow and texture of the draperies, effects that had taken great efforts to achieve. Burne-Jones recalled that the clothing on his models for the Arthurian queens had been 'designed under circumstances of great misery – to wit, the actions were difficult, and the models desired to faint'.

Also tapestrylike is the hieratic quality of the human figures. In spite of the fact that the figures were modelled from real people,

some as close to Burne-Jones as May Gaskell, who modelled the head of one of the watchers, or his daughter Margaret, the model for Morgan le Fay in whose lap King Arthur's head is laid, these are all symbolic, ideal 'types' of women. As Burne-Jones pointed out while he was painting the three queens, Queen Morgan le Fay, the Queen of Northgalis and the Queen of the Wastelands, 'They are queens of an undying mystery and their names are Lamentation and Mourning and Woe. A little more expression, and they would be neither queens nor mysteries nor symbols, but just – not to mention baser names in their presence – Augusta, Esmeralda and Dolores, considerably overcome by a recent domestic bereavement.'

This painting is Burne-Jones at his most romantic, poetic and abstracted. The whole concept and his way of treating it negates the possibility of human littleness. It is anti-materialist and supra-politics. *Arthur in Avalon* pours scorn on the commercial values of the art market in its very unmarketability. Burne-Jones worked on it year after year. Visitors to the Garden Studio were aware of the great canvas endlessly in progress. He worked on it oblivious of any deadline, once announcing that he did not expect to finish it till circa 1970.

Death and desolation seemed sometimes all around him. The great old artists of the earlier generation were declining. He was haunted by the memory of meeting Millais, his West London neighbour, in Kensington High Street. Millais was looking broken down in health and 'very wretched'. He said he had been crying. Burne-Jones took him off to visit the Mackails and their children in the house in Young Street, just around the corner, in an attempt to comfort him, apparently so successfully the children thought that Millais was 'a new cheery doctor' arriving to examine them. Though he still loved Millais, counted him his friend, Burne-Jones privately now shared in the general critical feeling that Millais had sold out to commerce in the latter part of his career. 'Has anything come over Millais I wonder, that he has so utterly gone to pieces,' he had written after seeing the four paintings Millais exhibited at the Royal Academy in 1894: 'what has happened – it is like

sending dishonour and how splendid the opening of life was for him'.

Millais was suffering from throat cancer. As his condition worsened Burne-Jones managed to obliterate this later disillusionment and recapture his early admiration for a Millais whose work seemed to him so marvellously iconoclastic and original. 'I grizzle a good deal over Millais,' Burne-Jones was admitting in 1896. 'He was such a hero to me when I was young – seemed like one of the celestials – and I did not want to be reminded that he is mortal.' Part of all this sadness was the memories of Ruskin and Millais's chivalric but morally ambivalent role in rescuing Effie from an arid marriage. Burne-Jones had started a drawing of her husband intended as a gift for Effie when Millais finally died in August 1896.

With Millais's death only one member of the original Pre-Raphaelite brotherhood remained, a surprisingly spry Holman Hunt, still hardly going grey at the age of seventy. 'He looked such a dear, fine old thing, so unworldly and strange,' said Burne-Jones after he and Georgie dined with the Hunts in Melbury Road in April 1897. Arthur Hughes was there as well. Holman Hunt took Georgie into dinner reminding everyone she was now his oldest friend.

Millais's death created a vacancy at the Royal Academy. He had succeeded Leighton as president out of a sense of duty after Leighton's own death in January 1896, when his much-quoted last words had been 'My love to the Academy'. Millais's tenure had been brief and now Burne-Jones's brother-in-law Edward Poynter had his sights on the presidency.

Despite both having married a Macdonald sister, the two Edwards were in most ways total opposites. Poynter, great-grandson of the neoclassical sculptor Thomas Banks, son of the architect-scholar Ambrose Poynter, was born into the Victorian art establishment. Unlike Burne-Jones, whose formal training had been minimal, Poynter began his training as an artist when he was fourteen with periods in Paris and Rome as well as at the Royal Academy Schools.

Although, like Burne-Jones, Poynter's work was broadly based in the decorative arts and in early days he too designed stained glass for James Powell and Sons, he soon became best known for large-scale meticulously detailed oil paintings.

Both were in their ways painters of dreams. But while Burne-Jones's visionary narratives dealt in the abstractions of psychological meaning and spiritual depth, Poynter's expertise lay in his apparently authentic recreations of classical and mythological scenes. *Atalanta's Race* of 1876; *Nausicaa and her Maidens Playing at Ball* of 1879; *A Visit to Aesculapius* of 1880: such paintings, all exhibited at the Royal Academy, combined dramatic classical action with gentle sexual titillation. Poynter's most ambitious painting, *The Visit of the Queen Sheba to King Solomon*, with a cast of over fifty figures, was completed in 1890 and has, rightly, been compared to the twentieth-century extravaganza movies of Cecil B. DeMille.

Meanwhile Poynter was set on a career of intrepid upward mobility. He had been appointed first Slade Professor at University College, London. He became the Principal of the National Art Training School at South Kensington in 1875, administering the government art training system. At this point Burne-Jones had commented sarcastically: 'Mr. Poynter has just been made head of the South Kensington affair so that the future art of this country now depends on him.' Then in 1894 Poynter had been made Director of the National Gallery, succeeding Sir Frederic Burton.

Two years later, he was successfully elected President of the Royal Academy, only the second man in history, Sir Charles Eastlake having been the other, to hold both these key positions simultaneously. In 1896 Poynter was knighted, eliciting the comment from his nephew Rudyard Kipling 'The Lord has hit Uncle Edward hard for his knighthood. He is an ex-officio member of about every utterly uninteresting society in England and spends his evenings eating with bores.'

Burne-Jones's reaction to his brother-in-law's rise was characteristically ambivalent. He had enough family feeling to be helpful where he could. He had supported Poynter's appointment to the

National Gallery, asking Mary Drew to intervene with her father, William Gladstone, on Poynter's behalf: 'the fact of his being a connection of mine does not come in it', he told her, 'and indeed is it human to call a brother-in-law a relation at all?' He stressed Poynter's best points: 'he is a good man of business, has a great knowledge of ancient art, indeed I think he has no superior in that science – and of modern too – moreover he is a most conscientious fellow and laborious and painstaking beyond words in all that he does'. When Poynter became President of the Royal Academy Burne-Jones seems to have been genuinely pleased, writing to Mary Elcho at Stanway: 'this morning's news about Poynter I am very glad of. He is the best man for the place, and it will please him.'

But in private Burne-Jones found Poynter anathema. In personality as in art they stood in total contrast. A perspicacious child said she 'always wondered why Sir Edward Burne Jones looked so cheerful and Sir Edward Poynter so sad'. It seems that the tall, bearded, dour and self-important Poynter lacked any sense of humour. Impossible to imagine him scribbling off an equivalent of Burne-Jones's witty *Unpainted Masterpieces* self-caricature.

For Burne-Jones, Poynter's 'dull excellencies' proved insuperable. 'I could sob, after an evening with him,' he wrote confidentially to Frances Horner, 'at the general discouragement of things that his very atmosphere brings – merely to be in the same room with him is to lose hope of salvation.'

He could not make out 'why Poynter ever wanted to paint nor why he gets up in the morning'. His highly successful brother-in-law remained a mystery to him.

Besides working on his great thematic paintings *The Sleep of Arthur in Avalon* and *The Car of Love*, Burne-Jones was now making an effort to complete other paintings started in the past and then abandoned. He worried unnecessarily about his income, in the way old people do, and was anxious not to burden Phil and Georgie with unfinished and unsaleable work after his death. One of the paintings he returned to was *Love and the Pilgrim*, a picture

begun in the middle 1870s, based on the quest for perfect love, as symbolised by the mystical heart of the rose.

He worked on it through the spring of 1897 so that the painting could be shown at the New Gallery in April. For much of the time he was terribly unwell: 'Caught chill, in bed, chill turned to influenza, influenza to melancholy, melancholy to despair, despair to coming back and beginning work again, the only remedy for all ills.' There had been a plan that once *Love and the Pilgrim* was completed he, Phil and Georgie would make an expedition to France together. He had not seen the great cathedrals of Beauvais and Chartres or the church at Abbeville since his tour in 1855 with William Morris, and from Rottingdean the coast of northern France looked tantalisingly near. But he was so exhausted and unwell that instead of France his doctor sent him off to Malvern to recuperate.

In May 1897 he and Georgie spent a dismal week in a hotel. Burne-Jones was resistant to hotel life in principle: 'I always dislike living in hotels', he said, 'and the lives that people lead in them are so different to anything I can imagine.' It seems that this hotel was particularly uncongenial, with not a single picture to be seen. The doctor had recommended bracing walks on the Malvern Hills but the weather was unusually cold for the time of year and he spent his days marooned with Georgie in their hotel room, 'in the worst of evil moods – fuming and raging'. He sat in a chair and glowered at the empty walls. The view from the window of the architecturally horrible new town of Malvern upset him even more. The meanly built red-brick houses all had shiny new slate roofs: 'here be 10,000 of them glittering away like sardine boxes as I look out of my window'. Malvern's townscape seemed to him a negation of beauty, an example of the ruination of the country he and Morris so much dreaded. He wrote to his doctor urgently, begging for permission to return to Rottingdean.

Rottingdean was still his favourite retreat. Once released from Malvern he brightened rapidly on the long railway journey south. Georgie describes him as positively merry as they travelled across

London, taking a four-wheel cab from Paddington to Victoria where they ate a memorably delicious lunch in the station restaurant. By the time they reached the village he no longer seemed an invalid at all.

The weather on the south coast was still blustery but they arrived at North End House to find the little garden flourishing, scented with sweet briar, full of irises and bluebells, borage, periwinkles, thousands of forget-me-nots. Burne-Jones, in frail old age, was more susceptible than ever to the look of country things: a blackbird's egg in a nest; apples seen against a clear blue sky. 'The little house always touches me with its innocence,' he writes. Then beyond the house and garden was the wild rough sea.

North End House had entered a new phase as the gathering point for the extended families of Georgie and her sisters as the Mackails, Baldwins, Poynters and Kiplings converged on Rottingdean for the summer holidays. 'I think this little house is made of india rubber so readily did it stretch,' Burne-Jones wrote in that summer of 1897. His small granddaughter Angela Mackail counted twenty-one visitors, some in the house, others lodged around the village. Still vivid in the memoirs that she wrote in middle age is the image of Georgie watching from the large middle window to spy out new arrivals. By the time they rang the doorbell she would be standing ready to greet them just inside the front door, 'a little, very upright figure, in sweeping skirts, arms stretched wide and saying "Welcome"'. In anyone else this might have seemed a bit theatrical. From her it had the ring of absolute sincerity.

There were now three Mackail children, with Nanny, to be welcomed: Angela aged seven, Denis who was five and Clare still a baby, born in 1896. The precocious Angela, nicknamed by her cousins 'AKB' for 'Angela Knows Best', was her grandfather's favourite by far, his very greatest pet. He had worshipped Angela since she was a baby 'plunging and kicking fat legs and foolish woollen feet into the air' and saying 'Yah'. When she started tentatively to walk and talk his delight in her increased: 'SHE calls "puppies" muffins,' he confided in another little favourite, Katie Lewis, 'and I am so pleased I don't know what to do.'

Now as she grew older he indulged her by writing her wonderful illustrated story-letters, as he had done for his own children. He painted a guardian angel on the whitewashed wall at the foot of her bed in the children's little attic night nursery at North End House. In the day nursery was her grandfather's fantasy landscape of a watermill with its large wheel reflected in the millpond: the evening light in this little mural was said to be 'the light of Avalon'. On another wall he painted a peacock in a tree for Angela, its long tail cascading down beneath the leaves. Finding Angela disconsolate in the 'punishment corner', having been placed there by her irate Nanny, her 'Papapa' got out his paintbox and painted a cat, a kitten playing with its mother's tail and a flight of birds to entertain her whenever Nanny punished her again.

Burne-Jones's extraordinary ability to relate to a child's mind reached its apotheosis with Angela the bookworm, J. M. Barrie's god-daughter, whose powers of absorption struck her family as being as great as Rudyard Kipling's when he was a boy. Burne-Jones, responding to her brightness, drew her into his own world of contrariness and quirkiness, planning to make Angela a history as he would like history to have been, with 'Cromwell's head cut off and Louis XIV's instead of the other one's and Nelson happily married to Lady Hamilton'. His loving rapport with sophisticated little Angela gave him a renewed interest in life.

Angela repaid Papapa's attentiveness. It is from her clear-eyed descriptions in *Three Houses*, her 1931 reminiscences, that we get the most vivid impression of life at North End House in the middle 1890s, in its inimitable combination of austere discomfort and Pre-Raphaelite romanticism. This was a place in which the summer house was furnished with a wooden table and queer curved wooden chairs 'suited to no known human body' that had been originally designed by Burne-Jones for the Knights of the Round Table in the *Holy Grail* tapestries. This was the house from which Lady Burne-Jones would issue forth on her 'cottage visits' to preach socialism to the local peasants, sometimes taking Angela with her:

There was no condescension in her visits and no familiarity, though the child who accompanied her was ready to cry with confusion as she sat with her large blue eyes fixed on some gnarled unlettered old woman, telling her tidings of comfort from *Fors Clavigera*.

The Burne-Jones granddaughter already showed the sharp observation of the novelist she would become.

Rudyard Kipling and his wife Carrie had returned from America in 1896. They settled temporarily in Devon, then gravitated back to Rottingdean with their two small children Josephine and Elsie. They too were made welcome at the 'india rubber house' while Carrie awaited the birth of a new baby. She, like others, found North End House lacking in facilities: 'the house is beyond words inconvenient there is no bathroom, the nurseries are on the 3rd floor the kitchen a cellar really in the basement'. A son, John, was born in August and the Kiplings moved in the following autumn to a rented house, The Elms, on the Rottingdean common just across from North End House.

Burne-Jones had been ecstatic at Kipling's reappearance. 'O my beloved Ruddy,' he had written, welcoming him back: 'So tomorrow to little Rottingdean, to laugh and roar and throw care to the dogs – which is a beast I hate.' The tall, wispy, almost ethereal-looking artist, the short thickset writer with bushy black eyebrows and keen alert eyes: in spite of their age difference the two of them got on extraordinarily well.

Kipling described how, after he returned, he and Uncle Ned had 'browsed about in couples' on the Sussex coast. 'It has been joyous and refreshing – a lift to me that I shall never forget. The things that that big man does not know, and cannot help in, might be written on a postage stamp. Just now we are deep in the Roman occupation of Britain (this with an eye to stories) and he sends me volumes on volumes; but one talk is worth libraries.' The frequent presence of Crom Price at North End House brought an added piquancy to the reunion. Sydney Cockerell's diary records an evening when Kipling read aloud his new school story 'In Ambush' in the presence of his one-time Westward Ho! headmaster.

By the middle 1890s Kipling was already a prolific and a celebrated writer. *The Jungle Book* was published in 1894 and *The Second Jungle Book* the following year. Kipling's *Just So Stories*, the first of which were published in 1897, had their origins in stories told to his daughter Josephine and to the Burne-Jones grandchildren while he was at Rottingdean. In Angela's opinion the printed version was 'a poor thing' in comparison with the fun of hearing these stories in the nursery, 'told in Cousin Ruddy's deep unhesitating voice'.

Kipling's best-known poem 'Recessional', a poem that roused the nation to the heights of patriotic fervour, was written in the summer of 1897 while the Kiplings were living at North End House. He had finished a poem for the Diamond Jubilee but, dissatisfied with it, had consigned it to the wastepaper basket where, on 16 July, it was discovered by Sally Norton, Charles Eliot Norton's daughter from America who was spending the summer with the Burne-Jones family. The poem was retrieved and there was then a family conference. Georgie supported its publication. After Kipling had made a few minor revisions, she and Sally took the poem to London that same afternoon and sent it across to *The Times* by express messenger. It was printed in the newspaper the following day.

Burne-Jones's response to 'Recessional' was at first enthusiastic. He wrote a note to Ruddy: 'I love your Hymn', he said, 'it is beautiful and solemn and says the word that had to be said.' He sent a copy to Mary Drew, asking her to let her father see it. He assumed that Gladstone did not take 'that odious paper' *The Times*.

But just a little later, as the poem with its all too potent catch-phrase 'lest we forget' became the hymn and battle cry of jingoistic politics, Burne-Jones had second thoughts. Much as he loved his nephew, he and Georgie came to distance themselves from Kipling's increasingly pro-imperialist stance.

Another family outpost was The Dene, a substantial house on the village green at right angles to North End House. This was the house where Cissie, Stanley Baldwin's wife, had been brought up and

where her mother and father, Edward Ridsdale, a retired master of the Royal Mint, resided. Stan had originally been attracted by Cissie's 'absolute innocence and unworldliness'. There was a lot of innocence in Rottingdean.

Amongst the Baldwin family papers in Cambridge University Library is a bizarre object packed up in a brown envelope. It is a little shapeless sackcloth garment with leg holes and blue buttons down the front. Enclosed is a letter to Stan from Burne-Jones:

At lunch to-day I suddenly thought that perhaps one day you might have a Baby. I don't know why I thought of it but I did and I grew anxious clothing should be in time – women are so dilatory. So I went down the village and bought a sack at Champions and bought trimming at Reed's and Margaret by my instructions has made the coat.

This kindly joke misfired, for the Baldwins' first child, a son, was stillborn in 1894.

However, by 1897 three Baldwin daughters, Diana, Lorna and Margot, had arrived. The family lived in Worcestershire where Stanley managed his father Alfred Baldwin's ironworks at Wilden as well as making his start in public life, taking part in local government and supporting his father who was Bewdley's Conservative MP. Each summer he transported the whole family to Sussex, arranging a special slip coach that was shunted from Stourport to Brighton with the Baldwin babies, their nannies and the luggage. The Ridsdales built on a new wing at The Dene to accommodate the now fast-growing family. In spite of the notoriously tactless comment of G. M. Young, Baldwin's official biographer, that 'there was not much passion in their mating', three more children were born to Stan and Cissie in the next five years.

These Rottingdean summers settled into a routine as the Burne-Joneses' grandchildren, great-nieces and great-nephews all assembled. There were morning processions of nannies and perambulators moving through the village on their way down to the beach led by Nanny Mackail in her summer uniform of 'stiff white piqué and severe straw hat', Angela walking along beside the pram with her green shrimping net and a shilling for Bath buns. An

annual picnic was held on the Downs to commemorate the marriages of Margaret and Jack Mackail and Cissie and Stanley Baldwin, both of which had been held in the church at Rottingdean. A farm wagon drawn by a lumbering carthorse was hired for the afternoon into which all the children and nurses were loaded with big hampers of food. The children had the task of writing verses for their parents, for example:

Beautiful Cissie and Stanley bold,
Seven long years have not made you seem old.

Burne-Jones himself would decorate a special cake for the anniversary of Margaret's wedding, outlining a picture of the church and landscape and tinting it in colours on the flat smooth icing-sugar top.

The children liked to creep into the church, which at that time of year was hung with fruit and flowers for the harvest festival. There was always a great sheaf of corn beneath the pulpit. Because the little church contained so many of their grandfather's stained-glass windows the Mackail children viewed it as an extension of their own home life. As well as the original windows for St Margaret's, designed in 1893 and 1894, there were two additions in 1897. Once again Burne-Jones donated the designs for the village church of which he was so fond.

These were for two tall lancet windows in the chancel. One design is *Jacob's Dream*, a vision of angels in perpetual motion on the ladder up to heaven. The other shows *The Tree of Jesse*. The gnarled branches of the tree twine up around the figures, exploiting the window's perpendicularity. The colours are refulgent. These windows have the marvellous energy and fluency characteristic of Burne-Jones's late stained glass. He himself would have liked more leeway in expanding his Jesse Tree. He wanted a vast space for it: 'it is the kind of thing that would be glorious spread over an acre of glass'.

Phil's room was kept ready for him at North End House. It was awkwardly placed, forming a kind of passageway between the

original Aubrey House and Prospect Cottage that the children were often tempted to dash through, invasions which Phil found irritating when he and Ambrose Poynter made occasional week-end visits to the family. When he came to Rottingdean he would be moody and erratic, sometimes wonderfully charming, sometimes edgy and vindictive. His niece Angela concluded that 'Phil had many gifts and great depths of affection, but he was a very unhappy man'.

Phil had been drifting through the 1890s, trying out modes of existence, none entirely satisfactory. There had been his country-cottage phase, then he had moved temporarily to Brussels. He was still addicted to country-house weekends. His correspondence tended to come from grand addresses: Stanway for example, the British Embassy in Paris, Hatfield House. His rootlessness was worrying to both his parents, Georgie writing confidentially to Charles Eliot Norton in 1897, 'He remains a very loving son and is also a strongly marked human being, and I have learned many lessons from this fact. He does not seem ever to think of marrying – and we would not think of urging him to do so – but when I think of the lonely old age it means for him I feel sad sometimes.'

If Phil was not contemplating marriage he was certainly prone to rather juvenile *grandes passions*. The famous actress Mrs Patrick Campbell, friend of his sister Margaret, was one of his attachments. To some extent she encouraged him but then she threw him over. Phil took a cheap revenge in his painting *The Vampire*, a large and lurid oil showing a shameless woman lurched over her victim, a dead or half-dead male laid out on a bed. The woman is easily recognised as Mrs Pat.

Georgie wrote loyally to Eleanor Leighton about Phil's latest painting: 'His father is pleased at the power it shows. It is a gruesome subject – "a vampire" – but I hope you will see it at the New Gallery.' The painting was hung in the same 1897 exhibition as Burne-Jones's own *Love and the Pilgrim* with accompanying verses by Phil's cousin Rudyard Kipling in the catalogue.

Phil's melodramatic *mise-en-scène* was in fact a travesty of his father's artistic philosophy of love and beauty, lacking the sense of

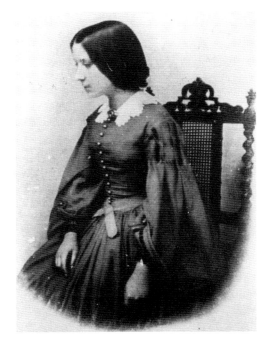

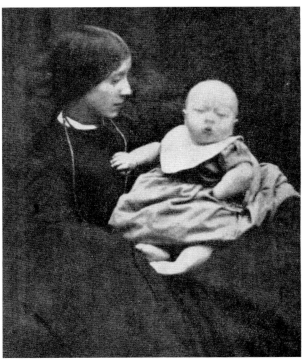

1 Fifteen-year-old Georgiana Macdonald at the time of her engagement to Edward Burne-
Jones in June 1856.
2 Georgiana Burne-Jones with baby Philip, 'Pip', who was born in 1861.

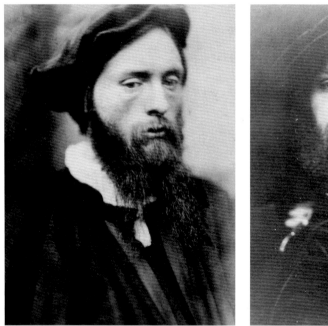
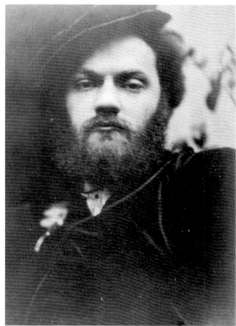
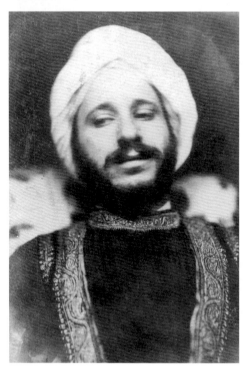
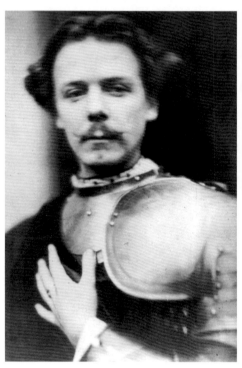

3 Edward Burne-Jones in Renaissance dress, photographed by David Wilkie Wynfield, 1860s.
4 Valentine Cameron Prinsep in costume, photographed by David Wilkie Wynfield, 1860s.
5 Simeon Solomon in Eastern dress, photographed by David Wilkie Wynfield.
6 George Du Maurier in armour, photographed by David Wilkie Wynfield, mid-1860s.

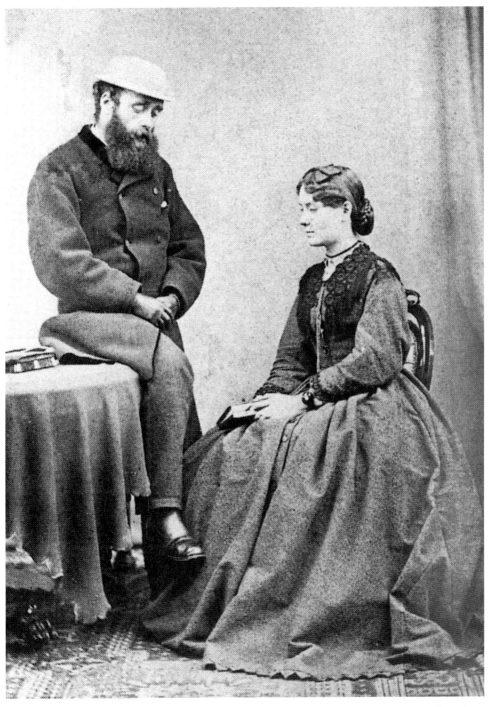

7 John Lockwood Kipling and his wife Alice (née Macdonald), Georgiana Burne-Jones's sister, c.1864.

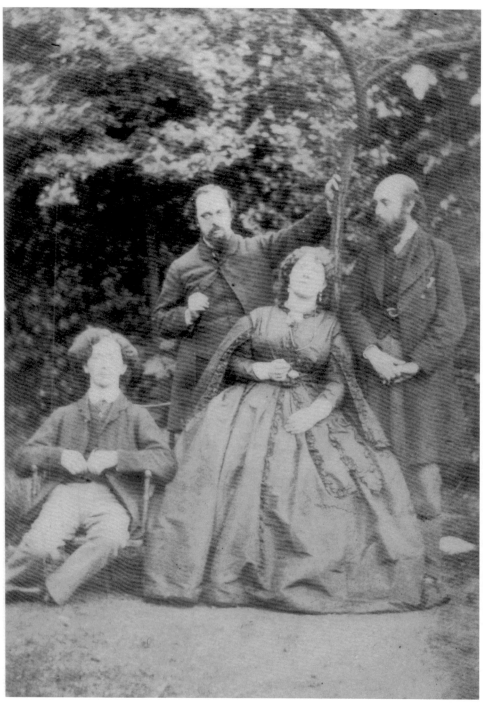

8 Swinburne, Dante Gabriel Rossetti, Frances Cornforth and William Michael Rossetti photographed by W. & D. Downey in the garden at 16 Cheyne Walk, 1863.

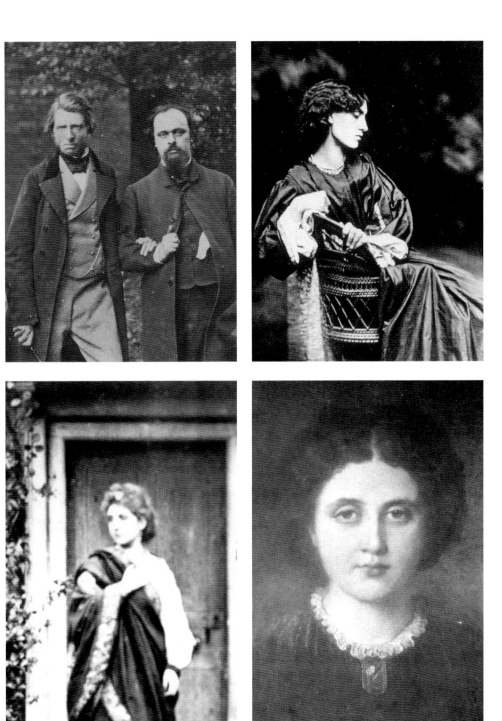

9 John Ruskin and Dante Gabriel Rossetti in Rossetti's garden.
Photograph by W. & D. Downey, 1863.
10 Jane Morris during a photographic session with Rossetti at 16 Cheyne Walk, July 1865.
11 Maria Zambaco in Greek dress.
12 A young Maria Zambaco photographed by Frederick Hollyer. The contrast with Burne-Jones's later idealised portraits is pronounced.

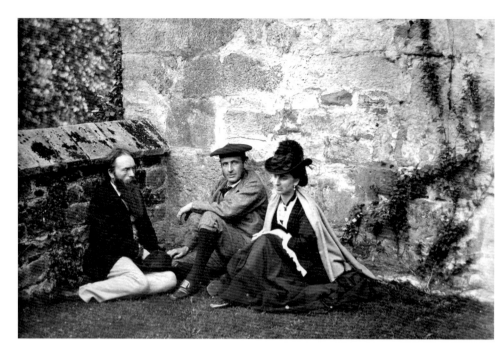

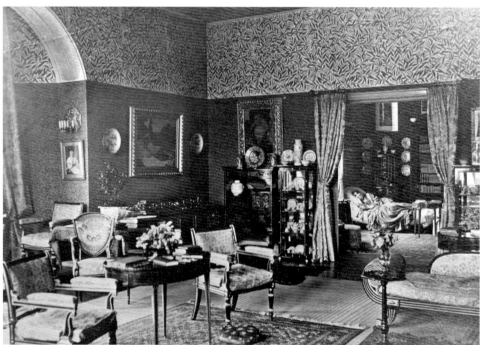

13 Burne-Jones at Naworth Castle with George and Rosalind Howard, c.1874.
14 Rosalind Howard on the day-bed in her drawing room at 1 Palace Green. The Morris &
Co. decor includes William Morris's *Willow Bough* wallpaper. Edward Poynter's portrait of
Georgiana Burne-Jones can be seen on the far left.

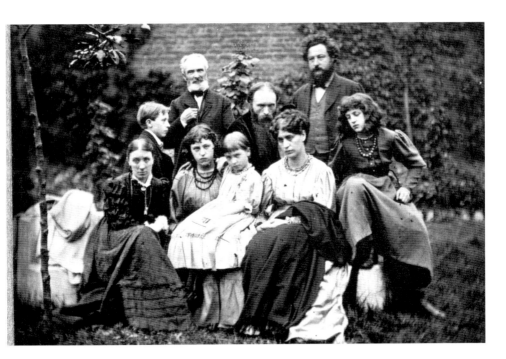

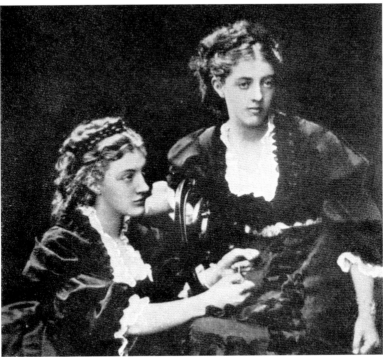

15 The Burne-Jones and Morris families photographed at the Grange by Frederick Hollyer in 1874. Edward Burne-Jones's father stands beside Phil in the back row.

16 Frances Graham (right) and her sister Amy, daughters of Burne-Jones's patron William Graham, photographed in Scotland, early 1870s.

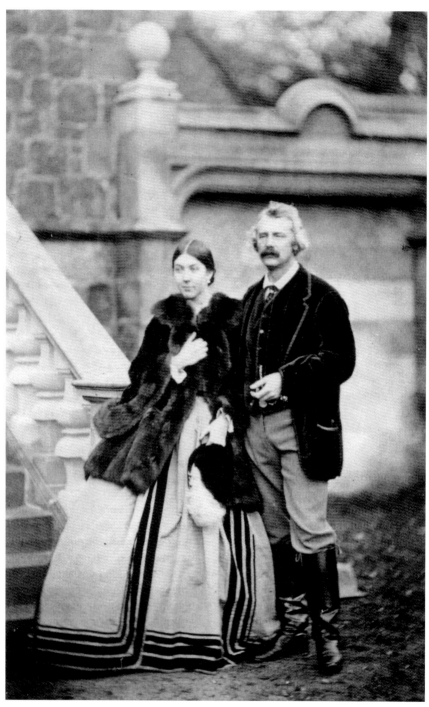

17 Sir Coutts and Lady Lindsay, artists and founders of the Grosvenor Gallery. *Carte de visite*, 1864.

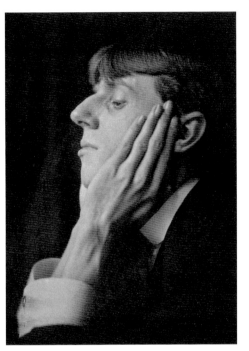

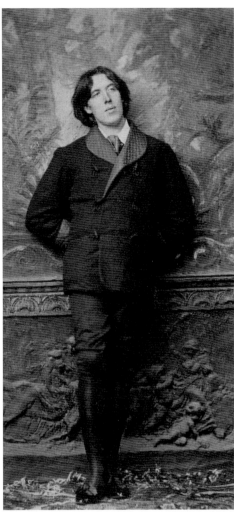

18 Aubrey Beardsley, photographed by Frederick Henry Evans, 1893.
19 Oscar Wilde, photographed by Napoleon Sarony, 1882.

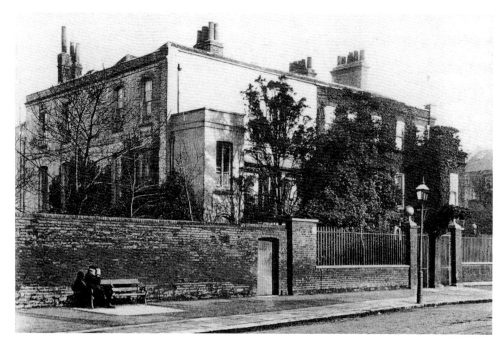

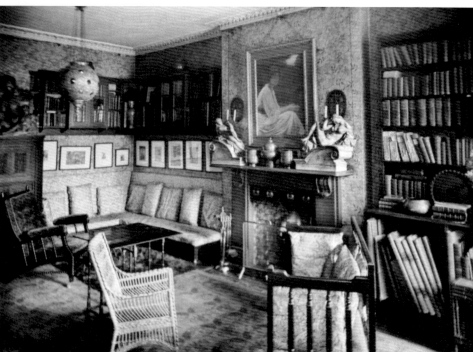

20 The Grange, North End Lane, Fulham. The Burne-Jones family lived here from 1867, occupying the white stuccoed section of the semi-detached building.

21 Sitting room at the Grange. W. B. Richmond's portrait of Margaret Burne-Jones hangs above the fireplace with casts from Michelangelo's *Night* and *Dawn* alongside.

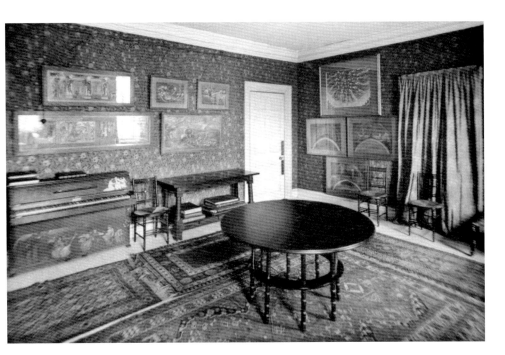

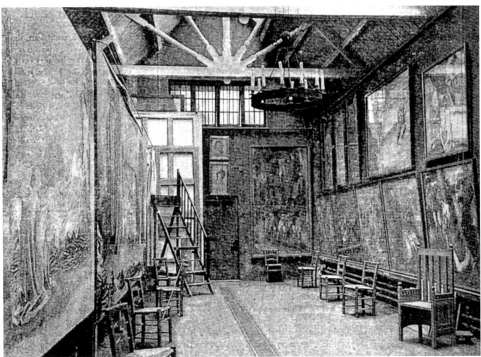

22 Music room at the Grange. The furniture includes the hand-painted *Chant d'Amour* piano dating back to the time of Burne-Jones's marriage, Morris & Co. black ebonised chairs and an oak table designed by Philip Webb.

23 The Garden Studio at the Grange, from a Hollyer photograph of 1887. *The Car of Love*, a huge ambitious painting Burne-Jones never completed, can be seen on the end wall.

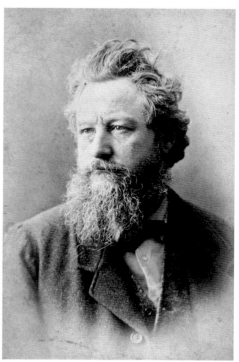

24 Helen Mary Gaskell ('May'), photographed in 1893.
25 Margaret Burne-Jones photographed in 1886, two years before her marriage.
26 Georgiana Burne-Jones photographed by Frederick Hollyer, 1880s.
27 William Morris photographed by Abel Lewis in 1880, three years before he joined the
revolutionary Socialist Democratic Federation.

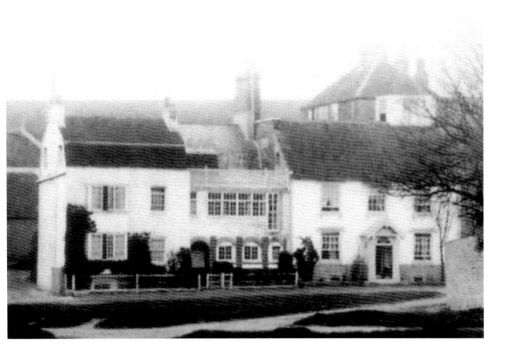

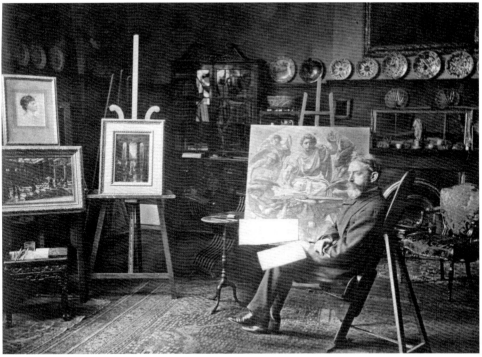

28 The Burne-Jones house at Rottingdean, near Brighton. The family originally occupied the cottage on the left. They later took over the small house in the centre. The two buildings were connected together by the architect W. A. S. Benson and renamed North End House.

29 Burne-Jones's brother-in-law Sir Edward Poynter, concurrently Director of the National Gallery and President of the Royal Academy, photographed by J. P. Mayall in his studio.

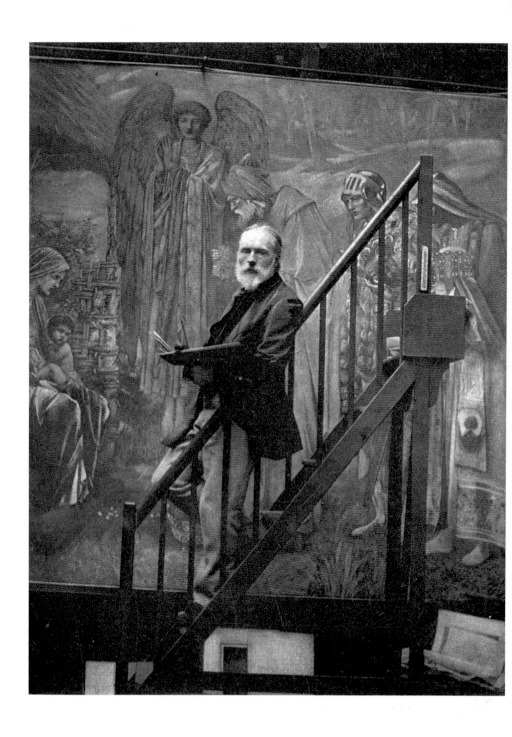

30 Edward Burne-Jones in his studio, photographed in 1890 by Barbara Leighton.
He is working on *The Star of Bethlehem*.

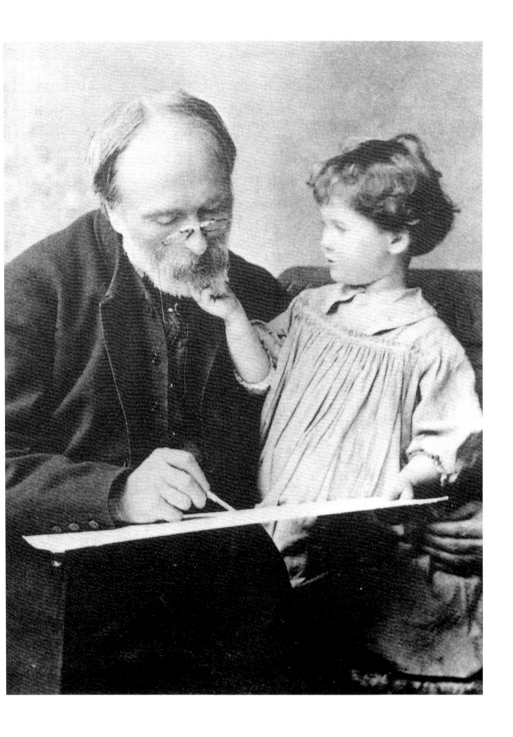

31 Burne-Jones with his granddaughter Angela Mackail who grew up to be the popular novelist Angela Thirkell. Colin MacInnes, author of *Absolute Beginners*, was her son.

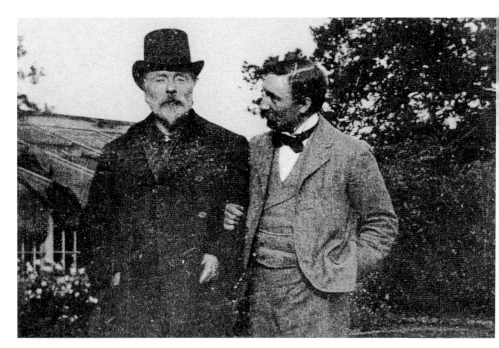

32 Sir Edward Burne-Jones with his son Phil who succeeded him to the baronetcy.
33 An aged Burne-Jones in the garden of North End House at Rottingdean.

distance and detachment, the deeply humane content of Burne-Jones's art. The *Vampire* episode was an embarrassing disaster. The critics were either unimpressed or else repelled. But there was a sequel when in 1915 a silent film was made based on the story, starring the then unknown actress Theda Bara and titled *A Fool There Was*. Theda Bara was the Vampire. So arose the term 'the Vamp'.

By late summer of 1897 Phil had taken on a safer assignment, a portrait of his father commissioned by Charles Eliot Norton. It is a small oil painting in the quite successful formula Phil had by then developed, showing Burne-Jones three-quarter-length at work in his off-white linen painting coat, his palette in his hand. He is occupied with a cartoon for a *Holy Grail* tapestry, the *Arming of Perseus* painting in the background. Although a good likeness, it leaves Phil's father looking rather predictable and staid with no hint of his enchanting whimsicality.

So pleased was Phil with the portrait when he finished it in March 1898 he could not bear to part with it and asked Norton if he would accept a replica. The original was shown in the Royal Academy that summer, Phil informing Norton, 'I hear through my uncle (Poynter the President) that they have given it a very good place.' Phil's picture of his father, as well as a portrait of his uncle Edward Poynter, is now in the National Portrait Gallery.

At the same time as sitting to Phil for his portrait, Burne-Jones himself was back at work on *The Sleep of Arthur in Avalon*. After the long gap caused by his illness he had been beginning to lose confidence. 'I'm not in good spirits about Avalon,' he confessed to Thomas Rooke on 8 June 1897, 'it looks as though it might turn out no more than a piece of decoration with no meaning in it at all, and what's the good of that. I shall have to pull myself together over it and go at it with more fury.' The general excitement over Queen Victoria's Jubilee passed him by. On 22 June he had been out on the streets to watch the Jubilee Day procession but had returned early to catch the last few hours of daylight and had spent the afternoon redesigning the drapery of the attendant fairy

supporting the dead King Arthur's feet. Six days later he forced himself, out of politeness, to attend a celebratory Royal Garden Party but he spent the whole time anxious to be back at *Avalon* and left quickly without even seeing the Queen.

Burne-Jones had never been satisfied with the conditions for working on *Avalon* in the Garden Studio at the Grange. The building was too narrow for the colossal painting to be viewed from the proper distance as a whole. In September he had the canvas moved to a much bigger studio, no. 9 St Paul's Studios in West Kensington, half a mile away. These studios, originally known as Barons Court Studios, had been purpose-built in 1885 to provide working and living accommodation for painters and sculptors, another of Sir Coutts Lindsay's enterprises in support of his contemporary artists. Burne-Jones took the studio on the first floor, said to be the largest single studio in London. Measuring 10.5 by 22.5 metres, the space was big enough to accommodate a cricket pitch. A later occupant, Sir Frank Brangwyn, called it a studio fit for Michelangelo. Phil at the time was using one of the smaller studios below.

The move to St Paul's Studio was itself traumatic. 'Avalon has travelled safely, but after infinite trouble and I am worn out with fidget and anxiety,' wrote Burne-Jones. What was most galling was that in its new surroundings the painting was looking less successful than it had done at the Grange. However, he was now 'longing to be at it' and went straight out to buy 'new brushes, new paints, new everything' that very afternoon.

Through the autumn of 1897 William Morris was much on his mind. It was not only the Arthurian connection. Sydney Cockerell had now recalled him to his duty in completing at least some of the drawings for *The Story of Sigurd the Volsung*, almost the last book to be published by Kelmscott Press. He had not touched these since the time of Morris's death. Of the original forty illustrations planned for the volume, in the end just two Burne-Jones illustrations were included in the small folio edition: *Gudrun Setting Fire to Atli's Palace* and *Fafnir Guarding the Hoard*.

Visiting the Grange on 7 October 1897, Sydney Cockerell found the artist 'alone and very nice' working on the Gudrun drawing, which Cockerell felt would be as fine as anything he had yet done for the press, 'a fitting conclusion' to William Morris's splendid enterprise. The next day Burne-Jones called in his assistant Thomas Rooke to give his opinion on the progress of the drawing and a tripartite discussion ensued between Rooke, Burne-Jones and Phil, as recorded by Rooke:

E B-J: Do you like it? Tell me if you see anything to better in it.
I: Wouldn't it be better if the torch were less straight in her hand?
PHILIP BURNE-JONES: No, I think it's all right.
I: Then two to one settles it.

Burne-Jones had promised Cockerell that he should have the drawing as a reward for his devoted care of Morris in his final illness. On 7 December, dining at the Grange, Cockerell found the original drawing for *Gudrun Setting Fire to Atli's Palace*, professionally framed for him by Guerant, waiting in his place on the dining table. 'That is your dinner,' Burne-Jones said. Over Christmas he was still poring over final details of the reproduction of the Fafnir and Gudrun illustrations. On 31 December he wrote, 'I think I have done this morning the last touches to the Kelmscott work. Alas, and for ever alas – and what will amend it!'

It was also with the memory of Morris and what they had achieved together that Burne-Jones adapted for tapestry a design for a painting, *The Passing of Venus*, he had started work on in 1881. The very last entry in his work list was 'Began a design for the tapestry of the Passing of Venus, that the tradition of tapestry weaving at Merton Abbey might not be forgotten or cease.'

The family gathered at Rottingdean for Christmas. Christmas Day itself was beautiful and sunny. But Burne-Jones returned to London before New Year, praying for a long uninterrupted spell of work. He had been involved in the 1898 Winter Exhibition at the New Gallery which included a large section on Rossetti, helping to locate Rossetti's works and persuading their current owners

to part with them, even in one case offering his own watercolour of *Galahad at the Chapel of the San Graal* as a temporary substitute. He finished it rapidly in order to clinch the deal. He felt a glow of triumph that nearly seventy Rossetti pictures were assembled, some of them for him 'heartbreaking little friends'. One evening, once the light had gone and his work was over for the day, he went down to the New Gallery to view the exhibition and then out to a pot-house for dinner with Hallé and others, back temporarily into the convivial male routines.

Georgie had meanwhile established her own independent patterns of behaviour. When Burne-Jones's illness prevented the journey to France they had planned in 1897 she had set out herself a few weeks later in a little party organised by the ever obliging Sydney Cockerell, touring around Abbeville, Beauvais and Amiens. Now in January 1898, when Georgie was far from well, she accepted an invitation for her and Phil to stay at Bordighera with the novelist George MacDonald and his family. MacDonald was best known for his children's stories, especially *The Princess and the Goblin*. The two families had been friends for many years.

Burne-Jones himself had not been tempted by Italy, certainly not by the Italian Riviera with its villas and hotels and expatriate communities. 'Shouldn't I feel Bordighera and the Riviera generally as a kind of celestial Malvern?' he enquired. He seems to have enjoyed himself on his own, working, seeing friends and entertaining them in the evenings at the Grange and reading a great deal. He was completely absorbed by Walter Scott's *The Antiquary* in spite of having read it twenty-seven times before.

It was around this time that Burne-Jones met the Detmold brothers, Maurice and Edward, precociously talented thirteen-year-old twins whose great-uncle Dr Shuldham had been a Birmingham schoolfellow of his. The boys were brought to see him at the Grange and Burne-Jones examined their drawings. He was still sharply receptive to the young and predicted a brilliant future for the twins so long as 'they do not go off the track'. As it happened, after an early rush of fame both the Detmold brothers eventually committed suicide.

In New Year 1898 Burne-Jones's flu symptoms returned, leaving him feeling intermittently weak. He took to needing a deep sleep for two hours or so at the end of a working afternoon. What was almost uncanny was that he automatically took up the same position on the sofa as the sleeping King Arthur in *Avalon*. Early in March he was feeling so exhausted he decided to go down to Rottingdean to gather strength. Thomas Rooke was to accompany him. Somehow they missed one another at Victoria and travelled down to the coast in separate compartments on the train. They both got out and Rooke caught sight of Burne-Jones about to get into a one-horse cab to take him to Rottingdean alone. He was looking grey-complexioned and worried. When she returned from Bordighera and Ned walked along the Brighton Road to meet her at the station, Georgie was even more anxiously aware of just how worn and ill he looked.

Part of the problem was depression. Through the early 1890s Burne-Jones's reputation had been steadily advancing. In 1892 there had been the biographical appreciation *Edward Burne-Jones: A Record and Review* written by Malcolm Bell, Edward Poynter's nephew, which went into four editions over the next few years. At Christmas 1894 his admirer Julia Cartwright's comprehensive if somewhat gushing account 'The Life and Work of Sir Edward Burne-Jones, Bart.' was published as a special issue of *Art Journal* and was well received, especially by Georgie who assured the author that her book was 'by far the best ever written about the painter'. When the Fine Art Society held its 1896 exhibition of Burne-Jones's studies and drawings, Julia Cartwright compiled the catalogue, a job she inherited from Phil who had flunked the task.

But by 1897 it was becoming clear that Burne-Jones's star was waning, both in Britain and on the Continent. He was forced to admit that 'the rage' for him was over. The whole concept of beauty, the Aesthetic Movement mantra, was going out of fashion. The urban realism Burne-Jones so much derided was now in the ascendant, popularised by the artists of the New English Art Club, founded in 1886. There was also the challenge of the Newlyn School of English Impressionists. Compared with the freshness of

the work of such artists as Stanhope Forbes and Frank Bramley, Burne-Jones was beginning to look passé and sententious. When students from the drawing schools brought in their work to show him Burne-Jones was often shocked by its blatant ugliness as well as by the carelessness of technique.

He watched the old Pre-Raphaelite tradition of the painter-poet dwindling. The art of visionary contemplation had now been superseded by quick effects and stridency: 'in the modern exhibition', as Burne-Jones saw it, 'it's bellow upon bellow, scream upon scream'. Even in his own special area of painting combined with decorative arts his supremacy was being challenged, not least by his one-time junior collaborator Walter Crane whose work in a multitude of disciplines was often illustrated in the high-profile *Studio* magazine and whose Continental reputation was now eclipsing Burne-Jones's own.

He of all people with his sweeping sense of history, the way in which whole civilisations rise and fall, understood the swings of fortune in the art market in London. 'People get tired of one; they've had all you can give them, and begin to feel about you as they would about a discarded mistress.' But however philosophical he tried to be, he took it very much to heart that *Love and the Pilgrim* had not sold in the New Gallery's 1897 exhibition. Then at the beginning of 1898 the pictures that had been on exhibition at the Royal Watercolour Society were also returned to him unsold.

He was losing confidence, anxious about the future, deciding in a panic that his policy of painting large thoughtful time-consuming pictures was a luxury he could no longer afford: 'I must paint only little pictures and sell them cheap.' In this mood of desperation he brought out more of his old paintings and reworked them, not always for the best. For the 1898 show at the New Gallery he went back to the *Prioress's Tale* watercolour he had started in 1865 and finished it. Even this he did not expect to sell. F. G. Stephens, writing in *The Athenaeum*, praised the overall sweetness and harmony. But even Stephens, Burne-Jones's old friend and staunch supporter, was forced to admit that 'in other respects the picture is by no means a masterpiece'.

He had lived too long, he felt. He was a relic, having 'no more to do with things than Cimabue'. The sale at Christie's in May 1898 of the collection of Joseph Ruston, which included *The Mirror of Venus* and *Le Chant d'Amour*, had made him very nervous. The ever sympathetic Julia Cartwright was at the Grange that day. 'He felt the beat of the hammer and shuddered over it. He is sure they will go for a song and feels that it is his best life work that is on the market.' To while away the time until the sale results were known, and intent on making a bad day even worse, Burne-Jones got out the damaged picture of *Love among the Ruins*. On the advice of Fairfax Murray, the film of egg white applied to the surface of the canvas while the picture was in Paris had now been partially removed by applying ox gall. Julia watched in horrified amazement as Burne-Jones started to repaint the ruined faces. It struck her as being like the dissection of a corpse.

The day ended more cheerfully with a telegram from Phil announcing that *Le Chant d'Amour* had been sold for £3,200 to Agnew's while *The Mirror of Venus* had been bought by Fairfax Murray for £5,450. Perhaps his sense of doom had been exaggerated. For a Burne-Jones painting sold at auction this was at the time a record price.

In April 1898 Burne-Jones had started work in earnest on *The Sleep of Arthur in Avalon* in St Paul's Studios. It was the first really good large space for painting he had ever occupied, with an excellent northern light. *Avalon* was the only work he did there. He and Rooke established a routine, arriving around nine in the morning, eating sandwiches for lunch. By May he was working at St Paul's Studios for three or four days each week. Compared with the rush of visits at the Grange, very few people arrived there to disturb him. 'Nothing so happy as being at work!' Burne-Jones declared. He felt that the enormously complex and demanding painting was at last making a real advance.

He worked and he worked. And as he worked he talked. Although he needed silence for the early stages of design and making studies, once he had begun on the final technical processes of painting he

would talk non-stop. From the late 1880s, encouraged by Georgie, Thomas Rooke had started keeping day-to-day records of these conversations, either making furtive notes on the backs of drawings or on scraps of newspaper or when this was not practical memorising what Burne-Jones had said and writing it down later. These 'studio conversations', which still exist in typescript, give a vivid impression of the outpouring of reminiscences of his father and his childhood, Rossetti, William Morris. It was as if the whole of his past life wafted before him as he worked on *Avalon*.

Rooke's 'studio conversations' record the progress of the picture as they painted in the irises, perfected Arthur's armour. On 20 May Burne-Jones was preparing to darken the water and continue changing the rocks in Avalon into grassy mounds, having had second thoughts. 'I shan't want any small brushes today, only thumpers and whackers,' he instructed Rooke.

More and more the work on the great painting had enveloped him. When Georgie was in Rottingdean he sent a daily letter. One of these informed her, 'I am *at* Avalon – not yet *in* Avalon.' Another was headed not 'St Paul's Studio' but simply 'Avalon'. Politics, even the growth of British imperialist action in South Africa on which he once had keen opinions, now had to be ignored. One evening in early May Burne-Jones went out to dinner and reported, 'There was a great deal of Rhodes talked – to my sickness – but it wasn't the time for angriness, and I let it pass. I shall let most things pass me by. I must, if ever I want to reach Avalon.'

There had been the unavoidable distraction of the window for St Deiniol's Church at Hawarden commissioned by the Gladstone children for their father. The detailed correspondence between Burne-Jones and the Gladstone family had been running on for the past two years, one of Mary's brothers proving particularly intractable. Burne-Jones finally wrote to him in desperation explaining 'yet again that it is impossible to put a central figure in a four light window'. He was obviously making the common mistake of thinking of stained glass as if it was a picture, whereas it demands a very different approach.

In fact the design for the Hawarden window exploits the full potential of stained glass as Burne-Jones had come to see it. The *Nativity* scene with the angels and the magi runs right across the four narrow lights. The lead lines are treated in what was now the standard Burne-Jones manner, not as necessary interruptions but intrinsic, 'part of the beauty of the work and as interesting as the lines of masonry in a wall'. Gladstone now had cancer of the palate. Once his serious illness was made public in the spring of 1898, work on the window had been speeded up. As with the Birmingham *Last Judgement* window, Burne-Jones took on Morris's old responsibility for the supervision of the final stages: 'harassed days these are', he wrote in April, 'and I seem to have lived on little suburban platforms trying to get to Merton Abbey – I want the Hawarden windows set up before sad inevitable things happen – and must go constantly – no one there to look after things now'.

Gladstone died on 19 May 1898. 'So that great creature is gone,' Burne-Jones lamented. The window was still not completely finished. But Burne-Jones rationalised the failure to deliver: 'perhaps it won't be amiss that they should have it to amuse them in that dreadful dull time there will be when the funeral's over'. He was there at the state funeral in Westminster Abbey of the formidable Liberal Prime Minister for whom, in Gladstone's lifetime, he had had such mixed feelings of love and respect and a terrible despair.

Burne-Jones was now retreating more and more within himself. He said he wanted to forget the world and live inside a picture. He returned to his speculative interests as a young man in science and especially astronomy, keeping books on astronomy beside his bed. The idea of wireless communication, then in its early days, fascinated him. 'There is a clever young chap at Bologna University . . . He is half English and half Italian, which is a promising thing in itself: his name is Marconi,' Burne-Jones wrote excitedly.

He often seemed vague and distracted. An old friend, the writer William Sharp, saw him in the street by chance and was aware of how exhausted he was looking and how haunted, gazing ahead out of his 'strange luminous eyes'. As he walked along alone his lips

could be seen moving 'as though in silent speech' or perhaps recit-
ing poetry. Recognising Sharp, Burne-Jones had stopped him and
told him he had just been thinking of his plans for a large picture
on the subject of Ave Maria. This was an idea that first occurred to
him at Oxford forty years before, suggested by William Morris's
poem 'The Hollow Land'. But would he ever paint it? He was now
aware that he had very little time left. Talking to Sharp, Burne-
Jones had predicted he would die that very May.

But in June 1898 he and Thomas Rooke were still at work on
Arthur in Avalon. It was almost as if working on this painting
was granting him an extension of life. He had now decided to fill in
the whole foreground of the picture with summer flowers and the
studio was piled up with the columbines and irises and forget-me-
nots that he and Rooke were painting day by day. The effect of the
flowers in the long grass in front of the tomb of Arthur pleased
him. He seemed to be cheerful and re-energised and on 6 June he
and Georgie went on a long-promised day trip by train to Hertford-
shire to visit the former Violet Maxse, now married to Lord
Edward Cecil and living with her husband's family, the Salisburys,
at Hatfield House. Georgie must have remembered her prediction
when Violet got married that 'the Cecils carried their wives off to
an inaccessible fastness and there chewed their bones'.

In June his connections with the theatre revived as the first
major London production of Maurice Maeterlinck's *Pelléas and
Mélisande*, in Jack Mackail's translation, went into rehearsal at
the Prince of Wales's Theatre. This mystical play by the Flemish-
born dramatist now seen as the leading light of Symbolist drama
had opened to great acclaim in Paris in 1893. The plot hinges on
the forbidden passion of Princess Mélisande for Golaud, half-
brother of her husband Pelléas. In the planned series of nine
matinée performances Mrs Patrick Campbell had been cast as
Mélisande, Martin Harvey as Pelléas and the absurdly handsome
and mellifluous Johnston Forbes-Robertson as Golaud. Henry
Irving had allowed one of Burne-Jones's sets from *King Arthur* to
be recycled for the production, the only set to survive the Lyceum
storeroom fire. Burne-Jones's other contribution to *Pelléas and*

Mélisande was a number of suggestions for the design of Mrs Pat Campbell's 'lovely golden dress'.

Burne-Jones admired Maeterlinck, feeling a rapport with a fellow visionary and melancholic. The respect was evidently mutual. Maeterlinck's house in the Bois de Boulogne was hung with photogravure reproductions of Burne-Jones's pictures. But although of course invited to attend one of the performances of *Pelléas and Mélisande* once it opened, Burne-Jones was evidently wary: 'I am afraid of having my conceptions of gods and heroes uprooted.' He felt that Maeterlinck's minimalist austerity might prove too much for him. He thought it might be wiser to stick to the classical version of the story. He told Elizabeth Lewis that he gathered 'the divergeance is very great'.

The ninth of June was the anniversary of Ned and Georgie's wedding. Phil and Margaret, with Jack, gathered round the dining table originally designed by Philip Webb for their parents' first rooms at Russell Place. Two days later May Gaskell's daughter Amy was married to a young army officer, son of Sir George Bonham, in a full-blown military ceremony at St Margaret's, Westminster, with a whole company of the second battalion of the Grenadier Guards in their scarlet uniforms forming a guard of honour down the nave. Burne-Jones was a witness to the signing of the register. He avoided the crowds at the reception back at the bride's family house at Marble Arch. But in another of the bizarre juxtapositions of his relations with May Gaskell, Burne-Jones dined out in town with the problematic Captain Gaskell and Amy's brother Hal on Amy's wedding night.

It was altogether a sociable week. On 13 June a musical friend of the Burne-Joneses, Mrs Morton, came to dinner at the Grange and entertained them for the evening, singing a whole sequence of old Italian songs, bringing back the memories of visits to Italy all those years before. The next night was a dinner party at the Lewises'. Just before he left Burne-Jones lingered in the hallway talking to George Lewis, who went back to the drawing room saying he had never seen Burne-Jones looking better. On Wednesday 15 June he was back at the studio, returning home earlier than

usual to receive some visitors, among them Percy Wyndham and two Wyndham grandchildren. The Mackail children had also come to tea and Burne-Jones was in grandfatherly high spirits, playing at 'Bear' on the carpet. Charles Hallé stayed on for dinner, after which the two men settled into a long philosophical conversation in which Burne-Jones admitted he had to face the fact that his influence on mankind had been negligible in terms of any widespread appreciation of art and the perfecting of technique. But at least he himself had come to know beauty. Sitting there in the dusk, Burne-Jones's white face and solemnity of voice made Hallé feel a little awestruck: 'It was like a summing up of his whole life.'

Thursday 16 June was a day of blazing summer. As Burne-Jones was leaving for the studio as usual he stopped for a few moments to discuss the day's work ahead with Georgie. He needed to correct the error he had made by painting in red apples alongside the spring flowers in the vale of Avalon. The unseasonal apples would have to be removed. Once again he returned home a little earlier than usual, taking a cab back to the Grange to greet two visitors, Alice Stuart Wortley, a married daughter of John Millais's, and Freda Stanhope, a young niece of Spencer Stanhope's and an aspiring artist who spent winters in Florence learning to paint in Stanhope's studio. Soon after the two women arrived Burne-Jones's doctor, Dr Harvey, came in briefly. Since his bad attack of influenza in February a close watch had been kept on Burne-Jones's heart and lungs and there had been a slight alarm the previous evening. Dr Harvey examined him and sounded his chest. He was said to be much better and the doctor left.

Burne-Jones then took Freda Stanhope down to the Garden Studio, Alice Wortley and Georgie staying tactfully behind. They were away for quite some time, viewing the still unfinished *The Fall of Lucifer* and *The Car of Love*, and on returning to the house Burne-Jones ushered Freda – in Georgie's account – 'almost straight through the drawing room up to his working studio'. He had lost none of his zest for entertaining and instructing impressionable and art-loving young girls. He gave Freda advice on techniques of oil painting and they both agreed that the purest and most beautiful

498

of all colours was blue. It was almost dusk before the visitors left and in the hall Burne-Jones remembered there was just one more thing he wanted her to see. He fetched a candle and he and Freda carefully examined the large watercolour of Christ hanging with arms outstretched on the Tree of Forgiveness, one of the designs for the mosaics at St Paul's Within-the-Walls at Rome.

There had been a plan for Ned and Georgie to go out to the theatre but to their relief this had been postponed. After dinner they brought out the dominoes and played together, still sitting at the dining table for a little while. Burne-Jones said he was tired and needed to write to Rudyard Kipling to tell him he would soon be arriving in Rottingdean. Georgie went into the drawing room and left him at the writing desk composing what Kipling was later to describe as 'one of his wild, nonsensical "lark" letters, a beautiful tissue of absurdities'. Georgie does not mention in her memoirs, and was maybe unaware, that he wrote another letter, one of his devoted missives to May Gaskell, who had now returned to Lancashire. He told her:

tomorrow I shall go back to Avalon and try that experiment for bettering a weak place in the picture. And on Saturday week I will go and see Ruddy for the Sunday and have some refreshing talk with him, and come back on the Sunday evening perhaps to dine with you – who knows – there is no knowing in such a wonderful world.

He sent the letters to catch the late-night post.

While he had been writing Georgie had had a kind of premonition, a cloud of 'nameless fear'. She made an attempt to play the piano but had only managed to lean forward with her arms folded on the music desk, in a state of semi-paralysis. When he came into the drawing room and lay down on the sofa, resting his eyes with his back to the light, she recovered enough to sit down by the reading lamp and find the place they had reached in Mary Kingsley's recently published *Travels in West Africa*. Burne-Jones listened 'with the keenest interest' to her description of the rapids of the River Ogowé. He and Georgie then retired to their separate rooms.

The two bedrooms were connected by a speaking tube. It was

through this very speaking tube that, not so long before, he had played a trick on Georgie, telling her he was tired and meant to stay in bed only to appear at her door a minute later fully dressed. Now at around 1.45 a.m. he summoned her urgently, complaining of an acute pain in the chest. He was soon in agony and deteriorating rapidly. She sent for Phil and the Mackails and summoned Dr Harvey. But they did not come in time. Ned died in her arms.

As Georgie so sweetly and decorously put it, 'Edward changed his life as Friday morning dawned.' It was 2.30 a.m. on Friday 17 June when he died of angina, failure of the coronary arteries. Burne-Jones was sixty-four. The reaper with the scythe had been a fearful figure in Burne-Jones's imaginative landscape. Now the man with a sharp blade like a crescent moon had come to mow him down himself.

Memorials
1898–1916

Although Burne-Jones had been in precarious health for years, his death when it came was unexpected. Georgie responded to it stoically, with 'that air of determined resignation that she wore after William Morris's death'. Once Phil and Margaret arrived at the Grange to be with her she suggested they threw open the windows of Burne-Jones's bedroom to let in the early morning light.

Phil responded with the greatest outpouring of emotion, guilty at his late arrival. 'I was sent for,' he told Charles Eliot Norton, 'but got to the Grange too late to see my Blessed alive. It has simply stunned me – and the blankness and darkness of the future without him will need all one's courage to face.' Margaret's initial responses were more reticent but perhaps her inner feelings can be gauged by her reaction when Burne-Jones's personal belongings were distributed, the special slippers he had worn while painting *Avalon* being dispatched as a memento to Norton at Shady Hill. Margaret burst out that *she* would like to wear all her father's clothes – 'only wishes she could!'

Georgie's sisters were all notified. Her only unmarried sister Edith was staying at the time with Alice and John Kipling, who had now returned from India and were living in retirement at Tisbury in Wiltshire. Here the news of Burne-Jones's death came 'like a thunder clap'. According to Edith they had 'all looked up to him as in every way the head of the family, the shock of his sudden

removal was terrible, and his loss made a blank in our lives never to be filled up'.

After breakfast at the Baldwins' London flat in Kensington Palace Mansions a telephone call came through from Phil for his aunt Louisa. He told her that 'after mercifully brief suffering' his father had died in the night. Louisa and Alfred both wept bitterly. Louisa went round to the Grange and found Agnes already there. 'Dear Georgie is wonderful,' Louisa wrote in that day's diary: 'She had scarcely wept yet she said "There will be time for tears".' Phil had now taken charge of all arrangements. Margaret proposed to sleep beside her mother's bed at night.

Of the younger generation of cousins, Rudyard Kipling received the news via the vicar of Rottingdean, to whom Phil had sent a telegram. It seemed at first 'like some sort of ghastly hoax'. They had been in such day-to-day communication. Then the grief took over. As he told Charles Eliot Norton a little incoherently: 'He was more to me than any man here: over and above my own life's love for him: and he had changed my life in many ways by his visits down here. The man was a God to me.' On the day after the death another Burne-Jones nephew, Ambrose Poynter, was brought over to the Grange to make a pictorial record of Burne-Jones's studio before it was dismantled for the contents to be sold.

The news spread quickly around local friends and neighbours. The Bensons too received a telegram from Phil asking William to come to the Grange at once. On being told the dreadful news he spent the morning there, and then, after going to Jane's lecture on the Naval War Game, he returned to the Grange in the evening to give the family his support. Sydney Cockerell had just been start-ing out that evening to call on Burne-Jones when he saw the sad announcement. He went straight on to the Grange, where Burne-Jones's secretary, Sara Anderson, was waiting outside the house to intercept him. They took a mournful walk in Richmond Park together.

Burne-Jones was to have dined that night with Madeline Wyndham to celebrate her birthday. But now, as she put it, it was clear he had a prior engagement in 'the Courts of Heaven. The

king of kings needed him.' Suddenly the air was thick with missed opportunities. Wilfrid Blunt responded with his usual self-centredness: 'Burne-Jones is dead. This is a vast misfortune.' The timing was so bad because Blunt's daughter Judith was to have been included as one of the mourners 'in Burne-Jones's last picture "The Vale of Avalon" but that will never now be'.

The announcement of Burne-Jones's death soon reached the wider world. As with the death of any famous figure, many people recollected for years later where they were precisely when they heard the news.

Mrs Patrick Campbell had her special reasons for remembering that she was just leaving the final rehearsal of *Pelléas and Mélisande*, opening at the Prince of Wales that afternoon, when she saw the news announced on the placards of the news-stands outside the theatre. The death of the man she called 'Dearest', who had so much loved her actressy flirtatiousness, now hit her hard. But Mrs Pat, the true professional, was on stage that afternoon as Mélisande wearing the glittering provocative gold dress.

The Burne-Jones aficionado Julia Cartwright had been on her way that afternoon to a Wagner opera. 'I went off at 4.30 to Covent Garden,' she recorded in her diary, 'and to my horror saw on the posters at St. Peter's *Death of Sir Edward Burne-Jones*. My God! What an awful shock! It still haunts me, and the words rang in my head all evening.' Wotan's wailing over Brünnhilde seemed to reflect all her love and grief for her 'own dear painter' whom she now knew she would never see again. Failing to find a hansom cab after the performance, she had walked down Long Acre thinking of Burne-Jones beyond the stars: 'And now he knows it all and many things are clear to him.' It seemed as if at last he had found his Holy Grail.

How the news was brought to Mells we cannot be quite certain. But soon after she heard of Burne-Jones's death Frances Horner was writing to her close confidante Edith Lyttelton, analysing the feelings that had built up through the years:

I think I had got to depend on him as a kind of background for life, and he had grown so spiritual and good and yet so human that I took everything to him . . . He never let me go for more than two or three days

silent, then he would scold me a little, and I got so used to it I daresay perhaps even you hardly knew how naturally and happily I lived in his love – it was the most unfailing thing I ever knew: and now at home I can't move or look up without seeing him: a picture on the wall, or a photograph or books which he gave – everything in my life seems to have been steeped in him.

He had asked Frances not to come to his funeral. But this was never a possibility.

The cremation was arranged for Monday 20 June 1898 at Woking, the only crematorium in Britain at that period. A little knot of spectators stood outside the Grange to see the hearse depart with 'the dear body', as Louisa referred to it. One woman called out to Thomas Rooke, 'Come to draw the funeral, Sir?' Another cried out in astonishment as Annie the cook came out carrying flowers to put in the hearse. Flowers had been discouraged but people had still sent them. Annie was not wearing mourning black. Her dress was in Burne-Jones's favourite colour, blue.

The cremation was a strictly private ceremony with only Phil, Edward Poynter, William Benson and Harry Taylor, a friend of the Burne-Jones children, present. A cryptic comment in one of Rudyard Kipling's letters that 'there are a few points about cremation that may be improved' suggests that all did not go smoothly. Venetia Benson records it in her diary as 'a most dreadfully trying day'. It was Phil's task to transport the ashes in their casket for the funeral the next day at Rottingdean.

Gradually that afternoon and evening the family assembled. Georgie and Margaret were driven south from London with Louisa. The Baldwins were all staying with the Ridsdales in the house across the green. The next day there would be a convergence of Kiplings at The Elms. Rudyard Kipling, seeing her just briefly, felt more than ever the sheer saintliness of Georgie: 'She was seeing and realizing all the glory and splendour of that death; but I don't think that the other realization had come to her quite – the full meaning of the wreck and the loneliness.' Margaret struck him as grimly self-composed: 'Margot's face was like pearl-shell and frightened

me a little. She wouldn't break and one felt that the break was what they all needed. Phil was quite quiet and deadly changed.'

Burne-Jones's drawing table had been carried over to the church and put in front of the altar. The plain oak casket containing the ashes, with its brass plate inscribed 'Edward Burne-Jones', was placed on the table with four altar candles burning and a family watch throughout the night. It was midsummer eve, a hot still night with no real darkness but a continuing kind of northern twilight. Phil and Jack Mackail took the watch from eight till twelve, Harry Taylor relieved them from midnight until two, Stanley Baldwin watched from two to four. During Stanley's watch, just as the bright dawn broke, Georgie and Margaret came over to the church, both dressed in white, to watch beside the ashes, disconcerting Stanley who said they made him feel 'like a profane heathen'. He crept out of the church until they called him back.

Rudyard Kipling took the watch from four to six. He too was interrupted by the more farcical arrival of 'old, old Mr. Ridsdale', Cissie Baldwin's father, 'rather an appalling figure at five a.m. – scrupulously dressed in black; looking rather like Father Time strayed in from among the tombs'. Mr Ridsdale stayed an hour. Rudyard found the night unearthly and upsetting. He was quite unable to connect the man he had loved so much with the little oak box before the altar. The drawing table and the stained-glass windows in the church 'were much more *him*'.

The last watch was taken by Stanley's father Alfred Baldwin, relieved by Phil who stayed in the church throughout the morning. People began arriving from London, many of them catching the 10.40 from Victoria to Brighton and then taking the fly across to Rottingdean. There was a chilly sea fog along the coast road. Mary Elcho, who travelled down with her parents Madeline and Percy Wyndham and her brother George, noted in her diary that nearing Rottingdean they met an obstacle: 'the road was blocked by a poor horse in a fit'.

The funeral service was at two o'clock. The mourners began to assemble in the churchyard and on the green before taking their places in the church. There were friends from Burne-Jones's early

Pre-Raphaelite period: Val Prinsep, Thomas Armstrong, the aged Holman Hunt. Burne-Jones's most confidential friend and patron George Howard, now the 9th Earl of Carlisle, was present; Charles Hallé and Joe Comyns Carr from the New Gallery; Frederick Hollyer who through the years had photographed the vast majority of Burne-Jones's oeuvre. So many disparate connections. Frances Horner and Henry James stood side by side in the church through the simple service. Frances wrote, 'I am glad we stood together in the strangely mingled crowd.'

The flowers too spoke their own language of the past. One wreath of red roses came from the Swinburne family, another from the Royal Society of Painters in Water Colours (as the Old Watercolour Society was now called). G. F. Watts sent a laurel wreath, the leaves having been cut from the laurel tree growing in his garden, the tree that had previously made wreaths for the funerals of Tennyson and Leighton. Ruskin, still alive though far from *compos mentis*, had sent Burne-Jones a bunch of forget-me-nots. May Gaskell did not attend the funeral. But she sent a wreath of lilies of the valley, the flowers that had borne special messages between them with their secret, sacred meaning of 'Return to Happiness' or 'Love Revived'.

The burial place had been chosen long before in a corner of the churchyard visible from the windows of North End House. Georgie in a winsome moment had declared, 'If you die first, you know, we shall still be near to one another, and I can still say "How do you do?" to you from my window which just looks out on you.' That time had now come. Phil and Margaret, dressed unconventionally for a funeral in a white dress with a black sash, carried the box with the ashes and lowered it themselves into the grave, which was lined with moss and roses. Georgie followed and all three sprinkled in some earth. Then she placed her own last offering of purple pansies – 'heartsease' – in her husband's grave. She behaved with a dignity Henry James described as 'simply amazing'. It was Crom Price who totally broke down.

The beauty and sincerity of the country burial left a lasting impression. After the service, as Kipling described it, there was

'no mobbing; no jabber; no idiotic condolences'. Georgie lingered at the grave, standing with her eyes tight shut. She then knelt down and stayed alone there praying for a moment or two more. The relations and friends gathered in informal groups on the village green or in the gardens of the local houses before going quietly back to town. There was now a little time to see Burne-Jones in perspective. Kipling reflected the next day:

His work was the least part of him. It is him that one wants – the size and the strength and the power and the jests and the God given sympathy of the man. He *knew*. There was never a man like him who *knew* all things without stirring.

A moving little tribute also came from Kipling's gardener, who did not know Burne-Jones well but had viewed his comings and goings between The Elms and North End House. 'What *did* strike me about him', said Marten the gardener, 'was his humanity. There aren't too many humane men in the world today.' From now on he gave himself the practical task of watering the grass on Burne-Jones's grave.

Georgie was taken back to London that same evening. A full-blown London memorial service was to be held at noon the following day, Wednesday 22 June. Complex negotiations, orchestrated by the Bensons, had been under way not to hold the service in St Paul's, where leading artists were usually honoured but which Burne-Jones was known to loathe. Westminster Abbey seemed a more congenial alternative and William Benson's cousin Robin, a banker and businessman, went to see the Dean of Westminster to ask for his approval. This was granted on condition that the Prince of Wales gave his backing, because of the historic royal connection with the abbey. Once the royal approval was received the petition needed to be taken round for signature by, among others, Lawrence Alma-Tadema, G. F. Watts and Sir Frederic Burton, a roll call of the influential artists of the time. William Benson and Alma-Tadema then took the petition to Kensington Palace for Princess Louise's signature where, in her absence, it was signed by Lord

Lorne. Within the day, with much expenditure of effort by the Bensons, the petition was delivered to the Dean and before Burne-Jones's ashes had been interred in Sussex the tickets for the next event had been sent out.

This was the first time a memorial service for an artist had been held in Westminster Abbey. All the people who had been at the service at Rottingdean now reassembled, together with many many more. The crowd was so great that the reporter for *The Times* apologised for being unable to register the names of all the well-known people who were there. Edward Poynter, who had merely been Burne-Jones's brother-in-law at the country church at Rottingdean, now came into his own as Sir Edward Poynter, President of the Royal Academy, leading an immense congregation of artists and writers, architects and art workers, intellectuals and Liberal politicians, the survivors of the Holland Park circle, the last vestiges of the Aesthetic Movement socialites, the widely assorted great and good for whom attendance at memorial services had become a way of life. '[J]udging from the number in the abbey,' observed Kipling, 'I suppose the best of Babylon had turned out.'

As they thronged into the abbey there was Hubert Parry – recently become Sir Hubert – on the organ. Then the funeral march, psalm, lesson, choral anthem, lesser litany, Lord's Prayer, and the final hymn 'O God, our help in ages past'. The service ended with Dr Bridge performing the Dead March from *Saul*. It was a scene of predictable, professional Church of England splendour with the Dean in black and white and red standing out against the gilt and marble of the sanctuary. But would Burne-Jones, who had wearily endured so many pompous funerals, have liked his own memorial? Hadn't he once said 'the kindest thing you can do to people when they're dead is to let them alone and be quiet'? For some of those who had been at both the ceremonies the more intimate farewell to Burne-Jones at Rottingdean had meant a great deal more.

On 12 July 1898 probate was granted on the will drawn up by Burne-Jones ten years earlier. He left £53,493 9s 7d, £3 million in today's money. Burne-Jones was not so poor as he imagined. This

sum excluded the paintings, studies and drawings still in the studio, which were to be sold at Christie's over two days, on 16 and 18 July. Phil was handling the detailed arrangements for the sale, which, although harassing, provided a welcome post-funeral distraction: 'It is a godsend to have these matters to attend to,' he wrote, 'it keeps one from sitting down and going crazy.'

The studio sale was in fact a great success. On the first day William and Venetia Benson went together: 'Great crowd, immense excitement – high prices.' They watched *Love and the Pilgrim* sell for 5,500 guineas; just a little more than the then record price for *The Mirror of Venus* when it was sold by Christie's two months before. Henry James was not at the Burne-Jones sale but he soon heard that 'everything went at prices – magnificent for his estate – that made acquisition a vain dream'. In all, the sale raised £29,500 13s 6d, approximately £1,700,000 today.

In late December 1898 an immense Memorial Exhibition opened at the New Gallery. Two hundred and thirty-five Burne-Jones works were shown. Joe Comyns Carr wrote a long, affectionate and in the circumstances allowably effusive introduction to the catalogue. Owners of the paintings were generous in lending. For many of the younger generation this exhibition gave them a first opportunity to view Burne-Jones's work in its totality. Sydney Cockerell, for instance, responded with excitement to 'a most glorious collection, many of them new to me'. What was most impressive was the way in which the oeuvre as a whole cohered together, demonstrating the artist's total commitment, the persistence of his vision of beauty, the thing William Sharp referred to in the *Fortnightly Review* as Burne-Jones's 'singular consistency'. And yet there was a feeling that by the time he died he was running out of energy. Had he reached his zenith? His more rigorous critics suspected that Burne-Jones had died at the right time.

In the months running up to the Burne-Jones retrospective there was much discussion on the subject of a lasting national memorial to the artist whose towering achievement was now generally acknowledged. An inaugural meeting of do-gooders and admirers

had been held at Brooks's Club on 28 June 1898, barely a week after Burne-Jones's death, with George Howard, Earl of Carlisle, in the chair. Again the Bensons were crucially involved. At this first meeting Edward Poynter had proposed that a committee should be formed to raise a fund of £3,000 to £5,000 to purchase a 'representative picture' by Burne-Jones 'to be presented to the Nation as a Memorial of him'.

An impressive General Committee was set up, the alphabetical list of members starting with the American ambassador and ending with the 2nd Baron Tennyson, the poet's son. Subscription lists were started and contributions ranged from Sir George Lewis's most munificent £105 to the single-guinea contributions from W. R. Lethaby, W. J. Stillman and Burne-Jones's old Oxford friend Canon Dixon. Janey Morris sent £5.0.0. By 20 July about £2,570 had been donated or promised, still far off the hoped-for total but encouraging enough.

As fund-raising proceeded the question remained of what painting would be truly 'representative' and indeed what painting would be affordable. The retrospective exhibition in 1898–9 gave the committee the opportunity to weigh up the options. *Psyche's Wedding* could be relatively easily obtained from the dealer Tooth's who offered it at 3,000 guineas. *Sir Launcelot's Dream in the Chapel of the San Graal*, which belonged to Graham Robertson who now wanted to sell it, was another practical possibility. But the committee ideally wanted to secure a work of greater stature, on the level of *The Beguiling of Merlin* or *The Hours*. The Merlin painting was clearly unaffordable since the owner, the Duchess of Marlborough, had insisted that the gallery insure it for £7,500. *The Hours* remained a possibility and Charles Hallé wrote to the owner to ask if she would sell it to the Memorial Fund committee. She said she would 'if she received a tempting offer'.

The delicate negotiations went on until William Benson triumphed with the idea that *King Cophetua and the Beggar Maid* might be made available. This solution, he could see, would 'probably unite all parties', silencing the supporters of *Pan and Psyche* and *Green Summer*, paintings that were still under consideration, with

what was generally accepted as the supreme example of Burne-Jones's art.

King Cophetua had already been offered to the Memorial Committee by its then owner the Earl of Wharncliffe. The price he named, £7,000, had seemed prohibitive and the offer was declined. Now, with Lord Wharncliffe's death, the situation had changed. In July 1899 a deal was struck whereby the painting was bought from the new Lord Wharncliffe by Agnew's for £6,500 and held for the committee until further subscriptions came in. Agnew himself contributed 50 guineas. Robin Benson generously undertook to share Agnew's risk up to £500. Edward Poynter was involved in the toings and froings though his name does not appear on the subscription list. On 26 July the Memorial Committee formally announced their selection to represent Sir Edward Burne-Jones for presentation to the nation as *King Cophetua and the Beggar Maid*.

Georgie had hoped that the painting would hang in the National Gallery, a place to which her husband's 'mind and soul constantly turned as a hallowed place while he was alive'. However, *King Cophetua* was assigned in 1900 to the then relatively new Tate Gallery where it still hangs in its original quasi-Venetian Renaissance gilt frame.

His widow lived through the days and weeks after Burne-Jones's death as if still in a dream. But she emerged to write one of the best memoirs ever written on the life of an artist. The two-volume *Memorials of Edward Burne-Jones* gives a superb account of her husband's working life within the day-to-day context of family events and the wider London social panorama. When Wilfrid Blunt called it 'a thorough woman's book' he was right. It is the woman's sense of the importance of domestic background and emotional history that distinguishes her book from the event-centred biographies of men written by men that were de rigueur at the period.

Mackail's *Life of William Morris* is a fine one but Georgie's life of her husband is still better in its glowing detail and convincing

intimacy of tone. She wrote the book partly from a sense of duty, as one of the very few people left alive who could remember Burne-Jones and William Morris in their optimistic prime. She was, she told Cockerell in a burst of confidence just a few days after Burne-Jones's death, 'thankful to have known those two men as she had known them, and "we must pay for the wine that we have drunk".' Probably much more than Georgie was aware, Morris too is centre stage in her biography. The *Memorials* tells a subtle story of a strange blameless Victorian *ménage à trois*.

Shortly before Burne-Jones died a new lease for the Grange had been negotiated. But Georgie now decided not to stay in London. That autumn was a time of 'slow weaning away'. To her satisfaction, since she liked the sense of continuity, Charles Fairfax Murray moved into the Grange in October 1898. 'Little Murray' was now the acknowledged international expert on Pre-Raphaelite art, and he used the Grange as his principal place of business, where he housed the collection of works by Burne-Jones among others that he had acquired so cannily over the years. By Christmas Georgie was regarding North End House at Rottingdean as her settled home.

William Benson was brought in to make the house more comfortable and manageable, connecting the basements of the original two buildings to provide more adequate servants' quarters. But the house was still austere. It remained the gathering place for her children and her grandchildren: the welcome to visitors was more than ever warm. The Kiplings returned to The Elms in the summer of 1899, having been in America since early in the year. They came back, tragically, without their daughter Josephine who died of pneumonia, aged six, in March. Georgie treated the bereaved and desolated Rudyard and Carrie almost as if they had been her own children. They would come over every evening after dinner, Carrie bringing her sewing and staying quietly for an hour or two.

Georgie had reinvolved herself in village life. She took her local politics seriously, having returned to Rottingdean for a Parish Council meeting only a few weeks after Burne-Jones's death. She

aligned herself more publicly with William Morris's Socialist views. Her granddaughter Angela Thirkell was later to describe how she asked some worthy village carpenter or wheelwright to the house once a week 'to discuss the socialism in which she so thoroughly and theoretically believed. All the snobbishness latent in children came to the fore in us as we watched the honoured but unhappy workman sitting stiffly on the edge of his chair in his horrible best clothes while my grandmother's lovely earnest voice preached William Morris to him.'

There are records of Georgie giving out the prizes at the first-ever exhibition of local handwork to be held at Rottingdean, apparently inspired by the villagers' reading of Mackail's newly published Morris biography. She became more revolutionary in her outlook. Cockerell remembered Georgie reading him one of Mazzini's addresses before taking him out for a walk across the Downs. Her pro-Boer sympathies clashed with Kipling's imperialism. In the surge of patriotic rejoicing that followed the relief of Mafeking in October 1900 Georgie hung out from her window a large blue banner on which she had hand-embroidered the message 'We have killed and also taken possession'. A little hostile crowd gathered outside North End House. It needed Rudyard Kipling to come over from The Elms to calm the situation down.

In the reorganisation of her house Georgie had created for herself an inner sanctum, converting Burne-Jones's studio into her own writing room. Here she worked most days on the *Memorials* till around three in the afternoon. 'Do not let us doubt that there is something for us to do as long as we are left here,' she had told herself soon after Burne-Jones died, echoing his own fanatical work ethic. But it was in many ways a daunting task. She was especially anxious to record the very early days of the painting of the Oxford Union in the 1850s, the beginnings of the friendship with Morris and Rossetti, 'those wonderful, *seething* days' as she described them, now almost vanished beyond recall.

The material Georgie assembled as the basis for her biography is now at the Fitzwilliam Museum in Cambridge, acquired by

Cockerell in his later days as the director, and it shows how inde-
fatigable she was in contacting survivors, cross-checking on their
memories, asking them for any letters from Burne-Jones that they
had kept. For instance, needing authentic information on her
husband's first meeting with Rossetti in 1856, she managed to
track down Vernon Lushington, who as a young man had engi-
neered the introduction. The now elderly lawyer was on travels
with his daughter and replied to her enquiry from Assonan in
Upper Egypt: 'Your interesting, to me very interesting note –
touching a deep ancient chord – has been forwarded to me *here*.'
Now in 1901 the incident had nearly gone from his memory. But
spurred on by her enquiry, it came back to him.

There in her seaside study Georgie went through the patient
processes familiar to most biographers. But because she was the
subject's widow rather than a professional outsider, gathering the
evidence had special poignancy. The influx of his idiosyncratic
charming letters, just so many letters, brought Burne-Jones pain-
fully close again. She could almost hear his own voice as she read
them. The letters were just 'so like his spoken word'.

There were also the illicit and impossibly romantic letters to
contend with, the ones he scribbled out in such a frenzy of devo-
tion to the succession of women he adored. With her selfless sense of
thoroughness Georgie now called in her husband's correspondence
with Frances Horner, Mary Drew, Eleanor Leighton, Elizabeth
Lewis, May Gaskell, receiving a rather mixed response. Judging
from the relatively innocuous letters now at the Fitzwilliam, some
of the correspondents may indeed have burned his letters as
Burne-Jones had instructed. May Gaskell had evidently had the
sense to send Georgie a small and carefully edited selection of her
letters, although a daunting number have survived in public and
private collections elsewhere.

Lady Lewis, with the caution of the top solicitor's wife, told
Georgie she had destroyed some of Burne-Jones's correspondence
and was prepared to send only extracts from her remaining letters.
Nor was Georgie herself above destroying letters. Just a few years
later, when May Morris was writing the introductions to her

father's *Collected Works*, she approached Georgie to ask for help with documentation. Georgie wrote apologising: 'I turned to my archives, and find that the letters from your father that I have kept only begin in 1876.'

One of Georgie's main sources of information was the wide-ranging 'studio conversations' in which Rooke assumed the role of Burne-Jones's Boswell. Georgie made an authorised holograph transcript of Rooke's original notes on scraps of paper and in note-books. We do not know what omissions or amendments she might have made. Probably quite a number, since even the later type-script copy made from the holograph, the copy now in the National Art Library, is annotated in Georgie's unmistakable handwriting 'Omit', 'Omit', against questionable entries, such as painful descriptions of Rossetti's illness, pejorative comments on her ultra-Tory sister Lady Poynter, insults to Queen Victoria and various swear words and obscenities.

Certainly there are lacunae in the *Memorials*. Maria Zambaco is not mentioned. Oscar Wilde, in spite of his closeness to the Burne-Jones family in the 1880s, is completely absent from the book. But what can one expect considering the biographical conventions of the time and the prime intention of Georgie's project which was to raise 'a cairn' over 'the band of men' who had been so much to her from childhood, most of all Burne-Jones and Morris? She leaves no doubt that her married life had its elements of wistfulness and sadness. In the circumstances, the *Memorials* are remarkably frank.

She found the writing hard work and emotionally wearing. 'It is like putting together a dissected Map,' she said. But as she progressed the train of events clarified: 'almost everything fits in, even letters and notes that at first sight look useless'. Gradually the book was taking shape. There were hurdles to get over. William Michael Rossetti, the guardian of his brother's reputation, wished to see the typescript copies Georgie had had made of Gabriel's letters and to know which she was using: 'I am not squeamish or fussy in such matters,' he told her, 'and have little doubt that, when you think fit to publish something, I shall think much the

same'. Everything she wrote was submitted for approval to Phil and to Margaret and Jack Mackail.

Georgie decided to fix the division point between the two volumes in the middle 1860s, at the point of the abandonment of plans for sharing Red House with the Morrises. 'It was', she wrote, 'because I realised how great a break in our life and that of Morris came in the end of the year 1864.' She felt that once she and Ned had moved to Kensington all that early history had been left behind them. The Zambaco years are skated over. Although she does not say so, the break between the volumes marked the change between innocence and the end of it.

When she read her first four chapters out loud to Sydney Cockerell in November 1902 she had found her ideal audience. He was not just impressed but almost overcome by emotion. Never had he been so moved, he said, since the day when Ruskin read him some new chapters of his memoir *Praeterita* or the dying Morris read him extracts from the manuscript of his last novel *The Sundering Flood*. The sense of his own later connections with the world she was describing sharpened the experience. 'These things', he told Georgie, 'caused me to feel so many thrills and stirrings that I scarcely knew how to face you when the last sentence came.' When he left North End House, although in good time for the omnibus to Brighton, he preferred to make a solitary walk along the coast road in a sober, thoughtful mood.

In early 1903 her progress on the book was interrupted by illness, a bronchial chill that had, frustratingly, meant a long period in bed. But later in the year she gathered strength and by February 1904 reported herself as 'still dizzy from the surprise of finishing my work'. There was then a long process of checking and cross-checking. Georgie, the stickler for accuracy, called in her old headmaster friend Crom Price to read and correct the typescript and compile the index. In a way she was reluctant to let it go. The work on the book had become her daily habit, her method of survival. She was conscious that her six years of concentration on Ned and their life together had now changed her: 'I think I should be a better companion to him if he came back.'

These years on the *Memorials* had taken a lot out of her. Venetia Benson, visiting her in early summer, found 'a little white wreck on the sofa'. The two volumes were published in late 1904. Those who had known Burne-Jones read them avidly. 'Now I have fallen on Lady Burne-Jones,' Wilfrid Blunt so characteristically put it. Responses were inevitably varied, some enthusiastic, some a little critical. For Philip Webb, the friend since Oxford, Georgie's book was 'a real story and the letters in it master-works of wit and wisdom'. Blunt, although impressed, felt as he had done when reading Mackail's *Morris* that it was 'beyond possibility to quite reproduce the individuality of either of the men we knew'. Norton too doubted whether it could ever be quite possible to capture Burne-Jones's evanescent and peculiar originality. He felt that Morris, Ruskin and Carlyle, because somehow more solid, were all easier subjects for a biographer.

Fairfax Murray took the harsher view that 'Lady Burne-Jones's *Memorials* to her husband is nothing but a collection of facts that may be useful to a future biographer, but they give an incomplete impression from much being omitted, purposely of course. The same would have to happen in regard to Swinburne.' He is right up to a point. But Murray was too blinkered, too much the art specialist and connoisseur, to understand its nuances and beauties or to see that Georgie's book was an astonishing achievement in an elderly woman who had never before carried to completion any sustained creative work.

Georgie survived to an indomitable old age, supporting the new Labour Party, rereading Ruskin, encouraging her grandchildren, supporting her ailing sisters and old friends, bracing herself to visit Janey Morris and her epileptic daughter Jenny in desolate Kelmscott Manor. It was Georgie who had the idea that Janey should return to live in London: 'She is still a splendid looking creature – nothing of the old woman about her . . . Why, we might live to see her holding, not exactly a "salon" but a sofa, of a brilliant kind, mightn't we?' Morris was more than ever on her mind, while Burne-Jones appears to be receding just a litle. In 1916 when she read the life of Tolstoy it struck

her how like William Morris he had been in his informal personality.

The First World War affected her profoundly: 'how sobered are our hearts, and how altered the world is'. She lived to welcome in the Russian Revolution.

The Return of King Arthur
2008

In autumn 1916, one of the worst phases of the First World War, soon after the British and French armies had begun the Somme offensive, Burne-Jones's last great painting *The Sleep of Arthur in Avalon* went on show at Burlington House. It was the central feature in a national exhibition of decorative arts organised by the Arts and Crafts Exhibition Society in the Royal Academy rooms. Burne-Jones's brother-in-law Sir Edward Poynter, now in his early eighties and still R. A. president, had encouraged this patriotic display of Britain's prowess in handcrafts and design, an area in which the Germans too were now excelling. The symbolic relevance of Burne-Jones's painting of King Arthur was potent at a time of resurgence of the chivalric values of courage, fidelity and self-sacrifice. According to the legend, Arthur's tomb bore the inscription 'King Arthur, once and future king'. In the national consciousness the promise of King Arthur was embedded deeply. When the nation needed him the king would come again.

The stupendous painting had not been seen in public since the Burne-Jones Memorial Exhibition in 1898. It appears that Thomas Rooke had filled in some final details in order to make the picture fit for exhibition. At that time Burne-Jones's *The Sleep of Arthur in Avalon*, along with his other major paintings, was considered as a possible candidate for purchase for the nation by the Burne-Jones Memorial Fund. It had the advantage that the artist's many preliminary sketches and studies for the painting could be made

available as well. But the claims of *King Cophetua* were considered stronger. Unlike *The Sleep of Arthur* it was indubitably finished, and it was a much more manageable size.

King Arthur disappeared into a private collection, being bought direct from Burne-Jones's executors by a wealthy MP, Charles Goldman, appropriately named since he had made a fortune from gold and diamond mining in South Africa. His considerable collection included a number of Pre-Raphaelite works. The picture Burne-Jones himself regarded as his *magnum opus* was more or less forgotten. Its sudden re-emergence as a patriotic emblem in the middle of the war evidently disconcerted the now elderly widow of the artist, who confided in Sydney Cockerell, 'I was very sorry when I learnt the big Arthur picture had been lent and also deprived of its frame.' The original magnificent gold frame with its inscription in Latin had been removed. Photographs show the frameless painting hanging in the 1916 exhibition looking naked, a bit desolate, as if it had become another wartime casualty.

This was a war in which the numbers of the dead seem to us now almost incomprehensible. Of almost a quarter of a million fatalities, 37,452 were officers, many of them still young men linked together by their family backgrounds and their schooling. Amongst the English aristocracy and upper middle classes, as the death tolls rose, it seemed as if few families escaped unscathed. By the end of the war Burne-Jones's much loved Mary Elcho, now the Countess of Wemyss, made a list of the lost sons within her own close circle of 'the Souls', the children of the Wyndhams and Tennants and Horners and others who had all grown up together. She counted twenty-five.

These were boys who had been brought up on Aesthetic Movement principles with a feeling for truth, beauty and asperity of character. The houses of their parents and their grandparents were furnished in the Morris style and many had, as children, known both William Morris and Burne-Jones. Arthurian legend was a kind of second nature. A photograph of Mary's son Yvo in the archive at Stanway shows a tiny boy wearing a tabard and a helmet, dressed

as an Arthurian knight in miniature. In 1915 Yvo was the first of the Charteris sons to be a casualty of war. He was then nineteen. His death was followed the next year by that of his older brother Ego, Lord Elcho, who was killed in Egypt, serving in the Royal Gloucester Hussars.

The household at Mells was struck by grief as well. Frances Horner's son Edward, a strong, athletic, highly intelligent young man six foot four in height and 'a picture of radiant masculine beauty', had been sent to France with his regiment, the 18th Hussars, in the spring of 1915. He had been badly wounded in the heavy fighting that followed the second battle of Neuve Chapelle. He was shot in the stomach, a kidney was removed and he spent months back in England in a nursing home. Although only semi-recovered, he insisted on returning to his regiment in France and was killed in the battle of Cambrai in November 1917.

'Edward Horner looked on life as a magnificent adventure to be lived magnificently and in great style,' wrote someone who had known him well. Sometimes these sons of 'the Souls' seem too Arthurian to be true. A statue of Edward on horseback, *The Cavalry Subaltern*, was made by Alfred Munnings and stands near the tapestry embroidered by his mother to Burne-Jones's design in the village church at Mells. Edward's great friend Raymond Asquith, his Eton and Balliol contemporary, husband of his sister Katharine and son of the Prime Minister H. H. Asquith, was also killed in the First World War in France.

One of the names in Mary Elcho's list of war dead was from the Burne-Jones family itself. This was John Kipling, Rudyard and Carrie's only son. At the beginning of the war, just before his seventeenth birthday, he had answered Kitchener's call for voluntary recruitment in the New Army. Though initially rejected on grounds of his poor eyesight, his father used his contacts to get him a commission in the Irish Guards. John was still only just eighteen when he left for France in August 1915, Rudyard giving him a send-off luncheon at the Bath Club. He fought in the notorious battle of Loos in which 20,000 British soldiers died. On 2 October a War Office telegram announced that Kipling's son was wounded and

missing. Hope of his survival faded. Kipling comforted himself as best he could: 'it's something to have bred a man'.

It was more than two years before the details of his death became known. Oliver Baldwin, Stanley's son, tracked down the Irish Guards sergeant who had been with John Kipling when he was shot through the head. The troops had been fighting their way through a tangled stretch of country known as Chalk-pit Wood. The sergeant had laid John's body in a shell hole. He now counted as one of the unlocated dead. Though he tried to be rational, the years of uncertainty took their toll on Kipling. The family no longer lived in Rottingdean but had moved to Bateman's in the Sussex Weald and it had been some time since Georgie met him. When the Kiplings came to visit her in January 1917 she was aware of a great change in him. It was 'as if he had died and been buried and risen again, and "had the keys of hell and of death"'.

Burne-Jones was once again in fashion in the mood of chivalric reverie that followed the slaughter of the First World War. Morris & Co. had a full order book from 1915 onwards into the early 1920s for memorial windows to fallen officers, erected by their grieving families. Burne-Jones's designs were resurrected and recycled. Most of these memorial windows were derived from Burne-Jones's well-tried format for stained-glass windows: the single static saintly figure in the upper panel with a scene from the saint's life, a scene of compressed drama like an image from a stained-glass comic strip, in the smaller square below.

There are dozens of these First World War windows to be found in churches up and down the country, remembering sons fallen in the battle of Arras, the battle of Ypres, the battle of the Aisne. Some windows commemorate as many as three sons. The inscriptions are poignant. A Burne-Jones *St Michael* at Halam in Nottinghamshire was 'erected by his stricken parents' in memory of a son who fell in action in 1918 in his thirtieth year. Another posthumous Burne-Jones window, this time a *Mary Virgin*, was erected at Merton in Surrey to memorialise the local parish priest 'who fell in action near Arras May 28 1918 while ministering to the wounded'.

In this context of desolation and remembering, Burne-Jones's 'sacred land' of the Arthurian took on a new meaning. In many of these windows Arthurian and Christian iconography has merged. One of the most popular subjects was St Michael. The Archangel Michael is again the central figure in the memorial window to Major Lord Bernard Gordon Lennox, killed at Ypres, in the Gordon family chapel at Fochabers. St Michael is in armour, like a questing knight. He slays the dragon in full military fashion with his broadsword. But Michael, we do not forget, is also the archangel with great scarlet angel's wings.

Burne-Jones would not have approved of these late windows. The colour is much cruder than he or William Morris would ever have allowed. There is the heavy mass of foliage and incidental detail Henry Dearle, still Morris & Co.'s principal designer, could not resist. On some stained-glass windows Dearle had gone to town with scrolls of honour, open books of remembrance, banners and regimental badges. The windows he designed on his own account take up the Burne-Jones themes of courage, fortitude and valour and reinterpret them with terrible sentimentality and mawkishness. *Christ and the Boy Scout*, a 1917 Morris & Co. adaptation of E. S. Carlos's painting *The Pathfinder*, was judged by A. C. Sewter, twentieth-century expert on Morris stained glass, as 'certainly one of the worst windows Morris & Co. ever made'.

Georgie was deeply affected by the aftermath of the First World War. 'I feel as if the whole surface of the world were being turned by a pitchfork,' she wrote in March 1919. She was now, in her late seventies, almost the oldest inhabitant of Rottingdean, becoming increasingly frail and often breathless, unable now to travel without an accompanying maid.

Towards the end of January 1920 she was staying with her now widowed sister Louisa in Kensington when she was taken ill. Margaret was anxious and called the doctor. A chill had developed into bronchitis. Georgie was put to bed and a professional nurse brought in to care for her. Annie, Louisa Baldwin's maidservant,

kept a record of events as Georgie worsened and finally became delirious:

28 January: 'my Lady would get up for Tea with Mrs. Arthur Severn which proved fatal in the end'

1 February delirium: 'talking very much of man that was good and pious and did see him at times in her bedroom? "Who is that man standing there?" she said'

2 February 'the last day on this earth'

Margaret described how she died that afternoon, 'her pretty head settled a little on one side, against a small gay cushion'. Before she died there had been a glimmer of recognition for her daughter. Phil arrived from Monte Carlo a few hours later. Once again he reached the deathbed just too late to say goodbye. The death of his mother was in some ways even worse than the death of the father Phil had worshipped. She had been his anchor in the increasingly unhappy years since Burne-Jones's death during which Phil's own work failed to prosper and the high life he aspired to failed to satisfy him. Not even as Sir Philip could he find his role.

Virginia Woolf, on her honeymoon in Venice a few years earlier, spotted Phil in St Mark's Square: 'He looked dissipated and lonely, like a pierrot who had grown old and rather peevish. He wore a light overcoat and sat, his foolish nervous white face looking aged and set, unhappy and eager and disillusioned, alone at a little white table.' Phil's lack of connectedness had always puzzled Georgie. In spite of his enormously wide circle of acquaintances, Phil clung to her as if she was the only person that he knew.

'I didn't know that life still had so much sorrow in store for me,' he wrote after her death. He went straight back to the Riviera after the funeral, desperate for the blaze of sun that might bring forgetfulness. From then on Phil continued the gadabout existence. His nerves got worse. There were more 'rest cures'. He died in a nursing home in London on 21 June 1926 aged sixty-four. The official cause of death was heart failure. People who had known him suspected suicide. Phil in his way was yet another fallen son.

In 1929 *The Sleep of Arthur in Avalon* was offered by its owner Charles Goldman on long loan to the Tate. It seems the painting was not received with great enthusiasm. Burne-Jones's reputation was now at a low ebb. His romantic escapist way of painting, damagingly challenged by the realism of the 1890s, had been further undermined by the feeling for 'pure form' of the Bloomsbury generation and the new developments in modernist and abstract art. Burne-Jones and the machine age looked incompatible. Besides, Burne-Jones had been around so long that a common reaction was simply one of boredom. Siegfried Sassoon was not alone in admitting 'Burne-Jones no longer gives me any pleasure at all'. When *Arthur in Avalon* arrived at the Tate it was hung in a rather ignominious position on a back staircase, again without a frame.

Four years later Burne-Jones's monumental painting was one of nearly ninety works in the Tate's exhibition celebrating the centenary of the artist's birth. The proposal for the exhibition came originally from a retired civil servant and scholarly Egyptologist, Ernest Seymour Thomas, assistant curator at the Pitt Rivers Museum in Oxford. Thomas revered Burne-Jones, whom he referred to as 'the Lord'. The then Director of the Tate, Sir William Rothenstein, had his own Pre-Raphaelite loyalties. His wife was the daughter of Walter Knewstub who had been Rossetti's pupil and assistant. Though conscious of Burne-Jones's unfashionability, Rothenstein took the long view that his art was 'a national possession' and that appreciation of its 'mysterious spiritual essence' would eventually return.

The exhibition had the backing of the Burne-Jones family. Margaret Mackail lent her own Sleeping Beauty watercolour. Exhibits were solicited from other elderly members of the Burne-Jones circle. May Gaskell lent the portrait of her long-dead daughter Amy. Lady Horner lent the *Orpheus and Eurydice* piano painted for her twenty-first birthday by Burne-Jones. Angela Thirkell, the termagant granddaughter who was now becoming a successful lady novelist, organised a tea party at the Tate on Friday 16 June 1933 to celebrate the opening of the exhibition.

The sense of déjà vu was overwhelming. Graham Robertson found it 'rather sad – a little crowd of forlorn old survivals paying their last homage to the beauty and poetry now utterly scorned and rejected'. He felt they should have been served sherry and seed cake instead of tea, together with copies of the burial service. William Rothenstein described the party in similar terms as 'a gathering of tender ruins', listing among others G. F. Watts's ancient widow, May Morris, George Bernard Shaw and Thomas Rooke, now in his nineties, who regaled those who would listen with his authentic accounts of Burne-Jones's working methods. The Master had favoured 'a stiff pigment of the texture of soft cheese' which he would then liquefy to let it run.

The celebrity at the centre of the scene was Stanley Baldwin. Stanley, having served two terms as Conservative Prime Minister, from 1923 to 1924 and 1924 to 1929, was now Lord President of the Council in the National Government, the second, powerful figure in a coalition headed by Ramsay MacDonald. Though as always at that period frantically busy with parliamentary business, Stanley's family loyalties were strong and he brought to the gathering in the Tate refreshment room a welcome element of gravitas.

Baldwin, who like his cousin Kipling had absorbed so much of storytelling, history and language from his Uncle Ned, spoke touchingly about those early days when he had thought to be an 'uncle' simply meant to be a painter. He re-evoked Burne-Jones's character: the 'singular charm' that sprung from 'natural grace and kindliness'. He reminded those who by then might be forgetting that Burne-Jones had one of the liveliest and most beautiful wits of any man or woman he had ever met. But not just that: Baldwin was perceptive in his comments on Burne-Jones's quite incredible work ethic and persistence. He had 'a will like iron and granite where the ideals he worked for were concerned'.

What Baldwin said that day in fact reflects his own ideals. He was a politician with his own distinct and, for the time, immovably upright set of values. He had been too old to fight in the First World War but emerged from it with strong convictions that the survivors must live up to the sacrifice made by the dead. Baldwin's

countrified, tweedy, pipe-smoking political persona came to be seen as the epitome of dependability. He had stood out for an old-fashioned moral integrity in the face of the sophisticated machinations of Lloyd George and the press barons, men he said he would not have in the house. Baldwin had a view of England that was essentially a countryman's view, steeped in love of England's physicality and the long panorama of its history. He was one of very few Prime Ministers who actually enjoyed being at Chequers, where he would take long ruminative walks. He was actively Christian: he and Cissie started every morning in prayer on their knees.

Baldwin's deeply held convictions reflected the culture of his childhood. His mother Louisa had been steeped in Walter Scott, medieval romance and the chivalric world of Malory just as Morris and Burne-Jones had. Stanley had absorbed the tenets of honour and truthfulness, self-abnegation, valour from a very early age. As a boy he had had an apparently unrequited passion for the twelve-year-old May Morris. Though so thoroughly Conservative, Baldwin also had an element of romantic Socialism in his complex make-up. His cousin Rudyard Kipling went so far as saying 'S. B. is a Socialist at heart'.

In 1935 Baldwin became Prime Minister again. A year later he was faced with the abdication crisis as the new king, Edward VIII, persisted in his intention to marry Mrs Simpson, the American whose second divorce was imminent. It was Baldwin whose remit it was to tell the king that he must either renounce Mrs Simpson or abdicate since marriage to a divorcee was not an option for God's anointed monarch. His Prime Minister was unable to persuade the king to follow the line of duty, and the instrument of abdication was signed on 10 December 1936. Baldwin was dismayed and disillusioned by what he could only see as the king's failure at this time of moral testing, attuned as he was to view the abdication crisis in chivalric and Arthurian terms.

Burne-Jones's rehabilitation came only very slowly. During the bombing raids of 1940 *Love and the Pilgrim*, which had sold for

£5,775 in 1898, was bought in at £21. Sale-room prices continued very low for the next two decades, with large parcels of Burne-Jones drawings being sold at Christie's for only a few pounds. Burne-Jones remained a specialist interest, almost a private joke between a small group of Pre-Raphaelite devotees. These included Evelyn Waugh, whose very first book was a study of Rossetti, and John Betjeman whose poetry exudes romantic feeling for Victorian Anglican church architecture, G. E. Street and Burne-Jones being his special heroes. The poem 'An Archaeological Picnic' was published in Betjeman's collection *New Bats in Old Belfries* in 1945:

> Sweet smell of cerements and of cold wet stones,
> Hassock and cassock, paraffin and pew;
> Green in a light which that sublime Burne-Jones
> White-hot and wondering from the glass-kiln drew,
> Gleams and re-gleams this Trans arcade anew.

His serious claims as a painter found a new champion in Robin Ironside, himself an artist in the neo-Romantic tradition and assistant keeper at the Tate from 1937 to 1946. Ironside, a brilliantly erratic figure, wrote a series of articles that argued for Burne-Jones's crucial position in the visionary tradition of art originally derived from William Blake and Samuel Palmer and 'kept flickering in England ever since the end of the eighteenth century, sometimes with a wild, always with an uneasy light, by a succession of gifted eccentrics'.

In an article 'Burne-Jones and Gustave Moreau' published in *Horizon* in 1940, Ironside went further in showing his relation to the poetic romantic form of painting that developed in Europe from the mid-nineteenth century. Besides Gustave Moreau, Ironside persuasively related Burne-Jones's richly elaborate and esoteric paintings to the Swiss visionary artist Ferdinand Hodler and to Gauguin. 'Nothing could be more mistaken', he argued, than to regard Burne-Jones's art as 'an exotic backwater'. He was a central figure, original, important. After Ironside's impassioned and knowledgeable advocacy people began to view Burne-Jones with new eyes.

Ironside was a designer of stage sets, medals and coins, as well as decorations for the coronation of Elizabeth II, usually working with his brother Christopher. It is here I make a minor appearance in this story. Growing up in London I attended Miss Ironside's School, a day school in Kensington run by Robin's aunt where his brother Christopher taught me art. I remember as a child going to Covent Garden to see Frederick Ashton's *Sylvia* starring Margot Fonteyn, the sets for which the Ironside brothers designed jointly. The scene of the sacred wood, delicately frondy, ineffably mysterious; the sea coast by the temple of Diana with its billowing cloud forms full of mystic possibility. Burne-Jones's lost designs for *King Arthur* must have had a not dissimilar visionary feel.

The revival of Burne-Jones's reputation, which had seemed 'a forlorn hope' to his few ancient admirers at the time of the centenary in 1933, became more of a certainty in the 1960s, a period in which Victorian art, design and architecture began to be appreciated widely in a surprising turnaround of public taste. The Pre-Raphaelite painters now had major exhibitions: Ford Madox Brown in 1964, Millais in 1967, Holman Hunt in 1969. Rossetti's would come in the early 1970s. Pre-Raphaelite memories were eagerly solicited from the artists' descendants and connections: Virginia Surtees, great-granddaughter of Rossetti's model Ruth Herbert; Lady Mander the chatelaine of Wightwick Manor, a Pre-Raphaelite show house; Diana Holman-Hunt, granddaughter of the artist. Diana Holman-Hunt's memoir *My Grandmothers and I*, published in 1960, introduced her many avid readers to the weirdness of day-to-day life in a Pre-Raphaelite milieu.

A new appreciation of Burne-Jones in his floating, flowing, 'greenery-yallery' mode was encouraged by the 1960s rediscovery of art nouveau. Surprisingly popular exhibitions at the Victoria and Albert Museum of the art of Alphonse Mucha and – more ironically in the Burne-Jones context – that of Aubrey Beardsley stimulated new developments in poster art and graphics. This was the beginning of the unexpected cult of Charles Rennie Mackintosh and the Glasgow school of decorative art. By the middle 1960s it seemed as if 'the Burne-Jones look' was everywhere. It

was an essential factor in young fashion. The London gallery owner Jeremy Maas, whose pioneering enthusiasm for Pre-Raphaelite art had done much to reverse the antipathy towards it, noticed how in the 1960s the younger generation of visitors 'had begun increasingly to resemble the figures in the pictures they had come to see'.

The Pre-Raphaelite style was adopted as the symbol of the alternative society. Pre-Raphaelite imagery, manner, code of dress became the epitome of hippydom. When Barbara Hulanicki's Biba first opened in 1964 in Kensington, in the converted Victorian chemist's shop not far from what was once the Burne-Joneses' house the Grange, the long drooping structureless clothes bore a distinct, though sexier, resemblance to the dresses of the girls in *The Golden Stairs* or the ghostly waiting women in *The Sirens*. The hippy look spread to the high street, a conscious soulful contrast to the hard-edged hedonistic fashions of a year or two before.

It affected male dress too. Sir John Pope-Hennessy had been Director of the Victoria and Albert Museum when the cartoon for Burne-Jones's stained-glass window *The Good Shepherd* was acquired and he noticed how the Christ figure 'with its silky, over-shampooed hair, its sensual lips, and its glassy introspective eyes, corresponded very closely with the models for male fashions shown in the window of Harrods in the Brompton Road'. The androgynous appearance of Burne-Jones's male figures reflected the sexually ambivalent feeling of the time.

Burne-Jones's dream worlds took on a new relevance, seeming to connect with those 1960s dream worlds of love-ins and anti-materialist protest movements. He seemed a perfect artist for that period of flower power, sex, drugs and rock 'n' roll. Writing in the *New Statesman* in November 1970, the critic Robert Melville pointed out, 'The young have discovered premonitions of the psychedelic experiment in Pre-Raphaelite colour, and associate the introverted beauty of the feminine images with pure sexuality.' The example he used was *Love's Shadow*, Frederick Sandys's profile study of a girl sucking pensively at a sprig of blossoms, calling this 'a first rate PR job for the Flower People'. An equally apposite

example would have been Burne-Jones's subliminally erotic *The Heart of the Rose*.

Andrew Lloyd Webber, a true child of the sixties, became an enthusiast at just this period. 'Rock 'n' roll was absolutely equally there with Rossetti,' he said in a television interview, describing his obsessive searching out of Pre-Raphaelite art since he was a boy. His father had once been the organist at All Saints, Margaret Street, William Butterfield's masterwork, and he was indoctrinated early into the decorative splendours of High Gothic. When Lloyd Webber was thirteen, on a school trip to Rome, he first saw the – to him – astonishing, entrancing Burne-Jones mosaics at St Paul's Within-the-Walls.

By the late 1960s, once his music for *Joseph and His Amazing Technicolor Dreamcoat* and *Jesus Christ Superstar* started making money, Lloyd Webber began collecting Burne-Jones in earnest, beginning with relatively inexpensive drawings and, as he became more able to afford them, gradually amassing the collection of nearly fifty works that occupied a whole large gallery at the Royal Academy when it was shown there in 2003. After thirty years of increasingly ambitious and discriminating buying, Lord Lloyd-Webber now has by far the most important and widely representative Burne-Jones collection in the world.

Jimmy Page, the Led Zeppelin guitarist and another famous figure of the sixties music world, acquired the Burne-Jones tapestry *The Quest for the Holy Grail: The Attainment*, the scene in which the knights arrive at the chapel that contains the mystic Grail. Page, who originally studied art himself, felt a particular personal rapport with the cultural iconoclasm and unconventional mores of the Pre-Raphaelites: 'The romance of the Arthurian legends and the bohemian life of the artists who were reworking these stories seemed very attuned to our time.' Burne-Jones visions became a part of drug-induced imaginings. The rock star hung his twenty-four-foot tapestry, one of the original set woven at Merton Abbey for William D'Arcy, in his house in Holland Park. This too was an Arthurian fantasy, a red-brick house called Tower House designed by William Burges. Burne-Jones was now acquiring his own

status as a superstar, his role in the fulfilment of fashionable dreams.

Yves Saint Laurent and his then lover and business partner Pierre Bergé had started their joint collection of paintings and objects in the late 1960s after the initial success of the Yves Saint Laurent couture house. The collection was an extraordinary one, mixing styles, eras and continents, combining fastidiously chosen paintings, furniture and objects. The only rule was that they always bought the best. There were three Burne-Jones works in the Saint Laurent-Bergé collection in Paris. One was *Luna*, the painting of the spirit of the moon that once hung in the Ionides drawing room in Holland Park. Burne-Jones's moon goddess suspended in the sky on the edge of the full moon wears a swirling blue-green robe. Yves Saint Laurent was of course another connoisseur of fabrics and the way they moulded themselves to the female form.

In Yves Saint Laurent's salon in the apartment in the rue de Babylone, the room people remember as 'a room of masterpieces', Burne-Jones's *Paradise, with the Worship of the Holy Lamb* hung alongside paintings by Goya, Delacroix and Géricault, the big Cubist Picasso, the De Chirico, the Brancusi carving, the modernist furniture, a collection of bronze horses, the whole expertly balanced eclectic mix. Both the scale and the ecclesiastical tenor of the five-panel Burne-Jones painting tended to take even the most sophisticated visitors by surprise.

This was Burne-Jones's original cartoon for the chancel east window for the Church of All Hallows at Allerton made in 1875 and described in his work record as 'a great window of Paradise'. The pencil cartoon had later been enhanced by Burne-Jones, hoping to find a buyer for it, in coloured wax crayon touched with gold. It had been in the collection of Lord Windsor, whose wife's portrait Burne-Jones had painted in the 1890s. As always with Saint Laurent and Pierre Bergé the provenance was immaculate.

Downstairs in the apartment was another *grand spectacle*, the tapestry *The Adoration of the Magi*. This was the eighth of the ten weavings of Burne-Jones's most magnificent and idiosyncratic

design for tapestry, commissioned in 1904 from Merton Abbey by the connoisseur and banker Guillaume Mallet for his new country house Le Bois des Moutiers at Varengeville-sur-Mer, near Dieppe. Mallet was an English Arts and Crafts enthusiast. The house was designed by Edwin Lutyens and gardens planned by Lutyens with Gertrude Jekyll. In the war when the house was taken over by the Nazis the *Adoration* tapestry was safely hidden. Saint Laurent and Bergé bought it from Mallet's family. Burne-Jones's inclusion as of right, not as a side issue or an aberration, in one of the great twentieth-century international collections is a final argument against the charges of provincialism that Bloomsbury and later critics have so loved to fling at him.

After Saint Laurent died the tapestry was scheduled to be included in the sale of the collection in February 2009, a three-day, 733-lot auction at the Grand Palais. But Pierre Bergé had a change of heart at the last minute. The *Adoration of the Magi* tapestry was withdrawn from the auction and donated to the Musée d'Orsay.

Burne-Jones's vast Wagnerian work *The Sleep of Arthur in Avalon* left this country in 1963. The canvas had been rolled up and stored in a very large stout box during the war, along with other paintings from the Tate collection. It was still in this great coffin when it arrived at Christie's to be sold by the heirs of Charles Goldman who had died in 1958. The Tate, with an annual purchasing grant of £40,000, could have well afforded to buy the Burne-Jones painting but short-sightedly chose not to. *Arthur in Avalon* was purchased from the sale for £1,680 by Luis Antonio Ferré, a Puerto Rican industrialist and philanthropist.

Ferré, who became governor of Puerto Rico, was a collector with a nose for paintings of a kind not yet in fashion and a special feel for the Victorian erotic. Another of his bargain purchases, for which he paid £2,000 at this period, was Leighton's *Flaming June*. Burne-Jones's *Arthur in Avalon*, dirty and dilapidated after its years of storage, was cleaned and restored in London before being taken off its stretcher, rolled on a roller and shipped to the

Caribbean where it was to be installed in a purpose-designed gallery in the new modernist Museo de Arte de Ponce financed by Ferré, which opened in 1967.

The painting then went virtually out of circulation. Occasional sightings were reported by scholars and Burne-Jones enthusiasts who made the journey to Ponce. But it was considered too expensive to transport the outsize painting for the three-venue Burne-Jones centenary exhibition organised by the Met in New York in 1998. *Arthur in Avalon* had not left Puerto Rico for more than forty years when the closure of the museum for renovation and a warming of relations with the Tate suddenly, almost miraculously, made possible the return of *Arthur* to Tate Britain in the spring of 2008.

A celebration lunch was held to welcome back the painting the Tate had at one time seemed eager to disown. The perception of Burne-Jones was now altogether different following a succession of important exhibitions. The first pioneering post-war survey took place in 1971 in Sheffield, which was where I first saw Burne-Jones's work in any quantity. I was then a young woman wheeling my infant daughter in her pushchair around the City Art Gallery. To begin with I found Burne-Jones mystifying but I liked him more and more.

Four years later came the large-scale Arts Council exhibition at the Hayward curated by John Christian. This was for many people their first real revelation of Burne-Jones's magnificent strangeness as an artist, unexpectedly enhanced by the Brutalist architecture of the gallery. It was followed by the Tate's own 1984 Pre-Raphaelite show and 1997 exhibition of Symbolist art which convincingly repositioned Burne-Jones as a pivotal figure in European Symbolism. When it came to the centenary exhibition at the Met the directors, in their foreword to the catalogue, remarked on the changed climate of opinion in which it was now possible to view Edward Burne-Jones 'as the greatest British artist of the nineteenth century, after Turner and perhaps John Constable'.

There was a mood of excitement and expectancy in the crowd assembled at Tate Britain on 15 April 2008. The combination of

legendary monarch and long-absent Burne-Jones masterpiece had proved intriguing, and pre-launch articles under such titles as 'Homecoming King' and 'Arthur's Return' had already been appearing in the press. On the previous morning an atmospheric radio documentary was broadcast charting the painting's return home from Puerto Rico. Burne-Jones had become *persona grata* at the gallery and the guest list for the lunch was on a different level to that of the pre-war group of 'survivals', the aged Burne-Jones aficionados gathered for his granddaughter Angela's Tate Gallery tea party in 1933.

The return of Arthur was now being applauded by the art world's great and good: Stephen Deuchar, Director of Tate Britain, Dr Nicholas Penny, recently appointed Director of the National Gallery, Richard Calvocoressi, Director of the Henry Moore Foundation, Alison Smith, the Tate's Head of British Art to 1900 and one of the world's experts on the Pre-Raphaelites. With her dark auburn hair, pale face and elegant black dress she could have passed for a Pre-Raphaelite stunner herself. The art critics and commentators had assembled and I was there myself as Burne-Jones's biographer as well as William Morris's, in a discreet onlooker's role.

As for the centrepiece, King Arthur himself, Burne-Jones's painting was now hung not in the obscurity of the Sargent staircase but had been given pride of place in its own gallery, Room 10, surrounded by his preliminary studies for the painting and contemporary photographs. A long bench had thoughtfully been placed in front of the picture so that visitors could contemplate the complexities of what Alison Smith, the display's curator, had called 'one of the great valedictory statements in the history of art'.

Seeing it for the first time in reality, close up, the painting so familiar from reproductions had acquired an extra quality of marvellous outlandishness. It seemed more than ever the expression of Burne-Jones's particular obsessions, his quest for love and beauty, his subdued eroticism. *Arthur in Avalon* is the ultimate Burne-Jones fantasy of the king at rest in his own flowery paradise surrounded by a cohort of the women he adored. Can we ever get

much nearer to his elusive oddity, the thing Du Maurier referred to as 'the Burne-Jonesiness of Burne-Jones'?

The return of King Arthur was for me, and for others, a moving experience, a little melancholy, reminding one of this Victorian artist's and many other artists' struggle for recognition. Burne-Jones himself saw it as a necessary cycle: 'Everything has to go through its period of neglect; if it survives that and comes to the surface again it's pretty safe.'

Sources and References

With abbreviations used in reference notes

Manuscript Sources

Bodleian Bodleian Library, Oxford
 E B-J correspondence with F. G. Stephens
 E B-J correspondence with Dante Gabriel Rossetti
 Elizabeth Lady Lewis and Lewis family papers

British Library British Library, London
 E B-J correspondence with Arthur Balfour
 E B-J correspondence with the Dalziel brothers
 E B-J correspondence with Mary Gladstone (later Mary Drew)
 E B-J correspondence with Helen Mary ('May') Gaskell
 G B-J correspondence with May Morris
 The Cockerell Papers
 William Morris Papers (the Robert Steele Gift)

Brotherton Brotherton Library, Leeds
 E B-J correspondence with Dante Gabriel Rossetti
 E B-J correspondence with Algernon Charles Swinburne

Cambridge Cambridge University Library
 Baldwin Papers

Castle Howard Castle Howard Archives, York
 E B-J and G B-J correspondence with George Howard (later 9th Earl of
 Carlisle) and Rosalind Howard
 Rosalind Howard diaries

Cheshire Cheshire and Chester Archives, Chester
 E B-J correspondence with Lady Leighton (later Lady Leighton-Warren)

Fitzwilliam Fitzwilliam Museum, Cambridge
 Blunt Papers
 Burne-Jones Papers (including material assembled by Georgiana Burne-Jones in writing her *Memorials* of her husband)
 Burne-Jones account books with Morris & Co.

Harvard Houghton Library, Harvard
 Norton Papers

NAL National Art Library, Victoria and Albert Museum, London
 Sydney Cockerell letters
 Ionides family letters
 Thomas Rooke typescript record of conversations with E B-J 1895–8
 G. Warrington Taylor letters

Princeton Princeton Library
 E B-J letters to Margaret B-J

RA Royal Academy Library, London
 Royal Academy records

RCS Royal College of Surgeons, London
 E B-J letters to Rudyard Kipling

Rylands John Rylands Library, University of Manchester
 E B-J correspondence with Charles Fairfax Murray

Stanway Stanway House family archive, Gloucestershire
 E B-J and G B-J correspondence with Mary Elcho (later Countess of Wemyss)

Texas Harry Ransom Humanities Research Center, University of Texas
 E B-J correspondence with Charles Fairfax Murray

TGA Tate Gallery Archive
 E B-J correspondence with Cormell Price
 E B-J correspondence with G. F. Watts

Wightwick Wightwick Manor, Wolverhampton (National Trust)
 E B-J and G B-J correspondence with the Grosvenor family and with M. H. Spielmann

WMG William Morris Gallery, Walthamstow
 J. W. Mackail notebooks used for his biography of William Morris
 William Morris correspondence with Charles and Kate Faulkner

Worcester Worcestershire Record Office, Worcester
 Baldwin family papers

Yale Yale Center for British Art, New Haven
 E B-J correspondence with Cormell Price

I have also drawn on letters in the private collections of descendants of Edward
and Georgiana Burne-Jones, Frances Graham (later Lady Horner), Luke
Ionides, Cormell Price, Maria Zambaco and other Burne-Jones friends.

Secondary Sources

Allingham ed. W. Allingham and D. Radford, *William Allingham: A Diary,
 1824–1889* (Harmondsworth: Penguin Books, 1967)
Bornand ed. Odette Bornand, *The Diary of W. M. Rossetti, 1870–1873* (Oxford:
 Clarendon Press, 1977)
Bryson ed. John Bryson, *Dante Gabriel Rossetti and Jane Morris: Their
 Correspondence* (Oxford: Clarendon Press, 1976)
Cockerell ed. Viola Meynell, *Friends of a Lifetime: Letters to Sydney Carlyle
 Cockerell* (London: Cape, 1940)
Dimbleby Josceline Dimbleby, *A Profound Secret: May Gaskell, Her Daughter
 Amy, and Edward Burne-Jones* (London: Doubleday, 2004)
Du Maurier ed. Daphne Du Maurier, *The Young George du Maurier* (London:
 Peter Davies, 1951)
Edel ed. Leon Edel, *Henry James Letters* (Cambridge, MA: Harvard
 University Press, 1974–84)
Emanuel ed. Angela Emanuel, *A Bright Remembrance: The Diaries of Julia
 Cartwright* (London: Weidenfeld and Nicolson, 1989)
Fredeman ed. William E. Fredeman, *The Correspondence of Dante Gabriel
 Rossetti*, 8 vols to date (Cambridge: D. S. Brewer, 2002–9)
G B-J Georgiana Burne-Jones, *Memorials of Edward Burne-Jones*, 2 vols
 (London: Macmillan, 1904)
Horner Frances Horner, *Time Remembered* (London: William Heinemann, 1933)
Kelvin ed. Norman Kelvin, *The Collected Letters of William Morris*, 5 vols
 (Princeton, NJ: Princeton University Press, 1984–96)
Lago ed. Mary Lago, *Burne-Jones Talking: His Conversations, 1895–98,
 Preserved by His Studio Assistant Thomas Rooke* (London: John Murray,
 1982)
Lang ed. C. Y. Lang, *The Swinburne Letters*, 6 vols (New Haven, CT: Yale
 University Press, 1959–62)
Mackail J. W. Mackail, *The Life of William Morris*, 2 vols (London: Longmans
 Green, 1899)
Masterman ed. Lucy Masterman, *Mary Gladstone (Mrs Drew): Her Diaries
 and Letters* (London: Methuen, 1930)

Pinney ed. Thomas Pinney, *The Letters of Rudyard Kipling*, 4 vols (London: Macmillan, 1990–9)

Ruskin ed. E. T. Cook and Alexander Wedderburn, *The Works of John Ruskin*, 39 vols (London: The Library Edition, 1903–12)

Surtees ed. Virginia Surtees, *The Diaries of George Price Boyce* (Norwich: Real World, 1980)

Select Bibliography of Burne-Jones and His Circle

The most essential contemporary biography of Burne-Jones is his wife's two-volume *Memorials* published in 1904, illuminating in its detailed evocation of the life of a leading London artist in the second half of the nineteenth century.

The indispensable illustrated survey of Burne-Jones's art in relation to his life is Stephen Wildman and John Christian's catalogue *Edward Burne-Jones: Victorian Artist-Dreamer*, published for the 1998 Burne-Jones centenary exhibition at the Metropolitan Museum of Art, New York. This includes a wide-ranging essay by Alan Crawford on 'Burne-Jones as a Decorative Artist'.

The other expert work of visual reference is Linda Parry's *William Morris*, the catalogue of the Morris centenary exhibition held at the Victoria and Albert Museum in 1996.

The following list of further books and essays is my personal choice of the writings on Burne-Jones I have found most valuable in the course of my research, either on account of their vivid contemporary memories or their fresh interpretations:

Stanley Baldwin, essay on Burne-Jones in *This Torch of Freedom*, 1935

Julia Cartwright, 'The Life and Work of Sir Edward Burne-Jones, Bart.', *Art Annual*, Christmas 1894

David Cecil, *Visionary and Dreamer: Two Poetic Painters, Samuel Palmer and Edward Burne-Jones*, 1969

Sidney Colvin, 'Edward Burne-Jones', essay in *Memories and Notes of Persons and Places, 1852–1912*, 1921

Josceline Dimbleby, *A Profound Secret: May Gaskell, Her Daughter Amy, and Edward Burne-Jones*, 2004

David B. Elliott, *Charles Fairfax Murray: The Unknown Pre-Raphaelite*, 2000

Penelope Fitzgerald, *Edward Burne-Jones: A Biography*, 1975

Judith Flanders, *A Circle of Sisters: Alice Kipling, Georgiana Burne-Jones, Agnes Poynter and Louisa Baldwin*, 2001

Joseph Jacobs, 'Some Recollections of Sir Edward Burne-Jones', *The Nineteenth Century*, vol. XLV, January 1899

Rudyard Kipling, accounts of the Burne-Jones household in *Something of Myself*, 1937

Colin MacInnes, 'A tardy revival', *Spectator*, 17 April 1976

W. Graham Robertson, *Time Was: The Reminiscences of W. Graham Robertson*, 1931

William Rossetti, *Some Reminiscences of William Michael Rossetti*, 2 vols, 1906

Frances Spalding, *Magnificent Dreams: Burne-Jones and the Late Victorians*, 1978

Angela Thirkell, *Three Houses*, 1931

For good short introductions to Burne-Jones's life and work see William Waters, *Burne-Jones: An Illustrated Life*, 1973, and Christopher Newall's entry on Burne-Jones in the *Oxford Dictionary of National Biography*, 2004.

Other books on specific aspects of Burne-Jones appear in the relevant chapter source notes.

Preface

xiv 'I mean' E B-J to Helen Mary Gaskell, Dimbleby p. 79

xv 'the mage' W. Graham Robertson, *Time Was*, 1931, p. 76

'I want to' John Ruskin to E B-J, March 1883, G B-J vol. 2, p. 130

'lives of men' E B-J to John Ruskin, Fitzwilliam

xvii 'I suppose' E B-J to Helen Mary Gaskell, 26 October 1894, private collection

1 Birmingham 1833–52

I have drawn my account of Burne-Jones's childhood and schooldays mainly from the early chapters of Georgiana Burne-Jones's *Memorials* and from the many flashbacks in the letters and recorded conversations of Burne-Jones's later years.

On the Macdonald family: Edith Macdonald, *Annals of the Macdonald Family*, privately printed, 1927; A. W. Baldwin, Earl Baldwin of Bewdley, *The Macdonald Sisters*, 1960; Ina Taylor, *Victorian Sisters: The Remarkable Macdonalds and the Four Great Men They Inspired*, 1987; Judith Flanders, *A Circle of Sisters*, 2001, in addition to numerous letters, diaries and photographs in public and private Burne-Jones, Baldwin and Kipling family collections. F. W. Macdonald's memoir *As a Tale that is Told*, 1919, is informative on Burne-Jones's Birmingham friendships.

On King Edward's School: T. W. Hutton, *King Edward's School Birmingham 1552–1952*, 1952; records and reminiscences by former staff and pupils in the school archives. On Pugin, Charnwood Monastery and Romantic Catholicism: Rosemary Hill, *God's Architect: Pugin and the Building of Romantic Britain*, 2007.

On mid-nineteenth-century Birmingham: Robert K. Dent, *Old and New Birmingham*, 1880; Eric Hopkins, *Birmingham: The Making of the Second City 1850–1939*, 2001. There is a good account of Birmingham's evolution from squalid town to model city in Tristram Hunt's *Building Jerusalem: The Rise and Fall of the Victorian City*, 2004.

The house in which Burne-Jones was born, 11 Bennett's Hill, still stands, marked by a Birmingham Civic Society plaque, although the surrounding buildings are much altered. Close by is the former St Philip's Church, now St Philip's Cathedral, containing some of the very best examples of Burne-Jones's stained glass.

CHAPTER 1 SOURCE NOTES

1 'I love the immaterial' G B-J vol. 2, p. 300

2 'iron and granite' Stanley Baldwin, *This Torch of Freedom*, 1935, p. 176
 'I have no politics' G B-J vol. 2, p. 125
 'upstart street' Robert Dent, *Old and New Birmingham*, 1880, p. 429

4 'a very poetical' E B-J to Thomas Rooke, 12 November 1895, Lago
 p. 55
 'I don't think' E B-J to Helen Mary Gaskell, Dimbleby p. 93
 'began with' E B-J to Helen Mary Gaskell, 1890s, private collection

5 'a little boy' G B-J vol. 1, p. 11
 'rejoice in' ibid. p. 2
 'the foundations' ibid. p. 12
 'Art was always' E B-J to Helen Mary Gaskell, 1890s, private collection

6 'He used to say' E B-J to Thomas Rooke, 13 February 1897, Lago p. 133
 'riding by the rock' G B-J vol. 2, p. 49
 'Books, books' G B-J vol. 1, p. 18
 'I was born' E B-J to Helen Mary Gaskell, 1895, private collection

7 'large anxious faces' G B-J vol. 1, p. 10
 'dark frightening' E B-J to Helen Mary Gaskell, 9 August 1894, British
 Library

8 'My dear Papa' G B-J vol. 1, p. 11
 'caused a pain' E B-J to Edward Richard Jones, 23 June 1842, ibid.
 'What are you?' ibid.

9 'swarthy, hirsute' Howard S. Pearson, 'Reminiscences of King Edward's
 School', *The Old Edwardians Gazette*, 1 July 1894
 'The Archbishop' E B-J to Thomas Rooke typescript, 1890s, NAL
 'solemn portal' The Revd Arthur Mozley, 'Reminiscences of King
 Edward's School', *The Old Edwardians Gazette*, 1 December 1891

10 'a certain scene' 'A visit to the Old School by an Old Boy', King Edward's
 School Chronicle, 27 March 1877
 'I was the kind' E B-J to Olive Maxse, *c.*1896, catalogue of sale of
 correspondence, Sotheby's, 4 July 1989
 'wheelbarrow fashion' E B-J to Thomas Rooke typescript, 1890s, NAL
 'reeked with' G B-J vol. 1, p. 36

11 'The country' Cormell Price, quoted Mackail vol. 1, p. 64

'the crack of the whip' E B-J to Thomas Rooke typescript, 3 January 1896, NAL

12 'I'll open' E B-J to Helen Mary Gaskell, 1890s, private collection
13 'Figure after figure' G B-J vol. 1, p. 38
'filled up moments' ibid.
14 'if there had been' G B-J vol. 2, p. 100
15 'the vision' anon., *Old Edwardians Gazette*, 1 July 1898
'an early maturity' G B-J vol. 1, p. 65
16 'A flirt's a beast' ibid. p. 66
'it couldn't be' G B-J vol. 2, p. 42
17 'whatever I do' Joseph Jacobs, 'Some Recollections of Sir Edward Burne-Jones', *The Nineteenth Century*, vol. XLV, January 1899
'the little aunt' G B-J vol. 1, p. 28
'the carver-and-gilders' ibid. p. 33
18 'the immortal-eyed' E B-J to Helen Mary Gaskell, 1890s, private collection
'Oh! I've been' G B-J vol. 1, p. 47
'I was quite surprised' ibid. p. 45
20 'there was a beautiful' ibid. p. 34
21 'peculiar catch' ibid. p. 18
'his natural destination' ibid. p. 38
'Edouard Cardinal' E B-J to Annie Catherwood, 8 June 1850, Fitzwilliam
'abundantly susceptible' Frederic W. Macdonald, *As a Tale that is Told*, 1919, p. 28
22 'I used to think' E B-J to Thomas Rooke, 25 October 1895, Lago p. 50
'Wherever he had' E B-J to Lady Leighton, 19 September 1890, Cheshire
'In an age' E B-J to Frances Horner, Horner p. 120
23 'he stands to me' ibid.
'More and more' G B-J vol. 2, p. 285
24 'destitute of any' G B-J vol. 1, p. 155
'blackguard, button-making' E B-J to Cormell Price, 24 January 1852, Yale
'I can't think' E B-J to George Howard, Castle Howard J22/27/226
'Birmingham is my city' E B-J to Julia Cartwright, Emanuel p. 165
25 'When I work hard' E B-J to Louisa Baldwin, 29 August 1856, Cambridge

2 Oxford 1853–5

3 Northern France 1855

4 Early London 1856–7

Besides Georgiana Burne-Jones's *Memorials* these chapters are drawn chiefly from the letters of William Morris, Dante Gabriel Rossetti and John Ruskin; J. W. Mackail's *Life of William Morris*; John Christian's essay on the evolution of Burne-Jones as an artist in the catalogue *Edward Burne-Jones: Victorian*

Artist-Dreamer, 1998; the early chapters of *Burne-Jones* by Martin Harrison and Bill Waters, 1973.

On Burne-Jones at Oxford: Cormell Price family correspondence and diaries; R. W. Dixon reminiscences in Mackail notebooks; Val Prinsep, 'A Chapter from a Painter's Reminiscences: the Oxford Circle: Rossetti, Burne-Jones and William Morris', *The Magazine of Art*, no. 2, 1904; John D. Renton, *The Oxford Union Murals*, 1983; Rosalie Mander, 'Rossetti and the Oxford Murals, 1857', *Pre-Raphaelite Papers*, ed. Leslie Parris, 1984; Edward A. Tunstall and Antony Kerr, 'The Painted Room at the Queen's College, Oxford', *Burlington Magazine*, February 1943; Jon Whiteley, *Oxford and the Pre-Raphaelites*, 1989.

On Archibald MacLaren and *The Fairy Family*: John Christian, 'Burne-Jones Studies', *Burlington Magazine*, vol. 115, 1973.

On Burne-Jones's tour of northern France: John Purkis, *Check-List of the Cathedrals and Churches visited by William Morris and Edward Burne-Jones*, 1987.

On Burne-Jones and Arthurianism: Christine Poulson, *The Quest for the Grail: Arthurian Legend in British Art 1840–1920*, 1999; Muriel Whitaker, *The Legends of King Arthur in Art*, 1990; Debra N. Mancoff, *The Return of King Arthur: The Legend through Victorian Eyes*, 1995; Mark Girouard, *The Return to Camelot: Chivalry and the English Gentleman*, 1981.

On Burne-Jones, Rossetti and the Pre-Raphaelite circle: ed. Virginia Surtees, *The Diaries of George Price Boyce*, 1980; Jan Marsh, *Dante Gabriel Rossetti, Painter and Poet*, 1999; Julian Treuherz, Elizabeth Prettejohn and Edwin Becker, catalogue of exhibition *Dante Gabriel Rossetti*, Walker Art Gallery, Liverpool, 2003; J. B. Bullen, 'Dante Gabriel Rossetti', *Oxford Dictionary of National Biography* entry, 2004; Teresa Newman and Ray Watkinson, *Ford Madox Brown and the Pre-Raphaelite Circle*, 1991; Jan Marsh, *The Legend of Elizabeth Siddal*, 1989; Jan Marsh, *Jane and May Morris*, 1986.

On Burne-Jones and John Ruskin: Tim Hilton, *John Ruskin: The Early Years*, 1985; John Christian, ' "A Serious Talk": Ruskin's Place in Burne-Jones's Artistic Development', *Pre-Raphaelite Papers*, ed. Leslie Parris, 1984.

On Burne-Jones and Swinburne: ed. Cecil Y. Lang, *The Swinburne Letters*, 6 vols, 1959–62; Philip Henderson, *Swinburne: The Portrait of a Poet*, 1974.

On Burne-Jones's early stained glass: A. C. Sewter, *The Stained Glass of William Morris and His Circle*, 2 vols, 1974–5; Aymer Vallance, 'The Decorative Art of Sir Edward Burne-Jones Bart', *Easter Art Annual*, 1900.

Burne-Jones's Oxford is more or less intact. The ill-fated Oxford Union murals can still be made out, but only just. There is a splendid example of his early glass

in Christ Church Cathedral, and other fine windows at Bradfield College, Berkshire. It is easy, and inspiring, to take Burne-Jones's and William Morris's route around the great churches and cathedrals of northern France. Of the various lodgings occupied by Burne-Jones in this unsettled London period most have disappeared, but no. 17 Red Lion Square is now marked with a plaque.

CHAPTER 2 SOURCE NOTES

26 'my own country' G B-J vol. 2, p. 130

27 'Oxford is a glorious' G B-J vol. 1, p. 75
'The day has gone' ibid. p. 97

28 'all friends' Horner p. 122
'not painting' *The Painted Eye: Notes and Essays on the Pictorial Art by Henry James*, ed. John L. Sweeney, 1956, p. 145

29 'It was clear' G B-J vol. 1, p. 72
'this College' ibid. p. 98
'omniscient in all' E B-J to Maria Choyce, 1855, Fitzwilliam
'like a room' G B-J vol. 1, p. 71
'the sort of material' E B-J to Thomas Rooke typescript, 1890s, NAL

30 'There, shoulder to shoulder' G B-J vol. 1, p. 71

31 'Morris's friendship' E B-J to J. Comyns Carr, quoted in catalogue of 1898 Burne-Jones exhibition at New Gallery

32 'stuffed to the fingernails' E B-J to Maria Choyce, 1855, Fitzwilliam
'His style is' E B-J to Cormell Price, G B-J vol. 1, p. 79

33 'one of the cleverest' E B-J to Cormell Price, *c.* March 1854, Yale
'There are two arts' E B-J to Thomas Rooke, 26 May 1897, Lago p. 146
'the ordinary bourgeois' William Morris to Andreas Scheu, 15 September 1883, Kelvin vol. 2, p. 227

34 'its gigantic wearisomeness' E B-J to Archibald MacLaren, G B-J vol. 1, p. 101
'They were tumbly' Mackail vol. 1, p. 51
'he has tinged' E B-J to Cormell Price, *c.* March 1854, Yale

35 'he began to show' R. W. Dixon, G B-J vol. 1, p. 86
'We chatted about life' G B-J vol. 1, p. 106
'fire and impetuosity' R. W. Dixon, Mackail vol. 1, p. 43
'It was something' ibid. p. 52

36 'We all had a notion' ibid. p. 43
'a poor fellow dying' E B-J to Olive Maxse, 3 August 1894, Penelope Fitzgerald, *Edward Burne-Jones*, 1975, p. 16

37 'remember I have set' E B-J to Cormell Price, 1 May 1853, Yale
'the most controversial' E B-J to Cormell Price, 29 October 1853, Yale
'His book of horrors' ibid.

38 'the mystery' G B-J vol. 1, p. 105
'the heartaches' ibid. p. 102
'suffering greater mental' ibid.

'a rose-garden' Algernon Charles Swinburne to Edwin Hatch, 17
February 1858, Lang vol. 1, p. 17
'I have fallen back' E B-J to Cormell Price, 1854, Yale
39 'should go to nature' Ruskin vol. 3, p. 624
'I was quick' E B-J to Thomas Rooke, 26 February 1895, Lago p. 94
40 'like a small Paradise' G B-J vol. 1, p. 81
'Is she old enough' E B-J to Archibald MacLaren, 1856, Fitzwilliam
41 '*false* drawings' ibid.
'Maclaren's forbearance' G B-J vol. 1, p. 135
42 'a terrible place' Julia Cartwright, Emanuel p. 165
'absolutely desolate' G B-J vol. 1, p. 93
'extreme simplicity' E B-J to Thomas Rooke, 26 February 1896, Lago p. 94
43 'Carlyle and Ruskin' ibid. *c.* 1870, Lago p. 29
'there is hardly' *The Oxford Companion to Literature*, 6th edn, 2000, p. 174
'it shivered the belief' E B-J to Maria Choyce, 1855, Fitzwilliam
'very firm and constant' ibid.
44 'Morris has become' G B-J vol. 1, p. 109
'Slowly, and almost insensibly' ibid. p. 108
'I wanted to go' ibid. p. 109

CHAPTER 3 SOURCE NOTES
45 'Returning home' G B-J vol. 1, p. 112
46 'speechless with admiration' ibid. p. 113
'the most beautiful' ibid.
47 'Of painting' Mackail vol. 1, p. 40
'ancient pictures' Mrs J. Comyns Carr, *Reminiscences*, 1926, p. 72
48 'transported with delight' G B-J vol. 1, p. 114
'we called him Angelo' Horner p. 108
'a good deal bored' Mackail vol. 1, p. 72
49 'sculptures half down' ibid.
50 'nasty, brimstone, noisy' William Morris, quoted Mackail vol. 1, p. 77
51 'we resolved definitely' G B-J vol. 1, p. 114
'Weary work' E B-J to Maria Choyce, Fitzwilliam
52 'Christmas Carol Christianity' E B-J to Thomas Rooke, 1870s?, Lago p. 27
'the little house' G B-J vol. 1, p. 115
'a medium' ibid.
53 'talked on myriad subjects' Cormell Price, quoted ibid. p. 118
'we have such a deal' E B-J to Maria Choyce, quoted ibid., p. 121
'he hopes not to lose' ibid.
54 'Ruskin and *The Quarterly*' Cormell Price to Sydney Cockerell, 16
October 1902, NAL
'He has written' G B-J vol. 1, p. 125
'It is a morning' 'The Cousins', *The Oxford & Cambridge Magazine*,
January 1856
55 'After he became' G B-J vol. 1, p. 125
'we feasted on it' ibid. p. 117

'round and round' ibid.

56 'To care as I care' E B-J to Helen Mary Gaskell, 30 March 1895, British Library

'roll out pages' Joseph Jacobs, 'Some Recollections of Sir Edward Burne-Jones', *The Nineteenth Century*, vol. XLV, January 1899

'Nothing was ever like' Horner p. 112

57 'I'm not Ted' G B-J vol. 1, p. 127

CHAPTER 4 SOURCE NOTES

58 'Ted Jones Painter' Sketch in letter from E B-J to Louisa Baldwin, Cambridge

'it never rained' G B-J vol. 1, p. 151

59 'the weirdness' ibid. p. 119

'I wanted to look' ibid. p. 128

'and so I saw him' ibid. p. 129

60 'first fearful talk' ibid.

'Sunday of Beauvais' E B-J to Helen Mary Gaskell, 11 July 1894, British Library

61 'and then we knew' G B-J vol. 1, p. 99

'the kind of stuff' ibid. p. 48

'drivelled his time away' ibid. p. 100

62 'the mingling of blood' E B-J to Thomas Rooke, 12 October 1895, Lago p. 46

'Gabriel is half a woman' E B-J to Frances Horner, 10 July 1892, private collection

'What he did' E B-J to Thomas Rooke, 12 October 1895, Lago p. 46

63 'a certain youthful Jones' G B-J vol. 1, p. 130

'no one ever' E B-J to Dante Gabriel Rossetti, 29 March 1877, Fitzwilliam

64 'There are not three' G B-J vol. 1, p. 137

'marvels of finish' John Christian, 'Early German Sources for Pre-Raphaelite Designs', *Art Quarterly*, no. 36, 1973

'He taught me' G B-J vol. 1, p. 149

65 'nobble' ibid. p. 132

'My chief feeling' Arthur Hughes, *Pall Mall Gazette*, 13 July 1912

'you would shudder' Horner p. 15

'Fogs and bitter cold' E B-J to George Howard, 30 September 1876, Castle Howard J22/27/287

66 'seemed to have been written' G B-J vol. 1, p. 134

'had as yet done nothing' Frederic W. Macdonald, *As a Tale that is Told*, 1919, p. 64

'She is still cheerful' Harry Macdonald to Cormell Price, Cambridge

'who came in between' G B-J to Edith Plowden, 11 October 1919, Cambridge

67 'she was small' Edith Macdonald, *Annals of the Macdonald Family*, 1927, p. 38

68 'in all parts' ibid. p. 17

'She knew my weakness' Frederic W. Macdonald, *As a Tale that is Told*, 1919, p. 48

'I had no precise idea' G B-J vol. 1, p. 142

'a very different kind' E B-J to Louisa Baldwin, 29 August 1856, Cambridge

69 'the quaintest room' Mackail vol. 1, p. 107

'such old autumns' E B-J to Louisa Baldwin, 28 September 1870, Fitzwilliam

70 'intensely mediaeval' Mackail vol. 1, p. 113

'they are as beautiful' G B-J vol. 1, p. 147

'very plain' E B-J to J. W. Mackail, Mackail notebooks, WMG

71 'I do so look forward' E B-J to Louisa Baldwin, 29 August 1856, Cambridge

73 'a grand looking fellow' G B-J vol. 1, p. 139

'Madox Brown is a lark!' Mackail vol. 1, p. 108

74 'Miss Siddall' *Ruskin: Rossetti: Pre-Raphaelitism: Papers 1854 to 1862*, ed. William Michael Rossetti, 1899, p. 19

75 'Just back from' G B-J vol. 1, p. 147

'Your father, sir' ibid.

76 'new and noble school' Ruskin vol. 12, p. 358

'the most wonderful' John Ruskin to Margaret Bell, 3–4 April 1859, *The Winnington Letters*, ed. Van Akin Burd, 1969, p. 149

'show it' G B-J vol. 1, p. 147

'it was long' ibid. p. 157

77 'of a more important' ibid. p. 174

'Christ is here' Aymer Vallance, 'The Decorative Art of Sir Edward Burne-Jones', *Easter Art Annual*, 1900

78 'the set, stony stare' ibid.

80 'At night' *Letters of Dante Gabriel Rossetti to William Allingham 1854–1870*, ed. George Birkbeck Hill, 1897, p. 203

'a fine specimen' Val Prinsep, 'A Chapter from a Painter's Reminiscences', *The Magazine of Art*, no. 2, 1904

'What fun we had' G B-J vol. 1, p. 163

82 'Now we were four' ibid.

'Why, there's a girl' W. R. Lethaby, *Philip Webb and his Work*, 1935, p. 21

84 'As this lady' Val Prinsep, 'A Chapter from a Painter's Reminiscences', *The Magazine of Art*, no. 2, 1904

'mental power' Jan Marsh, *The Legend of Elizabeth Siddal*, 1989, p. 62

'I cannot paint you' Morris's portrait is now in Tate Britain

85 'The only one' Val Prinsep, 'A Chapter from a Painter's Reminiscences', *The Magazine of Art*, no. 2, 1904

'very new' William Michael Rossetti to William Allingham, 18 January 1858, *Selected Letters of William Michael Rossetti*, ed. Roger W. Peattie, 1990, p. 93

'much defaced' John D. Renton, *The Oxford Union Murals*, 1983

5 Little Holland House 1858

6 First Italian Journey 1859

The sources for these chapters are mainly John Christian's illuminating essays in the catalogue *Edward Burne-Jones: Victorian Artist-Dreamer*, 1998, and my own retracings of Burne-Jones's Italian journeys, the first of which took place in 1859.

On Little Holland House: John Christian, introduction to *The Little Holland House Album by Edward Burne-Jones*, 1981; Caroline Dakers, *The Holland Park Circle*, 1999; Charlotte Gere, *Artistic Circles: Design and Decoration in the Aesthetic Movement*, 2010.

On Julia Margaret Cameron: Victoria Olsen, *From Life: Julia Margaret Cameron & Victorian Photography*, 2003; Colin Ford, catalogue of National Portrait Gallery exhibition *Julia Margaret Cameron*, 2003.

On G. F. Watts: M. S. Watts, *George Frederic Watts: The Annals of an Artist's Life*, 1912; Wilfrid Blunt, '*England's Michelangelo*', 1975; Veronica Franklin Gould, *G. F. Watts: The Last Great Victorian*, 2004; Barbara Bryant, entry on Watts in *Oxford Dictionary of National Biography*, 2004.

On Burne-Jones in Italy: Val Prinsep, 'An Artist's Life in Italy in 1860', *The Magazine of Art*, vol. 2, 1904; Francis Russell, 'Advice for a Young Traveller from Burne-Jones, Letters to Agnes Graham, 1876', *Apollo*, no. 108, December 1978; Michael Levey, 'Botticelli and Nineteenth-Century England', *Journal of the Warburg and Courtauld Institutes*, vol. 23, 1960.

On Ruskin and Venice: John Ruskin, *The Stones of Venice*, 3 vols, 1851–3; ed. J. L. Bradley, *Ruskin's Letters from Venice*, 1955; Robert Hewison, *Ruskin on Venice*, 2009; Sarah Quill, *Ruskin's Venice: The Stones Revisited*, 2000; Tim Hilton, *John Ruskin: The Early Years*, 1985.

Little Holland House is now demolished. It is still quite feasible to follow Burne-Jones's routes around Italy and to see most of the works of art he was so greatly influenced by and study the details of the paintings he copied as directed by John Ruskin.

CHAPTER 5 SOURCE NOTES

87 'the greatest bore' The Hon. Emily Eden, quoted Brian Hill, *Julia Margaret Cameron: A Victorian Family Portrait*, 1973, p. 42
'I seem to perceive' George Du Maurier to Thomas Armstrong, 1862, Du Maurier p. 119
'You must know' G B-J vol. 1, p. 159
'a lot of swells' E B-J to Edward Richard Jones, ibid.

'fell under the spell' G B-J vol. 1, ibid.
88 'she took possession' ibid. p. 178
'the nearest thing' Horner p. 18
'foreign in its ease' ibid.
'in spite of' G B-J vol. 1, p. 186
89 'The very strawberries' ibid. p. 182
'Jones, you are gigantic!' ibid.
'laughing sweetly' John Ruskin to Margaret Bell, 3–4 April 1859, *The Winnington Letters*, ed. Van Akin Burd, 1969, p. 149
'her incalculable ways' G B-J vol. 1, p. 183
90 'the sound' ibid. p. 186
'Dearest Auntie' John Christian, intro. to *The Little Holland House Album*, 1981, p. 9
91 'a defiant tone' G B-J vol. 1, p. 183
92 'He came to stay' M. S. Watts, *George Frederic Watts: The Annals of an Artist's Life*, 1912, vol. 1, p. 128
'nest of preraphaelites' George Du Maurier to his mother, February 1862, Du Maurier p. 112
'he paints' G B-J vol. 1, p. 159
93 'a painter's painter' Elizabeth Lady Lewis, 'Recollections of Edward Burne-Jones', Bodleian–
'It was Watts' E B-J to J. Comyns Carr, *c.*1872, quoted in catalogue of 1898 Burne-Jones Exhibition at New Gallery
94 'The Oxford frescoes' John Christian, intro. to *The Little Holland House Album*, 1981, p. 13
'a serious talk' M. S. Watts, *George Frederic Watts: The Annals of an Artist's Life*, 1912, vol. 1, p. 173
95 'Elgin marbles' John Christian, intro. to *The Little Holland House Album*, 1981, p. 13
'In the midst' Elizabeth Lady Lewis, 'Recollections of Edward Burne-Jones', Bodleian

CHAPTER 6 SOURCE NOTES
98 'Yes, this was Italy' Val Prinsep, 'An Artist's Life in Italy in 1860', *The Magazine of Art*, vol. 2, 1904
'some old pictures' G B-J vol. 1, p. 175
'We bowed' Val Prinsep, 'An Artist's Life in Italy in 1860', *The Magazine of Art*, vol. 2, 1904
'quite an educated man' G B-J vol. 1, p. 198
100 'poor worn out' E B-J to Agnes Graham, October 1876, private collectio
'are tightly swaddled' ibid.
'a Botticelli not mentioned' ibid.
'Botticelli isn't a wine' Herbert Horne, *Sandro Botticelli*, 1908, p. xiii
101 'Even M. Angelo' E B-J to Thomas Rooke, 29 October 1895, Lago p. 51
'where the Virgin' E B-J to Agnes Graham, October 1876, private collection

'I want to see' ibid.

'Oh dear' E B-J to George Howard, Castle Howard, J22/27

102 'You know my friend' Dante Gabriel Rossetti to Robert Browning, 21 September 1859, Fredeman vol. 2, p. 271

'the deepest and intensest' G B-J vol. 1, p. 153

104 'We are in the jolliest' ibid. p. 198

105 'You can't see Venice' Horner p. 34

'seemed to point out' William Morris, introduction to Kelmscott Press edition 'On the Nature of Gothic', 1892

106 'Ruskin in hand' Val Prinsep, 'An Artist's Life in Italy in 1860', *The Magazine of Art*, vol. 2, 1904

107 'MY DEAREST NED' John Ruskin to E B-J, 13 May 1869, Ruskin vol. 4, p. 357

'thinking there could be' E B-J to Joseph Jacobs, 7 January 1898, Lago p. 167

109 'His romantic treatment' William Michael Rossetti, *Some Reminiscences*, ed. Angela Thirkell, 1995, p. 139

'now he had seen' G B-J vol. 1, p. 200

'I want big things' G B-J vol. 2, p. 13

110 'There's an organ' E B-J to Helen Mary Gaskell, 1890s, private collection

7 Russell Place 1860–2

8 Second Italian Journey 1862

9 Great Russell Street 1862–4

10 Kensington Square 1865–7

For this, the period at which Burne-Jones was discovering and absorbing Italian art, my main resource was to spend a week in Venice, seeing as much as possible of the city visited by Burne-Jones in 1862, visiting Murano and Torcello, and searching out the works of art of which he made copies. There is much useful background in *The Pre-Raphaelites and Italy*, the book accompanying Colin Harrison and Christopher Newell's 2010 exhibition at the Ashmolean Museum in Oxford, and a very informative analysis of 'Burne-Jones's Second Italian Journey' by John Christian in *Apollo*, no. 102, November 1975.

On Venice in general, *Murray's Handbook Northern Italy*, 1866, provided useful background as did Hugh Honour's *The Companion Guide to Venice*, perceptive on the art and architecture, first published in 1965.

On Venice and Ruskin, Robert Hewison's *Ruskin on Venice*, 2009, is indispensable. The illustrated one-volume edition of Ruskin's *The Stones of Venice*, with

introduction by Jan Morris, 1981, is useful and Sarah Quill's photographic record *Ruskin's Venice: The Stones Revisited*, 2000, is comprehensive and beautiful.

On Burne-Jones's life in London at this period, the main sources – besides Georgiana Burne-Jones's *Memorials* – are *The Correspondence of Dante Gabriel Rossetti*, vols 2 and 3, ed. William E. Fredeman, 2002–3, and *The Diaries of George Price Boyce*, ed. Virginia Surtees, 1980.

On his friendship with George Howard: Christopher Ridgway, 'A privileged insider, George Howard and Edward Burne-Jones', *British Art Journal*, vol. 3, no. 3, 2002.

On Red House and the early days of Morris, Marshall, Faulkner & Co.: J. W. Mackail, *The Life of William Morris*, vol. 1, 1899; Jan Marsh, *William Morris and Red House*, 2005; catalogue of V&A exhibition *William Morris*, ed. Linda Parry, 1996; Charles Harvey and Jon Press, *William Morris: Design and Enterprise in Victorian Britain*, 1991.

On Burne-Jones's stained glass for Morris, Marshall, Faulkner & Co.: A. C. Sewter, *The Stained Glass of William Morris and His Circle*, 1974–5; Martin Harrison, *Victorian Stained Glass*, 1980, and Harrison's essay 'Church Decoration and Stained Glass' in V&A catalogue *William Morris*, 1996.

On Burne-Jones's tile designs: Richard and Hilary Myers, *William Morris Tiles*, 1996.

On Burne-Jones's designs for Morris's 'Cupid and Psyche': Joseph R. Dunlap, *The Book that Never Was*, 1971.

On the Old Watercolour Society: Simon Fenwick, *The Enchanted River: 200 Years of the Royal Watercolour Society*, 2004.

On Burne-Jones and William Graham and his family: Frances Horner, *Time Remembered*, 1933; Oliver Garnett, 'The Letters and Collection of William Graham', *The Walpole Society*, vol. LXII, 2000; Caroline Dakers, 'Yours affectionately, Angelo. The Letters of Edward Burne-Jones and Frances Horner', *British Art Journal*, vol. 2, no. 3, 2001; Francis Russell, 'Advice for a Young Traveller from Burne-Jones: Letters to Agnes Graham, 1876', *Apollo*, no. 108, December 1978.

61 Great Russell Street has been demolished and replaced by Great Russell Mansions but the view across the street as described in Burne-Jones's letters and as shown in Vilhelm Hammershol's 1906 painting *Street in London* remains more or less unchanged.

41 Kensington Square is still intact and Burne-Jones's residency is marked with a blue plaque.

CHAPTER 7 SOURCE NOTES

111 'sometimes he would' G B-J vol. 1, p. 202

112 'committing us both' ibid. p. 204

113 'He told her' E B-J to Thomas Rooke, 7 January 1898, Lago p. 166
'could understand' G B-J vol. 1, p. 171
'You see I am' Dimbleby p. 89

115 'Oh! I wish' E B-J to Helen Mary Gaskell, 1890s, private collection

116 'Jones's face melts' John Ruskin to Margaret Bell, 6 April 1859, *The Winnington Letters*, ed. Van Akin Burd, 1969, p. 157
'his manner of speaking' Ford Madox Brown to M. H. Spielmann, 6 June 1886, Rylands
'little preraphaelite-looking' George Du Maurier to his mother, February 1862, Du Maurier p. 114
'like a little girl' George Leslie to G. A. Storey, Gladys Storey, *All Sorts of People*, 1929, p. 58
'a little country violet' John Ruskin to Charles Eliot Norton, 2 June 1861, *The Correspondence of John Ruskin and Charles Eliot Norton*, ed. John Bradley and Ian Ousby, 1987, p. 64
'a pretty one' G B-J vol. 1, p. 217

117 'Swinburne, with his red-gold' Julia Cartwright diary, 12 April 1909, Emanuel p. 299
'restless beyond words' G B-J vol. 1, p. 215

118 'I hate poems' E B-J to Elizabeth Lewis, early 1880s, quoted G B-J vol. 2, p. 135
'She was well enough' G B-J vol. 1, p. 207

119 'romance and tragedy' ibid. p. 208

120 'those first wonderful years' E B-J to Helen Mary Gaskell, late 1890s, private collection
'the Jewjube' E B-J to Algernon Charles Swinburne, c.1866, British Library
'mysterious and poetic' George Leslie, quoted Gladys Storey, *All Sorts of People*, 1929, p. 58

122 'a real work' Algernon Charles Swinburne to E. T. Cook, 1901, Lang vol. 6, p. 29
'I am sorry' John Ruskin to Ellen Heaton, 13 May 1862, *Sublime & Instructive: Letters from John Ruskin*, ed. Virginia Surtees, 1972, p. 243
'the natural yearning' E B-J to F. G. Stephens, 25 June 1885, Bodleian

123 'exquisite cartoons' George Boyce diary, 20 January 1860, Surtees p. 28
'Present to draw' ibid. 12 March 1860, p. 29
'It was the silliest' E B-J to Thomas Rooke typescript, 27 November 1895, NAL

124 'We'll have a model' J. P. Emslie, chapter on 'Art-Teaching in Early Days', *The Working Men's College 1854–1904*, ed. Revd J. Llewelyn Davies, 1904, p. 52
'He looked very splendid' A. M. W. Stirling, *The Richmond Papers*, 1926, p. 167

125 'a very tired' G B-J vol. 1, p. 227
'more a poem' Dante Gabriel Rossetti to Charles Eliot Norton, 9 January 1862, Fredeman vol. 2, p. 441
'a thin fresh air' G B-J vol. 1, p. 208

126 'The house was strongly built' ibid. p. 209
'a woman with red hair' Jane Morris to Wilfrid Scawen Blunt, Blunt diaries, 5 May 1892, Fitzwilliam

128 'sitting in a royal manner' Mackail vol. 1, p. 161
'the beautifullest place' E B-J quoted Mackail vol. 1, p. 159

129 'work of a genuine' Circular for Morris, Marshall, Faulkner & Co., Mackail vol. 1, p. 151
'He told me' George Boyce diary, 26 January 1861, Surtees p. 32

130 'We are organising' Dante Gabriel Rossetti to William Allingham, c.20 January 1861, Fredeman vol. 2, p. 343

131 'increased breathlessness' *Leeds Mercury*, quoted Penelope Fitzgerald, *Edward Burne-Jones*, 1975, p. 77
'wanting to see' William Michael Rossetti diary, 15 August 1861, *Ruskin: Rossetti: Pre-Raphaelitism: Papers 1854 to 1862*, 1899, p. 281
'I have never been' E B-J to Helen Mary Gaskell, 1893, private collection
'could do Gothic' W. R. Lethaby, *Philip Webb and his Work*, 1935, p. 73

133 'hung up' G B-J vol. 1, p. 220
'Her latest designs' Dante Gabriel Rossetti to William Allingham, 29 November 1860, Fredeman vol. 2, p. 333
'excited and melancholy' G B-J vol. 1, p. 220
'with a kind of soft' ibid. p. 223
'If you can come' Elizabeth Rossetti to Dante Gabriel Rossetti, *Three Rossettis: Unpublished Letters to and from Dante Gabriel, Christina, William*, ed. J. C. Troxell, 1937, p. 8

134 'By the bye' Dante Gabriel Rossetti to Georgiana Burne-Jones, June–July 1861, Fredeman vol. 2, p. 383
'Edward seems' unnamed female quoted G B-J vol. 1, p. 221
'either a little Ned' ibid. p. 229
'intellect was' ibid. p. 230
'the prettiest boy' E B-J to Cormell Price, 23 February 1862, TGA

135 'Was there ever' G B-J vol. 1, p. 231
'in good health' ibid. p. 237

136 'Edward is greatly' ibid. p. 238

CHAPTER 8 SOURCE NOTES
137 'did everything *en prince*' G B-J vol. 1, p. 239

'Jones is always' *The Correspondence of John Ruskin and Charles Eliot Norton*, ed. John Bradley and Ian Ousby, 1987, p. 59

'a hope long cherished' G B-J vol. 1, p. 237

'for art-purposes' *The Winnington Letters*, ed. Van Akin Burd, 1969, p. 331

138 'with wholesome chaff' G B-J vol. 1, p. 240

'I'm going to take' John Ruskin to Ellen Heaton, *c.*1862, *Sublime & Instructive: Letters from John Ruskin*, ed. Virginia Surtees, 1972, p. 239

139 'striding away' G B-J vol. 1, p. 241

'the fair-haired girl' ibid. p. 299

141 'All we true people' John Ruskin to Edward Burne-Jones, 27 December 1864, Fitzwilliam

'I have a vision' G B-J vol. 1, p. 243

142 'sorry to go' John Ruskin to Charles Eliot Norton, 28 August 1862, *The Correspondence of John Ruskin and Charles Eliot Norton*, ed. John Bradley and Ian Ousby, 1987, p. 72

'a kind of rough' G B-J vol. 1, p. 244

'this chance' ibid. p. 246

143 'Georgie and I' E B-J to Dante Gabriel Rossetti, 18 June 1862, Fitzwilliam

'Venice do look' ibid.

144 'smoothing the way' E B-J to John Ruskin, June 1862, Fitzwilliam

'a little head' G B-J vol. 1, p. 245

'once one of the noblest' Ruskin vol. 21, p. 203

'A sketch is a slight name' G B-J vol. 1, p. 246

145 'four rotten little sketches' ibid.

'The look of the pictures' ibid. p. 245

'very sad' ibid. p. 247

'confided much' ibid. p. 246

146 'waste of wild sea' John Ruskin, *The Stones of Venice*, vol. 2, 1853, chapter 2, 'Torcello'

147 'If the Stones of Venice' E B-J to Mary Gladstone, 1879, Fitzwilliam

'get men to row you' ibid.

'Georgie begins' G B-J vol. 1, p. 246

148 'quite as exact' ibid. p. 245

'two Christs' ibid. p. 247

'I am drawing' E B-J to Agnes and Louisa Macdonald, July 1862, Fitzwilliam

149 'in all the world' E B-J to Agnes Graham, 20 October 1876, private collection

'all green' John Ruskin diary, 19 July 1862, *The Diaries of John Ruskin*, ed. Joan Evans and J. H. Whitehouse, vol. 2, 1958, p. 564

'My dear' E B-J to John Ruskin, *c.*1887, Fitzwilliam

CHAPTER 9 SOURCE NOTES

150 'eleven years' E B-J to Helen Mary Gaskell, 27 March 1895, British Library

'Come and stay' G B-J vol. 1, p. 259

151 'as fine' George Boyce diary, 14 April 1860, Surtees p. 29
152 'in great activity' G B-J vol. 1, p. 249
'The Groves of Blarney' Christopher Frayling, *Henry Cole and the Chamber of Horrors*, Victoria and Albert Museum, 2008, p. 77
'may challenge' Dante Gabriel Rossetti to Charles Eliot Norton, 9 January 1862, Fredeman vol. 2, p. 441
154 'Mural Decoration' Mackail vol. 1, p. 151
155 'How I wish' John Ruskin to Lady Waterford, 8 August 1863, *Sublime & Instructive: Letters from John Ruskin*, ed. Virginia Surtees, 1972, p. 49
156 'You try all you can' John Ruskin to John James Ruskin, 12 August 1862, *The Winnington Letters*, ed. Van Akin Burd, 1969, p. 369
157 'I'm pleased' G B-J vol. 1, p. 260
'now she's got to be' John Ruskin to Miss Corlass, 20 February 1863, Tim Hilton, *John Ruskin* vol. 2, 2000, p. 53
158 'Miss Bell' G B-J vol. 1, p. 263
'scarcely more' ibid. p. 264
159 'deeply moved' ibid. p. 266
'already I have schemed' ibid. p. 267
'in uniforms of blue' ibid. p. 269
160 'I wonder Georgie' John Ruskin to Margaret Bell, 9 April 1864, *The Winnington Letters*, ed. Van Akin Burd, 1969, p. 486
'the joint embroidery scheme' G B-J vol. 1, p. 276
161 'and ever so many' John Ruskin to Edward Burne-Jones, G B-J vol. 1, p. 271
'I went off to Ned Jones's' William Allingham diary, 18 July 1864, Allingham p. 103
'chattering like a small magpie' G B-J to William Allingham, 14 October 1863, *Letters to William Allingham*, ed. H. Allingham and E. B. Williams, 1911, p. 126
'an unsightly little Israelite' William Michael Rossetti to Frances Rossetti, 1 September 1858, *Selected Letters of William Michael Rossetti*, ed. Roger W. Peattie, 1990, p. 99
162 'fair little Hebrew' A. M. W. Stirling, *The Richmond Papers*, 1926, p. 660
'the rising genius' G B-J vol. 1, p. 260
'a painstaking young enthusiast' George Du Maurier, *Trilby*, 2006, p. 88
'*chevalier de la triste figure*' George Du Maurier to Thomas Armstrong, 25 December 1864, Du Maurier p. 249
'simply an angel' George Du Maurier to his mother, March 1862, ibid. p. 120
'marvellously coloured paintings' George Du Maurier to his mother, February 1862, ibid. p. 115
163 'delightful Evening' George Du Maurier to Thomas Armstrong, May 1862, ibid. p. 136
'a stall' George Boyce diary, 16 August 1862, Surtees p. 35
'most exquisitely fitted' ibid. 30 April 1863, Surtees p. 38
'There is a painter' Baldwin Papers, Cambridge
'I can't imagine anything' G B-J vol. 1, p. 233

'I stopped' ibid. p. 218

165 'perhaps the most' Holman Hunt to George Dalziel, 21 November 1861, E. and G. Dalziel, *The Brothers Dalziel*, 1901, p. 162

'a room crowded' E. and G. Dalziel, *The Brothers Dalziel*, 1901, p. 164

166 'like an old sin' E B-J to Mr Dalziel, *c.*1880, British Library

'in engraving' G B-J vol. 1, p. 254

167 'latterly there appears' ibid. p. 272

'Disgusted at finding' George Boyce diary, 16 April 1864, Surtees p. 40

'the naughty boys' corner' Thomas Rooke to E B-J, 20 June 1896, Lago p. 107

'one ugly big brute' E B-J to Thomas Rooke typescript, 18 January 1896, NAL

168 'a bedstead' *Art Journal*, June 1864

'seems to shake' ibid.

169 'We have been down' G B-J to William Allingham, 24 May 1864, *Letters to William Allingham*, ed. H. Allingham and E. B. Williams, 1911, p. 127

'made a design' G B-J vol. 1, p. 277

170 'in order to lose' ibid. p. 279

'revived and amplified' ibid. p. 281

171 'incredible rashness' ibid. p. 281

'a distressing state' Hannah Macdonald diary, 5 November 1864, Worcester

'laid as deep' G B-J vol. 1, p. 282

172 'the babe I lost' G B-J to Mary Elcho, end 1892, Stanway

'the troubled waters' G B-J vol. 1, p. 282

'The news has struck' ibid.

'little shadowy babe' G B-J to Rosalind Howard, 11 February 1892, Castle Howard J22/27/183

'I am *so* glad' G B-J to John Ruskin, 14 December 1864, Fitzwilliam

'the Towers of Topsy' Dante Gabriel Rossetti to Ford Madox Brown, 23 May 1860, Fredeman vol. 2, p. 296

173 'As to our Palace' William Morris to E B-J, November 1864, Kelvin vol. 1, p. 38

CHAPTER 10 SOURCE NOTES

174 'tyrannously beautiful' John Lockwood Kipling, quoted Judith Flanders, *A Circle of Sisters*, 2001, p. 103

175 'nice rooms all' E B-J to William Allingham, late January 1865, *Letters to William Allingham*, ed. H. Allingham and E. B. Williams, 1911, p. 118

'delightfully large' Agnes Macdonald to Louisa Macdonald, 13 March 1865, Cambridge

176 'Enter Mr. John Simon' William Allingham diary, 29 June 1867, Allingham p. 153

'a loving little thing' Agnes Macdonald to Louisa Macdonald, 13 March 1865, Cambridge

177 'Our dear ones' ibid. 12 April 1865, Cambridge

'Just fancy' ibid. 13 April 1865, Cambridge

178 'pale handsome English wife' G B-J vol. 1, p. 292
'where if ever' ibid. p. 292
'ten times more' ibid. p. 293

179 'a magnificent mood' ibid. p. 293
'A Portuguese person' Linda Merrill, *Oxford Dictionary of National Biography* entry on Charles Augustus Howell, 2004
'He had the gift' E. R. and J. Pennell, *The Whistler Journal*, 1921, p. 59
'one who had come' G B-J vol. 1, p. 294

181 'Big Story Book' William Allingham diary, 1 August 1866, Allingham p. 139

182 'wonderfully delicate' Sydney Cockerell to May Morris, 8 June 1922, British Library
'scribbly work' G B-J vol. 1, p. 254

183 'Morris and Ned' Warington Taylor to Dante Gabriel Rossetti, autumn 1867, NAL

184 'elevate public taste' Barbara Morris, *Inspiration for Design*, 1986, p. 175
'He was wonderfully swift' W. R. Lethaby, *Philip Webb and his Work*, 1935, p. 249
'A very beautiful' Burne-Jones account book with Morris & Co., April 18 1865, Fitzwilliam

186 'amid one of the pleasantest' Barbara Morris, *Inspiration for Design*, 1986, p. 40
'there can' Martin Harrison and Bill Waters, *Burne-Jones*, 1973, p. 85
'living the life' G. C. Williamson, *Murray Marks and his Friends*, 1919, p. 84

187 'pet witches' John Ruskin to Ellen Heaton, 18 November 1863, *Sublime & Instructive: Letters from John Ruskin*, ed. Virginia Surtees, 1972, p. 251
'hated thoroughly' T. White, 'Albert Moore and the *DNB*', *Notes & Queries*, 10th series, no. 8, 1907

188 'His face was that' G B-J vol. 1, p. 296
'he bought pictures' Horner p. 5
'appearing and disappearing' G B-J vol. 1, p. 296
'I want to ask' William Graham to E B-J, *c*.1884, private collection

189 'The two men' E B-J to Frances Horner, *c*.1884, private collection
'a sort of dressing gown' Horner p. 9
'her features' Ruskin vol. 34, p. 152
'my heart has been full' E B-J to Frances Horner, August 1885, private collection

190 'Drive into London' Raleigh Trevelyan, *A Pre-Raphaelite Circle*, 1978, p. 236

191 'A little gloomy sulkiness' G B-J vol. 1, p. 294
'So Phil's conjecture' E B-J to Alice and Louisa Macdonald, June 1866, Cambridge
'growing rather grand' E B-J to John Ruskin, *c*.1866, Harvard
'the house' Penelope Fitzgerald, *Edward Burne-Jones*, 1975, p. 104

193 'young, fresh and eager' G B-J vol. 1, p. 303
'in the handsomest' William Rossetti diary, 23 April 1867, *Rossetti Papers 1862 to 1870*, 1903, p. 230

194 'I joined a number' George Boyce diary, 13 January 1866, Surtees p. 43
'a character' E B-J to George Howard, mid–1860s, Castle Howard J22/27/302
'went off very pleasantly' G B-J to Rosalind Howard, 31 August 1867, Castle Howard J22/27/207
'Owl behaved most prettily' G B-J to George Howard, August 1867, Castle Howard J22/27/423

195 'a veritable Apollo' G. C. Williamson, *Murray Marks and his Friends*, 1919, p. 160
'I do so love' E B-J to Algernon Charles Swinburne, Brotherton

196 'My dear but Infamous Pote' *From the Pines*, letters to Swinburne privately printed by T. J. Wise, 1919, British Library

197 'some eight or ten' E B-J to George Howard, 1 September 1866, Castle Howard J22/27/203
'by means of gloves' William Allingham diary, 5 September 1866, Allingham p. 143

198 'shrieking for joy' G B-J to Rosalind Howard, 31 August 1867, Castle Howard J22/27/207
'Tell me how' G B-J vol. 1, p. 305

11 The Grange, One 1868–71

12 Third Italian Journey 1871

13 The Grange, Two 1872

14 Fourth Italian Journey 1873

Georgiana Burne-Jones's memoirs are informative on day-to-day life at the Grange and descriptions of their visits are given by many leading artists and writers of the period. For a particularly vivid twentieth-century account see Penelope Fitzgerald's 'Life at The Grange', *Journal of the William Morris Society*, autumn 1998.

Apart from my retracings of Burne-Jones's Italian journeys, the main sources for these chapters come from his own records: Burne-Jones's notebook of his 1871 Italian journey now in the Museum of New Zealand, Te Papa Tongarewa, Wellington, and his sketchbook of the 1873 Italian journey in the Fitzwilliam Museum, Cambridge. A descriptive analysis of the 1873 sketchbook is given by Duncan Robinson in 'Burne-Jones, Fairfax Murray and Siena', *Apollo*, no. 102, November 1975.

On Holland Park Aesthetics: Caroline Dakers, *The Holland Park Circle: Artists and Victorian Society*, 1999; Charlotte Gere, *Artistic Circles: Design and Decoration in the Aesthetic Movement*, 2010.

On the Greek colony: Alexander C. Ionides, *Ion: A Grandfather's Tale*, 1927; Luke Ionides, *Memories*, ed. Julia Ionides, 1996; Julia Ionides, 'The Ionides Family', *Antique Collector*, June 1987; Charles Harvey and Jon Press, 'The Ionides Family and 1 Holland Park', *Decorative Arts Society Journal*, no. 18, 1994; David B. Elliott, *A Pre-Raphaelite Marriage: The Lives and Works of Marie Spartali Stillman and William James Stillman*, 2006.

On Maria Zambaco: Eileen Cassavetti, 'The Fatal Meeting, The Fruitful Passion', *Antique Collector*, March 1989; Philip Attwood, 'Maria Zambaco: *Femme Fatale* of the Pre-Raphaelites', *Apollo*, vol. 124, no. 293, July 1986; Elisa Korb, 'Models, Muses and Burne-Jones's Continuous Quest for the Ideal Female Face', *Hidden Burne-Jones*, 2007.

On Charles Fairfax Murray: David B. Elliott, *Charles Fairfax Murray: The Unknown Pre-Raphaelite*, 2000.

On George and Rosalind Howard: Christopher Ridgway, 'A privileged insider, George Howard and Edward Burne-Jones', *British Art Journal*, vol. 3, no. 3, 2002, which draws on the correspondence between the Howards and the Burne-Joneses in the Castle Howard Archives and Rosalind Howard's diary; Virginia Surtees, *The Artist and the Autocrat: George and Rosalind Howard*, 1988; Charles Roberts, *The Radical Countess*, 1962.

On Burne-Jones's commissions for the Howards: Bill Waters, 'Painter and Patron, The Palace Green Murals', *Apollo*, no. 102, November 1975; Katharina Wipperman, 'The Cupid and Psyche Series for 1 Palace Green', catalogue of exhibition *Edward Burne-Jones: The Earthly Paradise*, Staatsgalerie, Stuttgart, 2009; Arthur Penn, *St. Martin's: The Making of a Masterpiece*, David Penn, 2008.

On Arthur Balfour and the *Perseus* cycle: Anne Anderson and Michael Cassin, *The Perseus Series*, Southampton City Art Gallery, 1998; Fabian Fröhlich, 'The Perseus Series', catalogue of exhibition *Edward Burne-Jones: The Earthly Paradise*, 2009.

On Burne-Jones and Frances Graham (Lady Horner): Frances Horner, *Time Remembered*, 1933; Caroline Dakers, 'Yours affectionately, Angelo. The Letters of Edward Burne-Jones and Frances Horner', *British Art Journal*, vol. 2, no. 3, 2001.

On Burne-Jones and the Gladstones: ed. Lucy Masterman, *Mary Gladstone (Mrs. Drew): Her Diaries and Letters*, 1930; ed. Lisle March-Phillipps and Bertram Christian, *Some Hawarden Letters 1878–1913*, 1917; Sheila Gooddie,

Mary Gladstone: A Gentle Rebel, 2003.

On the background to Morris & Co.: Charles Harvey and Jon Press, *William Morris: Design and Enterprise in Victorian Britain*, 1991.

The Grange was demolished in 1957 to make way for the residential Lytton Estate. Of the eight 1970s tower blocks, one is named 'The Grange' and another 'Burne-Jones'. The Burne-Joneses' original bell pull at the Grange was, however, kept as a memento by Georgie's nephew Rudyard Kipling and can still be seen at the entrance of his house, Bateman's in East Sussex, which now belongs to the National Trust.

CHAPTER 11 SOURCE NOTES
199 '[I]t is called' E B-J to George Howard, 22 October 1867, Castle Howard J22/27/254
 'inseparably connected' G B-J vol. 1, p. 307
200 'and then I shall be' E B-J to George Howard, Castle Howard J22/27/254
 'The only two days' ibid. J22/27/343
201 'attached by mere obstinacy' George Du Maurier to his mother, October 1860, Du Maurier p. 20
202 'We were all there' E B-J to George Howard, 1867, Castle Howard J22/27
 'a wonderful head' E B-J to Helen Mary Gaskell, January 1893, British Library
203 'She really is' Dante Gabriel Rossetti to Jane Morris, 4 March 1870, Fredeman vol. 4, p. 389
204 '*à genoux*' Thomas Armstrong, *Thomas Armstrong, A Memoir*, 1912, p. 196
 'some thunder' Alexander Constantine Ionides, *Ion: A Grandfather's Tale*, 1927
 'Two things' G B-J vol. 1, p. 309
 'ease and tutoiement' George Du Maurier to his mother, October 1860, Du Maurier p. 31
 'glorious red hair' Alexander Constantine Ionides, *Ion: A Grandfather's Tale*, 1927
205 'Georgy, whose life' Violet Hunt, *The Wife of Rossetti*, 1932, p. 284
 'after marriage' E B-J to Lady Leighton, 16 November 1882, Cheshire
 'EBJ's surroundings' W. Graham Robertson to Kerrison Preston, 29 July 1942, *Letters from Graham Robertson*, ed. Kerrison Preston, 1953, p. 491
206 'a woman' William Michael Rossetti diary, 26 December 1870, Bornand p. 37
207 'a set of "furriners"' Jeanette Marshall diary, 1888, Zuzanna Shonfield, *The Precariously Privileged*, 1987, p. 118
 'born at the foot' E B-J to Helen Mary Gaskell, *c.*1893, British Library
 'You ask me' ibid. 18 January 1893, British Library
 'I was particularly' Dante Gabriel Rossetti to Jane Morris, 30 July 1869, Fredeman vol. 4, p. 217
208 'noble-looking' G B-J vol. 1, p. 302

'I was being turned' E B-J to Helen Mary Gaskell, c.1893, British Library
'The heads done' ibid. 1898, private collection

209 'peculiarly associated' G B-J to Charles Fairfax Murray, 5 December 1899, Rylands
'full dress party' William Allingham diary, 27 May 1868, Allingham p. 181

210 'their life' Charles Eliot Norton to John Ruskin, 19 September 1868, *The Correspondence of John Ruskin and Charles Eliot Norton*, ed. John Bradley and Ian Ousby, 1987, p. 116
'This year' G B-J vol. 2, p. 3
'I have been ill' E B-J to George Howard, September 1868, Castle Howard J22/27/279
'the object being' William Michael Rossetti diary, 24 July 1868, Bornand p. 320
'"And", said Howell' Helen Rossetti Angeli, *Pre-Raphaelite Twilight: The Story of Charles Augustus Howell*, 1954, p. 167

211 'Poor old Ned's affairs' Dante Gabriel Rossetti to Ford Madox Brown, 23 January 1869, Fredeman vol. 4, p. 147

212 'to see what' Rosalind Howard diary, 29 January 1869, Castle Howard J23/102/15
'He and Topsy' Dante Gabriel Rossetti to Ford Madox Brown, 23 January 1869, Fredeman vol. 4, p. 147
'been too weak' G B-J to Rosalind Howard, January 1869, Castle Howard J22/27/236
'I am very sorry' G B-J to Susan Norton, January 1869, Harvard
'thinking that Georgy' Rosalind Howard diary, 26 January 1869, Castle Howard J23/102/15

213 'tender thoughtfulness' G B-J to Rosalind Howard, January 1869, Castle Howard J22/27/326
'the like of' E B-J to George Howard, July 1871, Castle Howard J22/27/241
'how often I tried' E B-J to Frances Horner, 13 September 1892, private collection
'children and pictures' E B-J to Thomas Rooke typescript, c.1894, NAL

214 'but I agree' Agnes Poynter to Louisa Baldwin, 30 January 1869, Cambridge
'dearest George' E B-J to George Howard, early 1869, Castle Howard J22/27/325
'It feels funny' G B-J to Rosalind Howard, 24 February 1869, Castle Howard J22/27/218
'Indeed, my dear' G B-J to Rosalind Howard, 18 February 1869, Castle Howard J22/27/263
'Would Georgie?' E B-J to Helen Mary Gaskell, 9 March 1893, British Library
'frequent rushes' Rosalind Howard diary, 5 April 1869, Castle Howard J23/102/15

215 'Mrs. Jones sang' George Boyce diary, 10 April 1869, Surtees p. 50

'My dearest Ned' William Morris to E B-J, 25 May 1869, Fredeman
vol. 4, p. 76

'My dear Murray' William Morris to Charles Fairfax Murray, *c*.25 May
1869, Fredeman vol. 4, p. 76

216 'those stormy years' J. W. Mackail to Aglaia Coronio, 12 May 1899,
quoted *Times Literary Supplement*, 7 September 1951

'Once upon a time' E B-J to Charles Eliot Norton, 1869, Harvard

'looked as beautiful' Rosalind Howard diary, 18 November 1869, Castle
Howard J23/102/15

217 'the awful and deliberate' ibid. 26 January 1869, Castle Howard J23/102/15

'So off I went' ibid. 8 December 1869, Castle Howard J23/102/15

'I only want' Warington Taylor to Philip Webb, August 1869, NAL

218 'Why Mrs. Jones' Jeanette Marshall diary, quoted Philip Attwood, 'Maria
Zambaco: *Femme Fatale* of the Pre-Raphaelites', *Apollo*, vol. 124, no. 293,
July 1986

'Isn't Ned Jones's' Dante Gabriel Rossetti to Jane Morris, August 1879,
Bryson p. 110

'the idea' *The Times*, 27 April 1870

'fickle and repentant' *The World*, 22 September 1903

219 'a gentle and refined' G B-J vol. 2, p. 11

'I cannot look upon' ibid. p. 12

220 'The head of Phyllis' E B-J to Helen Mary Gaskell, 1893, British Library

'I think I have made' Dante Gabriel Rossetti to Jane Morris, 4 March
1870, Fredeman vol. 4, p. 389

'I like Mary' ibid.

221 'Dearest Madame Cassavetti' E B-J to Euphrosyne Cassavetti, 1870,
Cassavetti collection

222 'Gabriel says' William Michael Rossetti diary, 4 July 1871, Bornand
p. 320

'the charges' ibid. 3 January 1873, p. 224

'saying wouldn't I buy' Luke Ionides, *Memories*, 1996, p. 46

223 'they go about' E B-J to Charles Fairfax Murray, 14 July 1873,
Fitzwilliam

'as I went home' G B-J vol. 2, p. 18

'In every vain' Ruskin vol. 22, p. 104

'as the strength' ibid.

224 'You know more' E B-J to Charles Eliot Norton, 1871, Harvard

'trembly and sick' E B-J to Charles Fairfax Murray, 28 August 1871,
Fitzwilliam

'so as to go' G B-J to Rosalind Howard, 27 September 1871, Castle
Howard J22/27/229

'I can write' ibid.

CHAPTER 12 SOURCE NOTES

226 'Whoever finds' Burne-Jones sketchbook c.1870–5, Victoria and Albert Museum
'choose as you would' G B-J vol. 2, p. 20
'a little bright jewel' ibid. p. 19

227 'very clean' *Murray's Handbook for Travellers in Central Italy*, 1875
'a kind of distant Hastings' E B-J to Charles Fairfax Murray, 26 December 1871, Fitzwilliam
'the picturesque forms' *Murray's Handbook for Travellers in Central Italy*, 1875

228 'it's pretty of him' E B-J to Frances Graham, October 1876, private collection
'I belong to old Florence' E B-J to Charles Eliot Norton, 1871, Harvard
'I have travelled' Sidney Colvin, *Memories and Notes of Persons and Places*, 1921, p. 56

229 'most dear people' E B-J to Charles Fairfax Murray, 6 September 1873, Fitzwilliam
'I went to Orvieto' E B-J to Charles Eliot Norton, 1871, Harvard

230 'It isn't possible' G B-J vol. 2, p. 25
'The Renaissance in me' E B-J to George Howard, 1860s, Castle Howard J22/27/302

231 'he bought the best' G B-J vol. 2, p. 26
'Haman is perfect' Notebook of 1871 Italian Journey, Museum of New Zealand, Te Papa Tongarewa, Wellington

232 'are made for myself' ibid.
'No men or women' ibid.

233 'very ruined' ibid.
'A long narrow street' ibid.
'learned by heart' G B-J vol. 2, p. 26

234 'the most pure' ibid. p. 347
'a quiet beautiful' Notebook of 1871 Italian Journey, Museum of New Zealand, Te Papa Tongarewa, Wellington

235 'stole the lovely' ibid.
'I care most' ibid.
'the miserable feeling' E B-J to Charles Eliot Norton, 1871, Harvard
'certain friends' William Michael Rossetti diary, 30 October 1871, Bornand p. 120
'I quarrel now' E B-J to J. Comyns Carr, c.1872, quoted in catalogue of 1898 Burne-Jones Exhibition at New Gallery

CHAPTER 13 SOURCE NOTES

237 'I have sixty pictures' E B-J to Charles Eliot Norton, 1871, Harvard
238 'all my affairs' E B-J to Charles Fairfax Murray, 26 December 1871, Fitzwilliam
239 'seven blissfullest years' G B-J vol. 2, p. 13

240 'the richness and beauty' Charles Eliot Norton journal, 12 November
 1872, *Letters of Charles Eliot Norton*, ed. Sara Norton and M. A. de Wolfe
 Howe, vol. 1, 1913, p. 427
 'With Rossetti' E B-J to George Howard, July 1871, Castle Howard
 J22/27/24
241 'utterly broken down' E B-J to Charles Eliot Norton, 1872, Fitzwilliam
242 'She gave me none' William Morris to Louisa Baldwin, 12 June 1872,
 Fitzwilliam
 'I suppose you will' William Morris to Aglaia Coronio, 25 November
 1872, Kelvin vol. 1, p. 171
 'meretricious and so ugly' Philip Attwood, 'Maria Zambaco: *Femme Fatale*
 of the Pre-Raphaelites', *Apollo*, vol. 124, no. 293, July 1986
 'the one who hurt' E B-J to Helen Mary Gaskell, 1890s, private collection
243 'very stunning' George Du Maurier to Thomas Armstrong, 1873, Leonée
 Ormond, *George du Maurier*, 1969, p. 210
 'I want in gratitude' George Eliot to E B-J, 20 March 1873, *Selections from
 George Eliot's Letters*, ed. Gordon S. Haight, 1985, p. 414

CHAPTER 14 SOURCE NOTES
244 'a fountain' G B-J vol. 2, p. 35
 'the most beautiful' William Morris to Jane Morris, 6 April 1873, Kelvin
 vol. 1, p. 183
245 'all his life' G B-J vol. 2, p. 36
 'who can forget' A. M. W Stirling, *A Painter of Dreams*, 1916, p. 333
 'I say she is' A. M. W Stirling, *A Scrapheap of Memories*, 1960, p. 75
246 'a pretty house' E B-J to Philip Burne-Jones, G B-J vol. 2, p. 35
 'beyond any' E B-J to Thomas Rooke, 7 January 1896, Lago p. 77
 'but with far less' Mary Gladstone diary, 6 March 1874, Masterman p. 88
 'It was a great pity' E B-J to Thomas Rooke, 7 January 1896, Lago p. 77
 'a queer wild' William Morris to Emma Shelton Morris, 9 April 1873,
 Kelvin vol. 1, p. 184
 'the barbarous' ibid.
247 'the lemons and oranges' William Morris to Jane Morris, 6 April 1873,
 ibid. p. 183
 'Mind you' William Morris to Philip Speakman Webb, 10 April 1873,
 ibid. p. 185
 'captivated my heart' E B-J to Charles Eliot Norton, May 1873, Harvard
 'flowers painted naturally' Sketchbook of 1873 Italian journey, Fitzwilliam
248 'Left Murray' E B-J to Charles Eliot Norton, May 1873, Harvard
 'Italy breaks my heart' ibid.
 'I am writing' ibid.
249 'at Ravenna' E B-J to Agnes Graham, 20 October 1876, private collection
 'the fever' E B-J to Charles Fairfax Murray, 12 February 1874, Texas
 'the copy' ibid.
 'I haven't said' ibid. 6 October 1874, Texas

250 'She was very pale' Dante Gabriel Rossetti to Jane Morris, 2 December
 1877, Fredeman vol. 7, p. 457
 'Mary Z' ibid. 9 October 1879, Fredeman vol. 8, p. 356
251 'a favourite model' Charles Fairfax Murray to Samuel Bancroft, 13
 October 1895, Delaware Art Museum
 'There are only 2' Jeanette Marshall diary, November 1888, Zuzanna
 Shonfield, *The Precariously Privileged*, 1987, p. 161
 'Dear and ill-used friend' E B-J to Maria Zambaco, 3 February 1888,
 Cassavetti collection

15 The Grange, Three 1874–6

16 The Grosvenor Gallery 1877–80

17 Rottingdean, One 1881–2

18 The Grange, Four 1883

19 The Grange, Five 1884

20 Rome 1885

The papers of Sir George and Elizabeth Lady Lewis in the Bodleian Library in
Oxford and Burne-Jones's correspondence with Lady Leighton (later Lady
Leighton-Warren) in the Cheshire and Chester Archives provided particularly
useful background for these chapters. William Morris's Socialism is covered in
detail in my own biography *William Morris: A Life for Our Time*, 1994. The
catalogue of *The Earthly Paradise*, the exhibition held at the Staatsgalerie,
Stuttgart and the Kunstmuseum, Bern in 2009–10, is illuminating on the cycles
of paintings of this period, and the chapter on the Burne-Jones mosaics at St
Paul's Within-the-Walls could not have been written without seeing them in
Rome.

On the Grosvenor Gallery: ed. Susan P. Casteras and Colleen Denney, *The
Grosvenor Gallery: A Palace of Art in Victorian England*, 1996; Christopher
Newall, *The Grosvenor Gallery Exhibitions*, 1995; Virginia Surtees, *Coutts
Lindsay 1924–1913*, 1993; Leonée Ormond, *George du Maurier*, 1969.

On the Whistler vs Ruskin libel trial: Linda Merrill, *A Pot of Paint: Aesthetics
on Trial in Whistler v. Ruskin*, 1992; James A. M. Whistler, *The Gentle Art of
Making Enemies*, 1919; E. R. and J. Pennell, *The Whistler Journal*, 1921.

On North End House, Rottingdean: Angela Thirkell, *Three Houses*, 1931; ed.
Ian Hamerton, *W. A. S. Benson*, 2005.

On Kipling, Cormell Price and Westward Ho!: Rudyard Kipling, *Something of Myself*, 1937; Lorraine Price, ' "Uncle Crom": Kipling's Friendship with Cormell Price', *Kipling Journal*, March and June 1994.

On Burne-Jones, sea-nymphs and mermaids: see John Christian's essay in Christie's catalogue *Important British Art*, 14 June 2005, p. 106.

On Burne-Jones's engravings: *The Reproductive Engravings after Sir Edward Coley Burne-Jones*, catalogue by Julian Hartnoll with notes by John Christian and essay by Christopher Newall, 1988.

On Burne-Jones's jewellery and Whitelands College: Charlotte Gere and Geoffrey C. Munn, *Artists' Jewellery: Pre-Raphaelite to Arts and Crafts*, 1989; Malcolm Cole, *Whitelands College May Queen Festival*, 1981; Malcolm Cole, *Whitelands College: The Chapel*, 1985.

On Burne-Jones's mosaics: Richard Dorment, 'Burne-Jones's Roman Mosaics', *Burlington Magazine*, February 1978; Judith Rice Millon, *St. Paul's Within-the-Walls in Rome*, 1982; Colin Harrison and Christopher Newall, *The Pre-Raphaelites and Italy*, book accompanying their exhibition at the Ashmolean Museum, Oxford, 2010.

On the Hon. Percy and Madeline Wyndham and Clouds: Jane Abdy and Charlotte Gere, *The Souls*, 1984; Caroline Dakers, *Clouds: The Biography of a Country House*, 1993; chapter on 'Clouds' in Cynthia Asquith, *Haply I May Remember*, 1950.

On Eleanor Leighton (later Lady Leighton-Warren): Rosalyn Gregory, 'The History of a Commission: Eleanor Leighton-Warren and the Burne-Jones window in Tabley Chapel, Cheshire (1897)', *Journal of William Morris Studies*, no. 4, summer 2008.

On Sir George and Lady Lewis and Katie: John Christian introduction to *Letters to Katie from Edward Burne-Jones*, 1983; Lionel Lambourne, 'Paradox and Significance in Burne-Jones's Caricatures', *Apollo*, no. 102, November 1975; Richard Davenport-Hines, entry on Sir George Henry Lewis in *Oxford Dictionary of National Biography*, 2004.

The Grosvenor Gallery façade can still be identified, although the dramatic classical portico was demolished in 1925. Up to the early 1970s the original West Gallery, latterly known as the Aeolian Hall, was used as a BBC concert hall. None of the interiors survive in recognisable form.

Burne-Jones's mosaics at St Paul's Within-the-Walls in Rome are in good condition and can easily be viewed.

The Burne-Joneses' house at Rottingdean, later extended and known as North End House, is still privately owned.

CHAPTER 15 SOURCE NOTES

253 'Found him at home' George Boyce diary, 18 December 1873, Surtees p. 43
'now beginning' G B-J vol. 2, p. 45
'paradise' Rudyard Kipling, *Something of Myself*, 1937, p. 9
'Charles Faulkner' G B-J vol. 2, p. 46

254 'the beloved Aunt' Rudyard Kipling, *Something of Myself*, 1937, p. 12

255 'Georgie is tremendous' E B-J to George Howard, Castle Howard
J22/27/354
'Could you come' ibid. J22/27/153
'I could think' E B-J to Miss Stuart Wortley, Wightwick
'changing my three' G B-J to Rosalind Howard, 13 February 1876, Castle
Howard J22/27/34

256 'Pure water-colour' G B-J vol. 2, p. 62

257 'I can't manage' E B-J to Helen Mary Gaskell, Dimbleby p. 103
'Every Sunday' E B-J to Charles Eliot Norton, 1874, Harvard
'a pleasanter' Charles Eliot Norton to G. W. Curtis, 20 June 1869, *Letters
of Charles Eliot Norton*, ed. Sara Norton and M. A. de Wolfe Howe, vol. 1,
1913, p. 343

258 'not conducive' W. Graham Robertson, *Time Was*, 1931, p. 96
'How we came' G B-J vol. 2, p. 47
'dreadfulness and dearness' E B-J to Charles Eliot Norton, October 1871,
Harvard
'it will be easily' G B-J vol. 2, p. 47

259 'I wish you hadn't' Algernon Charles Swinburne to E B-J, 22 February
1875, Lang vol. 3, p. 17
'Today I carry' E B-J to Rosalind Howard, September 1874, Castle
Howard J22/27/298
'the Spartan mother' E B-J to Louisa Baldwin, 17 November 1874,
Cambridge
'after all dear' E B-J to Philip Burne-Jones, 29 September 1874, Fitzwilliam
'loss of daily sight' E B-J to Louisa Baldwin, 17 November 1874,
Cambridge

260 'monstrous fine gentleman' Philip Webb to Jane Morris, Christmas 1877,
British Library
'how much happier' E B-J to Philip Burne-Jones, 9 October 1874,
Fitzwilliam

261 'the ignominy' E B-J to Dante Gabriel Rossetti, 1874, Fitzwilliam

262 'the irascible' E B-J to Thomas Rooke, 7 May 1896, Lago p. 100
'As for Rossetti' E B-J to Charles Fairfax Murray, 14 August 1875,
Fitzwilliam

263 'one of those' *The Times*, 11 November 1872
'Have you heard' Dante Gabriel Rossetti to Ford Madox Brown, 19 April
1873, Fredeman vol. 6, p. 125

264 'a thing unmentionable' Algernon Charles Swinburne to Edmund Gosse,
15 October 1879, Lang vol. 4, p. 107

'sickened to death' Dante Gabriel Rossetti to Ford Madox Brown, 19
April 1873, Fredeman vol. 6, p. 125
'a remote neighbourhood' Robert Ross, *Masques and Phases*, 1909, p. 141
265 'You know, Simeon' Bernard Falk, *Five Years Dead*, 1938, p. 320
'Your loving friendship' E B-J to George Howard, 2 February 1876,
Castle Howard J22/27/50
266 'E B Jones' Rosalind Howard diary, 28 October 1872, Castle Howard
J23/102/15
'I went this morning' E B-J to Rosalind Howard, Castle Howard
J22/27/134
'Ned Jones says' Rosalind Howard diary, 15 November 1869, Castle
Howard J23/102/15
267 'a very good space' Philip Webb to George Howard, 6 September 1869,
Castle Howard J22/64/39
'some blank' Walter Crane, *An Artist's Reminiscences*, 1907, p. 167
'considerable freedom' ibid. p. 168
268 'I hope Crane' E B-J to George Howard, Castle Howard J22/27/324
269 'As to Palace Green' ibid. February 1882, Castle Howard J22/27/426
'the whole appears' *Studio*, 1898, p. 3
'a colossal work' Burne-Jones account book with Morris & Co., May 1880,
Fitzwilliam
'I am very glad' William Morris to George Howard, spring or summer
1881, Kelvin vol. 2, p. 40
270 'My Naworth journey' G B-J vol. 2, p. 50
271 'Plenty of cream' Blanche Dugdale, *Arthur James Balfour*, 1936, p. 191
'both him and his company' G B-J vol. 2, p. 235
'at once fell a prey' Arthur Balfour, *Chapters of Autobiography*, 1930, p. 233
'I have just had' E B-J to George Howard, Castle Howard J22/27/47
272 'his new friend' Arthur Balfour, *Chapters of Autobiography*, 1930, p. 233
'The whole room' E B-J to Arthur Balfour, 27 March 1875, British
Library
'The chief argument' ibid. 1875, British Library
273 'looking up' E B-J to Philip Burne-Jones, May 1875, Fitzwilliam
'All evening' G B-J vol. 2, p. 61
274 'She has often' ibid. p. 80
'grow as slowly' E B-J to Lady Leighton, 10 December 1892, Cheshire
'even if the pictures' E B-J to Arthur Balfour, 27 March 1875, British
Library
'My rooms are so full' E B-J to Charles Eliot Norton, 1880, Harvard
275 'the sharpest and most impudent' G B-J vol. 2, p. 127
'I cannot keep them' E B-J to G. F. Watts, TGA
'an artist' Charles Fairfax Murray to William Silas Spanton, March 1872,
quoted David B. Elliott, *Charles Fairfax Murray*, 2000, p. 25
'F has got such a beauty' Mary Gladstone diary, 14 February 1875,
Masterman p. 94

276 'When I was eighteen' Horner p. 26
'a leader' E. A. M. Asquith, *The Autobiography of Margot Asquith*, 1962, p. 134
'The new pet' John Ruskin to Sara Anderson, 5 January 1878, Bodleian

277 'a treat' Mary Gladstone diary, 6 March 1874, Masterman p. 89
'talked hard' ibid. 12 February 1875, p. 94
'at his designs' ibid. 25 June 1875, p. 97

278 'Very odd' Mary Gladstone to Lavinia Lyttelton, quoted in diary for 1879, ibid. p. 144
'Papa rushed off' Mary Gladstone diary, 4 September 1876, ibid. p. 109
'The summer' G B-J vol. 2, p. 73

279 'You see' E B-J to Rosalind Howard, Castle Howard J22/27/68
'I mustn't again' ibid. J22/27/87

CHAPTER 16 SOURCE NOTES

280 'seven blissfullest years' G B-J vol. 2, p. 13
'Burne-Jones goes on' George Eliot to Mrs Mark Pattison, 3 March 1876, *George Eliot Letters*, ed. Gordon S. Haight, vol. 6, p. 229

281 'From that day' G B-J vol. 2, p. 23
'Your plan' Dante Gabriel Rossetti to Charles Hallé, 27 January 1877, Fredeman vol. 7, p. 350
'As to the Grosvenor' E B-J to Dante Gabriel Rossetti, July 1876, Fitzwilliam

282 'I worked till Thursday' E B-J to Philip Burne-Jones, April 1872, G B-J vol. 2, p. 75
'all that London held' Louise Jopling, *Twenty Years of my Life*, 1925, p. 114
'The gallery is very splendid' Julia Cartwright diary, 16 May 1877, Emanuel p. 91

283 'wonder and delight' W. Graham Robertson, *Time Was*, 1931, p. 47
'sucks all the colour' G B-J vol. 2, p. 77

284 'mysteries and miracle pictures' *The World*, quoted Walter Crane, *An Artist's Reminiscences*, 1907, p. 174
'the lion of the exhibition' Henry James, *The Painter's Eye*, ed. John L. Sweeney, 1956, p. 144
'unintelligible puzzles' *The Times*, 1 May 1877

285 'It is the art' Henry James, *The Painter's Eye*, ed. John L. Sweeney, 1956, p. 144
'I expected' ibid. p. 161
'The B-Jones's are splendid' Mary Gladstone diary, 30 April 1879, Masterman p. 154

286 'have just begun' E B-J to Mary Gladstone, October 1879, British Library
'The picture is finished' G B-J vol. 2, p. 103
'deep-set, narrow eyes' F. G. Stephens, *The Athenaeum*, 8 May 1880

'he wanted everyone' G B-J vol. 1, p. 297

'a nice innocent damsel' E B-J to George Howard, Castle Howard J22/27

287 'a Grosvenor' Henry James, *The Painter's Eye*, ed. John L. Sweeney, 1956, p. 205

'craze' ibid. p. 182

'How beautiful a play' Luke Ionides, *Memories*, 1996, p. 60

288 'declared that the whole thing' George Du Maurier, *A Love-Agony*, *Punch*, 5 June 1880

289 'been practising' George Du Maurier, *Modern Aesthetics, Punch Almanack*, 1878

290 'the Sleeping Palace' W. Graham Robertson, *Time Was*, 1931, p. 73

291 'It is so easy' Julia Cartwright diary, 2 June 1878, Emanuel p. 102

'in their grave wisdom' W. Graham Robertson, *Time Was*, 1931, p. 75

292 'style in conversation' Dante Gabriel Rossetti to Jane Morris, February 1881, Bryson p. 173

'she had acted' E B-J to George Howard, late 1870s, Castle Howard J22/27/86

293 'like hotels' E B-J to Helen Mary Gaskell, 1894, private collection

'a simpler household' E B-J to Rosalind Howard, Castle Howard J22/27/158

'the worst possible thing!' E B-J to George Howard, August 1879, Castle Howard J22/27/130

'hateful nerves' ibid. J22/27/129

'the stupidest guest' ibid.

'The difficulty' G B-J vol. 2, p. 98

294 'I will not speak' Henry James, *The Painter's Eye*, ed. John L. Sweeney, 1956, p. 143

'For Mr. Whistler's own sake' John Ruskin, *Fors Clavigera*, 2 July 1877

'It's mere nuts and nectar' G B-J vol. 2, p. 86

'simply the only artwork' John Ruskin, *Fors Clavigera*, 2 July 1877

295 'the art of brag' E. R. and J. Pennell, *The Whistler Journal*, 1921, p. 325

'rather surprised' Walter Crane, *An Artist's Reminiscences*, 1907, p. 199

296 'the tiniest feet' Linda Merrill, *A Pot of Paint: Aesthetics on Trial in Whistler v. Ruskin*, 1992, p. 130

'trembled a good deal' E B-J to Joan Severn, 27 November 1878, *The Brantwood Diary of John Ruskin*, ed. Helen Gill Viljoen, 1971, p. 424

'painted some works' transcript of trial in Linda Merrill, *A Pot of Paint: Aesthetics on Trial in Whistler v. Ruskin*, 1992, p. 171

297 'never disliked anything' E B-J to George Howard, November 1878, Castle Howard J22/27/124

'I was like' E B-J to John Ruskin, 26 November 1878, *The Brantwood Diary of John Ruskin*, ed. Helen Gill Viljoen, 1971, p. 424

'Mr. Whistler has started' E B-J to Mary Gladstone, August/September 1879, British Library

298 'Really by the side' E B-J to Thomas Rooke, 16 December 1896, Lago
p. 124
'it means the ruin' E B-J to Mary Gladstone, 1 November 1879, British
Library
'joined by Burne-Jones' Avril Denton, 'W. A. S. Benson: A Biography',
chapter in *W. A. S. Benson*, ed. Ian Hamerton, 2005, p. 50
'I am not coming' *Oxford and Cambridge Undergraduates' Journal*, quoted
Tony Pinkney, *William Morris in Oxford*, 2007, p. 15

299 'at such a pace' *Cambridge Review*, quoted Tony Pinkney, ibid. p. 15
'it means more' E B-J to Mary Gladstone, *c.*24 November 1879, British
Library

300 'Her manner' Charles Eliot Norton to G. W. Curtis, 29 January 1869,
Letters of Charles Eliot Norton, ed. Sara Norton and M. A. de Wolfe Howe,
vol. 1, 1913, p. 319
'her heart' E B-J to Mary Gladstone, October 1879, British Library
'I never saw anyone' E B-J to George Howard, November 1878, Castle
Howard J22/27/124
'she met me' E B-J to Mary Gladstone, October 1879, British Library
'much torn' W. Graham Robertson, *Time Was*, 1931, p. 294

301 'to do battle' G B-J vol. 2, p. 103
'If it alters' ibid. p. 104
'strain of special sadness' George Eliot to E B-J, 20 March 1873,
Selections from George Eliot's Letters, ed. Gordon S. Haight,
1985, p. 414

CHAPTER 17 SOURCE NOTES

302 'No doubt you know' Dante Gabriel Rossetti to Jane Morris, February
1882, Bryson p. 173
'I knew that Ned' Jane Morris to Dante Gabriel Rossetti, 5 March 1881,
ibid. p. 175
'might run down' G B-J vol. 2, p. 109

303 'she said' E B-J to Lady Frances Balfour, Fitzwilliam
'expending his strength' G B-J vol. 2, p. 109
'play about' ibid. p. 81
'bespattered with blood' ibid.

304 'who march about' ibid.
'a fiasco of a holiday' ibid. p. 110
'creating a building' William Morris quoted W. A. S. Benson, *Notes on
Some of the Minor Arts*, 1883, p. 1
'a sitting-room' W. A. S. Benson, *Notes on Some of the Minor Arts*, 1883,
p. 2

305 'I have been wanting' E B-J to Kate Faulkner, September 1880,
Fitzwilliam

306 'the little funny place' E B-J to Canon Melville, 1894, Dimbleby p. 132
'of jewelled brilliance' Angela Thirkell, *Three Houses*, 1931, p. 123

'the dean of the Rottings' E B-J to Lady Leighton, 1888, Cheshire
'and other intimate' G B-J vol. 2, p. 123
'till all is blue' E B-J to Lady Leighton, 1887, Cheshire
'The housekeeper' ibid. 10 June 1887, Cheshire
'more prophetically true' ibid. 2 January 1888, Cheshire

307 'less interesting' ibid. 7 November 1889, Cheshire
'he does not seem' G B-J to Rosalind Howard, 22 January 1878, Castle Howard J22/27/113
'I feel as if' ibid. 6 May 1879, Castle Howard J22/27/135
'the small stranger' G B-J vol. 1, p. 230
'ploughed' Philip Burne-Jones to Mary Elcho, 16 July 1882, Stanway
'gone out' E B-J to F. G. Stephens, June 1885, Bodleian

308 'son of the painter' footnote to *Henry James Letters*, Edel vol. 3, p. 148
'the most glorious hat' E B-J to Rosalind Howard, Castle Howard J22/27/150
'a maiden I knew' Rudyard Kipling to Edmonia Hill, 13 July 1888, Pinney vol. 1, p. 252
'Sweet are the summer meadows' first published in *Coterie*, nos 6 and 7, winter 1920–1

309 'the kind of letters' Angela Thirkell, quoted Margot Strickland, *Angela Thirkell: Portrait of a Lady Novelist*, 1977, p. 159
'O Margaret!' E B-J to G. F. Watts, TGA
'exceptionally strong' G B-J to Charles Eliot Norton, January 1897, Harvard

310 'a plain, pink, thin boy' ibid. 20 September 1890, Harvard
'lean, slow-spoken' Rudyard Kipling, *Something of Myself*, 1937, p. 21

311 'low, soft drawl' ibid. p. 37
'the blaze is going' E B-J to Charles Eliot Norton, 1883, Harvard
'out on the downs' E B-J to Sidney Colvin, c.1882, Sidney Colvin, *Memories and Notes of Persons and Places*, 1921, p. 56
'so has the spirit' G B-J vol. 2, p. 127
'the little grey church' ibid. p. 124

312 'I hope you have' G B-J to Canon Melville, Dimbleby p. 131
'the most soothing' G B-J vol. 2, p. 118
'to be one soul' E B-J to Lady Leighton, 10 October 1882, Cheshire
'don't ask any one' ibid. 28 November 1882, Cheshire

313 'I am wildly excited' Lady Leighton to E B-J, 10 October 1882, Cheshire
'for alack' E B-J to Lady Leighton, 28 October 1882, Cheshire
'It was all like' G B-J vol. 2, p. 177

314 'many scenes of life' E B-J to Lady Leighton, 12 September 1882, Cheshire

CHAPTER 18 SOURCE NOTES

316 'crimson sleeves' G B-J vol. 2, p. 113

573

'everything was very kind' E B-J to Elizabeth Lewis, 22 June 1881,
Bodleian
'I want to come' G B-J vol. 2, p. 130

317 'Ruskin flourishes' E B-J to Charles Eliot Norton, 9 January 1883,
Harvard
'I'm so glad' G B-J vol. 2, p. 130
'this greatly gifted' Ruskin vol. 33, p. 297
'an outline' ibid. p. 301

318 'It should be a ground' ibid. p. 296
'At National Gallery' John Ruskin diary, 16 March 1883, Ruskin vol. 3,
p. 1048
'the great one' Ruskin vol. 33, p. 303
'I never did' Algernon Charles Swinburne to E B-J, 15 May 1883, Lang
vol. 5, p. 21

319 'some more cheerful' G B-J vol. 2, p. 129
'*the likeablest*' Malcolm Cole, *Whitelands College May Queen Festival*,
1981, p. 19

320 'You don't know' E B-J to John Ruskin, April 1883, Fitzwilliam
'gone where the hawthorn' John Ruskin to Simon Beevor, 28 May 1875,
Charlotte Gere and Geoffrey C. Munn, *Artists' Jewellery*, 1989, p. 130

321 'Sapphire is truth' Horner p. 121
'a P.B. neighbour' Lady Frederick Cavendish diary, 23–9 February 1880,
The Diary of Lady Frederick Cavendish, vol. 2, ed. John Bailey, 1927, p.
242
'a wonderfully nice' Henry James to Elizabeth Boott, 14 October 1883,
Edel vol. 3, p. 9
'so gentle' Emma Lazarus to Helena Gilder, *Emma Lazarus in Her World*,
ed. Bette Roth Young, 1995, p. 111
'The New Studio' Philip Burne-Jones to Mary Wyndham, 28 December
1882, Stanway

322 'Sir E. Burne-Jones' 'Legends – Sir E. Burne-Jones', *English
Contemporary Art*, part 2, 1898, p. 207
'Burne-Jones was' Mary Gladstone diary, 9 April 1883, Masterman p. 287
'a huge barrack' W. Graham Robertson, *Time Was*, 1931, p. 76
'a many coloured piece' Angela Thirkell, *Three Houses*, 1931, p. 22

323 'yelling infant' E B-J to Thomas Rooke typescript, 14 October 1895, NAL

324 'It was only after' Lady Frances Balfour, *Ne Oblivicaris*, 1930, p. 229
'he is so like' E B-J to Frances Horner, July 1894, private collection
'She is an Angel' G B-J to Sydney Cockerell, 17 December 1916, NAL

325 'imagined by its gifted' Jane Abdy and Charlotte Gere, *The Souls*, 1984,
p. 86
'Again and again' G B-J to Mary Elcho, 14 January 1889, Stanway

326 'All gone' Jane Abdy and Charlotte Gere, *The Souls*, 1984, p. 91
'I heard something' Dante Gabriel Rossetti to Jane Morris, 26 July 1881,
Bryson p. 182

'Brilliant, Formidable' Michael Smith, *The Grange: A Brief History of a House and Its Residents*, 1994, p. 8

'a strange woman' W. Graham Robertson to Kerrison Preston, 16 November 1921, *Letters from Graham Robertson*, ed. Kerrison Preston, 1953, p. 75

327 'I haven't chocolate cakes' E B-J to Elizabeth Lewis, 20 June 1881, Bodleian

'happy happy Walton' ibid. 16 February 1882, Bodleian

'a lovely creature' Elizabeth Lady Lewis, 'Recollections of Edward Burne-Jones', Bodleian

328 'This morning' E B-J to Philip Burne-Jones, May 1882, John Christian, intro. to *Letters to Katie from Edward Burne-Jones*, 1988, p. 22

'fascinating villainy' Oscar Wilde to Elizabeth Lewis, June 1882, *The Letters of Oscar Wilde*, ed. Rupert Hart-Davis, 1962, p. 95

329 'Katie, I have been' *Letters to Katie from Edward Burne-Jones*, ed. John Christian, 1988, p. 66

330 'She has to cover' ibid. p. 49

331 'He didn't know' E B-J to Thomas Rooke, November 1897, Lago p. 164

'fresh from Oxford' Alice Comyns Carr, *J. Comyns Carr: Stray Memories*, 1920, p. 129

'a kindly liking' Alice Comyns Carr, *Reminiscences*, 1926, p. 85

'I saw the wretched' Dante Gabriel Rossetti to Jane Morris, 1 October 1881, Bryson p. 188

'I must admit' William Morris to Jane Morris, 31 March 1881, Kelvin vol. 2, p. 38

332 'It seems to me' Oscar Wilde to William Ward, July 1878, *The Letters of Oscar Wilde*, ed. Rupert Hart-Davis, 1962, p. 52

'Oscar Wilde was very nice' E B-J to Elizabeth Lewis, 20 June 1881, Bodleian

'Mr. Oscar Wilde' Margaret Burne-Jones to Mary Wyndham, 1 January 1881, Stanway

'luckily' Alice Kipling to Rudyard Kipling, 18 March 1882, Lord Birkenhead, *Rudyard Kipling*, 1978, p. 106

333 'If you get sea-sick' Richard Ellmann, *Oscar Wilde*, 1987, p. 149

'I remember once' Oscar Wilde lecture, 9 January 1882, *Essays and Lectures*, 1908, p. 132

'I am going' Richard Ellmann, *Oscar Wilde*, 1987, p. 170

'my friend Oscar Wilde' E B-J to Charles Eliot Norton, 23 December 1881, *The Letters of Oscar Wilde*, ed. Rupert Hart-Davis, 1962, p. 123

'Was it funny of me' E B-J to Charles Eliot Norton, 9 January 1883, Harvard

'he knows little' ibid.

334 'It was like a dream' G B-J to Charles Eliot Norton, 26 January 1884, Harvard

'I haven't the heart' E B-J to Charles Eliot Norton, 9 January 1883, Harvard
'mildly chaffy indecencies' William Michael Rossetti to Theodore
Watts-Dunton, 20 December 1882, *Selected Letters of William Michael
Rossetti*, ed. Roger W. Peattie, 1990, p. 441

335 'Helephant' Hall Caine to George Bernard Shaw, 24 September 1928,
British Library
'after whom' E B-J to Helen Mary Gaskell, late 1890s, private collection
'Gabriel. His talk' G B-J vol. 2, p. 117

336 'tea at B-Js' Mary Gladstone diary, 18 November 1882, Masterman p. 274

337 'many a patient design' E B-J to John Ruskin, 15 March 1883, Fitzwilliam
'anything we specially loved' Mary Countess of Wemyss, *A Family
Record*, 1932, p. 25
'always I shall be' E B-J to Lady Elcho, Stanway

338 'the most shy' Mary Gladstone to Lord Rosebery, 29 July 1885, Sheila
Gooddie, *Mary Gladstone*, 2003, p. 190
'I assure you' E B-J to Lady Leighton, 25 December 1885, Cheshire
'I am glad' E B-J to Mary Gladstone, Sheila Gooddie, *Mary Gladstone*,
2003, p. 192
'I don't quite see' E B-J to Mary Gladstone, December 1885, British
Library
'Half-child, half Kelpie' Doll Liddell, quoted *The Letters of Arthur
Balfour and Lady Elcho*, ed. Jane Ridley and Clayre Percy, 1992, p. 21
'little witch' Laura Lyttelton diary, 10 September 1883, Nancy Crathorne,
Tennant's Stalk, 1973, p. 178
'with so much fuel' E B-J to Frances Horner, G B-J vol. 2, p. 148

339 'It is the sorrowfullest' G B-J vol. 2, p. 166

340 'peacock tomb' E B-J to Frances Horner, 1886, private collection
'We shall all feel it' E B-J to Mary Drew, 1886, British Library
'If you put' E B-J to Lady Elcho, 1888, Stanway

CHAPTER 19 SOURCE NOTES

341 'that is a type' E B-J to Helen Mary Gaskell, 1890s, private collection
'I work daily' E B-J to Frances Horner, c.1883, private collection

342 'look unappetizing' E B-J to Lady Leighton, 1883, Cheshire
'his finest thing' Henry James to Elizabeth Boott, 2 June 1884, Edel vol. 3,
p. 43
'roused mingled feelings' Isabel McAlister, *Alfred Gilbert*, 1929, p. 147
'This very hour' E B-J to Pamela Wyndham, 23 April 1884, G B-J vol. 2,
p. 139
'Technically speaking' F. G. Stephens, *The Athenaeum*, 3 May 1884

343 'one of the finest' *The Times*, 1 May 1884
'in the Crivelli manner' John Christian, *The Reproductive Engravings after
Burne-Jones*, 1988, p. 36
'The spirit which informs' Claude Phillips, *The Magazine of Art*, vol. 8,
1885

344 'rushed out to buy' Cynthia Asquith, *Haply I May Remember*, 1950, p. 83
'Oh, I say' *Punch*, 24 May 1884
'divergence of opinion' G B-J vol. 2, p. 139
'ministering to the swinish luxury' W. R. Lethaby, *Philip Webb and his Work*, 1975, p. 94

346 'polyticks is forbid' E B-J to Thomas Armstrong, *Thomas Armstrong, A Memoir*, 1912, p. 25
'river of fire' William Morris, 'The Prospects of Architecture', lecture 1881
'I never minded' E B-J to Thomas Rooke, 24 October 1896, Lago p. 118
'How can some men' E B-J to Mary Gladstone, 1883, British Library

347 'the artist's life' Sidney Colvin, *Memories and Notes of Persons and Places*, 1921, p. 59
'I shall never try' E B-J to Mary Gladstone, 1883, British Library
'a good deal of argument' Cormell Price diary, 6 January 1884, Lorraine Bowsher

348 'is always our dear Morris' G B-J to Charles Eliot Norton, 15 May 1886, Harvard
'unsped by sympathy' G B-J vol. 2, p. 193
'a University man' H. M. Hyndman, *The Record of an Adventurous Life*, 1911, p. 350
'who ought to have' E B-J to Thomas Rooke, 12 February 1896, Lago p. 92
'When he went' ibid.

349 'I sing paians' E B-J to George Howard, January 1885, Castle Howard J22/27/363
'why did he let himself' E B-J to Elizabeth Lewis, 1885, Bodleian
'I am an artist' *The Daily News*, 22 September 1885

350 'Please address' G B-J to Editor of *The Commonweal*, 30 September 1885, International Institute of Socialist History, Amsterdam
'If we are walking' G B-J to Charles Eliot Norton, 15 May 1886, Harvard

CHAPTER 20 SOURCE NOTES
351 'big things to do' G B-J vol. 2, p. 13
'the chance of working' ibid. p. 114

352 'the Yankee Episcopalians' G. E. Street quoted Richard Dorment, 'Burne-Jones's Roman Mosaics', *Burlington Magazine*, February 1978

353 'the Roman Church' E B-J to George Howard, February 1882, Castle Howard J22/27/426
'Dr. Nevin' E B-J to Mary Gladstone, *Some Hawarden Letters*, ed. Lisle March-Phillipps and Bertram Christian, 1917, p. 107
'I'm sure Heaven' E B-J to Agnes and Louisa Macdonald, G B-J vol. 1, p. 152

354 'an unthankful task' E B-J to Lady Leighton, 8 November 1883, Cheshire
'Gabriel with the lily' Angela Thirkell, *Three Houses*, 1931, p. 104

'It would be impossible' G B-J vol. 2, p. 141

355 'I hate travelling' E B-J to Mary Gladstone, July 1882, British Library
'Clouds – centre blue' E B-J to Giovanni Castellani of the Venezia-Murano Co., quoted Richard Dorment, 'Burne-Jones's Roman Mosaics', *Burlington Magazine*, February 1978

356 'O Rookie' E B-J to Thomas Rooke, 1884, G B-J vol. 2, p. 142
'Mosaic has come' E B-J to Thomas Rooke, 1 September 1884, G B-J vol. 2, p. 144
'I want to go on' E B-J to Frances Horner, June 1886, private collection

357 'a major work' Henry Russell-Hitchcock to J. R. Millon, 1982, archives of St Paul's Within-the-Walls
'VISIBLE, INTELLIGIBLE' E B-J to Thomas Rooke, 1884, G B-J vol. 2, p. 143

358 'I must have' E B-J to J. H. Dearle, 1898, A. C. Sewter, *The Stained Glass of William Morris and His Circle*, vol. 2, 1975, p. 91
'I love to work' G B-J vol. 2, p. 159
'it can't be sold' ibid.
'mighty Mosaic' E B-J to Lady Leighton, 23 June 1884, Cheshire

359 'all it has gathered' G B-J vol. 2, p. 160
'crushed and depressed' ibid. p. 219
'I couldn't face it' ibid.

21 The Royal Academy 1885–7

22 Rottingdean, Two 1888–9

23 Mells 1890–3

24 Kelmscott, One 1894–5

25 Kelmscott, Two 1895–6

26 Avalon 1897–8

27 Memorials 1898–1916

Epilogue: The Return of King Arthur 2008

Over this period, besides his wife's *Memorials*, Burne-Jones's daily movements and thoughts can best be gauged by the almost daily outpouring of his letters to Frances Horner and Helen Mary Gaskell, his beloved 'May'. An important additional source is the 'studio conversations' noted down by Burne-Jones's assistant Thomas Rooke from 1887 onwards, a selection from which was

published as *Burne-Jones Talking*, edited by Mary Lago, in 1982. A fuller typescript is in the National Art Library.

On Burne-Jones and the Royal Academy: see the official records in the Royal Academy library of Burne-Jones's humiliating failure to be elected a full Royal Academician.

On the New Gallery: Mrs J. Comyns Carr, *Reminiscences*, 1926.

On the *Briar Rose* cycle: John Christian, 'The Briar Rose Series', chapter in *Edward Burne-Jones: The Earthly Paradise*, book accompanying exhibition at the Staatsgalerie, Stuttgart, 2009.

On Burne-Jones and Arts and Crafts: Alan Crawford, 'Burne-Jones as a Decorative Artist', essay in catalogue *Edward Burne-Jones: Victorian Artist-Dreamer*, 1998.

On Burne-Jones and Frances Horner: Frances Horner, *Time Remembered*, 1933; Caroline Dakers, 'Yours affectionately, Angelo. The Letters of Edward Burne-Jones and Frances Horner', *British Art Journal*, vol. 2, no. 3, 2001.

On Burne-Jones and Helen Mary Gaskell: Josceline Dimbleby, *A Profound Secret: May Gaskell, Her Daughter Amy, and Edward Burne-Jones*, 2004.

On Morris & Co. tapestry: H. C. Marillier, *History of the Merton Abbey Tapestry Works*, 1927; Linda Parry, *William Morris Textiles*, 1983; Oliver Fairclough and Emmeline Leary, *Textiles by William Morris and Morris & Co. 1861–1940*, 1981; Helen Proctor, *The Holy Grail Tapestries*, 1997.

On the Kelmscott Press: H. Halliday Sparling, *The Kelmscott Press and William Morris Master-Craftsman*, 1924; William S. Peterson, *The Kelmscott Press: A History of William Morris's Typographical Adventure*, 1991; Paul Needham, Joseph Dunlap and John Dreyfus, *William Morris and the Art of the Book*, 1976; Duncan Robinson, *William Morris, Edward Burne-Jones and the Kelmscott Chaucer*, 1982; John Dreyfus, 'The Kelmscott Press', essay in *William Morris*, catalogue of Victoria and Albert Museum exhibition, 1996; 'Making of drawings for the Kelmscott Chaucer', May Morris amended Sydney Cockerell, 1922, British Library.

On Burne-Jones and Aubrey Beardsley: Matthew Sturgis, *Aubrey Beardsley*, 1998; Stephen Calloway, *Aubrey Beardsley*, 1998; Alan Crawford, entry on Beardsley in *Oxford Dictionary of National Biography*, 2004.

On Burne-Jones and Luke Ionides: Luke Ionides, *Memories*, with afterword by Julia Ionides, 1996; Violet Hunt, 'Luke Ionides: *Le beau Luc*', *Life and Letters*, June 1924.

On Burne-Jones's designs for *King Arthur*: Christine Poulson, 'Costume Designs by Burne-Jones for Irving's production of *King Arthur*', *Burlington Magazine*, January 1986.

On *The Sleep of Arthur in Avalon*: 'Avalon', chapter in Martin Harrison and Bill Waters, *Burne-Jones*, 1973; Alison Smith, 'The Return of the King', essay accompanying Tate exhibition, 2008.

On Burne-Jones and Sydney Cockerell: correspondence in National Art Library; Sydney Cockerell MS diaries, British Library; *Friends of a Lifetime: Letters to Sydney Carlyle Cockerell*, ed. Viola Meynell, 1940; Stella Panayotova, *I Turned It Into a Palace: Sydney Cockerell and the Fitzwilliam Museum*, 2008.

On later days at Rottingdean: Angela Thirkell, *Three Houses*, 1931; Rudyard Kipling, *Something of Myself*, 1937.

On Burne-Jones and Edward Poynter: Cosmo Monkhouse, 'Sir Edward Poynter', *Art Journal*, Easter 1897; Alison Inglis, entry on Sir Edward Poynter in *Oxford Dictionary of National Biography*, 2004; chapter on Poynter in Charles Saumarez Smith, *The National Gallery: A Short History*, 2009.

On Burne-Jones's reputation in Europe: Laurence de Cars, 'Edward Burne-Jones and France', essay in catalogue *Edward Burne-Jones: Victorian Artist-Dreamer*, 1998; Philippe Saumier, 'Edward Burne-Jones et la France: Madeleine Deslandes, une préraphaelite oubliée', *Revue de l'Art*, no. 123, 1999–2001; catalogue of Tate exhibition *The Age of Rossetti, Burne-Jones and Watts: Symbolism in Britain 1860–1910*, 1997. This was the exhibition that established Burne-Jones as a key figure in the wider context of European art.

On Burne-Jones's followers and later reputation: John Christian, 'A Critical Somersault', essay in catalogue *Edward Burne-Jones: Victorian Artist-Dreamer*, 1998; ed. John Christian, catalogue of Barbican Art Gallery exhibition *The Last Romantics: Burne-Jones to Stanley Spencer*, 1989; Richard Dorment, 'Realists and Romantics, Storytellers and Symbolists', essay in catalogue of Royal Academy exhibition *Pre-Raphaelite and Other Masters: The Andrew Lloyd Webber Collection*, 2003; Jeremy Maas, 'The Pre-Raphaelites: A Personal View', *Pre-Raphaelite Papers*, ed. Leslie Parris, 1984; Mary Lago, 'A Golden Age Revisited, Ernest S. Thomas and the Burne-Jones Centenary', *Apollo*, no. 102, November 1975.

The vast studio in which Burne-Jones worked on *The Sleep of Arthur in Avalon* still exists in what was then known as St Paul's Studios and is now 151 Talgarth Road, its former peace disturbed by the commotion of London traffic heading west. In the 1930s the Russian ballet master Nicolai Legat established his school there. Ballet classes were held in the studios. When Legat died in 1937 his body lay in state in the studio in which *Avalon* was painted, a peculiarly suitable change of use.

CHAPTER 21 SOURCE NOTES

360 'I have for the last year' William Graham to Lord Wharncliffe, April 1884, Oliver Garnett, *The Letters and Collection of William Graham, The Walpole Society*, vol. LXII, 2000, p. 169

361 'Representing as it does' ibid.
'He has always' William Graham to Lord Wharncliffe, 30 September 1884, ibid. p. 170
'I daresay it may' William Graham to E B-J, May 1885, ibid. p. 269

362 'Mr A. is now' ibid. p. 270
'They are very clever' William Graham to E B-J, June 1885, ibid. p. 273
'Agnew has just gone' ibid. 30 June 1885, p. 278
'When you write' ibid.
'The drawing room' Mary Gladstone diary, 20 July 1885, Masterman p. 360

363 'Fifty times a year' G B-J vol. 2, p. 155
'or meet the artists' ibid.
'If Laocoön's there' ibid. p. 158

364 'of white stone' ibid. p. 156
'Dear Ned' ibid. p. 150

365 'Don't say' ibid. p. 154
'he does not make' Henry James, *The Painter's Eye*, ed. John L. Sweeney, 1956, p. 170
'strange and without reason' E B-J to Frederic Leighton, G B-J vol. 2, p. 151

366 'As to the Academy' ibid. p. 154
'anxious dream' Frederic Leighton to E B-J, ibid. p. 152
'hard to thwart' E B-J to F. G. Stephens, June 1885, Bodleian
'So many of us' Joseph Edgar Boehm to E B-J, G B-J vol. 2, p. 153
'could help the cause' G. F. Watts to E B-J, 5 June 1885, TGA

367 'The fact is' Beatrix Potter diary, 4 June 1885, *The Journal of Beatrix Potter*, ed. Leslie Linder, 1966, p. 145
'Gentlemen, accept my thanks' E B-J to the Royal Academy, 9 June 1885, RA
'lost entirely' E B-J to Frances Horner, 1886, G B-J vol. 2, p. 165
'in providing' *The Times*, 1 May 1886

368 'a picture of importance' F. G. Stephens, *The Athenaeum*, 24 April 1886
'you would be amused' Rudyard Kipling to Margaret Burne-Jones, 17 June 1886, Pinney vol. 1, p. 135
'I wouldn't mind' E B-J to G. F. Watts, TGA

369 'It's a rude old habit' ibid.
'you on your part' E B-J to the President and Council, 10 February 1893, RA
'pain and distress' Sir Frederic Leighton to E B-J, G B-J vol. 2, p. 233
'because he was never' note on E B-J resignation, RA, 1893

370 'It is an honour' E B-J to Helen Mary Gaskell, 9 September 1893, British Library

'resume your old place' Alfred Hunt to E B-J, 2 November 1886, G B-J vol. 2, p. 169

'useless at all meetings' E B-J to Alfred Hunt, 3 November 1886, ibid. p. 170

'*You must come in*' Alfred Hunt to E B-J, 3 November 1886, ibid. p. 171

'Why on earth' ibid. p. 171

371 'lit the match' ibid. p. 179

'I am troubled' ibid. p. 180

372 'I suspect' E B-J to Frances Horner, Horner p. 113

373 'As to poor Lady Lindsay' E B-J to Lady Leighton, 16 October 1884, Cheshire

'I am a sombre' ibid. 13 November 1884, Cheshire

'Poor deserted Lady Lindsay' Mary Gladstone diary, 9 March 1883, Masterman p. 283

374 'smoking drinking' Charles Hallé to F. G. Stephens, 29 October 1887, Bodleian

'steadily and surely' G B-J vol. 2, p. 179

'it seems to me' E B-J to George Howard, November 1887, Castle Howard J22/27/369

375 'Yesterday I was with' Charles Hallé to F. G. Stephens, January 1888, Bodleian

'We shall have' ibid. 20 December 1887, Bodleian

376 'You will enter' E B-J to Lady Leighton, 15 February 1888, Cheshire

'My husband' Mrs J. Comyns Carr, *Reminiscences*, 1926, p. 162

'I have seen' G B-J vol. 2, p. 181

CHAPTER 22 SOURCE NOTES

377 'Ah, but *you* don't' G B-J vol. 2, p. 160

'with her *detached* exterior' Henry James to Charles Eliot Norton, 6 December 1886, Edel vol. 3, p. 147

378 'with her unawakened heart' G B-J to Charles Eliot Norton, 29 September 1887, Harvard

'a dream of loveliness' Mary Gladstone diary, 17 February 1888, Masterman p. 399

'the most complete' Cynthia Asquith, *Haply I May Remember*, 1950, p. 82

'grave learned' E B-J to G. F. Watts, 1888, TGA

'Did you ever' E B-J to Sebastian Evans, 3 February 1888, Fitzwilliam

379 'Here is my darling' E B-J to Lady Leighton, 3 February 1888, Cheshire

'I never thought' G B-J to Lady Leighton, 6 February 1888, Cheshire

'more long faced' E B-J to Lady Leighton, 16 July 1888, Cheshire

'peeping into rooms' ibid. 22 August 1888, Cheshire

380 'I daresay' G B-J vol. 2, p. 183

'tomorrow is the fatal 4th' E B-J to Rudyard Kipling, 3 September 1888, RCS

'pretty well' E B-J to Lady Leighton, 15 September 1888, Cheshire

'no scenes, no tears' Agnes Poynter to Louisa Baldwin, 5 September 1888, Cambridge

'a bush' E B-J to Frances Horner, 21 September 1888, private collection

381 'It is a perfect setting' Margaret Mackail to Charles Eliot Norton, 8 October 1888, Harvard

'the beautiful, hairy' E B-J to Lady Leighton, 22 August 1888, Cheshire

'as if that mattered' ibid. 8 August 1888, Cheshire

382 'I thought it was' E B-J to Thomas Rooke typescript, 7 January 1896, NAL

'didn't it occur' E B-J to Frances Horner, 13 September 1892, private collection

383 'His spirit lived' intro. to catalogue of Edward Burne-Jones Exhibition at New Gallery 1898

'He sitting stately' C. R. Ashbee, *Memoirs*, July 1887, NAL

'always been' E B-J to G. F. Watts, TGA

384 'great work' William Morris, 'The Revival of Handicraft', *The Fortnightly Review*, November 1888

'amongst some stuff' G B-J vol. 2, p. 190

'when the New Gallery' Rosalind P. Blakesley, *The Arts and Crafts Movement*, 2006, p. 61

385 'lauding it' E B-J to F. G. Stephens, 8 October 1888, Bodleian

'Certainly these men' Julia Cartwright diary, 13 November 1888, Emanuel p. 154

386 'the noblest' William Morris, 'Textiles', *Arts and Crafts Essays*, 1893

'I remember' G B-J to Alfred Stephens, 11 January 1905, Bodleian

387 'only one man' William Morris to Thomas Wardle, 14 November 1877, Kelvin vol. 1, p. 409

388 'Uncle Ned' William Morris to Jenny Morris, 28 February 1883, Kelvin vol. 2, p. 160

389 'Big tapestry's' E B-J to Thomas Rooke, 11 June 1896, Lago p. 105

'own peculiar vein' *Art Journal*, June 1891

390 'it would not be easy' William Morris to Wilfrid Scawen Blunt, 11 October 1890, Kelvin vol. 3, p. 219

'chance led my footsteps' Mrs Alice Hyde Oxenham, *World-literature*, March 1892, quoted Stephen Wildman and John Christian, *Edward Burne-Jones: Victorian Artist-Dreamer*, 1998, p. 296

'I do like Paddies' E B-J to Lady Leighton, 23 December 1890, Cheshire

391 'Burne-Jones and I' Henry James to Charles Eliot Norton, 25 March 1889, Edel vol. 3, p. 253

'he had a most beautiful' E B-J to Thomas Rooke typescript, 16 December 1895, NAL

392 'It is like' E B-J to Lady Leighton, 1 April 1889, Cheshire

393 'he lives a sublime life' ibid.

'period of reaction' G B-J to Charles Eliot Norton, 10 May 1889, Harvard

'delicate, unpretentious work' E B-J to G. F. Watts, 1888, TGA

'clever but rather "finicking"' Robert Browning to Robert Barrett Browning, 11 April 1889, *Letters of Robert Browning*, ed. Thomas J. Wise, 1933, p. 303

'Phil follows him' Henry James to Charles Eliot Norton, 25 March 1889, Edel vol. 3, p. 253

394 'the Fawcetts' E B-J to Lady Leighton, 19 June 1889, Cheshire
'a glorious wreck' Mary Drew diary, 9 July 1886, Masterman p. 391
'Under the apple tree' Jeanette Marshall diary, 9 July 1886, Zuzanna Shonfield, *The Precariously Privileged*, 1987, p. 118
'ancient malaria' E B-J to Lady Leighton, 5 July 1889, Cheshire
'Dined at the Burne Jones's' Rudyard Kipling to Edmonia Hill, 18 December 1889, Pinney vol. 1, p. 372

395 'the likelihood' G B-J to Charles Eliot Norton, 10 May 1889, Harvard
'a sanitorium' E B-J to Lady Leighton, 22 August 1888, Cheshire
'The magician's hand' E B-J to Frances Horner, 28 August 1889, private collection

396 'It is strange' G B-J to Charles Eliot Norton, 20 September 1890, Harvard
'it is good' E B-J to Lady Leighton, 9 August 1890, Cheshire
'rattle the dice box' E B-J to Lily Norton, 19 September 1889, Harvard
'full of' E B-J to Lady Leighton, 27 September 1889, Cheshire
'Georgie says' ibid. 4 June 1890, Cheshire

398 'the fag end' Walter Sickert, annotation on his copy of *Degas* by Paul Jamot, quoted Matthew Sturgis, *Walter Sickert*, 2005, p. 107
'What do they do?' E B-J to Thomas Rooke, 16 December 1896, Lago p. 122

399 'silent and beautiful' Robert de la Sizeranne, 'In Memoriam, Sir Edward Burne-Jones: A Tribute from France', *The Magazine of Art*, 1898
'enwrapped by' Fernand Khnopff, 'In Memoriam, Sir Edward Burne-Jones: A Tribute from Belgium', *The Magazine of Art*, 1898
'a dreary-lively dinner' Rudyard Kipling to Edmonia Hill, 25 December 1889, Pinney vol. 1, p. 375
'It was funny' G B-J vol. 2, p. 202
'I hate' ibid. p. 203

CHAPTER 23 SOURCE NOTES

401 'Work at Sleeping Beauty' G B-J vol. 2, p. 204
'thousands of the most' *The Times*, 18 June 1898

402 'she entered keenly' Julia Cartwright diary, 17 July 1890, Emanuel p. 162
'I wonder if' E B-J to Lady Leighton, 8 April 1884, Cheshire
'The briars have come' ibid. 16 October 1884, Cheshire
'My nearest approach' E B-J to Thomas Rooke, 9 March 1898, Lago p. 173

403 'I know so much' ibid.
'As to the Briar Rose' E B-J to Lady Leighton, 10 May 1890, Cheshire

404 'as if they had' G B-J vol. 2, p. 205
'After luncheon' Wilfrid Scawen Blunt, 'Secret Memoirs', 12 August 1892, Blunt Papers, Fitzwilliam
'which above all' E B-J notebook 1872, Fitzwilliam
405 'It's the old story' E B-J to Elizabeth Lewis, 1890, Bodleian
'Sometimes I have thought' ibid.
'When we betake' Horner p. 116
406 'I loved' Frances Horner to Edith Lyttelton, June 1898, private collection
'I felt a daughter' Horner p. 77
'I hate the country' Frances Horner to E B-J, 30 November 1894, private collection
'what I told you' E B-J to Frances Horner, November 1892, private collection
'it is hard' ibid. 19 June 1892
'you won't lose' ibid. 26 June 1892
407 'a seething pot' ibid. 25 June 1892
'fifty people ate her' E B-J to Helen Mary Gaskell, 21 August 1892, British Library
'I love you' E B-J to Frances Horner, 16 September 1892, private collection
'in the world' ibid. 17 September 1892
'tingling, trembling' ibid. 18 September 1892
408 'I'm travelling to Clouds' ibid. 6 October 1892
409 'shield things' ibid. 10 July 1892
'it is so nice' ibid. 10 October 1892
'I shall make up' ibid. 20 October 1892
'how shall we ever' ibid. 5 November 1892
'I am sick' ibid. 6 November 1892
410 'I keep thinking' E B-J to Helen Mary Gaskell, 26 October 1894, British Library
411 'I watched you' ibid. Dimbleby p. 124
'I don't think' ibid. 13 October 1894, British Library
'I have thought' ibid. Dimbleby p. 157
412 'Tomorrow about 5' ibid. winter 1892–3, British Library
'a profound secret' ibid. Dimbleby p. 84
'I'll write gently' ibid. p. 83
'I wish I could' ibid. 7 January 1894, private collection
413 'as Frances won't be' ibid. 26 October 1892, British Library
'she has no right' ibid. Dimbleby p. 163
'I gave you' ibid. p. 90
'this delicious' ibid. April–May 1893, British Library
'life days prettier' ibid. Dimbleby p. xxi
'off we'll go' ibid. p. 100
414 'one very delicious' Helen Mary Gaskell to Sir Alfred Milner, Dimbleby p. 148

'You said he wasn't' E B-J to Helen Mary Gaskell, Dimbleby p. 104

415 'He used to' Helen Mary Gaskell to Sir Alfred Milner, Dimbleby p. 148
'darlink dafny' E B-J to Daphne Gaskell, Dimbleby p. 105
'full of ancient souvenirs' E B-J to Helen Mary Gaskell, Dimbleby
p. 131

416 'as men drank' E B-J to Olive Maxse, catalogue of sale of correspondence,
Sotheby's, 4 July 1989
'It is change' E B-J to Helen Mary Gaskell, Dimbleby p. 112
'hadn't I better say' ibid. 11 August 1893, British Library

417 'the sorrow B. J. felt' Luke Ionides, *Memories*, 1996, p. 49
'the whole thing' E B-J to Charles Fairfax Murray, 22 August 1893,
Fitzwilliam
'Saturday night' E B-J to Helen Mary Gaskell, Dimbleby p. 112
'if only' Frances Horner to E B-J, August or September 1893, private
collection

418 'I was absolutely ignorant' E B-J to M. H. Spielmann, 30 September
1893, Wightwick
'these photographic processes' ibid.
'here and there' ibid.
'a kind of nervous' E B-J to Helen Mary Gaskell, 22 August 1893, private
collection

419 'there was an unhappy' ibid. Dimbleby p. 113
'there tonight I lie' ibid. p. 157
'a dark sort of wrap' Julia Cartwright diary, 2 December 1890, Emanuel
p. 164
'it's so ludicrous' E B-J to Lady Leighton, 20 May 1891, Cheshire

420 'the muscle has disappeared' G B-J to George Howard, 31 July 1891,
Castle Howard J22/27/388
'a thick wire' E B-J to Thomas Rooke typescript, 1 February 1895, NAL
'best easy chair' G B-J vol. 2, p. 235
'Oh I think' J. Comyns Carr, *Some Eminent Victorians*, 1918, p. 83

421 'Howell is *really* dead' Ellen Terry to W. Graham Robertson, Penelope
Fitzgerald, *Edward Burne-Jones*, 1975, p. 227
'Poor Harry Mac' E B-J to Crom Price, 13 July 1891, Lorraine Bowsher
'Today about noon' E B-J to Frances Horner, 16 October 1891, Horner
p. 105

422 'there should have been' G B-J vol. 1, p. 78
'He knew no middle way' G B-J vol. 2, p. 240

423 'He looks so like' Horner p. 116
'Paderewski on Thursday' G B-J vol. 2, p. 237
'a hand that clings' Horner p. 116

424 'It will be like' G B-J vol. 2, p. 230
'a peculiar sensation' ibid. p. 231
'I know' G. F. Watts to E B-J, 18 January 1893, TGA

426 'scarcely daring' G B-J vol. 2, p. 240

'third age' I am indebted to John Christian for introducing me to Anthony Storr's chapter on 'The Third Age', *The School of Genius*, 1988
'trumpet call' E B-J to Frances Horner, private collection

CHAPTER 24 SOURCE NOTES

427 'most "beciting" news' Venetia Benson diary, 5 February 1894, private collection
'the sanction' W. E. Gladstone to E B-J, 27 January 1894, G B-J vol. 2, p. 240
'I scarcely dare' E B-J to Helen Mary Gaskell, 1894, British Library
'The baronetcy' Jane Morris to Wilfrid Scawen Blunt, 12 March 1894, Fitzwilliam
'a great profession' W. E. Gladstone to E B-J, 27 January 1894, G B-J vol. 2, p. 240

428 'I do love Phil' E B-J to Helen Mary Gaskell, 1893, British Library
'seen to be pining' Venetia Benson diary, 5 February 1894, private collection
'I know you have' E B-J to Helen Mary Gaskell, 1893, British Library
'anything that Phil' E B-J to Mary Drew, November 1893, British Library
'Well, a man' Jane Morris to Wilfrid Scawen Blunt, 12 March 1894, Fitzwilliam
'started the idea' ibid.

429 'Oh let me' E B-J to George Du Maurier, Fitzwilliam
'Sad to see' G B-J vol. 2, p. 268
'The best way' ibid.

430 'old dream' ibid. p. 216
'went crazy' ibid. p. 217
'the most superbly' Algernon Charles Swinburne, quoted *William Morris* catalogue of 1996 V&A exhibition, p. 325

431 'I wonder' G B-J vol. 2, p. 217
'All the time' E B-J to Helen Mary Gaskell, Dimbleby p. 104
'he belongs' ibid. 16 January 1893, British Library
'something like' Julia Cartwright diary, 3 November 1895, Emanuel p. 197
'Magister Lapicida' G B-J vol. 2, p. 278

432 'especially he had' E B-J to Algernon Charles Swinburne, 3 August 1896, Brotherton
'looked so disappointed' E B-J to Helen Mary Gaskell, 1893, British Library

433 'I have just' ibid. November 1894, private collection
'we should have' E B-J to Arnold Dolmetsch, early 1894, Kelvin vol. 3, p. 118
'a large drawing' Sydney Cockerell diary, 30 November 1890, British Library

434 'Mr. Burne-Jones' William Morris to Frank (or Robert) Smith, 17 November 1893, Kelvin vol. 4, p. 108
'a house' William Morris to Georgiana Burne-Jones, 10 June 1890, Kelvin vol. 3, p. 164

'tapestry to go round' E B-J to Lady Leighton, 23 December 1890, Cheshire

435 'the most beautiful' A. B. Bence-Jones, *The Stanmore Tapestry. Some Notes on the Sanc Graal Arras*, 1893–5, typescript NAL
'handsome gentleman' G B-J vol. 2, p. 209

436 'Scolded him well' E B-J to Helen Mary Gaskell, private collection

437 'Oh my dear' E B-J to Frances Horner, Fitzwilliam
'a living power' G B-J vol. 2, p. 270

438 'There is *no* doubt' Aubrey Beardsley to A. W. King, 12 July 1891, A. W. King, *An Aubrey Beardsley Lecture*, 1924, p. 29
'like a silver hatchet' William Rothenstein, *Men and Memories*, 1931, p. 187
'not pretty enough' Matthew Sturgis, *Aubrey Beardsley*, 1998, p. 98

440 'he'd be precious glad' E B-J to Thomas Rooke, 18 March 1898, Lago p. 174
'unless it was' ibid. p. 175
'more lustful' ibid. 24 May 1898, p. 187

441 'all that horrid set' ibid. 18 March 1898, p. 174
'entirely invented' ibid. p. 175
'Dear Sir' E B-J to Rudyard Kipling, 1897, RCS

442 'I can't expect' G B-J vol. 2, p. 247
'We looked down' Margaret Mackail diary, 31 October 1894, G B-J vol. 2, p. 247

443 'one of his greatest' Mrs J. Comyns Carr, *Reminiscences*, 1926, p. 208
'it is curious' W. Graham Robertson, *Time Was*, 1931, p. 157
'I can't breathe' Ellen Terry, *The Story of My Life*, 1908, p. 350
'made very pretty' E B-J to Helen Mary Gaskell, British Library

444 'Moses and Aaron' Mrs J. Comyns Carr, *Reminiscences*, 1926, p. 207
'in a frenzy' E B-J to Helen Mary Gaskell, British Library
'catchpenny jingo' ibid.

445 'a very real' Mrs J. Comyns Carr, *Reminiscences*, 1926, p. 208
'splendid picture' Bernard Shaw, *Our Theatres in the Nineties*, vol. 1, p. 19
'while reciting' Augustus John, *Autobiography*, 1973, p. 381
'I don't know' E B-J to Helen Mary Gaskell, 1 April 1895, British Library

446 'artists must see' E B-J to Mary Gladstone, 19 May 1881, British Library
'sense of dilapidation' E B-J to Helen Mary Gaskell, 4 April 1895, British Library
'very much distressed' Venetia Benson diary, 5 April 1895, private collection
'I wish Beardsley' E B-J to Helen Mary Gaskell, 8 April 1895, British Library
'the poor wretch' ibid. 25 May 1895

447 'all my charming things' Oscar Wilde to Lord Alfred Douglas, early 1897, *The Letters of Oscar Wilde*, ed. Rupert Hart-Davis, 1962, p. 451
'And lo!' E B-J to Helen Mary Gaskell, 22 February 1896, British Library
'I should shake hands' E B-J to Thomas Rooke, 9 February 1897, Lago p. 132

'That is a splendid poem' E B-J to Elizabeth Lewis, March 1898, Bodleian

448 'Tomorrow Solferino' E B-J to Luke Ionides, collection Anthea Goldsmith (née Ionides)

'at the pot house' ibid.

'B. J. was enchanted' Luke Ionides, *Memories*, 1996, p. 47

449 'the Luke story' E B-J to Helen Mary Gaskell, 3 April 1895, British Library

'*le beau Luc*' Violet Hunt, 'Luke Ionides', *Life and Letters*, June 1924

'I never had' Luke Ionides, *Memories*, 1996, p. 49

'Luke has gone' E B-J to Helen Mary Gaskell, 1 March 1895, British Library

450 'but he is' ibid. 16 April 1895

'the brother' ibid. Christmas 1895

451 'men do' Luke Ionides, *Memories*, 1996, p. 93

452 'absolutely hated' Julia Cartwright diary, 8 July 1894, Emanuel p. 184

'a very bad painter' E B-J to Thomas Rooke, 11 May 1898, Lago p. 182

'An age that makes' ibid. 9 May 1896, Lago p. 102

'The colour' E B-J to Frances Horner, May 1896, private collection

453 'his art' ibid. 21 May 1896, private collection

'the expression' G B-J vol. 2, p. 140

'why pervade' *The Times*, 27 April 1895

454 'Such a solemn' E B-J to Helen Mary Gaskell, 1895, private collection

455 'those frogs' ibid. British Library

'the scent' quoted in sale catalogue, Christie's, 23 November 2005, lot 17, *Portrait of Baronne Madeleine Deslandes*

456 'painting dress' Thomas Rooke studio diary, 12 December 1895, Lago p. 65

'he has finished' G B-J to Lady Leighton, 26 February 1896, Cheshire

'I don't want it' E B-J to Helen Mary Gaskell, 1898, private collection

CHAPTER 25 SOURCE NOTES

457 'I sat between' E B-J to Helen Mary Gaskell, 11 May 1895, British Library

'What a rum affair' E B-J to Thomas Rooke typescript, 6 January 1896, NAL

'They used to tell' E B-J to Helen Mary Gaskell, June 1895, private collection

458 'There are scores' G B-J vol. 2, p. 298

'Do you know' E B-J to Frances Horner, G B-J vol. 2, p. 285

'very undesirably' E B-J to Helen Mary Gaskell, 9 August 1894, British Library

459 'she has grown' E B-J to Olive Maxse, catalogue of sale of correspondence, Sotheby's, 20 July 1989

460 'Do you know' G B-J to Lady Leighton, 14 June 1894, Cheshire

'Look, if ever' E B-J to Violet Maxse, March 1893, Viscountess Milner, *My Picture Gallery 1886–1901*, 1951, p. 36

'I think you are' E B-J to Violet Maxse, April 1893, sale catalogue of letters, David Brass, 2007

'And after' E B-J to Violet Maxse, 26 September 1893, Viscountess Milner, *My Picture Gallery 1886–1901*, 1951, p. 43

461 'Can anybody' ibid. 21 March 1894, p. 59

'happy Fortune' E B-J to Helen Mary Gaskell, Dimbleby p. 141

462 'I am so tired' ibid. 27 March 1895, British Library

'for she gets' ibid. *c*.1894

'just the very people' ibid. Dimbleby p. 94

'she excludes thus' E B-J to Elizabeth Lewis, 'Recollections of Edward Burne-Jones', Bodleian

'Georgie is sound' E B-J to Helen Mary Gaskell, 13 October 1895, British Library

'who is always' ibid. 9 August 1894

'I've been indoors' G B-J to the Countess of Carlisle, 12 October 1893, Castle Howard J22/27

463 'The skill and tact' G B-J vol. 2, p. 229

'Well now' William Morris to G B-J, 14 December 1894, Kelvin vol. 4, p. 241

'So luminously put' E B-J to Mary Watts, 17 December 1894, Fitzwilliam

464 'so pert and fierce' E B-J to Helen Mary Gaskell, 1 March 1895, British Library

'it is all right' ibid. 11 June 1895

'Morris has been ill' G B-J vol. 2, p. 277

465 'He is ill' E B-J to Helen Mary Gaskell, 22 February 1896, British Library

'they are going better' G B-J vol. 2, p. 276

'12 more designs' E B-J to Lady Leighton, 29 January 1896, Cheshire

'Finishing is such' E B-J to Thomas Rooke, 20 April 1896, Lago p. 98

'something glorious' ibid. 7 July 1896, Lago p. 109

466 'It doesn't matter' ibid. 15 July 1896, Lago p. 111

467 'I have worked' G B-J vol. 2, p. 278

'When Morris and I' ibid.

'without his heart' ibid. p. 269

'I have got' ibid. p. 270

468 'glorious it is' E B-J to Helen Mary Gaskell, private collection

'a pokey hole' E B-J to Thomas Rooke, 9 May 1896, Lago p. 100

'caving in' E B-J to Thomas Rooke, 15 July 1896, Lago p. 110

'full of misgivings' E B-J to Lady Leighton, 4 July 1896, Cheshire

'The voyage' ibid. 3 August 1896

469 'I don't think' E B-J to the Earl of Carlisle, 3 October 1896, Castle Howard J22/27

'Burne-Jones became' Charles Ricketts diary, 26 September 1902, *Self-Portrait of Charles Ricketts*, ed. Cecil Lewis, 1939, p. 82

'all their ideas' Wilfrid Scawen Blunt diary, 5 October 1896, Fitzwilliam

470 'E B-J standing' J. W. Mackail notebook, WMG

'The burial' E B-J to Helen Mary Gaskell, 9 October 1896, British
Library
'of course' G B-J to Sydney Cockerell, 11 October 1896, NAL
'flew at his work' G B-J vol. 2, p. 289
471 'what a church' E B-J to Helen Mary Gaskell, 1897, private collection
'ghost-ridden' G B-J vol. 2, p. 338

CHAPTER 26 SOURCE NOTES
473 'Avalon gets to look' E B-J to Dr Sebastian Evans, 29 June 1896,
Fitzwilliam
474 'he-fairies' E B-J to Lady Leighton, 8 November 1883, Cheshire
'When I begin' E B-J to Thomas Rooke, 11 June 1896, Lago p. 105
'designed under' E B-J to Lady Leighton, 8 November 1883, Cheshire
475 'They are queens' G B-J vol. 2, p. 141
'very wretched' E B-J to Thomas Rooke, 20 April 1896, Lago p. 98
'a new cheery doctor' G B-J vol. 2, p. 244
'Has anything come' E B-J to Helen Mary Gaskell, 1 August 1893, British
Library
476 'I grizzle' ibid. p. 283
'He looked' ibid. p. 303
'My love to' Mrs R. Barrington, *Life, Letters and Work of Frederic
Leighton*, vol. 2, 1906, p. 334
477 'Mr. Poynter' E B-J to Charles Fairfax Murray, 14 May 1875, Fitzwilliam
'The Lord' Rudyard Kipling to Charles Eliot Norton, 31 December 1896,
Pinney vol. 2, p. 280
478 'the fact' E B-J to Mary Drew, 21 August 1892, British Library
'this morning's news' E B-J to Mary Elcho, 1896, Stanway
'always wondered' Lady Tweedismuir, *The Lilac and the Rose*, 1952,
p. 57
'dull excellencies' E B-J to Frances Horner, 26 August 1892, private
collection
479 'Caught chill' E B-J to Thomas Rooke, 8 March 1897, Lago p. 159
'I always dislike' ibid. 25 May 1897, Lago p. 145
'in the worst' E B-J to Dr Sebastian Evans, 13 May 1897, Fitzwilliam
480 'The little house' E B-J to Helen Mary Gaskell, May 1898, private
collection
'I think' E B-J to Sally Norton, 28 September 1897, Harvard
'a little, very upright' Angela Thirkell, *Three Houses*, 1931, p. 50
'plunging and kicking' E B-J to Eva Muir, 9 June 1890, Fitzwilliam
'SHE calls "puppies"' E B-J to Katie Lewis, 22 January 1892, Bodleian
481 'the light of Avalon' Angela Thirkell, *Three Houses*, 1931, p. 60
'Papapa' Venetia Benson diary, 15 August 1891, private collection
'Cromwell's head' E B-J to John Ruskin, Fitzwilliam
'suited to no known' Angela Thirkell, *Three Houses*, 1931, p. 80
'cottage visits' ibid. p. 78

482 'the house' Caroline Kipling to Meta de Forest, 25 June 1897, Judith
 Flanders, *A Circle of Sisters*, 2001, p. 276
 'O my beloved' G B-J vol. 2, p. 312
 'browsed about' Rudyard Kipling to Charles Eliot Norton, 16–17
 December 1897, Pinney vol. 2, p. 324
483 'a poor thing' Angela Thirkell, *Three Houses*, 1931, p. 88
 'I love your Hymn' E B-J to Rudyard Kipling, 7 July 1897, RCS
 'that odious paper' E B-J to Mary Drew, 17 July 1897, British Library
484 'absolute innocence' Stanley Baldwin to Louisa Baldwin, April 1892,
 H. M. Hyde, *Baldwin*, 1973, p. 27
 'At lunch to-day' E B-J to Stanley Baldwin, Cambridge
 'there was not' G. M. Young, *Stanley Baldwin*, 1952, p. 23
 'stiff white piqué' Angela Thirkell, *Three Houses*, 1931, p. 124
485 'Beautiful Cissie' ibid. p. 106
 'it is the kind' G B-J vol. 2, p. 295
486 'Phil had many' Angela Thirkell, *Three Houses*, 1931, p. 66
 'He remains' G B-J to Charles Eliot Norton, 1 September 1897, Harvard
 'His father' G B-J to Lady Leighton, 28 March 1897, Cheshire
487 'I hear' Philip Burne-Jones to Charles Eliot Norton, 15 April 1898,
 Harvard
 'I'm not' E B-J to Thomas Rooke, 8 June 1897, Lago p. 147
488 'Avalon has travelled' E B-J to Helen Mary Gaskell, September 1897,
 British Library
 'alone and very nice' Sydney Cockerell diary, 7 October 1897, British
 Library
489 'Do you like it' E B-J to Thomas Rooke, 8 October 1897, Lago p. 161
 'That is your dinner' Sydney Cockerell diary, 7 December 1897, British
 Library
 'I think I have done' G B-J vol. 2, p. 318
 'Began a design' ibid. p. 331
490 'heartbreaking little friends' ibid. p. 326
 'Shouldn't I feel' ibid. p. 327
 'they do not' Sydney Cockerell diary, 19 July 1897, British Library
491 'by far the best' Julia Cartwright diary, 8 November 1894, Emanuel p. 191
492 'in the modern exhibition' E B-J to Thomas Rooke, 19 February 1897,
 Lago p. 137
 'People get tired' ibid. 26 October 1897, Lago p. 162
 'I must paint' ibid. 6 April 1898, Lago p. 178
 'in other respects' F. G. Stephens, *The Athenaeum*, 7 May 1898
 'no more to do' E B-J to Thomas Rooke typescript, 18 December 1895,
 NAL
493 'He felt the beat' Julia Cartwright diary, 21 May 1898, Emanuel p. 227
 'Nothing so happy' G B-J vol. 2, p. 340
494 'I shan't want' E B-J to Thomas Rooke, 20 May 1898, Lago p. 187
 'I am *at* Avalon' G B-J vol. 2, p. 340

'There was a great deal' ibid.

'yet again' E B-J to Mary Drew, 1896, British Library

495 'part of the beauty' ibid.

'harassed days' E B-J to Elizabeth Lewis, 30 April 1898, Bodleian

'So that great creature' E B-J to Thomas Rooke, 20 May 1898, Lago p. 187

'There is a clever' G B-J vol. 2, p. 304

'strange luminous eyes' William Sharp, obituary of Edward Burne-Jones, *Fortnightly Review*, August 1898

496 'the Cecils' Viscountess Milner, *My Picture Gallery 1886–1901*, 1951, p. 58

'lovely golden dress' Mrs Patrick Campbell, *My Life and Some Letters*, 1922, p. 127

497 'I am afraid' E B-J to Elizabeth Lewis, June 1898, Bodleian

498 'It was like' G B-J vol. 2, p. 345

'almost straight through' ibid. p. 346

499 'one of his wild' Rudyard Kipling to Charles Eliot Norton, 22 June 1898, Pinney vol. 2, p. 339

'tomorrow I shall go' E B-J to Helen Mary Gaskell, 16 June 1898, Dimbleby p. 166

'nameless fear' G B-J vol. 2, p. 350

500 'Edward changed' G B-J to Charles Eliot Norton, 19 June 1898, Harvard

CHAPTER 27 SOURCE NOTES

501 'that air' Sydney Cockerell diary, 23 June 1898, British Library

'I was sent for' Philip Burne-Jones to Charles Eliot Norton, 2 July 1898, Harvard

'only wishes' G B-J to Charles Eliot Norton, 28 June 1900, Harvard

'like a thunder clap' Edith Macdonald, *Annals of the Macdonald Family*, 1927, p. 59

502 'after mercifully brief' Louisa Baldwin diary, 17 June 1898, Worcester

'like some sort' Rudyard Kipling to Charles Eliot Norton, 22 June 1898, Pinney vol. 2, p. 338

'He was more' ibid. p. 339

'the Courts' Madeline Wyndham to Mrs Patrick Campbell, 17 June 1893, Mrs Patrick Campbell, *My Life and Some Letters*, 1922, p. 129

504 'Burne-Jones is dead' Wilfrid Scawen Blunt diary, 19 June 1898, *My Diaries*, vol. 1, 1980, p. 294

'I went off' Julia Cartwright diary, 17 June 1898, Emanuel, p. 228

'I think' Frances Horner to Edith Lyttelton, 1898, private collection

504 'the dear body' Louisa Baldwin diary, 18 June 1898, Worcester

'Come to draw' Thomas Rooke conversations, 20 June 1898, Lago p. 188

'there are' Rudyard Kipling to Charles Eliot Norton, 22 June 1898, Pinney vol. 2, p. 339

'a most dreadfully' Venetia Benson diary, 20 June 1898, private collection

'She was seeing' Rudyard Kipling to Charles Eliot Norton, 22 June 1898, Pinney vol. 2, p. 340

505 'old, old Mr. Ridsdale' ibid.
'the road was blocked' Mary Elcho diary, 21 June 1898, Stanway
506 'I am glad' Horner p. 110
'If you die' T. J. Cobden-Sanderson diary, 27 June 1898, *The Journals of Thomas James Cobden-Sanderson*, vol. 1, 1926, p. 375
'simply amazing' Henry James to Charles Eliot Norton, 26 December 1898, Edel vol. 4, p. 97
507 'no mobbing' Rudyard Kipling to Charles Eliot Norton, 22 June 1898, Pinney vol. 2, p. 341
'What *did* strike' ibid.
508 '[J]udging from the number' ibid.
'the kindest thing' E B-J to Thomas Rooke, 10 July 1896, Lago p. 109
509 'It is a godsend' Philip Burne-Jones to Charles Eliot Norton, 2 July 1898, Harvard
'Great crowd' Venetia Benson diary, 16 July 1898, private collection
'everything went' Henry James to Charles Eliot Norton, 26 December 1898, Edel vol. 4, p. 97
'a most glorious' Sydney Cockerell diary, 28 December 1898, British Library
'singular consistency' William Sharp, obituary of Edward Burne-Jones, *Fortnightly Review*, August 1898
510 'representative picture' Records of Burne-Jones Memorial Committee, 28 June 1898, Castle Howard J22/28
'if she received' Charles Hallé to the Earl of Carlisle, 3 January 1899, Castle Howard J22/28
'probably unite' W. A. S. Benson to the Earl of Carlisle, 9 January 1899, Castle Howard J22/28
511 'mind and soul' G B-J to the Earl of Carlisle, 7 August 1899, Castle Howard J22/27/405
'a thorough' Wilfrid Scawen Blunt to Sydney Cockerell, 4 January 1905, Cockerell p. 174
512 'thankful to have known' Sydney Cockerell diary, 23 June 1898, British Library
'slow weaning away' G B-J to Louisa Baldwin, 18 November 1898, Cambridge
513 'to discuss' Angela Thirkell, *Three Houses*, 1931, p. 79
'We have killed' ibid.
'Do not let us' G B-J to the Earl of Carlisle, 18 October 1898, Castle Howard J22/28/31
'those wonderful' G B-J to Charles Fairfax Murray, 2 October 1889, Rylands
514 'Your interesting' Vernon Lushington to G B-J, 16 January 1901, Fitzwilliam
'so like' G B-J to Charles Fairfax Murray, 23 June 1899, Rylands
515 'I turned' G B-J to May Morris, 6 September 1910, British Library

'a cairn' G B-J to Sydney Cockerell, 4 December 1902, NAL
'It is like' G B-J to Louisa Baldwin, 18 November 1898, Cambridge
'almost everything' G B-J to Charles Fairfax Murray, 16 November 1901,
Rylands
'I am not squeamish' William Michael Rossetti to G B-J, 8 November
1899, *Selected Letters of William Michael Rossetti*, ed. Roger W. Peattie,
1990, p. 621

516 'It was because' G B-J to Charles Eliot Norton, 12 July 1901, Harvard
'These things' Sydney Cockerell to G B-J, 17 November 1902, NAL
'still dizzy' G B-J to Sydney Cockerell, 28 May 1904, NAL
'I think' G B-J to Charles Eliot Norton, 28 November 1904, Harvard

517 'a little white wreck' Venetia Benson diary, 14 May 1904, private collection
'Now I have fallen' Wilfrid Scawen Blunt to Sydney Cockerell, 3
December 1904, Cockerell p. 171
'a real story' W. R. Lethaby, *Philip Webb and his Work*, 1935, p. 221
'beyond possibility' Wilfrid Scawen Blunt to Sydney Cockerell, 3
December 1904, Cockerell p. 171
'Lady Burne-Jones's' Charles Fairfax Murray to Sydney Cockerell, 16
April 1915, Cockerell p. 91
'She is still' G B-J to Sydney Cockerell, 1 March 1905, NAL

518 'how sobered' ibid. New Year's Eve 1917–18, NAL

EPILOGUE SOURCE NOTES

520 'I was very' G B-J to Sydney Cockerell, 29 October 1916, NAL

521 'a picture' The Earl of Birkenhead, quoted Horner p. 223
'Edward Horner' ibid. p. 225

522 'it's something' Rudyard Kipling to Brigadier L. C. Dunsterville, 12
November 1915, Pinney vol. 4, p. 345
'as if he had' G B-J to Sydney Cockerell, 31 January 1917, NAL

523 'certainly one of' A. C. Sewter, *The Stained Glass of William Morris and
His Circle*, vol. 2, 1975, p. 161
'I feel' G B-J to Sydney Cockerell, 17 March 1919, NAL

524 '28 January' diary of Annie, Louisa Baldwin's maidservant, Worcester
'her pretty head' Margaret Mackail to Sydney Cockerell, 3 February 1920,
NAL
'He looked' Virginia Woolf diary, 22 August 1929, *The Diary of Virginia
Woolf*, ed. Anne Olivier Bell, vol. 3, p. 248
'I didn't know' Philip Burne-Jones to Mr Wynne, 16 February 1920,
private collection

525 'Burne-Jones no longer' Siegfried Sassoon to Sydney Cockerell, 30
December 1923, Cockerell p. 34
'a national possession' Sir William Rothenstein, speech at opening of
Burne-Jones Centenary Exhibition, 16 June 1933, Maas Gallery

526 'rather sad' W. Graham Robertson to Kerrison Preston, 18 June 1933,
Letters from Graham Robertson, ed. Kerrison Preston, 1953, p. 290

'a gathering' Sir William Rothenstein to Max Beerbohm, June 1933, Clark Library, University of California at Los Angeles
'a stiff pigment' Thomas Rooke, 'Burne-Jones's Medium', note in catalogue of Burne-Jones Centenary Exhibition, 14 June–31 August 1933
'singular charm' Stanley Baldwin, speech at opening of Burne-Jones Centenary Exhibition, 16 June 1933, Cambridge

527 'S. B. is a Socialist' Rudyard Kipling to H. A. Gwynne, 26 August 1931, Pinney vol. 6, p. 50

528 'kept flickering' Robin Ironside, 'Comments on an exhibition of English drawings', *Horizon*, September 1944
'Nothing could be' Robin Ironside, 'Burne-Jones and Gustave Moreau', *Horizon*, June 1940

529 'a forlorn hope' W. Graham Robertson to Kerrison Preston, 18 June 1933, *Letters from Graham Robertson*, ed. Kerrison Preston, 1953, p. 291

530 'had begun increasingly' Jeremy Maas, 'The Pre-Raphaelites: A Personal View', *Pre-Raphaelite Papers*, ed. Leslie Parris, 1984, p. 233
'with its silky' John Pope-Hennessy, *Learning to Look*, 1991, p. 195
'The young' Robert Melville, *New Statesman*, 20 November 1970

531 'Rock 'n' roll' Andrew Lloyd Webber to Melvyn Bragg, *South Bank Show*, September 2003
'The romance' Jimmy Page interview, *Daily Telegraph*, February 2008

532 'a room of' James Stourton, *Great Collectors of Our Time: Art Collecting Since 1945*, 2007, p. 38

534 'as the greatest' Directors' foreword, *Edward Burne-Jones: Victorian Artist-Dreamer*, 1998, p. viii

535 'one of the great' Alison Smith, 'The Return of the King', essay accompanying exhibition, Tate 2008

536 'the Burne-Jonesiness' George Du Maurier to E B-J, 9 February 1893, Fitzwilliam
'Everything has to' E B-J to Thomas Rooke, 6 February 1896, Lago p. 29

Acknowledgements

My first acknowledgements are to the dead: to Burne-Jones's widow Georgiana, whose wonderfully intimate *Memorials* of her husband were published in 1904, and to my still lamented friend Penelope Fitzgerald, whose 1975 biography first aroused my serious interest in Burne-Jones and his life. Penelope had a phrase 'the squeeze of the hand' by which she meant an almost physical passing on of knowledge and enthusiasm from one generation to another. I like to think of this book being the squeeze of her hand onwards to me.

Of contemporary Burne-Jones experts, my great debt is to John Christian for his constant encouragement and to Stephen Wildman, Director of the Ruskin Library at the University of Lancaster. Their joint catalogue for the Burne-Jones centenary exhibition held in 1998 at the Metropolitan Museum of Art, New York, has been an invaluable resource.

Amongst Burne-Jones's descendants my special thanks go to Katherine and Serena Thirkell; Robert Thirkell; Sophia Kitson; Edward Ryde who produced Burne-Jones's painting smock for me; Charles Yorke who took me on a memorable expedition to Steyning to view the Burne-Jones room at Chantry House.

I need to acknowledge the following for their generosity in sharing their own research on Burne-Jones and in some cases transcribing letters for me: Eileen Cassavetti; Peter Cormack; Alan Crawford; Caroline Dakers; Josceline Dimbleby; Anthea Goldsmith; Julia Ionides; Meredith Lloyd-Evans; Douglas Schoenherr; Bill Waters. My long friendship with Professor Norman Kelvin, admirable editor of the William Morris letters, has been an enormous asset too.

The late Earl of Oxford and Asquith guided me around the many Burne-Jones works at Mells and Lady Gibson generously showed me her collection of nineteenth-century paintings and drawings. I am grateful to Hon. Simon Howard for permitting me to work with the Castle Howard Archives and to Lord Neidpath for giving me access to the collection at Stanway. Andrew Lloyd Webber kindly allowed me to spend a day alone with his Pre-Raphaelites at Sydmonton Court.

Whilst I was following Burne-Jones's Italian journeys Christopher Newall was my expert guide in Venice, Joachim Strupp in Florence and Norman Coady in central Italy. Pat Schleger assisted my search for Leyland's tomb in Brompton Cemetery. Peter Parker investigated and photographed Burne-Jones's splendid windows for St Paul's Cathedral, Calcutta, on my behalf.

I received valuable help from Stephen Calloway, Victoria and Albert Museum; Miss T. A. Clements, Wightwick Manor; Kasia Drozdziak, Brotherton Library, University of Leeds; Simon Fenwick, Archivist at the Royal Watercolour Society; Dr Peter Funnell, National Portrait Gallery; Peter Greenhalgh, Fitzwilliam Museum, Cambridge; Colin Harris, Bodleian Library, University of Oxford; Gilly King, Archivist, Whitelands College, University of Roehampton; Father Lawrence Maclean, St Mark's English Church in Florence; Peter Meadows, Cambridge University Library; Mark Pomeroy, Archivist at Marlborough College; Dr Christopher Ridgway, Curator, and Alison Brisby at Castle Howard; Victoria Robson, Museum of New Zealand Te Papa Tongarewa; Dr Terry Rogers, Archivist, Marlborough College; Jeff Saunders, Worcestershire County Council; the late Tessa Sidey, Birmingham Museums and Art Gallery; Alison Smith, Tate Britain; Philip Venning and Matthew Slocombe at the Society for the Protection of Ancient Buildings; the Revd Dr Michael Vono and Andrea d'Agosto, St Paul's Within-the-Walls, Rome; Alison Wheatley, King Edward the Sixth Schools, Birmingham.

The following friends and colleagues provided both specific suggestions and ongoing discussion – Ian Beck; Tim Burnett; Richard Calvocoressi; Julian Cassavetti; Roy and Jane Darke; David B. Elliott; Donato Esposito; Peter Faulkner; Suzi Feay; James Fergusson; Professor Sir Christopher Frayling; the Hon. Hugh Gibson; Annabel Gooch; Roger Harper; Birkin Haward; Mary Haynes; Bevis Hillier; Alan Hollinghurst; Virginia Ironside; James Joll; Joan Leach; Andrew Lycett; Rupert Maas; Jan Marsh; Penny Mittler; Adam Pollock; Christine Poulson; Charles Saumarez Smith; Maria Schleger; Frank Sharp; Richard Shone; Frances Spalding; John and Hilary Spurling; Virginia Surtees; David Taylor; Julian Treuherz; Nigel Viney; Marina Warner; Christopher Whittick.

I need to thank Michael Holroyd, without whom, for various complicated reasons, this book would not have happened and my dear friend Laura Hampton who once lived in William Morris's own house by the Thames.

In my own office Anna James gave valuable assistance in the early stages of research, Penny Lumb carried out the exacting task of transferring my handwritten text to digital, while Kristie Lawton and Amelia Parsons cross-checked the text prior to delivery. I have much appreciated their interest and support.

At Faber and Faber I would like to thank my editor Julian Loose, Kate Murray-Browne who saw this book so expertly through to publication and Ron Costley for his wonderfully sympathetic design. This is the fourth biography on which Ron and I have worked together. Merlin Cox copy-edited my text

immaculately and I am grateful for his constructive comments. Douglas Matthews has again provided a superlative index.

My indefatigable agent Michael Sissons has given me good advice at every stage.

For permission to quote from copyright material, my thanks go to the following descendants of Burne-Jones: Susan Hill; Georgiana Keane; Sophia Kitson; Michael McInnes; Simon M. C. McInnes; Edward Ryde; Robert Thirkell; Serena Thirkell; Thomas Thirkell.

Acknowledgements are also due to Lorraine Bowsher for quotation from the Cormell Price family papers; to Lord Neidpath for quotation from the Stanway Archive; to the Hon. Simon Howard for quotation from the Castle Howard Archive; to the Earl of Oxford and Asquith for quotation from his family papers; and to the Syndics of the Fitzwilliam Museum for quotation from the Burne-Jones papers.

Index